THE
EXPANDING DISCOURSE

THE
EXPANDING DISCOURSE

Feminism and Art History

EDITED BY

Norma Broude and Mary D. Garrard

IconEditions
An Imprint of HarperCollins*Publishers*

HarperCollins books may be purchased for educational, business, or sales
promotional use. For information, please write: Special Markets Department,
HarperCollins Publishers, Inc., 10 East 53rd Street, New York, NY 10022.

FIRST EDITION

Designed by Abigail Sturges

Library of Congress Cataloging-in-Publication Data

The Expanding discourse : feminism and art history / edited by Norma
 Broude and Mary D. Garrard.—1st ed.
 p. cm.
 Includes bibliographical references and index.
 ISBN 0-06-430391-8 (cloth) / ISBN 0-06-430207-5 (pbk.)
 1. Feminism and art. I. Broude, Norma. II. Garrard, Mary D.
N72.F45E96 1992
704'.042—dc20 91-58341

92 93 94 95 96 CC/CW 10 9 8 7 6 5 4 3 2 1
92 93 94 95 96 CC/CW 10 9 8 7 6 5 4 3 2 1 (pbk.)

CONTENTS

PREFACE

The twenty-nine essays assembled in this volume represent what is to our minds some—though certainly not all—of the best feminist art-historical writing of the last decade. In gathering materials for our first volume in 1981, we found ourselves literally working to define a new genre of art-historical investigation, one that was distinguished more by an attitude than by a methodology, and which had not yet been given a name or a clear identity. Our selections came from a wide array of sources: some were conference papers; a few came from the ground-breaking, now defunct *Feminist Art Journal;* others were unpublished. A surprising number of pieces came from published books and from mainstream journals such as *The Art Bulletin,* and many of these had not been written from a self-consciously feminist point of view. We pulled these disparate contributions—on topics and periods ranging from prehistory to the twentieth century—together into a new whole, to demonstrate the possibility of a continuous feminist perspective on art history in every cultural period.

A decade later, our task was entirely different. We were confronted by a rich harvest of scholarship in art history, nourished by new theoretical and critical perspectives and by the new interdisciplinary fields of "women's studies" and "gender studies." The problem now was what to select from that wealth of publications that might best represent its abundance, diversity, and main conceptual threads. One of our earliest decisions was to limit the scope of this volume to the period from the Renaissance to the present, since much of the work done by feminist art historians in the last decade has focused on this time span. We felt that the connections among the essays, as well as the usefulness of the book, would be strengthened by this chronological focus. And considering the plethora of examples of feminist art-historical scholarship in articles and essays, we also decided not to include any excerpts from books, nor examples of feminist art criticism. By now, these are exemplary categories in their own right. The former is represented, for example, by such publications as Whitney Chadwick, *Women Artists and the Surrealist Movement* (Thames and Hudson, 1985 and 1991); Lisa Tickner, *The Spectacle of Women: Imagery of the Suffrage Campaign, 1907–14* (University of Chicago Press, 1988); Gloria Feman Orenstein, *The Reflowering of the Goddess* (Pergamon Press, 1990), and H. Diane Russell, *Eva/Ave: Women in Renaissance and Baroque Prints* (National Gallery of Art, Washington, D.C., 1990, and The Feminist Press,

1991). The latter category is represented, for example, by Arlene Raven, Cassandra L. Langer, and Joanna Frueh, eds., *Feminist Art Criticism: An Anthology* (UMI Research Press, 1988, and HarperCollins, 1991).

Our selection has been guided as well by a distinction that is elusive but important. All of the essays included here take, in our view, a feminist as opposed to a gender-conscious approach to art and art history. Gender-focused analysis purports to aim for an even-handed exploration of sexual difference, and therefore proceeds from what appears to be a value-neutral position. For example, a recent trend in gender studies has been the investigation of "gendered subjectivity" as the underpinning for art movements that have been masculinist preserves, such as Abstract Expressionism and Minimalism. Such gender-conscious analyses may show us, by implication, how and why it was that women had no access to the Abstract Expressionist and Minimalist myths, but this is not their stated mission or goal. Their focus remains male centered, like the canonical art history that enshrined these styles in the first place, and whose values they now self-consciously name but still often tacitly accept and perpetuate. In looking at male subjectivity in isolation, such analyses leave untouched the cultural assumption that artistic agency is a male prerogative, thus reifying both the values and the power mechanisms of the styles in question. In a society still largely patriarchal and still gender imbalanced, such purported "neutrality," it seems to us, is premature and effectively pro-masculinist.

Feminist scholarship, on the other hand, proceeds from the recognition that our histories and the values that shape them have been falsified, because of the asymmetrical power positions of the sexes. Seeing the writing of history as a process of continual correction and expansion, feminist scholars find their mission in the need to "set things right." Their subject is not neutral material, but a nest of live distortions here, a basket of telling omissions there. Feminist scholars share a commitment to change history, by creating a fuller and more accurate account of the part played both by real women and by thematized and constructed Woman in its making. It is important, we believe, to sustain this feminist project as long as it serves a corrective need.

We extend our gratitude to the contributors to this book, first for their creative and ground-breaking work, but also for their enthusiastic support of this project and their cooperation in bringing this book to fruition. We are especially grateful for the trust and professional respect implied in the ready agreement, on the part of every contributor, to be included in a book whose contours were as yet unknown.

We are most deeply indebted to Cass Canfield, Jr., our editor at HarperCollins (and before its name change, Harper & Row). It is to Cass's extraordinary vision that both *Feminism and Art History* and *The Expanding Discourse* owe their existence, in the first case when his intuition proved more reliable than that of a substantial number of naysaying editors at other houses, and in the second case when he persuaded us of the need for a sequel volume. We have once again enjoyed the support and assistance of the admirable professional staff at Harper, especially Bronwen Crothers, Bitite Vinklers, and our designers, C. Linda Dingler and Abigail Sturges.

And, once again, we thank one another, for inspiration and criticism, patience and tolerance, creative differences and constructive disagreements, and for the joys and pleasures of a fruitful collaboration.

INTRODUCTION: THE EXPANDING DISCOURSE

NORMA BROUDE AND MARY D. GARRARD

A decade ago, the forerunner of this book was published, *Feminism and Art History: Questioning the Litany,* the first collection of feminist art historical essays to appear in the United States. At that time, when the feminist enterprise in art history was popularly understood to mean the rediscovery of forgotten women artists and their introduction into the established canon, we considered it important to emphasize that our book was "not about women artists," but "about Western art history and the extent to which it has been distorted, in every major period, by sexual bias." Feminism, we maintained, "has raised other, even more fundamental questions for art history as a humanistic discipline, questions that are now affecting its functioning at all levels and that may ultimately lead to its redefinition."[1] The twenty-nine essays collected in the present volume bear eloquent witness to the impact that feminism has had upon the enterprise of art history over the last ten years, an effect we have compared to "a fresh wind . . . which, blowing pervasively throughout, might set in motion profound rearrangements of the values, categories, and conceptual structures of our field."[2]

Along with feminism, one of the greatest influences upon the practice of art history in the 1980s

has been the advent and application of postmodern theory. Most of the essays in this book have been touched in one way or another by the new critical standpoints and tools of analysis introduced in the United States in the 1970s and 1980s under the banner of postmodernism, a practice that embraces many of the concerns that were central to the essays in *Feminism and Art History,* while providing new linguistic structures with which to express them. For this reason, we begin with an overview of the postmodern critique of traditional art history, a critique largely shared with and in part introduced by feminism. We will then consider the ways in which feminist art-historical practice in the last decade has simultaneously extended and challenged the tenets of postmodernism, both in general terms and in specific application to the essays selected for this volume.

About a decade ago, under the powerful influence of French poststructuralist writers—Foucault and Derrida, especially—and of semiotic and psychoanalytic theory, a critique of the tenets and practices of art history was mounted from both inside and outside the discipline. Foucault's analysis of the role of power in the construction of

knowledge, and his identification of the body as the site of the operations of power; Derrida's characterization of history and culture as not fixed unchanging realities but texts, unstable and subject to an infinite variety of readings, and his description of our understanding of all reality as mediated by language, itself polyvalent; Lacan's thesis that even the unconscious is shaped by language—all these ideas and more converged to fuel the deconstructive enterprise of the 1980s, led by but not limited to practitioners of literary criticism.[3] To be deconstructed were the patterns and edifices of power, predicated linguistically and socially upon binary oppositions and their implied hierarchies of value. To replace them came nonhierarchic structures, the questioning of "totalizing" theories and other agendas of mastery, "difference," the emphasis on the role of the interpreter in the creation of meaning, the "death of the author," and the problematizing of the very concepts of "representation" and "interpretation."[4]

The postmodern skepticism about absolute values, truth claims, and universalizing explanations has most strongly influenced those humanistic disciplines with rationalist and positivist roots in Enlightenment thinking. In art history, as in philosophy, history, and literature, such concepts as the following have been sharply under attack: the idea that there are stable, unchanging realities or truths to be uncovered by reason; belief in the objectivity and neutrality of scholarship; the positing of mechanical models to explain the relationships of art works to one another (for example, "influence," "context"); belief in the reality of a framework of abstractions that orders the relationships of art and artists (period labels, style developments); belief in art as a discrete category, a transcendent discourse, whose relation to other discourses (for example, history) can be defined without violation of its own borders.

Postmodernism,[5] pointing to the socially constructed nature of labels and categories, has seen as problematic that which had previously been assumed. The "author" or artist ("Shakespeare," "Van Gogh") is not a simple designation but a description, something that is produced by culture, and that trails characteristics and associations. The concept "author" is not identical with the human individual who bore that name; rather, it is a set of meanings generated around that name. And since the process of producing an "author" necessitates countless decisions and exclusions by biographers or art historians, "what counts as authorship is determined by 'interpretative strategies.' "[6] Similarly, one cannot speak unproblematically of the "meaning" of a work of art, for whereas traditional art history has assumed it to be possible to reconstruct original meaning, in its own time and according to the artist's intentions, contemporary semiotic theory does not privilege artists' intentions. In this view, art works do not have fixed meanings, but a multiplicity of meanings depending on audiences (receivers), and there is no fixed priority among the different meanings that the image has had as a "signifier," at different times or at the same time to different people. Nor can one resort to explaining a work of art in terms of its historical "context," for if the "text" (work of art) cannot offer a stable meaning, it cannot be assumed that what makes up the "context" (really, only a collection of texts) is any clearer or more legible than the visual text.[7]

In art history, as in literature, postmodern ways of thinking have sustained a profound questioning of some basic evaluative absolutes, among them the concept of quality in art, artistic genius, and the canon of great art and artists. It is important to note, however, that these formerly hallowed principles were first identified as ideological constructs in the 1970s and early 1980s by such feminist art historians as Linda Nochlin, Carol Duncan, and Lise Vogel, who exposed the inherent bias of the genius mystique, pointing to the elevation of males and the exclusion of females inherent in art history's standards of value.[8] In the early 1980s, feminists became concerned with the instrumental role played by art and art history both in preserving masculine power and in constructing and consolidating gender difference. In 1981, Griselda Pollock and Rozsika Parker wrote:

To discover the history of women and art is in part to account for the way art history is written. To expose its

underlying values, its assumptions, its silences and its prejudices is also to understand that the way women artists are recorded is crucial to the definition of art and artist in our society.[9]

And in 1982, in the Introduction to *Feminism and Art History,* we said:

To reexperience art from a feminist perspective will also mean in many cases to divorce it from the ivory tower context of pure, aesthetic, and "universal" values, and to see it not as a passive reflector of social history but as a tool that can be and has been used in every historical period as a powerful social force. Several of the essays in this book reveal the extent to which art, through its imagery and its associations and through its cultural status, has functioned as an instrument of sex-role socialization, helping to create and reinforce a norm of social behavior for women in a patriarchal world.[10]

While feminist art historians in North America first formulated their challenges and arrived at their conclusions by way of the women's movement and social activism, British feminist art historians and film critics found inspiration and support for their critical practice in the tenets of Marxism and in the work of French feminists such as Hélène Cixous, Julia Kristeva, and Luce Irigaray, whose writings (preceded by those of Simone de Beauvoir) were helping to connect structuralist and poststructuralist thought with the concerns of feminism.[11] Although poststructuralist theory had generally ignored the dimension of gender,[12] the feminist application of poststructuralist methodologies—specifically, their analyses of power, their recognition of the "prisonhouse of language" (in Fredric Jameson's phrase) that helps enforce sexual oppression, and their skepticism about universal values—helped to foster the analysis of gender as a socially constructed category. Above all, poststructuralist theory gave feminism a valuable intellectual framework within which to articulate the largely experiential insights of its first wave. And, specifically because of its concern with other than gender issues, poststructuralism provided a broader basis for challenging patriarchal discourses. Two concepts in particular proved invaluable for the feminist enterprise: Ferdinand de

Saussure's analysis of "difference," or the inclusion of an implied opposite in the definition or meaning of a given term (as in masculine-feminine), and Derrida's identification of such binary oppositions as inherently hierarchic within the Western tradition.[13]

As a result, throughout the 1980s, feminist art historians on both sides of the Atlantic became more self-conscious about the theoretical bases for their practice, a practice that has increasingly intersected with and drawn upon the tenets and strategies of Marxism, structuralism, semiotics, psychoanalytic theory, and film theory. This has led many writers to focus not on artists or art objects, but on the systems that produced them both. In neo-Marxist and poststructuralist terms, for example, art and art history have been analyzed by some feminists as forms of "cultural production" designed for "consumption." Adherents of this approach aim to counteract the "genius" paradigm or narrative that glorifies the artist and the notion of art as pure private expression. In this view, art and art history, as elitist activities that have participated in patterns of race, class, and gender oppression in modern capitalist societies, cannot simply be reformed and altered, but must be deconstructed and dismantled if social transformation is to occur. On the other hand, those who might be named "liberal" feminist art historians continue to maintain the liberal or Enlightenment notion that artists (of both sexes) have individual identities and voices that are not solely the products of societal forces, and that are not invariably anti-feminist. Like the other group, which might be called "social constructionist," liberal feminists recognize art's historic functioning as a tool or residual effect of oppression, but they would point also to its historical uses as an instrument of dissent and resistance. Liberal feminists would sustain art history's traditional concern with art and artists but from altered critical perspectives, and they maintain that this practice will eventually transform the discipline from within.[14]

In both cases, the feminist art-historical project of the 1980s, under the impact of postmodernism, has been marked by an escalation of its earlier shift

away from traditional formalist concerns toward the study of the sociopolitical conditions under which art objects are made and experienced. Feminist art historians have analyzed the role that both culture and the conventions of visual representation have played in establishing and maintaining the secondary status of women in patriarchal society. They have approached individual works as "texts" that are shaped by, but that also participate in, cultural practices that create and reinforce notions of gendered difference and subjectivity. They have analyzed the role of the spectator, historically assumed to be male, in the production of meaning. And in an effort to resist the gendered hierarchies of the dominant culture, they have tried to avoid "totalizing narratives," and have questioned fixed meanings and universal structures of values or perception.[15]

But even though the actual practice of feminist art history has both contributed to and gained much from the insights of postmodern theory, many feminist scholars, critics, and theorists have argued cogently against feminism's uncritical embrace of postmodernism. Postmodernist theories, for example, have been seen as foreclosing political action and hence preventing rather than expediting the social transformation that feminists seek. For to reject "totalizing discourses" that impose authority by making false claims to universality, and to substitute instead, in resistance to the dominant culture, a picture of reality as composed of multiple subjectivities, inherently fragmented and unstable, is to deny the possibility of coherent political action against that dominant culture and ultimately to be complicit in sustaining it. Postmodernist theories, contends Nancy Hartsock (1987), "are theories that deny marginalized people the right to participate in defining the terms of interaction with people in the mainstream." In the same spirit, Luce Irigaray (1985) has asked if postmodernism may not be the "last ruse" of patriarchy.[16] For if followed to its extreme and logical conclusions, the death of the author as subjective agent as posited by postmodernism may lead only to the death of feminism as an agent for positive political—or, indeed, art-historical—change. Such feminist political theo-

rists as Christine Di Stefano and Nancy Hartsock have pointed out that "postmodernism expresses the claims and needs of a constituency (white, privileged men of the industrialized West) that has already had an Enlightenment for itself and that is now ready and willing to subject that legacy to critical scrutiny." They ask: "Why is it, just at the moment in Western history when previously silenced populations have begun to speak for themselves and on behalf of their subjectivities, that the concept of the subject and the possibility of discovering/creating a liberating 'truth' become suspect?"[17]

In the same spirit, some art historians have observed that the death-of-the-author theories emerged, perhaps not fortuitously, just at the time when feminist scholars were attempting to gain a place for women artists within the historical canon.[18] To this we can add a further caveat. For while the mystified concept of "quality" has served historically as an instrument of discrimination against women and minorities, the postmodern position that no qualitative standards in art are legitimate can in turn become another instrument of discrimination for those in power, to deprive artists who are not male and white of any basis for attaining a rightful place in an expanding and changing canon. Moreover, the current critical debate about "the canon" itself may ultimately serve masculinist ends. For to declare the idea of a canon obsolete in theory does not render it so in practice: the existing canon has not died, and will not die, through this mere theoretical pronouncement. From this perspective, a cynic might observe that postmodernism declared the very idea of a canon dead in order to avoid opening up the existing one to women and minorities. Or, as Craig Owens succinctly put it in 1983, pointing to the omission of the female voice in postmodernist theory: "Postmodernism may be another masculine invention engineered to exclude women."[19]

The 1980s saw a period of feminist self-criticism that at times seemed a parody of masculinist thought, forever trapped in binary oppositions—modernism vs. postmodernism, essentialism vs. constructivism, theory vs. practice—pairs of extremes that continually framed and

reframed reality, but without offering any new paradigm to redefine it. One such binary opposition was posited between "constructivism," the thesis that woman/female/feminine is a social construct, and "essentialism," the position that there exists such a thing as a biologically based female essence. Quite rightly, the opponents of essentialism resist a definition that is limited by anatomy, since, historically, the female body has been defined and devalued by men and consigned by them to a lower order of being. And anti-essentialists rightly insist on women's equal claim to the realm of mind and spirit. But if essentialism is wrong because it defines women by their bodies, constructivism is surely no better for defining them by their minds, at the cost of denying their bodies. The categoric rejection by some feminists of any and all notions of an essential femaleness reconfigures the old masculinist separation of mind and body (along with essence and existence, form and matter), a separation that should be totally alien to feminist thinking, and that is even being questioned by cognitive scientists.[20]

In the 1980s, the polarizing model of binary thinking that has characterized patriarchal Western culture and philosophy also briefly infected the models used by feminist art historians to chronicle and describe the history of their own enterprise. Thalia Gouma-Peterson and Patricia Mathews, the first to take on the task of writing this history, defined differences within feminist art-historical practice as generational changes—theoretically enlightened daughters improving upon and obliterating the work of outdated mothers—thereby repeating the structures of patriarchal history that privilege hierarchic difference, binary opposition, and generational conflict.[21] Recently, however, feminists in many disciplines—especially in North America—have begun to think beyond the theoretical constraints of postmodernism and its categoric oppositions. Teresa de Lauretis, for example, has questioned the "agonistic frame of argumentation . . . and focus on division" exhibited in Linda Alcoff's essay "Cultural Feminism versus Post-Structuralism: The Identity Crisis in Feminist Theory," and she protests a book by Chris Weedon for its "reductive

opposition . . . of a *lumpen* feminist essentialism . . . to a phantom feminist poststructuralism."[22] Among art historians, too, the oppositional mentality has begun to give way to a willingness to admit a spectrum of methodologies and to the acceptance of diversity as inherent in the postmodern condition of art history as elsewhere.[23] Whether this tendency is called "postdeconstruction" or "post-postmodernism" or even "the new modernism," it suggests that an insistence on theoretical absolutes may in fact be a dead end for a viable feminist practice in any discipline.

The feminist theoretical preoccupation with the essentialist heresy, moreover, continues by default to give to males the power to define the nature of female bodies, for it leaves unchallenged the hierarchy of values that makes "female-feminine" an inferior position and continues to privilege the socially constructed "masculine" by offering no alternative to it. (Ironically, feminist anti-essentialists do continue to posit a fundamental male nature. For example, the charge of essentialism has been especially leveled at feminists who support the theory of a pre-patriarchal matrifocy, yet it is the opponents of this theory who would seem to be the essentialists, since they implicitly do not question the notion of a timeless and "natural" patriarchal structure and its concomitant—an essential, historically unchangeable nature for both males and females.) The task is now to engage the patriarchal discourses that produced these definitions, and to redefine "woman" out of women's experience, reintegrating the parts of the social *and* natural whole that is a human of either sex and that have been dualistically torn apart by the masculinist mind/body split—the patriarchal strategy that has literally conquered by dividing.

Acknowledging our own position as liberal feminist art historians, we reject the binary opposition embedded in the distinction between modernism and postmodernism, for this opposition preserves repressive value hierarchies and forces artificial wedges between connected entities. It is to modernism and the modernist ethos, after all, that we owe the feminist identification of gender as a category of analysis in the first place, and it is to

postmodernism that we owe many of the tools and strategies with which that analysis has been effectively carried out over the past decade. And surely there are aspects of Enlightenment rationality that are worth preserving, and that may be distinguishable as not exclusively masculine but human traits, even though men have struggled in the past—and in the postmodern present as well—to exclude women from their practice. Therefore, as feminists in other disciplines have already done, we would advocate for feminist art history a pragmatic, "foot in both camps" philosophy. As described by the feminist theorist Sandra Harding, this would recommend that feminism hold to certain modernist (Enlightenment) precepts while utilizing postmodern techniques of analysis to deconstruct others. "At this moment in history," she writes, "our feminisms need both Enlightenment and postmodern agendas—but not in the same forms or for the same purposes as white, bourgeois, androcentric Westerners."[24]

It is a postmodernist position that there are many discourses, not one, and that there are many feminisms, not one. The title of this book, *The Expanding Discourse,* reflects both an acknowledgment of the useful idea of discourse,[25] and a challenge to the implication that discourses can only be discrete soliloquies that never combine into an interactive dialogue. Feminism, we contend, may have many voices, but it also represents a whole, a larger feminist discourse to which individual feminisms contribute. While, in the past, this feminist discourse has been broadly distinguished in binary terms from a masculinist one, the two, we believe, may also be seen as engaging each other in a metadiscourse, in which feminist and masculinist positions interact, challenge one another, compete, and realign.

By thus speaking of a larger feminist discourse, we do not seek to advance the notion of a singular "feminist standpoint" that is truer than the previous masculinist one. For to do so, as the feminist theorist Jane Flax has argued, would be not only to perpetuate oppressive Enlightenment belief in a singular true reality but also to suggest that the oppressed have a privileged ability to define that reality.[26] Instead, we acknowledge the historical

convergence of many individuals upon a general position called feminism, which has been shared by women and men, though in different ways and with the different inflections of race and class affiliations and of individual temperament.

The interesting metaphor of "standpoint," however, invariably recalls the classic problem of all hermeneutics, the lack of an Archimedean viewpoint: there can be no "objective" position, because no one can occupy a point outside the universe from which to view it objectively. The feminist answer to this dilemma is to reject the binary opposition that is hereby assumed and that is intended to foreclose solutions. For while we may be unable to occupy a point outside, we are not necessarily limited to an embedded point within, nor should it be assumed that our subjectivities preclude valid interpretation. Through the imagination, at least, we can posit a collective knowledge position that may embrace all our subjective positions without being uniquely rooted in any one of them. The theory of the Archimedean point, typically masculinist, seeks a position of mastery, regarding participation in the thing one would examine as contaminating that object of scrutiny. A feminist corrective to this model, the "foot in both camps" approach, would posit one foot in our history and experience, conceived not just as rootless subjectivity but as one kind of basis to construct understanding, and the other foot outside, able to take us beyond the binary opposition and the local perspectives. To seek a position that is neither outside nor above, but which builds upon a dynamic exchange between two equally useful positions, inside and outside, seeing their alleged opposition as complementarity, is a perspective that can help us transcend the limitations inherent in the polarized opposites that we have constructed, even as it transcends the limitations of its own origins in women's historical experience as both subject and object, self and other.

Such an approach might be seen to counter the kind of postmodern theory that posits contradictory modes that can never be reconciled, binary oppositions that—despite Derrida's call for their deconstruction—seem to remain forever at the level of having been named, frozen in time. In this

mode of discourse, terms that have to do with movement and change are negativized or avoided; the concept that entities and realities evolve over time, a biological and a modernist metaphor, has no place. It is this kind of thinking that has led some writers to see art history itself as fatally wrong, in need of wholesale demolition and replacement, and to fault other art historians whose work appears partial and inconsistent when measured by some visionary standard. But it is naïvely utopian to believe that we can dismantle an outdated system overnight, much less replace it with something that will not itself soon harden into a system. Like any other long-range endeavor, the art-historical project moves along by partial insights, which lead to others. Little by little, as old conceptual frameworks are discarded, new questions asked and new agendas created, the discipline is transformed into something that may still resemble yet radically differ from its former self, through a collective process that happens over time.

There is no reason, then, in our view, to preserve the theoretical fiction of a "traditional art history," monolithic and intact, when in fact the inherited categories have always yielded and will continue to do so, as art history changes and evolves. And there is no reason to deride the process of creating a "new art history" as a superficial effort to "season the old with current intellectual fashions or theory soup,"[27] when women's oppositional difference over the last two decades has brought incremental changes that have shaken the discipline at its foundations. We continue, therefore, to see our collective enterprise as a central agent in the creation of a larger, expanded, and conceptually transformed art history. The best way to change art history, in our view, is simply to practice it in a new way.

In the following brief preview of the essays in this book, we have found it convenient to organize the essays and our discussion of them into a few distinct, though interrelated and sometimes overlapping, critical categories. Not one of these essays, however, is merely an example of a category or of a particular issue, for each contains a wealth of ideas and insights that cannot be adequately represented by a short summary. Readers will undoubtedly find ways of connecting and comparing the essays beyond those that are presented here. In suggesting the following way of seeing them as a collective whole, we emphatically do not mean to preclude other readings.

The Female Body and the Male Gaze

A central critical principle of feminist and other postmodern theory of the past decade has been the concept of the "male gaze." In a gender-imbalanced world, as Laura Mulvey explained in an influential article of 1973, males assert their power through the privileged and, in linguistic terms, the "subject" position of looking, while females are the passive, powerless objects of their controlling gaze.[28] Mulvey, a filmmaker and leading exponent of feminist film theory, made creative use of the psychoanalytic theories of Freud and Lacan to explore the practices of representation and spectatorship in films, and to define the mechanism by which films afford voyeuristic pleasure but also power to the (presumed) male spectator, who, as possessor of the gaze and identified with the male protagonist, exercises control over the objectified female body. Much recent writing on the body proceeds from the idea that the male in culture and art has been the privileged subject and exclusive possessor of subjectivity, while the female has been primarily object, stripped of access to subjectivity.[29] Theoretical attention has focused upon the objectification of the female body, and the process by which it has been converted into a signifier for a host of ideas projected onto it, a vessel of conceptual meaning more than a state of natural being.[30]

The postmodern consciousness that representations, especially of the body, are steeped in gender assumptions, and that these play a powerful role in the production and perpetuation of ideological gender attitudes has strongly informed the work of feminist art historians. Many of the essays in this volume present historical instances of the dominating male gaze and the sociocultural uses of the

female body as signifier. Patricia Simons, writing about the female profile portrait in fifteenth-century Florence, examines the operations of the gaze in a "display culture" in which the presentation of the female sitter with "an averted eye and a face available to scrutiny" served the needs of a strongly male-dominated society in which brides and wives were visible emblems of status and property exchange. Simons extends to the painted portrait the analysis of such historians as Diane Owen Hughes and Christiane Klapisch-Zuber, who have called attention to the importance of visual display in clothing, jewelry, and other commodities making up the bride's dowry, to demonstrate that in Quattrocento art theory, as in life, female beauty was considered a patriarchal economic asset. For this reason, argues Simons, the portraits were not so much images of human individuals as they were highly idealized "bearers of wealth," presenting a fixed display of fetishized body parts, dress, and ornament to the appraising male eye.

What can it have been like to live as a woman in Renaissance Florence? Few if any artistic images offer female self-representation; the great majority of images of women present them according to an elaborate set of social codes that governed their expected behavior as wives and mothers. Images often served to exemplify and reinforce correct moral behavior for both women and men, but with the difference that messages to women were of regulation and control, while those to men were of inspiration and caution. Themes that reinforced the patriarchal order and male dominance were woven, subtly and not so subtly, into images with which women lived in their homes and into the monuments that defined the public spaces of their city. This basic fact is less obvious to us in images that have been highly celebrated as works of art, as Lilian Zirpolo shows in a revealing discussion of Botticelli's *Primavera*. Although scholars have recently identified a wedding as the occasion of this painting's commission, few have connected its imagery to Florentine marriage rituals, and no one seems to have recognized that one of its primary functions was as a model of behavior for the bride. Zirpolo connects the *Primavera's* imagery with female instruction in Quattrocento

letters and treatises, which placed a premium on chastity, submission to the husband, and procreative fertility. Adducing humanist explanations of the origin of marriage in the legend of the rape of the Sabine women (to justify forced marriage and marital violence), Zirpolo is able to provide a new context for the troubling inclusion of the rape of Chloris within Botticelli's idyllic scene. She also provides an instructional rationale for the abundance of fertility imagery in the painting.

An important lesson to be learned from Zirpolo's essay is that the mystification of a painting as "art" (whether on the grounds of its ineffable beauty or its iconographic complexity, both of which apply to the *Primavera*) can elevate its genre while masking its basic purpose. This principle applies to other icons of art history discussed in this volume, by Yael Even and Margaret D. Carroll—Benvenuto Cellini's *Perseus*, Giovanni da Bologna's *Rape of the Sabine Women*, and Rubens's *Rape of the Daughters of Leucippus*. As these famous works have been repeatedly celebrated, elevated, and valued as aesthetic objects, pieces of art history, their underlying social functions and crude political purposes have been increasingly concealed. Even and Carroll expose and clarify those purposes, showing how representations of the violent subjugation of the female body worked to enforce patriarchal social control.

Even identifies the Piazza della Signoria in Florence as a primary site of the expression of gender ideology, pointing to the frequent relocation in the square of Donatello's *Judith and Holofernes* and its displacement by the larger statues of Cellini and Giambologna—statues in which violence is done to a woman by a man rather than to a man by a woman. She suggests that a psychological as well as political need to express the radical subordination of women to men underlay the gradual suppression of Donatello's statue and the decisions to commission images glorifying Perseus' decapitation of Medusa and the rape of the Sabine women. In Even's reading, the aestheticized eroticism of these statues is merely a disguise for what has really been represented and glorified: a brutal murder and a violent rape, figured in images that stand in the public center of Flor-

ence—mythic exaggerations of the real gender politics of the culture that produced them.

Carroll's essay, written earlier than Even's and Zirpolo's, interprets Rubens's *Rape of the Daughters of Leucippus* as an allegorical legitimization of the use of force in the context of dynastic marriage and territorial ambition. The Roman myth of the rape of the Sabine women is seen by Carroll to play a central justificatory role, as Zirpolo found it to do in Botticelli, both for Rubens's painting and for its important antecedent, Giambologna's *Rape of the Sabines*. In the latter work, the myth was used to "thematize" not only husbands' domination over their wives but also the Medici dukes' success in regaining control of Florence from their rivals, thus introducing a category of extended meaning for the female body as symbol of land and territory, subject to political possession. Carroll then shows how the rape depicted by Rubens embraces both these meanings, as a mythological imaging of the "Exchange of Princesses," the name that was given to the double marriage of the kings of France and Spain to each other's sister in 1615. The resulting dynastic union between the two countries was symbolized by Rubens in the now famous image of two women held in flowing suspension by their handsome abductors—an image we now better understand as a clear example of the female body-as-property topos, on both a human and territorial level.

Margaret R. Miles looks at the Renaissance female body from another viewpoint, raising the question of its cultural empowerment under certain circumstances. She considers a prevalent image in fourteenth-century Tuscan art, the Virgin Mary with one breast exposed, distinguishing the meaning such an image would have held for fourteenth-century viewers from the "sex-object" implications of female breasts for modern audiences. Signifying her role as the nurturing mother of Christ, the Virgin's bare breast took on added meaning in the mid-fourteenth century, when repeated plagues brought severe food shortages and famine to Tuscany. Miles proposes that images of the nursing Virgin served to allay anxiety over food supply and infant nourishment at a time of crisis. In a witty inversion of Leo Steinberg's asser-

tion that the phallus is "the body's best show of power," she puts forth the female breast as a comparably empowered form, appearing in images that "both formulated and attempted to control one of the most awesome powers of women, the power to nourish."

The concept of female empowerment is examined by Mary D. Garrard in the art of Leonardo da Vinci. Leonardo's portraits of women, she argues, differ dramatically from their Quattrocento Florentine counterparts in presenting vital, self-possessed, and psychologically charged human beings. Leonardo's unusual imaging of living women was complemented, she observes, by his advanced understanding of the active part taken by woman in procreation, as expressed in his anatomical drawings, which deviated from the misogynist Aristotelianism of his time. Establishing a context for this discourse in the ancient association between woman and nature, Garrard aligns Leonardo with such Roman writers as Lucretius, who considered the highest cosmic power to be female, and she argues that the artist's paintings collectively present a philosophical statement about nature, explicitly gendered as female, as the most powerful force in the universe. She connects this outlook, rare in patriarchal Italy, with Leonardo's alleged homosexuality, but unlike other writers (such as Freud), Garrard does not seek in the artist's sexual orientation an "explanation" for his exceptional female images; rather, she considers both of these to derive from his unusual independence from conventions of all kinds, those of gender as well as sex.

In an essay on Titian's *Sacred and Profane Love*, Rona Goffen offers another unusual instance of the culturally empowered female in Renaissance art, one that in her view calls into question the assumption that the dynamic of the male gaze is "the inevitable concomitant of the display of nude women." She reminds us that females who are imaged in art also have gazes, with which, empowered, they may confront the controlling spectator. Emphasizing the positive importance of sexuality for the definition of identity, Goffen offers a radically new interpretation of Titian's painting, in which the two female figures—one

clothed, the other nude—are understood as two aspects of the identity of Laura Bagarotto, the Venetian wife who is the subject of the picture and who may even have commissioned it. She proposes that Titian here detached female sexuality from its usual connections with chastity or marital fecundity, honoring it instead in terms that celebrated female eroticism without limiting it to the category of conjugal duty.

The instances discussed by Miles, Garrard, and Goffen—of art in which subjectivity and beneficent power are attributed to the female body by male artists—are exceptions to the Renaissance norm. Far more pervasive are images that reinforce the power of the male—as beholder, patron, and subjective agent within the work of art. This is exemplified as well in the continuation of patterns of extended meaning that accrue to the female body into the modern period. The association of woman with land and territory—in part generated from the concept of woman-as-property in marriage, but also from the ancient association of woman with nature—is taken up here in subsequent essays on eighteenth-, nineteenth-, and twentieth-century topics. Natalie Kampen considers the theme of woman as man's Other, a projection of binary opposition that has cast the female into the realms of nature (vs. culture), the private (vs. public), the irrational (vs. the rational), in each case a subordinate position carrying lower value. Analyzing the related imagery of Roman Republican reliefs and late eighteenth-century French paintings, Kampen identifies the treatment of gender in such images as a means of conveying a "normative relationship between Self and Other." The story of the Sabine women, she shows, served the Romans as a model for correct female conduct (anticipating, and likely influencing, its Renaissance application), Other acceding to Self. The same kind of gender message, intended to "mute" the danger of the female outsider, recurs in such neoclassical images as David's *Oath of the Horatii*, in which female emotionality is contrasted with male resolve. Through such images, Kampen contends, women's difference is socially controlled by "the playing down of essence and nature in favor of conduct and civilization."

To the moralizing minds of Renaissance humanists and eighteenth-century classicists, woman's otherness was best controlled by the enshrinement of certain values defined as masculine, values to which women were culturally induced to adhere. By the later nineteenth century, however, the extended associations of woman as Other with nature, the erotic, and the irrational had come to seem more appealing than threatening to certain urban males surfeited with the dubious rewards of "civilization." Such was the case with Paul Gauguin, according to Abigail Solomon-Godeau, who sought in his flight from Paris to Brittany and Tahiti an ecstatic embrace of the primitive, now also linked with the feminine and with mysterious Otherness. Gauguin's desired possession of the Maori body, however, both as a man and as an artist, replicates a "dynamic of knowledge/power relationships" that reenacts the "violent history of colonial possession and cultural dispossession—real power over real bodies." In Solomon-Godeau's reading, Gauguin's reenactment of French colonialism in his paintings, in which the primitive and the feminine converge and are equally subject to the controlling male gaze, places him on the side of the colonizers and in the dominant tradition of masculinist ideology.

Peter Brooks takes a different view of the myth of Tahiti and its promise for Gauguin of uncorrupted innocence, sexual liberation, and freedom from European repressions. Drawn by its "mysterious past" (Gauguin's phrase), the artist sought in the female Tahitian body access to the ancient soul—the liberated prehistory—of that already sadly colonized culture. Brooks's interpretation of Gauguin's quest differs from Solomon-Godeau's in presenting the artist's "Tahitian Eve" as a deliberate revision of the debased and degraded female nudes of nineteenth-century French academic art, now stripped of guilt-laden Western morality. In Brooks's reading, Gauguin does not merely perpetuate, he questions the Western objectification of the female nude. In his art, whose visual difference Brooks insists upon, the female body is still offered to the viewer's gaze but unselfconsciously and without self-display; it is still allegorized but on new, revitalized terms.

Brooks's essay was originally presented as a paper in a College Art Association session of 1990 called "Denaturalizing the Nude," and in a heated debate it was described critically by some feminists as an effort to "renaturalize the nude"— that is, an attempt to justify a particular male artist's construction of the female body as natural and normal, an endeavor perceived as running counter to the larger feminist enterprise. As the art historian Carol Duncan has put it, in another context,

I note a tendency among some art historians . . . to try to save art-historical "greats" whose phallic obsessions have lately gotten embarrassing by fitting them out with new, androgynous psyches or secret female identities or by applying to their work new, postmodern "readings" that shore up or restore their eroding universality.[31]

These controversies have opened up to continuing debate some important issues: whether distinctions of degree and kind among female nudes depicted by male artists can validly be made, and whether such distinctions are repressive rationalizations or progressive contributions to a fully articulated feminist art history.

These questions are also raised by other essays in this volume that locate the polarizing paradigms of male culture and female nature in images of the female body. Matisse's paintings of odalisques, images of women in Oriental dress, are interpreted by Marilynn Lincoln Board as freighted with Western phallocentric ideologies, particularly those of Orientalism (as defined by Edward Said), in which geopolitical and sexual chauvinism are interdependent.[32] In these images, Board sees the reactionary need to assert the controlling power of the male artist over the female model as an echo of French colonial reactions to challenges from the Orient itself and from the women's movement. But Board also presents Matisse's agenda, like that of Brooks's Gauguin, as an effort to redeem a corrupt European art tradition through the purifying effects of a "'primitive' female principle." And in the cutouts of Matisse's later art she finds a union of the polarized oppositions of Self and Other, West and East, male and

female that effectively resolved earlier conflicts. In this portion of her account, as in Brooks's account of Gauguin, a male artist is understood to have personally transcended a masculinist norm.

Taking a similar position, Norma Broude proposes the newly resurgent feminist movement in France around 1880—the conflicts and anxieties it generated and the new social alternatives it advanced—as a key to the much debated meanings of Degas's *Spartan Girls Challenging Boys.* Broude interprets this painting (whose figures Degas transformed around 1880 from classicizing to contemporaneous Parisian types) as a metaphor for the relationship between the sexes in contemporary European society. And she connects both the revised painting and the series of brothel monotypes undertaken by Degas around this time to the artist's friendship with the Italian critic Diego Martelli, a committed and highly vocal feminist activist. Rejecting recent interpretations of the monotypes (which have ranged from expressions of "voyeurism," to gratuitous pornography, to images that supported calls for stricter government regulation of prostitution), Broude points to the overlooked feminist position *against* state-regulated and sanctioned prostitution—a position eloquently advanced in Martelli's writings—as a guide to more plausible interpretations of the monotypes. While making no claims for Degas's personal position vis-à-vis the feminist movement of his day, Broude maintains that "feminism and its principles were an increasingly visible part of the modern world that Degas had set himself to interpret," and thus form part of the necessary social context in which the meanings of his works should be explored.

Whereas Broude sets Degas in the context of the feminist movement of his period as an artist whose work may be seen to subvert the patriarchal order, Tamar Garb presents Pierre-Auguste Renoir as a misogynist who believed deeply in the myths of woman's animal-like nature, lack of intellect, and destructive sexual powers; and she suggests that Renoir's Arcadian nostalgia for woman-as-Nature in his pictures was in fact a conservative reaction to the contemporary women's movement in France. Garb examines the subject matter of

Renoir as a non-subject in the critical literature, a non-subject precisely because of its nearly exclusive focus upon the female body, which, Garb observes, "operates as an undeclared extension of matter . . . outside of an ideological construction of womanhood [that] exists rather as a natural extension of a natural will to form." Renoir's practice of painting naked women has accordingly been understood by critics as a response to nature itself, free of any ideological assumptions about woman, nature, or art. But by the late nineteenth century, "the joys of motherhood" and "woman's nature" had, this essay shows, become poisonously confining constructs for women, fictions that limited their legal and personal rights, and inhibited the turn-of-the-century feminist drive for social reform. As in eighteenth-century France, the cult of motherhood, and its attendant celebration of fecundity and breast-feeding, continued to promote an ideal of "true womanhood" that was strongly supported by the visual imagery of the period and by the "idealized" nudes of Renoir in particular.

For Carol Duncan, the masculinist "obsession with a sexualized female body" and the modern artist's "quest for spiritual transcendence" are two "parts of a larger psychologically integrated whole." Pointing to the large number of images of "monstrous, threatening females" by acknowledged masters of modern art (Picasso, Léger, Lipchitz, and others) in the Museum of Modern Art's collection, and identifying them as an expression of a fundamental masculine "fear of and ambivalence about women," Duncan describes modernist abstraction as an effort to transcend material nature through a flight to higher cosmic realms. In such images as De Kooning's *Women,* says Duncan, the dangerous sexuality and power of the ancient mother-goddess are compromised, controlled, and presumably transcended by the artist's vulgarizing and pornographizing of the dreaded female. As in Renaissance examples here discussed—and as in a pornographic image from *Penthouse* offered as an analogy by Duncan—female sexuality and violence are conjoined in these modernist images, which are designed to assert masculine psychological control over the self and social and physical control over women.

In the art of the Surrealists we find perhaps the ultimate violence done to the female body for the empowerment and satisfaction of the male gaze. In such works as André Masson's caged and gagged mannequin and Hans Bellmer's dismembered dolls, Mary Ann Caws discovers an affront to women so horrible that the question must be posed: How do or should women look at such images? "Is there some way of looking that is not the look of an intruder," Caws asks, "some interpretation from which we could exempt ourselves as consumers?" Caws's effort to find an acceptable relationship with such art for women is echoed by recent feminist writers who observe that gaze theory allows no place for the female viewer or for female desire.[33] Finding for the female subject or viewer of such images no possible role but "enforced submission"—a submission literally demonstrated in Man Ray's photograph of the artist Méret Oppenheim posed in submissive juxtaposition to a sinister wheel, evocative of torture—Caws addresses women as an "interpretative community," challenging them to speak out and to initiate the creative reconstruction of their artistically dismembered and violated bodies.

Femininity as a Social Construct

Another major organizing principle of feminist art history in the 1980s was the idea that "femininity" is a social construct and not the natural state of woman. The application of this concept to a critique of the practices of art and art history was pioneered in 1981 by Griselda Pollock and Rozsika Parker.[34] In their book *Old Mistresses* they described the category "feminine" as marked by characteristics drawn from social stereotypes about women (for example, weak, passive, delicate, irrational), stereotypes that pretend to describe biological traits but that are in fact based on standing social assumptions and on the binary opposition of masculine and feminine, value-weighted toward the masculine. These characteristics are then projected back onto women—or, in the case of women artists, onto their art—as if they had been generated by nature rather than

culture, in a self-reinforcing process that limits women and their work to perpetual inferiorization.

Some of the essays in this book examine the cultural production and exaggeration of gender characteristics in a deconstructive spirit. Patricia Reilly finds in the Renaissance controversy over design vs. color *(disegno—colore)* a set of hierarchical oppositions that is gender based. In the writings of Renaissance theorists and artists, color was associated with the feminine, a stigmatization that reinforced the widespread theoretical view of color as inferior to design, which was associated with the masculine. In a sequence of heavily gendered polarities, color was linked with matter, the senses, body, ornament, emotion, and immoral seductiveness; while design was linked with form, the intellect, the spirit, reason, and moral rectitude. Reilly's analysis uncovers a hidden dynamic of gender that helps explain the intensity of the controversy over the relative merits of line and color in art academies from the sixteenth through the eighteenth centuries, and its perpetuation well into the nineteenth century. The curious injection of a moral dimension into what appears to be a formalist debate connects the form-color discourse with that of style. For if one juxtaposes Reilly's essay with Natalie Kampen's, it becomes obvious that gender associations promote the privileging of classicism as the style that embodies moral norms, just as gender associations also support the formal element (design) that classicism itself privileges.

In the nineteenth century, the emergence of the category of "feminine art" served to contain female creativity within socially constructed parameters. Women's practice of the domestic arts of quilting and other needlework, album-making, and folk art was validated and encouraged by numerous writers who argued that women by nature were suited to artistic activities that required patience and a taste for detail and for work that was presumed to be unintellectual and uncreative. In a study of women's private albums, a hitherto neglected category of "feminine art," Anne Higonnet presents an artistic genre that was "structured by gender conventions" but that also represented women's definition of themselves. Higonnet argues that in this genre, and in the related activity of amateur watercolors and sketches, women did not have femininity imposed upon them, but participated creatively in the social construction of femininity. Imagery in the world of women's albums, she points out, is marked by the celebration of personal relationships and family activities rather than by solitary acts, and by a recurrent focus on the private rather than the public sphere. Clearly, Higonnet claims, "women brought to the making of images underlying values of their own," "ideals of social harmony and emotional bonding." Yet in a wider world of power inequity, whose aesthetic criteria are defined by men, women's albums have been judged trivial and amateurish by "high art" standards: they have been judged, in a word, "feminine."

But then, insidiously, a type of "feminine" imagery based on women's amateur production found a professional outlet in the commercial world in fashion illustration. In magazines aimed at a female audience, Higonnet shows, fashion illustrations both exploited and shaped women's ideas of themselves, thus revealing "the vulnerability of feminine self-expression in a capitalist culture" that would eventually merge the categories of the feminine and the consumer. The problem raised by Caws, the problem of women's unintentional complicity with systems that exploit them, is thus addressed by Higonnet in a different realm.

This problem is also exemplified by the critical category known in France as *l'art féminin*, a construct that flourished in the nineteenth century, as Tamar Garb shows, with the approval and support not only of male critics but also of many women artists. In the *Salons des femmes*, the professional woman artist came to represent a type of naturally womanly woman, who reinscribed the so-called natural order in her art by demonstrating the culturally assigned, "feminine" characteristics of imitative skill, lack of originality, capacity for feeling (but not for rigorous thinking), and so on. Clearly these are restrictive categories, especially when pitted against their more prestigious opposites, allotted to males—originality, reason, and so on.

But as Garb points out, the societal approval of one's femininity was for aspiring women professionals a "mark of pride and the source of their strength." As some middle-class women artists thus resisted and disavowed the demands of the rising suffragist movement, all women artists were caught in a cross-fire of definitions, in which *l'art féminin* represented both the "feminine art" that pleased male critics, and the utopian vision of a group of women artists, the *Union des femmes peintres et sculpteurs,* whose goal was to elevate and broaden the category of the feminine and to give it a larger purpose—to rescue French culture from the radical and threatening new tendencies represented by Impressionism and naturalism. Women, in this argument, were seen as uniquely capable of executing this task, Garb explains, because art and cultural values were considered to lie naturally within "the sphere of Woman, the conserver, both socially . . . and artistically."

The creation in the nineteenth century of *l'art féminin* as a separate critical category, whose borders women artists themselves were called upon to patrol, clearly helped to contribute to the lower valuation of the genres of "women's work." It also provided a convenient holding area that could effectively inhibit the movement of women in large numbers from a low-status, amateur category to the realm of the professional artist who might compete with men on the upper levels of the art-making hierarchy. Such movement, of course, was to be prevented at all costs. For in a culture that prized originality and subjectivity as the highest artistic virtues, women who functioned as "high artists" would be culturally authorized, like men, to present their own subjectivity in universalizing terms.

Griselda Pollock examines Mary Cassatt and Berthe Morisot, who were among the few to cross that difficult barrier in late nineteenth-century France, from the viewpoint of the constraining "femininity" that followed them across the divide. Working as independent artists in Paris, far from being liberated to practice their art in subjective freedom, Cassatt and Morisot were limited by the socially contrived boundaries of the spatial environment. For while male artists such as

Manet and Degas found their subjects in cafés, bars, brothels, and other urban spaces that increasingly defined modernity for the avant-garde, Morisot and Cassatt, by virtue of their class and gender, were socially prevented from frequenting such spaces, and as a result produced images that displayed their real-life restriction to the female spaces of dining rooms, drawing rooms, balconies, and gardens. Pollock argues, further, that pictorial space in their art is structured by their gender-specific way of relating to urban spaces, to being looked at and to looking. She points out that modernism is not an independent category to which women can be added, albeit on different terms, for modernism itself is organized by sexual difference. "Femininity" not only shapes the spaces of women, but those of men as well, for in the spaces forbidden to respectable women, "femininity" weighs heavily as "the ideological form of the regulation of female sexuality."

Linda Nochlin also deals with the gendered nature of Impressionist subject matter and demonstrates how our understanding of it in general can be radically altered when we begin to take seriously into account the work of women who were Impressionists. In a close reading of a single painting by Berthe Morisot, Nochlin examines the operations of gender ideology about work and leisure in the world of upper-class women. *The Wet Nurse and Julie,* she says, is an image of "one of the most unusual circumstances in the history of art . . . a woman painting another woman nursing her baby." Both activities, Nochlin explains, the nursing and the painting, might be presumed in a female context to be merely private and pleasurable ones, but in fact, in each case "a product is being produced or created for a market, for profit." Nochlin situates the image in the context of nineteenth-century myths about working women and nursing mothers, and the tendency to identify all women's work with the idea of leisure, whether their own (in the bourgeois household) or for men's recreative pleasure (as prostitutes or barmaids), thus debunking and exposing the gendered roots of the once canonical scholarly assumption that "work" was not an important subject in Impressionist painting.

The wet nurse, as one who "sells her body but for a virtuous cause," was a fixture in Parisian households and in visual imagery, an asset that uniquely provided independence from the "natural" realm of motherhood for well-off mothers. In examining Morisot's complex symbiotic relationship with her surrogate, Nochlin asks that we observe how critical assessments of Morisot's artistic career have been affected by the confining stereotypes of gender—the "femininity" of her art treated as "a construction implying certain natural gendered lacks and failures"—and that we think differently about the extreme dissolving of form in Morisot's art, considering it progressive rather than a lack, inscribing as it does "modernism's profoundly deconstructive project."

The power to present one's subjectivity in universalizing terms through "high art" was conferred upon few women in the nineteenth century. And when it was, self-definition was often severely limited by the conflicting demands of artistic professionalism and social femininity. When a woman artist's sense of self or her ambition conflicted with societal expectations, however, the problem—or a solution to it—could nevertheless find expression in her art. Looking at the art of Rosa Bonheur, James Saslow has found it to offer, unexpectedly, "a radical intervention in the visual and cultural construction of nineteenth-century femininity and masculinity." Saslow interprets Bonheur's notorious habit of dressing in masculine attire as an overt expression of her lesbian identity, a self-presentation that appears as well in her art. Figures in group compositions who are ostensibly masculine prove instead to be, as Saslow shows, disguised self-images of Bonheur. Bonheur's transgressive behavior in both art and life represents, in this reading, a subversive effort to claim masculine prerogatives, to gain access to male social spaces, and to circumvent the social constrictions endured by most females.[35] For Saslow, animals in Bonheur's paintings, symbols of natural freedom, are to be understood as surrogates for women in general, and homosexual women (and men) in particular, who have sought release from restrictive gender norms.

Essentialism, Postmodernism, and the Woman Artist

In feminist art-historical writing, the idea of stereotypical femininity was joined in the later 1980s by a corollary cultural construct perceived by feminists as damaging to women: the idea of "essentialism," or the belief in characteristics or qualities that are inherent in woman's nature and not socially produced. The cultural belief that women are especially endowed with certain qualities (which can in fact be positive ones, such as intuition, flexibility, altruism) found reinforcement in the 1970s, during an early phase of the most recent women's movement, when new-found pride in women's identity was a necessary spur to political action. Today, proponents of this doctrine are hardly to be found; the idea of essentialism is kept alive mainly by its detractors, who argue that any characterization or definition of woman that is biologically based is inherently limiting and repressive.[36]

The problem of essentialism—the dead hand of "woman's nature"—was one that plagued women's relation to art long before the concept was embraced by feminists in the 1970s. Barbara Buhler Lynes shows, in an article on Georgia O'Keeffe, that even a woman artist's wary resistance to theories about the essence of womanhood could not prevent her from being caught in their net. Due to the proselytizing efforts of Alfred Stieglitz, O'Keeffe's art was characterized by critics in the Stieglitz circle as expressive of her female sexuality. Paul Rosenfeld wrote: "Her art is gloriously female. . . . The organs that differentiate the sex speak. Women, one would judge, always feel, when they feel strongly, through the womb." O'Keeffe would have none of this, violently objecting to such views of her art as embarrassing, and resisting definition as a "woman artist." On the other hand, she spoke of her own work as having "a woman's feeling," and was an ardent feminist and supporter of women's rights early in the twentieth century. These potential contradictions surfaced dramatically when in the 1970s O'Keeffe was celebrated by feminist artists and critics Judy Chicago, Miriam Schapiro, and Linda

Nochlin for her organic, centralized flower imagery, which they saw as evocative of female sexuality. Again she resisted, sharply separating herself from their aims.

Lynes leads us to see that O'Keeffe's position may not have been inconsistent. It seems clear to us today that she resisted the sexual interpretations of her work because for her they were equated with eroticism on male terms, with woman—even the woman artist—once again forced to become the object of the male gaze. She could not see in the feminists' championing of her flowers what they saw: the potential for women's self-empowerment and redefinition of the "feminine." As a feminist herself, O'Keeffe also faced the dilemma that has subsequently been named, the dilemma of essentialism: to claim that there is an intrinsic feminine is to invoke biological determinism, yet the only available way out of that bind, declaring the category "woman" to be a mere social construction, requires denying the reality and the power of that "woman's feeling" named by O'Keeffe.

Other essays in this book explore the problems of women artists who sought to evade or diffuse essentialist stereotyping. Helen Langa examines the experience of women in the New Deal art projects of 1930s America. Although such programs as the WPA/FAP Graphic Arts Project offered employment to women on unusually equal terms, and although many women claimed to have experienced no sex discrimination while on the project, Langa observes that the imagery of New Deal art is strongly gender differentiated, preserving traditional divisions of labor and showing women in their maternal roles, though also in the new roles of professional and consumer (the latter not all that new, as Higonnet's article reminds us). In a close study of the art produced in the Graphic Arts workshop, Langa looks at a situation in which working conditions promoted gender equality to a degree rare in "free market" society—for example, nude imagery was prohibited, and with it a whole category of female-objectified art. She found that, on the one hand, different gender perspectives emerge in the way that women and men are imaged in the art produced by men and

women, respectively, in the project. At the same time, women artists tended to minimize their identity as women in their thematic choices, and did not want to be considered as a separate category of artists. Thus Langa finds "complex tensions between the egalitarian vision of professional comradeship and the multiple enactments of gendered experience."

Many women artists in the twentieth century have experienced similar tensions between their gender identity and their artistic subjectivity, in the face of the historical conflict between these two terms. The problem of constructing the self against the grain of cultural expectation is a particularly difficult one for the artist who is also a wife, with a designated social role, and it is inflected differently still for the artist who is the wife of another, more celebrated artist. Anne Wagner examines the life and art of Lee Krasner, who was married to Jackson Pollock, with these considerations in mind. Despite her solid training and serious activity as a painter, Krasner suffered critical neglect as Pollock's career skyrocketed in the late forties. Repeatedly defined in the media as his wife, she sought to counter gender prejudice by signing her works L. K., so as not to be recognized as a woman, and, on one occasion, she seems to have resisted showing with other women artists. In Krasner's paintings of the late 1940s and early 1950s, particularly in her first solo exhibition in 1951, Wagner finds her hard-won answer to the problem she faced: "establishing an otherness to Pollock that would not be seen as the otherness of Woman." As she had done before, Krasner subsequently destroyed twelve of the fourteen paintings in the 1951 show, an act of critical self-erasure, a refusal of self-definition, that conflicts oddly with her intense ambition to position herself outside Pollock's orbit. Krasner's effort to avoid a feminine label, to seek the neutral, authorial mantle of fictive masculine identity, was a strategy of disguise and self-concealment that may thus be compared with that of Rosa Bonheur, though the details of its execution and the nature of its self-expression are very different.

The dilemma faced by Georgia O'Keeffe, Lee Krasner, and the women printmakers of the WPA

represents a historically recurrent problem for women artists. Lacking the endowment of mythic powers that culture has ascribed to men artists—heroic creative agency—women have not been culturally allowed to have an artistic persona that is firmly separable from the content of their art. Lacking an Other, they are doomed to be both subject and object of their own art. They create out of their experience at the risk of being labeled "feminine," they create like a man at the risk of denying some part of the self. The problem experienced by women artists, their disempowerment as creative agents, is thus symbiotically related to the problem caused by men artists, whose mythologized Self and status as genius could be attained only by the diminishment and objectification of everyone else.

The critical deconstruction of the Author, initiated by Foucault and Barthes in the mid-1960s (though not widely influential in the United States until the 1970s, when their writings became available in English), was an extreme reaction to the tyrannically dominating presence of the author/artist in modern culture: a quasi-deified male, larger than life, compounded of ego and power. The effort to topple this figure came in part from early feminism, an effort supported and eventually absorbed by the larger postmodern project to deconstruct what has been called "the totalized narrative of the-man-and-his-work."[37] The task for the postmodern critic was a reversal of priority, so that the reader/critic might acquire the authority previously vested in the male artist. Female artists, however, did not benefit from this postmodern reversal of power, for they were swept into the disempowerment of artists in general, losing an authority they had never had. Although the mantle of the artist-genius had never been bestowed on a woman, once the death-of-the-author thesis took hold, fame and canonization became politically incorrect goals for the woman artist—one is tempted to add, *especially* the woman artist, since the prohibition seems to be invoked mainly in self-policing feminist art theory.[38] Moreover, critical theory's privileging of text over author was potentially devastating for female artists, whose identities were already historically vulnerable to being subsumed into their art, the reverse of the situation for the male artist, whose art was traditionally explained by the heroic biography of the man.[39]

Indeed, the male artist paradigm *cannot* apply to the female artist, because the subject of men's art has so frequently been the gendered construction of male-female, culture-nature oppositions. As Gayatri Spivak has put it, "the discourse of man is the metaphor of woman."[40] How would a female artist position herself in such a discourse? If she defines herself as creator, what is her "created"? What is her relationship to nature? Who are her demons, whom does she transcend? How can she thematize power when she does not truly possess it? How can she, whose name is unknown, renounce authority and the canon? Since the defining characteristics of the male artist patently do not fit female artists who have functioned in patriarchal culture, a new paradigm for the woman artist would seem to be called for. What has not been satisfactory are those critical efforts that measure her by the male model, and then declare her problematic or unsuccessful if she does not fit.

These issues are exemplified here in essays that treat specific women artists. The problem of the conflation of the artist's life and her work in essentialist terms has surfaced in recent critical attention given to Frida Kahlo. In the deluge of advertising images and commentaries that accompanied the celebration of Kahlo in several New York exhibitions in 1990–91, a recurrent emphasis was placed upon the painter's tragic, crippling accident, her anguished life with Diego Rivera, her physical and emotional pain, and her self-identification with her Mexican and Indian roots—all used to define her art as a highly personal expression of her own angst, within a timeless framework of elemental feminine experiences—love, birth, miscarriage. But as Janice Helland shows, Kahlo's use of and identification with native culture was not solely or even principally the product of mystic woman-nature associations. Rather, as an anti-imperialist Communist intellectual, Kahlo shared with other Mexican nationalists an admiration for the ancient Aztecs as political independents. Allusions to pre-Columbian cultures—only the Az-

tecs, and no others—in Kahlo's art, as well as her many biting references to industrialized culture, express the social convictions of a deeply committed political artist, who must be understood within the framework of modern international political history. Helland observes: "Certainly, as [Cixous] and [Irigaray] have suggested, women must 'speak' and 'write' their own experiences, but the speaking must also be related to the context."

A variant of this problem of essentialist stereotyping has affected the critical and art-historical treatment of women of color. In the 1970s and 1980s, feminism helped to bring critical attention to African-American artists such as Elizabeth Catlett, Faith Ringgold, and Betty Saar. But when these artists "spoke" their own experiences as black women, they risked being defined by white critics in the stereotypical terms of "Otherness"— exotic, closer to nature, and so on—"Other" now to white women as well as to men. Adrian Piper has lamented such "focusing on the otherness of the artist rather than the meaning of the art," describing the redaction of the "colored woman artist (CWA)" as follows: "A CWA who expresses political anger or who protests political injustice in her work may be depicted as hostile or aggressive; or a CWA who deals with gender and sexuality in her work may be represented as seductive or manipulative."[41] Women artists of color, and also Mexican women artists such as Frida Kahlo, have been subject to racial as well as gender stereotype. They have been especially vulnerable to a process by which a single aspect of their art is critically filtered out and focused upon, and then used to define them as one-issue artists: Kahlo and nature, Faith Ringgold and African-American storytelling traditions. Although these themes are significant parts of the art of each, they do not represent the whole of such complex artists. Accordingly, we here include essays that emphasize other aspects of their work, especially the dimension of their political engagement—a dimension notably resistant to "feminine" stereotyping.

Lowery Sims looks at Faith Ringgold's paintings of the 1960s against the background of the then-ascendant Pop Art movement. Building on an observation of Elsa Fine, that artists of the Black Art movement were "deeply committed to the images and forms in their work," unlike the more aesthetically oriented Pop artists, Sims explores Ringgold's use of popular imagery—flags, stamps, comic books—to create intensely charged paintings that are not "cool" or ironic manipulations of American cultural icons such as the Pop artists presented. Rather, Ringgold offers political challenges to the icons themselves, pointing up the gap between the promise of national ideals and the realities of racism and sexism, and also pointing up the expressive emptiness of the "cultivated disjuncture between content and technique" found in Pop Art. As Helland defines Kahlo, Sims defines Ringgold as an activist whose art contributes to the political discourse of an age of radical social upheaval and change.

Freida High Tesfagiorgis pursues the theme of political expression in the art of Ringgold and Elizabeth Catlett in the 1960s and 1980s. With special interest in the self-images and self-definition of black women, Tesfagiorgis uses the term "Afrofemcentrism" to embrace the intersecting spheres of the black and female positions, and the consequent "double consciousness" of black women's culture. Contrasting black and "Eurocentrist" feminist aesthetic principles in certain respects, she notes the priority of black self-identification—for Catlett, at least, and by extension for other African-American women artists. For Tesfagiorgis, Afrofemcentrism offers a corrective prioritizing of race over gender, and the opportunity thus to liberate " 'Black feminism' from the blackenized periphery of feminism." We might note, however, that both Ringgold and Catlett can be connected with the Eurocentrist tradition that Tesfagiorgis would minimize. For example, the political art of Käthe Kollwitz is recalled in Ringgold's *Atlanta Children (Vienna is Dying! Save Its Children!)* and in Catlett's *Harriet (Outbreak).* [42] The forging of such links with a feminist visual model suggests that, on the political level, women artists may sometimes be more united by gender than separated by race.

Yet there is a great danger of saying just that, for to point to an underlying connection between

Ringgold and Kollwitz in this instance is to imply that women's special commitment to children is a gender trait that transcends race and class. And to characterize "women-as-a-group" in such essentializing terms takes us right back to where Renoir left off, to the notion of woman's instinctive role as mother hen. There is an important distinction, of course. For Renoir, woman's maternal role was a physical condition that linked her with animals, explained her presumed lack of intellect, and justified her inferior status. For Ringgold and Kollwitz, the defense of children and the prioritization of ongoing life was an intellectual position and a moral choice (and, in a patriarchal world that subordinates such values, perhaps an enlightened moral position). It is a historical fact that Kollwitz spoke through her art (when others did not) to protest the consequences for children of social neglect in 1920s Vienna, and that Ringgold protested murders of black children in 1980s Atlanta when other artists did not. Is concern for children a maternal instinct, a universal human quality, or a male lack? Can we make any generalizations at all about women artists that are not subject to conversion into unwelcome and limiting stereotypes?

For artists as diverse as Rosa Bonheur in the nineteenth century and Georgia O'Keeffe and Lee Krasner in the twentieth, missing from the map of the world was a positive image of the female self as wellspring of artistic creativity. A scant twenty years after Krasner's gendered artistic crisis of 1951, the women's movement brought to the art world the ideals of feminist self-affirmation, the celebration of female creativity, the rehabilitation of forgotten women in history, and the reconstruction of a female tradition in art. Perhaps no single work of art embodies these goals, which have now inspired a generation of women artists, as fully as Judy Chicago's *Dinner Party*. In an article written shortly after *The Dinner Party* was completed in 1979, Josephine Withers describes the "vision of women's history" embedded in its complex structure, emphasizing Chicago's creative identification with women of the past and her intention to document and honor the extensive participation of women in the making of history. As Withers

points out, the Eucharistic imagery of *The Dinner Party* echoes that of patriarchal religions, but it has materialized, in the artist's vision, at the bidding of the Great Goddess, the origin and symbol of female creative power. *The Dinner Party* thus represents one of the most acute and direct challenges to patriarchy—and in particular to the longstanding idea that artistic creation is inherently masculine—to be found in this book, and perhaps anywhere. The recent controversy generated by *The Dinner Party*, documented by Withers in an afterword to her original article, testifies to its deeply subversive power.

Early 1970s feminists such as Judy Chicago took the cultural construction "woman" in a transformative spirit, changing it from object to subject, and converting it into an instrument of power. In the outlook of 1980s female artists, a distinctly different one from that of their predecessors, the feminist slogan "the personal is political" came to be supplanted by the postmodern idea that the personal is a myth. In this view, since the artist is not so much a unique individual as a cultural construction, and since the work of art is an object of production and consumption that acts as a shaping force, the work of art itself, the end product of a chain of signifiers, may be a more potent cultural agent than its author. From this vantage point, Judy Chicago's heroization of thirty-nine historical figures, women who are credited with having influenced history, may seem a romantic exaggeration.

The work of postmodern women artists—such as Cindy Sherman, Sherrie Levine, and Barbara Kruger—considered here in an essay by Craig Owens, offers a reversal of the approach of 1970s feminists such as Judy Chicago and Faith Ringgold. In place of collaborative sisterhood and social idealism is a sophisticated and sometimes ironic exploration of the female Self, now problematized by the new consciousness of the privileged male gaze and the stereotypically objectified female body. Many contemporary feminist artists have practiced a deconstructive mode, investigating, as Owens puts it, "what representation *does* to women . . . in a culture in which visibility is always on the side of the male, invisibility on the

side of the female." In a relatively early discussion of these artists, Owens raised important questions about the meaning of their images. Does Sherrie Levine, who "takes" images of other photographers, such as Edward Weston, "dramatiz[e] the diminished possibilities for creativity in an image-saturated culture," or is she refusing the "father" whose work she appropriates his culturally sanctioned role as prime creator?

Such questions, or ambiguities, are also deliberately built into the art by artists such as Cindy Sherman, whose "untitled film stills" present Sherman herself in the guise of heroines of Hollywood films of the fifties and sixties. Sherman reiterates the social construction of femininity, in self-conscious parody of the gender conventions of viewer and viewed, in order (perhaps) to raise the question whether an authentic female identity can ever slip free of stereotypes. At the same time, Sherman's involvement is with the stereotype, and not with the possibility of creating an original female self-image. This is an understandable position in an age in which the very notion of originality is so suspect, but it can also be connected with nineteenth-century strategies of such women artists as Marie Bashkirtseff, who, as Tamar Garb has shown, employed the masquerade of femininity as a disguise to ward off masculine anxiety, reinscribing "woman as castrated object" "to reassure both a hostile world and a guilt-ridden subject."[43] In the art of Barbara Kruger, the gendered ambiguities of role and voice, speaker and spoken, are made explicit in a less accepting, more critical and confrontational mode. *Your Gaze Hits the Side of My Face,* like other intensely charged images by Kruger, is at once succinct and polyvalent. Many interpretations are possible, yet it can be said that the image of woman here is less victimized than empowered, and that the artist is not conflated with the subject, but instead stands apart as a knowing, ironic—but also feminist—observer.

The feminist art-historical project of the 1980s has been a multifaceted one. It has included the deconstruction of the misogynist intentions of many canonical monuments of Western art, whose oppressive messages and purposes have long

been masked by art-historical invocations of the universal truth of "great art" (in this volume, among others, essays that examine Quattrocento portraiture, art in the Piazza della Signoria, and famous works by Botticelli, Rubens, David, Renoir, Gauguin [Solomon-Godeau], and the Surrealists). Another dimension has involved the uncovering and explication of art that has overtly challenged or covertly resisted the patriarchal system. This facet of feminist art-historical practice (represented here by essays on Leonardo, Titian, Bonheur, Degas, women album makers, Gauguin [Brooks], Kahlo, O'Keeffe, Chicago, and Ringgold) implicitly rejects the postmodern proposition that "the author is dead." It proceeds instead from the modernist and liberal feminist premise that no matter how powerful a force patriarchal society has been in shaping male and female identities and in imposing limitations on individuality, acts of choice and resistance, though often partial or flawed, have always been possible for individuals, and continue to remain so. For some of the artists represented in this set of essays, the unique creative experience has involved an attempt to escape the limits of gender convention and to express, by going against the grain, aspects of the human condition that might transcend the social constructs that define sexual practice and identity too narrowly.

A corollary to this essentially liberal feminist position is an affirmation of the importance of artistic intention. For many of the writers in this book, belief in artistic intention and in the "original meaning" of a work of art (that is, the something in particular that was meant by the artist or patron and understood contextually within a synchronous community) remains on some level an assumption, though now a problematized one. Feminist art historians have been reluctant to give up the notions of artistic intention and original cultural context as entirely irrelevant, even though these concepts no longer provide the totalizing explanations we once believed in. For without positing "original meaning" and its possible recovery, we deprive ourselves as historians of the means to measure and deconstruct the power of the dominant culture to appropriate artistic forms and im-

ages that may sometimes originate in a need to challenge orthodoxy, but which in time are coopted to serve totally different ideological ends (e.g., Degas's brothel monotypes).[44]

Similarly, the social and political purposes originally served by works of art (for example, images of rape and sexual violence, cloaked as classical myth) have often gone unrecognized by later audiences because of the tendency for "Art" to acquire glorified and heroized meaning over time, as its cultural status and its aesthetic and economic value rise. Here, it is the clarification of original meaning—denied, ironically, by poststructuralism—that can be most essential to the deconstructive enterprise. For by exposing the oppressive cultural purposes that a revered object originally served, it may be possible to neutralize its covert and unacknowledged powers—powers that can continue to work as long as there are new receivers for the image. To adapt an observation made by Adrienne Rich some two decades ago, a feminist art-historical practice calls for the presumption of original meaning and its recovery "not to pass on a tradition but to break its hold over us."[45]

Also essential to the practice of a feminist art history, however, is the postmodernist recognition that works of art can never have a singular meaning at all times and for all audiences, but that they become, almost from the moment of their creation, objects of contending and overlapping interpretations brought to bear on them both by random viewers and by institutionalized cultural discourses. Reinterpretations of works of art, whether they purport to uncover original meanings or whether they propose additional alternative meanings, can radically change a viewer's relationship to an object as Art and can diminish the power of the object to bear certain kinds of meaning. However, such reinterpretations will not necessarily succeed in diminishing a work's status as Art, nor in destroying the image's capacity to go on producing cultural meanings for centuries after its genesis.[46]

To take an example discussed in *Feminism and Art History: Questioning the Litany*, Nancy Luomala's radical rereading of the Egyptian statue *King Mycerinus and Queen Khamerernebty II*

may effectively kill the power of the particular social discourse that has been woven around the object by patriarchal culture, but it does not destroy the object itself, nor its power to convey a message—although it may be a different message from the one we once thought it had.[47] Moreover, Luomala's challenging reinterpretation of this canonical piece as an expression of female rather than male dynastic power may interrupt or qualify its status as a work of art for some men, while enhancing that status for some women. Similarly, art-historical exposure of the ideological underpinnings of the sexual violence central to many "masterpieces" of Western art, such as the works by Rubens, the Surrealists, or De Kooning discussed in this volume, may diminish or spoil these objects as "Art" in the eyes of many women, for whom color and form can no longer compensate for vicious and politically oppressive content perceived to be aimed at themselves. For other women and for some men, however, such exposures and rereadings may not alter significantly or at all the status of these objects as Art, for clearly not all people will respond to their sexism as feminists do. What turns out to be "timeless," then, in the work of art is not its allegedly single and universal meaning, but rather its polyvalence—its apparently endless capacity to mean different things at different times or at the same time to different people—and its participation in an ongoing, open-ended, cultural discourse, a participation that may be viewed as positive or negative depending on one's own position in the discourse.

In acknowledging as parallel historical realities both original meaning and its subsequent elaboration or alteration, we advocate for feminist art history, here as elsewhere, a pragmatic "foot-in-both-camps" philosophy—a refusal to be trapped by theoretical absolutes and by the Procrustean mentality of either-or that can throw roadblocks in the path of political and cultural change, and of art-historical understanding. In the ongoing debate among feminist art historians during the last decade about whether art history, a practice that has surely been complicit in the structuring of gender-power relations, must be subverted and destroyed by interventions or whether it cannot be

more gradually transformed and rebuilt from within, we ourselves continue to take the latter position. Yet we recognize the strategic value of the coexistence of both points of view.

The continuing vitality of the discipline of art history—today a vastly altered discipline—is amply affirmed, we believe, by the essays collected in this book. Distinguished by their productive fusion of theory and practice, they simultaneously challenge and employ both the theories of postmodernism on the one hand and the methods and categories of a "traditional" art history on the other. In choosing the essays, we have tried to show the range and variety that exist in contemporary feminist art-historical scholarship. By thus gathering in one volume representative examples of a number of theoretical positions and methodologies, our aim has been to affirm their compatibility and complementarity as well as (or even over) their difference and diversity. For feminism's diversity, we believe, does not fragment and paralyze it but, rather, strengthens and enriches it.

NOTES

1. Norma Broude and Mary D. Garrard, eds., Introduction, *Feminism and Art History: Questioning the Litany* (New York: Harper & Row, 1982), p. 1.

2. Norma Broude and Mary D. Garrard, "An Exchange on the Feminist Critique of Art History," *Art Bulletin* 71 (March 1989): 125.

3. Especially: Michel Foucault, *The History of Sexuality, Vol. I: An Introduction*, trans. R. Hurley (New York: Vintage/Random House, 1980); Foucault, *Power/Knowledge: Selected Interviews and Other Writings, 1972–1977*, ed. C. Gordon (New York: Pantheon, 1980); Jacques Derrida, "Structure, Sign and Play in the Discourse of the Human Sciences" (1967), in Derrida, *Writing and Difference*, trans. A. Bass (University of Chicago Press, 1978); Derrida, *Of Grammatology* (1967), trans. G. C. Spivak (Baltimore: Johns Hopkins University Press, 1976); Jacques Lacan, "The Agency of the Letter in the Unconscious or Reason Since Freud," in Lacan, *Ecrits: A Selection*, trans. A. Sheridan (London: Tavistock Publications, 1977). See also Hazard Adams and Leroy Searle, *Critical Theory Since 1965* (Gainesville: University Presses of Florida, 1986).

4. See Michel Foucault, "What Is an Author?" (1969), in *Language, Counter-Memory, Practice: Selected Essays and Interviews*, ed. D. F. Bouchard (Ithaca, N.Y.: Cornell University Press, 1977); Roland Barthes, "The Death of the Author," in *Image-Music-Text*, ed. and trans. S. Heath (New York: Hill and Wang, 1977); Jonathan Culler, "Beyond Interpretation," 1 in *The Pursuit of Signs: Semiotics, Literature, Deconstruction* (Ithaca, N.Y.: Cornell University Press, 1981); Culler, *On Deconstruction: Theory and Criticism After Structuralism* (Ithaca, N.Y.: Cornell University Press, 1982); Jean-François Lyotard, *The Post-Modern Condition: A Report on Knowledge* (Minneapolis: University of Minnesota Press, 1981); and Mieke Bal and Norman Bryson, "Semiotics and Art History," *Art Bulletin* 73 (June 1991): 174–208, esp. 184–89.

5. Although in European thought, poststructuralism superseded, and was philosophically distinct from structuralism, they arrived at about the same time in the United States; hence the terms are sometimes used interchangeably. "Postmodernism," a broader rubric first popularized in architectural criticism, connotes a general cultural attitude supplanting "modernism," marked by relativism, eclecticism, et cetera. Although "poststructuralism" is, more narrowly, identified with philosophy and critical theory, the two terms are frequently used synonymously.

6. Bal and Bryson, 1991 (as in n. 4), paraphrasing Jonathan Culler.

7. See Bal and Bryson, 1991, esp. pp. 176–84, for a useful discussion of context and "death-of-the-author" theories. Exemplary of the postmodern critique of traditional art history are: Svetlana Alpers, "Is Art History?" *Daedalus* 106 (1977): 1–13; Craig Owens, "Representation, Appropriation and Power," *Art in America* 70 (May 1982): 9–21; Norman Bryson, *Vision and Painting: The Logic of the Gaze* (New Haven, Conn.: Yale University Press, 1983); Bryson, ed., *Calligram: Essays in the New Art History from France* (New York: Cambridge University Press, 1988); Hans Belting, *The End of the History of Art?* trans. C. S. Wood (Chicago: University of Chicago Press, 1987); A. L. Rees and F. Borzello, eds., *The New Art History* (Atlantic Highlands, N. J.: Humanities Press International, 1988); and Donald Preziosi, *Rethinking Art*

History: Meditations on a Coy Science (New Haven, Conn.: Yale University Press, 1989).

8. Linda Nochlin, "Why Are There No Great Women Artists?" in *Women in Sexist Society,* eds. Vivian Gornick and Barbara Moran (New York: Basic Books, 1971), pp. 480–510, reprinted as "Why Have There Been No Great Women Artists?" *Art News,* January 1971; and in *Art and Sexual Politics,* eds. Thomas B. Hess and Elizabeth C. Baker (New York and London: Collier Books, 1971); Carol Duncan, "When Greatness Is a Box of Wheaties," *Artforum* 14 (October 1975): 60–64; Lise Vogel, "Fine Arts and Feminism: The Awakening Consciousness," *Feminist Studies,* vol. 2, no. 1 (1974), pp. 3–37, reprinted in *Feminist Art Criticism: An Anthology,* eds. Arlene Raven, Cassandra L. Langer, Joanna Frueh (Ann Arbor, Mich., and London: UMI Research Press, 1988; New York: Harper Collins, 1991).

9. Griselda Pollock and Rozsika Parker, *Old Mistresses: Women, Art and Ideology* (London: Routledge & Kegan Paul, 1981), p. 3.

10. Broude and Garrard (as in n. 1), p. 14. See also Thalia Gouma-Peterson and Patricia Mathews, "The Feminist Critique of Art History," *Art Bulletin* 69 (September 1987): 326–57, esp. the section "Art History, Women, History and Greatness" (pp. 326–29).

11. Feminist writings from the 1970s by the Americans Linda Nochlin, Ann Sutherland Harris, Carol Duncan, ourselves, and others, and by the British writers Laura Mulvey, Griselda Pollock, Rozsika Parker, Lisa Tickner, Tamar Garb, and others are discussed extensively by Gouma-Peterson and Mathews, 1987 (as in n. 10). For a convenient compilation of key French feminist texts, see *New French Feminisms: An Anthology,* ed. and intro., Elaine Marks and Isabelle de Courtivron (Amherst: University of Massachusetts Press, 1980).

12. See Irene Diamond and Lee Quinby, eds., *Feminism and Foucault: Reflections on Resistance* (Boston: Northeastern University Press, 1988), Introduction, p. xiv; and Christine Di Stefano (quoted by Sandra Harding), in *Feminism/Postmodernism,* ed. and intro., Linda J. Nicholson (New York: Routledge, 1990), p. 86.

13. These central concepts are given clear, brief exposition by Joan W. Scott, "Deconstructing Equality-Versus-Difference: Or, the Uses of Poststructuralist Theory for Feminism," in *Conflicts in Feminism,* eds. Marianne Hirsch and Evelyn Fox Keller (New York: Routledge, 1990), pp. 134–48, esp. 136–37.

14. Some of these differences, and others, are explicated in "An Exchange on the Feminist Critique of Art History," Norma Broude and Mary D. Garrard, Thalia Gouma-Peterson and Patricia Mathews, *Art Bulletin* 71 (March 1989): 124–27. The difference emphasized here, between focus upon social vs. individual factors, is the one

that has emerged most sharply in published debates. This issue is not inherent in feminism, however, but in art history itself, for it is one that earlier generations of art historians have also debated (cf. Erwin Panofsky, "The History of Art as a Humanistic Discipline," in *Meaning in the Visual Arts* [Garden City, N. Y.: Doubleday Anchor Books, 1955], pp. 1–25).

15. This, however, has been a program far easier to posit than to carry out consistently and without internal contradiction. For example, in her review of writings by Griselda Pollock *(Vision and Difference)* and Laura Mulvey *(Visual and Other Pleasures),* both known for their pioneering and influential adaptations of poststructuralist and psychoanalytic theories to the terrain of feminist art history and feminist film theory and criticism, Karen-edis Barzman observes: "Pollock's impulse to fix meaning depends on a notion of universal structures of perception that cannot be reconciled with the concerns of postmodern feminism. The implication is that all viewers will construe the same meaning, or that her own interpretations will be universally embraced on the presumption that she has uncovered some essential truth based on the authority of Freud and Lacan. . . . Moreover, psychoanalytic theories lead one to question Pollock's and Mulvey's omniscient I's/eyes—the transcendent subject positions from which they speak and their totalizing discourses of coherence and authority denied the rest of humankind (on the assumption that subjectivity is always fragmented and unstable, that we can never know or say all there is to know). A crucial project for feminists now is to explore how we can use theory in ways that will enable resistance, avoiding Utopian solutions that make it impossible to see how to get from the oppressive here to an emancipatory there" (*Woman's Art Journal* 12 [Spring/Summer 1991]: 38, 41).

16. Both Hartsock and Irigaray are quoted by Sandra Harding, in *Feminism/Postmodernism* (as in n. 12), p. 85. See also *Feminism and Foucault* (as in n. 12), including the introduction, in which Diamond and Quinby discuss the problems that Foucault's analyses of power present for feminists.

17. Hartsock and Di Stefano, in *Feminism/Postmodernism* (as in n. 12), p. 75.

18. Bal and Bryson, 1991 (as in n. 4), p. 184; and Linda S. Klinger, "Where's the Artist? Feminist Practice and Poststructural Theories of Authorship," *Art Journal,* vol. 50, no. 2 (Summer 1991), pp. 39–47.

19. Craig Owens, "The Discourse of Others: Feminists and Postmodernism," p. 487 in this volume.

20. An important exponent of the new direction in cognitive science is George Lakoff, *Women, Fire, and Dangerous Things: What Categories Reveal About the Mind* (Chicago: University of Chicago Press, 1987). According to Lakoff, "experientialism" recognizes that

"thought fundamentally grows out of embodiment." As he explains, "human reason is not an instantiation of transcendental reason; it grows out of the nature of the organism and all that contributes to its individual and collective experience: its genetic inheritance, the nature of the environment it lives in, the way it functions in that environment, the nature of its social functioning, and the like" (Preface, p. xv).

21. Gouma-Peterson and Mathews (as in n. 10). Their oppositional organizing principle has been questioned by Broude and Garrard (as in n. 2); by Bal and Bryson (as in n. 4), p. 201, n. 128; and Flavia Rando, "The Essential Representation of Woman," Art Journal, vol. 50, no. 2 (Summer 1991), p. 51.

22. Teresa de Lauretis, "Upping the Anti [sic] in Feminist Theory," in Conflicts in Feminism, eds. Marianne Hirsch and Evelyn Fox Keller (New York: Routledge, 1990), pp. 255–70, esp. 261. See also Linda Alcoff, "Cultural Feminism versus Post-Structuralism: The Identity Crisis in Feminist Theory," Signs: Journal of Women in Culture and Society 7 (Spring 1988): 405–37; and Chris Weedon, Feminist Practice and Poststructuralist Theory (Oxford: Basil Blackwell, 1987).

23. For example, Patricia Mathews's review of Whitney Chadwick, Women, Art, and Society (New York: Thames and Hudson, 1990), in Art Bulletin 73 (June 1991): 336–39, especially the introductory paragraphs.

24. Sandra Harding, "Feminism, Science, and the Anti-Enlightenment Critiques," in Feminism/Postmodernism (as in n. 12), p. 100.

25. It is impossible to fix a precise meaning for this currently ubiquitous word, but it connotes something between the dictionary definition ("communication of thought by words; talk; conversation") and that of Foucault ("a form of power that circulates in the social field . . .") in the paraphrase of Jana Sawicki in Feminism and Foucault (as in n. 12), p. 185.

26. Jane Flax, "Postmodernism and Gender Relations," in Feminism/Postmodernism (as in n. 12), p. 56.

27. Griselda Pollock, Vision and Difference: Femininity, Feminism and the Histories of Art (London: Routledge, 1988), p. 17.

28. Laura Mulvey, "Visual Pleasure and Narrative Cinema" (written in 1973 and published in 1975 in Screen), in Mulvey, Visual and Other Pleasures (Bloomington: Indiana University Press, 1989) pp. 14–26.

29. John Berger, in Ways of Seeing (London: British Broadcasting Corporation and Penguin Books, 1972), presented essentially the same concept in different language (though emphasizing women's complicity): ". . . men act and women appear. Men look at women. Women watch themselves being looked at. . . . The surveyor of woman in herself is male: the surveyed female. Thus she turns herself into an object—and most particularly an object of vision: a sight" (p. 47). Also: "In the average European oil painting of the nude the principal protagonist is never painted. He is the spectator in front of the picture and he is presumed to be a man. Everything is addressed to him" (p. 54). Norman Bryson, in Vision and Painting: The Logic of the Gaze (New Haven, Conn.: Yale University Press, 1983), uses the term "Gaze"—now capitalized—extensively, but without citation of source.

30. Francis Barker describes this as a process of verbal distancing in which "the bourgeois subject substitutes for its corporeal body the rarefied body of the text. . . . The carnality of the body has been dissolved and dissipated until it can be reconstituted in writing at a distance from itself" (The Tremulous Private Body: Essays on Subjection [New York: Methuen, 1984], pp. 62–63).

31. Carol Duncan's reply to a letter from Leo Steinberg on her article "The MoMA's Hot Mamas," "Letters to the Editor," Art Journal, vol. 49, no. 2 (Summer 1990), p. 207.

32. On Orientalism in nineteenth-century French painting, see Linda Nochlin, "The Imaginary Orient," The Politics of Vision: Essays on Nineteenth-Century Art and Society (New York: Harper & Row, 1989), pp. 33–59.

33. For example, Joyce Fernandes, "Sex into Sexuality," Art Journal, vol. 50, no. 2 (Summer 1991), p. 37; also Flavia Rando (as in n. 21), p. 51.

34. Griselda Pollock and Rozsika Parker, Old Mistresses (as in n. 9).

35. For a related analysis of dress codes and their rejection in the work of a twentieth-century artist who was a lesbian, see Sandra L. Langer, "Fashion, Character and Sexual Politics in Some Romaine Brooks' Lesbian Portraits," Art Criticism, 1, no. 3 (1981): 25–40.

36. See Diana Fuss, Essentially Speaking: Feminism, Nature, and Difference (London: Routledge, 1989); Linda Alcoff (as in n. 22); Gayatri Chakravorty Spivak, "Displacement and the Discourse of Women," in Displacement: Derrida and After, ed. Mark Krupnick (Bloomington: Indiana University Press), pp. 169–95; and Teresa de Lauretis, Alice Doesn't: Feminism, Semiotics, Cinema (Bloomington: Indiana University Press, 1984). The latter two writers question deconstruction and even feminist theory as masculinist, as Flavia Rando notes ("The Essential Representation of Woman," as in n. 21).

37. Bal and Bryson (as in n. 4), p. 182.

38. Foucault has described the mechanism of self-policing through the metaphor of Jeremy Bentham's Panopticon, a model prison in which each inmate, perpetually visible from the supervisor's tower, internalizes the operation of power and becomes his own jailer (Discipline and Punish: The Birth of the Prison, trans. Alan Sheridan [New York: Vintage Books, 1979], pp. 200ff.).

39. Linda Klinger has effectively described this problem for the woman artist: "Conceptually postulating the artist as a critical trope, poststructuralist theories of authorship reify her as an abstraction, and return that abstraction to us as the subject of art" ("Where's the Artist? Feminist Practice and Poststructuralist Theories of Authorship," *Art Journal,* vol. 50, no. 2 [Summer 1991], p. 44).

40. Gayatri Spivak (as in n. 34), p. 169.

41. Adrian Piper, "The Triple Negation of Colored Women Artists," in *Next Generation,* exhibition catalogue, Southeastern Center for Contemporary Art, Winston-Salem, N.C., 1990, pp. 15–22.

42. Kollwitz's *Vienna Is Dying!* and *Outbreak* are illustrated, respectively, in *Feminism and Art History: Questioning the Litany,* ch. 14, fig. 6; and in Linda Nochlin, *Women, Art and Power, and Other Essays* (New York: Harper & Row, 1988), ch. I, fig. 14.

43. Tamar Garb, " 'Unpicking the Seams of her Disguise': Self-Representation in the Case of Marie Bashkirtseff," *Block* 13 (Winter 1987–88): 79–86.

44. For an extension of this argument in application to Impressionist landscape painting, see Norma Broude, *Impressionism, a Feminist Reading: The Gendering of Art, Science, and Nature in the Nineteenth Century* (New York: Rizzoli, 1991), esp. pp. 14–16 and 178–79.

45. Adrienne Rich, "When We Dead Awaken: Writing as Re-Vision" (1971), in *On Lies, Secrets, and Silence: Selected Prose, 1966–1978* (New York: W. W. Norton, 1979), p. 35.

46. David Freedberg, *The Power of Images: Studies in the History and Theory of Response* (Chicago: University of Chicago Press, 1989).

47. Nancy Luomala, "Matrilineal Reinterpretation of Some Egyptian Sacred Cows," in *Feminism and Art History: Questioning the Litany* (as in n. 1).

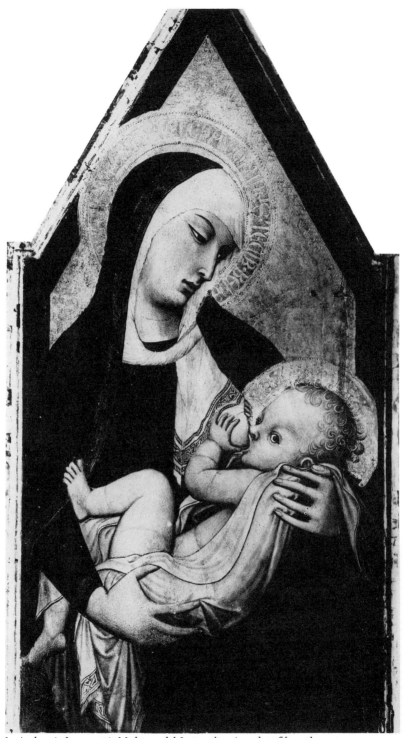

1. Ambrogio Lorenzetti, *Madonna del Latte*, altarpiece, late fifteenth century.
Siena, Chiesa di San Francesco.

1

THE VIRGIN'S ONE BARE BREAST

Nudity, Gender, and Religious Meaning in Tuscan Early Renaissance Culture

MARGARET R. MILES

*A sign is a thing which causes us to
think of something beyond the impression
the thing itself makes upon the senses.*

—Augustine, *De doctrina christiana*, II.1.1

Some of the most puzzling historical images and the most difficult to interpret are those in which nude human bodies or nude parts of bodies play a central role in the visual communication. As Julia Kristeva has remarked, "Significance is inherent in the human body."[1] Yet no pictorial subject is more determined by a complex web of cultural interests than visual narrations of the female body; such images are not susceptible to simple naturalistic interpretation. Moreover, with no depicted object is it less safe to assume a continuity or even a similarity of meaning between its original viewers and the modern interpreter. We will examine one historical example of a complex exchange of communications related to visual images of a woman's partially denuded body.

The Virgin/Mother Mary is repeatedly shown in fourteenth-century Tuscan paintings and sculpture with one breast exposed. Although it is not a completely new image, the insistence and pointedness of the emphasis on the breast that nour-

ished the infant Christ and, by identification with him, all Christians, is startling. Mary is shown nursing or preparing to nurse Christ [1] or, as in a painting by an anonymous Florentine painter [2], cupping in her hand one breast, which she shows to the adult Christ, while pointing to a group of sinners, huddled at her feet, for whose salvation she pleads. The inscription reads: "Dearest son, because of the milk I gave you, have mercy on them." Depictions of Mary with an exposed breast are numerous from the beginning of the Trecento and for the next three hundred years; it was a popular subject, frequently placed in churches and monasteries, and painted on small devotional objects for private use.[2]

Interpretation of these visual images requires both knowledge of their cultural context and methodological sophistication. Before we begin to examine the various religious and social resonances the Virgin's one bare breast was likely to have had in early Renaissance Tuscan culture, let us make explicit some methodological assumptions. First, a visual image repeatedly depicted may be assumed to have popular attraction for people of its original culture. This attraction may relate to the image's ability to address the strong anxieties, interests, and longings common to most

2. Florentine painter, unknown, *Intercession of Christ and the Virgin*, tempera on canvas, fourteenth century. New York, Metropolitan Museum of Art, Cloisters Collection.

determines that aspects of the painting congruent with their interests will be seen, and those aspects unrelated to understanding and coping with their lives will be ignored or, more precisely, not seen.

This essay will focus on the identification of messages intended by commissioners and painters and received by the original viewers of images of the Virgin with one bare breast. Since the messages intended by the commissioner or painter do not necessarily match the interpretive lexicon of viewers, a search for iconographic precedents or for a text that explains the visual elements of a painting is not sufficient if what we seek to understand is a complex communication signaled by the painting within a particular community. Moreover, it will be important to determine the popular accessibility of interpretive associations if we do not focus on the associations and interpretation of a viewer who was culturally or educationally privileged in relation to most people in his culture. I have not, for example, searched for interpretive material in sermons and texts originating in, and limited to, monastic settings.

How, then, can we find clues that direct our understanding of paintings of the Virgin with one bare breast? The ratification of texts must still protect our interpretations from idiosyncratic arbitrariness, but the texts that help us to identify the messages received by most people will by necessity be popular texts, texts that were available in spoken, sung, or dramatic form to those who could not read. Popular fourteenth-century Italian devotional treatises, such as *The Golden Legend* of Jacobus da Voragine or the *Meditations on the Life of Christ* by the pseudo-Bonaventure, can provide us with some of the religious interpretive associations that were popularly accessible.

In addition, the modern interpreter must identify elements of the original cultural experience immediately related to the image. Such crucial variables as life expectancy, availability of food, marriage customs[4] and child-raising practices, gender conditioning, laws, and punishments are all aspects of communal life that can reveal reasons for the popularity of a particular visual image in a particular time and geographical location.

A much more diffuse cultural ground must be

or all people of that society. Second, in addition to its general attractiveness, a visual image contains a range of messages specific to individuals in particular life situations. On the side of the image, particular and even idiosyncratic interpretations are permitted by the multivalence of the image. "All images are polysemous," Roland Barthes wrote; "they imply underlying their signifiers, a floating chain of signifieds." The viewer is able "to choose some and ignore others."[3] On the side of the viewer, an "interest" determined by life situation and the need for meaning directs the viewer's conscious or unconscious choice of messages. In uncritical or nonreflective viewers, this "choice"

sought for messages received than for messages given. One of the most important aspects of this cultural context is visual associations. While the visual associations of a modern viewer of an image of Mary with one breast bared may consist largely of the soft pornography that covers our newsstands, a medieval viewer's visual associations were quite different. Anne Hollander writes that "images of breasts are always sure conveyors of a complex delight,"[5] but an interpretation of the content of this delight necessitates careful reconstruction of the cultural factors that determined its specific content.[6] The medieval viewer was likely to associate the sight of an exposed breast not with soft pornography but with an everyday scene in which a child was being nursed. The similarity of the Virgin and actual women was one of the immediate visual associations of the image.

We need, then, to explore the image of Mary with one exposed breast from three different perspectives: first, in the cultural setting of fourteenth-century Tuscany; second, in the context of publicly accessible religious meanings; and third, as paintings and sculpture among other contemporary depictions.

I

The first setting for early Renaissance Tuscan visual images of the Virgin with one exposed breast is that of the social situation in which these images became popular. Although I cannot reconstruct here a comprehensive picture of Tuscan society, two aspects seem especially relevant to understanding the images. The first is the physical conditions of human life. Even before the onset of pandemic plague in the mid-fourteenth century, severe crises of food supply were frequent. The food surplus of the preceding centuries that had enabled the European population to increase by 300 percent over the tenth-century population[7] drew to a close in the last decades of the thirteenth century. The already high fertility rates continued to increase throughout the thirteenth century, but additional arable land was no longer in supply.

From 1300 on, crop failures caused food shortages and brought about a continent-wide famine in 1309, the first such famine in 250 years.[8] Although the populations of major Italian cities were usually able to find provisions by seizing the harvest from the surrounding countryside, even the wealthy and competently administered city of Florence could not avoid the terror and social chaos caused by hunger. By mid-century, in addition to the existence of endemic malnutrition, recurring waves of plague swept western Europe, devastating populations and creating high levels of anxiety concerning personal survival and the preservation of orderly society. In 1347, even though bread was being issued daily to 94,000 people in Florence, contemporary sources say that 4,000 Florentines died "either of malnutrition or from diseases which, if malnutrition had not first existed, would never have proved fatal."[9] The Florentine chronicler Giovanni Villani wrote:

The famine was felt not only in Florence but throughout Tuscany and Italy. And so terrible was it that the Perugians, the Sienese, the Lucchese, the Pistolese and many other townsmen drove from their territory all their beggars because they could not support them. . . . The agitation of the [Florentine] people at the market of San Michele was so great that it was necessary to protect officials by means of guards fitted out with an axe and block to punish rioters on the spot with the loss of their hands and their feet.[10]

Thus, chronic malnutrition and anxiety over food supply constituted one of the most striking features of Florentine society at the time of the greatest popularity of paintings of the nursing Virgin. In this context of personal and communal suffering and instability, it is not difficult to see why symbolic expressions of nourishment and dependence became attractive to people. Visual images of the infant Christ, held and suckled by his mother, reflected the viewer's sense of dependence and need for support and nourishment.

The second feature of social life that bears a special relevance to the paintings we are considering is the nursing of infants in early Renaissance Tuscan culture. Recent research in family history has examined practices and attitudes relating to infant nourishment; these studies provide an im-

portant piece of the social setting of visual images of the nursing Virgin. As Mary Martin McLaughlin states in an article in *The History of Childhood*, "The infant's survival depended on one thing above all else: its access to breast milk of good quality."[11] In a time without refrigeration, the constant availability of milk was a life-or-death matter for infants. Animal milk, in addition to practical problems of preservation and transportation, was considered harmful for human infants. Since children were thought to exhibit characteristics reflecting the physical appearance and personality of their milk source, it was not acceptable to imbibe animal milk. A fourteenth-century Tuscan child-care manual states:

Be sure that the wet-nurse has plenty of milk because if she lacks it she may give the baby the milk of a goat or sheep or ass or some other animal because the child, boy or girl, nourished on animal milk doesn't have perfect wits like one fed on women's milk, but always looks stupid and vacant and not right in the head.[12]

Infant nourishment also carried complex social connotations. The practice of wet-nursing, although it had existed from antiquity, was written about frequently in fourteenth-century Tuscany. This body of advice, injunctions, and warnings shows the existence of contradictory, or at least ambivalent, attitudes as to whether mothers should themselves nurse their infants. Mothers were frequently instructed to nurse their own infants for the good of the infant, since the danger of employing an unsuitable wet nurse was evident. The most popular preachers of the day, such as Bernardino of Siena, urged maternal feeding in their sermons:

Even if you are prudent and of good customs and habits, and discreet . . . you often give your child to a dirty drab, and from her, perforce, the child acquires certain of the customs of the one who suckles him. If the one who cares for him has evil customs or is of base condition, he will receive the impress of those customs because of having sucked her polluted blood.[13]

Despite the frequency of these popular sermons on the desirability of maternal nursing, the practice of employing a wet nurse was common for middle-class urban families. Ross describes the early fortunes of a middle-class child in Renaissance Tuscany: "Birth in the parental bed, bath in the same room, and baptism in the parish church were followed almost at once by delivery into the hands of a *balia* or wet-nurse, generally a peasant woman, living at a distance, with whom the infant would presumably remain for about two years or until weaning was completed."[14] At the same time that the preachers and child-rearing manuals insisted on maternal feeding, the employment of a wet nurse was for middle-class families a sign of upward mobility, a symbol of gentility.[15] Social meanings were apparently in direct conflict with strong and consistent advice to mothers from preachers and child-rearing manuals to nurse their own offspring. For many Florentine parents, an additional factor came into play: wet nurses were frequently slave women brought by traders to Tuscany from the Levant in increasing numbers in the fourteenth century.[16] Petrarch called this large slave population "domestici hostes," domestic enemies. The frequent employment as wet nurses of women regarded as hostile and untrustworthy must have contributed substantially to the anxiety surrounding wet-nursing.[17] Given this situation of conflicting feelings and values, a great deal of ambivalence must have attended a couple's decision about infant nourishment.

One of the cultural associations with visual images of the nursing Virgin must have been this ambivalence, an ambivalence frequently tipped in the direction of strong guilt feelings in the case of parents whose infants had undergone the not-infrequent fate of infants in the care of wet nurses—"smothering," perhaps a generic name for death from poor care as well as from deliberate suffocation. From the perspective of the message given, visual images of the nursing Virgin may have been a deliberate message to women, in line with popular sermons, urging their emulation of the mother of Christ. It is, however, important to remind ourselves of the probability of a difference between messages intended by the ecclesiastical or aristocratic commissioner of a religious painting and messages received by different people within the Christian community. The range of messages

likely to have been received from visual images of the nursing Virgin will be discussed in the concluding section.

II

From the third century on, the Virgin's central theological meaning was that she guaranteed Christ's humanity. Tertullian wrote: "Christ received his flesh from the Virgin . . . certain proof that his flesh was human" (*De carne Christi*, 17). At the Council of Ephesus (431), Mary was called Theotokos, God-bearer, in order to affirm that Christ, born from her, was true God as well as true man, and in the technical descriptions of Saint Thomas Aquinas, Mary's humanity was understood as the guarantee of that of her son.

In addition to these theological affirmations of Mary's centrality to the redemption of humanity, theologians understood her importance for the devotional needs of communities. Posing for himself the question "whether the matter of Christ's body should have been taken from a woman," Thomas gives this response:

Because the male sex excels the female sex, Christ assumed a man's nature. So that people should not think little of the female sex, it was fitting that he should take flesh from a woman. Hence Augustine says, "Despise not yourselves, men, the son of God became a man; despise not yourselves, women, the son of God was born of a woman."[18]

Despite the evident androcentrism of this statement, his use of the quotation from Augustine raises a theme of incarnational doctrine that was fundamental from the earliest theological treatments of the Virgin's role until the Italian Renaissance: the devotional need of women and men for gender parallelism in Christian verbal and visual symbols.

The development of Marian theology took the form of an ever-more articulated parallelism between the character of Christ and the events of his life, and the Virgin's attributes and events of her life. Christ's conception was paralleled by Mary's Immaculate Conception, an unscriptural doctrine, rejected by Thomas and heavily contested

and tortuously argued by theologians from the fourth century onward. Christ's birth and Mary's birth both receive their full share of apocryphal legends. Christ's circumcision finds its parallel in Mary's purification: neither was necessary, but both were willingly accepted. Christ's presentation in the temple is matched by the apocryphal account, often depicted in paintings, of the Virgin's presentation in the temple at the age of three years. The ministry years of Christ's life do not always find iconographical parallels in events in the Virgin's life, but popular devotional works wove through the scenes of Christ's ministry liberal accounts of the Virgin's activities and emotions.[19] The Virgin was an indispensable spectator/participant in the passion of Christ. She and her more flamboyant counterpart, Mary of Magdala, provided the hearer of these devotional stories or the viewer of religious paintings with models of the emotions that they were instructed to experience. Because Christ's bodily ascension was clearly taught in scripture, the bodily assumption of Mary, although unscriptural and heavily contested by theologians until its definition as dogma in 1950, was a devotional requirement as a parallel for Christ's ascension.

At no time had Marian popular devotion been more prominent in Tuscan culture than in the fourteenth and fifteenth centuries. Theologians of religious orders debated heatedly about the Virgin's attributes and powers; councils invoked Mary's presence and wisdom; academic theologians such as Jean Gerson, chancellor of the University of Paris, attested her presence and participation at the Last Supper and Pentecost. Affirming her appointment to the priesthood, Gerson called her the "Mother of the Eucharist," the one who made the original offering of Christ, the pure victim. But excitement over the Virgin and her power was not confined to a theological elite; the most popular Tuscan preacher of the first half of the fifteenth century, the Franciscan Bernardino of Siena, preached the praises of Mary in extravagant terms in his lengthy and passionate sermons. He waxed eloquent over "the unthinkable power of the Virgin Mother." This charismatic evangelical preacher said:

Only the blessed Virgin Mary has done more for God, or just as much, as God has done for all humankind. . . . God fashioned us from the soil, but Mary formed him from her pure blood; God impressed on us his image, but Mary impressed hers on God. . . . God taught us wisdom, but Mary taught Christ to flee from the hurtful and follow her; God nourished us with the fruits of paradise, but she nourished him with her most holy milk, so that I may say this for the blessed Virgin, whom, however, God made himself, God is in some way under a greater obligation to us through her, than we to God.[20]

Paintings in churches focused contemplation and provided access to worship for people for whom worship may have been, as both Catholic and Protestant reformers in the sixteenth century repeatedly describe, primarily a visual activity. And visual images did not merely delight the predominantly illiterate people of these congregations; they directed the religious affections in fundamental ways understood as essential to salvation. Accessible to all members of Christian communities on a daily basis, they were the media images of medieval people, informing their self-images and ideas of relationship, God, and world in strong and immediate ways. The function of religious paintings in conditioning religious and social attitudes cannot be overestimated. It is in this context of social and religious significance that we must place images of Mary with one bare breast.

III

How did images of the nursing Virgin differ from what people were accustomed to seeing in their local churches? How were these images related to other new themes and subjects in the same time and place? Since the artistic environment of most early Renaissance people was limited to images displayed in local churches, we can expect that new styles or subjects were noticed and their personal meaning and value more or less consciously determined by the individuals who were their first viewers.

Visual images of Mary with one exposed breast were part of an artistic trend, in effect since the beginning of the fourteenth century, where the Virgin was depicted as a humble peasant woman, sometimes barefooted and seated on the floor or ground. Painted in a naturalistic style, these Madonnas of Humility could hardly be in more striking contrast with the depictions of the Virgin they replaced. Throughout the thirteenth century, the Virgin was pictured as a Byzantine empress, luxuriously robed, heavily jeweled, and seated on a throne surrounded by angels and worshipers. The visual message of the new Madonnas suggested the Virgin's accessibility, sympathy, and emotional richness.[21] Depictions of the nursing Virgin and Child in which the Child twists around to engage the viewer's eye employed an established visual device for inviting the viewer to participate in the pictured scene.[22] Within this artistic movement toward portraying scriptural figures as humble people with strong feelings, the bare-breasted Virgin represents perhaps the furthest extension of homey simplicity and unpretentious accessibility. Paintings of the nursing Virgin by Simone Martini and by painters associated with his workshop and influence, such as Lippo Memmi, Botticelli, Taddeo Gaddi, Andrea de Bartolo, and others, indicate a Tuscan origin for the image.[23]

There are, however, some especially vexing problems associated with the representation of nude bodies or parts of bodies in religious painting. Recently Leo Steinberg called attention to a large number of Renaissance paintings that feature a nude Christ, arguing that these paintings presented simultaneously the "full humanity" and the innocence and sinlessness of Christ in visual form. In some images of the resurrected Christ, power appears to be a primary message; Christ is shown with an artfully draped but unmistakable erection. Steinberg finds this an appropriate device for communicating the Resurrection; the resurrected phallus, "the body's best show of power," is the sign and guarantee of Christ's vivified flesh. "The supreme power," he writes, "is the power that prevails over mortality," a power "reasonably equated with the phallus."[24] Yet reactions to these paintings by many of their first viewers were negative. Some of the most famous, such as Michelangelo's epic depiction of the Last Judg-

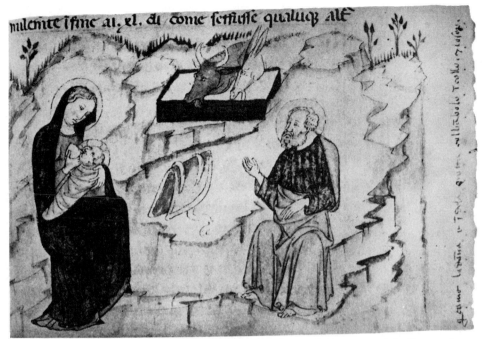

3. Illustration from *Meditations on the Life of Christ: An Illustrated Manuscript of the Fourteenth Century* (Paris, Bibliothèque Nationale, Ms. Ital., 115), translated and edited by Isa Ragusa and Rosalie B. Green, 1961.

ment on the apse wall of the Sistine Chapel, were soon overpainted, and in 1563 the Council of Trent officially, though not always effectively, banned nudity in religious painting.

Nudity or partial nudity in religious paintings creates in viewers tensions of two kinds. First, there is a tension between cultural and natural meanings. The bare-breasted Virgin, for example, evokes visual associations that emphasize her similarity with other women, while popular devotional texts and sermons contradict these evoked associations by insisting on her difference. The *Meditations on the Life of Christ* describe the nursing Virgin [3] thus: "How readily she nursed Him, feeling a great and unknown sweetness in nursing this Child, such as could never be felt by other women!"[25] Second, nudity in religious paintings creates a tension between erotic attraction and religious meaning.

Anne Hollander, in *Seeing Through Clothes*, has argued that nudity in art always carries a sexual message; visual depictions of a nude body are never so thoroughly devoid of sexual associations as to become a perfect vehicle for an abstract theological message. At the same time, nudity can intensify the narrative, doctrinal, or devotional message of a painting by evoking subliminal erotic associations. In a religious painting that intends to stimulate in viewers a complex response of affective piety, nudity must be carefully balanced with other visual content so that an erotic response does not dominate, causing the viewer's engagement with the painting to collapse into "mere" sensuality. On the one hand, then, nudity must be depicted naturalistically enough to evoke the viewer's erotic interest; on the other hand, it must not be dominant enough to render this erotic attraction primary; the religious message must dominate, with the erotic component in a subordinate and supportive role.

Were images of the Virgin with an exposed breast successful in maintaining a balance of erotic and religious messages? Two pictorial devices guarantee that the religious message of the

painting—the viewer's participation in an inti-
mate scene in which humanity and divinity are
closely woven—would be strengthened rather
than undermined by its erotic content. First, in
our early Renaissance examples, the huge breast
that Christ sucks did not meet the contemporary
cultural requirements for an erotic female image;
on secular female nudes and clothed figures of the
Renaissance, breasts are small and high. In order
to create an erotic response, pictured nudity must
"display the emphatic outline, posture, and gen-
eral proportions of a body customarily clothed
in fashionable dress, so as to make it seem
denuded."[26] In erotic painting, viewers are led to
imagine that they are seeing a denuded body of
the kind that their cultural visual conditioning has
designated as sexually appealing.

Second, in depictions of the nursing Virgin or
the Virgin displaying the breast with which she
nursed the Christ Child, Mary's dress does not
display the provocative disarrangement of an
erotic exposure of the breast. Moreover, the cov-
ered side of Mary's chest is perfectly flat while the
exposed breast is round and ample [4]. The
viewer's impression is not of a privileged glimpse
of a normally concealed breast, but rather that the
cone-shaped breast from which the Christ Child
was nourished is not actually a part of Mary's body
but an appendage. These paintings and sculptures
could be a literal translation of Jacobus da Vorag-
ine's text: "Such indeed was Mary's innocence
that it shone forth even outside of her, and quelled
any urgency in the flesh of others. . . . Although
Mary was surpassing fair, no man could look upon
her with desire."[27]

IV

We must now gather the religious, social, and
visual contexts of Tuscan early Renaissance paint-
ings of the Virgin with one bare breast in order to
understand the messages likely to have been re-
ceived by the original viewers of these images.
Jane Gallop's statement that "The visual mode
produces representations as a way of mastering
what is otherwise too intense" is helpful for our
analysis.[28] In addition, these visual images of the

4. Andrea and Nino Pisano, *Madonna del Latte*,
ca. 1345–50. Pisa, Museo Nazionale.

Virgin are *men's* images of a woman; as far as can
be determined, not a single Renaissance image of
this type was commissioned or painted by a
woman. As men's images, they express and at-
tempt to "master" a cultural situation in which, as
we have seen, human life was extraordinarily vul-
nerable and precarious. Far from presenting a sim-
ple message encouraging viewers to greater affec-
tive piety, our paintings both expressed and
evoked in viewers highly complex and ambivalent
responses.

Because of the social conditions prevailing
when it became a popular image, the nourishing
breast was simultaneously a symbol of threat and
of comfort, focusing a pervasive, chronic anxiety
over nourishment. In a society in which women's

milk was a practical, emotional, and religious issue, the nursing Virgin was an intensely ambivalent symbol, evoking for men a closely woven mixture of danger and delight and, for women, the emotional quandaries surrounding the nursing of infants. The "bad mother," either the natural mother who did not choose to nurse her child or the irresponsible or incapable wet nurse, was a source of continual cultural and personal anxiety, as popular sermons and child-rearing manuals demonstrate.

Unlike actual women who might or might not be acceptable mothers, the Virgin represented a fantasy of a totally good mother. She was a mother who could be counted on to nurse not only her son but, through him, all Christians. Mary was called *mater omnium* and *nutrix omnium*. [29] The scenes depicting physical nourishment at a woman's breast, the earliest delight of all fourteenth-century people, evoked both fundamental sensual pleasure and spiritual nourishment. Mary's humility, obedience, and submissiveness in unquestioningly offering her body as shelter and nourishment for the Christ Child must have been at least part of the message intended by commissioners and painters. The Virgin was presented as a model for actual women.

At the same time, however, visual images of the nursing Virgin might have evoked in viewers a strong sense of the nourishing power of women at a time of personal anxiety and cultural crisis. If the Virgin gained cosmic power by nursing her son, what was to prevent actual women from recognizing their power, derived from the same source, and irresistible to their adult sons? Images of the nursing Virgin signify power to conceive, to nourish, shelter, and sustain human life, a power that may well have been understood by fourteenth-century people as "the body's best show of power." It was understood, nevertheless, as a power that must be firmly directed to the socially desirable ends of a patriarchal society—that is, to keeping women "in their place." Women had to be guided to accept the model of the nursing Virgin without identifying with her power—a power derived from her body but ultimately a social as well as a physical power.

Did men have reason to be uneasy about women's social powers? The conditions of social instability that existed in early Renaissance Tuscan towns were those in which women were more likely than men to be able to consolidate and extend personal and social power. [30] Some women were able to exercise economic independence, to own and manage business enterprises, and to dispose of their own property without their husbands' consent. The cost of dowries had never been higher, indicating the importance to men of advantageous marriages for their sisters and daughters—advantageous to the men, that is, whose wealth and power often depended to a large extent on such marriages. Moreover, women were living longer than men, as a 1427 population census attests. [31]

There is, however, little evidence that women identified with the Virgin's power. A delicate message of social control was communicated, apparently effectively, by the creation of a dissonance between verbal and visual messages: the latter emphasized the *similarity* of the Virgin and actual women, but it was the *contrast* between actual women and the Virgin that was prominent in late medieval and early Renaissance preachers and popular devotional texts. A spiritual attachment to the Virgin was presented as an alternative to appreciation of and attachment to one's actual mother. This theme had appeared as early as the twelfth century as a leitmotif in the writings of Cistercian monastic women and men. Aelred of Rievaulx wrote of the Virgin: "It is she . . . who has given us life, who nourishes and raises us; . . . she is our mother much more than our mother according to the flesh." [32] Moreover, it was not only the mothering Virgin who was supposed to take the place of an actual mother in the life of a monk; Bernard of Clairvaux, the most influential author on late medieval spirituality, assimilated the role of mothering to the male Jesus, just as contemporary abbots described their roles within monastic communities as providing motherly care and spiritual nourishment. [33] Dame Julian of Norwich, the fourteenth-century English recluse, gave a vivid account in her *Showings* of Jesus as contrasted to and displacing an earthly mother:

We know that all our mothers bear us for pain and for death. O, what is that? But our true Mother, Jesus, he alone bears us for joy and for endless life. This fair, lovely word "mother" is so sweet and so kind in itself that it cannot truly be said of anyone or to anyone except of him and to him who is the true mother of life and of all things. To the property of motherhood belong nature, love, wisdom, and knowledge, and this is God.[34]

Theological descriptions of Mary or of Jesus as ideal mother use maternal imagery as the vehicle for drawing a strong contrast between the ideal woman and actual women. In fourteenth-century popular devotional literature there is no comparable effort to curtail men's identification with the male Christ. The appearance of God in the male sex was understood as privileging that sex, making men less vulnerable to evil than women. The 1484 *Malleus maleficarum* states that men are much less likely to associate with the devil in witchcraft than women, because they belong to Christ's sex: "And blessed be the Highest who has so far preserved the male sex from so great a crime: for since He was willing to be born and to suffer for us, therefore He has granted to men this privilege."[35] While men were encouraged to identify with the male Christ, women's identification with the female Virgin was blocked by verbal emphasis on the unbridgeable chasm between the ideal Virgin and actual women, and by presenting attachment to the mothering Virgin as an alternative to attachment to actual mothers.

Paintings of the Virgin with one bare breast constitute a remarkably explicit objectification of what was almost certainly the most pressing personal and collective anxiety of fourteenth-century Tuscan people—the uncertainty of food supply. We have no direct evidence as to how women understood and reacted to these images. Embedded in the intricate social fabric, these images "worked" to the extent that their communication remained subliminal. Just as modern women are not continually conscious of the shaping of our self-images and behavior by the media images we live with daily, medieval women probably could not have articulated the specific effect of *their* media images—paintings on the walls of churches—on their affective lives and their actions. Yet they were certainly affected by these messages.

No simple reduction of the conflicting messages of verbal and visual communications to a single dominant message to and about women can do justice to the complexity of fourteenth-century Tuscan culture. Rather, both visual messages that acknowledge women's power over life and death and verbal messages that deny the identity of actual women with the powerful Virgin must be considered if we are to represent accurately the ambivalence toward women of a strong but threatened male-designed and administrated society. The visual images we have examined from the perspective of their social context, their religious significance, and their visual environment have helped us to explore a complex form of social control in an early stage of the Italian Renaissance. Images of the Virgin with one bare breast both formulated and attempted to control one of the most awesome powers of women, the power to nourish.

NOTES

1. Julia Kristeva, *The Powers of Horror* (New York: Columbia University Press, 1983), p. 10.

2. Victor Lazareff posits a Byzantine origin for the *Virgo lactans* image that came into frequent use in Italy in the Dugento through Sicily and Venice. The "once severe icon theme" changed dramatically during the thirteenth century to more and more naturalistic treatment,

a "completely genre conception"; "Studies in the Iconology of the Virgin," *Art Bulletin* XX (1938): 35–36.

3. Roland Barthes, *Image/Music/Text* (New York: Hill and Wang, 1977), p. 39.

4. Brucia Witthoft, "Marriage Rituals and Marriage Chests in Quattrocento Florence," *Artibus et Historiae* III, no. 5 (1982): 43–59.

5. Anne Hollander, *Seeing Through Clothes* (New York: Viking, 1980), p. 186.

6. For a modern example of the complex delight occasioned by the breast, see Wilson Brian Key's discussion of the strong subliminal attraction of a *Playboy* cover (February 1970) that shows a nude model, seen from the side and slightly from the back, holding a stack of magazines with *Playboy* on top at her left breast. Key comments on the model's nursing position: "Notice the curvature of the left shoulder and arm, the tenderness with which the arms support the magazines . . . the expression of nursing tranquillity. . . . What is a nursing mother doing on the cover of *Playboy*? Very simply, she is nursing the *Playboy* reader. . . . She is looking in adoration at the printed word 'Playboy' "; *Subliminal Seduction* (New York: New American Library, 1972), pp. 121ff.

7. Robert S. Gottfried, *The Black Death: Natural and Human Disaster in Medieval Europe* (New York: The Free Press, 1983), p. 15.

8. Ibid., p. 27.

9. Phillip Ziegler, *The Black Death* (New York: Harper Torchbooks, 1969), p. 44.

10. Ferdinand Schevill, *History of Florence* (New York: Frederick Ungar, 1961), p. 237.

11. Mary Martin McLaughlin, "Survivors and Surrogates: Children and Parents from the Ninth to the Thirteenth Centuries," in *The History of Childhood*, ed. Lloyd de Mause (New York: Harper Torchbooks, 1974), p. 115.

12. Paolo da Certaldo, *Libri di buoni costumi*, quoted by James Bruce Ross, "The Middle Class Child in Urban Italy, Fourteenth to Early Sixteenth Century," in *The History of Childhood*, ed. Lloyd de Mause (New York: Harper Torchbooks, 1974), p. 187.

13. Ross, p. 186.

14. Ibid., p. 184.

15. Ibid., p. 186.

16. Iris Origo emphasizes that slaves were owned by middle-class Tuscan people: "Every prosperous noble or merchant had at least two or three; many had more. Even a notary's wife or a small shopkeeper's would have had at least one, and it was far from uncommon to find one among the possessions of a priest or nun"; "The Domestic Enemy: The Eastern Slaves in Tuscany in the Fourteenth and Fifteenth Centuries," *Speculum* XXX, no. 3 (1955): 321.

17. Ibid., pp. 321ff.

18. Saint Thomas Aquinas, *Summa theologica*, 3a, q. 31, art. 4 (New York: McGraw-Hill, 1969).

19. Aquinas's description of Mary's talents indicates his awareness that Christ's power and the Virgin's power might easily be construed as competitive rather than complementary: "She possessed extraordinary gifts but could not use them publicly since it would detract from Christ's teaching" (*Summa theologica*, 3a, qs. 27–30).

20. Translated by Hilda Graef, *Mary: A History of Doctrine and Devotion*, I (New York: Sheed and Ward, 1963), pp. 316–17.

21. Millard Meiss, *Painting in Florence and Siena After the Black Death* (New York: Harper Torchbooks, 1964), pp. 132ff.

22. Michael Baxandall, *Painting and Experience in Fifteenth Century Italy* (New York: Oxford University Press, 1972), pp. 72ff.

23. Meiss, pp. 133ff.

24. Leo Steinberg, *The Sexuality of Christ in Renaissance Art and in Modern Oblivion* (New York: Pantheon, 1984), p. 90.

25. Pseudo-Bonaventure, *Meditations on the Life of Christ: An Illustrated Manuscript of the Fourteenth Century*, trans. and ed. Ida Ragusa and Rosalie B. Green (Princeton, N.J.: Princeton University Press, 1961), p. 55.

26. Hollander, p. 88.

27. Jacobus da Voragine, *The Golden Legend*, trans. Granger Ryan and Helmut Ripperger (New York: Arno Press, 1969), p. 150.

28. Jane Gallop, *The Daughter's Seduction: Feminism and Psychoanalysis* (New York: Cornell University Press, 1982), p. 35.

29. Meiss, pp. 151–52.

30. Joan Kelly-Gadol, "The Social Relation of the Sexes: Methodological Implications of Women's History," in *Signs: A Journal of Women in Culture and Society* I, no. 4 (1976): 810.

31. David Herlihy, "Life Expectancies for Women in Medieval Society," in *The Role of Women in the Middle Ages*, ed. Rosemary Thee Morewedge (Albany: State University of New York, 1975), p. 15.

32. Caroline Walker Bynum, *Jesus as Mother: Studies in the Spirituality of the High Middle Ages* (Berkeley: University of California Press, 1982), p. 137, n. 90.

33. Ibid., p. 145.

34. Julian of Norwich, *Showings*, trans. Edmund Colledge, O.S.A., and James Walsh, S. J. (New York: Paulist Press, 1978), pp. 297–99.

35. Heinrich Kramer and Jame Sprenger, *The Malleus maleficarum*, trans. Montague Summers (New York: Dover, 1971), p. 47.

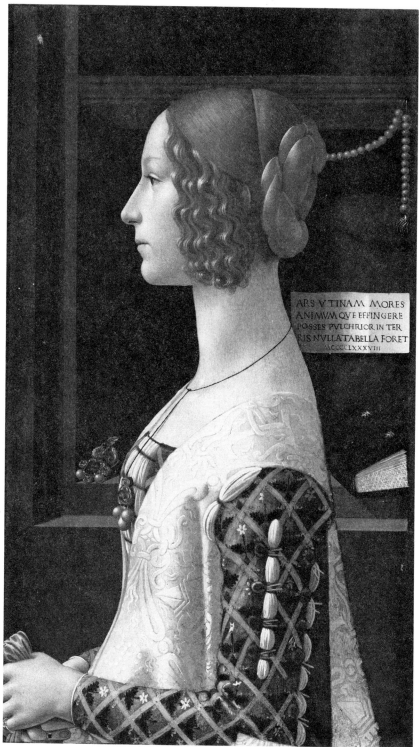

1. Domenico Ghirlandaio, *Giovanna Tornabuoni, née Albizzi*, 1488.
Lugano, Thyssen-Bornemisza Collection.

2

WOMEN IN FRAMES

The Gaze, the Eye, the Profile in Renaissance Portraiture

PATRICIA SIMONS

Studies of Renaissance art have had difficulty in accommodating contemporary thinking on sexuality and feminism. The period which is presumed to have witnessed the birth of Modern Man and the discovery of the World does not seem to require investigation. Renaissance art is seen as a naturalistic reflection of a newly discovered reality, rather than as a set of framed myths and gender-based constructions. In its stature as high culture, it tends to be either applauded or ignored (by the political right or left respectively) as an untouchable, elite production. My work on profile portraits of Florentine women attempts to bring theories of the gaze to bear on some of these traditional Master theories, thereby unmasking the apparent inevitability and neutrality of Renaissance art.

Around forty independent panel portraits of women in profile survive from Quattrocento (fifteenth-century) Tuscany [1, 2], but it is thought that this genre began in Italy around the years 1425–50 with a cluster of five male portraits.[1] The only extended discussions of the Renaissance pro-

file convention tend to presume a male norm for all surviving panels. Jean Lipman in 1936 wrote of the female figures' "bulk and weight" and "buoyant upthrust," Rab Hatfield's study on the five male profiles of their "bravura" and "strong shapes."[2] Both writers were imbued by Jakob Burckhardt's interpretation of the Renaissance as a period giving birth to modern, individualistic man.[3] For the art historian specifically, the rise of an individualistic consciousness during the Renaissance, plotted by Burckhardt in 1860, explains the development of individualized and more numerous portraiture at the time.[4] Hence for Lipman these figures—"completely exposed to the gaze of the spectator"[5]—were self-sufficient, invulnerable, displaying by the surface emphasis of the design only the surface of the self-contained person. Hatfield's later attention to social context shifted the emphasis, for he argued that "intimacy is deflected" because "social prestige" is being celebrated and a family "pedigree" formed in the images. But the portrayed were characterized by their visual order as reasoned, intelligent men whose *virtù*, or public and moral virtue, required "admiration and respect."[6] For both writers, the profile portrait celebrates fame, and derives from public pictorial conventions.

From *History Workshop: A Journal of Socialist and Feminist Historians* 25 (Spring 1988): 4–30. Copyright © 1988 by Patricia Simons. Reprinted by permission of the author.

Only in one brief footnote did Lipman recognize that "the persons portrayed" were "almost all women." The note went on, probably sharing Renaissance assumptions, to say that "the feminine profile was intrinsically flatter and more decorative."[7] So, in an article devoted to stylistic analysis, natural and aesthetic reasons "explained" the predominance of the female in this format. Hatfield's focus on the five male examples meant that he too avoided a problem which my paper insists upon, namely, that civic fame and individualism are not terms applicable to fifteenth-century women and their imaging. The environment can be investigated by way of the kind of "admiration" and "gaze" to which the decorative images and the seemingly flattered women were exposed.

Other investigations, such as John Pope-Hennessy's survey of Renaissance portraiture, or Meyer Schapiro's examination of the profile in narrative contexts, also fail to make gender distinctions.[8] Usually, the utilization of the profile in fifteenth-century art is explained by recourse to the revival of the classical medal and the importation of conventions for the portrayal of courtly rulers, evoking the celebration of fame and individualism. Such causal reasoning is inappropriate to the parameters and frames of Quattrocento women. In this paper, profile portraits will be viewed as constructions of gender conventions, not as natural, neutral images.

Behind this project lies a late-twentieth century interest in the eye and the gaze, largely investigated so far in terms of psychoanalysis and film theory.[9] Further, various streams of literary criticism and theory make us aware of the construction of myths and images, of the degree to which the reader (and the viewer) are active, so that, in ethnographic terms, the eye is a performing agent. Finally, feminism can be brought to bear on a field and a discipline which are only beginning to adjust to a de-Naturalized, post-humanist world. Burckhardt again looms here, for he believed that "women stood on a footing of perfect equality with men" in the Italian Renaissance, since "the educated woman, no less than the man, strove naturally after a characteristic and complete individuality."[10] That the "education given to

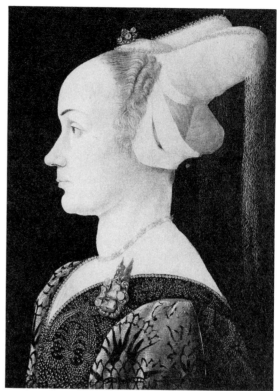

2. Anonymous, *Profile Portrait of a Lady,* 1470s. Melbourne, National Gallery of Victoria.

women in the upper classes was essentially the same as that given to men" is neither true, we would now say, nor adequate proof of their social equality.[11]

Joan Kelly's essay of 1977, "Did Women Have a Renaissance?," opened a debate amongst historians of literature, religion and society, but art historians have been slower to enter the discussion.[12] A patriarchal historiography which sees the Renaissance as the Beginning of Modernism continues to dominate art history, and studies of Renaissance painting are little touched by feminist enterprise.[13] Whilst images of or for women are now beginning to be treated as a category, some of this work perpetuates women's isolation in a separate sphere and takes little account of gender analysis. Instead, we can examine relationships between the sexes and think of gender as "a primary field with which or by means of which power is articulated."[14] So we need to consider the visual

construction of sexual difference and how men and women were able to operate as viewers. Further, attention can be paid to the visual specifics of form rather than content or "iconography," so that theory can be related to practice.

The body of this paper investigates the gaze in the display culture of Quattrocento Florence to explicate further ways in which the profile, presenting an averted eye and a face available to scrutiny, was suited to the representation of an ordered, chaste and decorous piece of property. A historical investigation of the gaze which has usually been discussed in psychoanalytic terms, this study might be an example of what Joan Scott recently called for when she worried about "the universal claim of psychoanalysis." She wants historians "instead to examine the ways in which gendered identities are substantively constructed and relate their findings to a range of activities, social organizations, and historically specific cultural representations."[15] So my localized focus could be a supplement, perhaps a counter, to Freudian universalizing, and to neutered generalizations previously made about Renaissance portraiture. On the other hand, I would prefer to attempt a dialogue rather than a confrontation between historical and psychoanalytic interpretations. Here an interdisciplinary foray will characterize the gaze as a social and historical agency as well as a psychosexual one.

The history of the profile to ca. 1440 was a male history, except for the occasional inclusion of women in altarpieces as donor portraits, that is, portraits of those making their pious offering to the almighty. But from ca. 1440 nearly all Florentine painted profile portraits depicting a single figure are of women (except for a few studies of male heads on paper, probably sketches for medals and sculpture when they are portraits and not studio exercises). By ca. 1450 the male was shown in three-quarter length and view, first perhaps in Andrea Castagno's sturdy view of an unknown man whose gaze, hand and facial structure intrude through the frame into the viewer's space.[16] Often this spatial occupation and bodily assertion were appropriately captured in the more three-dimensional medium of sculpture, using either relatively cheap terracotta or more prestigious, expensive marble. The first dated bust from the period is Piero de' Medici's, executed by Mino da Fiesole in 1453.[17]

For some time, however, women were still predominantly restricted to the profile, and most examples of this format are dated after the mid-century. Only in the later 1470s do portraits of women once more follow conventions for the male counterparts, moving out from the restraining control of the profile format, turning towards the viewer and tending to be views of women both older and less ostentatiously dressed than their female predecessors had been. Such a change has not been investigated and cannot be my subject here, which is to highlight the predominance of a female presence in Florentine profile portraits.

Painted by male artists for male patrons, these objects primarily addressed male viewers. Necessarily members of the ruling and wealthy class in patrician Florence, the patrons held restrictive notions of proper female behavior for women of their class. Elsewhere in Italy, especially in the northern courts, princesses were also restrained by rules of female decorum but were portrayed because they were noble, exceptional women.[18] In mercantile Florence, however, that women who were not royal were recognized in portraiture at all appears puzzling, and I think can only be understood in terms of the visual or optic modes of what can be called a "display culture." By this I mean a culture where the outward display of honor, magnificence and wealth was vital to one's social prestige and definition, so that visual language was a crucial mode of discourse. I will briefly treat the conditions of a woman's social visibility and then, having considered why a woman was portrayed, turn to the particular form of the resultant portrait.

To be a woman in the world was/is to be the object of the male gaze: to "appear in public" is "to be looked upon," wrote Giovanni Boccaccio.[19] The Dominican nun Clare Gambacorta (d. 1419) wished to avoid such scrutiny and establish a convent "beyond the gaze of men and free from worldly distractions."[20] The gaze, then a metaphor for worldliness and virility, made of Renaissance woman an object of public discourse,

exposed to scrutiny and framed by the parameters of propriety, display and "impression management."[21] Put simply, why else paint a woman except as an object of display within male discourse?

Only at certain key moments could she be seen, whether at a window or in the "window" of a panel painting, seen and thereby represented. These centered on her rite of passage from one male house to another upon her marriage, usually at an age between fifteen and twenty, to a man as much as fifteen years her senior.[22] Her very existence and definition at this time was a function of her outward appearance. Pleading for extra finery and household linen, rather than merely functional clothing, to be included in her dowry, one widow implored her children, when her brothers forced her into a second marriage, "Give me a way to be dressed."[23] This woman virtually pictures herself as naked and undefined unless a certain level *(modo)* of (ad)dress or representation as well as wealth can be attained. Costume was what Diane Owen Hughes calls "a metaphorical mode" for social distinction and regulation. The "emblematic significance" of dress made possible the visible marking out of one's parental and marital identity.[24] A bearer of her natal inheritance and an emblem also of her conjugal line once she had entered the latter's boundaries, a woman was an adorned Other who was defined into existence when she entered patriarchal discourse primarily as an object of exchange.[25]

Without what Christiane Klapisch-Zuber calls "publicity," the important alliance forged between two households or lineages by a marriage was not adequately established.[26] Without witnesses, the contract was not finalized. By contrast, a priest's presence at this time was not legally necessary. Visual display was an essential component of the ritual, a performance which allowed, indeed expected, a woman's visible presentation in social display and required an appropriately honorable degree of adornment.

The age of the women in these profile portraits, along with the lavish presence of jewelry and fine costumes (usually outlawed by sumptuary legislation and rules of morality and decorum), with

multiple rings on her fingers when her hands are shown, and hair bound rather than free-flowing, are all visible signs of her newly married (or perhaps sometimes betrothed) state. The woman was a spectacle when she was an object of public display at the time of her marriage but otherwise she was rarely visible, whether on the streets or in monumental works of art. In panels displayed in areas of the palace open to common interchange, she was portrayed as a sign of the ritual's performance, the alliance's formation and its honorable nature.

An example of a father's attention to his daughter before marriage, however, also points up attitudes taken to a woman's public appearance.[27] Whilst Giovanni Tornabuoni granted jewelry to his daughter Ludovica as part of her lavish dowry, his will of 1490 nevertheless stipulated that two of the valuable, carefully described items ultimately remain part of his male patrimony, for they were to return to his estate upon her decease. A cross surrounded by pearls, probably the "crocettina" mentioned in Giovanni's will, hangs from Ludovica's neck in her portrait by Domenico Ghirlandaio within the family chapel at Santa Maria Novella, decorated at her father's expense between 1486 and 1490. She also wears a dress richly brocaded with the triangular Tornabuoni emblem. So, at the time when she was betrothed but not yet married, not long before she passed beyond their confines, she is displayed forever as a Tornabuoni woman, wearing their emblem and wealth.

Ludovica is also represented as a virginal Tornabuoni exemplar, attendant at the *Birth of the Virgin* and with her hair still hanging loose, as it had in her earlier medal, where a unicorn on the reverse again emphasized her honorable virginity. In the chapel fresco Ludovica is presented as the perfect bride-to-be, from a noble and substantial family, about to become a child-bearing woman. Her father's solicitude and family pride oversaw the construction of a public image declaring her value and thereby increasing Tornabuoni honor. Soon her husband will conduct her on her rite of passage, collect his dowry and appropriate her honor to the needs of his own lineage.

When the bride went *fuori* ("outside") and was "led" or "taken away", by her husband, she bore a counter-dowry of goods supplied by him.[28] One mother, Alessandra Strozzi, happily reported of her daughter in 1447 that "When she goes out of the house, she'll have more than 400 florins on her back" because the groom Marco Parenti "is never satisfied having things made for her, for she is beautiful and he wants her to look at her best."[29] That same Marco later recovered his investment, one which doubtless weighed heavily on the back of his adolescent wife, by having each garment unpicked and selling every gem and sleeve.[30] Neither dowry nor counter-dowry seems to have become entirely a woman's property.

In wanting his bride "to look at her best" Marco was seeking a visible, displayable sign of his honor. Indeed a wife's costume was considered by jurists a sign of the husband's rank.[31] "Being beautiful and belonging to Filippo Strozzi," Alessandra wrote to her son of a potential bride in 1465, "she must have beautiful jewels, for just as you have won honor in many things, you cannot fall short in this."[32] Like the "golden facade" of a palace, "such adornments . . . are taken as evidence of the wealth of the husband more than as a desire to impress wanton eyes," wrote Francesco Barbaro in his treatise *On Wifely Duties* of 1416.[33] To Barbaro, a wife's public appearance was a sign of her propriety and her husband's trust: wives "should not be shut up in their bedrooms as in a prison but should be permitted to go out [*in apertum*], and this privilege should be taken as evidence of their virtue and probity."[34]

He then went on, "By maintaining a decorous and honest gaze in their eyes, the most acute of senses, they can communicate as in painting, which is called silent poetry."[35] Just such uprightness is silently communicated by the profile panel, where, as Lipman noted, "the head was kept to the quality of still life, often as objectively characterized and as inanimate as the cloth of the dress."[36] Attributes of costume, jewelry and honorable bearing are as much signs as the occasional coats of arms in these portraits. And in Florence, these heraldic devices are the husband's, for the woman has been renamed and inscribed into a

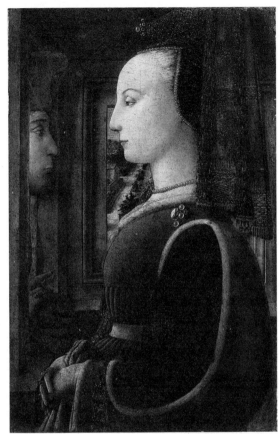

3. Filippo Lippi, *Portrait of a Man and Woman at a Casement,* early 1440s. New York, Metropolitan Museum of Art.

new lineage. Hence in Filippo Lippi's *Portrait of a Man and Woman at a Casement*, [3], the Scolari man's coat of arms is matched not by her own natal heraldry but by her motto, embroidered in his pearls on the sleeve she has been given, which avows "Loyalty" to him.[37]

Perhaps we can find an explanation for those numerous donor portraits represented in profile by considering the earlier cited linkage, by the nun Clare Gambacorta, between "the gaze of men" and "worldly distractions." Particularly when shown in profile, the donors' faces are visible to both divine and "worldly," sacred and "secular" (yet sacralized) realms, seen by the adored sanctities yet also viewed by priests and devotees, including the donors themselves. Like nuns and donors,

the women portrayed in profile are displayed and visible objects, and yet they are removed from "worldly distractions." They are inactive objects gazing elsewhere, decorously averting their eyes. In this sense they are chaste, if not virginal, framed if not (quite) cloistered. However, unlike nuns, these idealized women are very much not "beyond the gaze of men."

A young Florentine patrician girl rarely became anything other than a nun or a wife.[38] In each instance she was defined in relation to her engagement with men, either marrying Christ or a worldly husband and eschewing all other men. Girls who entered a convent sometimes made their own choice, but often they were ugly, infirm or deformed, or else they might be surplus girls in a family overburdened by the potential costs of expensive dowries. When assessing future wives, the groom's lineage carefully weighed the ties of kinship (parentado) to be formed and the dowry's value, with other matters such as the woman's beauty and the purity and fertility of her female ancestors.[39] "Beauty in a woman," wrote Leon Battista Alberti,

must be judged not only by the charm and refinement of her face, but still more by the grace of her person and her aptitude for bearing and giving birth to many fine children. . . . In a bride . . . a man must first seek beauty of mind (le bellezze dell'animo), that is, good conduct and virtue.[40]

It is this "beauty of mind" which is displayed in the idealizing profile protrait as it was earlier exhibited (mostrare, to exhibit, is the verb)[41] to selectors before her marriage. Since Alessandra Strozzi and others spoke of the bride as "merchandise" ("who wants a wife wants ready cash," she said)[42] we can speak of an economics of display in fifteenth-century Florence. Alberti advised that the future groom

should act as do wise heads of families before they acquire some property—they like to look it over (rivedere) several times before they actually sign a contract.[43]

The girl was an object of depersonalized exchange by which means a mutual parentado was estab-

lished, a dowry of capital was brought by the girl and a husband's honor became hers to display. She also supplied an unsullied heritage and "beauty of mind."

The late fifteenth-century Florentine bookseller Vespasiano da Bisticci also wrote of a woman's virtue as a possession or dowry. He ended his Life of the exemplary Alessandra de' Bardi exhorting women to

realise that a dowry of virtue is infinitely more valuable than one of money, which may be lost, but virtue is a secure possession which may be retained to the end of their lives.[44]

Alberti has the elderly husband didactically address his new, very young wife in terms even more closely related to portraits:

Nothing is so important for yourself, so acceptable to God, so pleasing to me, and precious in the sight of your children as your chastity (onestà). The woman's character is the jewel (ornamento) of her family; the mother's purity has always been a part of the dowry she passes on to her daughters; her purity has always far outweighed her [physical] beauty.[45]

Visually, the strict orderliness of the profile portrait can be seen as a surprising contradiction of contemporary misogynist literature. Supposedly "inconstant," like "irrational animals" without "any set proportion," living "without order or measure,"[46] women were transformed by their "beauty of mind" and "dowry of virtue" into ordered, constant, geometrically proportioned and unchangeable images, bearers of an inheritance which would be "precious" to their children. A woman, who was supposedly vain and narcissistic,[47] was nevertheless made an object in a framed "mirror" when a man's worldly wealth and her ideal dowry, rather than her "true" or "real" nature, was on display.

Giovanna Tornabuoni's portrait by Domenico Ghirlandaio [1] contains an inscription, with the date 1488, indicating that "conduct and soul" were valuable, laudable commodities carried by the woman.[48] Further, depiction strove for the problematic representation of these invisible virtues: "O art, if thou were able to depict the con-

duct and soul, no lovelier painting would exist on earth." Having died whilst pregnant in 1488, the now dead Giovanna née Albizzi is here immortalized as noble and pious, bearing her husband's initial, L for Lorenzo, on her shoulder and his family's simplified, triangular emblem on her garment. She is forever absorbed as part of the Tornabuoni heritage, displayed in their palace to be seen by their visitors and themselves, including her son, who bore their name.

Within the panel, she is framed by a simple, closed-off room; within the palace, we know from an inventory, she was actually framed in "a cornice made of gold" on show in a splendid "room of golden stalls."[49] Sealed in a niche like her accoutrements of piety and propriety, she is an eternally static spectacle held decorously firm by her gilded costume and by the architecture of her arm, neck and spine. Giovanna's very body becomes a sign, attempting to articulate her intangible but valuable "conduct and soul." The "dowry of virtue" is encased and contained within her husband's finery, each enhancing the other. Forever framed in a state of idealized preservation, she is constructed as a female exemplar for Tornabuoni viewers and others they wished to impress with this *ornamento*.

Profile portraits such as Giovanna's participate in a language of visual and social conventions. They are not simply reflections of a preexistent social or visual reality. Neither in the streets nor in the poetry of Renaissance Florence was a patrician woman like Giovanna capable of the sort of independent existence she might seem to have in her portrait. Invisible virtues, impossible to depict unless one were in paradise according to the poetry written by Petrarch and Lorenzo de' Medici,[50] are paradoxically the realm of these highly visible portraits on show in a display culture keen to engage in impression management. In these portraits a woman can wear cosmetics and extravagant decoration forbidden by legal and moral codes.[51] There this orderly creature was visible at or near a window, yet she was explicitly banished from public appearance at such windows.[52] There a dead wife or absent daughter or newly incorporated, deflowered wife was made an

object of commemoration, as eternally alive and chaste.

Perhaps the profile form became increasingly contradictory and archaic, leading to its partial abandonment in favor of the three-quarter format already available for male portraiture. At times, however, the profile's memorable and remote nature still suited requirements for the visual preservation and enhancement of what Elizabeth Cropper has called a "memory image that fills the void of her absence."[53] Portraits, said Biondo in the sixteenth century as Alberti had in the fifteenth, "represent the absent and show us the dead as if they were alive."[54] Such a contradiction, or at least tension, could both explicate the profile's eventual demise and lead us to comprehend its earlier existence. The paradoxical rendering visible of invisible virtues, available to the visual medium as it was not possible in social reality, meant that artistic representation was a contribution to rather than a reflection of social language or control. A woman's painted presence shares with cultural values of the time an idealized signification. Indeed, it increases the stock of impressive, manipulative language available within Quattrocento culture. Visual art, it can be argued, both shared and shaped social language and need not be seen as a passive reflection of predetermining reality. For the representation of women, the profile form and its particulars were well suited to the construction, rather than reflection, of an invisible "reality."

It is not only the display of attributes like jewelry and costume (perhaps often more splendid fantasies than were the actual possessions) which pronounce the portrayed woman as the bearer of "wealth" both earthly and invisible. The profile form itself is amenable to the construction of a display object, since the viewed is rendered static by an impersonal, typifying structure. A ruler (such as Jean Le Bon or Henry V) or Leonine Warrior[55] can be powerful, iconic images in profile, but the decorative, generalizing and idealizing potential of the profile made it an apt and numerically predominant convention for the reification of Florentine women.

When the Florentines Andrea Verrocchio or

Leonardo da Vinci carved or drew Alexandrine heroes in profile, they elaborated masculinity by way of solid helmets and breastplates even more three-dimensional than the faces, which are also modeled in some relief.[56] But Florentine female profiles tend to appear on unstable, spindly bases, with an elongated neck exaggerating their attenuation. The vulnerable and elegantly artificial neck also separates the face from its already insubstantial body. Fine, isolated features exist precariously in a flat sea of pale flesh. Volume is repressed in portraits such as Alesso Baldovinetti's *Portrait of a Lady in Yellow* [4];[57] cheekbones and shoulder blades are denied by an image caught on the painted surface like a butterfly. In Baldovinetti's production, the hair (probably a false, fashionable adornment at the back) and the lively yellow sleeve bearing a husband's large heraldic device are each more capable of energetic mobility through space than the woman seems to be.

"Individuality" appears to the degree that simplifying silhouettes can represent particular faces. But full characterization depends upon facial asymmetry, and momentary moods are also denied by the timeless patterning profile. In these mostly anonymous profile portraits, face and body are as emblematic as coats of arms. They mark a renaming, a remaking, in which individual names are omitted. The face contributes to identification, as legislators realized when they banned the use of a veil by all women other than prostitutes.[58] The latter were marked as bodies granted sexual license, their potential lack of control hence brought under masculine and visual rein. Through the regulatory language of facial display, all women were sexually labeled and controlled. Officials could interrogate a veiled woman, seeking her identity not by first name but by naming her father, husband and neighborhood.[59] Occasionally a first name is included in a three-quarter view of a woman by such means as the juniper *(ginepro)* behind Leonardo's portrait of Ginevra de' Benci,[60] but in the profile portraits the family name, never a matrilineal one, is paramount.

The traditional immortalizing of a dead man or a male ruler by use of the profile was appropriated for female representation, yet the form's restric-

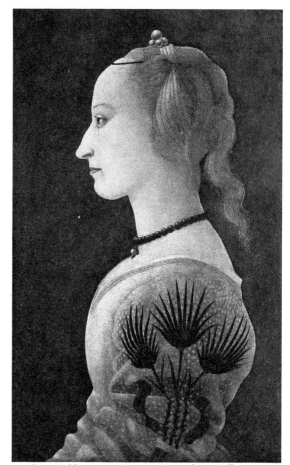

4. Alesso Baldovinetti, *Portrait of a Lady in Yellow*, ca. 1465. London, National Gallery of Art.

tive capacity was accentuated. One of the few surviving pairs in which both the male and female portraits are in profile, Piero della Francesca's depiction of the Duke and Duchess of Urbino [5,6], couples a ruler with a woman.[61] Because the duke suffered from a battle wound to his right eye he had to be shown in profile. This necessity is turned to advantage by strong blocks of color (which are especially balanced either side of the stabilized face), hard virile silhouette, massive neck and swarthy, modeled flesh. This is contrasted with a pale, heavily decorated lady who has been plucked, powdered and adorned into a chaste emblem. On the reverse of her portrait rides the Triumph of "feminine virtues," on his the Tri-

umph of Fame.[62] Both ruler and woman are type-cast and stand for more than their individual selves, but the male is constructed as a more active, dominant figure.

Giovanna Tornabuoni and her peers lived and died in a Mediterranean display culture where honor and reputation were vital commodities and appearance was always under scrutiny. Sumptuary legislation, for instance, governed adornment "inside the home or without,"[63] acting on the belief that state actions could, as well as should, enter various spaces and determine the rules of display. Neither the woman, nor her accoutrements, nor her portrait, had much "private" space. "Shun every sort of dishonor, my dear wife," counseled Alberti's elder. "Use every means to appear to all people as a highly respectable woman."[64]

In an oligarchic, patrilineal society where little value was ascribed to women except as carriers of a "dowry of virtue," women were encouraged to stress their restraint and seemly inheritance. Their own complicit investment in their "secure possession" appears extensive, judging by the relatively few records which survive. Patriarchal definitions of proper, obedient behavior were accepted by literate matrons like Alessandra Strozzi. When advising her son about being a husband she wrote, "a man, when he really is a man, makes a woman a woman."[65] Where then might we find a woman's "view" of her profile portrait?

Two distinctions made recently by historians of Renaissance culture can guide us; first, Klapisch-Zuber's between the dowry and the trousseau.[66] Whilst the dowry passed from father to husband, the bride could carry a few minor, intimate items from her mother. Mostly for personal use and

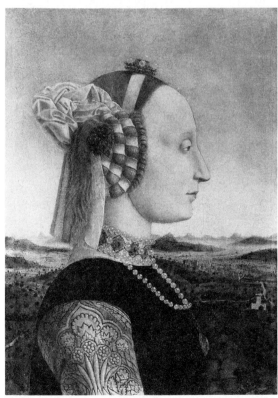

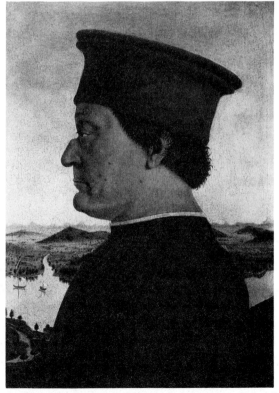

5. Piero della Francesca, *Battista Sforza, Duchess of Urbino,* after 1474. Florence, Uffizi (*Soprintendenza per i beni artistici e storici Gabinetto Fotografico, Florence*).

6. Piero della Francesca, *Federigo do Montefeltro, Duke of Urbino,* after 1474. Florence, Uffizi (*Soprintendenza per i beni artistici e storici Gabinetto Fotografico, Florence*).

often associated with a procreative role, these goods could be dolls, Books of Hours, sewing tools and articles for her toilette. Klapisch-Zuber argues that "the trousseau is the principal channel by which feminine goods, often heavily symbolic, passed from mother to daughter" and these were "the fragments of a hidden or incomplete feminine discourse."[67] In a sense, a profile portrait could be one such "fragment." A young female viewer was instructed by her mother's portrait and shaped herself in her mother's image.[68] When preparing her own "dowry of virtue," which was informed by both the maternal and paternal inheritance, she was also attending to a kind of "trousseau of *onestà*."

The second set of distinctions is one pointed to by Hughes, between *meretrice* (prostitute), *matrona* (matron), daughter and wife. When a liminal border was crossed and a woman was recognized as sexually mature, for instance, she became subject to sumptuary legislation.[69] The older woman could also wittily contravene sumptuary restrictions, and argue with her husband over clothing expenses.[70] As one Bolognese woman claimed in the mid-fifteenth century, men could win success and honor in many fields but only ornamentation and dress were available to women as "signs of their valour."[71] Older women performed a kind of labor, converting their "dowry of virtue" into an investment "retained to the end of their lives."[72] When nubile daughters were in the house, mothers assisted with the trousseau's collection. Maternal guardians of their sons, they assessed the virtue and appearance of potential brides. With or without the presence of children and grandchildren nearby, a woman continually defended her respectability and image, resorting like men to "signs" in a display culture. The commodity of virtue was circulated amongst a female economy, from grandmother to mother, to daughter, to her children. For instance, a woman could boast about the "nobility and magnificence of her family" especially to other women, and her "upbringing" was carefully assessed by her female elders.[73] Guardians of their family's honor and piety, including their own,[74] women when portrayed in profile were often visually addressing

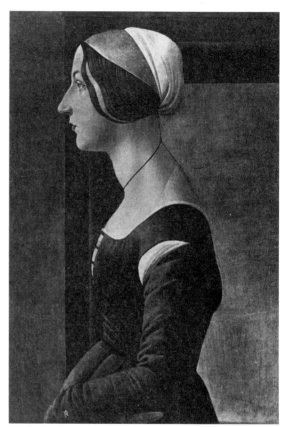

7. Sandro Botticelli, *Profile Portrait of a Lady*, 1480s. Florence, Palazzo Pitti (*Soprintendenza per i beni artistici e storici Gabinetto Fotografico, Florence*).

their daughters as exemplars, reinforcing, even enlarging, standards of virtue.

But women were daughters or matrons in a man's world, these very distinctions being ones (like nun or wife) formed by a woman's relationship to men. Again we must analyze gender, not to negate a "hidden . . . feminine discourse," but to comprehend visual artifacts which were not hidden, not only seen as personal female "fragments." Profile portraits were primarily objects of a male discourse which appropriated a kind of female labor or property. When wives were charged under the sumptuary laws, it was men who paid the fines, just as they had paid for the jewels and dresses in the first place. Men also paid for the portraits, on which they appended male coats of arms.

When young, women were cordoned off in the profile form which could later instruct their own daughters. When older, women became informed actors in the selection of a bride, scrutinizing others' daughters.[75] The active female eye was virtually always that of an elderly guardian. The choice and examination of a possible bride necessitated the gathering of information about her appearance. A well-known instance of this process from Britain is Hans Holbein's deceptive portrait of Anne of Cleves, sent to Henry VIII before their marriage in 1540. Some Florentine letters survive, several by women, which contain verbal portraits of prospective brides when (rarely) one of the partners was away from the city. In 1467 Lucrezia Tornabuoni, Lorenzo de' Medici's mother, traveled to Rome to examine Clarice Orsini, who did become Lorenzo's wife (Sandro Botticelli's panel in the Pitti Palace may represent Clarice about ten years later [7]).[76] She was

fair and tall . . . of good height and has a nice complexion, her manners are gentle, but not so winning as those of our girls, but she is very modest . . . her hair is reddish . . . her face rather round . . . Her throat is fairly elegant, but it seems to me a little meagre or . . . slight. Her bosom I could not see, as here the women are entirely covered up, but it appeared to me of good proportions. She does not carry her head proudly like our girls, but pokes it a little forward; I think she was shy, indeed I see no fault in her save shyness. Her hands are long and delicate. . . .

Well might she have been shy under Lucrezia's merciless eye!

In 1486 a male report to Lorenzo de' Medici on his son's future wife in Naples noted her "neck which is somewhat thick at the back" and said that her guardians "would sooner show one of their girls to ten men than to one woman."[77] Virtually taking on a surrogate male position, these fierce female observers were also defending their stake in their own economy. But they were adopting standards convenient to a patriarchy, using "male language in order to be heard."[78] To some as yet unknown extent they may have refined definitions, avoided or flaunted others, but women's "culture" or "networks," currently being investigated by social historians, do not readily appear in what are usually categorized as "domestic," but should be termed "palatial," representations produced for and by men.

Like the detailed epistolary reports, ideal descriptions of the Beloved or the Ideal personification, especially in poetry, were "anatomizing," as Ruth Kelso, Nancy Vickers and others have argued.[79] The female body is scattered into separate areas such as neck, eyes, skin, mouth and hair, and other factors like her size and bearing are also examined. The profile form, already a fragmentary statement fixing one side of the upper body but absenting the rest, complements such an aesthetic typology due to its simplifying clarity. Hence it easily became an early format for caricature in the

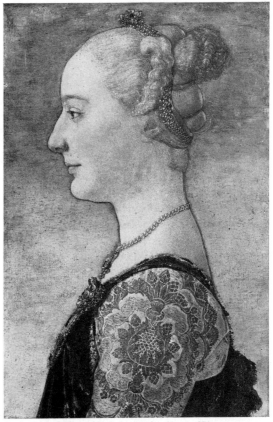

8. Antonio Pollaiuolo, *Portrait of a Young Woman*, ca. 1470. Florence, Uffizi (*Soprintendenza per i beni artistici e storici Gabinetto Fotografico, Florence*).

work of artists like Leonardo or Gian Lorenzo Bernini.[80] Lipman noted a clear color division in the profile portraits between hair, head, corsage and sleeves,[81] but other features, like the silhouette of neck and nose, lips, jawline and untainted skin color, are also marked out distinctly [8].

A "rounded" or integrated, plastic character is denied by the impersonal, claustrophobic presentation of a face which has no space or volume of its own. The groom and girl in Lippi's double portrait, for instance [3], are each framed by a series of windows which allow our merciless scrutiny but cannot enable their own engagement with each other or with the viewer. The averted eye and face open to scrutiny, necessarily presented by the profile view, permit the close, cool and extended exposure of the body reported in fifteenth-century letters and poems. Barbara Kruger's recent comment on the eye's intrusion and violence, using the caption "Your gaze hits the side of my face," aptly chose a female profile as accompaniment.[82]

In fifteenth-century society, lowered or averted eyes were the sign of a woman's modesty, chastity and obeisance.[83] A loose woman, on the other hand, looked at men in the street.[84] Temptation or a lover were avoided or discouraged if a virtuous woman did not return the gaze.[85] Whilst actual behavior doubtless included surreptitious glances or longing looks, it is indicative that the poet Veronica Gambara, when she explicitly looked on her object of "desire," was comforted not by a man but, unexpectedly and ironically, by "hills," "waters" and a "gracious site."[86] Being a noble woman, she was not allowed an optic engagement with men nor had poetic conventions left space for female poets who could actively look. With wit, her sonnet slips between contradictions, not even requiring an unavailable male object of the gaze: "desire is spent except for you alone," she said to her "blest places."

"Bury your eyes," exhorted San Bernardino addressing women from the pulpit, in what was only a particularly concrete version of a commonplace concerning the decorum of the viewed eye.[87] In the profile form eyes cannot be obviously downcast, for this would disturb the strict patterning, but the woman's eye and face are deflected, buried, to the extent that they are averted. Thence she is decorously chaste, the depersonalized and passionless object of passion.

Passion leads us to the poetics and psychology of the eye. The poetic convention of "love's fatal glance," especially since Petrarch's writings, imaged the dangerous woman whose "arrows" of love from her eyes could aggressively pierce the lover.[88] In a sonnet by Petrarch "her eyes have the power to turn [him] to marble" and Pietro Bembo later plays with the same optic fear.[89] In one poem "I gaze defenselessly" into a woman's "lovely eyes" and "lose myself"; in another, of ca. 1500, he "sculpted [her image] in my heart" yet "you burn me, if I gaze on you, you who are cold stone." Around 1542 his fellow Venetian Pietro Aretino also worked with the popular, Petrarchan conventions, writing of Titian's "brushes" as equivalent to Love's "arrow," so that male tools are capable of some control over a danger of their own making.[90] The beloved's wounding glance, voiced in poetry, is especially made modest and mute by the profile format; the male lover can behold and possess without being seen and hence without becoming vulnerable. The ideally passive and modest young woman appropriately "appears" rather than "acts"[91] in the static form, unable to arouse, distract or engage with the authoritative ocular presence. Any potential "Medusa effect,"[92] the unmanning caused by Medusa's stony and fatal gaze, is defused.

The male profile was a short-lived form in panel portraiture, perhaps because it presented too inactive and disengaged a view of these virile family exemplars.[93] In psychoanalytic terms, further, the near "blindness," implicit in the profile form's "buried" eye, threatened any male portrayed in profile with impotence or castration.[94] In classic Freudian terms, a blind man can no longer see a woman's lack of the phallus. He cannot then be aware of his own sexual and potent difference, so he is in a sense castrated, undifferentiated. Scopophilia, a sexual gaze, is constructed as a masculine activity in Renaissance poetry and Freudian psychoanalysis. The viewing active male, outside the profile's frame and looking on, was virile. When

a sixteenth-century Sienese novelist wanted to characterize Florentines, famed for "sodomy," he wrote of them "not wanting to look at women in the face."[95] A century earlier his compatriot San Bernardino frequently spoke of homosexual or uninterested husbands not looking at their wives.[96] The Dominican Fra Giovanni Dominici also interpreted face-to-face contact in heterosexual terms. He adapted a Biblical injunction against a father's indulgence of his daughter (Sirach 7:24) by casting it in the language of the eye and face and extending the distrust to the mother: the father is not to smile on the daughter "lest she fall in love with his virile countenance" nor must the mother "ever . . . show [her son] a face which will cause him while still little to love women before knowing what they are."[97] The language of the eye could be a sensual and hence feared, even repressed one. The passionless, chaste state of a woman in profile is the product of this burden.

The de-eroticized portrayal of women in profile meant female eyes no longer threaten the seeing man with castration. Her eyes cannot ward off his, nor send "arrows" to the lover's heart. Castration anxieties are also displaced by fetishization, by the way in which a woman's neck, eye and other features are rendered safe commodities through fragmentation and distancing, excessive idealization.[98] A psychoanalytic level of interpretation can also be offered for viewers who were female. When the female guardian assessed other women, or when the exemplary mother was visually presented to her daughters, it may be that a feminine parallel to masculine fetishism, that is, narcissism, was operating. But the "maternal gaze" posited by the film theorist E. Ann Kaplan or the narcissistic desire to see one's self in one's children posited by Sigmund Freud does not adequately fit the evidence left to us in Quattrocento artifacts.[99] Remembering the degree of female complicity in an extreme patriarchy, we could take account of a summarizing phrase employed by Linda Williams in her study of female spectators of film: "her look even here becomes a form of not seeing anything more than the castration she so exclusively represents for the male."[100]

The potential instability of sexual identity is controlled by a fixed and immutable sign of difference constructed in the profile portrait. Female impotence is contrasted with the potent flesh or brush of the male viewer or artist. Lacking both phallus and any genitalia of her own in these truncated images, the woman is seen as an absence of an absence. As Diane Owen Hughes suggests in her study of family portraiture in early modern Europe, images of women can be interpreted "not as reflections . . . but rather as idealized or admonitory representations of what is desired or what is feared."[101]

To turn now from sensuality to politics, from one form of potency to another, is not to suggest that the divisions are clear or absolute between seemingly interior and exterior acts. Whilst contemporary studies of the gaze focus upon psychic theories, the investigation above has tried to excavate a historical dimension. When theories of the gaze are applied to physical objects like paintings, especially those from pre-Freudian times when the language of sexuality and codes for the eye's conduct were different from ours, we need to consider a range of cultural and historical factors. Here Michel Foucault's *History of Sexuality*, particularly derived from a study of ancient Greece and Rome, has done much to alert us to the changing and historically determined nature of what is unthinkable, what performed.[102] Jeffrey Weeks also has argued for a contextual understanding of sexuality, supported by his own studies of nineteenth- and twentieth-century Britain.[103] Sexuality and the operation of the gaze in fifteenth-century Italy will have their own histories and contexts, too.[104] Castration anxiety may be an ahistorical or transhistorical phenomenon, for instance,[105] but profile portraits are far more than specific manifestations of a universal fear. They existed for a relatively short time in a particular region and "display culture" for a variety of reasons. Feminist historians can use their practice to question, refine or deconstruct Freudian orthodoxy and patriarchy's appearance of natural inevitability.

We could, for instance, recall Foucault's investigation of the "Eye of Power" in post-Enlightenment France, which observed "captive sil-

houettes" in the Panopticon, or viewing machine, built mainly as schools, army dormitories and prisons.[106] But we could speak of ocular politics in terms of patriarchy and gender, as Foucault does not. The gaze as an instrument of control and supervision, particularly over women, operated earlier than Foucault would seem to believe, in less technological or awesome architecture.[107] The peep-hole in monastery, nunnery and asylum doors, for instance, or the wrought-iron grill behind which cloistered folk were incarcerated yet seen, allowed the regulatory eye's performance. In the first decade of the sixteenth century a man versed in courtly practice advised cardinals to hide viewing or listening tubes in their audience chambers "so that men's speech, gestures and expressions can be more clearly studied by means of observation."[108] Deception was necessary, otherwise "those who come to pay their court are moved to abandon their natural behavior."[109]

Earlier architectural advice concerning the observation of young women did not seem to require a hidden eye, perhaps because "natural behavior" was not allowed or desired from women anyway. Around 1464 the Florentine architect Antonio Filarete, who worked often in ducal Milan, described a proto-Panopticon for the housing and education of very young girls.

From the outside one can look into the rooms where the skills are being learned and can see what is being done . . . they need to be seen, so they can be married . . . [but] no man can enter for any reason.[110]

Here is the protective, potent male eye operating.

The power of the female gaze, especially that of girls and widows (both of whom were considered sexually available), was feared or denied when it was likely to be engaged with the male look. But older women had more authority when their gaze operated for the purposes of protecting and aug-

menting the reputation of the lineage. The young woman was anatomized by scopic, patriarchal scrutiny when she was the bearer or potential bearer of assessable property. The profile portrait of a woman presented a sign of kinship exchange, displaying the nobility of her natal line, the exemplary nature of her own virtue and then her husband's honor and possession. The female eye was disempowered and her body an emblem for the display of rank, honor and chastity.

By the late fifteenth century the profile portrait had been displaced. Florentine women portrayed in three-quarter view and length began to include older exemplars dressed in plainer costume, such as Lorenzo de' Medici's relatively influential mother, Lucrezia Tornabuoni, who is probably shown mourning her husband's death.[111] But the profile was still utilized on occasion. Leonardo's portrayal of another powerful woman, Isabella d'Este, belongs to the tradition of north Italian ruler portraits in profile, as had an earlier profile portrait of a princess, possibly also of an Este woman, by Pisanello.[112]

In Florence, paired portraits of married couples, such as the one by Sebastiano Mainardi in the Huntington Library, San Marino, California, showed the male in three-quarter view in front of a landscape with a city and worldly activity, but the female was in profile, painted in a flatter, more absent manner, cut off in a loggia and housebound.[113] Artists of the sixteenth century at times reverted to the archaic profile. Hence the poet Laura Battiferi was shown in striking profile by Agnolo Bronzino in the mid-century[114] and Jacopo Pontormo's Alessandro de' Medici draws his beloved lady in profile as a sign of his singular regard for (that is, of) her.[115] The male gaze continued in its triumphant potency while the female gaze remained repressed: one reason, we may speculate, why the female artist has, until very recently, been a rare creature.

NOTES

A shorter version of this paper was delivered in a symposium convened by Natalie Boymel Kampen: "Gender and Art History: New Approaches," at the College Art Association annual conference in 1987. I am grateful to several editors of History Workshop, *especially Lyndal Roper, for their interest and comments. All translations are my own, unless otherwise indicated.*

1. Jean Lipman, "The Florentine Profile Portrait in the Quattrocento," *Art Bulletin* 18 (1936): 54–102, remains the basic survey and catalogue. Much of its argument is repeated in J. Mambour, "L'évolution esthétique des profils florentins du Quattrocento," *Revue belge d'archéologie et d'histoire de l'art* 38 (1969): 43–60. The five male portraits are considered by Rab Hatfield, "Five Early Renaissance Portraits," *Art Bulletin* 47 (1965): 315–34. For the painting illustrated in Figure 1, see Patricia Simons, "A Profile Portrait of a Renaissance Woman in the National Gallery of Victoria," *Art Bulletin of Victoria* 28 (1987): 34–52.

2. Lipman, "The Florentine Portrait," pp. 64, 75; Hatfield, "Five Early Renaissance Portraits," p. 317.

3. Jakob Burckhardt, *The Civilization of the Renaissance in Italy*, S.G.C. Middlemore, trans., London, 1960, especially Part II, "The Development of the Individual," and Part IV, "The Discovery of the World and of Man" (first published in German in 1860).

4. The chief survey of Renaissance portraiture is John Pope-Hennessy, *The Portrait in the Renaissance*, London, 1966. See also Lorne Campbell, *Renaissance Portraits: European Portrait Painting in the 14th, 15th and 16th Centuries*, New Haven, Conn., and London, 1990.

5. Lipman, "The Florentine Profile Portrait," p. 96.

6. Hatfield, "Five Early Renaissance Portraits," pp. 319, 321, 326.

7. Lipman, "The Florentine Profile Portrait," n. 69.

8. Pope-Hennessy, *The Portrait in the Renaissance*; Meyer Schapiro, *Words and Pictures: On the Literal and the Symbolic in the Illustration of a Text*, The Hague, 1973. Campbell, *Renaissance Portraits*, p. 81.

9. See, for instance, Laura Mulvey, "Visual Pleasure and Narrative Cinema," *Screen* 16, no. 3 (Autumn 1975): 6–18; Laura Mulvey, "Afterthoughts on 'Visual Pleasure and Narrative Cinema,' inspired by *Duel in the Sun*," *Framework* 15–17 (1981); Mary Ann Doane, "Film and the Masquerade: Theorising the Female Spectator," *Screen* 23, nos. 3–4 (1982): 74–87; E. Ann Kaplan, *Women and Film: Both Sides of the Camera*, London, 1983; L. Mykyta, "Lacan, Literature and the Look: Woman in the Eye of Psychoanalysis," *Substance* 39 (1983): 49–57; Jacqueline Rose, *Sexuality in the Field of Vision*, London, 1986.

Mulvey's essays are reprinted in her *Visual and Other Pleasures*, Bloomington, Indiana, 1989, where her "Changes: Thoughts on Myth, Narrative, and Historical Experience" (first published in *History Workshop*, Spring 1987) makes interesting adjustments to her earlier arguments. In general, the notion of "the gaze" is becoming a more complex, less binary one, and I tried to extend the range of possible masculine and feminine positions in an exhibition called "The Female Gaze" at the Museum of Art, University of Michigan, Ann Arbor, February 8–March 24, 1991.

10. Burckhardt, *The Civilization of the Renaissance*, pp. 240, 241.

11. Ibid., p. 240. Studies on education relevant here include Margaret King, "Thwarted Ambitions: Six Learned Women of the Italian Renaissance," *Soundings* 59 (Fall 1976): pp. 280–304; Gloria Kaufman, "Juan Luis Vives on the Education of Women," *Signs* 3 (1978): 891–6; *Beyond Their Sex: Learned Women of the European Past*, Patricia Labalme, ed., New York, 1980.

12. Joan Kelly, "Did Women Have a Renaissance?" in *Becoming Visible: Women in European History*, Renate Bridenthal and Claudia Koonz, eds., Boston, 1977, repr. in Joan Kelly, *Women, History and Theory*, Chicago, 1984. For an introduction to current thinking, with a few essays on art after the Quattrocento, see *Rewriting the Renaissance: The Discourses of Sexual Difference in Early Modern Europe*, Margaret W. Ferguson, Maureen Quilligan and Nancy J. Vickers, eds., Chicago, 1986.

13. Svetlana Alpers, "Art History and Its Exclusions: The Example of Dutch Art," in *Feminism and Art History: Questioning the Litany*, Norma Broude and Mary D. Garrard, eds., New York, 1982; Patricia Simons, "The Italian Connection: Another Sunrise? The Place of the Renaissance in Current Australian Art Practice," *Art-Network* 19–20 (Winter–Spring 1986): 37–42.

14. Joan W. Scott, "Gender: A Useful Category of Historical Analysis," *American Historical Review* 91 (1986): 1069.

15. Scott, "Gender," p. 1068. The interaction between psychoanalysis and history is a complex and controversial issue; see Elizabeth Wilson, "Psychoanalysis: Psychic Law and Order?" and Jacqueline Rose's response, "Femininity and Its Discontents," each reprinted in *Sexuality: A Reader*, Feminist Review, ed., London, 1987. The latter is also reprinted in Rose, *Sexuality in the Field of Vision*. And see Lisa Tickner, "Feminism, Art History, and Sexual Difference," *Genders* 3 (Fall 1988): 92–128.

16. Fern Rusk Shapley, *Catalogue of the Italian Paintings*, National Gallery of Art, Washington, D.C., 1979, vol. 1, pp. 127–29; Marita Horster, *Andrea del Castagno*, Oxford, 1980, pp. 32–33, 180–81, pl. 93.

17. John Pope-Hennessy, "The Portrait Bust," in his *Italian Renaissance Sculpture*, London, 1958. Irving Lavin, "On the Sources and Meaning of the Renaissance Portrait Bust," *Art Quarterly* 33 (1970): 207–26, by arguing that a presentation of *totus homo* was the aim of these busts, does not consider issues of gender.

18. These portraits of women (mainly from Ferrara or Milan) are also usually in profile, as are several portraits of north Italian male rulers. A separate study could be done of the courtly, imported profile convention for such powerful aristocrats, and of the occasional use of the profile for male portraiture in fifteenth-century Venice, where very few women at all are portrayed before the sixteenth century.

19. Giovanni Boccaccio, *The Corbaccio*, A. K. Cassell, trans., Urbana, Ill., 1975, p. 68.

20. Richard Kieckhefer, *Unquiet Souls: Fourteenth-Century Saints and Their Religious Milieu*, Chicago, 1984, p. 47.

21. The last phrase is a major category used by the sociologist Erving Goffman in his *The Presentation of Self in Everyday Life*, Garden City, N.Y., 1959.

22. Christiane Klapisch-Zuber, *Women, Family, and Ritual in Renaissance Italy*, Lydia Cochrane, trans., Chicago, 1985, especially pp. 19–20, 101ff., 110–11, 170.

23. Ibid., pp. 127, 226.

24. Diane Owen Hughes, "La moda proibita. La legislazione suntuaria nell'Italia rinascimentale," *Memoria* 11–12 (1984): 95, 97, with the example of women dressed in Albizzi family insignia on pp. 94–95.

25. I am here applying the interpretations offered in Gayle Rubin, "The Traffic in Women: Notes on the 'Political Economy' of Sex" in *Towards an Anthropology of Women*, Rayna Reiter, ed., (New York, 1975), and Elizabeth Cowie, "Woman as Sign," *m/f* 1 (1978) 50–64.

26. Klapisch-Zuber, *Women, Family, and Ritual*, pp. 183ff, 188, 190, 218.

27. The following is drawn from Patricia Simons, "Portraiture and Patronage in Quattrocento Florence, with Special Reference to the Tornaquinci and Their Chapel in S. Maria Novella," Ph.D. dissertation, University of Melbourne, 1985, especially pp. 139, 299. Publications which appeared after my article would now enable a greater problematization of the relationship between fathers and daughters. See Lynda E. Boose, "The Father's House and the Daughter in It: The Structures of Western Culture's Daughter-Father Relationship," in L. Boose and Betty S. Flowers, eds., *Daughters and Fathers* (Baltimore and London, 1989), pp. 19–74; Heather Gregory, "Daughters, Dowries and the Family in Fifteenth-Century Florence," *Rinascimento*, ser. 2, no. 27 (1987): 215–37; Anthony Molho, "Deception and Marriage Strategy in Renaissance Florence: The Case of Women's Ages," *Renaissance Quarterly* 41 (Summer 1988): 193–217.

28. Klapisch-Zuber, *Women, Family, and Ritual*, ch. 10, "The Griselda Complex: Dowry and Marriage Gifts in the Quattrocento."

29. Alessandra Macinghi negli Strozzi, *Lettere di una gentildonna fiorentina del secolo XV*, Cesare Guasti, ed., (Florence, 1877), p. 5; translated in Lauro Martines, "A Way of Looking at Women in Renaissance Florence," *Journal of Medieval and Renaissance Studies* 4 (1974): 25.

30. Klapisch-Zuber, *Women, Family, and Ritual*, p. 277.

31. Ibid., p. 245 n. 101; Hughes, "La moda proibita," pp. 89, 102–3.

32. Strozzi, *Lettere*, p. 446; translated in Martines, "A Way of Looking at Women," p. 26.

33. Francesco da Barbaro, *De re uxoria*, Attilio Gnesotto, ed., (Padua, 1915), p. 79; translated in *The Earthly Republic: Italian Humanists on Government and Society*, Benjamin G. Kohl and Ronald G. Witt, eds., (Manchester, 1978), p. 208.

34. Barbaro, *De re uxoria*, p. 74; Kohl and Witt, *The Earthly Republic*, p. 204, adapted slightly here.

35. Barbaro, *De re uxoria*, p. 74; Kohl and Witt, *The Earthly Republic*, p. 204, again adjusted.

36. Lipman, "The Florentine Profile Portrait," p. 97.

37. Federico Zeri with the assistance of Elizabeth E. Gardner, *Italian Paintings; a Catalogue of the Collection of The Metropolitan Museum of Art: Florentine School* (New York, 1971), pp. 85–87. Ringbom has argued that the man's position looking in through a window is usually the location occupied by a painting's donor: Sixten Ringbom, "Filippo Lippis New Yorker Doppelporträt: Eine Deutung der Fenstersymbolik," *Zeitschrift für Kunstgeschichte* 48 (1985): 133–37. If this is the case, then a visual convention is also constructing him as the painting's patron, a man of wealth and status. On Lippi's portrait see also Dieter Jansen, "Fra Filippo Lippis Doppelbildnis im New Yorker Metropolitan Museum," *Wallraf-Richartz-Jahrbuch* 48–49 (1987–88): 97–121, which argues for an alternative date and identification of the figures; Robert Baldwin, "Gates Pure and Shining and Serene: Mutual Gazing as an Amatory Motif in Western Literature and Art," *Renaissance and Reformation/Renaissance et réforme* 10, no. 1 (1986): 30ff, which suggests a relationship to the Song of Songs.

38. Richard Trexler, "Le Célibat à la fin du Moyen Age: les religieuses de Florence," *Annales E.S.C.* 27 (1972): 1329–50.

39. Paolo da Certaldo, for instance, advised that one check a woman's family, health, sanity, honor and "bel viso," or beautiful face: quoted in Giovanni Morelli, *Ricordi*, Vittore Branca, ed. (Florence, 1956), p. 210 n. 1, with other references.

40. Leon Battista Alberti, "I libri della famiglia," in his *Opere volgari*, Cecil Grayson, ed. (Bari, 1960), vol. 1., pp. 110–11, translated in *The Family in Renaissance Florence*,

Renée Neu Watkins, trans. (Columbia, S.C., 1969), pp. 115–16.

41. For instance, Strozzi, *Lettere*, p. 445; B. Buser, *Lorenzo de' Medici als italienischer Staatsmann* (Leipzig, 1879), p. 171.

42. Strozzi, *Lettere*, p. 4; Baldassar Castiglione, *Le lettere*, Guido La Rocca, ed., (Milan, 1978), vol. 1, p. 265.

43. Alberti, "I libri della famiglia," p. 110; translated in *The Family in Renaissance Florence*, p. 115.

44. *Renaissance Princes, Popes and Prelates: The Vespasiano Memoirs, Lives of Illustrious Men of the XVth Century,* William George and Emily Waters, trans., (New York, 1963), p. 462.

45. Alberti, "I libri della famiglia," p. 224; translated in *The Family in Renaissance Florence*, p. 213. Paolo da Certaldo, *Libro di buoni costumi*, Alfredo Schiaffini, ed. (Florence, 1945), p. 129, said that "a good wife is a husband's crown, his honour and status *(stato).*"

46. The phrases are from Paolo da Certaldo, *Libro*, p. 105 ("La femina è cosa molto," p. 239), Cennino Cennini, *The Craftsman's Handbook*, Daniel V. Thompson, Jr., trans. (New York, 1960), pp. 48–49, and Marsilio Ficino in David Herlihy and Christiane Klapisch-Zuber, *Tuscans and Their Families: A Study of the Florentine Catasto of 1427* (New Haven, Conn., 1985), p. 148.

47. Boccaccio, *The Corbaccio*, passim, with other references to misogynist literature of the time.

48. Philip Hendy, *Some Italian Renaissance Pictures in the Thyssen-Bornemisza Collection* (Lugano, 1964), pp. 43–45; Simons, "Portraiture and Patronage," pp. 142–45.

49. Archivio de Stato, Florence, Pupilli avanti il Principato, 181, folio 148 recto.

50. *Petrarch's Lyric Poems: The "Rime sparse" and Other Lyrics*, R.M. Durling, trans. (Cambridge, Mass., 1976), sonnets 77 and 78; Lorenzo de' Medici, "Comento" in his *Scritti e scelti*, Emilio Bigi, ed. (Turin, 1955), pp. 364ff.

51. Boccaccio, *The Corbaccio*, passim; Diane Owen Hughes, "Sumptuary Law and Social Relations in Renaissance Italy," in *Disputes and Settlements: Law and Human Relations in the West*, John Bossy, ed. (Cambridge, 1983); Hughes, "La moda proibita."

52. For instance, Diane Bornstein, *The Lady in the Tower: Medieval Courtly Literature for Women* (Hamden, Conn., 1983), pp. 24, 74. Doris Lessing's comment on another context might be pertinent here: "In Purdah women gaze out of windows and keep opening doors quickly a little way to see what might be happening on the other side; it is a place where you listen and watch for the big events going on outside the room you are imprisoned in": *The Wind Blows Away Our Words and Other Documents Relating to the Afghan Resistance* (London, 1987), p. 134.

53. Elizabeth Cropper, "The Beauty of Woman: Prob-

lems in the Rhetoric of Renaissance Portraiture," in Ferguson, Quilligan and Vickers, *Rewriting the Renaissance*, p. 188.

54. Ibid., p. 188; Leon Battista Alberti, *On Painting*, John R. Spencer, trans. (New Haven, 1966 revised edition), p. 63: "Painting contains a divine force which not only makes absent men present . . . but moreover makes the dead seem almost alive."

55. Anonymous French School, *Jean II Le Bon*, Paris, Louvre (second half of the fourteenth century); Anonymous English School, *Henry V* (1387–1422), London, National Portrait Gallery (the latter however is a sixteenth- or seventeenth-century panel, probably derived from a larger votive or donor portrait). For the Leonine Warrior see n. 56, below.

56. Peter Meller, "Physiognomical Theory in Renaissance Heroic Portraits," in *Studies in Western Art. Acts of the XX International Congress of the History of Art* (Princeton, N.J., 1963), vol. 2, pp. 53–69. Titian's portrait of the Duke of Urbino (ca. 1537) was compared with "Alexander's face and torso" by Pietro Aretino, whose sonnet mentions such features as the Duke's "fiery spirit in his eyes" and the "courage" burning "in his breastplate and in his ready arms." For the text and translation see Mary Rogers, "Sonnets on Female Portraits from Renaissance North Italy," *Word and Image* 2 (1986): 303–4.

57. Martin Davies, *The Earlier Italian Schools* (National Gallery, London, revised edition, 1961), pp. 42–43; Eliot Rowlands, "Baldovinetti's "Portrait of a Lady in Yellow," *Burlington Magazine* 122 (1980): 624, 627.

58. Hughes, "La moda proibita," pp. 97–98.

59. Loc. cit. An interesting comparison could be made with strict Muslim practice, where women are veiled and only the husband can permit photography of a wife's face. The faces of old women and children seem less solely the man's to possess: Lessing, *The Wind Blows*, pp. 78, 80, 108.

60. Shapely, *Catalogue of the Italian Paintings*, pp. 251–55, pl. 171.

61. Kenneth Clark, *Piero della Francesca* (London, 1951), pp. 206–7, pls. 101–10, who notes that the duke's neck was thickened so that "the present outline accentuates the monumental character of the silhouette." Derived from this pairing of a ruler with a wife, each in profile, are Ercole Roberti's portrait of the Bolognese despot *Giovanni II Bentivoglio* with *Ginevra Bentivoglio:* Shapley, *Catalogue of the Italian Paintings*, pp. 406–7, pls. 288–89. A third pair by an Emilian artist emphasizes the woman's profile by posing her face against a dark window: John Pope-Hennessy, assisted by Laurence B. Kanter. *The Robert Lehman Collection. I: Italian Paintings* (Metropolitan Museum of Art, New York, and Princeton, N.J., 1987), pp. 214–19. David Buckland's photographic portrait of *The Numerologist* (1984), displayed with *The Wife* (1985) in his exhibition *On a Grand Scale* at the Photogra-

phers' Gallery, London (20 March–25 April 1987), con-
sciously refers to Piero's paintings. The woman's pale flesh,
decoratively curled hair, thin body and neck projecting less
into space than the man's, for instance, all recall the repre-
sentation of the duchess of Urbino.

62. Clark, *Piero della Francesca*, p. 206.

63. Florentine legislation of 1355/6, translated in Boc-
caccio, *The Corbaccio*, pp. 154–62 passim.

64. Alberti, "I libri della famiglia," p. 224; translated in
The Family in Renaissance Florence, p. 213. Similar ad-
vice was given by Paolo da Certaldo, in the context of
which he wrote of a woman's "fame of chastity" being
"like a beautiful flower": *Libro*, p. 73.

65. Strozzi, *Lettere*, p. 471; translated in Martines, "A
Way of Looking at Women," p. 22.

66. Christiane Klapisch-Zuber, "Le 'zane' della sposa.
La fiorentina e il suo corredo nel Rinascimento," *Memoria*
11–12 (1984): 12–23.

67. Ibid., pp. 20, 21.

68. See, for example, Alberti, quoted at n. 45, above;
Kaufman, "Juan Luis Vives," p. 892; Bornstein, *The Lady
in the Tower*, p. 70.

69. Hughes, "La moda proibita," pp. 98–99; also Diane
Owen Hughes, "Representing the Family: Portraits and
Purposes in Early Modern Italy," *Journal of Interdiscipli-
nary History* 17 (Summer 1986): 7–38.

70. Hughes, "La moda proibita," pp. 82, 93–96 passim.

71. Ibid., pp. 93–94, translated here from Hughes's
paraphrase.

72. Bisticci, quoted at n. 44, above.

73. For the first quotation see Boccaccio, *The Cor-
baccio*, pp. 38–39, 50–51, 69ff; for the second, Alberti,
The Family in the Renaissance, p. 115.

74. See, for example, Elizabeth Swain, "Faith in the
Family: The Practice of Religion by the Gonzaga," *Journal
of Family History* 8 (1983): 177–89. Male Afghan refugees
also leave "an old woman in command of everything,"
including the children and wives, when the men return to
battle: Lessing, *The Wind Blows*, pp. 107, 109; see also
pp. 113, 149, and n. 59, above.

75. Alberti, *The Family in Renaissance Florence*, p.115.

76. *Lives of the Early Medici as Told in Their Corre-
spondence*, Janet Ross, trans. and ed. (London, 1910), pp.
108–9; Gabriele Mandel, *The Complete Paintings of Bot-
ticelli* (London, 1970), no. 49.

77. Buser, *Lorenzo de' Medici*, p. 171.

78. Lisa Tickner, "Nancy Spero: Images of Women and
La Peinture Féminine," in *Nancy Spero* (London, 1987),
p. 5, referring in particular to the ideas of Luce Irigaray.

79. Ruth Kelso, *Doctrine for the Lady of the Renais-
sance* (Urbana, Ill., 1956), especially p. 195; Elizabeth
Cropper, "On Beautiful Women, Parmigianino, *Petra-
chismo*, and the Vernacular Style," *Art Bulletin* 58
(1976): 374–94; Nancy Vickers, "Diana Described: Scat-

tered Woman and Scattered Rhyme," *Critical Inquiry* 8
(Winter 1981): 265–79; see also Rodolfo Renier, *Il tipo
estetico della donna nel medio evo* (Ancona, 1885); Em-
manuel Rodocanachi, *La femme italienne avant, pendant
et après la Renaissance* (Paris, 1922; reprint of the 1907
edition), pp. 89ff.; Giovanni Pozzi, "Il ritratto della donna
nella poesia d'inizio Cinquecento e la pittura di Giorg-
ione," *Lettere italiane* 31 (1979): 3–30.

80. Schapiro, *Words and Pictures*, p. 45; A.E. Popham,
The Drawings of Leonardo da Vinci (London, 1946), espe-
cially pls. 133ff., passim; Irving Lavin, "Bernini and the
Art of Social Satire," in *Drawings by Gianlorenzo Bernini:
from the Museum der Bildenden Künste Leipzig, German
Democratic Republic*, Irving Lavin et al. (Princeton,
1981).

81. Lipman, "The Florentine Profile Portrait," p. 76.

82. Barbara Kruger, *We Won't Play Nature to Your
Culture* (London, 1983).

83. For example, Barbaro, *De re uxoria*, pp. 72–73, 74
(the latter is quoted at n. 34, above). The restriction has
a long history. Celie's sister wrote to her from Africa: "To
'look in a man's face' " is a brazen thing to do . . . it is our
own behaviour around Pa" (Alice Walker, *The Color Pur-
ple*, London, 1983, p. 137).

84. Gene Brucker, *Giovanni and Lusanna: Love and
Marriage in Renaissance Florence* (Berkeley, 1986), p. 27.
In an Italian ceramic trencher of about 1525–30, a man
and a woman looking at each other are accompanied by
the inscription "All things are done by money," which
probably indicates an ocular and monetary exchange with
a prostitute: A.V.B. Norman, *Wallace Collection. Cata-
logue of Ceramics I. Pottery, Maiolica, Faience, Stoneware*
(London, 1976), pp. 117–18. Pornography often shows the
woman directly looking at the viewer: Rosalind Coward,
"Sexual Violence and Sexuality" in *Sexuality: A Reader*,
p. 318. However, complicity or equality can be the point
of the mutual gaze, depending on the context's gender
loading, narrative, and so on. Thus, the Virgin Mary some-
times looks out at the viewer (of either sex) in Renaissance
paintings to suggest her intercessory role. The usual pres-
ence of the Christ Child with her reinforces the foreclosed
possibility of a taboo sexual encounter with the Mother.

85. For example, Judith Brown, *Immodest Acts: The
Life of a Lesbian Nun in Renaissance Italy* (Oxford,
1986), p. 55; Bisticci, *Renaissance Princes, Popes and Prel-
ates*, p. 453.

86. Veronica Gambara, "Since I, by my fortune, return
to look on" in *The Defiant Muse: Italian Feminist Poems
from the Middle Ages to the Present*, Beverly Allen, Muriel
Kittel and Keala Jane Jewell, eds. (New York, 1986), pp.
4–5 (with Italian text).

87. Iris Origo, *The World of San Bernardino* (London,
1964), p. 68.

88. Ruth Cline, "Heart and Eyes," *Romance Philology*

25 (1971–72): 263–97; Lance Donaldson-Evans, *Love's Fatal Glance: A Study of Eye Imagery in the Poets of the "Ecole Lyonnaise,"* Place University, 1980; Rogers, "Sonnets on Female Portraits," p. 291. A bowl of about 1535 mildly illustrates the convention: a young couple look at each other whilst Cupid's arrow is about to be released very close to the man's head (Norman, *Wallace Collection,* pp. 91–92).

89. *Petrarch's Lyric Poems,* no. 197 (pp. 342–43); for Bembo see Rogers, "Sonnets on Female Portraits," p. 301.

90. Ibid., p. 303. On the phallic brush in modern painting see Carol Duncan, "Virility and Domination in Early Twentieth-Century Vanguard Painting," in Broude and Garrard, *Feminism and Art History.*

91. The distinction between depicted female and male figures is drawn in John Berger, *Ways of Seeing* (Harmondworth, 1972), p. 47.

92. Craig Owens, "The Medusa Effect or, The Spectacular Ruse," in Kruger, *We Won't Play Nature.*

93. Of course many men continue to be portrayed in profile within larger works, as donors in altarpieces or as onlookers in religious and historical narratives. Donor and "courtly" portraiture conventions are in part being utilized in such works, but it could be said also that the men are shown as active, at times scopic, viewers. Engaged with the artifact's entire action or focus, these men are not contained within the tight frame of an independent profile which provides no object for the portrayed person's gaze.

94. For the importance of visual evidence to Freud's theories, see Stephen Heath, "Difference," *Screen* 19 (Autumn 1978): 51–112. On the loss of an eye symbolizing impotence in medieval France see Jacqueline Cerquiglini, " 'Le Clerc et le louche': Sociology of an Esthetic," *Poetics Today* 5 (1984): 481.

95. Pietro Fortini, *Novelle di Pietro Fortini Senese,* T. Rughi, ed. (Milan, 1923), p. 64.

96. Origo, *The World of San Bernardino,* pp. 50, 53, 70. For a man's virile and "fiery spirit in his eyes" see n. 56, above.

97. Giovanni Dominici, *Regola del governo di cura familiare compilata dal Beato Giovanni Dominici fiorentino,* Donato Salvi, ed. (Florence, 1869), p. 144. The first phrase is translated in Origo, *The World of San Bernardino,* p. 64, the second in David Herlihy and Christiane Klapisch-Zuber, *Tuscans and Their Families,* p. 255, but neither text treats *both* injunctions to the male and female partner.

98. On fragmentation see Coward, "Sexual Violence and Sexuality," pp. 318–19.

99. Kaplan, *Women and Film;* reviewed by D. Waldman and J. Walker, "Is the Gaze Maternal?," *Camera Obscura,* 13–14 (1985): 195–214.

100. Linda Williams, "When the Woman Looks," in *Re-Vision: Essays in Feminist Film Criticism,* Mary Ann Doane, Patricia Mellencamp, and Linda Williams, eds. (Los Angeles, 1984), p. 88.

101. Diane Owen Hughes, "Representing the Family," p. 11.

102. Michel Foucault, *The History of Sexuality,* Robert Hurley, trans. (London, 1979), vol. 1: *An Introduction.*

103. Jeffrey Weeks, *Sex, Politics and Society: The Regulation of Sexuality Since 1800* (London, 1981); Jeffrey Weeks, *Sexuality* (Chichester, 1986).

104. The possibility, in relation to profile portraiture, is raised in nn. 17 and 93, above.

105. Scott, "Gender," p. 1068.

106. Michel Foucault, "The Eye of Power," in his *Power/Knowledge: Selected Interviews and other Writings, 1972–77,* C. Gordan, ed. (Brighton, 1980).

107. For instance, see n. 83, above. An unveiled woman away from Purdah was probably observed by "the area Eye, the little policeman" in Peshawar: Lessing, *The Wind Blows,* pp. 118–19. Interesting implications about politics and the eye are raised by the texts cited in Marc Bensimon. "The Significance of Eye Imagery in the Renaissance from Bosch to Montaigne," *Yale French Studies* 47 (1972): 266–90, and Cerquiglini, "Le Clerc et le louche," pp. 479–91.

108. Kathleen Weil-Garris and John F. D'Amico, "The Renaissance Cardinal's Ideal Palace: A Chapter from Cortesi's *De Cardinalatu,*" in *Studies in Italian Art and Architecture,* Henry A. Millon, ed. (Rome, 1980), p. 83.

109. Ibid., p. 83; see also p. 95, on ways of conducting an audience and "judging the motion of their eyes."

110. Antonio Filarete, *Treatise on Architecture,* John R. Spencer, trans. (New Haven, Conn., 1965), pp. 242–43.

111. Shapley, *Catalogue of the Italian Paintings,* pp. 203–4, pl. 140.

112. Popham, *The Drawings of Leonardo,* pl. 172; Germain Bazin, *The Louvre,* M.I. Martin, trans. (London, 1979, revised edition), pp. 131–32, on Pisanello's *A Princess of the House of Este.*

113. Raimond van Marle, *The Development of the Italian Schools of Painting* (The Hague, 1931), vol. 13, pp. 209ff., pls. 142–43, 145, who illustrates the male half of the Huntington pair and both portraits of a similar pair in the Staatliche Museen, Berlin.

114. Elizabeth Cropper, "Prolegomena to a New Interpretation of Bronzino's Florentine Portraits," in *Renaissance Studies in Honor of Craig Hugh Smyth,* Andrew Morrogh et al., eds. (Florence, 1985), vol. 2, p. 158 n. 4, cites L. Bellosi and relates this portrait to the typological profiles of Dante, not to the gender conventions discussed above.

115. Leo Steinberg, "Pontormo's Alessandro de' Medici, or, I Only Have Eyes for You," *Art in America* 63 (January–February 1975): 62–65, which could be taken further in the light of the argument offered above.

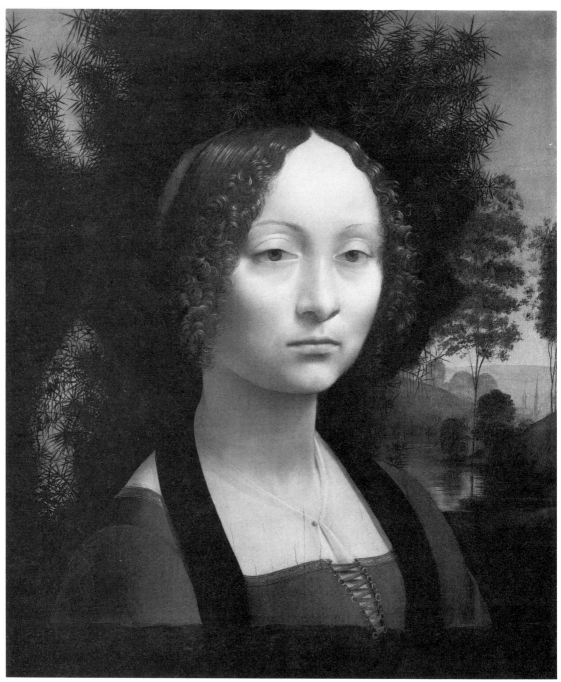

1. Leonardo da Vinci, *Ginevra de' Benci*, ca. 1478–80. Washington, D.C., National Gallery of Art, Ailsa Mellon Bruce Fund.

3

LEONARDO DA VINCI

Female Portraits, Female Nature

MARY D. GARRARD

In 1944, Langton Douglas, one of the many writers on the art of Leonardo da Vinci, noted what he called the "strange psychological fact" that Leonardo shows greater insight into human personality in his female portraits than in his portraits of males. In 1961, K. R. Eissler elucidated Douglas's observation through the psychology of the homosexual, whose empathy with women, he explained, is borne out in clinical studies.[1] For the proof of Leonardo's sexual orientation we are indebted to a suggestive smattering of documentary evidence from the fifteenth century, but much more influentially, to Sigmund Freud's classic essay on Leonardo of 1910, in which the father of psychoanalysis, and of psychobiography, examined Leonardo as a case study of the deviant sexual development of the homosexual, interpreting the artist's extraordinary female images, most particularly the *Mona Lisa,* as a consequence of his lifelong fixation upon his mother.[2]

I shall return to the question of Leonardo's homosexuality, but that is not precisely my subject here. For the explanation of Leonardo's artistic unorthodoxy by way of what was seen as his sexual unorthodoxy does not so much explain one curiosity as reveal another. Why should a man's empathy with women be considered a facet of abnormal psychology? If one Renaissance artist's presentation of the female in sympathetic or psychologically complex images is so unusual as to demand special explanation, what does that tell us about gender attitudes in Renaissance Italy and today? In this essay, I will suggest a way of looking at Leonardo's art that reveals it as indeed abnormal, but in social rather than psychological terms. For Leonardo presented through art a view of the female sex that was culturally abnormal in the patriarchy of his day: woman understood individually as an intelligent being, biologically as an equal half of the human species, and philosophically as the ascendant principle in the cosmos. His position deserves our attention, for it was distinctive in a period when women were neither politically nor socially empowered to make such a case for themselves.

I begin with the earliest preserved portrait by Leonardo's hand, the *Ginevra de' Benci* in the National Gallery, Washington, D.C. [1], probably painted in the late 1470s, which puts forth a fun-

damentally new female image. The sitter is posed in a three-quarter view and engages the eyes of the viewer. Full-faced female sitters appeared occasionally in Northern European portraits of the fifteenth century, and in painting Ginevra de' Benci, Leonardo may have followed a Netherlandish type, just as he shows some influence of Netherlandish style.[3] In Italy, however, Leonardo's portrait of Ginevra de' Benci was revolutionary, setting in motion the replacement of the profile portrait type customary for women in the first three-quarters of the fifteenth century. The painting's influence is reflected, for example, in Lorenzo di Credi's slightly later portrait in the Metropolitan Museum, New York [2], which may represent the same sitter, and in other three-quarter–posed sitters who appear increasingly in late Quattrocento and early Cinquecento portraits.[4]

The change in the preferred pose for female sitters initiated by Leonardo was of greater than mere formal significance. Occasionally in Northern fifteenth-century portraits, but—as far as I can tell—never before in Italian portraits, does a female sitter look directly into the eyes of the viewer. The difference is profound, for the reason that Leonardo himself stated in the famous aphorism "The eye is said to be the window of the soul."[5] The sitter who looks at the viewer confronts us on equal terms and forms a connection with us personally, piercing the picture plane to establish a psychic intercourse in human time. The originality of the *Ginevra de' Benci* in this respect has not gone entirely unrecognized. John Walker called this picture "the earliest of all psychological portraits," while John Pope-Hennessy described it as bringing to the history of the portrait "a new sense of the mystery and uniqueness of the human personality."[6] Writing in the 1960s, however, these scholars could not fully acknowledge how exceptional it was that the first psychological portrait produced in Renaissance Florence should have depicted a woman and not a man.

Recent feminist scholarship has clarified the terms of this exceptionality. As Patricia Simons has shown, the Quattrocento profile portrait convention presented young women, usually at the time of their marriages, as beautiful but passive

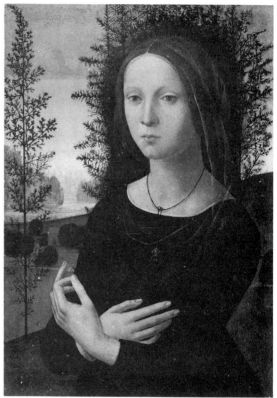

2. Lorenzo di Credi, *Portrait of a Woman*, late fifteenth century. New York, Metropolitan Museum of Art, Bequest of Richard de Wolfe Brixey, 1943.

possessions of male heads of households, inert mannequins for the display of family wealth to the gaze of other males.[7] The convention supported patriarchal values, draining the bride of any sign of inner animation or worth, and reifying the inequality of the marital partners. By contrast, Leonardo presents the woman named Ginevra de' Benci in dramatically different terms: imbued with psychic life, she confronts the viewer's gaze with an icy, noncoquettish stare. The latter distinction is important, because it separates the National Gallery painting from a class of female "portraits" that emerged at the turn of the sixteenth century, of which Bartolommeo Veneto's *Portrait of a Woman* is an example [3], women recognizable as courtesans or prostitutes by their provocative gaze at the viewer, a posture that marked them as brazen because, in art, ordinary

Renaissance wives did not directly engage the (male) viewer's eye.[8]

But then, Ginevra de' Benci was not an ordinary Renaissance wife. She was a member of a wealthy and educated family, the Benci, who were of considerably greater cultural influence than the man she married in 1474, Luigi Niccolini. Ginevra's grandfather, Giovanni de' Benci, was general manager of the Medici bank and an artistic patron in his own right; her father, Amerigo, was patron and friend of the Neoplatonist Marsilio Ficino.[9] Ginevra de' Benci herself, born in 1457, was recognized as a poet, though we know almost nothing of her literary work. The Washington picture was long ago identified with a portrait of Ginevra de' Benci said by Vasari and other writers to have been painted by Leonardo da Vinci, and it has long been regarded as her marriage picture. The identifying feature of the image is the juniper bush behind the sitter's head, which recurs as a sprig on the obverse of the panel, an allusion to the name "Ginevra" (the Italian for juniper is *ginepro*). The inscription on the obverse, VIRTUTEM FORMA DECORAT (she adorns her virtue with beauty), has been taken to refer to the attributes relevant to the sitter's status as a bride.[10]

As a woman of renowned beauty, Ginevra de' Benci was also the subject of ten poems written by members of the Medici circle, Cristoforo Landino and Alessandro Braccesi, and of two sonnets by Lorenzo de' Medici himself. The ten poems were commissioned by Bernardo Bembo (the father of the writer Pietro Bembo), who was in Florence in 1475–76 and again from 1478 to 1480 as Venetian ambassador, and who—by the evidence of the poems—selected Ginevra de' Benci as the object of his platonic love.[11] It has recently been argued that Bembo may have also commissioned the portrait now in the National Gallery. Jennifer Fletcher has pointed out that the emblematic design on the verso of the panel [4], a bay laurel and a palm branch encircling a sprig of juniper, is almost identical with Bernardo's personal device, a near-circular wreath formed by embracing laurel and palm branches, with varying elements inside [5].[12] In this interpretation, the emblem painted by Leonardo on the back of the panel should be read as Bernardo's impresa framing Ginevra's, paralleling her desire to join herself to his family line, a desire attributed to Ginevra herself by Landino (and Fletcher).[13]

Bernardo's passion for Ginevra may have been personally grounded, but it also partook of a poetic literary convention in which a female paragon of ideal beauty, beloved by the poet, inspires his love, virtue, and artistic achievement. The classic models are Dante's Beatrice and Petrarch's Laura. Leonardo's portrait of Ginevra de' Benci, along with its emblematic verso, has been linked with this genre by Elizabeth Cropper, as a painter's response to Petrarch's claim that perfect beauty could not be realized in a pictorial image.[14] Cropper argues that in Leonardo's *Ginevra*, "the poet's denial of the validity of painted appearance is refuted through painting itself," and that the image joins the discourse of competition between

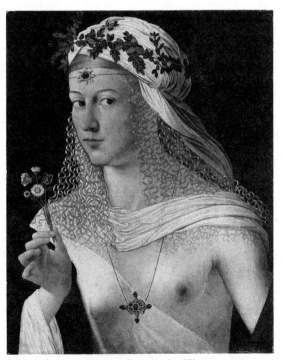

3. Bartolommeo Veneto, *Portrait of a Woman*, early sixteenth century. Frankfurt-am-Main, Städelsches Kunstinstitut.

4. Leonardo da Vinci, *Ginevra de' Benci*, reverse, ca. 1478–80. Washington, D. C., National Gallery of Art, Ailsa Mellon Bruce Fund.

5. Marsilio Ficino, *Commentarium in Platonis Convivium de Amore*, 1484, fol. 1r, detail of Bernardo Bembo's emblem. Oxford, Bodleian Library.

painting and poetry, demonstrating the power of art to sustain the presence of the absent living.[15] Thus she interprets the juniper behind the sitter's head and on the verso as a punning reference to her own name, Ginevra, which is intended to invoke the parallel association of Petrarch's Laura with laurel.[16]

These new interpretations of the Ginevra de' Benci portrait—that it was produced to signify Bembo's platonic (or romantic) love for Ginevra, and that it was produced to demonstrate the power of the art of painting—offer fresh explanations for the painting's genesis. The Bembo thesis in particular is useful for moving the work out of the category of the conventional marriage portrait and for permitting a stylistically more plausible dating, between 1476 and 1481.[17]

Examined closely, however, the new theories have problems too. If Bembo commissioned the picture, why did he not take it back to Venice with him when he returned? It was apparently not uncommon for gentlemen in humanist circles to commission portraits of their beloveds (platonic or otherwise) and even to keep them in their homes,[18] but the whole point of ordering such an image was as a substitute possession. Yet there is

no evidence that the painting went to Venice, and good reason for thinking it did not.[19] On the other hand, it would hardly have been a welcome addition to either of Ginevra de' Benci's Florentine households. A picture whose painted verso expressed the wish Landino ascribed to "La Bencia" herself, to join her family line to Bembo's, would have had no particular value for the Benci, and certainly none for Luigi Niccolini; it would have had meaning only for the presumably lovestruck Bembo on his return to Venice, as a reminder of his absent beloved. It is also not necessary to assume that Bembo had adopted the encircling laurel and palm device prior to his Florentine sojourns of 1475–80. True, it adorns two manuscripts in his possession, one of which was an autograph copy of Ficino's *Commentary on Plato's Symposium on Love*, but since this copy is in Latin, it could not have been acquired before 1484, when the first Latin text of Ficino's *Commentary* was published.[20] Moreover, it is implausible that a small, sketchy impresa should have been the model for a large, carefully detailed, and tightly constructed painted design, rather than vice versa. Equally possible, therefore, and equally consistent with Bembo's obsession with Ginevra

de' Benci, is that the emblem he adopted as his personal device was an imitation of the design on the back of his beloved's portrait.

If, on the other hand, the emblems of the verso were meant to refer to Petrarch's Laura, as Cropper suggested, it seems curious that Leonardo would devote one half of his painting to sustaining the memory of an allegorical precedent that he was supposedly trying to displace. By the later fifteenth century, the Petrarchan tradition was held up to ridicule as well as reverence, as we see in Leonardo's own mocking remark: "If Petrarch was so fond of laurel, it was because it has a good taste with sausages and roast thrush: I cannot set any store by their twaddle."[21] It is hard to believe that the same Leonardo would have produced a pictorial apostrophe to Petrarch's Laura in deadly serious terms. For, if the issue of the *paragone* was indeed in his mind at the time, Leonardo's very achievement in this painting, the demonstration of the superior powers of the art of painting, depended upon his replacement of the Petrarchan poetic abstraction with the image of a living woman, not the ideal Laura but the real Ginevra.

It is this woman, the proper and compelling subject of the portrait, who is curiously absent from recent discussions about it.[22] Curious, since every feature of the portrait can be explained by Ginevra's own celebrity as a poet (surely exceptional enough in Quattrocento Florence to qualify for commemoration): the honorific form of the bust-length image; the sober, dignified expression; the laurel and palm alluding to poetry and victory.[23] At the compositional heart of the emblematic verso is the subject of its visual sentence: *she* who triumphs in the field of poetry is represented by the sprig of juniper that is Ginevra's personal emblem. Why should not the message of this image be simply that Ginevra is honored by the laurel of poetry and the palm of fame—representing the aspiration of all poets and the extraordinary achievement of the female poet?[24]

An obvious answer is that women in Quattrocento Florence were not usually celebrated by men for their personal achievements. Praised instead in Renaissance literature, quite incessantly, are female modesty and chastity and, above all, female silence, for these qualities are, as Peter Stallybrass has written, "homologous to woman's enclosure within the home," as part of a "property category."[25] The strategy collectively employed by Bernardo Bembo, the Neoplatonist writers, and Lorenzo de' Medici—to build a literary monument to Ginevra's beauty and virtue, absorbing her individuality in an abstraction of platonic love, silencing and canceling her poetic voice through rhetorical celebration of her mute beauty—was a strategy all too frequently employed by the painters of women's portraits as well. It is impossible to know what unusual talents, what distinctive personalities, might be concealed behind the masks in that dreary lineup of Quattrocento profile portraits. The only exceptions were portraits of certain obviously distinguished women—Lucrezia Tornabuoni, Caterina Cornaro—typically painted when they were older women who could not be subsumed into the category of generic beauty. Ghirlandaio's engaging portrait in the National Gallery, Washington, of Lucrezia Tornabuoni, the cultivated and influential mother of Lorenzo the Magnificent, may have been a precedent for Leonardo's *Ginevra*, as a three-quarter view of an intellectual woman treated sympathetically,[26] but she does not engage the viewer's eyes, and she does not exhibit the extraordinary self-possession and dignity of the image of Ginevra de' Benci. Only one line of poetry written by Ginevra de' Benci has survived, the opening of a *sestina*, which reads: "I ask your forgiveness and I am a mountain tiger."[27] Without the missing context, we cannot know how she meant these lines, but at the very least, they suggest a forceful personality.

I propose that we take Leonardo's painting at its face value, as an honorific image of a young woman who had achieved recognition as a poet, and whose physical beauty is here presented as coextensive with her intellectual beauty. Her beauty adorns her virtue, here with the normative association with female chastity, but perhaps also shaded with the masculine association of the term *virtù* with cultural pursuits. Culturally prominent women in the Renaissance were sometimes cited for their "manly virtues"[28]—why not Ginevra de'

Benci? As it happens, Leonardo enjoyed a personal friendship with the Benci family. He was a close friend of Ginevra's brother, Giovanni, with whom he exchanged books, maps, and precious stones. Ginevra was evidently also quite close to her brother, since on her death in ca. 1520, she left him her entire estate.[29] And, according to Vasari, Leonardo's unfinished *Adoration of the Magi* was owned by Amerigo de' Benci, Ginevra's nephew.[30] Possibly, as early scholars proposed, Leonardo painted the portrait in gratitude for having stayed at the Benci palace. It is also possible that, out of friendship with an unusually talented young woman of his own generation, he painted a portrait that would commemorate not a Petrarchan emblem of feminine virtue, but Ginevra de' Benci, the poet of intellectual *virtù*.[31]

The unconventionality of the *Ginevra de' Benci* is sustained in other female images produced by Leonardo. Two portraits painted at the court of Lodovico Sforza in Milan, where Leonardo worked from 1483 to 1499, both partake of and deviate from the category they helped to establish. Most firmly accepted as autograph is the portrait of Cecilia Gallerani, paramour of Duke Lodovico and, like Ginevra de' Benci, a woman of a noble family who wrote poetry. Acclaimed for her incomparable beauty and sparkling intelligence, Gallerani was noted for her ability to carry on learned discussions with famous theologians and philosophers. She wrote epistles in Latin and poems in Italian, which were celebrated in other poems.[32] Orphaned at about fifteen on her father's death in December 1480, she was taken up by Duke Lodovico, who gave her a residence at Saronno in 1481, and for ten years she was his lover. Tradition has described Cecilia Gallerani as the duke's mistress, but it is difficult to reconcile her high social status and intellectual renown with the previously clandestine and inferior position of mistresses at court.[33] More likely, Gallerani's position at the Sforza court was as an early instance of the courtesan, the new type emerging in the late fifteenth century who—in contrast to the silent, chaste, and obedient wife—was rhetorically celebrated as intelligent, accomplished, outspoken, and sensual. She may herself have been a model for the court lady who would be celebrated a quarter century later by Castiglione.[34] In 1491, soon after Lodovico's legitimate wife, Beatrice d' Este, arrived, Cecilia Gallerani married Count Lodovico Bergamino, and set up her own intellectual courts in Milan and in the *campagna* of Cremona. These gatherings attracted celebrated writers, philosophers, musicians, and poets, including Matteo Bandello, who dedicated two of his *novelle* to her and described the "virtuosa signora Cecilia Gallerani" as "one of our two muses," one of "two great lights of the Italian language" (the other was Camilla Scarampa). As with Ginevra de' Benci, however, no one seems to have bothered to preserve a single ray from such a great literary light.[35]

Leonardo's portrait of Cecilia Gallerani [6], painted ca. 1484–85, is widely recognized as a major advance in the history of portraiture, introducing, as Martin Kemp describes it, a new "living sense of the sitter's deportment" and "of human communication," as Gallerani is seen to interact with someone outside the picture, an achievement for which "there simply is no equal . . . in contemporary or earlier portraiture." The focus of Leonardo's analysis of the human face under precise conditions of light and shade, the Gallerani portrait and the *Ginevra de' Benci* were identified by Pope-Hennessy as the chief agents of Leonardo's new type of portrait.[36] This self-possessed woman now rotates on her own axis and firmly grasps the animal that alludes either to her own name (γαλεη is Greek for weasel) or to the ermine that was the duke's emblem. The prominent hand exhibits the force of ideal structure, rhyming in shape with the animal under its control, and thereby suggesting that the sharp, fierce creature might stand for an aspect of her personality or for someone under her dominance.[37]

But while Leonardo's portrait projects a vital personality commensurate with the historical identity of an unusual woman, literary celebrations of Cecilia Gallerani's portrait define the sitter simply as a model of generic beauty. A sonnet by Bernardo Bellincioni casts the portrait as the product doubly of nature and of art. The image of Cecilia is praised because she is shown listening

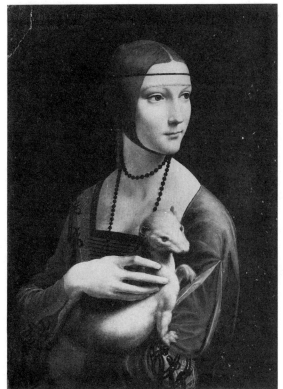

6. Leonardo da Vinci, *Lady with an Ermine (Cecilia Gallerani)*, ca. 1484–85. Cracow, Czartoryski Museum.

In light of the widespread literary tendency to apostrophize beautiful women as the product and commodity of men or divine forces, two interesting facts about Leonardo and Cecilia stand out. One is that, although Lodovico Sforza may have commissioned the portrait, Gallerani retained possession of it after her marriage.[40] The second is that, after leaving the Sforza court, she enjoyed a continuing friendship with Leonardo himself, according to one of the painter's earliest modern biographers.[41] These points suggest that Cecilia Gallerani was an unusually independent woman in her day, and that the artist Leonardo may have appreciated her independence even as he valued his own. There is, in fact, a striking analogy between the situations of artists and mistresses, whose relationships with their ducal patrons were undergoing similar transformation in the late Quattrocento courts: from mistress to courtesan, from craftsman to artistic genius. Each was a move from a hierarchic business relationship to a more personal one that acknowledged the intellectual brilliance of the artist or courtesan, resulting in a gain in status (though perhaps a loss of personal freedom). Leonardo was at that moment personally helping to accomplish the transition for the artist[42] and, in this context, he would have had reason to identify with a brilliant woman whose social progression mirrored his own.

The picture in the Louvre known as *La Belle Ferronière* [7], which has been tentatively identified with Leonardo's recorded portrait of Lodovico's mistress Lucrezia Crivelli, similarly presents a self-possessed woman with a thoughtful expression, who turns her head, engaging the eyes of someone in the viewer's space.[43] Its projection of inner vitality is entirely contrary to a Latin epigram written in praise of the Lucrezia Crivelli portrait, which asserts: "Vincius might have shown the soul here as he has portrayed everything else. He did not, so that the image might have greater truth, for it is thus: the soul is owned by Maurus [Il Moro] her lover."[44] The sitter's avoidance of the viewer's gaze, in both this and the Gallerani portrait, paradoxically now preserves for the sitter some freedom from patronly possession (even as earlier Ginevra de' Benci's independent

rather than speaking (a curious emphasis, given her legendary intellectual brilliance), and because, as the creation of Leonardo's hand, she will keep the sitter's beauty alive for generations to come.[38] In its emphasis upon the superior power of art to preserve nature's creations, Bellincioni's poem echoes the thought of Leonardo himself, who wrote, in his defense of painting's powers over those of music, "How many paintings have preserved the image of divine beauty of which time or sudden death have destroyed Nature's original, so that the work of the painter has survived in nobler form than that of Nature, his mistress."[39] The emphasis is somewhat different, however, for while Leonardo argues that the painting's value lies in its ability to preserve a lost beauty, in Bellincioni's sonnet Cecilia's personal identity is overshadowed by the artist, by her patron, and even by creative nature.

identity is conveyed *through* engagement of the viewer's eyes), for by the 1490s, the direct gaze was already a sign of courtesanal seductiveness in portraits by Leonardo's own followers [8].[45] By displacing the sitter's attention to an invisible third party, away from the man who paid for the portrait and allegedly owns her soul, the artist subtly undermines the man's power and heightens the sitter's. In these respects, *La Belle Ferronière*, whether or not literally identical with the portrait of Lucrezia Crivelli here eulogized, is sharply at odds with that conventional poem celebrating traditional gender/power relationships. In the discrepancy between them, we can glimpse a disjunction between the profound originality of Leonardo da Vinci's lifelike and independent images of women and the terms on which they were received in the masculine society of his day.

Of six surviving portraits by Leonardo, five represent women, one a man. This statistic, accidental though it may be, is nevertheless unusual in Renaissance Italy, where a far higher percentage of portraits depicted men.[46] Thus, ironically, Leonardo's creation of psychologically complex and engaging images—speaking likenesses of humans who turn and move in space—was achieved through the female figure, but on behalf of both sexes. The successors to *Ginevra de' Benci* were not only *Cecilia Gallerani*, *La Belle Ferronière*, and *Mona Lisa*, but also Giorgione's Giustiniani portrait, Raphael's *Baldesar Castiglione*, and Titian's *Man with the Blue Sleeve*. In direct contrast to the Quattrocento situation, the female type now became progressive, inasmuch as the new Cinquecento portrait created by Leonardo was based upon the study of women as prime examples of the human organism.

In the category of female portraits, however, Leonardo's progressive exploration of human personality was soon subverted by the very circumstances that first sustained it—namely, the flourishing of portraiture within court circles, the rise and increasingly ambiguous status of intellectual courtesans, and the full-blown emergence of the generic beauty portrait. In Parmigianino's *Antea*, for example, it is not clear whether the sitter is a married lady or a courtesan, a particular individual

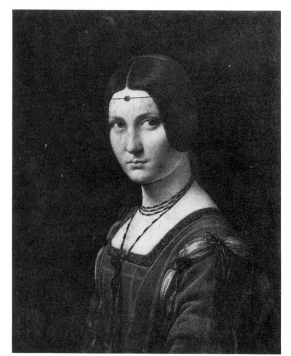

7. Leonardo da Vinci, attributed to, *La Belle Ferronière*, 1490s. Paris, Louvre *(Musées Nationaux)*.

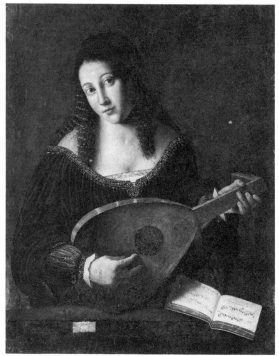

8. Bartolommeo Veneto, *A Lady Lutanist*, early sixteenth century. Boston, Isabella Stewart Gardner Museum.

or an ideal, all these possibilities being subsumed in the broader category of the exemplum of female beauty.[47] Such female portraits, however different in appearance from the Quattrocento profile type of the bourgeois household, nevertheless represent a similar form of commodification of the female image: the patron's wife as a particularized material possession now in the new key of the mistress as his ideal amatory possession. From the vantage point of the altered tradition, it may be arguable whether Leonardo's *Cecilia Gallerani* and *La Belle Ferronière* hold their own as autonomous presences or whether, as images of a duke's paramours, they retain a lingering aura of commodification.

The spectacular example of resistance to commodification is the so-called *Mona Lisa* [9], the world's most famous portrait, of a woman who—whatever else she may be—is no known person's mistress and only conjecturally someone's wife. A host of writers on the *Mona Lisa*, from Walter Pater to Kenneth Clark, have recognized that it is not only, and perhaps not at all, a portrait, but rather an image that conflates portraiture with broader philosophical ideas. The picture may have begun as a Florentine female portrait ca. 1503–6,[48] but it is not known to have left Leonardo's hands, and when he went to France for the final three years of his life, he almost certainly took the painting with him. Its only association with any patron is a mention in 1517, by a writer who visited Leonardo in France, that the portrait was "a certain Florentine lady, made from nature at the instigation of the late Magnificent Giuliano de' Medici."[49] It is likely, as Martin Kemp has argued, that Leonardo reworked the painting for Giuliano de' Medici during the period that he was in the Capitano's employ (1513–16), and in the intervening years repainted the image along the lines of his own interests.[50] Thus for ten years or longer, this female image seems to have served the artist as a vehicle for private philosophical expression.

Since the nineteenth century, the *Mona Lisa* has frequently been identified as a female archetype. This is typified by Walter Pater's famous

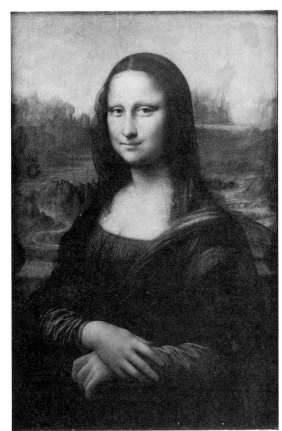

9. Leonardo da Vinci, *Mona Lisa*, ca. 1505–14. Paris, Louvre *(Musées Nationaux).*

description (1869): "She is older than the rocks among which she sits; like the vampire, she has been dead many times, and learned the secrets of the grave."[51] Pater's version of the archetypal female draws heavily upon the nineteenth-century femme fatale, yet he implies an identity between this ancient woman, or Woman, and the cycles of geological time. Similarly, Kenneth Clark noted that the woman's face and the landscape background together express the processes of nature as symbolized by the image of a female, whose connection with human generation links her sex with the creative and destructive powers of nature.[52] The medical historian Kenneth D. Keele at once localized and enlarged this interpretation, identifying in the portrait image unmistakable signs of a woman at an advanced stage of pregnancy,

which he understood as a symbol of Genesis, "God-the-Mother . . . enclosed within the body of the earth."[53]

More recently, David Rosand has connected the *Mona Lisa* with the Renaissance concept of the portrait as an image of triumph over mortality and death.[54] Pointing to Leonardo's "preoccupation with transience" and the ravages of time ("O Time, who consumes all things!"), Rosand quotes the artist's expressed belief in the competitive edge held by art over destructive nature: "O marvelous science [i.e., painting], which can preserve alive the transient beauty of mortals and endow it with a permanence greater than the works of nature; for these are subject to the continual changes of time, which leads them to inevitable old age."[55] According to Rosand, the *Mona Lisa* holds in dialectical tension the fluid and changing landscape, subject to endless deformation by water, agent of time and the generative and destructive forces of life, with the contrasting image of perfect human beauty—a figure who, in life, would undergo the same transformations of time but who, as a creation of art, will live forever.[56] In Rosand's view, the beautiful woman is not herself identified with the forces of nature, except as a product of them, subject to their ravages; symbolically, she is allied with the realm of art, as image of perfection and permanent substitute for transitory life. In this interpretation, the *Mona Lisa* is another example of the genre of female portraits in which a beautiful woman's image represents the triumph of art, functioning, in Elizabeth Cropper's words, "as a synecdoche for the beauty of painting itself."[57]

The *Mona Lisa* conspicuously departs from this convention, however, in the very hypnotic strangeness that has made it uniquely famous, in Leonardo's personal stylization of a beauty that is quite different from living or ideal specimens. Moreover, as many writers have observed, she is of a piece with her setting. Laurie Schneider and Jack Flam have pointed to "a system of similes" between figure and landscape, of visual echoes between curved arcs and undulating folds, and to a unity between them expressed through the diffuse lighting and consistent sfumato.[58] Martin

Kemp has also taken account of the extraordinary geological activity in the background of the *Mona Lisa*, which he sees (as had Keele and Clark) as coextensive with the portrait image, not in dialectical opposition to it. Noting correspondences between the flowing movements and dynamic processes visible in the landscape and the cascading, rippling patterns of the lady's clothing and hair, Kemp describes them as united exempla of the "processes of living nature." For Kemp, the painting expresses Leonardo's idea of the earth as a "living, changing organism," a macrocosm whose mechanisms and circulations of fluids are echoed in the microcosm of human anatomy, and whose fecundity is echoed in "the procreative powers of all living things."[59]

Webster Smith has likewise interpreted the *Mona Lisa* as a micro-macrocosmic commentary on the geological processes of the earth, pointing to Leonardo's comparison of the circulation of blood in the human body with rivers on the earth.[60] In contrast to Schneider and Flam, who consider the painting to be a metaphor or personification of the inner forces of nature, Smith reminds us that for Leonardo this relationship is not merely metaphoric, since he describes the earth not as "like a living body" but literally *as* a living body.[61] Smith is hard pressed, however, to explain why this philosophical commentary should be joined with a female portrait (he can adduce only the stock association of female portraiture with Petrarchan beauty and the *paragone* between painting and poetry). Similarly, Kemp, exemplifying Leonardo's micro-macrocosm theory with the *Mona Lisa*, the *Leda*, and the "Great Lady" drawing [9, 10, 16], does not comment upon Leonardo's persistent choice of the female figure to illustrate the analogy between "the body of man [sic] and the body of the earth."[62]

Missing from these analyses is a framework that would situate in historical perspective the analogy between woman and nature, an analogy that was already ancient in the Renaissance. The use of a female figure to symbolize the nutritive and generative processes of nature is found in a long line of writers, from Plato, who described the earth metaphorically as "our nurse," to the twelfth-century

poet Alain of Lille, who ascribed human and natural generation to a cosmic force personified as the goddess Natura.[63] The figure of *Natura creatrix* had been given impetus by Roman writers such as Lucretius and Cicero, who believed the universe to be ruled by an intelligent and divine female Nature, identical with god yet immanent in the material world. As a deity this figure was exalted in the early Middle Ages by Boethius and Claudian. Claudian describes how "mother Nature made order out of elemental chaos," preserving one of many versions of the creation myth in which the creator of the universe is female. Boethius personifies this Natura as an awesome figure who drives the earth like a charioteer, echoing the Natura of the late antique Orphic hymns, Physis, the self-engendered and almighty Mother of All.[64]

However, in ancient and medieval philosophy the metaphoric figure of a powerful and creative female Natura coexisted with misogynous beliefs about the deficiency of woman's nature. The key text for the negative gendering of nature is Aristotle's *Generation of Animals,* where it is argued that human procreation is the result of the generative action of masculine form upon inert female matter.[65] This viewpoint provided the philosophical foundation for the Christian view of nature as corrupt and the female as corrupting, epitomized by Saint Augustine's doctrine of original sin, and for the nexus that developed in the Middle Ages between the evil of the flesh, the negativity of matter, and the femaleness of matter.[66] A similar position was taken by the Neoplatonists, particularly Macrobius, in whose Great Chain of Being the phenomena of nature are called "the bottommost dregs," and Chalcidius, who described matter as "insignificant and evil," ugly, lacking in form, like a woman without a husband.[67]

Leonardo entered a discourse to which he made a conscious and original contribution, by affirming to a remarkable extent that the relationship between nature and the female passed beyond the metaphoric, and by presenting evidence in his anatomical studies that directly refuted dominant views about women's deficiencies. Although he had once depicted sexual intercourse in an image

that distinctly privileged the male role,[68] reflecting Aristotle's influential dictum that females contributed only passive matter to human procreation while the male played the vitalizing part, he increasingly questioned this theory. Instead, Leonardo drew upon the philosophical opinion of Lucretius and the medical opinion of Galen that both female and male contribute "seed" necessary for conception. In effect, he took one side of a debate ongoing since the fourteenth century among doctors and philosophers over the Aristotelian and Galenist views on procreation, philosophers leaning toward Aristotle and medical practitioners toward the second-century physician Galen. Whereas the Galenic writers shared with the Aristotelians the belief that the female is biologically inferior to the male, they believed that the mother also "seminated," playing a more active role in conception than was accorded by the Aristotelians.[69] During his years in Milan, Leonardo read Galen, Avicenna, and the early fourteenth-century anatomist Mundinus, as well as Lucretius.[70] In this period, he was still aligned with Aristotle, but on his return to Florence, beginning ca. 1504–6, he was drawn more and more to Galenist views, becoming stronger in this orientation until ca. 1513, when he took the position of independence from authority, basing his conclusions strictly on observation.[71]

About 1509–10, Leonardo obtained a copy of Galen's *De usu partium,* which initiated his period of intense Galenism. The so-called Great Lady drawing [10], which dates from ca. 1510, exemplifies his adoption of a new understanding of human generation. In an annotation on this sheet addressed to Mundinus, Leonardo challenges the Aristotelian view of generation passed on by Mundinus, that the "spermatic vessels" (ovaries) do not generate real semen, observing instead that these vessels "derive in the same way in the female as in the male." Here he adopts the Galenic position that both sexes contribute in equal part.[72] Elsewhere, citing the ability of a white mother mating with a black father to produce a child of mixed color, Leonardo concludes that "the semen of the mother has power in the embryo equal to the semen of the father."[73] On

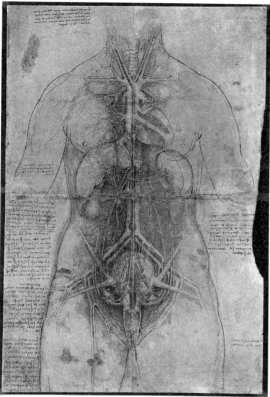

10. Leonardo da Vinci, *Composite Study of the Respiratory, Circulatory, and Urinogenital Systems in a Female Body* (the "Great Lady" drawing), ca. 1510. Windsor Castle, Royal Library, no. 12281.

the same sheet, he asserts that the mother nourishes the fetus with her life, food, and soul (anima), countering the Aristotelian belief still commonly held then that women, deficient in soul, were mere incubators for gestation: "As one mind governs two bodies . . . likewise the nourishment of the food serves the child, and it is nourished from the same cause as the other members of the mother and the spirits, which are taken from the air—the common soul of the human race and other living things."[74] Leonardo further appears to identify the active power of the womb as generative rather than nutritive, an important distinction within the camp of those who considered the womb to have active power, under which nutritive virtue would generate something joined to it, while the greater virtue, generative, would pro-

duce a distinct entity. For he asserts—and illustrates—that there is no continuity between the vascular systems of mother and fetus, as if in response to a standing argument that was to reverberate down to the eighteenth century (when the position taken by Leonardo was finally proved correct).[75]

In the "Great Lady" drawing, Leonardo presents a synthesized image of circulatory, respiratory, and generative processes in the female body. The drawing differs significantly in this respect from his representations of male anatomy, which typically illustrate blood circulation, the genitourinary system, and other workings in independent images. The distinctive graphic completeness of the drawing expresses Leonardo's precocious awareness that blood flow in the female body is linked with its role in procreation, and implies his comprehension of the systemic order of organic process in the female body, in opposition to the Aristotelian view that menstrual blood was inchoate, given form by sperm, a view that prevailed until William Harvey's discovery of the circulation of blood in the seventeenth century.[76] If we remember Leonardo's preoccupation with the interconnected functions of microcosm and macrocosm, it is a short step from here to a belief that the living earth *is* female, in its regenerative capability and its mysterious life-supporting powers.

For all that Leonardo wrote, it was to his visual explorations that he entrusted the primary task of representing nature: "Painting presents the works of nature to our understanding with more truth and accuracy than do words or letters."[77] Because for Leonardo art was an instrument of discovery, a form of knowing and not merely an illustration of what was already known, the anatomical drawings reveal a process of visual reasoning. The image of an idea *is* the idea, and frequently it tells us something quite different from what the accompanying words say. The words are practical explanations of the matters that preoccupied Leonardo, or they may be the questions that prompted him to the analysis. The drawings, however, reflect an effort to infer a process of nature from a static slice, and for that reason they convey

the artist's understanding (or expectation) that form reveals function, just as the functioning of the microcosm is a key to that of the macrocosm—because they are not only metaphorically, but also organically, related to each other.

The well-known drawing of a fetus in the uterus [11], though not studied from human example and inaccurate in many ways, nevertheless expresses the process of gestation and birth more clearly than a modern textbook. Having promised himself to describe what makes the fetus push out,[78] Leonardo shows this happening, the bursting of the fetus from its uterine container into the world, in the sequential small images that visually analogize the process to a nut breaking out of its shell. In the largest image on the sheet, the compact density of the fetus coiled in its umbilicus suggests a seed in a pod (Leonardo had noted that all seeds and nuts have umbilical cords), and the interlocking spirals of its body convey the sense of potential growth and development. Originating in observation but developed under belief in the correspondence between microcosm and macrocosm, this image gives information about human birth that is of a philosophical order, expressing its connection with other forms of birth and growth in the universe. Leonardo found analogy everywhere—the movement of wind currents is like that of water currents, and the trajectories of a bouncing ball are like both. "The earth has a spirit of growth," he said, whose flesh is the soil, whose bones are the mountains, whose blood is its waters.[79]

Leonardo's belief in the interconnection of nature's largest patterns and smallest elements was sharply at odds, however, with prevailing beliefs about nature in the fifteenth century. A medieval distinction that remained in force throughout the Quattrocento was that between *natura naturans* and *natura naturata,* between the dynamic creative, generative principle and the inert material result of that creation. For Alberti, Nature was a vestigial female personification (carried over from the medieval allegorical figure Natura), "the wonderful maker of things" who "clearly and openly reveals" such things as the correct proportions of the human body. The principles of Nature's true

order—largely mathematical and proportional—might be inferred from disparate imperfect examples by the artist, who could reproduce them in corrected form.[80] In this way of thinking, art was not to imitate the mere phenomena of nature *(natura naturata)* but, rather, its higher invisible principles *(natura naturans);* and by giving them perfected visible form, art could successfully compete with Nature herself.

The strength of this theory, and its intensification under the Neoplatonist doctrines that dominated later fifteenth-century Florence, may be the chief reason why Quattrocento art does not display a linear progressive naturalism. The hierarchic distinction between an abstract creative principle and the discredited material forms of the visible world effectively kept intellectually serious painters (such as Piero della Francesca) from too close an involvement with the latter. The hierar-

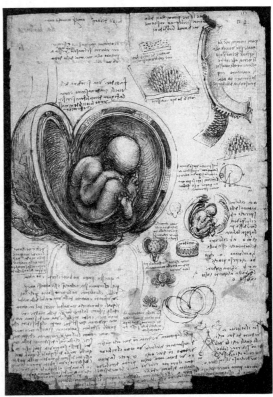

11. Leonardo da Vinci, *A Fetus in the Womb,* drawing, ca. 1512. Windsor Castle, Royal Library, no. 1910r.

chy was reinforced by its gender associations, in that the Aristotelian differentiation of form and matter—the active male principle molding passive and static female matter—supported the binary opposition of, and value distinction between, *natura naturans* and *naturata*. However, creative and material nature were in another sense conflated into a single entity, a female Nature whose creative powers were challenged by the male artist. These overlapping metaphoric structures are most clearly expressed in the model of perspective space construction, in which the artist positions himself *outside* nature, the better to attain mastery over it, and assigns his eye hierarchic priority over the segment of the world that it surveys, symbolically the whole of nature. What is implied in the Albertian perspective diagram is boldly stated in an image by Dürer [12],[81] where we see the omniscient male eye focused through a framing device upon his subject, a recumbent female form, who is surely a metonymic figure for Nature herself: objectified, passive matter, a mere model, waiting to be given meaningful form in art by the creative powers of the artist.

In the paintings of Botticelli, Leonardo's contemporary, we see an exaggerated separation of the two forms of nature: the elevation of cosmic Nature to the plane of personification, and the demotion of physical nature to the realm of insignificance. A philosophical concept of nature is very much at the core of the *Primavera* (ch. 5, fig. 2) and the *Birth of Venus*, closely related paintings that may symbolize respectively earthly and celestial nature, but that in any event present Nature in the figure of Venus, the antique goddess reborn in the Renaissance who, trailing her multiple associations with cosmic and human generation, merged with the Christian Virgin Mary. In the influential Neoplatonism of Marsilio Ficino, the celestial Venus is equated with Mind and divine perfection, while the earthly Venus is conjoined with the sensory realm and with matter.[82] Although both are female, a subtle distinction between them depends upon the lower status of the world of human generation, for Ficino connected the word *"materia"* (matter) with *"mater"* (mother) to eulogize the higher celestial Venus as immaterial, born of no mere human mother. Botticelli, accordingly, presents nature's material elements in highly abstracted form, radically suppressing empirical realities in favor of transcendent ones [13]. The solid surfaces of water or grass are presented schematically, rendered as inert. Vitality is exclusively to be found in the contour lines, the most abstract and least material of art's elements. Growth, change, development are not assigned to the organic world in Botticelli's universe; they belong to the spiritual order, measured in the metamorphic progression of figures across the *Primavera*, or in the transition

12. Albrecht Dürer, *Perspective Study: Draftsman Drawing a Reclining Nude*, woodcut, ca. 1525, fig. 67 in *The Painter's Manual (from* The Painter's Manual, *translation and commentary by Walter L. Strauss, 1977).*

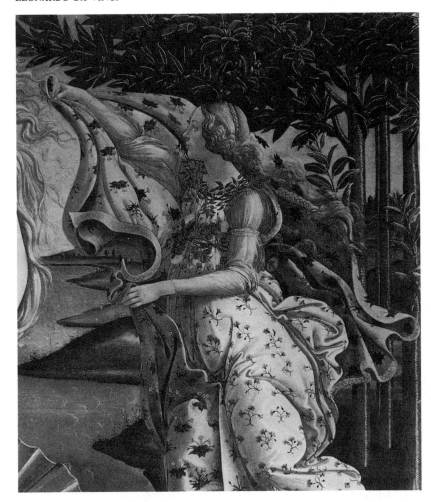

13. Sandro Botticelli, *Birth of Venus*, detail, ca. 1484–86. Florence, Uffizi *(from Ronald Lightbown,* Botticelli, Life and Work, *1989).*

from that earthly realm to the higher one represented in the *Birth of Venus.*

In Leonardo's contemporaneous painting, the *Virgin of the Rocks,* the Louvre version of the 1480s [14],[83] material nature is described in meticulous detail, but in a form that assures the presence of cosmic nature as well. The distinctive difference lies not in the degree, but in the nature of Leonardo's naturalism. Here, as in numerous independent drawings [15], Leonardo forms the image of a plant in shapes that emphasize its pattern of growth, implying that the source of change is within matter and not transcendent of it. The arrangement of the leaves at the plant's base evokes the spiral form of generation, now presented as inseparable from matter itself. Whereas Botticelli had symbolized nature as a cosmic power, Leonardo expresses its cosmic operations through its particulars, deriving his understanding of the larger movements from observation of the smaller. The element of movement is critical to their fusion, for it defines their shared participation in time. Thus form and matter are conjoined through motion, just as the barrier between form and space is broken down through the soft-edged sfumato. Botticelli and Leonardo both present generative nature as female, but Leonardo's vision of her powers is broader, for he conceives her as a dynamic, not static, presence, and he finds her immanent in the entire physical world.

In his visual expression of this idea, Leonardo is most deeply Aristotelian, for Aristotle had defined nature *(physis)* as "the essence of things which have a source of movement in themselves," placing the agent of change within matter, in keeping with his dynamic, teleological vision of nature as matter evolving from inner direction toward its final form.[84] In this, Leonardo has followed an aspect of Aristotle's thought that does not subordinate or denigrate the material world but rather sees it as imbued with (implicitly female) cosmic power. On the other hand, as we have seen, he rejected Aristotle's model of human biology in favor of one that accorded an active role for the female in generation.

Over and over, in the *Virgin of the Rocks,* the *Mona Lisa,* the surviving designs for the *Leda,* the Burlington House cartoon, and the *Saint Anne,* Leonardo explicitly associated powerful female images with highly developed, visually extraordinary surrounding landscapes, as if to assert the unity between the physical universe and the female cosmic generative principle as a philosophical claim. The collective impact of this "statement" about the nature of nature may be more pronounced than that of any other single idea in

14. Leonardo da Vinci, *Virgin of the Rocks,* ca. 1483–86. Paris, Louvre *(Musées Nationaux).*

15. Leonardo da Vinci, *Star of Bethlehem,* drawing, ca. 1508. Windsor Castle, Royal Library, no. 12424.

his pictorial oeuvre. The lost painting of *Leda and the Swan* of ca. 1506, whose composition is known from surviving studies and copies [16], has been widely recognized as symbolic of the analogy between female and natural procreation.[85] Leonardo made this connection quite clear through the bursting of Leda's babies from eggs and the adjacent explosion of growing plants. We may further observe that, especially in his first studies for this painting, he converted a lesser character of classical mythology into a more primal figure, not merely one of Jupiter's conquests, but the origin of life itself, both human and vegetal, symbolized in the image of the kneeling Leda, who rises in a spiral, self-created, from the earth.

Much earlier, he had essayed a similar image of the generative mother goddess (no other term will do, though he would not have used it) in the *Virgin of the Rocks*. In the Louvre painting [14], the Virgin rises from the dark, dense vegetation in a slow spiral turn, hovering over her child, whose tightly curved body and crossed legs anticipate the later drawing of the fetus in the womb. This archetypal mother presides over her son and their solemn attendants in an awesome and mysterious setting of plants, rocks, and a mist-shrouded distance whose remote inaccessibility suggests a recession into time as well as depth, evoking the primeval early life of the planet. The entire painting is already incipiently an image of "formative nature," as Leonardo called her, before whose "various and strange shapes" he described his sensations of fear and curiosity, in the famous passage about a great cavern among some gloomy rocks.[86] The mother in this image, universalized by her conspicuous identification with the natural cosmos, is empowered through movement and gesture as the controlling and motivating agent of the composition. In a sheet that includes studies for the *Virgin of the Rocks* [17], we see the artist thinking through the female figure to arrive at the monumental pyramidal composition that would later become the emblem of Cinquecento pictorial design. It is well known that Leonardo created the innovative pyramidal design that Raphael and others would build on, but it is less often observed that the artist atypically used a female character

16. Leonardo da Vinci, study for *Leda and the Swan*, ca. 1506. Rotterdam, Museum Boymans–Van Beuningen *(Frequin-Photos)*.

17. Leonardo da Vinci, study for the *Virgin and Holy Children*, 1480s. New York, Metropolitan Museum of Art, Rogers Fund, 1917.

for the study of the human figure in motion (just as he had for the portrait), and that he was the first to make a viable theme of the active female body.[87]

If the *Virgin of the Rocks* and *Leda* express the cosmic female genesis of human and vegetal life, then the Louvre *Virgin, Christ Child, and Saint Anne* [18] and the closely related Burlington House cartoon are clearly meditations on human generation over time. Possibly originating in political circumstance, and certainly displaying advanced notions of *contrapposto* figure composition, the Saint Anne images nevertheless also represent an extension of Leonardo's thinking about the female and nature, now focused upon the cycles of human reproduction.[88] This is sug-

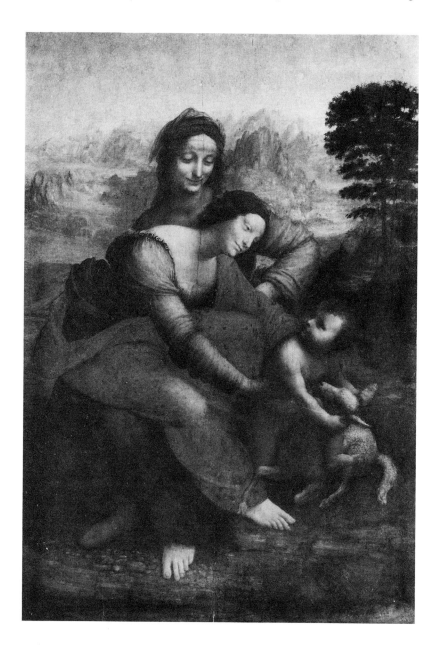

18. Leonardo da Vinci, *Virgin, Christ Child, and Saint Anne,* ca. 1508. Paris, Louvre *(Musées Nationaux).*

gested in the Louvre painting especially, in the cascading sequence of curved arms that, in conjunction with the glacial and terrestrial landscapes, imply a sequence from geological into human time.[89] The monumental pair of mothers who preside over, or have procreated, the earth's formation and every aspect of life that derives from it might be thought of as a Christian counterpart to the Neoplatonic twin Venuses, Saint Anne representing the remote celestial Venus and Mary the more human terrestrial Venus—a polarity that is reinforced by the two-part landscape. Yet in their symbiotic configuration, Leonardo's mothers seem less hierarchically distinguished than causally and generatively connected. They remind us more deeply of the ancient mother-daughter pairing of Demeter-Persephone, who in turn reflect the twin aspects of the even more ancient mother goddess, as she appeared in many pre-Greek images in the Mediterranean world [19]. Leonardo had no special interest in classical myth, and there is no reason to believe he knew any preclassical images. I would suggest instead that in his curious return to, and almost obsessive expression of, the ancient prehistoric identification of the highest cosmic power as female, Leonardo was unusually attuned to, and spontaneously reinvented, a way of thinking periodically voiced in antiquity and the Middle Ages, which would not seem at all strange to us today had it not been consistently subjected to patriarchal distortion.

Leonardo was in many ways a man of his age, for he not only shared but helped define his era's faith in the capacity of art to preserve life and transcend time. In his passionate championing of the art of painting, the artist had no peer, and he proclaimed often in his notebooks what many other Quattrocento artists believed, that "the painter strives and competes with nature." However, that was only part of Leonardo's complex understanding of the relationship between nature and art. In both his writings and his art, he demonstrated constantly that nature (mentioned far more frequently than God) is the superior guide, the teacher of all good artists.[90] Implicit in

19. Mycenaean, *Three Deities*, ca. 1500–1400 B.C. Athens, National Museum.

his thinking about art and nature is a recognition of nature's preeminence: "for painting is born of nature—or, to speak more correctly, we shall call it the grandchild of nature; for all visible things were brought forth by nature, and those her children have given birth to painting."[91] In a similar spirit, he announces nature's superiority to technology: "Though human ingenuity may make various inventions which, by the help of various machines, answer the same end, it will never devise any invention more beautiful, nor more simple, nor more to the purpose than Nature does; because in her inventions nothing is wanting and nothing is superfluous."[92]

Clearly, Leonardo shared with other men of his era a number of man-centered presumptions, including the belief that art and technology could in various ways improve upon or control nature for human benefit. This is demonstrated in his many mechanical inventions and designs for water management or urban planning. Yet his faith in human ability to control or direct nature was limited, both by his own pessimism and by his respect for nature's ultimate superiority. This point of view was not common in Renaissance Italy, when the quest to master and dominate nature grew

20. Leonardo da Vinci,
Deluge, drawing, ca. 1515.
Windsor Castle, Royal
Library, no. 12380.

steadily, and such slogans as "art is more powerful than nature" (Titian's motto) were brandished. Leonardo's drawings representing the Deluge [20] may thus be understood as a response to man's dream of mastering nature. In those images of ferociously spiraling explosions of water, a giant apocalyptic flood repeatedly destroys the tiny structures of cities and towns. It is a celebration, rare in Italian Renaissance art, of the superior power of nature over human civilization—implicitly also a gender construct, of the endurance of female generation over male culture.

Let me close by returning to the consideration raised at the outset. Might Leonardo's exceptional philosophical privileging of the female over the male be linked with his unproved, though reasonably presumed, homosexuality? Certainly the issue of homosexuality has recurred in the Leonardo literature as an explanatory factor. Kenneth Clark connected the strange androgyny of Leonardo's art with his homosexual bent, finding in the *Mona Lisa's* face the features of the artist's young lover

Salai, and describing Leonardo's aversion to women ("They horrified him; but so did nature"), who were "the symbol of all that was alien to him," and who provoked in him "alternating repugnance and detached fascination."[93] In this, Lord Clark reflects a classic preconception about homosexuality (opposite that of K. R. Eissler), for there is not a shred of documentary evidence that Leonardo disliked women (his description of genital sex as repulsive was not focused upon the female), and, in fact, it is probably as common for homosexuals to identify with the opposite sex as to be repelled by it.[94]

Leonardo's sexual preference might better be understood as not a cause but a symptom of an even broader unconventionality in his psychological makeup, which was his unusual freedom from cultural dogma, an independence of thought and behavior that also marked him eccentric, in an orthodox world, for being a left-hander who wrote backward (something perfectly logical viewed apart from convention). In the context of the androcentric patriarchy of his day, it was not Leo-

nardo's sexuality, but his detached curiosity about, and comparatively unbiased observation of, the female sex that made his viewpoint unusual among Renaissance men. Modern writers on Leonardo, accepting the gender attitudes of Renaissance males as normative, inevitably found his version of the female peculiar. Freud sought an explanation for the artist's strange attitude toward women in homosexuality, while Clark, who perhaps came closest to acknowledging Leonardo's celebration of the ascendant female principle in nature's processes, undermined his own insight by an unsupported projection of misogyny onto Leonardo's art. Thus the *Mona Lisa* became, for these and many other writers, an expression of the alien Other—an emblem of mystery, not of the mysterious nature of biological and geological life, but of Woman unknowable and remote.[95]

I would suggest instead that the androgyny of the *Mona Lisa* may result not from Leonardo's alienation from women, but from the psychic inclusion of the painter himself in an image of a woman, or Woman, who holds the key to nature's secrets, and with whom he imaginatively identified. An androgynous self-image could have given Leonardo an enabling perspective with positive implications for both his art and philosophy, one that minimized bias against, and broadened his imaginative access to, the viewpoint of the opposite sex. One might then postulate that it was an unbiased receptivity to the female, as located in living women, in female anatomy, and in the female in himself, his anima (to invoke Jung instead of Freud), that allowed Leonardo to develop a radically new understanding of nature in relation to art, within the discourse in which nature was gendered as female.

Leonardo was not characterized as homosexual by Renaissance writers, perhaps because sodomy was so prevalent it was scarcely noteworthy, but also because such a reputation would have conflicted with the legend of Leonardo, which was founded upon his beauty (not feminized) and his divine intellect, strength, and agility.[96] Homosex-

uality held cachet in Renaissance Italy only insofar as preference for a male lover could be equated with the ideal love of Platonic antiquity, a thing of the spirit, as opposed to the base procreative function served by heterosexual union. Effeminacy in men was disparaged, as was male passivity.[97] And femininity, not yet identified with artistic creativity,[98] was quite low in status on the philosophical scale. Thus what we might see today as the most radical dimension of Leonardo's art and thought, a sympathetic identification with the female sex, was quite obviously missed entirely by his contemporaries and followers, for if recognized in that misogynist culture, it would have been the kiss of death.

In defining a pro-female philosophical position for Leonardo, I am not suggesting any real equivalence between his and a woman's viewpoint, for he could never have experienced the world as did Ginevra de' Benci or Cecilia Gallerani, whose perspectives may have been equally interesting. Nor would I propose that Leonardo's vision of woman holds some universal truth-value—indeed, from a modern feminist standpoint, his position might be criticized as romantic and essentialist.[99] Yet if it seems to us today constrictive to identify the female primarily with procreation, it is well to remember that Leonardo's understanding of human generation challenged a descriptive model that was both inaccurate and demeaning to women. Breaking out of the masculinist norm in two directions, he painted revolutionary portraits of culturally distinguished women, presenting them in forceful visual images that fully convey their dignity and intellectual vitality. And he described female-identified nature as the greatest force in the universe, at a time when other men discredited nature's power and sought to control it. By sustaining and concretizing the woman-nature metaphor, Leonardo acknowledged and symbolized in positive terms a realm of female power that the majority of men in his era could acknowledge only inversely, through the repressive strategy of declaring women inferior beings.

NOTES

1. Robert Langton Douglas, *Leonardo da Vinci; His Life and His Pictures* (Chicago: University of Chicago Press, 1944), p. 89; K. R. Eissler, *Leonardo da Vinci: Psychoanalytic Notes on the Enigma* (New York: International Universities Press, 1961), p. 128.

2. Sigmund Freud, *Leonardo da Vinci: A Study in Psychosexuality* (Vienna, 1910); English trans., A. A. Brill (New York: Vintage Books, 1916, 1947). (See also n. 96, below.) Julia Kristeva ("Motherhood According to Bellini," in her *Desire in Language: A Semiotic Approach to Literature and Art* [New York: Columbia University Press, 1980], pp. 237–70) essentially accepts Freud's view of Leonardo in an interpretation that sharply differs from the one presented here.

3. See Erwin Panofsky, *Early Netherlandish Painting* (Cambridge Mass.: Harvard University Press, 1958), pl. 101, 138, 220, 259. On the question of Northern influence upon the *Ginevra*, see Fern R. Shapley, *Catalogue of the Italian Paintings* (Washington, D. C.: National Gallery of Art, 1979), vol. I, p. 252; also Paul Hills, "Leonardo and Flemish Painting," *Burlington Magazine* 122 (September 1980): 609–15.

4. See Federico Zeri (with Elizabeth E. Gardner), *Italian Paintings, A Catalogue of the Collection of the Metropolitan Museum of Art, Florentine School* (New York: Metropolitan Museum of Art, 1971), pp. 69–71; and John Walker, "*Ginevra de' Benci* by Leonardo da Vinci," *National Gallery of Art. Report and Studies in the History of Art*, vol. 1, 1967 (Washington, D. C.: National Gallery of Art, 1968), pp. 13–18.

5. Jean Paul Richter, ed., *The Literary Works of Leonardo da Vinci*, third ed., 2 vols. (London and New York: Phaidon, 1970), vol. I, p. 56, no. 23. The aphorism, classical in origin, is also found in the treatise on sculpture written by Leonardo's contemporary Pomponius Gauricus (John Pope-Hennessy, *The Portrait in the Renaissance* [Princeton, N.J., Princeton University Press, 1979], pp. 62–63).

6. Walker, 1968, pp. 25–26; Pope-Hennessy, 1979, p. 105.

7. Patricia Simons, "Women in Frames: The Gaze, the Eye, the Profile in Renaissance Portraiture," *History Workshop: A Journal of Socialist and Feminist Historians*, no. 25 (Spring 1988), pp. 4–30 (ch. 2 in this volume).

8. On the courtesan portrait, see Elizabeth Cropper, "The Beauty of Woman: Problems in the Rhetoric of Renaissance Portraiture," in *Rewriting the Renaissance: The Discourses of Sexual Difference in Early Modern Europe*, eds. Margaret W. Ferguson, Maureen Quilligan, and Nancy C. Vickers (Chicago: University of Chicago Press, 1986), pp. 175–90; and Giovanni Pozzi, "Il ritratto della donna nella poesia d'inizio Cinquecento e la pittura di Giorgione," in *Giorgione e l'umanesimo veneziano*, ed. R. Pallucchini (Florence: Leo S. Olschki, 1981), vol. I, pp. 309–41. See also Lynne Lawner, *Lives of the Courtesans: Portraits of the Renaissance* (New York: Rizzoli, 1987).

9. Luigi Niccolini, a widower of thirty-two when he married Ginevra de' Benci in 1474, became a Florentine city official (*gonfaloniere* in 1478, *priore* in 1480). Never wealthy, he suffered a financial crisis in 1480, and at the time of his death in 1505, his heirs could not repay Ginevra's dowry. She was apparently supported mainly by her own family (see Walker, 1968, pp. 2ff.).

10. The painting was acquired by the National Gallery of Art in 1967; for the provenance, which cannot be traced before the eighteenth century, see Shapley, 1979, vol. I, pp. 251–55. It was Bode who first identified the sitter in the picture; the painting and its juniper attribute are discussed by Kenneth Clark, *Leonardo da Vinci: An Account of His Development as an Artist* (Baltimore: Penguin Books, 1959), pp. 27–29. Leonardo's portrait of Ginevra de' Benci was mentioned in the *Libro* of Antonio Billi (written between 1481 and 1530), in the Anonimo Gaddiano (1542–48), and in Vasari's life of Leonardo (1550).

11. For texts of the poems by Landino and Braccesi, including English translations, see Walker, 1968, app. III.

12. Jennifer Fletcher, "Bernardo Bembo and Leonardo's Portrait of Ginevra de' Benci," *Burlington Magazine* 131 (December 1989): 811–16.

13. Landino claims, in one of the poems addressed to Bembo, that "wishing to be made famous for eternal love she [Ginevra] desires the distinguished name of an adopted house; and when two letters have been changed in her family stock, her name, which once was Bencia, will be Bembia." Fletcher (1989, p. 812) argues that by embracing her device (and its inscription) with his own similar one, "Bembo satisfies Ginevra's desire to join herself to his house," a wish "that is recorded by Landino."

14. Elizabeth Cropper, 1986, pp. 175–90. Petrarch asserted this in two sonnets on Simone Martini's portrait of Laura.

15. Cropper, 1986, pp. 188–90.

16. Ibid., p. 187. In this reading, the laurel and palm again refer to Petrarch, as the "ramoscel de palma / et un di Lauro" brought to Petrarch by the dead Laura in a vision.

17. Ludwig H. Heydenreich offered the chief stylistic arguments for dating the painting 1478–80 (*Leonardo da Vinci* [New York: Macmillan, 1954], vol. I, p. 180). According to Fletcher, Kenneth Clark was always troubled by the early dating, and eventually rejected the marriage-

portrait thesis in favor of a 1478–80 date (*Drawings of Leonardo*, 1968).

18. Jane Schuyler (*Florentine Busts: Sculpted Portraiture in the Fifteenth Century* [Garland Publishing, 1976], p. 180) has found evidence for this practice in the Medici inventory. Schuyler's discussion of the bust of a *Lady with Flowers*, in the Bargello, which is ascribed to Verrocchio and which she identifies as Ginevra de' Benci, is pertinent to the issues raised here.

19. At the risk of undermining her own argument, Fletcher (1989, p. 813) advances several reasons why the portrait was probably never in Venice: there is no mention of it in any Venetian commentaries (including Marcantonio Michiel's description of the collection of Pietro Bembo), nor any reflection of it in Venetian portraiture.

20. Ficino's *Commentarium in Platonis Convivium de Amore* was published for the first time in 1484; it was preceded by his Latin translation of Plato's text of 1469, which bore the title *De amore*, and by an Italian version produced in 1474, which circulated in manuscript form (see Marsilio Ficino, *Commentary on Plato's Symposium on Love*, trans., introduction, and notes, Sears Jayne [Dallas: Spring Publications, 1985], Introduction). The manuscript owned by Bembo, with the full Latin title *(Commentarium . . .)*, thus appears to have been the 1484 edition. The date of the other manuscript bearing Bembo's impresa, Paolo Marsi's poem describing Bembo's Spanish sojourn of 1468–69, is not given by Fletcher. However, this impresa, sketched by Bembo's friend Bartolomeo Sanvito, could have been added at any time, just as owners of books often inscribe their own names in their copies long after the book's publication date. A later acquisition of the emblem by Bembo would be consistent with its third appearance, on the restored tomb of Dante in Ravenna, commissioned by Bembo in 1483 (Fletcher, p. 811 and fig. 3).

21. Richter (vol. II, p. 312, no. 1332), quoted by Martin Kemp ("Leonardo da Vinci: Science and the Poetic Impulse," *Royal Society of Arts Journal* 133/5343 [February 1985]: 203), who, noting the "grindingly monotonous word-play on the name of Petrarch's beloved Laura as the virtuous 'laurel,'" comments that "Leonardo's mockery conforms to a vigorously acid brand of anti-Petrarchan burlesque, which coexisted humorously in the courts alongside the sweet cadences of unrequited love."

22. John Walker (1968) gives her more due than recent writers, but offers a highly romanticized interpretation of her biography.

23. These are the most standard meanings of laurel and palm. Cropper (1986, p. 187) quotes the words of Petrarch's Laura: "The palm is victory . . . the laurel means triumph."

24. Emil Möller ("Leonardos Bildnis der Ginevra de'

Benci," *Münchener Jahrbuch der bildenden Kunst* 12 [1937/38]: 191) and Walker (1968, p. 11) interpreted the laurel and palm as straightforward references to Ginevra's own accomplishments.

25. Peter Stallybrass, "Patriarchal Territories: The Body Enclosed," in *Rewriting the Renaissance: The Discourses of Sexual Difference in Early Modern Europe*, eds. Margaret W. Ferguson, Maureen Quilligan, and Nancy J. Vickers (Chicago and London: University of Chicago Press, 1986), p. 127. In the many Renaissance conduct books that offer advice on proper domestic behavior to brides, a common admonition was to obedience and silence; characteristic are Juan Luis Vives, *Instruction of a Christen Woman* (1523) and Henry Smith, *A Preparative to Marriage* (1591). Francesco Barbaro writes in his *On Wifely Duties* (1415): "It is proper . . . that not only arms but indeed also the speech of women never be made public; for the speech of a noble woman can be no less dangerous than the nakedness of her limbs" (in *The Earthly Republic: Italian Humanists on Government and Society*, eds. Benjamin G. Kohl and Ronald G. Witt, with Elizabeth B. Welles [Phildelphia: University of Pennsylvania Press, 1978], p. 205). The praise of women for their *taciturnitas* is also discussed in Ian Maclean, *The Renaissance Notion of Woman* (Cambridge, England: Cambridge University Press, 1980), ch. 4.

26. For Lucrezia Tornabuoni's portrait (c. 1475), see Shapley, 1979, vol. I, pp. 203–4, and vol. II, pl. 140. Gentile Bellini's portrait of Caterina Cornaro, Queen of Cyprus and patroness of the legendary literary court at Asolo, is reproduced in Pope-Hennessy, 1979, p. 51.

27. The fragment is quoted in a letter written to Ginevra de' Benci in 1490 by a writer known from his signature as "G + H"; see Walker, 1968, app. II.

28. On the praise of women for manly virtues, see Maclean, 1980, pp. 51ff. The Latin inscription, VIRTUTEM FORMA DECORAT, can be read in more than one way, either as "beauty adorns virtue" or "she adorns her virtue with beauty." The presence of the juniper sprig, her surrogate here, supports the latter reading. Although "forma" and "pulchritudo" seems to be interchangeable in the poems of Landino and Braccesi, "pulchritudo" is the more common term for female beauty in Renaissance literature (Bembo speaks of Ginevra de' Benci as "matronarum pulcherimam" in his annotation of Ficino's *Commentary*), while "forma" carries connotations of the intellect, and was not applied to women at all in classical literature (*Thesaurus Linguae Latinae* [Lipsius: B. G. Teubneri, vol. VI, 1912–26], pp. 1066ff., 1072ff.)

29. Möller, 1937/38, p. 199. Ginevra de' Benci had no children.

30. Vasari-Milanesi, vol. IV, p. 27.

31. Walker, 1968, p. 8; Müller, p. 208, offered the

gratitude theory. In a master's thesis paper in progress at the American University, "Neoplatonic Love in the Renaissance: A Closer Look at Ginevra de' Benci," Ronald Meek presents a different proposal for the painting's origins. Though his conclusions and focus are different from my own, he has independently concluded that the evidence for Bembo's commissioning of the portrait is weak, and that Ginevra de' Benci's own intellectual virtue is to some degree celebrated in the portrait.

32. Information about Cecilia Gallerani comes from Felice Calvi, *Famiglie Notabili Milanesi,* vol. III (Milan: Antonio Vallardi, 1884), n.p.; and from Francesco Malaguzzi-Valeri, *La Corte di Lodovico il Moro* (Milan: V. Hoepli, 1929), vol. II, esp. pp. 465ff. Gallerani's achievements are praised by Francesco Agostino della Chiesa, *Theatro delle donne letterate* (Mondovì, 1620), p. 124.

33. As described in Sergio Bertelli, Franco Cardini, Elvira Garbero Zorzi, *The Courts of the Italian Renaissance* (Facts on File Publications, 1986), p. 10.

34. Baldesar Castiglione, *The Book of the Courtier,* Book III, defines the ideal intellectual and social virtues of the court lady (not necessarily a courtesan). *Il cortegiano,* published in 1528, was drafted at the court of Urbino in 1507. See also Maclean, 1980, pp. 64–65.

35. Matteo Bandello, *Le novelle,* vol. I (Bari, 1910), p. 259. Cited by Malaguzzi-Valeri, 1929, vol. II, p. 470.

36. Kemp, 1981, p. 201; Pope-Hennessy, 1979, p. 101. See also Jaynie Anderson, "The Giorgionesque Portrait: From Likeness to Allegory," in *Giorgione: Atti del convegno internazionale di studio per il 5° centenario della nascita* (Castelfranco, 1979), pp. 153–58. Despite uncertainty by earlier writers, the painting at Cracow has been definitively accepted by recent scholars as Leonardo's autograph portrait of Gallerani.

37. This white animal is likely to be an ermine (a subspecies of the weasel, which turns white in winter). It is not clear when il Moro took the ermine as his personal emblem; conceivably he took it on the model of Gallerani's name. Another possibility is that Leonardo liked the idea of an image that might punningly allude to both their identities.

38. The full text of Bellincioni's poem, which was published in his *Rime* (1493 ed.), is given in Malaguzzi-Valeri, 1929, vol. II, p. 470; and in Richter, vol. I, p. 77, n. 33.

39. Ibid.

40. Isabella d'Este, sister of Lodovico's wife, Beatrice, asked to borrow it in 1498 from Cecilia Gallerani, in order to compare it with "certain beautiful portraits" by Giovanni Bellini, perhaps considering Leonardo's work a model of portraiture (Adolfo Venturi and Alessandro Luzio, "Nuovi documenti su Leonardo da Vinci," *Archivio storico dell'arte,* vol. I [1888], pp. 45–46). Gallerani agreed reluctantly, stating (as if she were recalling Bellin-

cioni's conceit) that, through no fault of the painter, the portrait no longer resembled her (Kemp, 1981, p. 200; Heydenreich, 1954, vol. I, p. 36).

41. Carlo Amoretti, *Memorie storiche su la vita, gli studi e le opere di Leonardo da Vinci* (Milan, 1804) (cited by Malaguzzi-Valeri, 1929, vol. II, p. 471).

42. Leonardo was a leading advocate among Quattrocento artists for the elevation of the visual arts to the Liberal Arts, as intellectual, not manual, activities. His emphasis upon the artist's imaginative faculties is developed in portions of the *Trattato* written in the 1490s. See Rudolf Wittkower, *The Artist and the Liberal Arts* (London, 1952); and M. D. Garrard, "The Liberal Arts and Michelangelo's First Project for the Tomb of Julius II (with a Coda on Raphael's 'School of Athens')," *Viator* 15 (1984): 347–48.

43. Kenneth Clark (1959, pp. 56–57) explains the attribution and identification of the painting, and dates it in the middle to late 1490s. Technical examination suggests that the panel was cut from the same trunk as that of the *Cecilia Gallerani* (K. Kwiatkowski, *"La Dame à l'Hermine" de Leonardo da Vinci: ètude technologique* [Warsaw, 1955]). Some writers argue that only the head and shoulders were painted by Leonardo (e.g., Pope-Hennessy, 1979, p. 105).

44. The epigram is quoted by Kemp, 1981, p. 199.

45. The Gardner picture (fig. 8) is a variant of a painting by a Leonardesque artist in the Pinacoteca Ambrosiana, Milan, once held to be Cecilia Gallerani herself (see Malaguzzi-Valeri, 1929, vol. II, fig. 537).

46. A contrasting proportion of female to male portraits by Titian is supplied by Harold Wethey (*The Paintings of Titian,* vol. II: The Portraits [London, 1971]), who counts among 117 autograph portraits only fifteen women, a group that includes six wives of rulers, four images said to be the painter's daughter Lavinia, plus the "portrait" of Flora (cited by Jaynie Anderson, 1979, p. 156).

47. Parmigianino's *Antea* and the issues surrounding its identification are discussed by Cropper, 1986, pp. 176ff.; and also by Cropper in "On Beautiful Women, Parmigianino, *Petrarchismo,* and the Vernacular Style," *Art Bulletin* 63 (September 1976): 391ff.

48. The identification of the portrait with "M[ad]onna Lisa," wife of the Florentine silk merchant Francesco del Giocondo, does not go back further than Vasari, and may have resulted from Vasari's effort to connect the picture with a portrait of Francesco by Leonardo mentioned in earlier sources (see Kemp, 1981, p. 268). Other candidates for the lady's identity, none of which has gained acceptance, are listed by Laurie Schneider and Jack D. Flam, "Visual Convention, Simile and Metaphor in the Mona Lisa," *Storia dell'arte* 29 (1977): 19. For literature on the picture, see Roy McMullen, *Mona Lisa: The Picture and*

the Myth (Boston: Houghton Mifflin, 1975).

49. The description is that of Antonio de Beatis; quoted more fully in Kenneth Clark, "Mona Lisa," Burlington Magazine 115 (March 1973): 144–50.

50. Kemp's reconstruction of the dating of this picture is the most plausible so far (1981, pp. 268ff.). See also Clark, 1973, p. 146.

51. Pater's essay on Leonardo (1869) was reprinted in 1873 in The Renaissance (see Clark, 1973, p. 148). For discussion of a similarly mystified interpretation of the image by Théophile Gautier (1858) and by other Romantics, in the context of the femme fatale, see George Boas, "The Mona Lisa in the History of Taste," Journal of the History of Ideas 1 (1940): 207–24.

52. Clark, p. 149. See also Charles De Tolnay, "Remarques sur la Joconde," Revue des arts 2 (1952): 18–26, who describes the figure as a "personification" of the landscape.

53. Kenneth Keele (M.D.), "The Genesis of the Mona Lisa," Journal of the History of Medicine and Allied Sciences 14 (1959): 135–39.

54. David Rosand, "The Portrait, the Courtier, and Death," in eds. Robert W. Hanning and David Rosand, Castiglione: The Ideal and the Real in Renaissance Culture (New Haven, Conn.: Yale University Press, 1983), pp. 91–129.

55. Richter, vol. I, p. 77, no. 32.

56. Rosand, 1983, p. 112.

57. Cropper, 1986, p. 176.

58. Schneider and Flam, 1977, pp. 15–24.

59. Kemp, 1981, pp. 261–65; 275–77.

60. Webster Smith, "Observations on the Mona Lisa Landscape," Art Bulletin 67 (June 1985); 183–99; esp. 185.

61. Repeating comparisons of the human body and the earth's body written by a thirteenth-century predecessor, Ristoro d'Arezzo, Leonardo "turns them into expressions of his conviction, seemingly not shared by the thirteenth-century writer, that the earth itself is indeed a kind of autonomous and organic body" (Smith, 1985, pp. 189–90).

62. Kemp, 1981, p. 261.

63. Plato, Timaeus, 32C-34B; 36E and 40C; Alain of Lille, De planctu naturae (lines 1160–72).

64. Lucretius, De rerum natura; Cicero, De natura deorum; Statius, Thebaid; Boethius, The Consolation of Philosophy; Claudian, De raptu Proserpinae. See also George D. Economou, The Goddess Natura in Medieval Literature (Cambridge, Mass.: Harvard University Press, 1972).

65. Aristotle, De generatione animalium (Generation of Animals), esp. 716a 3–24; 729a 10–15; 729a 28–34; 730a 25–29. See Maryanne Cline Horowitz, "Aristotle and Women," Journal of the History of Biology 9, no. 2 (Fall

1976): 183–213.

66. Augustine, The City of God, bk. XIII, ch. 13.

67. Macrobius, Commentary on the Dream of Scipio, I.xiv.15; and Chalcidius, CCCXXX, 324–25. See Arthur O. Lovejoy, The Great Chain of Being: A Study of the History of an Idea (Cambridge, Mass.: Harvard University Press, 1936).

68. The drawing is reproduced in ch. 4 of this volume (fig. 3). See also Charles D. O'Malley and J. B. de C. M. Saunders, Leonardo on the Human Body, Leonardo da Vinci (New York: Dover reprint, 1983), p. 460.

69. The Galenic view gained support from Poggio Bracciolini's discovery in 1417 of a manuscript of Lucretius's De rerum natura, a text that asserted women's contribution of semen to generation (O'Malley and Saunders, 1983, p. 454). See Michael Boylan, "The Galenic and Hippocratic Challenges to Aristotle's Conception Theory," Journal of the History of Biology 17 (Spring 1984): 83–112; Helen Rodnite Lemay, "Masculinity and Femininity in Early Renaissance Treatises on Human Reproduction," Acta Academiae Internationalis Historiae Medicinae 18, nos. 1/4 (Amsterdam, 1983): 21–31; and also Vern L. Bullough, "Medieval Medical and Scientific Views of Women," Viator 4 (1973): 485–501. (I am grateful to Elizabeth B. Welles for knowledge of the latter two sources.) Also valuable is Thomas Laqueur, "Orgasm, Generation, and the Politics of Reproductive Biology," in The Making of the Modern Body: Sexuality and Society in the Nineteenth Century, ed. Catherine Gallagher and Thomas Laqueur (Berkeley: University of California Press, 1987), pp. 1–41.

70. O'Malley and Saunders, 1983, p. 20. (Vasari had noted Leonardo's study of Galen.) Leonardo's familiarity with Lucretius's De rerum natura is evident in his writings (e.g., Richter, vol. II, p. 373, no. 1492); according to O'Malley and Saunders (1983, p. 454), he was influenced by Lucretius's statement that the fetus "is always fashioned out of the two seeds."

71. O'Malley and Saunders, 1983, p. 23.

72. Ibid., p. 456 (Q 1 12r; written c. 1510). For Galen's text, see Galen: On the Usefulness of the Parts of the Body (De usu partium), trans., introduction, and commentary, Margaret Tallmadge May (Ithaca, N.Y.: Cornell University Press, 1968), vol. II, books 14 and 15.

73. O'Malley and Saunders, 1983, p. 484 (Q 111 8v; c. 1510–12).

74. Ibid. Leonardo repeats this important insight when he asserts that Nature puts into the bodies of animals "the soul of the body which forms them, that is, the soul of the mother which first constructs in the womb the form of the man and in due time awakens the soul that is to inhabit it. And this at first lies dormant and under the tutelage of the soul of the mother, who nourishes and vivifies it by the

umbilical vein, with all its spiritual parts . . ." (Richter, vol. I, p. 101, no. 837).

75. O'Malley and Saunders, 1983, p. 472 (Q 1 1r; written c. 1504–9): "The uterine veins and arteries of the woman have the same intermingling by contact with the terminal vessels of the umbilical cord of her child. . . . But the vessels of the infant do not ramify in the substance of the uterus of the mother but in the secundines. . . ."

76. See also sheet Q 111 7v, representing one of Leonardo's few dissections of a human fetus, where he demonstrates the nourishment of the child by the mother's menstrual blood, conveyed through the umbilicus (O'Malley and Saunders, 1983, p. 482; dated c. 1510–12).

77. Richter, vol. I, p. 35, no. 7 (Urb. 2b, 3a, Trat. 7).

78. Ibid., vol. II, p. 86, no. 797.

79. Leic. 34r, Edward MacCurdy, *The Notebooks of Leonardo da Vinci,* arranged by E. MacCurdy (New York, 1938), vol. I, p. 91, cited by Keele, 1959, p. 147. On Leonardo's comparison of water and wind currents, see Kemp, 1981, ch. II.

80. L. B. Alberti, *De pictura,* esp. I.37 and III.55 (*Leon Battista Alberti, On Painting and On Sculpture,* ed. and trans., Cecil Grayson [London: Phaidon, 1972], pp. 73–75, 99). Although Alberti does not specifically distinguish *natura naturans* from *natura naturata,* implicit in his argument is a recognition that the source of underlying principles is differentiated from those things in the natural world that artists study.

81. Made for *The Painter's Manual,* published in 1525; see *The Painter's Manual by Albrecht Dürer,* trans. and commentary, Walter L. Strauss (New York: Abaris Books, 1977), p. 435. H. Diane Russell, in *Eva/Ave: Women in Renaissance and Baroque Prints* (Washington, D. C.: National Gallery of Art, 1990), p. 23, offers a related reading of this print.

82. For the connection between the Neoplatonic twin Venuses and Botticelli's *Primavera* and *Birth of Venus,* see especially E. H. Gombrich, "Botticelli's Mythologies; a Study in the Neoplatonic Symbolism of His Circle," *Journal of the Warburg and Courtauld Institutes* 18 (1955): 16ff.; Erwin Panofsky, *Renaissance and Renascences* (Stockholm: Almqvist & Wiksell, 1960), pp. 191–200; and Edgar Wind, *Pagan Mysteries of the Renaissance* (New York: Barnes & Noble, 1968), Chaps. 7 and 8.

83. See Kemp, 1981, pp. 93ff., for a summary of the arguments concerning the relationship between the Paris and London versions and their dating.

84. Aristotle, *Metaphysics,* Book Delta, lines 1072 a, b; and *Generation of Animals,* A3. See also R. G. Collingwood, *The Idea of Nature* (Oxford: The Clarendon Press, 1945), pp. 80–82.

85. E. g., Clark, 1963, p. 117, and Kemp, 1981, p. 270.

86. Describing a rocky landscape, Leonardo wrote:

"Drawn by my eager desire, wishing to see the great manifestation of the various and strange shapes made by formative nature, I wandered some way among gloomy rocks, coming to the entrance of a great cavern, in front of which I stood for some time, stupefied and incomprehending such a thing. . . . Suddenly two things arose in me, fear and desire: fear of the menacing darkness of the cavern; desire to see if there was any marvellous thing within it" (B.L.115r; written c. 1480). This passage was also connected with the *Virgin of the Rocks* by Kemp, 1981, p. 99.

87. Between 1478 and 1483, Leonardo developed at least five Madonna and Child compositions, only one of which seems to have been prompted by a commission (see Kemp, 1981, p. 53).

88. Kemp, 1981, p. 226, emphasizes political meaning in the pictures. The Burlington cartoon and the Louvre painting are usually dated c. 1498 and c. 1508–10, respectively; Kemp suggests a dating of c. 1508 for the cartoon. Patricia Leighten has located the Burlington Cartoon within a tradition of images that emphasize the physicality of birth and the generative cycle ("Leonardo's *Burlington House Cartoon,*" *Rutgers Art Review* 2 [1981]: 31–42). Meyer Schapiro ("Leonardo and Freud: An Art-Historical Study," *Journal of the History of Ideas* 17, no. 2 (1956): 147–78) discusses the Virgin with Saint Anne as a compositional type popular around 1500.

89. Although Leonardo did not invent the Virgin and Saint Anne theme, he concentrated and charged an essentially static and anecdotal pyramidal group with symbolic meaning, through complex formal linkings between figures and landscape. See Alexander Perrig, "Leonardo: Die Anatomie der Erde," *Jahrbuch der Hamburger Kunstsammlungen* 25 (1980): 51–80, who interprets the landscape backgrounds of the *Virgin of the Rocks, Mona Lisa,* and *Saint Anne* in conjunction with Leonardo's geological studies, and also as emotional correlatives of the paintings' subjects.

90. Richter, vol. I, pp. 371–72, no. 660. For the painter's competition with nature, see the adjacent no. 662.

91. Ibid. vol. I, p. 367, no. 652; the same text appears in the Trattato (Richter, vol. I, p. 38, no. 13).

92. Ibid. vol. II, pp. 100–1, no. 837.

93. Clark, 1973, pp. 149, 150.

94. "The act of procreation and the members employed therein are so repulsive that if it were not for the beauty of the faces and the adornments of the actors and the pent-up impulse, nature would lose the human species" (Edward MacCurdy, *The Notebooks of Leonardo da Vinci* [New York: George Braziller, 1958], vol. I, p. 97). Clark may have been influenced by the opinion of Dr. A. A. Brill, who in the introduction to Freud's study of Leonardo,

avowed that "many overt homosexuals speak of a *horror feminae* (a horror of women) which they claim to experience when confronted with the physical or erotic elements of femininity." However, Brill added that many homosexuals do not dislike women otherwise: "on the contrary, they often prefer feminine companionship." Modern literature on male homosexuality, though not typically concerned with the issue of attitudes toward women, reflects a similar dichotomizing. Representative are: Richard A. Isay, M.D., *Being Homosexual: Gay Men and Their Development* (New York: Farrar, Straus and Giroux, 1989), esp. pp. 42, 75ff.; and Robert J. Stroller, *Presentations of Gender* (New Haven, Conn.: Yale University Press), 1985, ch. 3.

95. Clark, 1973, esp. p. 149.

96. Patricia Rubin, "What Men Saw: Vasari's Life of Leonardo da Vinci and the Image of the Renaissance Artist," *Art History* 13 (March 1990): 34–43. Leonardo was characterized by sixteenth-century biographers as physically beautiful; skilled in mathematics, perspective, and lute-playing; eloquent in speech; and a master of design and invention (Anonimo Magliabechiano, in *Il codice Magliabechiano*, ed. Carl Frey [Berlin, 1892; Farnborough, England: Gregg International Publishers, 1969], p. 110). In Paolo Giovio's eulogy, Leonardo is described as "extraordinarily handsome, affable, generous, lute-playing, philosophizing . . . intelligent, curious and impatient"

(Rubin, pp. 38–39). Vasari repeats these characteristics, adding an emphasis upon his "beauty, grace and virtue," which is interpreted by Rubin as part of a larger rhetorical strategy.

The modern view of Leonardo as homosexual, which apparently originated in Freud's biography, draws support from (1) the 1476 accusation of sodomy; (2) his bachelorhood and lifelong attachments to Salai, and later, Melzi; (3) the androgynous, and increasingly feminized, type of ideal beauty projected in his late paintings. The characterization of Leonardo as homosexual was also supported by Meyer Schapiro (see n. 88), who generally accepted Freud's position, providing a firmer art-historical basis for some of his insights.

97. See James M. Saslow, *Ganymede in the Renaissance: Homosexuality in Art and Society* (New Haven, Conn.: Yale University Press, 1986), pp. 77ff.

98. The appropriation of the feminine by male artists was an eighteenth-century phenomenon; this is discussed by Norma Broude in *Impressionism, a Feminist Reading: The Gendering of Art, Science, and Nature in the Nineteenth Century* (New York: Rizzoli, 1991), pp. 149ff.

99. For the contemporary debate about essentialism (the belief that there are fixed, unchanging, and "natural" essences of femaleness), see Diana Fuss, *Essentially Speaking: Feminism, Nature and Difference* (New York: Routledge, 1989).

1. Guercino (Giovanni Francesco Barbieri), *Personifications of Painting and Drawing*, 1657. Dresden, Gemäldegalerie Alte Meister.

4

THE TAMING OF THE BLUE

Writing Out Color in Italian Renaissance Theory

PATRICIA L. REILLY

In his *On the True Precepts of the Art of Painting* (1587), Giovanni Battista Armenini chastises painters for using beautiful colors to win the approval of the public.[1] In this way he voices an animosity toward color and its unregulated use that can be found to permeate the treatises of writers on both sides of the *disegno/colore* controversy. For Armenini, those who "devote themselves to the facility and charm of colors" show themselves to be the "vile and sluggish artists they really are,"[2] a sentiment he shared with Giorgio Vasari, who condemned the Venetian painter's practice of concealing "under the charm of his colouring his lack of knowledge of how to draw."[3] Indeed, in their discussion of painting, this valuation, or more often *de*valuation, of color is one that Italian Renaissance authors found of pivotal importance.

Such deprecation was certainly not new, as illustrated by Aristotle's judgment that a canvas "smeared" with colors would not give as much

This essay was developed from a paper read at the 1990 College Art Association Annual Meeting. Also published in *Genders* 12 (Winter 1991): 77–99, the essay was revised by the author for this edition. Copyright © 1991 by Patricia L. Reilly. Reprinted by permission of the author and University of Texas Press.

pleasure as an outline,[4] and it is not the intent of this paper to document the history of this bias. What this paper does attempt to offer is an exploratory investigation into the figures of gender employed both to praise and to deprecate color, and their effects on the way color was subsequently perceived and written out in the Renaissance.[5] Through figures of femininity, theorists characterize color as beautiful but dangerous, engaged in a complex and antagonistic relationship with a masculinized *disegno*. When kept in line, color contributes to the glory of *disegno*, lending its charms and beauty to make *disegno* "look good." However, the materiality of *colore* can also obscure the *disegno*, and it is the tension between color's capacity to flesh out the artist's idea or usurp it that is played out in these texts.

In other fields of inquiry scholars are investigating and bringing into question the conceptual framework of their discipline. For instance, in *The Science Question in Feminism*, Sandra Harding notes that the metaphors of gender in the writings of the fathers of modern science can no longer be accepted as individual idiosyncrasies or as irrelevant to the meaning that science holds for its enthusiasts.[6] The same can be seen to hold true for the history of art: what we know from such

forefathers as Vasari is not what he saw, but what he *wrote* about what he saw—writing that is structured by inherently valuative classifications and conceptual schemata. Indeed, the history of art is first and foremost language, and has until very recently exercised the luxury of ignoring its reliance on, and more pointedly its manipulation of, this language. This is not to say that art historians have been oblivious to their use of language, merely unwilling to subject it to scrutiny. As Michael Baxandall notes in his discussion of humanist theories of art, learning a label for any class of phenomenon inherently directs our attention to the quality by which it is delimited; names and categories become selective sharpeners of attention.[7] In the treatises under examination here, figures of gender do just that. Relying upon commonly understood meanings of femininity, Renaissance theorists relegate color to its proper place in the grand design.

The relationship between *disegno* and *colore* as one of gendered opposition originates in antique conceptions of form and matter. Form, or the idea in its ideal state, is equated with the male. It exists prior to, and is of greater significance than, its feminized complement, matter. Matter is subservient to form, merely fleshing out the divine world of ideas; the form provides the rule, or norm, to which it is subjected. Thus, though relations between the two are necessary, the less tainted form is by such relations with matter, the purer it remains. Aristotle in particular notes that

Form is better and more divine in its nature than the Matter, it is better also that the superior one should be separate from the inferior one. That is why wherever possible and so far as possible the male is separate from the female, since it is something better and more divine in that it is the principle of movement for generated things, while the female serves as their matter.[8]

Indeed, the interdependent, and often antagonistic, relationship between the sexes provides Aristotle with the fundamental metaphor for the relationship between form and matter. It is this Aristotelian view that "the female always provides the material, the male provides that which fash-ions the material into shape" that surfaces in Renaissance texts as a masculinized *disegno* grappling with its feminized counterpart, *colore.*[9]

Leon Battista Alberti's advice to painters in his treatise *On Painting* (1436) that they should first "circumscribe the plane with their lines" and then "fill the circumscribed places with colours" reveals the ornamental and supplementary role he believed color plays in its relation to *disegno.*[10] Alone, color is simply matter, actualized only through the imposition of form: "Thus, every material, though it be base," Armenini notes, "is transformed by design into a thing of great value, since when it is shaped into various forms . . . it is esteemed by honorable men."[11] This is evidenced too in Vasari's definition of a painting in *The Lives of the Most Excellent Italian Architects, Painters and Sculptors* (1568) as a "plane covered with patches of color on the surface of wood, wall, or canvas filling up the outlines which, by virtue of a good design of encompassing lines, surround the figure."[12] And though these "patches of color" do indeed enliven a composition, what is often described as the source of perfection in painting is precisely their lack. As Alberti notes,

I certainly agree that copiousness and variety of colours greatly add to the pleasure and fame of a painting. But I should like the [highest level of attainment] in industry and art to rest, as the learned maintain, on knowing how to use black and white.[13]

This suppression of color to painting's greater glory is expressed too by Vasari, who praises as the pinnacle of the painter's art Michelangelo's cartoon for the *Battle of Cascina* [2]. This cartoon, he notes, overwhelmed all the other artists with admiration and astonishment, "for it was a revelation of the perfection that the art of painting could reach."[14] Perfection, it appears, rests solely in the untainted, uncolored *disegno*.

This attitude toward color may appear a far cry from the laudatory treatment color receives at the hands of Leonardo da Vinci. Indeed, in his *paragone*, or comparison of painting and sculpture, Leonardo asserts that painting's superiority over sculpture rests largely on the properties of colors, noting that "the art of painting includes in its

2. Aristotile da Sangallo, copy after Michelangelo's cartoon for the *Battle of Cascina,* 1542.
Viscount Coke and the Trustees of the Holkham Estate (© *Coke Estates Limited*).

domain all visible things, and sculpture with its limitations does not, namely, the colours of all things in their varying intensity and the transparency of objects."[15] Far from demeaning the painter's art, colors here prove the source of painting's superiority and prestige.

To Leonardo, the painter's palette provides him with the means to create lifelike appearances through variation in tones, something the sculptor cannot achieve. Yet Leonardo's valuation of the painter's materials over those of the sculptor involves more than just the ability to approximate the appearances of things as diverse as hair and flesh. Of pivotal importance for Leonardo's distinction is the additive nature of the painter's materials, as opposed to the subtractive nature of the sculptor's. "The sculptor is always taking off from the same material," he notes, "while the painter is always putting on a variety of materials."[16] The sculptor is described as having to wrest his form or idea from the stone, a process that

leaves him covered with sweat and his face "pasted and smeared all over with marble powder." The painter, on the other hand, leisurely adds colors to his work; "he is well-dressed and handles a light brush dipped in delightful color"[17]—his body remains unsullied by his materials. The painter's materials are confined to the painter's brush, to be applied in accordance with his design, not wrestled with in an effort to reveal it. Leonardo implies that, unlike the sculptor, the painter inscribes his idea first in the form of a drawing, to which colors are added only later. This additive nature of painting ensures the primacy of the painter's idea or form, and thus the superiority of his art. In this Aristotelian sense, the painter and his perfected form are never polluted by their relationship with the materials. Indeed, as Leonardo makes clear, the additive qualities of painting allow the painter to subject, rather than be subjected to, the nature of his materials.

Although theorists such as Leonardo praise

color in such comparisons, they still deem color as the lesser of two evils, and within the medium of painting itself, the only one. For though it is more successfully kept at arm's length, the materiality of the painter's *colori* is still very real. It is this aversion to the material qualities of pigments that informs the Venetian theorist Paolo Pino's warning to the painter in his *Dialogue on Painting* (1548) that "our master should not let himself be seen with his hands besmirched with paint."[18] Of this double standard, Pino provides an interesting example. As does Leonardo, Pino initially asserts the superiority of painting over sculpture, based on the nature of color. The sculptor, he claims,

cannot endow a figure with anything beyond its form, which is its essential being; whereas we painters, in addition to form and being, adorn it with the specifications [that make] for integral being. And this consists in our feigning the whole composite carnal form, in which one may discern the diversity of complexions, the distinction of the eyes from the hair and other members, not merely in their form, but also in their colors, just as they are distinguished in the live model.

Yet he undercuts this prestige by adding, "and if you want to argue that these effects inhere in the colors, I say they do not . . . indeed pigments cannot produce such effects of themselves, without the addition of the master's artifice."[19] At once asserting the importance of color only then to undermine it, Pino voices an ambivalence toward color that traverses these texts.

For theorists who wished to claim painting as an art of the intellect rather than one of the senses, color's materiality was the source of both its attraction and repulsion. The fear of colors' potential to obscure, and thus undermine, the master plan of the artist, to "produce effects of themselves," is one voiced by Vasari, who warns that if colors

are laid on flashing and vivid in a disagreeable discordance so that they are like stains and loaded with body . . . the design becomes marred in such a manner that the figures are left painted by the patches of colour rather than by the brush.[20]

It is only when "the intelligence of the painter has by the harmony of his colours assured the excellence of the design" that the painter is deemed successful.[21] Though it may require little physical effort, keeping color in line is described as an arduous and essential task, a true challenge to the painter's ingenuity. Drawing, though "the most necessary" to the painter's art, is also considered "the easiest"; it is the handling of colors that is deemed "in truth a very difficult and burdensome part, yet the most necessary of all for painting."[22] For even the painter is distracted by the seductive "qualities and materials of colors," qualities that ultimately compel him "to come to the actual test and give them form in an orderly manner."[23] Thus, it is not *disegno* itself so much as the control of *colore* through the assertion of *disegno* that is celebrated in the Renaissance. Indeed, one of the forms of painting considered the most challenging was the one in which color was at its most recalcitrant and unpredictable—fresco. For fresco required a "hand that is dexterous, resolute and rapid, but most of all a sound and perfect judgement; because while the wall is wet the colours show up in one fashion, and afterwards when dry they are no longer the same."[24] Armenini notes that "At times, these changes are so great that even the most expert masters did not foresee them and thus find themselves at the mercy of materials they badly understand," adding, "Thus, you risk your reputation and honor, if by bad luck your works do not turn out well."[25] It is not surprising, then, to find that the masterful art of fresco is deemed by Vasari as "truly the most manly [*più virile*], most certain, most resolute and durable of all the other methods."[26] Indeed, this seems quite an apt description of the prowess required to keep color in hand when we read that "painting, especially in fresco, is no work for men who have passed a certain age."[27] It appears that the challenge posed by color could be met only by the most virile of painters.

Color was often seen as competing for the attention of the viewer, showing up the *disegno* rather than showing it off, and it was the painter's task to tone down its seductive qualities. Thus, even among proponents of *colore,* there existed a hierarchical distinction between color that exhib-

ited the hand of the master and that which was considered pure and unmanipulated. Pure color was deemed base; only color that had been mastered was considered worthy of praise. As Lodovico Dolce notes in his *Aretino* of 1557,

And let no one think that what gives coloring its effectiveness is the choice of a beautiful palette . . . for these colors are just as beautiful without their being put to work. Rather this effectiveness comes from knowing how to handle them in the proper way.[28]

Thus, colors were considered beautiful only when they conformed to expectation, and were described, as were women, as subject to the rigors of decorum. Indeed, a popular topic in discussions about women at the time was just that—the appropriate coloring of their constituent parts: Cheeks, hair, and thighs were all required to exhibit just the right amount and tone of color.[29] Further, the treatment of the correct disposition and coloring of this "female matter" often appears within these treatises on art. This connection between the two norms of beauty is noted by one scholar, who observes that, in the sixteenth century, female beauty that elicited the proper effect from the beholder was analyzed and used to create the canon of perfected female beauty. This in turn served in the creation of a canon for such perfection in art.[30] As the following introduction to Pino's *Dialogue* reveals, this conflation of women and art played a significant role in the way color was treated in Renaissance texts.

The discussion of painting opens with the two interlocutors, Lauro and Fabio, exclaiming over the beauty of Venetian women. Their beauty, Lauro notes, is incomparable, it wholly conforms to the ideal. "Not the tiniest jot in them is out of place," he exclaims; "they are wholly graceful, wholly beautiful."[31] The two then discuss the creation of such perfect women through the competing means of art and nature. In an effort to instruct the painter on how to triumph over nature in this task, Fabio "draws" with words "those [female body] parts" that men find most pleasing. Painting the lips of these women "sanguine-red and small"; their thighs "white as marble," Fabio then adds to this drawing the appropriate colors.[32]

It appears that the material beauty of color and women prompted a desire to inscribe them with signs of conformity to a master plan. In order for either to bring the painter honor, it was required to bear the impress of submission to the master's *disegno*. Indeed, this concept of feminine materials conforming to a governing rule is one that recalls the Plotinian query:

From what source, then, did the beauty of Helen whom men fought for shine out, or that of all the women like Aphrodite in beauty? . . . Is not this beauty everywhere form, which comes from the maker upon that which he has brought into being, as in the arts it was said to come from the artists upon their works?[33]

Painting provided the opportunity for the painter to ensure the conformity of both his body of colors *and* the body he was coloring—a body that was, more often than not, female. By fashioning feminine identity through feminized materials, the painter fashioned himself as a creator. Such power outside the realm of painting was difficult, if not impossible, to achieve. Indeed, for the master of painting, pigments proved more malleable than women and, as we shall see, more likely to bear the impress of his ideas.

This notion of feminized *colori* that conform to and flesh out the master's conception is of particular import in descriptions of the painter's reproduction of the human body. His ability to approximate the appearance and texture of flesh through colors resulted in the two being equated: "Every stroke of colour made by the brush," we read, "appears to be living flesh rather than mere paint applied by the hand of an artist."[34] Oil painting, in particular, provided the most appropriate means for such an endeavor. Painters explored the viscous properties of the oil medium, experimenting with its body, texture, and opacity. Indeed, they were described as actually adding skin and bones to their creations, as in Marco Boschini's claim in 1660 that Titian "gradually covered with living flesh those bare bones, going over them repeatedly until all they lacked was breath itself. . . . With a dab of red, like a drop of blood, he would enliven some surface—in this way bringing

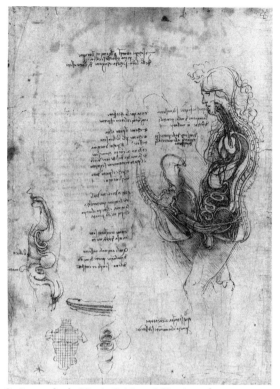

3. Leonardo da Vinci, *Coition of Hemisected
Man and Woman*, drawing, 1500. Windsor,
Royal Library, no. 19097 verso.

his animated figures to completion."[35] Dolce, too,
reports that, for his *Saint Sebastian*, Titian was
seen to have "put flesh and not colors onto this
nude,"[36] and Vasari comments on figures that are
so well colored "that they seem to be made of
living flesh rather than paint."[37]

Colors were described as the body through
which the painter was literally able to reproduce
life. Painting was described not merely as imitat-
ing flesh but as reproducing it, and artists such as
Giorgione were deemed to have been "born to
infuse life into painted figures and to represent the
freshness of living forms."[38] Indeed, as if he were
describing the gestation process, Pino's Fabio
notes how, through the medium of oils, "first the
cadaver is framed, following anatomical princi-
ples; then it is covered with flesh, and the veins,
ligaments and members are defined, using true

means to reduce it to complete perfection."[39] It
was these "true means" that proved the key to the
artist's creation. The painter's mind innervated
his pigments, and, as Vasari notes, "human intelli-
gence, through the imperfect medium of colours,
brought painted objects to life."[40] Color alone
was incapable of producing this life; for that it
needed the active agency of the painter. As Pino
notes, "No pigment is capable on the basis of its
inherent properties of producing the least of na-
ture's effects, because for that it requires the intel-
ligence and practical skill of a good master."[41]

This concept of masculine reproduction outside
the normal means of procreation is one voiced by
the philosopher Marsilio Ficino (1433–1499),
who states: "Some men, either on account of their
nature or their training, are better equipped for
offspring of the soul than for those of the body.
. . . The former pursue heavenly love, the latter
earthly." To this he adds, "The former, therefore,
naturally love men more than women."[42] In es-
sence, the painter's *colori* offered him the most
perfect means by which to realize his conception:
The idea went straight from his brain to physical
realization without relations with a female. For, as
a drawing of coition by Leonardo reveals [3], the
brain was seen as directly connected to the semi-
nal canal. During the act of procreation, the con-
ception was transmitted from the mind of the
male to the womb of the female. Indeed, as por-
trayed here by Leonardo, the male's brain is inte-
gral to the act of procreation, whereas the
woman's need not even be present. The painter,
however, could realize his creation without having
to employ the natural means to which those with-
out his genius were forced to resort. In this sense,
the painter was the source of both conception and
generation. This desire to reproduce through art
rather than through women is based, as Svetlana
Alpers notes in her discussion of Rembrandt,
upon the belief that the painter's art can serve as
an ideal, unreal mistress. Unlike relations with a
real woman, relations with this mistress permit *the
painter* to give birth to his conception.[43] Coloring
in oil truly is, as Armenini noted, "the most per-
fect method because in oil one can express best
one's every idea."[44]

The familiar alliance of woman with nature and man with culture informs Ficino's observation that "human arts construct by themselves whatever nature herself constructs, as if we were not slaves of nature but rivals."[45] These artists were seen to reproduce life through materials other than those provided by women, and in doing so, surpass them. Dolce's statement that Titian "moves in step with nature, so that every one of his figures has life, movement and flesh which palpitates,"[46] points to artists' reliance on this other means of "natural" reproduction. This concept of the painter's art as a competing means of reproduction is one to which Titian's impresa testifies. A representation of maternal molding, as David Rosand notes, this image of a bear licking her still-unformed cub into shape represented the female capacity to generate and issue life. Inscribed below the image is the motto NATURA POTENTIOR ARS, or "art more powerful than nature."[47] Indeed, Pino relates an incident in which the generative capacity of woman comes in direct confrontation with that of the painter. Pino receives a complaint about his painting of a young woman from her mother. When the woman complains that he has failed to reproduce her daughter accurately, Pino patronizingly responds that his painting "is not the same as spinning yarn," to which the mother, patting her daughter's cheek, replies, "and this is not the same as painting."[48]

Ficino's notion that those who produce offspring of the intellect necessarily shun the company of women is one that actively informs these treatises on art. Cautioned to turn away from relations with women, the painter is advised to devote his energies instead to his artistic creations. "It will not be appropriate for him to be burdened with a wife," Pino notes, for marriage "shrivels our perfection, and cuts short our freedom on account of our attachment to the children and our wife's persuasions."[49] Reproductive relations with women were seen to draw the painter into the world of body, emotion, and irrationality—a world he was well advised to avoid. "He should eschew coition to which the rein of reason is not applied," Pino advises the painter, "for it weakens one's virile powers, debases the spirit, causes melan-

choly and shortens one's life."[50] Indeed, the damage of channeling one's generative powers in the wrong arena seems to have prompted Pino's dictate that "when a painter marries he should renounce his art."[51]

The importance of fidelity to one's art is illustrated by Vasari, who relates what became of the talented colorists who overindulged their sensual nature. Raphael, for example, who is described as "a very amorous man with a great fondness for women" was "always indulging his sexual appetites." This folly ultimately led to his demise when, after a bout of "excess," he returned home with a fever and died.[52] Vasari often documents the sensual exploits of those undisciplined colorists whose weakness for the flesh extended to their private lives as well as to their paintings. He recounts how Giorgione, for instance, "always a very amorous man," contracted the plague from a very pleasurable affair with a "certain lady," and shortly thereafter died. Correggio, too, "burdened as he was by family cares," died of his efforts to meet them.[53]

Although these theorists commonly equated *colori* with human flesh, a point of contention among them was whether this equation elevated or debased the art of painting. Unlike *disegno*, which brought the human form nearer to perfection, *colore* brought it nearer to reality. For Pino, this was the pinnacle of the art of painting; for Vasari, its base. Though Vasari admired the way in which these painters created figures that were "coloured so beautifully as to appear alive,"[54] it was to God-likeness, not life-likeness, that he believed painters should aspire. Indeed, painting's chief province—"namely, the reproduction of the human form," according to Vasari—necessitated eschewing the charms of color, a task at which no painter was more adept than the divine Michelangelo. In this pursuit, Michelangelo

left to one side the charm of coloring and the caprices and novel fantasies of certain minute and delicate refinements that many other artists, and not without reason, have not entirely neglected. For some artists, lacking Michelangelo's profound knowledge of design, have tried by using a variety of tints and shades of colour

. . . to win themselves a place among the most distin-
guished masters.[55]

To the perfection of the human form, color added
little, but to the reproduction of the less than
perfect human *body,* color proved invaluable. It
was the colorists' descent to the body rather than
ascent to the mind that elicited such consterna-
tion from the likes of Vasari. Though he notes
that Titian deserved "to be celebrated as the finest
and greatest imitator of nature as far as colour was
concerned," it was the imitation of the divine idea
that concerned Vasari. To this end, he notes that
had the naturalist Titian developed "a foundation
of the supreme method of design he would have
rivalled both the painter from Urbino and Buonar-
roti."[56] Rivaled perhaps, but enmeshed as he was
in the material world, Titian could never have
equaled the supreme Michelangelo. *Disegno* was
the only means by which the painter could approx-
imate divinity.

For Pino, however, it was usurping the nature
of color rather than suppressing it that raised Ti-
tian above Michelangelo. The Venetian *colorito,*
unlike the *colore* of the Florentines, was described
as an additive process of creation, one in which
the powers of nature and God were equated. In-
deed, as Boschini reports, Titian, "wishing to imi-
tate the operation of the Supreme Creator," used
to observe that he, too, in forming the human
body, "created it out of earth with his hands."[57]
For theorists such as Pino and Boschini, it was
through *colorito* that the painter could most
closely approximate the activity of the divine cre-
ator; for even God's first idea as form required
realization in the material world. To flesh out the
divine concept of man, God, like the painter, did
so through pigments taken from the earth. In this
sense, the imitation of the divine process of cre-
ation to which Renaissance theorists felt painting
should aspire lay not in Vasari's beloved *disegno*
but in the Venetian activity of *colorito.*

Ironically, it was the painters who made up
Titian's legacy who received the severest criticism
from the proponents of the art of *colorito.* Cen-
sured for what was deemed an irresponsible, im-

moral use of color, these painters were often de-
scribed as *painting up* the bodies in their works
rather than simply painting them. The realism of
flesh these painters achieved prompted theorists
to fear a too lifelike response from the beholder.
Unlike Titian, whom Dolce describes as having
"shown in his works no empty gracefulness, but a
palette which is properly appropriate; no artifi-
ciality of ornamentation, but a masterly concrete-
ness,"[58] these colorists were described as far from
appropriate or proper. Drawing heavily upon fig-
ures of prostitution, theorists described these
painters as painting faces for profit, slapping on
color to please their clients. It is this seductive
practice that Armenini describes when he notes,

In truth these disastrous hacks insinuate themselves as
practitioners of such venerable arts, even though they
are not enlightened by fine design. They think only of
creating an effect among the common people and, gain-
ing the favor of the majority with their ugly and vulgar
pictures, they entice the common people with bright
colors and make them approve their ways. . . . They use
undiluted colors to please fools. In short, they pervert
the good technique which ought to be employed in fine
paintings.[59]

Thus Dolce's comment that "there is nothing
that habitually draws attention to itself and feasts
the beholder's eyes to the same degree as painting
does"[60] describes also the effects of painting as it
was practiced by another accomplished group of
painters at the time—women.

Indeed, the activity of this group of painters
was the subject of much discourse. "Displeasing
certainly, to every honest eye, is paint in any lady,"
Federigo Luigini states in his treatise of 1554, *The
Book of Fair Women,* adding that only bold
courtesans "anoint and put colour on their
faces."[61] And, like courtesans, painters who ex-
ceeded the delineated boundaries of decorum,
who exploited the sensual aspects of color, were
described as prostituting their wares. Whether on
a woman or on a canvas, colors elicited a sensual
response; they drew "with admirable force the
eyes of the beholder," as Armenini noted, daz-
zling the eye by the "charm" of their various
hues.[62] Alberti, too, deals with the use of paints

or cosmetics by women in another of his treatises, *The Family in Renaissance Florence* (1432). Here, Alberti devotes several pages to a conversation between two gentlemen, Giannozzo and his companion Lionardo, in which they discuss how to prevent their wives' use of cosmetics. To this end Lionardo invokes the wisdom of the ancients, whom he claims

instructed their wives never, in bearing and behavior, to let themselves appear less virtuous than they really were. It is also described how they tried to persuade women, for this very reason, never to paint their faces with white powder, brazilnut dye, or other make-up.[63]

Regaling his wife with tales to convince her to refrain from engaging in the activities of some females who, "all made up and plastered and painted," imagine that they are pleasing men,[64] Giannozzo relates how he successfully curbed her practice of painting. For him, the honorable reputation of the master and his household lay in the assurance of his wife's virtue, the most obvious sign of which was her decorous behavior. A woman who painted herself put that virtue into question by establishing, as did the courtesan, an overt sexual identity.

The use of paints by women was treated, too, by Cennino Cennini, in his treatise *The Craftsman's Handbook* (1437), in which he admonishes women to abstain from coloring their faces with paints. Such practice, he notes, is "contrary to the will of God and of our Lady [the Virgin Mary]."[65] Indeed, the equation of these two groups of painters—artists and women—is described in Franco Sacchetti's *Trecentonovelle*. Here, Sacchetti (c. 1330–c. 1400) relates a discussion between Florentine painters and other masters during which the question was posed, Who, aside from Giotto, was the greatest master of painting? After a lengthy and serious debate, the discussion disintegrates into sarcasm, the final answer being: The contemporary women of Florence, whose skills in the art of face-painting prompted the debaters to conclude that no painter, not even Giotto, "coloured better than the women."[66] This similarity between the two types of painters is further underscored when one considers the role the mirror played in each of their professions. As Alberti notes in *On Painting*,

A good judge for you to know is the mirror. I do not know why painted things have so much grace in the mirror. It is marvellous how every weakness in painting is so manifestly deformed in the mirror. Therefore things taken from nature are corrected with a mirror.[67]

The mirror provided both male and female painters the means by which they could assess whether they had successfully "corrected" nature; but in contrast to male painters, who were considered to be improving upon nature, women who painted themselves were seen as violating nature's laws.[68]

Women's practice of painting themselves seldom elicited anything but disapproval and mistrust, as evidenced by Baldesar Castiglione's treatise on the Renaissance gentleman, *The Book of the Courtier* (1528). In his discussion of the female equivalent to the male courtier, Castiglione's Count Lodovico da Canossa comments on "how much more attractive than all the others is a pretty woman who is quite clearly wearing no make-up on her face," adding, "such is the uncontrived simplicity which is most attractive to the eyes and minds of men, *who are always afraid of being tricked by art*" (my italics).[69] Indeed, while male painters were considered to practice the art of painting proper, the practice of women was that of painting *im*proper. While male painters were lauded for their ability to improve upon God's creations, women were warned that "God's work and His creations must not be meddled with in any manner," especially with applied colors, which may "spoil and mar his natural lineaments."[70] And, as is evidenced by Pino, women who attempted to enter the realm of painting proper were equally reproved. As Pino's Lauro notes, "It does not please me to hear women equalled to the excellence of men in this virtue [painting]; and it seems to me that the art is debased by this, and the female species drawn outside of what is proper to it." He is countered, however, by Fabio, who insists that, since these women "partook of the masculine," they "deserve to be appreciated as women who, seeing their own imperfection, attempted (by departing from their

own nature) to imitate the nobler being, man." However, "the converse, an effeminate man," Fabio takes care to conclude, "is a disgraceful thing."[71] It was such "effeminate" men, men who painted bodies to seduce the beholder, that were deemed so "disgraceful."

Painters who controlled the nature of color were held up as exempla to which women who painted themselves should aspire, not the other way around. Dolce relates the tale of Propertius, who reproves his Cynthia "for her use of rouges," urging her instead to display the "plainness and purity of color" one saw in the paintings by Apelles.[72] For, in the Renaissance, too, as one scholar notes of classical France, the complaint against makeup was that it blurred the distinctions necessary for the beholder to maintain mastery of himself. Paints produced a pleasure in the viewer that was not subject to any rule, nor obedient to any law. In contrast to human relations, art provided a realm in which the beholder could maintain mastery of himself.[73] *Disegno* provided the assurance of the greater guiding principle of order and intellect, and the viewer came to gaze upon the female body confident of a beauty that had been brought into line, that conformed to his desires. A living "painted woman" guaranteed no such security to men who were always afraid, as Canossa observed, of being "tricked" by women's art. The difference between the two is one observed by Manuel Chrysoloras, a transplanted Byzantine scholar who greatly influenced the way in which Italian humanists discussed painting and sculpture. According to Chrysoloras, the source of pleasure in viewing the female body was not to be found in living women, but in their presentation through art:

The beauties of statues and paintings are not an unworthy thing to behold; rather do they indicate a certain nobility in the intellect that admires them. It is looking at the beauties of women that is licentious and base. What is the reason for this? It is that we admire not so much the beauties of the bodies in statues and paintings as the beauty of the mind of their maker.[74]

Those painters, therefore, who failed to bring the sensuality of color into line, who instead used

it to entice the viewer, were seen as prostituting their art. In contrast to fresco, dubbed by Vasari as truly the most manly art because of its ability to control the nature of color,[75] the exploitation of color in oil was described by theorists such as Pino and Armenini as just the opposite—as a feminine practice of seduction. Luring the beholder with their seductive blandishments, these painters were perceived as breaking trust, as truly "perverting" the fine technique of painting. Thus, praise such as Dolce's for the "refined colorist" Francesco Parmigianino's ability to endow his creations with "a certain loveliness which makes whoever looks at them fall in love with them" was modified when this painting of faces got out of hand.[76] As Pino's Fabio notes in this discussion with Lauro, these painters tread a fine line between respectability and infamy. Lauro asks what Fabio thinks about the "ravishing type of painter," to which Fabio responds:

He pleases me the most, but I tell you that this charm is the seasoning in our works. But by charm I certainly do not mean ultramarine blue at sixty *scudi* the ounce or a beautiful red lake pigment, since colors are also beautiful by themselves in their containers; nor is a painter to be praised as ravishing because he gives all his figures rosy cheeks and blond hair. . . . But true charm is none other than comeliness or grace, generated from an accord or just proportion of things, such that, even as paintings are true to the qualities of things, they also have charm and bring the master honor.

To this Lauro bemoaningly responds, "In how bad shape I would find myself, if those beautiful colors were not sold, which bring me credit and profit!" Lauro then asks Fabio what he thinks of those who paint with great facility and speed, to which among other things Fabio responds, "That smearing about [*empiastrare*] to display skill of hand . . . is an infamous approach, and those who follow it show how little they know."[77] To degrade this practice, Pino uses the verb *empiastrare* here, a term meaning to make up one's face, as it is employed by Castiglione in his description of overly painted faces of women.[78] Similarly, Dolce admonishes painters to "banish" from their paintings "vermillion cheeks with lips of coral, because

faces treated in this fashion look like masks."[79]

As Lauro's comment about his reliance on color reveals, the painter is compelled to acknowledge that, though undecorous, he must appeal to the tastes and appetites of his clients. For the painter's art, like the courtesan's, was an art of pleasure. As Dolce observes, "Painting was invented primarily in order to give pleasure," concluding that, "By this token, then, if the artist fails to please, he remains unnoticed and devoid of reputation"— and, one might add, a livelihood.[80] Benedetto Varchi similarly notes in his *Paragoni* of 1549 that "to the same degree that colors, the objects of the eyes, are infinitely pleasing, painting surpasses sculpture." Yet this pleasure was one that Varchi, too, knew could get out of hand, prompting him ultimately to conclude that "intelligent men derive more beauty and greater pleasure from sculpture."[81]

Painting, women, pleasure, and profit are all sublimely conflated in Castiglione's *The Book of the Courtier*. Here, Canossa concludes his discussion of the arts with this observation:

So you see that a knowledge of painting is the source of very profound pleasure. And let those reflect on this who are so carried away when they see a beautiful woman that they think they are in paradise, and yet who cannot paint; for if they did know how to paint they would be all the more content, since they would then more perfectly discern the beauty that they find so agreeable.[82]

Indeed, not only would they be able to discern such beauty, but more precisely, discern how to profit from it. For painters, like courtesans, were described as playing upon the fancy of "signori"

and other noble citizens, alluring them with red lips and rosy cheeks. As Armenini notes, vivid colors enrapture and please men, especially *signori*, for *signori* take more delight and pleasure in the variety and charm of colors than in the excellence of design. They follow not the dictates of the mind but those of the eyes.[83] Ultimately, it was these enraptured *signori* who bought the wares of both the painter and the courtesan. In this sense, the painter's colorful art can be seen as merely an attempt to claim a market share in an economy of pleasure.

Even though writers such as Pino insisted that they had "no intention" of discussing those painters who applied themselves to "working with fine colors just to earn a little money,"[84] the threat these painters posed to the art of painting proper could not go without comment. In essence, the exploitation of the seductive charms of color in painting constituted a defection to what can be seen as the female competition, one which elicited, at the very least, an uneasy concern on the part of Renaissance theorists.

Figures of gender form a significant (and colorful?) thread running through the rhetorical fabric of art history—one that can be pulled in many directions. But here, in the tradition of Sandra Harding, I offer only the following notions to consider: What relevance do the writings of the fathers of art history have to contemporary art historical practice, and how do factors such as gender continue to shape the cognitive form and content of art historical theories and practices?[85] As art historians we are now forced to acknowledge that we are not only using language, it is using us.

NOTES

This essay is a result of research done at Bryn Mawr College, and I am grateful for the advice and encouragement I received from Steven Z. Levine and Stephen Melville. Most of all, however, I am deeply indebted to Gridley McKim-Smith. By bringing my attention to the use of gendered language in a Spanish Baroque treatise, Professor McKim-Smith set me on the path that was to result, though not end, in this work.

1. Giovanni Battista Armenini, *On the True Precepts of the Art of Painting*, ed. and trans. Edward J. Olszewski,

(Burt Franklin and Co., 1977), p. 118. (*De' veri precetti della pittura*, a cura di Marina Gorreri, prefazioni di Enrico Castelnuovo, Giulio Einaudi editore, 1988.)

2. Ibid., p. 140.

3. Giorgio Vasari, *The Lives of the Artists*, a selection, trans. George Bull (New York: Penguin, 1979), p. 444. (*Le vite de' più eccellenti pittori, scultori e architettori*, nelle redazioni del 1550 e 1568, testo a cura di Rosanna Bettarini, commento secolare a cura di Paola Barocchi, Florence: Sansoni editore, 1966.)

4. Aristotle, *Poetics*, trans. W. Hamilton Fyfe, The Loeb Classical Library (Cambridge, Mass.: Harvard University Press, 1960), 1450 b.

5. As regards the post-Renaissance debate over the value of *disegno* and *colore*, John Gage has recently pointed to some potentially fruitful topics for feminist scholarship. "Color in Western Art· An Issue?" *The Art Bulletin* 72 (December 1990): 519.

6. Sandra Harding, *The Science Question in Feminism* (Ithaca, N.Y.: Cornell University Press, 1986), p. 23.

7. Michael Baxandall, *Giotto and the Orators: Humanist Observers of Painting in Italy and the Discovery of Pictorial Composition, 1350–1450* (Oxford: Clarendon Press, 1971), p. 48.

8. Aristotle, *Generation of Animals*, trans. A. L. Peck, The Loeb Classical Library (Cambridge, Mass.: Harvard University Press, 1963), 732a. This concept is reiterated in Baldesar Castiglione's *The Book of the Courtier*. During a discussion in which the participants attempt to construct the female counterpart to the perfect courtier, Signore Gaspare states the following: "I shall say only that, as you know, it is the opinion of very learned men that man is as the form and woman as the matter, and therefore just as form is more perfect than matter, and indeed it gives it its being, so man is far more perfect than woman" (p. 220). See n. 69.

9. Ibid., 738 b.

10. Leon Battista Alberti, *On Painting*, trans. John R. Spencer (New Haven, Conn.: Yale University Press, 1966), p. 51. (*Della pittura*, ed. Luigi Malle, Florence: G. C. Sanzoni, 1950.)

11. Armenini, *Precepts*, p. 106.

12. Vasari, *On Technique*, trans. Louisa S. Maclehose; ed. G. Baldwin Brown (London: J. M. Dent and Co., 1907), p. 208.

13. Alberti, *On Painting*, p. 82.

14. Vasari, *Lives*, p. 341.

15. *Paragone: A Comparison of the Arts by Leonardo da Vinci*, trans. Irma A. Richter, (Oxford: Oxford University Press, 1949), p. 104.

16. Ibid., p. 102.

17. Ibid., p. 95. Though both women and men were painting at this time, these treatises assume both a male painter and reader. They seldom acknowledge female painters as such and, as in the case of Pino, when they do, they often regard them as women who "partake of the masculine," using their art to "imitate the nobler being, man." See n. 72.

18. Mary Pardo, "Paolo Pino's "Dialogo di Pittura": A Translation with Commentary," University of Pittsburgh, Ph.D. dissertation, 1984; University Microfilms International, p. 379. (*Dialogo di pittura*, edizione critica a cura di Rodolfo e Anna Pallucchini [Venice: Daria Guarnati, 1946].)

19. Ibid. pp. 360ff.

20. Vasari, *On Technique*, p. 218

21. Ibid., p. 220.

22. Armenini, *Precepts*, p. 174.

23. Ibid., pp. 120ff.

24. Vasari, *On Technique*, p. 221.

25. Armenini, *Precepts*, p. 181.

26. Vasari, *On Techique*, p. 222.

27. Vasari, *Lives*, p. 384.

28. *Dolce's "Aretino" and Venetian Art Theory of the Cinquecento*, trans. Mark W. Roskill (New York: New York University Press, published for the College Art Association of America, 1968), p. 155.

29. Pino, *Dialogo*, p. 310.

30. Leatrice Mendelsohn, *Paragoni: Benedetto Varchi's Due Lezzioni and Cinquecento Art Theory* (Ann Arbor, Mich.: UMI Research Press, 1982), p. 62.

31. Pino, *Dialogo*, p. 300.

32. Ibid., p. 310.

33. Plotinus, *Ennead*, V.8.15, "On the Intelligible Beauty," trans. A. H. Armstrong, The Loeb Classical Library (Cambridge, Mass.: Harvard University Press, 1984), p. 241.

34. Vasari, *Lives*, p. 290.

35. As translated in David Rosand's "Titian and the Critical Tradition," in *Titian: His World and His Legacy*, ed. David Rosand (New York: Columbia University Press, 1982), p. 24. (Marco Boschini, *La carta del navegar pittoresco*, a cura di Anna Pallucchini, Venice: Istituto per la collaborazione culturale, 1966. Fonti e documenti per la storia dell'arte veneta, 4.)

36. Dolce, *Aretino*, p. 191.

37. Vasari, *Lives*, p. 287.

38. Ibid., p. 273.

39. Pino, *Dialogo*, p. 362.

40. Vasari, *Lives*, p. 294.

41. Pino, *Dialogo*, p. 339.

42. Marsilio Ficino, *Commentarium in Convivio Platonis*, trans. Sears R. Jayne (Columbia: University of Missouri Press, 1944), p. 207. The concept that men and, in this case, male artists should keep to themselves is voiced in Michelangelo's sonnet to Tommaso Cavalieri:

The love for what I speak of reaches higher;
Woman's too much unlike, no heart by rights
Ought to grow hot for her, if wise and male.

The Complete Poems and Selected Letters of Michelangelo, trans. Creighton Gilbert; ed. Robert N. Linscott (Princeton, N.J.: Princeton University Press, 1980), sonnet 258, p. 145. (*Michelangelo Buonarroti rime*, a cura di Enzo Noe Girardi, Bari: G. Laterza, 1960.) For a discussion of the relationship between misogyny and homosexuality in the Renaissance, see James Saslow, *Ganymede in the Renaissance: Homosexuality in Art and Society* (New Haven, Conn.: Yale University Press, 1986).

43. Svetlana Alpers, *Rembrandt's Enterprise: The Studio and the Market* (Chicago: University of Chicago Press, 1988), p. 30.

44. Armenini, *Precepts*, p. 190.

45. Ficino, as quoted by Alistair Crombie, "Experimental Science and the Rational Artist in Early Modern Europe," in *Daedalus*, Summer 1968, p. 59. ("Theologica Platonica," in *Opera omnia* [Turin: Bottega d'Erasmo], book 4, chapter 1.)

46. Dolce, *Aretino*, p. 185.

47. David Rosand, "Titian and the Critical Tradition," p. 16.

48. Pino, *Dialogo*, p. 374.

49. Pino, *Dialogo*, p. 378. Metaphors of sexuality abound in these texts. The conflation of art and male potency, and the waste of such in seemingly masturbatory acts, can be seen to inform Vasari's description of the Florentine painter Uccello, who, ignoring his wife's entreaties to come to bed, stayed up all night compulsively drawing perspective studies. Of this Vasari notes: "But anyone who studies them excessively is squandering time and energy, choking his mind with difficult problems, and, often enough, turning a fertile and spontaneous talent into something sterile and laboured" (*Lives*, p. 95).

50. Pino, *Dialogo*, p. 378.

51. Ibid., p. 324.

52. Vasari, *Lives*, pp. 312/320.

53. Ibid., pp. 272/276 (Giorgione), and p. 282 (Correggio).

54. Ibid., p. 295.

55. Ibid., p. 379.

56. Ibid., p. 446.

57. Marco Boschini, as translated in David Rosand's, "Titian and the Critical Tradition," p. 24. See n. 35.

58. Dolce, *Aretino*, p. 185.

59. Armenini, *Precepts*, p. 118.

60. Dolce, *Aretino*, p. 115.

61. Federigo Luigini, *The Book of Fair Women*, trans. Elsie M. Lang (J. Pott and Co., 1907 [?]), pp. 144ff. ("Il libro della bella donna," in *Trattati del cinquecento*, a cura di Giuseppe Zonata, Bari: G. Laterza e figli, 1913.) The subject of women's cosmetics was a common topic in treatises such as Angelo Poliziano's *Rispetti*, Aretino's *Il Marescalo* and *Ragionamenti*, Firenzuola's *Dialogo della bellezza delle donne*, and Alessandro Piccolomini's *La Raffaella*.

62. Armenini, *Precepts*, p. 96.

63. Alberti, *The Family in Renaissance Florence*, trans. Renée Neu Watkins (Columbia: University of South Carolina Press, 1969), p. 212. (*I libri della famiglia*, a cura di Ruggiero Romano e Alberto Tenenti, Giulio Einaudi editore, 1972.)

64. Ibid., p. 214.

65. Cennino Cennini, *The Craftsman's Handbook*, trans. Daniel V. Thompson, Jr. (New Haven: Yale University Press, 1933), p. 123. (*Il libro dell'arte*, New York: Dover Publications, 1933.)

66. Franco Sacchetti, *Tales from Sacchetti*, trans. Mary G. Steegmann (London: J. M. Dent and Co., 1908), pp. 114ff.

67. Alberti, *On Painting*, p. 83.

68. Sacchetti, *Tales*, p. 354.

69. Baldesar Castiglione, *The Book of the Courtier*, trans. George Bull (New York: Penguin, 1987), p. 86.

70. Luigini, *The Book of Fair Women*, p. 156.

71. Pino, *Dialogo*, pp. 322ff.

72. Dolce, *Aretino*, p. 153.

73. Jacqueline Lichtenstein, "Making Up Representation: The Risks of Femininity," *Representations* 20 (Fall 1987): 82 ff. Of course "herself" applies here as well, but the assumed viewer in these treatises is male. Again, I am addressing the theory, not the practice, of making and viewing images.

74. Manuel Chrysoloras, as translated in Michael Baxandall's *Giotto and the Orators*, pp. 78ff. (Manuel Chrysoloras, *Patrologiae cursus completus*, ed. J. P. Migne [Paris: Series Graeca, vol. 156, 1866].)

75. See n. 26.

76. Dolce, *Aretino*, p. 183.

77. Pino, *Dialogo*, pp. 341ff.

78. Castiglione, *The Courtier*, p. 86.

79. Dolce, *Aretino*, p. 153.

80. Ibid., p. 149.

81. Benedetto Varchi, as translated in Leatrice Mendelsohn's *Paragoni*, pp. 121/131. See n. 30. (*Scritti d'arte del cinquecento*, tomo 1, a cura di Paola Barocchi, Milan-Naples: Riccardo Ricciardi editore, 1971–76.)

82. Castiglione, *The Book of the Courtier*, p. 101.

83. Armenini, *Precepts*, p. 176.

84. Pino, *Dialogo*, p. 321. I have changed the translation from "farthings" to "a little money."

85. Harding, *The Science Question in Feminism*, p. 24 (see n. 6).

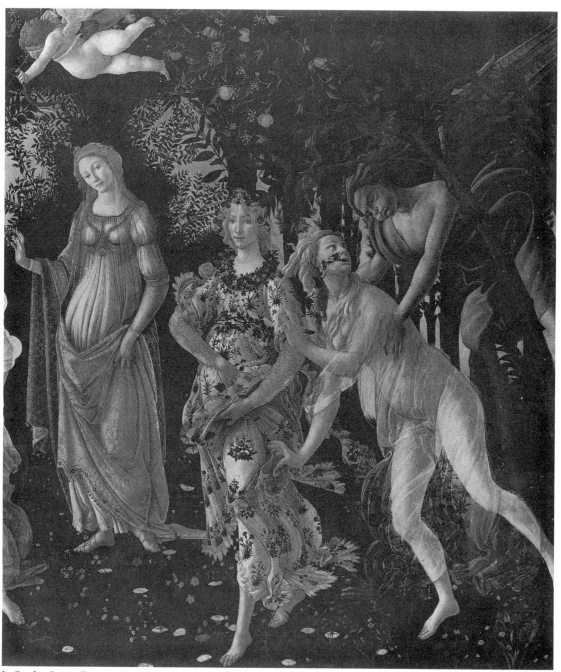

1. Sandro Botticelli, *Primavera,* right half, ca. 1482. Florence, Uffizi.

5

BOTTICELLI'S *PRIMAVERA*

———

A Lesson for the Bride

———

LILIAN ZIRPOLO

The *Primavera* [1, 3] by Sandro Botticelli depicts a mythological scene that must be read from right to left, beginning with the figure representing Zephyrus, the West Wind. He chases the nymph Chloris, who, startled by his pursuit, produces a string of flowers from her mouth. Chloris, in turn, is transformed into Flora, the third figure, whose garment is luxuriously decorated with an abundance of floral motifs. Flora gathers her dress and cradles some flowers amidst the folds. She scatters these flowers throughout, primarily in the direction of Venus, the goddess of love, who occupies the central position in the painting. To Venus's right are the Three Graces, her frequent companions. Cupid, the product of the union between Venus and Mercury (standing at the far left), hovers above his mother while pointing his flaming arrow at one of the Graces. This scene takes place in a fertile garden filled with an innumerable variety of blossoms and shaded by orange trees in the background.

The *Primavera* has been the subject of numerous writings. Art historians who have contributed to the understanding of its highly complex iconographic program have usually interpreted this work within the context of Neoplatonism, which dominated the philosophy of the Medici circle. Botticelli was a Medici protégé and as such he enjoyed the company of the most brilliant Florentine humanists, scholars, and poets with whom Lorenzo the Magnificent surrounded himself, including Marsilio Ficino, the greatest exponent of Neoplatonism.[1] In fact, E. H. Gombrich has suggested that Ficino himself may have been responsible for the program of the *Primavera*.[2]

Umberto Baldini, who has also interpreted the *Primavera* from a Neoplatonic point of view, has perceived the work as a symbolic reference to the Platonic cycle: "the passage from the active to the elevated, more contemplative life, from the temporal to the eternal plane."[3] Mirella Levi D'Ancona has also recognized the embodiment of Neoplatonic thought in the *Primavera* and has described it as

the manifest of sensual beauty of bodies and nature regulated by the rhythm of dance and music . . . conceived as an inducement to enjoy the far greater pleasures of the soul, which consist of intellectual study and metaphysical rapture. . . . As the various images unfold

2. Sandro Botticelli, *Camilla and the Centaur (?)*, ca. 1482–83. Florence, Uffizi.

in the picture, the soul of the beholder is gradually led from the beauty of this world to the far greater beauty of the heavenly spirit which pervades all things.[4]

Scholars have also related the *Primavera* to the literature that was either read or written by members of the Medici circle. Theories associating this work with literary sources abound. To mention only a few examples, Paul Barolsky discusses the relationship of Botticelli's panel with Dante's *Divine Comedy*,[5] Aby Warburg associates it with Ovid's *Fasti*,[6] and Charles Dempsey proposes an analogy between the *Primavera* and Poliziano's *Rusticus*.[7]

In this article, it is not my goal to disprove that Neoplatonism and literary works by authors such as Dante, Ovid, and Poliziano were influential in the development of the iconographic program of the *Primavera*. But there is an element that has

been overlooked by scholars in dealing with this painting. Although art historians now believe that the *Primavera* was commissioned on the occasion of the wedding of Lorenzo di Pierfrancesco de' Medici to Semiramide d'Appiani,[8] few relate its iconography to nuptial rituals and customs practiced in Florence during the Quattrocento. Paul Barolsky, for example, has written that the *Primavera* is

. . . a sort of epithalamium or poem celebrating marriage, in which the goddess of love appears as in an epiphany amid the very flowers of the Tuscan spring . . . to greet and bless the patron and his bride.[9]

The *Primavera* can indeed be viewed as an epithalamium, a visual poem in honor of the bride and groom, as Barolsky describes it. Yet, rather than dealing with the implications of the premise that the *Primavera* celebrates a marriage, Barolsky pursues the connection between Botticelli's painting and Dante's *Earthly Paradise*.[10]

It is my intention to argue that Botticelli's painting, while embodying the Neoplatonic philosophy and drawing from a gamut of literary sources, was originally meant to have a specific function as a work of art that celebrated the marriage of Lorenzo di Pierfrancesco to Semiramide: to serve as a model of behavior for the bride to follow. Therefore, its analysis should be treated in the context of Renaissance marriage rituals, and the status of the bride must be taken into account. To accomplish this task, it is necessary to examine the *Primavera* as part of a greater whole, since the painting was originally a component of a decorative program.

In 1975, Webster Smith published an article dealing with the original location of the *Primavera*, based on the results of archival studies relating to Lorenzo di Pierfrancesco's possessions.[11] Examining Medici inventories dated 1499, 1503, and 1516, Smith concluded that the *Primavera* was originally located in the Medici house on the Via Larga in Florence, in a room adjoining the nuptial chamber shared by the young Lorenzo and his bride. Smith was also able to reconstruct the manner in which this adjoining room was furnished. The *Primavera* was affixed directly on one

of the walls above a *lettuccio,* or bedstead. The *lettuccio,* apparently a highly ornate object, as suggested by its elevated value in the inventory of 1499, was mounted on a predella. Its backrest served as a *cappellinaio* where hats were hung, and its base functioned as a *cassone,* or marriage chest. Botticelli's so-called *Pallas and the Centaur* [2] and a *Madonna and Child* whose artist is not mentioned in the inventories also decorated this area. According to the inventory of 1499, *Pallas and the Centaur* was located above the entrance way of the room, opposite the wall occupied by the *Primavera.* The *Madonna and Child* adorned a third wall, while the fourth side of the chamber was taken up by an armoire. A bed, a table with stools, and some chairs completed the decor.[12]

Smith's reconstruction leads me to believe that the decorative program of this room adjoining the marital chamber served as a means of admonishing Lorenzo di Pierfrancesco's bride and supplying her with lessons on appropriate behavior in her new role as a Medici wife. Chastity was one of those lessons. The noblewomen of the Renaissance were bound to chastity, and the paintings in the adjoining room provided Semiramide with the symbolic encouragement to chaste behavior.[13]

In 1975, John Shearman interpreted Botticelli's *Pallas and the Centaur* as a symbol of chastity, an interpretation that was reiterated by Ronald Lightbown in his 1978 monograph on the artist.[14] As Shearman points out, in the inventory of 1499 *Pallas and the Centaur* is referred to as *Camilla and a Satyr,* an identification that is plausible since Pallas's spear and the aegis bearing the head of a Medusa are not present in the painting.[15] As Shearman explains, Camilla is one of the heroines of Virgil's *Aeneid,* where she is described as a Volscian warrior maiden who carries a battle ax not unlike the weapon held by the female figure in Botticelli's picture. In the *Aeneid,* she is referred to as "Decus Italiae Virgo," or Glorious Maiden of Italy. She is a servant of Diana, the goddess of the hunt, and as such she cherishes her weapons and her virginity.[16]

Shearman also found mention of Camilla in Boccaccio's *De mulieribus claris,* where, as in the *Aeneid,* she is portrayed as a model of virtuous

and chaste behavior. Boccaccio, at the end of his chapter, advises the young women of his day to follow in the footsteps of the remarkable Camilla by exercising moderation in speech, gestures, and food and beverage consumption, and, most important, by curbing their lascivious urges.[17] The desirable womanly qualities stressed by Boccaccio in the fourteenth century were still considered befitting of the women of the Quattrocento. In Francesco Barbaro's influential treatise *On Wifely Duties,* written in 1415 in honor of the marriage of Lorenzo de' Medici, the son of Giovanni de' Bicci, to Ginevra Cavalcanti, the writer asserted, "Moderation in a wife is believed to consist especially in controlling her demeanor, behavior, speech, dress, eating and lovemaking."[18]

The iconography of Botticelli's *Camilla and the Centaur* gains deeper meaning in the light of this literary discourse. The restraining action by the female figure upon the centaur, a lustful creature whose behavior is governed by his animal nature, can be interpreted as a symbol of the control of carnal desires represented by the centaur, and the restraint of inappropriate conduct referred to by Boccaccio. Thus, the lesson offered to the bride by Botticelli's *Camilla and the Centaur* is that she, too, is expected to be chaste and virtuous, a true Decus Italiae Virgo.

The theme of chastity found in *Camilla and the Centaur* is repeated in the *Primavera.* Here the Three Graces also allude to chaste behavior. They are the attendants of Venus who are described by Seneca as virgins, because they are "pure and undefiled and holy in the eyes of all."[19] The pearls adorning the hair of the Grace on the right, as well as the pearl on her necklace, allude to her purity and that of her two companions. Cupid points his arrow at one of these female figures, implying that she is about to abandon virginity for marriage,[20] just as Lorenzo di Pierfrancesco's bride relinquished her virginity after viewing the *Primavera* upon entering her husband's bedroom for the first time.[21]

Botticelli's Graces, like Camilla, represent not only purity and chastity but also the demeanor that befitted the virtuous Renaissance woman. Their measured and elegant gestures and their

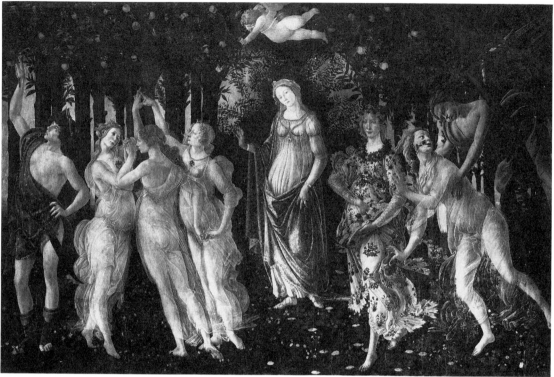

3. Sandro Botticelli, *Primavera*, ca. 1482. Florence, Uffizi.

unemotional facades evoke not only Boccaccio's concept of the commendable maiden but also Barbaro's notion of the ideal wife. In the *Primavera*, the Three Graces perform a dance with movements that are as calculated and restrained as the movements that Barbaro had recommended for a virtuous wife, as suggested in the following passage in his *On Wifely Duties:*

I therefore would like wives to evidence modesty at all times and in all places. They can do this if they will preserve an evenness and restraint in the movements of the eyes, in their walking, and in the movement of their bodies; for the wandering of the eyes, a hasty gait, and excessive movement of the hands and other parts of the body cannot be done without loss of dignity.[22]

One must ask, however, whether Semiramide would have recognized the female figure in *Camilla and the Centaur* and the Three Graces in the *Primavera*, and whether she would have understood what these figures were meant to repre-

sent. In the Renaissance, humanist desire to revive classical ideals provided for an arena in which education, not only for men but also for women, became the norm rather than the exception.[23] However, men were educated differently. Humanists argued that the study of books by Demosthenes, Aristotle, Pliny, and others would provide boys of the nobility with the necessary preparation for their future role as complete citizens and capable social servants.[24] Girls, on the other hand, were molded into the role of perfect wives and mothers. They were taught social graces, including dancing, singing, and playing a musical instrument.[25]

Leonardo Bruni, the humanist who served as chancellor of Florence from 1427 to 1444, advocated female instruction. Yet for him, limits had to be set in what women should learn, since, in his view, certain studies were improper for a lady. While setting no boundaries on subjects suitable for males, he advocated history, poetry, reli-

gion, and morals as the only appropriate studies for females. Bruni's views are clearly expressed in a letter he addressed to Baptista Malatesta, which begins by praising her for her intelligence and encouraging her efforts to expand her knowledge:

I am led to address this Tractate to you, Illustrious Lady, by the high repute which attaches to your name in the field of learning; and I offer it partly as an encouragement to further effort. Were it necessary I might urge you by brilliant instances from antiquity: Cornelia, the daughter of Scipio whose Epistles survived for centuries as models of style; Sappho the poetess, held in so great honour for the exuberance of her poetic art. . . . Upon these, the most distinguished of a long range of great names, I would have you fix your mind; for an intelligence such as your own can be satisfied with nothing less than the best. You yourself indeed may hope to win a fame higher even than theirs.[26]

Bruni went on to indicate the types of learning that he deemed appropriate for a woman:

To her neither the intricacies of debate nor the oratorical artifices of action and delivery are of the least practical use if indeed they are not positively unbecoming. What Disciplines then are properly open to her? In the first place she has before her, as a subject peculiarly her own, the whole field of religion and morals. . . . First among such studies I place History: a subject which must not on any account be neglected by one who aspires to true cultivation. . . . I come now to Poetry and the Poets—a subject with which every educated lady must show herself thoroughly familiar.[27]

In the instruction of women on poetry and the classics, humanists placed an emphasis on works by authors such as Cicero, Virgil, and Seneca, who supplied them with lessons in womanly virtues.[28] Paintings such as the *Primavera* and *Camilla and the Centaur* provided women with readily recognizable visual versions of these literary lessons.

Another lesson furnished for the bride was the importance of submission to her husband. During the Renaissance, noble marriages were arranged as political, economic, and dynastic strategies.[29] The marriage of Lorenzo di Pierfranceso to Semiramide was arranged by Lorenzo the Magnificent, the groom's cousin and guardian.[30] Through this union, the Magnificent was able to secure the

support of the Appiani against the pope and the king of Naples, and gain access to the iron mines of Elba, which were part of the Appiani domain.[31]

Since marriages were arranged as strategic maneuvers, it was of the utmost importance that the bride conform to the wishes of the families involved in the liaison, and that she submit to her new husband, regardless of her feelings. In the *Primavera,* this vision of marriage for the sake of the families and the emphasis on the bride's submission are expressed by the depicted rape scene showing Chloris pursued by Zephyrus, the West Wind, whose intention is to ravish her. This scene stems from Ovid's *Fasti,* where Chloris narrates that she was raped by Zephyrus and then rewarded for the violence perpetrated against her. To compensate Chloris for his actions, Zephyrus married her and gave her the domain of flowers, changing her name to Flora.[32]

Within the festive atmosphere that permeates the *Primavera,* the brutality of the rape scene can hardly be discerned. Yet, upon close scrutiny it becomes evident that, in contrast to the other female figures in the painting, who are tall, slender, and graceful, Chloris has a beastlike appearance. Her stance resembles that of a frightened and defenseless animal, a panic-stricken creature who tries in vain to flee as she is about to fall prey to her hunter.

Why a rape scene in a painting that commemorates a marriage? It has been suggested that although an image representing such a violation is unsuitable for a marriage painting, nevertheless in this case the scene is justifiable, since Zephyrus married Chloris and restored her honor.[33] There is, however, a more logical explanation. The Roman humanist Marco Antonio Altieri (1450–1532) perceived the origin of marriage in the rape of the Sabine women. In his treatise *Li nuptiali,* he wrote that all wedding ceremonies recall this collective rape.[34] In his view, when a man takes his wife by the hand, he is exhibiting the same use of violence on her as was used against the Sabine women.[35] Altieri's treatise is filled with connections between this story from antiquity and the nuptial rituals of the Renaissance. For example, he viewed the raising of a sword over the heads of the

4. Apollonio di Giovanni, *Rape of the Sabine Women*, fragment, fifteenth century. Edinburgh, National Galleries of Scotland.

bride and groom during nuptial ceremonies as an evocation of the forced marriages of the Sabine women performed by Romulus while holding a sword in his hand.[36]

In the Renaissance, *cassoni*, marriage chests in which bridal trousseaus were stored, were often decorated with rape scenes, including the rapes of Proserpina, Helen, Europa, and, most important, the Sabine women [4].[37] As Altieri's writings suggest, the scenes were used to evoke the ancient myth of the founding of Rome and to imply that, just as the Sabine women were submitted to collective rape in order to ensure the survival of Romulus's settlement, submission to the male by the Quattrocento female was necessary to guarantee a stable society and the perpetuation of the species.[38] Thus, the image of the rape of Chloris by Zephyrus depicted in the *Primavera* served to

instruct the bride to submit to her new husband for the sake of order, stability, and the continuation of the race, or in this case the Medici family.

The *Primavera,* as stated earlier, was originally located above a *lettuccio* that also served as a *cassone.* Although the inventories do not describe the decoration on the *cassone,* they do specify that the length of this piece of furniture corresponded to the length of the *Primavera.*[39] This suggests that the painting and the *lettuccio* were meant as an ensemble, and that the scene depicted in the *Primavera* may have complemented the scenes on the *cassone,* emphasizing the lesson on the need for order, stability, and survival of the family. It should be mentioned that, in Florence, images of ancient history and contemporary Italian literature began to be elevated from the surface of *cassoni* and other furnishings to large-scale

panels during the decade of the 1470s, when artists such as Pollaiuolo and Botticelli initiated the use of these themes in painting.[40]

A final lesson conferred upon the bride by the *Primavera* was that procreation was the main purpose of marriage. During the Middle Ages and the Renaissance sexual intercourse was officially viewed as only for procreative purposes, a means of producing heirs. This notion originated in theological writings that advocated marriage as a cure to fornication, and described sexual intercourse as a sin unless performed with breeding in mind. Saint Augustine had already asserted these principles in the fifth century.[41] That his ideas remained in full force during the Middle Ages is evidenced in the writings of men such as Peter Lombard and Saint Thomas Aquinas, both of whom viewed sexual intercourse within marriage for any reason other than begetting children as a sin worse than fornication, incest, and adultery.[42] In the Renaissance, these thoughts continued to prevail, as is suggested by the following passage in Francesco Barbaro's *On Wifely Duties* (1415):

the union of man and wife was first invented, and ought to be esteemed especially, for the purpose of procreation. . . . We should indulge in sexual intercourse not for pleasure but only for the purpose of procreating offspring.[43]

Similarly, Leon Battista Alberti in his *Della famiglia* (1432–34) wrote that the object of marriage is to have children.[44] He believed that in choosing a wife, a man must look for not only virtue and good habits but also the ability to bear strong and healthy children. The following passage from his treatise clearly expresses his attitude:

As for physical beauty, we should not only take pleasure in comeliness, charm and elegance, but should try to have in our house a wife well-built for bearing children and strong of body to insure that they will be born strong and robust.[45]

It was important for Alberti to choose a wife well-built for bearing children because in the Florence of his era a noble wife had an obligation to produce a large number of healthy descendants in order to ensure the continuation of the family.[46] This message was provided for Lorenzo di Pierfrancesco's bride in the *Primavera*. As Charles Dempsey has observed, there is a connection between Venus, the central figure in this work, and Columella's *De re rustica* (c. A.D. 60).[47] In *De re rustica*, Venus, assisted by Cupid, presides over the spring mating rituals:

Now's the time when all the world is mating. . . . The spirit of the world in Venus's revel joins and, headlong urged by Cupid's goads, itself its progeny embraces and with teeming offspring fills. . . . Hence even the whole wide world is celebrating spring . . . till Venus, satiated, impregnates their fruitful members . . . and ever fills the world with new offspring.[48]

The protagonists in the *Primavera* clearly engage in a celebration of spring similar to the one described by Columella. That Venus in the *Primavera* is depicted as Columella's goddess of fertility is indicated by her central position, the emphasis on her abdominal area, and the fruitful garden where the scene takes place. Flora can be interpreted in a similar manner. In Ovid's *Fasti* she exclaims, "I was the first to scatter new seeds among the countless peoples" (*Fasti* V: 221–22). In the *Primavera* she scatters flowers throughout, while Mercury raises his caduceus and stirs the clouds to ensure the fertility of the garden. Flora's abdomen is accentuated, like that of Venus, to emphasize her potential fecundity. Tamed and domesticated, Flora is explicitly contrasted with the wild and animal-like Chloris. Flora's smile shows her satisfaction not only with her new status as a bride but also with the prospect of motherhood, the wife's primary role in marriage. The *Madonna and Child* displayed in the same room as the *Primavera* served to emphasize this point by representing the perfect example of Christian motherhood.

When Gombrich wrote his article on Botticelli's mythologies in 1945, he saw a relation between Botticelli's *Primavera* and a letter written to Lorenzo di Pierfrancesco by his tutor Marsilio Ficino.[49] In this letter, Ficino described Mercury as Reason, and Venus as Humanitas. He advised the young Lorenzo:

Your Luna—the continuous motion of your soul and body—should avoid the excessive speed of Mars and the tardiness of Saturn. . . . Furthermore, this Luna within you should continuously behold the Sun, that is God Himself . . . for you must honor Him above all things. . . . She should also direct her gaze on Mercury, that is on good counsel, reason and knowledge, for nothing should be undertaken without consulting the wise, nor should anything be said or done for which no plausible reason can be adduced. . . . Finally, he should fix her eyes on Venus herself, that is to say on Humanity. . . . For Humanity herself is a nymph of excellent comeliness, born in heaven and more than others beloved by God all highest.[50]

For Gombrich, Ficino's letter to Lorenzo di Pier-francesco inspired Botticelli to create the *Primavera,* and the scene depicted was meant as Ficino's visual lesson for his young pupil. However, as I hope to have demonstrated, while Ficino provided

the groom with a humanist lesson, at the same time lessons for the bride on the subjects of chastity, submission, and procreation were also supplied through Botticelli's painting. These lessons may also have been directed to the groom, as enforcer of his wife's expected behavior.

In Florence, as elsewhere in Renaissance Italy, noblemen functioned in the public arena, and were inculcated with social virtues. Noblewomen, on the other hand, though given educational opportunities, were in general confined to the home and expected to behave as chaste wives and virtuous mothers.[51] Works of art such as the *Primavera,* while embodying Neoplatonic thought and reflecting the intellectual activities of the Medici circle, also served as visual tools to provide women with models of expected behavior and, at the same time, as reminders of their lesser role in society.

NOTES

An earlier version of this paper was delivered at the 1989 Frick Collection–Institute of Fine Arts Symposium in New York. I am grateful to Rona Goffen for her support and for introducing me to a new approach to art history.

1. Umberto Baldini, *Primavera: The Restoration of Botticelli's Masterpiece,* trans. Mary Fitton (New York: Harry N. Abrams, 1986), pp. 12, 27–28.
2. E. H. Gombrich, "Botticelli's Mythologies: A Study in the Neoplatonic Symbolism of His Circle," *Journal of the Warburg and Courtauld Institutes* 8 (1945): 7–60. Gombrich's theory is discussed in greater detail later.
3. Baldini, *Primavera,* p. 90, has described the *Primavera* as follows: "Zephyr, personifying human love and the life-giving power of nature, seizes Chloris, who is transformed into Flora. Venus, with the aid of Eros/Cupid, both kindles this carnal love and guides it, through a process of intellectual sublimation (the Graces), toward the goal of contemplation (Mercury)."
4. Mirella Levi D'Ancona, *Botticelli's Primavera: A Botanical Interpretation Including Astrology, Alchemy and the Medici* (Florence: Leo S. Olschki Editore, 1983), p. 21.
5. Paul Barolsky, "Botticelli's *Primavera* and the Tradition of Dante,"*Konsthistorisk Tidskrift* 52, no.1(1983): 1–6.
6. Aby Warburg, "Sandro Botticelli's *Geburt der Venus* und *Frühling,*" in *Gesammelte Schriften* (Nendeln-Lichtenstein, 1969), p. 32.
7. Charles Dempsey, "Mercurius Ver: The Sources of

Botticelli's *Primavera,*" *Journal of the Warburg and Courtauld Institutes* 31 (1968): 251–73.
8. The wedding took place in May 1482. Ronald Lightbown, *Botticelli: Life and Work* (Berkeley: University of California Press, 1978), vol. I, p. 72, was the first to suggest that Botticelli's *Primavera* was painted on the occasion of this wedding, a suggestion that has been accepted by several scholars, including Barolsky, "Botticelli's *Primavera,*" p. 2, and D'Ancona, *Botticelli's Primavera,* pp. 11–14.
9. Barolsky, "Botticelli's *Primavera,*" p. 2.
10. Ibid., p. 4.
11. Webster Smith, "On the Original Location of the Primavera," *Art Bulletin* 57 (March 1975): 31–39. John Shearman, who had conducted an archival study similar to Smith's, published the results of his research in the same year. See John Shearman, "The Collections of the Younger Branch of the Medici," *Burlington Magazine* 117 (January 1975): 12–27.
12. Smith, "On the Original Location," pp. 32–35. See also Shearman, "The Collections," p. 18.
13. For a noteworthy discussion on the issue of chastity, see Joan Kelly-Gadol, "Did Women Have a Renaissance?" in *Becoming Visible: Women in European History,* ed. Renate Bridenthal and Claudia Koonz (Boston: Houghton Mifflin, 1977), pp. 152–61.
14. Shearman, "The Collections," p. 19; and Lightbown, *Botticelli,* vol. I, pp. 83–85.
15. Shearman, "The Collections," p. 18; and Smith,

"On the Original Location," p. 36.

16. *Aeneid,* XI passim, especially 508, 582–84, and 651.

17. Giovanni Boccaccio, *De mulieribus claris,* XXXIX.

18. Francesco Barbaro, "On Wifely Duties," trans. Benjamin G. Kohl, in *The Early Republic: Italian Humanists on Government and Society,* ed. Benjamin G. Kohl and Ronald G. Witt (Philadelphia: University of Pennsylvania Press, 1978), p. 202.

19. Seneca, *Moral Essays,* trans. John W. Basore (Cambridge, Mass.: Harvard University Press, 1935), p. 15.

20. Lightbown, *Botticelli,* pp. 75–77.

21. It should be mentioned that chastity was not considered to be tainted by marriage, as suggested by the following passage in Barbaro, "On Wifely Duties," p. 213: "I wish that she will curb herself so that she will be . . . chaste in that sort of temperance from which chastity is derived. It would be conducive to achieving this result if, from the very beginning, husbands would accustom themselves to serving as helpers of necessity rather than passion. And wives should bear themselves with decorum and modesty in their married life so that both affection and moderation will accompany their lovemaking."

22. Ibid., p. 202.

23. Melinda K. Blade, *Education of Italian Renaissance Women* (Mesquite, Texas: Ide House, 1983), pp. 14–21.

24. William Harrison Woodward, *Vittorino da Feltre and Other Humanist Educators,* second ed. (New York: Columbia University Teachers College, 1963), pp. 182–84.

25. Blade, *Education,* p. 31.

26. Quoted by Shirley Nelson Kersey, *Classics in the Education of Girls and Women* (Metuchen, N.J.: The Scarecrow Press, 1981), pp. 20–27.

27. Ibid., pp. 23–25.

28. Woodward, *Vittorino da Feltre,* pp. 247–48.

29. Elizabeth Ward Swain, "My Excellent and Most Singular Lord: Marriage in a Noble Family of Fifteenth-Century Italy," *Journal of Medieval and Renaissance Studies* 16 (1986): 171.

30. Lorenzo di Pierfrancesco and his brother, Giovanni, came under the custody of Lorenzo the Magnificent in 1476 upon the death of their father, Pierfrancesco.

31. Lightbown, *Botticelli,* p. 72. For background information on the rivalry between the Medici, and the pope and the king of Naples see Harold Acton, *The Pazzi Conspiracy: The Plot Against the Medici* (London: Thames and Hudson, 1979).

32. Ovid, *Fasti,* V, 195–212. See also Lightbown, *Botticelli,* p. 79.

33. D'Ancona, *Botticelli's Primavera,* p. 44.

34. Marco Antonio Altieri, *Li nuptiali,* ed. Enrico Narducci (Rome, 1873), p. 73: "Si che representandose in ogne apto nuptiale la memoria del quel rapto de Sabine."

35. Ibid., p. 93. According to legend, the Sabines were invited by Romulus, the founder of Rome, to a festival in the new settlement. Romulus wanted to provide wives for his men so that they could populate the city. During the celebration, the Sabine women were seized and their men were driven away. War ensued between the two nations, and it was not until the Sabine women placed themselves between the two armies that peace was finally achieved. Both groups came to an agreement and assented to the joint rule of Romulus and the king of the Sabines. See Livy, *Ab urbe condita,* I, ix–xiii passim, especially ix: 7–16 and xiii: 1–5.

36. Altieri, "Li nuptiali," p. 52. For a comprehensive interpretation of *Li nuptiali,* see Christiane Klapisch-Zuber, *Women, Family, and Ritual in Renaissance Italy,* trans. Lydia Cochrane (Chicago: University of Chicago Press, 1985), pp. 247–60.

37. For other examples see Paul Schrubing, *Cassoni* (Leipzig, 1915), table XI, no. 75; table LXIV, no. 280; table LXXXVIII, no. 377; table CX, no. 466; and table CXI, no. 476.

38. Diane Owen Hughes, "Representing the Family: Portraits and Purposes in Modern Italy," *Journal of Interdisciplinary History* 17 (1986): 12. For further interpretations of images on *cassoni,* see Ellen Callmann, *Apollonio di Giovanni* (Oxford: Oxford University Press, 1974), pp. 39–51; Callmann, "The Growing Threat to Marital Bliss as Seen in Fifteenth-Century Florentine Paintings," *Studies in Iconography* 5 (1979): 73–92; and Brucia Witthoft, "Marriage Rituals and Marriage Chests in Quattrocento Florence," *Artibus et Historiae* 5, no. 5 (1982), pp. 43–59.

39. Shearman, "The Collections," p. 18. There is no reason to doubt that the *cassone* was decorated, since embellishing such furnishings with either historical or literary scenes was common practice during the Quattrocento. The high value assigned to this piece in the 1499 inventory emphasizes this point.

40. Callmann, *Apollonio di Giovanni,* pp. 23–24, 39.

41. Vern L. Bullough, *Sexual Variance in Society and History* (New York: Wiley, 1976), p. 372.

42. Ibid., 379–80.

43. Barbaro, "On Wifely Duties," p. 212.

44. Guido A. Guarino, ed., *The Albertis of Florence: Leon Battista Alberti's "Della Famiglia"* (Lewisburg, Pa.: Bucknell University Press, 1971), p. 125.

45. Ibid., p. 122.

46. Swain, "My Excellent and Most Singular Lord," p. 194.

47. Dempsey, "Mercurius Ver," pp. 261–62.

48. Quoted by Dempsey, "Mercurius Ver," pp. 261–62.

49. Gombrich, "Botticelli's Mythologies," pp. 16–17.

50. Quoted by Gombrich, "Botticelli's Mythologies," pp. 16–17.

51. Kelly-Gadol, "Did Women Have a Renaissance?" p. 154.

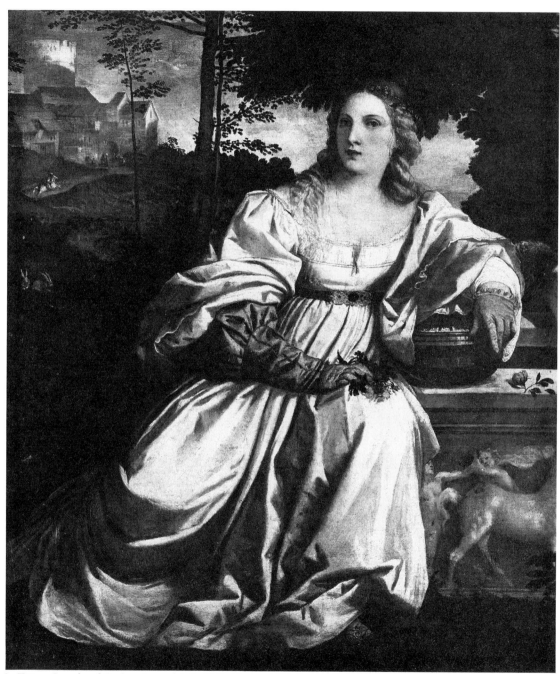

1. Titian, *Sacred and Profane Love*, detail of left side, ca. 1514. Rome, Galleria Borghese.

TITIAN'S *SACRED AND PROFANE LOVE* AND MARRIAGE

RONA GOFFEN

The erotic appeal of Titian's women is undeniable, and the sensual enjoyment of his nudes and *poesie* by his patrons and admirers evidently had much to do with their success. Eroticism, however, does not—and certainly, in the sixteenth century, did not—explain everything. Sexual desires and sexual identities are not eternal verities but are constituted within specific social practices.[1] To be sure, human biology is the same now as it was in the Cinquecento, but, in Gayle Rubin's words, "We never encounter the body unmediated by the meanings that cultures give to it."[2] It is precisely such an interpretation of Titian's women, mediated by a consideration of Venetian Renaissance culture, which has been wanting in art history. Despite an occasional foray into the comparatively asexual Neoplatonism, the preponderant view of such images has involved a one-sided appreciation of their overt eroticism. In some cases, Titian's women have been reduced to "pinups" by historians rebelling against the ascetic analyses of iconographers.[3] Each of these critical approaches is fundamentally flawed, however—the one because it slights the sexuality of Titian's women, the other because it ignores the historicity of sexuality.

Other critics have posited a different but equally reductive analysis of Titian's images, according to the dynamic of active male beholder and passive female object—an exploitation to which we moderns are particularly sensitive.[4] But can we be certain that this confrontation is necessarily implicit in all such images, the inevitable concomitant of the display of nude women? Though some degree either of scopophilia or of voyeurism is inherent in the act of viewing per se, whether the subject be male or female, this would have been mitigated in the Renaissance imagination by the belief in the magic of images.[5] An image may hear, speak, and see: undeniably Titian's women (no less than his men) seem to see us, to return or to compel our gaze. When they do so, they imply reciprocity. And when they do so, unlike their Giorgionesque predecessors, for example, they are never shy; the force of their gaze empowers them. In any case, our modern resent-

This essay is based on a paper presented at the "Titian 500" Symposium sponsored by the Center for Advanced Study in the Visual Arts, National Gallery of Art, Washington, D. C., 1990. Revised by the author for this edition. An expanded version, including passages from archival sources and other additional material, will appear in *Studies in the History of Art* (Washington, D. C.: National Gallery of Art, 1993). Copyright © 1991 by Rona Goffen. Reprinted by permission of the author and the National Gallery of Art.

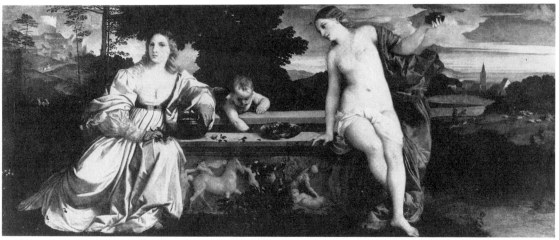

2. Titian, *Sacred and Profane Love,* ca. 1514. Rome, Galleria Borghese.

ment of the presentation of the female as object no more offers an adequate explanation of Titian's women than the single-minded appreciation of their conspicuous sexuality or the high-minded erudition oblivious of that sexuality.

Titian's women represent incisive, multifaceted, and *sensual* characterizations of the female. For Titian, humanity (male as well as female) was defined by sexuality, not merely by gender, and human sexuality was interpreted as a potent, positive quality central to the individual's identity and a concomitant of her (or his) personality. While this is always present but always subsidiary in Titian's conception of the male, his definition of the female privileges her sexuality, defined (perforce?) with reference to the masculine other, even when the male presence is merely invoked, in works such as the *Sacred and Profane Love* [1, 2].

The title derives from the fact that the same woman is shown twice, clothed as a sixteenth-century contemporary and nude as an ancient goddess.[6] The conception has a classical pedigree: Plato distinguished two Venuses, Celestial and Terrestrial; Praxiteles sculpted two Venuses—one draped, the other a "celestial" nude; and Philostratus described "two Venuses, one draped, the other nude" among the company at the feast of Hymen.[7] The juxtaposition of the same beautiful woman clothed and unclothed may also evoke the

debates in Cinquecento literature: which is the lovelier, adorned or unadorned beauty? (Firenzuola, at least, opted for the former.)[8] But as we shall see, Titian's painting is primarily concerned with the reality and the ideality of women in marriage, and not with theoretical treatises on beauty.[9] Indeed, new archival evidence shows how the *Sacred and Profane Love* reflects the particular social and psychological concerns of the actual husband and wife who commissioned it.[10]

The coat of arms of the Venetian Nicolò Aurelio was recognized long ago in the fictive relief of the sarcophagus, and Alice Wethey's more recent identification of a second stemma, within the silver bowl, [3] has confirmed the circumstances of the commission: Aurelio's marriage in 1514 to the Paduan Laura Bagarotto.[11] Typical of his class— he was an "original citizen"—the groom had been serving the state in various official positions since adolescence, for forty of his fifty-three years.[12] His bride, also typically, was younger than he, probably in her mid-twenties or even younger; but unlike Aurelio, Laura Bagarotto had been previously married. She was the widow of the Paduan nobleman Francesco Borromeo—not Lombardo, as the diarist Sanudo recorded, perhaps confusing the name with the family's origins.[13] Sanudo's error, repeated by everyone else until now, has concealed important information about Laura's first hus-

band. Like his kinsmen, Francesco Borromeo had supported the imperial forces in 1509, and was declared a traitor by the Venetian Republic.[14] The order for his surrender also named several of his wife's kin, including her maternal uncle, her cousin, her brother, and her illegitimate half-brother.[15] Her father had already been arrested. The Venetians seem to have declared a vendetta against these two prominent Paduan families, and even their womenfolk, presumably including Laura herself, were temporarily imprisoned.[16] Some of the men either escaped or were eventually pardoned, but not Francesco Borromeo, not Laura's uncle, and not her father. Though I have found no information regarding Borromeo's death, we may safely assume that it was not a natural one, and in any case dead he was by 1514, when Laura was described as *relicta,* the widow of a Paduan rebel.[17]

The widow was also fatherless, the orphan of the convicted traitor Bertuccio Bagarotto, *Iuris utriusque doctor* and professor at Padua, who was hanged between the columns in the Piazza in 1509 before the eyes of his wife and children (a purposefully sadistic, humiliating death). Nonetheless, five years after his execution, in 1514, the Collegio—consisting of Doge Leonardo Loredan, the councillors, and the heads of the Council of Ten—granted approval of Aurelio's marriage to Bagarotto's daughter.[18] This procedure was most unusual: official approbation was evidently considered necessary because her first husband's complicity in the loss of Padua, the imperial sympathies of both his and her kinsmen, and above all her father's condemnation for treason ostensibly made Laura Bagarotto a most inappropriate wife for citizen Aurelio, then secretary of the Ten.

3. Titian, *Sacred and Profane Love,* detail.

Perhaps governmental approval of her wedding implied some doubt about her father's guilt—indeed, Bagarotto had died maintaining his innocence, and his son unceasingly reiterated the claim, until their state pension was eventually restored (1519)—which Sanudo interpreted as tacit admission that the Paduan had in fact been a loyal Marchesco (follower of Saint Mark).[19] Hoped-for rehabilitation of the bride's patriline may be related in turn to the commission of Titian's painting to commemorate her remarriage.

In addition to the inclusion of the Aurelio and Bagarotto arms, several other features of the *Sacred and Profane Love* refer to the marital context of the commission, most notably the garments of the so-called Profane Love. These have been recognized as the traditional dress of a Venetian (and Paduan) bride: white gown, belt, gloves, roses, the myrtle wreath *(myrtus coniugalis),* and hair loose on the shoulders.[20] Laura Bagarotto herself was married once and perhaps twice in such a gown—indeed, probably this very gown—for the first item listed in the record of her dowry is "a wedding gown of white satin."[21] In this case, the bride's white gown has a red sleeve, red being another bridal color in Renaissance Venice, though it may also be intended to identify her as a widow.[22] (The red of her underskirt appears at the hem of her gown.) This uxorial context suggests the most likely explanation for her lidded vessel, which has puzzled art historians: sixteenth-century Venetian brides received wedding gifts in such silver caskets.[23]

But if Titian indeed replicated her gift and her gown—which would have been in keeping with the contemporary practice of portraiture—if so, did he then also portray their owner? Whatever Laura Bagarotto may have looked like, I find it difficult to believe that this idealized beauty is a portrait in the sense of a purposeful record of individual appearance, as has been suggested by others.[24] The generic, Titianesque quality of her face and figure, resembling the chaste mother of the Paduan fresco and anticipating the *Flora*—she was probably the same model—is very different from Titian's undisputed, unidealized portraits of women, such as the *Schiavona* [4]. And

there is another reason to reject the bride as a portrait likeness per se. The *Sacred and Profane Love* shows the protagonist twice, dressed as a bride and dressed in her birthday suit; if it is literally Laura Bagarotto whom we see clothed, it is also literally she whom we see nude. This seems unthinkable in light of sixteenth-century Venetian mores, even in the context of a domestic commission.[25] But if the image is not a likeness, if identity is not here defined by physiognomy, how then does Titian characterize his woman as an individual? The answer is that Laura Bagarotto's identity is subsumed in her nuptial status, characterized in turn by female sexuality. To be sure, a woman's individuality was customarily defined by her familial roles—first as daughter, then as wife, ultimately as widow.[26] While seeming to reiterate this Renaissance commonplace, Titian nonetheless asserts a new kind of dignity and power for his women, and he does this by honoring female sexuality. Marriage was considered the only legitimate arena for the exploitation of female fecundity—that most fundamental means of production, on which the family's, and indeed society's, well-being depends—and which means were almost totally controlled by men. But here Titian effectively frees female sexuality from these familiar constraints.

The nude is characterized as superior, something almost every commentator has recognized: higher than the clothed woman, the nude is understood to be metaphorically above her as well, and her superior status is encapsulated in the lamp that she holds. Whatever precise meaning the lamp may have, it surely signifies something exalted and exalting, though Celestial Love, the traditional name for Titian's figure, is probably correct. She recalls a work by Sodoma, painted ca. 1504, inscribed CELESTES and STINSI TERENAS [5]. Bare-breasted and helmeted, this Celestial Love extinguishes the fire of earthly passion (fed by mere twigs) while lighting a taper with the flame of heavenly love burning in a brazier.[27] Combustion is equally relevant to Titian's conjugal allegory. Love, it was generally agreed, begins with the glance, when the eye sends forth a flame; the nude's lamp, afire with the flame of love, resembles the *Hypnerotomachia*'s "antique metal vessel in the opening of which was burning a flame . . . [namely] Love."[28] The nude's red drapery represents the same idea, in color and in the contrived movement of the cloth.

The nude's superiority, then, is as clear as Titian and pictorial tradition could make it. Indeed, as female nudes go, this one is modest; her sex is covered not by a coy gesture but by the unambivalent means of a white drapery. Moreover, her legs are firmly locked together, unlike those of Giorgione's *Male Nude* for the Fondaco dei Tedeschi [6], whose pose she otherwise duplicates, and also purposefully unlike the parted thighs of the bride. Even the Celestial Love's proportions, slender in contrast with the bride, idealize and dematerialize her. There is nothing prurient about her presentation, and her turning away from us to glance at her counterpart underscores the nude's purity. So does her antiquity, as it were. Her nudity itself—an antique device par excellence—suggests another, ideal level of being. Her lamp is classical in

4. Titian, *La Schiavona,* ca. 1510. London, National Gallery of Art.

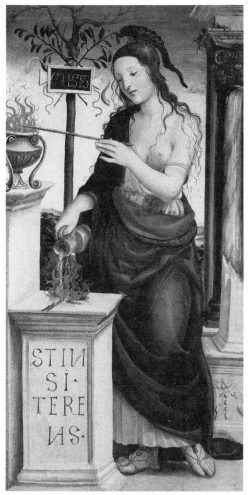

5. Giovanni Antonio Bazzi, called Sodoma, *Allegory of Celestial Love*, ca. 1504. Siena, Monte dei Paschi di Siena, Raccolta Chigi Saraceni.

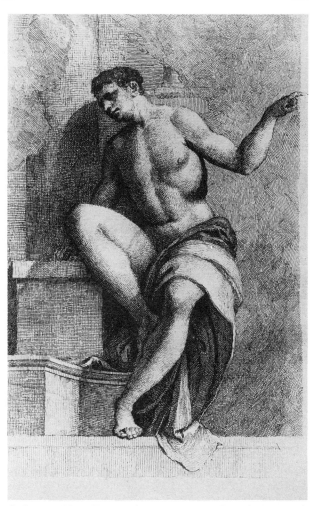

6. Antonio Maria Zanetti after Giorgione, *Male Nude*, engraving. Venice, Museo Correr.

design, and Titian's knowledgeable invention of ancient reliefs for the sarcophagus also evokes the past, whereas everything associated directly with the bride is modern. Does this mean, then, that two times are indicated and that two women are present? Or is this one woman in two guises, embodying two aspects of herself? To be sure, ancient epithalamia may characterize the bride as Venus's twin, so like the goddess that the Loves cannot distinguish them.[29] To liken one's beloved to Venus was another commonplace, and it is tempting to see Titian's women here as twins—

that is, as Venus and the bride who resembles her. But in the visual tradition, when two figures look alike, they in fact represent the same person, usually in different moments of a narrative, sometimes in different conditions or states of being. (Rizzo's monument of Doge Nicolò Tron, which shows him both alive and dead, was an example well known to Titian: it flanks his *Assunta* in the Frari.)[30] I suggest that this is what Titian intended in the *Sacred and Profane Love*. The repetition of red and white, and the juxtaposition of their attributes seem to confirm the single identity

of the two women, figured as bride and as wife: As bride, crowned with myrtle, she holds Venus's roses and the gift presented by her husband at their marriage; and as wife, nude yet chaste, she turns to the bride as though to exhort her(self) to the Love symbolized by her lamp. Perhaps like the humanist Alessandro Piccolomini, she extols a love of her husband that is not servile but reverential.[31] Or perhaps like the more old-fashioned Frate Cherubino, she counsels an affectionate (*cordiale*) love of her husband.[32]

The landscape background likewise seems to incorporate elements or aspects appropriate to the bride and wife. In the background just below the nude's lamp a rabbit flees two hunters and their dog; nearby a shepherd tends his flock and lovers embrace; and on the far shore of the lake are houses and a church with a campanile. To be sure, Venetian Renaissance landscapes commonly include such figures and buildings. Yet they seem particularly apposite here: lust is discountenanced, while protective love and affectionate love are recommended, under the aegis of the church. Similarly, and with unmistakable symbolic significance, two preternaturally large rabbits behind the bride refer to fertility, to the hope for children.[33] Farther back, a horseman and several pedestrians enter a city gate, beyond which rises a round tower. Perhaps the fortified city is to remind us that marriage is a social institution founded on (female) chastity.

Laura Bagarotto's having been married and widowed put her in an ambivalent position, shared by all widows, of sexual experience coupled with presumed (but not so easily demonstrable) chastity. This ambivalence was aggravated in her case by the unseemly death of her father: who can attest to the virtue of an orphaned widow? Laura had been left with only her brother to fill the roles customarily taken by father, uncle, or husband—but his own political situation was still precarious at the time of her remarriage, and this may have precluded or hampered his acting on her behalf. While Titian has emphasized Laura's womanliness—not just her sex, but her sexuality—he has seemingly done nothing to reassure us about her chastity (unless her gloves and the background

tower are the guarantors of her virtue).[34] Yet the Renaissance bride is chaste by definition, this virtue being foremost in any contemporary recitation of her desired qualities. Looking at this bride from a sixteenth-century point of view, we realize that Titian appreciated the coincidence of chastity and sexuality: they are not antagonistic but sympathetic aspects of her character. In order to fulfill her role as *mater familias*, she must be both pure and sexual, Mary and Eve. Titian recognized this fundamental dichotomy of the female, as understood by Renaissance people, and sought to harmonize these seemingly disparate qualities in his imagery. First of all, he acknowledges the woman's sexuality. While the bride's attire is appropriate for a wedding, the folds and fabric of the gown are exploited to emphasize the sensuality of the figure. Michelangelo suggested how the male beholder would respond to a beautiful woman dressed this way: he will envy garments that "press and touch her breast" and the belt that embraces her waist, "where I would wish to hold her forever!" to quote his sonnet of 1507 to a Bolognese lady.[35] Such sartorial eroticism may have been an innovation for bridal imagery, one perhaps more commonly associated with pictures of the "other woman," such as Palma's composition of ca. 1515 in Vienna [7]. Earlier and contemporary literature had advised temperance and restraint in a husband's love of his wife.[36] In the first edition of his treatise on living a nobleman's life, for example, Alessandro Piccolomini had counseled his godson to save erotic passion for extramarital relations; but in the second edition, published in Venice in 1560, he reversed himself, now urging marital fidelity and extolling sexual love within marriage: "One love only at one time must one love."[37] Titian seems to have anticipated this change: the husband's beloved is his own wife, and her sexuality is represented as integral to her personality.

Visualization of the bride's sexuality is here tantamount to her empowerment as a female, and Titian magnifies this power by means of her posture. Titian had anticipated this seated *contrapposto* with legs akimbo in his so-called *Judith* for the Fondaco dei Tedeschi, completed in 1509, though he may also have consulted the poses of

7. Jacopo d'Antonio Negreti, called Palma Vecchio, *Woman in Green*, ca. 1515. Vienna, Kunsthistorisches Museum, Gemäldegalerie.

Michelangelo's prophets in the Sistine Ceiling.[38] If so, Titian eroticized Michelangelo's masculine *terribilità* to express a different but equally forceful feminine ideal. This physical embodiment of female power is matched by the psychological aspect, visualized by the bride's glance. Her addressing the beholder directly in this way is neither brazen nor submissive, as modern observers have suggested. To be sure, she invites us to picture the original beholder of her image—namely, her husband—but this does not imply her objectification, her passivity before the active male observer. On the contrary, Renaissance people understood that such a glance implies reciprocation; and, still more important in this context, that it signifies love communicated through sight, the highest sense. Sight is the noblest sense precisely because the eyes are the windows of the soul, as innumerable authors have declared since ancient times; and this is true for female as well as male eyes. Behold-

ing her husband as he stands before her image, the bride promises marital love, a joining of souls—which is the justification of the sexual fulfillment promised by her body, her garments, and her pose.

Placing the nude to the right of the bride, Titian underscores (or relieves?) the sexual tension, suggesting the removal of the clothes that have aroused the beholder's jealousy and his desire.[39] Yet the nude effectively countermands the left-right inclination by turning toward the bride; this implies simultaneity rather than a sequential relationship. Perhaps the juxtaposition of the women—the consummation of the composition—alludes to the sacrament of marriage, sealed by sexual consummation, which is justified by the birth of children.[40] (It is worth remembering that, in theory at least, this justification applied equally to women and to men: sexual intercourse was condoned only in marriage, and almost only for progeneration.[41]) But first the marriage must be given legitimacy by publicity and by consent, visualized by the outward glance of the bride. Addressing the beholder—in effect, her husband and, through him, the community—she asserts the societal preconditions for matrimony. A marriage is legitimized, however, only with the very private act of sexual consummation.[42] Hence the nude's superiority: as the private, conjugal self, she looks back at her bridal or public self, addressing her injunction not to society but only to herself.[43] With her flaming lamp, the nude exalts sexual love from the terrestrial to the higher plane, sanctified by matrimony and procreation. Two stages of matrimony are embodied in two incarnations of the same woman.[44]

The church asserted these marital conditions as obligatory—consent, publicity, consummation—but there was another requirement, a sine qua non in practice if not in canon law: the bride had to be dowered.[45] When Laura lost her father and her first husband, she also lost her dowry: the Venetian Republic had confiscated the estates of the Paduan rebels, thereby coincidentally absorbing the dowries of their wives.[46] But a husband was entitled only to the usufruct of his wife's dowry, which remained her property. Consequently, in keeping with law and custom, the Council of Ten

8. Lorenzo Lotto, *Messer Marsilio and His Wife*, 1523. Madrid, Prado.

9. Bartolomeo di Frusino, *Desco da parto*, 1428, tempera. New York, New-York Historical Society, The Bryan Collection, on loan to the Metropolitan Museum of Art.

had decreed in 1510 that the dowries of Paduan rebels' widows be restored to them. In Laura Bagarotto's case, this restitution was four years in coming.[47] Her dowry, including the white bridal gown, was itemized in a document recording its return to her in 1514—dated May 16, one day before her remarriage—and written in her future husband's hand.[48] In addition to the gown, pearls, and considerable real estate, the document specifies the healthy sum of 2,100 ducats. (Even a nobleman might have been satisfied with this settlement, very generous indeed for a citizen's marriage.) Aurelio, who had been impoverished by the necessity of dowering two of his sisters, who had been so poor that he shared with his brother a house worth a paltry two ducats a year in rent, whose destitution had made marriage impossible—though not impossible the production of an illegitimate son—Aurelio was finally, in his midfifties, a bridegroom, and his bride's dowry promised to make him rich.[49] Whether he was in a position to expedite the restoration of her dowry and whether this was the price of her consent to marriage, we can never know. But consent she did, as Titian's painting attests, and perhaps insists.

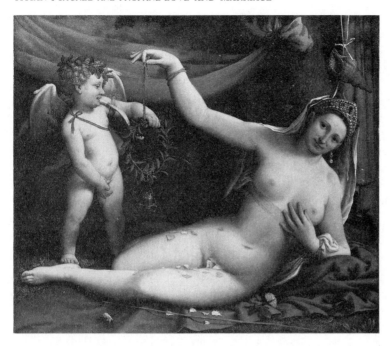

10. Lorenzo Lotto, *Venus and Cupid*, ca. 1520. New York, Metropolitan Museum of Art. Purchase, Mrs. Charles Wrightsman Gift, 1986.

That Titian's two protagonists in the *Sacred and Profane Love* are female represents in itself another remarkable departure from tradition: wedding pictures characteristically and appropriately represent couples, not women alone. Such paintings as the Marsilio wedding portrait by Lotto present visual documentation of marriage, signified by the couple's gesture of taking and giving hands (and by Cupid's yoke)[8].[50] The relevance to continuing concerns about consent and public notice (as opposed to the bugaboo of clandestinity) is readily apparent, providing Titian's subtexts as well. Indeed, the bride's incisive gaze is here tantamount to her consent—consent that Laura Bagarotto, widow and orphan, was empowered to give without any of the usual constraints, parental or financial.

Of course, there is a male figure in the *Sacred and Profane Love*, but he is only a boy. Cupid is clearly subsidiary to the two women, not just in size but in every way: absorbed in stirring the waters of the fountain, he does not relate directly to the others or to the beholder—though his action is pertinent to the bride and to her unseen groom. Precisely by stirring the water, the putto

encourages its flow from the metal spout that has transformed an ancient sarcophagus into a fountain, and the spout is adjacent to the new husband's coat of arms. Thus the sterility of Laura Bagarotto's widowhood is transformed into the fecundity of remarriage. The emission of liquid from a tube, caused by a male figure, however small, represents ejaculation, or its frequent symbolic equivalent, urination. Any temptation to groan dismissively should be quelled by reference to the urinating boy of Bartolomeo di Frusino's *Desco da parto* (birth tray), with its inscription about fertility[9].

More precise in its allusion to heterosexual reproduction is the wedding picture by Lorenzo Lotto in the Metropolitan Museum of Art[10].[51] Lotto's picture clearly depicts a likeness: the idiosyncrasies of appearance leave no doubt that an individual could be recognized from this portrayal. Cupid leers at her while urinating or ejaculating, taking careful aim so that the liquid penetrates a marriage wreath. It seems that Lotto's panel was painted in Bergamo for local clients; such unreserved explicitness would not have suited the mentality of the Venetian patriciate and citizens

regarding matrimony. Lotto has reduced this bride's individuality to her reproductive function; Titian frees his woman's identity and her sexuality from this biological limitation—and that in itself constitutes a sexual revolution.

Titian's painting is also more disguised in its eroticism, if no less potent than Lotto's. Titian's bridal Venus is the powerful and primary embodiment of generative force, and the male is a supernumerary in her opera. This visualization of human sexuality did not even have the sanction of physicians and philosophers, to say nothing of theologians. However daunted they might have been by Lotto's erotica, they would at least have immediately understood his gynecology: the female is the passive receptacle of the male's life-giving seed. Titian's only nod in the direction of this common view of human reproduction seems to be the placement of the stemme: the bride's in a bowl, Aurelio's near the spout—though this may have more to do with the embarrassment of the Bagarotto family than anything else. But what's heraldic dominance worth in the company of these magnificent women? And between them is Cupid stirring the waters of the fountain, making the spout flow to nourish the rose—Venus's favorite blossom, and a traditional marriage flower. A more subtle, polite version of Lotto's urinating putto, Titian's imagery is also a more positive interpretation of the female role: not only is her presence doubled and male participation minimized, but we are shown that it is love, Cupid, who encourages male fertility to nurture Venus's flower.

When they were married, Nicolò Aurelio himself could not have afforded this painting: only Laura Bagarotto's dowry can have paid for it. Was she in fact Titian's patron? Or did the new couple act together? Aurelio was known to be a learned man—"una persona di molte lettere," according to Sansovino—and may well have had ideas of his own about the composition.[52] In any case, the bride's consent to marriage—and presumably to Titian's painting—and her prominence (dominance?) within it are leitmotifs of the *Sacred and Profane Love*. She seems to have had "prominence" in her marriage as well: Aurelio treated his

wife with considerable solicitude and generosity in his holograph will, though, like most husbands, he was ready to be more generous if she was willing to remain a widow after his death.[53] Of course, Laura Bagarotto had been compelled to decide her own fate by the deaths of her first husband and father and the imprisonment or exile of her other kinsmen. Surely her extraordinary experience, coupled with her privileged financial position, colored Aurelio's attitude toward her; by his own account, she was "prudent and wise," and knew very well how to deal with "the adversities of this world."[54]

Titian's image of bridal consent is very different from the traditional Renaissance man's picture of marriage as a property exchange negotiated by men and sealed by rape, to which the Sabine woman eventually accedes—she being the prototypical bride according to humanist sociology.[55] Perhaps Titian's fictive relief—a pastiche of antique motifs—alludes to that myth or to the Venetian variant, the legend of the Twelve Marys, or to a sexual rite of antiquity, evoked by the herm at the left. Perhaps the scene represents the banishment of lust (or its chastisement), because lust has no place in marriage and is supplanted by Celestial Love, which the nude both embodies and extols to the bride. Like the Celestes of Sodoma's painting, Titian's Celestial Love would also extinguish the baser instincts, *stinsi terrenas*. Yet the relief reminds us that love (or sex) and violence, actual or feigned, are frequently associated in Western societies: hence the ritual flagellations of sexual initiation in antiquity;[56] the chivarees and mock battles of Renaissance weddings;[57] and the bellicose themes of *cassone* painting.[58] Possibly the bride's involvement in the creation of Titian's picture of marriage, both as subject and as client, determined his innovative characterization of these women. Be that as it may, in the *Sacred and Profane Love*, Titian introduces us to a new personality in art, a woman as a fully realized individual, "prudent and wise," as Nicolò wrote of Laura, a loving wife, mother, and stepmother—and well capable of dealing with "the adversities of this world": the decisive protagonist of her own life.

NOTES

I gratefully acknowledge the critical suggestions of Kathleen Weil-Garris Brandt, Elizabeth Cropper, Marilyn Aronberg Lavin, Sarah Blake McHam, and the editors of this volume, Norma Broude and Mary Garrard.

1. See Michel Foucault, *The History of Sexuality*, vol. 1: *An Introduction*, trans. Robert Hurley (New York, 1978); Natalie Zemon Davis, " 'Women's History' in Transition: The European Case," *Feminist Studies* 3 (1976): 83–103; Joan Wallach Scott, "Gender: A Useful Category of Historical Analysis" (1986), in idem, *Gender and the Politics of History* (New York, 1988), pp. 53–67; and Gayle Rubin as cited in the following note.

2. "Thinking Sex: Notes for a Radical Theory of the Politics of Sexuality," in *Pleasure and Danger: Exploring Female Sexuality*, ed. Carole S. Vance (Boston, 1984), pp. 276–77.

3. For the Neoplatonic interpretation, see esp. Otto J. Brendel, "The Interpretation of the Holkham *Venus*," *Art Bulletin* 28 (1946): 65–75; and Erwin Panofsky, "The Neoplatonic Movement in Florence and North Italy (Bandinelli and Titian)," in idem, *Studies in Iconology: Humanistic Themes in the Art of the Renaissance* (1939) (New York: Harper Torchbooks, 1962), pp. 129–70. For Titian's women as "soft porn," with no purpose beyond titillation, see Daniel Arasse, *Tiziano, Venere d'Urbino* (Hermia, 8 [Venice, 1986]); Carlo Ginzburg, "Tiziano, Ovidio e i codici della figurazione erotica del Cinquecento," in *Tiziano e Venezia* (1976) (Vicenza, 1980), pp 125–35; and Charles Hope, "Problems of Interpretation in Titian's Erotic Paintings," in *Tiziano e Venezia*, pp. 111–24. See also Elizabeth Cropper, "The Beauty of Woman: Problems in the Rhetoric of Renaissance Portraiture," in *Rewriting the Renaissance: The Discourses of Sexual Difference in Early Modern Europe*, ed. Margaret W. Ferguson, Maureen Quilligan, and Nancy J. Vickers (Chicago, 1986), pp. 175–90, 355–59; and Goffen, "Renaissance Dreams," *Renaissance Quarterly* 40 (1987): 684–86, 691–97.

4. This kind of criticism owes much to writing about film—e.g., Laura Mulvey, "Visual Pleasure and Narrative Cinema," in *Feminism and Film Theory*, ed. Constance Penley (New York and London, 1988), pp. 57–68, esp. 62ff., on "Woman as Image, Man as Bearer of the Look." For the dynamic of masculine/active/beholder and feminine/passive/object in earlier fifteenth-century art, see Patricia Simons, "Women in Frames: The Gaze, the Eye, the Profile in Renaissance Portraiture," *History Workshop* 25 (1988): 4–30; ch. 2 in this volume. On the presumed physical and emotional "availability" of Venetian images, see Mary Rogers, "Sonnets on Female Portraits from Re-

naissance North Italy," *Word and Image* 2 (1986): 291–305; and idem, "The Decorum of Women's Beauty: Trissino, Firenzuola, Luigini and the Representation of Women in Sixteenth-Century Painting," *Renaissance Studies* 2 (1988): 47–88.

5. On the distinction between scopophilia (Freud's looking as a source of pleasure), which may be fetishistic, and voyeurism, which may be associated with sadism, see Mulvey, "Visual Pleasure," pp. 59, 64. On the magical powers of images, see Goffen, *"Nostra Conversatio in Caelis Est:* Observations on the *Sacra Conversazione* in the Trecento," *Art Bulletin* 61 (1979): 220–21, with bibliography; and Richard C. Trexler, "Florentine Religious Experience: The Sacred Image," *Studies in the Renaissance* 19 (1972): 7–41.

6. The painting was first mentioned in 1613 as "Beltà disadorna e Beltà ornate"; the more familiar "Amor sacro e profano" seems to have been coined by Vasi in his *Itinéraire* (Rome, 1793). For this and other early bibliography, see Maria Luisa Ricciardi, *"L'amor sacro e profano:* Un ulterior tentativo di sciogliere l'enigma," *Notizie di Palazzo Albani* 15 (1986): 38–43.

7. For Praxiteles, see Pliny, *Historia naturalis* 36:20; and Panofsky, "Neoplatonic Movement," p. 153. For Philostratus, *Imagines* I, 2, see Edgar Wind, *Bellini's Feast of the Gods: A Study in Venetian Humanism* (Cambridge, Mass., 1948), p. 47. Alessandro Piccolomini analyzed Plato's views of the two Venuses, Celeste and Volgare, in *Della institutione morale, libri XII* (Venice: Giordano Ziletti, 1560), pp. 429ff. It should be noted that Praxiteles represented the same goddess in two guises, whereas Plato distinguished two beings. The identity of Titian's two figures is considered in the text above, at n. 29.

8. Celso, Firenzuola's spokesman, says that sometimes dressed is better, because lovelier, than nude; Agnolo Firenzuola, *Le bellezze, le lodi, gli amori, e i costumi delle donne, con lo disacciamento delle lettere* (1541, 1544) (Venice: Barezzo Barezzi, 1622), p. 15. See also James V. Mirollo, *Mannerism and Renaissance Poetry: Concept, Mode, Inner Design* (New Haven, Conn., and London, 1984), p. 138.

9. Cf. Ricciardi, *"L'amor sacro e profano"*; Giles Robertson, "Honour, Love and Truth, An Alternative Reading of Titian's *Sacred and Profane Love*," *Renaissance Studies* 2 (1988): 268–79; and Edward Fry, "In Detail: Titian's *Sacred and Profane Love*," *Portfolio* 1 (Oct./Nov. 1979): 34–39 (kindly brought to my attention by Professor Wendy Stedman Sheard). All related the painting to Aurelio's marriage, though they reached rather different conclusions from mine (which is in part based on newly discovered archival materials).

10. For partial transcriptions of these sources and a translation of Aurelio's will, see my essay in *Studies in the History of Art.*

11. For Aurelio's arms (the forequarters of a lion in profile on a blue field above, and below, a gold field with a blue ribbon), see Umberto Gnoli, "L'Amor sacro e profano," *Rassegna d'arte* 2 (1902): 155–59. For the Bagarottos', Harold E. Wethey, *The Paintings of Titian: Complete Edition,* vol. 3, *The Mythological and Historical Paintings* (London, 1975), pp. 22, 177: "three blue bars on a silver field" (very difficult to see in photographs).

12. On Aurelio and his social class, see Mary Frances Neff, "Chancellery Secretaries in Venetian Politics and Society, 1480–1533," Ph.D. dissertation, University of California, Los Angeles, 1985, esp. p. 361. Aurelio had begun his career as a ballot carrier in 1476 (Venice, Archivio di Stato [hereafter ASV], Collegio, Notatorio, reg. 12, c. 43), and therefore cannot have been born later than 1464, given the age requirement for that position. He eventually became grand chancellor but was compelled to resign his office (see n. 52 below).

13. I calculate her age based on the fact that she had evidently not been long married when she was widowed, in part because she was still childless in 1509 and still fertile in 1527, when she had her second and last child, a son, Antonio, named for Nicolò Aurelio's brother. Moreover, Francesco Borromeo is not listed in the Estimo (tax records) for 1507–8, which suggests that he was still living as a dependent in his father's, Antonio's, household; Padua, Archivio di Stato, Estimo, Busta 35, 202–208v. For the incorrect identification of her first husband, see Marino Sanudo, *Diarii,* vol. 18 (Venice, 1887), ed. Federico Stefani et al., col. 199.

14. On Francesco Borromeo, whom Sanudo never connects with Laura Bagarotto but whose traitorous activities he documents, see *Diarii,* vol. 8 (Venice, 1882), ed. Nicolò Barozzi, cols. 152, 261–62, 550–51 (the order for Borromeo's arrest on 24 July); and ibid., col. 9 (Venice, 1883), ed. Stefani, cols. 16, 56. Borromeo seems to have died shortly after the latter date, 14 August 1509, when he was seen in the enemy camp. The Paduan Borromeo were a branch of the illustrious family of Milan; see Giuseppe Vedova, *Biografia degli scrittori padovani* (Padua, 1832–36) vol. 1, p. 141.

15. Sanudo, vol. 8, cols. 152, 170, 241, 243–44, 533, 542, 550–51; ibid., vol. 9, cols. 73, 116, 295, 353; ibid., vol. 17 (Venice, 1886), ed. Stefani et al., col. 370; Roberto Abbondanza, "Bagarotti, Bertuccio," in *Dizionario biografico degli italiani* vol. 5 (Rome, 1963), pp. 169–70; and Emmanuele Antonio Cicogna, *Delle inscrizioni veneziane,* vol. 6/1 (Venice, 1853; rpt. Bologna, 1970), pp. 241–45.

16. ASV, Consiglio de' X, Reg. 1, Criminale, 1509,

125v. For a contemporary's hair-raising account of the torture and execution of Bagarotto and the harsh treatment of his family, see Luigi da Porto, *Lettere storiche scritte dall'anno MCIX al MDXII* (Venice, 1832), pp. 127–35. N.B. also Antonio Bonardi, "I Padovani ribelli alla Republica di Venezia (a. 1500–1530). Studio storico con Appendici di documenti inediti," *Miscellanea di storia veneta della R. Dep. Veneta di Storia Patria* 49 (1902) [= ser. 2, vol. 8]: 303–614.

17. ASV, Consiglio de' Capi de' X, Misto, Registro 36, 1513–1514, 80, dated 5 January 1513 Venetian style—i.e., modern 1514.

18. Sanudo, vol. 18, col. 199.

19. Sanudo, vol. 26 (Venice, 1889), ed. Stefani et al., col. 378, 19 January 1518 Venetian style (i.e., 1519).

20. For the plant, see Edgar Wind, *Pagan Mysteries in the Renaissance* (New Haven, Conn., and London, 1958), p. 123. On bridal colors and coiffures in Venice, see Francesco Sansovino, *Delle cose notabili* (Venice, 1561); idem, *Venezia città nobilissima* (Venice, 1663), p. 401; and Jacopo Morelli, "Delle solennità e pompe nuziali già usate presso li veneziani" (1793), in idem, *Operetto,* vol. 1 (Venice, 1820), pp. 148, 150.

21. ASV, Consiglio de' X, Misc. Codici: "unam vestem muliebrem rasi albi."

22. See Morelli, p. 147. Cf. Hans Ost, "Tizians 'Himmlische und irdische Liebe,'" *Wallraf-Richartz-Jahrbuch* 41 (1980): 101; and Wethey, vol. 3, p. 21. Whatever symbolic value the red may have, it also serves to associate the bride with the nude.

23. Sanudo, vol. 37, cols. 445, 456; also Stella Mary Newton, *The Dress of the Venetians, 1495–1525* (Aldershot, England, and Brookfield, Vt., 1988), p. 111.

24. Hope, *Titian* (London, 1980), pp. 34–37; followed by Rogers, "Sonnets" and "Decorum."

25. Paintings like this were displayed in bedrooms or in antechambers—e.g., Savoldo's reclining nude, displayed above a bed in the camera of Andrea Odoni, according to Marc'Antonio Michiel, writing in 1532; *Notizia di opere di disegno,* ed. Jacopo Morelli (Venice, 1800), p. 62. The vantage point implies that the *Sacred and Profane Love* was hung high on the wall.

26. The treatise by Titian's admirer Lodovico Dolce is a case in point, as its title makes clear; [*I saggi*] *Ammaestramenti, che appartengono alla honorevole, e virtuosa vita virginale, maritale, e vedovile* (rpt. Venice: Barezzo Barezzi, 1622). Similarly, when he refers to Laura Bagarotto in his holograph will, Aurelio identifies her as his wife; he never uses her name.

27. For Sodoma's *Allegory of Celestial Love,* see Roberto Bartalini in *Domenico Beccafumi e il suo tempo* (exhibition catalogue, Milan, 1990), pp. 242–43. Christian Love—that is, Charity—is traditionally represented with

a lamp and associated with the color red, which also lines the mantle of Sodoma's *Celestial Love*. The flame signifies God's love in the traditional imagery of Charity.

28. *Hypnerotomachia Poliphili*, quoted in Bartalini, ibid.

29. See epithalamia by Statius and by Claudian, cited by Ost, "Tizians," pp. 87–104.

30. Goffen, *Piety and Patronage in Renaissance Venice: Bellini, Titian, and the Franciscans* (New Haven, Conn., and London, 1986), p. 87.

31. *Institutione morale*, pp. 497–98, 505.

32. Frate Cherubino da Siena, *Regole della vita matrimoniale* (ca. 1450–81), ed. Francesco Zambrini and Carlo Negroni (Bologna, 1858), pp. 26, 27, citing Saint Paul on "cordial love."

33. Ost, "Tizians," pp. 87–104, notes that Statius also uses rabbits to suggest fertility. For fertility imagery in wedding decorations, see Andrew C. Minor and Bonner Mitchell, *A Renaissance Entertainment, Festivities for the Marriage of Cosimo I, Duke of Florence, in 1539* (Columbia, Mo., 1968), p. 74. Bagarotto and Aurelio eventually had two children, Giulia and Antonio; and Laura Bagarotto also became the affectionate stepmother of Aurelio's illegitimate son. See Aurelio's holograph will, transcribed and translated in the appendix to my essay in *Studies in the History of Art*.

34. A woman's glove may be the focus of desire and a sign of conquest, but also a "guarantor of chastity and protector of the flesh." See Mirollo, *Mannerism and Renaissance Poetry*, pp. 127–30, explaining the Petrarchan source of this imagery.

35. Quoted by Rogers, "Decorum," p. 59.

36. According to Saints Augustine and Jerome, a husband commits adultery if he loves his wife too much—i.e., more than God. See Jean-Louis Flandrin, "Sex in Married Life in the Early Middle Ages: The Church's Teaching and Behavioural Reality" (1982), in *Western Sexuality, Practice and Precept in Past and Present Times*, ed. Philippe Ariès and André Béjin, trans. Anthony Forster (series Family, Sexuality, and Social Relations in Past Times [Oxford and New York, 1985]), pp. 121–23. N.B. also Francesco Barbaro, who considered that the mother of a man's children is not his harlot and should not be the object of "excessive" love; see Margaret L. King, "Caldiera and the Barbaros on Marriage and the Family: Humanist Reflections of Venetian Realities," *Journal of Medieval and Renaissance Studies* 6 (1976): 19–50.

37. *Della institutione morale*, p. 445. For the opposite advice, cf. the first edition, *De la institutione di tutta la vita de l'huomo nato nobile e in città libera . . .* (Venice, Hieronumum Scrotum, 1542; rpt. 1543). See also Alessandra Del Fante, "Amore, famiglia e matrimonio nell' 'Institutione' di Alessandro Piccolomini," *Nuova rivista*

storica 68 (1984): 511–26, esp. 520–21. For changing attitudes toward women, increasingly positive already in the fifteenth century, see Stanley Chojnacki, "The Power of Love: Wives and Husbands in Late Medieval Venice," in *Women and Power in the Middle Ages*, ed. Mary Erler and Maryanne Kowalski (Athens, Ga., and London, 1988), pp. 126–48. N.B. that women had greater liberty in the Veneto and in Liguria than elsewhere in Italy; see Evelina Rinaldi, "La donna negli statuti del comune di Forlì, sec. XIV," *Studi storici* 18 (1909): 185; and Guido Ruggiero, *The Boundaries of Eros: Sex Crime and Sexuality in Renaissance Venice* (New York and Oxford, 1985, pp. 163–65). On Venetian feminism in the sixteenth century, see Patricia Labalme, "Venetian Women on Women: Three Early Modern Feminists," *Archivio veneto* 152 (1981): 81–109; and Constance Jordan, *Renaissance Feminism: Literary Texts and Political Models* (Ithaca, N.Y., and London, 1990), pp. 138–72 and passim.

38. The relation to Michelangelo's *Ezekiel*, completed c. 1510, was suggested by Johannes Wilde, *Venetian Art from Bellini to Titian* (Oxford, 1974), p. 131; see also Creighton Gilbert, "Some Findings on Early Works of Titian," *Art Bulletin* 62 (1980): 36–75, esp. 45.

39. See also Rogers, "Decorum," p. 66; but her implication that this is a progression from virgin to bride is incorrect. The widow Laura Bagarotto was of course not a virgin when she married Aurelio, and the "progression" is not linear but circular, as the nude returns our attention to the bride.

40. For humanist interpretations of these beliefs, see King, "Caldiera and the Barbaros," p. 32 and passim.

41. For the eventual acceptance of sexual intercourse as an expression of marital love, see Flandrin, "Sex in Married Life," pp. 114–29. Traditionally theologians had justified sexual intercourse on two grounds: to beget children and to fulfill the promise of the marriage contract. But after the thirteenth century, they added a third justification: marital coition was useful in combatting a spouse's lustful desires (ibid., p. 115). Only at the end of the sixteenth century did they admit that husbands and wives who embrace with no particular object in mind commit no sin—so long, of course, that they do nothing to impede procreation, still considered the primary purpose of sexual relations.

42. Pope Alexander III had emphasized in his decretal *Veniens ad Nos* the need for "present consent," freely given between parties, to create a valid marriage. "Future consent" creates an indissoluble marriage only if that consent is followed by sexual intercourse. This suggests in turn a distinction between betrothal (consent) and marriage (consummation); the idea of a preliminary stage in a process of marriage was thus incorporated in canon law. See James A. Brundage, *Law, Sex, and Christian Society in*

Medieval Europe (Chicago and London, 1987), pp. 334, 345; and Beatrice Gottlieb, "The Meaning of Clandestine Marriage," in *Family and Sexuality in French History*, ed. Robert Wheaton and Tamara K. Hareven (Philadelphia, 1980), pp. 49–83.

43. Yet the bride seems not to be aware of the nude, and it may be that her superiority is also characterized by invisibility. For this conception in the *Fête champêtre*, see Wind, *Pagan Mysteries*, p. 123, n. 1.

44. Medieval and Renaissance matrimony was accomplished over a period of time, sometimes quite protracted. See Morelli, "Delle solennità e pompe nuziali," pp. 137, 147–49, 167–69; and Gottlieb, "Clandestine Marriage," pp. 52, 72. On the symbolic gifts that mark these stages, see Christine Klapisch-Zuber, "The Griselda Complex: Dowry and Marriage Gifts in the Quattrocento," in Klapisch-Zuber, *Women, Family, and Ritual in Renaissance Italy*, trans. Lydia Cochrane (Chicago and London, 1985), pp. 231–33.

45. According to civil law and "common law," a woman was legally entitled to a dowry, which constituted her share of her father's estate, and which could be payable as a pre-inheritance—i.e., during his lifetime. But even after her father's death, his estate was responsible for payment of her dowry; that is, his heirs (the men of his lineage, and in some cases his widow, if specifically so designated by his will) were obligated to dower the man's daughter. It should also be noted that a dowry was a "disinheritance" in that it was never equivalent to a son's share in the father's estate.

46. Sanudo, vol. 8, col. 543, 17 July 1509.

47. Laura's petition to have her dowry restored, 5 January 1514, is ASV, Consiglio de' X, Misc., Reg. 83B, Vendite di beni dei ribelli di Padova, ff. 38v–40v. See also ASV, Consiglio de' Capi X, Misto, Registro 36, 1513–1514, 80, which I consulted at the suggestion of Dott.ssa Alessandra Sambo.

48. For the identification of the hand, see Neff, "Chancellery Secretaries," p. 252 n. 26. Aurelio is named in ASV, Consiglio de' X, Misc., Reg. 83B, Vendite di beni dei ribelli di Padova, f. 39.

49. Neff., pp. 210, 211, 340, 344 n. 2, 362, 363 on Aurelio's financial burdens and his property in 1514, citing ASV, Decima, 1514, B. 49, S.M. Zobenigo, no. 15. Laura Bagarotto's claim on her father's estate gives the value of property in the Padovano at 2,100 ducats; ASV, Cons. X, Miscell., Reg. 83B, Vendite di beni dei rebelli di Padova, dic. 1511–lug. 1516, ff. 38v–40v: This part of the register is in Aurelio's hand. See also ASV, Cons. X, Misti, reg. 35, cc. 93r–v, 12 September 1512; and Neff, "A Citizen in the Service of the Patrician State: The Career of Zaccaria de' Freschi," *Studi veneziani* n.s. 5 (1981): 57 n. 132.

50. For this motif in Italian art, see Creighton Gilbert,

"The Renaissance Portrait," review of *The Portrait in the Renaissance* by John Pope-Hennessy, *Burlington Magazine* 110 (1968): 281. The yoke of marriage has a classical origin—e.g., the bride is urged to submit to the "husband's yoke" in Statius, *Silvae*, pp. 28–29, I. ii. 162–69. Christian imagery implies that the yoke is shared, in keeping with the theory, if not always the practice, of Christian matrimony.

51. Keith Christiansen, "Lorenzo Lotto and the Tradition of Epithalamic Paintings," *Apollo* 124 (1986): 166–73.

52. Sansovino, *Venetia . . . descritta* (Venice, 1581), p. 121v. For the kind of education Aurelio received at the School of San Marco, see Felix Gilbert, "The Last Will of a Venetian Grand Chancellor," in *Philosophy and Humanism: Renaissance Essays in Honor of Paul Oskar Kristeller*, ed. Edward P. Mahoney (Leiden, 1976), pp. 508–10. For Aurelio's friendship with Bembo, see Robertson, "Honour, Love, and Truth," pp. 272–73 n. 21, 278, citing Bembo's letter, 27 August 1523, on the occasion of Aurelio's election as grand chancellor (Archivio Segreto Vat., MS Fondo Borghese, series 1, no. 175, fols. 144v–145). Aurelio was forced to resign from his office in the following year; Sanudo, vol. 36, cols. 413, 418, 421, 437, 441, 449, 456, 460, 464–65. He never fully recovered financially, politically, or socially from this disgrace, despite unceasing efforts at rehabilitation until his death in 1531. As for the *Sacred and Profane Love*, given the early style of the painting and the fact that no upper-class marriage could be hastily concluded in Renaissance Venice (and certainly not this one), we may surmise that Titian began work sometime before the restitution of Laura Bagarotto's dowry on 16 May 1514, a day before her marriage to Aurelio. If Titian received any kind of initial payment (which would have been customary), only Laura Bagarotto can have paid it. On the other hand, her wedding gown, part of her confiscated dowry, may not have been available to Titian until after 16 May 1514, assuming that he copied the garment in the painting. Thus it seems likely that the painting was commissioned before but completed after the Bagarotto-Aurelio marriage.

53. For the will, see the appendix in my essay in *Studies in the History of Art*. That their first child was named Giulia, for the child's maternal grandmother, was a noteworthy departure from the Venetian rule of honoring agnatic kinfolk and indicative of Laura Bagarotto's status. She remained unmarried after Aurelio's death in 1531, and thereafter moved their family back to Padua—another indication of her unusual independence, a prerogative endorsed by Aurelio in his codicil.

54. ASV, Testamenti Cesare Ziliol, Busta 1260, no. 768, 3v. Aurelio also appreciated his wife's love of his illegitimate son, Marco, as though he were her own child.

As J. Hajnal notes, the emotional content of a marriage, the relations between the couple and other relatives, "and other things cannot be the same . . . where a bride is . . . a girl of 16 and . . . [where] she is typically a woman of 24." See his "European Marriage Patterns in Perspective," p. 132, in *Population in History: Essays in Historical Demography,* ed. D. V. Glass and D.E.C. Eversley (Chicago, 1965).

55. Klapisch-Zuber, "An Ethnology of Marriage in the Age of Humanism," pp. 247–60, in idem, *Women, Family, and Ritual in Renaissance Italy,* an analysis of Marco Antonio Altieri, *Li nuptiali,* ca. 1506–9.

56. For ancient initiation rites and a different interpretation of Titian's relief, see Wind, *Pagan Mysteries,* pp. 124–25. He sees the protagonists as antithetical and distinct; I see the bride fulfilling the ideal of celestial love in marriage.

57. In Venice, every year on 31 January (the Transfer of Saint Mark), twelve deserving but impoverished girls were dowered by the Serenissima and married by the bishop in San Pietro di Castello, the cathedral of Venice. On one such occasion, in "ancient times," pirates from Trieste carried off the brides and their dowries, but the Venetians pursued them, killed the villains, and recovered the women and their treasures, before the Triestines could do their worst. See Edward Muir, *Civic Ritual in Renaissance Venice* (Princeton, N.J., 1981), pp. 135–55, esp. 136–38. The saga of the Marys, including its annual commemoration in the cathedral, implies a conception of marriage as a matter of public concern; see E. Volpi, *Storie intime di Venezia repubblica* (Venice, 1893), pp. 250–51. For staged violence at a fifteenth-century wedding celebration, see Flaminio Cornelio, *Opuscula quatuor* (Venice, 1758), pp. 167–72; and also Klapisch-Zuber, "The 'Mattinata' in Medieval Italy," pp. 261–82, in *Women, Family, and Ritual.* For other iconographic possibilities, see Maurizio Calvesi, "Un amore per Venere e Proserpina," *Art e dossier* 4 (1989): 27–34.

58. Carla Bernardi et al., *Mostra dell'arredamento del Cinquecento veneto* (Vicenza, 1973), p. 11, illustrates a *cassone* with paintings by Bartolomeo Montagna in a private collection in Milan. Left to right the scenes represent the Slaying of a Virgin, Aeneas Fleeing Troy, and a Scene of Homage.

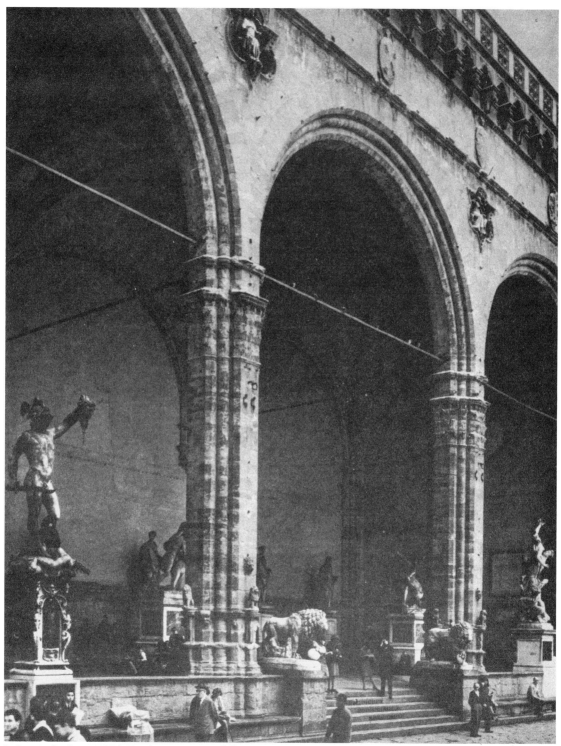

1. Loggia dei Lanzi, 1376–82. Florence, Piazza della Signoria.

THE LOGGIA DEI LANZI

A Showcase of Female Subjugation

YAEL EVEN

As a politically oriented sculpture gallery, the Loggia dei Lanzi on the Piazza della Signoria in Florence (1376–82) [1] is an artistic arena for patriarchal propaganda.[1] The piazza's most publicly acclaimed artworks—Benvenuto Cellini's bronze *Perseus and Medusa* (1545–54) [2] and Giovanni da Bologna's marble *Rape of a Sabine* (1581–83) [3]—were conceived both as overt and covert symbols of ruling powers. Depicting popular heroic exploits from classical antiquity, the two statues explicitly glorify the Medici reigns of Cosimo I and Francesco I, who, respectively, commissioned them. At the same time, presenting these mythical feats of bravery as sexualized conquests wherein male protagonists subdue female adversaries, they proclaim as well, perhaps subconsciously, men's longed-for control over women.[2]

The Loggia dei Lanzi, originally a ceremonial gallery for government officials, was built on the south side of the Piazza della Signoria at right

angles with the Palazzo Vecchio [4]. In the sixteenth century, it was adorned with statues, and it gradually became more of what Carol Duncan in another context has described as a "ritual setting" for "male transcendence" and a "powerful engine of ideology."[3] Donatello's bronze *Judith and Holofernes* (1456–57) [5], the first image of rule to be placed under the west arch, in celebration in 1506 of the Florentine citizenry[4] and the only one to display the courageous deed of a biblical female hero, was destined to be eclipsed by other, more patriarchially sanctioned images. In 1554, its dominant presence was counteracted by Cellini's *Perseus and Medusa*, which was placed beside it under the east arch. Less than thirty years later, it was replaced altogether by *Rape of a Sabine* by Giovanni da Bologna (also known as Giambologna) and was removed, partly away from the public eye, to the south arch, the only location in the gallery that does not face the Piazza della Signoria. Referred to in 1504 as "a deadly symbol" that had not found favor with the stars,[5] Donatello's *Judith and Holofernes* no longer graces the Loggia dei Lanzi. In 1919, it was moved to the back of the ceremonial parapet of the Palazzo Vecchio [4], where it remained until 1980, when it was placed inside the palace.[6] The celebrated

This essay was developed from a paper read at the Sixteenth-Century Studies Conference and at the University of Missouri–St. Louis, October 1990, and published in *Woman's Art Journal* 12, no. 1 (Spring/Summer 1991): 10–14. Revised by the author for this edition. Copyright © 1991 by Yael Even. Reprinted by permission of the author and *Woman's Art Journal*.

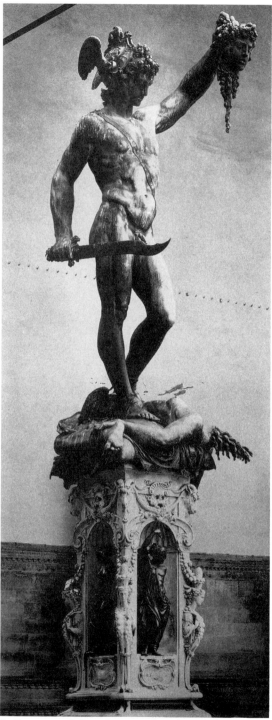

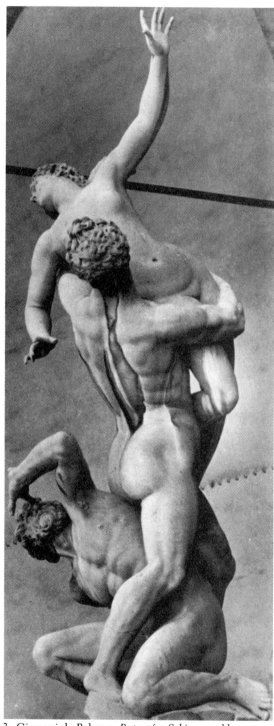

2. Benvenuto Cellini, *Perseus and Medusa*, bronze, 1545–54. Florence, Piazza della Signoria, Loggia dei Lanzi.

3. Giovanni da Bologna, *Rape of a Sabine*, marble, 1581–83. Florence, Piazza della Signoria, Loggia dei Lanzi.

4. Florence, Piazza della Signoria with Palazzo Vecchio, 1290–ca.1320, and Loggia dei Lanzi, 1376–82.

sculpture was supplanted not only by Cellini's equally renowned *Perseus and Medusa* and Giambologna's famous *Rape of a Sabine,* but more recently also by Pio Fedi's less distinguished *Rape of Polyxana* (1866), another conspicuous image of female subjugation on display between the gallery's east and south arches.

The relentless attempt all but to dispose of the *Judith and Holofernes* was a blatant manifestation of misogynous attitudes, yet this verifiable fact has not been fully examined. The repeated displacement of Donatello's highly regarded sculpture was so uncommon a course of action that it was noted as excessive in contemporary accounts.[7] Resentment or unease about the statue's female protagonist surfaced at the time that the sculpture was granted public status. Despite its origins as a private commission by Piero de' Medici about 1456, the *Judith and Holofernes* evolved into a civic monument as soon as it had been completed. Records reveal that one of its inscriptions was a dedication by its patron to the invincibility of the Florentine republic.[8] Thus the statue came to function as a symbol of republican virtue. In 1495, following the expulsion of the Medici from Florence, it became the property of the government as well as a landmark of the commune. Transferred from the garden of the Palazzo Medici to the ceremonial parapet next to the entrance of the Palazzo Vecchio, the *Judith and Holofernes* heralded the transformation of the Piazza della Signoria into the political center of the city.

Public awareness of the significance of the sculpture's location there arose in 1504 during the debates concerning the placement of the newly completed *David* by Michelangelo (1501–4, Accademia, Florence).[9] At this time the monumental marble statue of David was recognized as the supreme symbol of republican virtue, which resulted, in part, in a devaluation of Donatello's much smaller bronze statue as a personification of the state. Moreover, the decision to move the *David* from the cathedral to the square entailed a reassessment of the central vantage point that the

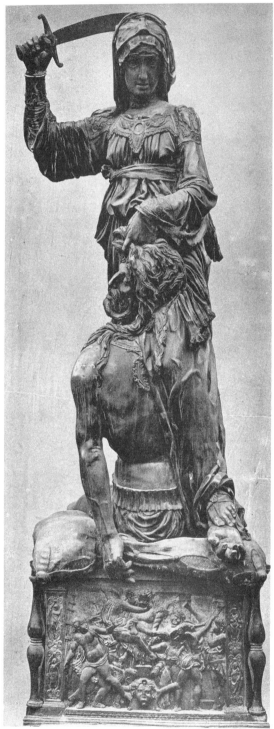

5. Donatello, *Judith and Holofernes*, bronze, 1456–57. Florence, Piazza della Signoria.

Judith had occupied since 1495. Of the arguments voiced in this regard, the most revealing and influential was that of Francesco di Lorenzo Filarete, the representative of the Signoria, the Florentine governing body. Like other members of the appointed committee, he recommended the substitution of the *David* for the *Judith*. More important, he discredited Donatello's image, which he described as a metaphor of death, and deplored its unsuitability, because it presented a female hero slaying a male adversary. Filarete stated, "It is not fitting for the Republic—especially when our emblems are the cross and the lily—and I say it is not fitting that the woman should kill the man."[10] The sculpture was removed to the courtyard of the Palazzo Vecchio (1504) and then to the Loggia dei Lanzi (1506), where, however, it was not fated to remain for long.

Benvenuto Cellini was the first to restore patriarchal order in this public gallery when he planned his *Perseus and Medusa* more in direct competition with Donatello's *Judith and Holofernes* than as a pendant to it.[11] Symbolizing what Margaret Carroll has described as Cosimo I's "absolutist conception of political rule,"[12] the *Perseus and Medusa* was designed to downplay the symbolism of the *Judith and Holofernes,* which had come to represent the struggles against tyranny of the now-defunct Florentine republic. Indeed, commissioned in 1545, the *Perseus and Medusa* was to celebrate the grand duke's success, two years earlier, in convincing Charles V to withdraw his Spanish troops from the Fortezza in Florence and the port of Piombino. It was to invoke a mythological scene featured on a medal honoring his predecessor Alessandro de' Medici, and thus glorify not only his own triumph but also that of the Medici dynasty.[13] Officially, Cellini's statue was to commemorate Cosimo I's move from the Palazzo Medici to the Palazzo Vecchio in 1540, and it became one of the numerous metaphors of his power in the Piazza della Signoria. Unofficially, however, it must have been calculated to undermine the impact of what had been said to be the distasteful beheading in public of a male adversary by a female protagonist.

The subject of Cellini's bronze group was perfectly suited for this task. As Marina Warner has observed, in ancient Greek culture Medusa's downfall at the hands of Perseus, like the Chimaera's death by Bellerophon, represented the defeat of matriarchy.[14] According to Warner, the decapitation of the detested Gorgon, later to evolve into the Freudian symbol for female castration, became "the expression of the required subordination of wives and mothers in patrilineage."[15] That Cellini chose to reinforce this traditional notion in order to deflect the challenge of Donatello's portrayal is evident in his unprecedented conception of Medusa's destruction. Like the *Judith*, the *Perseus and Medusa* features a defeated figure at the bottom of the composition. Thus, like the *Judith*, it was designed to personify the triumph of Virtue over Vice.[16] Such a conception deviates from earlier interpretations of the Medusa myth, most of which show only the valiant hero with the severed head in his hand [6].[17]

The decision to introduce the figure of Medusa was made by the artist and not the patron, and was not motivated by the wish to promote the political symbolism of the sculpture. As Cellini records in his autobiography: "The Duke requested, that I make a statue of Perseus . . . with the said head in hand, and nothing else. I made it . . . with the said head in hand . . . and in addition with Medusa's entire body under foot."[18] Nor could such a thematic choice have been prompted by mere stylistic considerations, as Pope-Hennessy seems to suggest.[19] Had Cellini really intended to create a composition that would complement Donatello's, he might have presented Medusa seated, like Holofernes, or perhaps kneeling rather than reclining.[20] Two analogous contemporary sculptural groups, Michelangelo's *Victory* (1528–29) in the nearby Palazzo Vecchio and Baccio Bandinelli's *Hercules and Cacus* (1534) in front of the palace, portray the subdued figures as crouching. Presenting Medusa's body sprawled naked under Perseus' feet [7],[21] the sculptor rendered her destruction more absolute. In addition, displaying the headless body more alive than dead,[22] he conveyed her total subjugation as a sexual conquest.

6. Etruscan, *Perseus*, bronze, ca. 350 B.C. Hamburg, Museum für Kunst und Gewerbe.

Cellini's hero towers not over the hideously decapitated female monster described in literary sources as having impenetrable scales and double finlike wings,[23] but over a titillatingly headless female body, a veritable sex object. Under his feet, the mutilated corpse turns into a voluptuous body seething with energy and desire. It is made to wrap its legs and arms around the pedestal as if in sexual bondage and to lie still, open and waiting. Generated in an age that produced so many depictions of seductive female nudes, very few are as explicitly erotic as this one. What an antithesis to Donatello's Holofernes, who sits, as if in prayer, his dignity still intact![24] What a visual rebuttal to the threat implied in an image of the unbearable victory of a woman over a man! Not only does

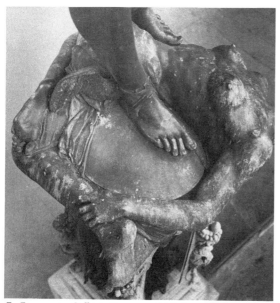

7. Benvenuto Cellini, *Perseus and Medusa*, detail.

Cellini's portrayal of Medusa attest to the masculine prowess of Perseus, it also encapsulates many a male sexual fantasy even as it epitomizes men's belief in their superiority over women.

Unlike the severed head, which functions only as a marginal component of the statue as a whole, the decapitated body was evidently not envisioned as marginal. Cellini's preoccupation with this figure, his proper brainchild, manifests itself in the various changes that the figure underwent during the planning and casting phases of the work. The surviving models in wax [8] and bronze display Medusa in different positions, first dressed and then naked. Based on studies of the sixteen-year-old Dorotea di Giovanni, the artist's mistress who was to be the mother of his son,[25] they attest to the special importance that the female figure had in the artist's eyes. Why else would he have cast the female nude beneath Perseus' feet in the kind of bronze documented to have been superior to that used for the figure of Perseus? For what other reason did he refer to it endearingly as *"mia femina"* (*my* woman), and to the heroic figure of the protagonist only as *"l'anima del Perseo"* (Perseus' soul)?[26]

Pope-Hennessy, who has described Medusa's body as "Maillol-like," connected the pose of Medusa with that of the Venus who appears in the center of Bronzino's *Exposure of Luxury* (1546, National Gallery, London),[27] suggesting that the similarities between the two figures were "fostered by common aesthetic convictions and common structural principles." As convincing and enlightening as this observation may be, it is nevertheless limited in scope. Pope-Hennessy, who compares Cellini's female nude to Bronzino's only in terms of style, does not find it necessary to mention how similarly erotic they are.[28] Furthermore, he does not appear to notice that, despite the formal resemblance, the two are made to play different roles: Venus that of power, and Medusa that of powerlessness.[29]

Most scholars support the traditional view that Cellini's *Perseus and Medusa* was planned to complement, not undermine, Donatello's *Judith and Holofernes* and that the two were to be experienced as matching companion pieces. Yet none of them seems to think it strange that less than thirty years after its installation in the Loggia dei Lanzi, the *Judith* was taken away from its originally appointed location, whereas the *Perseus* remained.[30] The fact that Donatello's homage to a female hero, who put the enemy of her people to death, was made to concede its prestigious spot in the gallery has never been related to the apparently unpleasant connotations of the subject. Many, if not all, art historians have neglected to mention that this acclaimed monument was moved in 1582 from the west arch, where it had been in full view of the Piazza della Signoria, to the south arch, the only location in the Loggia that does not face the public square. Very few have found it worth noting that the *Judith and Holofernes* was not only taken away from the west arch but supplanted by another conspicuous tribute to a male hero who violated an unsuspecting female—namely, *Rape of a Sabine* by Giovanni da Bologna. Nor has any of them considered it important to point out that in 1919 the *Judith and Holofernes* was for all time removed from the Loggia dei Lanzi and placed in the back of the ceremonial parapet of the Palazzo Vecchio, as far

away as possible from Michelangelo's *David* and Bandinelli's *Hercules and Cacus* [4].[31] That Donatello's bronze group was kept for safety's sake in the Museo Nazionale during the First World War seems to be the only explanation, or rather excuse, provided by critics for its removal from the south arch of the Loggia dei Lanzi.

The substitution in 1582 of the *Rape of a Sabine* for the *Judith and Holofernes* under the west arch of the Loggia dei Lanzi differed significantly from the substitution in 1504 of Michelangelo's *David* for the *Judith and Holofernes* on the ceremonial parapet of the Palazzo Vecchio. The removal of Donatello's sculpture from the parapet can be interpreted, at least in part, as the replacement of an old monument with a modern one. Since Donatello's *Judith and Holofernes* and Michelangelo's *David* were regarded as true counterparts both in subject and symbolism,[32] they were perfectly interchangeable. Presenting the coura-

geous struggles of two biblical heroes who saved their nation, they came to embody the courageous spirit of republican Florence.[33] Thus the conception of the *David* did not directly challenge the notion of a female hero. And, although displaced by the colossal *David* on the parapet of the Palazzo Vecchio, Donatello's *Judith* was not denied public exposure nor robbed of its public function in its new location under the west arch of the Loggia dei Lanzi. On the other hand, the removal of the *Judith* less than thirty years later from the west arch and its replacement by Giambologna's colossal tribute to Medicean autocratic rule, one which features a subjugated female victim, is a manifestation of misogynous sentiments.

Unlike the *Perseus and Medusa*, the *Rape of a Sabine* was not the product of a Medici commission. In deviation from custom, the project was initiated by the artist, Giambologna, and was already under way when Francesco I decided to become its patron. According to John Shearman, the marble statue originated primarily as an experimentation in form and, like many other Mannerist works, was conceived as "the expression of artistic qualities" or, in Charles Avery's words, "purely as a compositional exercise."[34] One of the contemporary sources that confirm such an interpretation, Raffaello Borghini's *Il Riposo* of 1584, reads in part, "And thus [the sculptor] made, solely to show his excellence in art, and without having any subject in mind, a bold youth who snatches a most beautiful girl from an old man."[35] Borghini tells us that Giambologna, who was intent on demonstrating his virtuosity, remained indifferent to the specific meaning of his would-be masterpiece.

One cannot deny that Giambologna's concern with the formal aspects of his marble statue dictated his conception of it. Yet his recorded disinterest in the subject appears actually to have been a disinterest in the type of rape scene that this work was to feature.[36] In 1579, the sculptor indicated in a letter that one of his small bronze groups "might represent the Rape of Helen, or perhaps of Proserpine, or even of one of the Sabines."[37] A similar indifference to the particular incident of rape, combined with a patriarchal

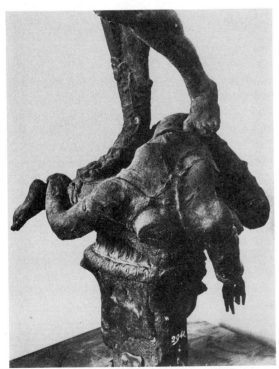

8. Benvenuto Cellini, model for *Perseus and Medusa*, detail, wax. Florence, Museo Nazionale.

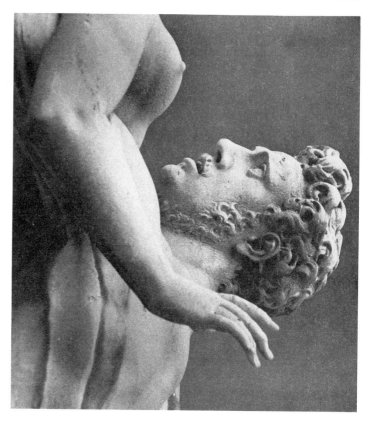

9. Giovanni da Bologna, *Rape of a Sabine*, detail.

heroization of rape itself, was expressed by several contemporary authors, who, on seeing the *Rape of a Sabine* in the Loggia dei Lanzi shortly after its completion, were neither certain nor overly eager to ascertain which mythical account of female subjugation was represented by the monumental sculpture. The Englishman Fynes Moryson, for example, described it in 1594 as "one of a virgin taken by force, and of the ravisher beating her keeper and treading him under his feet."[38]

We have no way of knowing whether Francesco I's decision to appropriate Giambologna's *Rape of a Sabine* was prompted by its formal appeal or by the political significance traditionally associated with "heroic" scenes of abduction. Margaret Carroll insists that, in his choice, the grand duke typifies most princes of the period, who "came to appreciate the particular luster rape scenes could give to their own claims to absolute sovereignty."[39] Nevertheless, questions remain. What

motivated the Medicean ruler to substitute Giambologna's *Rape of a Sabine* for Donatello's *Judith and Holofernes* in the Loggia dei Lanzi rather than for one of the less renowned monuments that had by then been added to the Piazza della Signoria? Why did he not order it installed in place of Baccio Bandinelli's much-ridiculed *Hercules and Cacus* on the ceremonial parapet of the Palazzo Vecchio next to Michelangelo's *David*? Was Francesco I reluctant to remove the *Hercules and Cacus* simply because the statue had been conceived at the request of Alessandro de' Medici, the first "Duke of the Florentine Republic"? Or was he trying once and for all to eliminate Donatello's *Judith and Holofernes,* the only metaphor of republican virtue in the square featuring a female protagonist, and to supplant it with a forceful image of patriarchal rule?

What most distinguishes Giambologna's *Rape of a Sabine* is its effectiveness in disguising the

brutality of the scene that it represents.[40] Within this amazingly compact rendition of three gracefully intertwined nudes, the movements that bind the male aggressor with his female victim evoke the idea of love, not war. Firmly but gently, the young Roman lifts the Sabine as if saving her from the older man who kneels at his feet, and in beautifully coordinated motions the two unite in what resembles an embrace. Unlike Cellini's Perseus, Bandinelli's Hercules, or Michelangelo's David, the man is unarmed and seems to be harmless.[41] Although his captive is allowed conventional expressions and gestures of distress, she remains unscathed. His slightly open mouth almost touches her breast; his eyes are wide open, as if in rapture [9]. The violence of his action is not apparent. Expertly masked, such a representation of rape exemplifies Susan Brownmiller's observation that "down through the ages, imperial conquest, exploits of valor and expressions of love have gone hand in hand with violence to women in thought and in deed."[42] Giambologna's portrayal of the Sabine's reaction to her abductor's grasp differs, for example, from the portrayal of Antaeus' reaction to Hercules' grasp in *Hercules Slaying Antaeus* (ca. 1578, Kunsthistorisches Museum, Vienna), a small bronze group made in collaboration with his assistant Antonio Susini.[43] Whereas Antaeus is depicted trying to push his attacker away, the Sabine shows no sign of objection or any attempt to defend herself.[44] Completely passive, she embodies the misogynous notion that, in the words of Germaine Greer, "women subconsciously or even consciously desire to be raped, that rape liberates their basic animality, and that, like she-cats, they want to be bloodily subdued."[45]

Giambologna captures the essence of Ovid's description of the violent episode that the statue was to commemorate. Of the rape of the Sabine women Ovid wrote, "Grant me such wage and I'll enlist today."[46] As Margaret Carroll points out, the "Roman celebrant of love" himself extolled sexual violence by assuring his readers, "She whom a sudden assault has taken by surprise is pleased."[47] Indeed, Giambologna's invocation of love and female pleasure helps disguise the actual incident of rape.

For the past three centuries, the Loggia dei Lanzi in the Piazza della Signoria in Florence has functioned as a gallery of statues designated to symbolize civic virtues. Even though it no longer serves overtly as a political arena, the two popular masterpieces that it still features, Cellini's *Perseus and Medusa* and Giambologna's *Rape of a Sabine*, continue to act as propagandistic artifacts that convey a powerful message: the political and biological subjugation of the female by the male. However, the aesthetic appeal of the two sculptural ensembles is so strong that it masks the subliminal message of the classical myths that they represent. It is so overwhelming as to make us forget that Donatello's displaced female hero Judith, now conspicuous in her absence, once reigned alone over the Loggia dei Lanzi, as she had, once before, over the entire Piazza della Signoria.

NOTES

I am grateful to Mary Garrard, whose invaluable suggestions helped me develop what began as as paper into an article. I also thank the Center for International Studies at the University of Missouri–Saint Louis for its ongoing support of my research.

1. The Loggia dei Lanzi was built by Benci di Cione and Simone Talenti after a design by Orcagna. For the related documents, see Karl Frey, *Die Loggia dei Lanzi zu Florenz* (Berlin: Wilhelm Hertz, 1885). One of the most recent interesting examinations of the loggia, "The Loggia dei Lanzi and the Architecture of Tyranny," was presented by Robert Russell at the 24th International Congress on Medieval Studies in 1989.

2. Margaret Carroll, who addresses the celebratory aspect of artwork featuring rape scenes in "The Erotics of Absolutism: Rubens and the Mystification of Sexual Violence," *Representations* 25 (Winter 1989): pp. 3–29 (ch. 8 in this volume), notes of Giambologna's *Rape of a Sa-*

bine (p. 10) that this "public monument at once thematizes the grand duke's dominion over his subjects and rivals, and at the same time . . . the dominion those male subjects may have hoped to enjoy over the women in their own homes."

3. See Carol Duncan, "The MoMA's Hot Mamas," *Art Journal,* Summer 1989, pp. 171–78, which is a provocative and enlightening study of the many images of female nudes that "masculinize" the "social environment" of the Museum of Modern Art in New York, where they are exhibited, and turn our "spiritual quest" there into "a male quest"; reprinted in this volume.

4. H. W. Janson, *The Sculpture of Donatello* (Princeton, N.J.: Princeton University Press, 1963), p. 198, and Charles Seymour, Jr., *Michelangelo's David: A Search for Identity* (Pittsburgh: University of Pittsburgh Press, 1967), p. 145.

5. This comment was made by Francesco di Lorenzo Filarete, the representative of the Signoria, in 1504. Janson, *The Sculpture of Donatello,* p. 199, and Seymour, *Michelangelo's David,* p. 145.

6. During the First World War the *Judith and Holofernes* was kept in the Museo Nazionale. See Janson, *The Sculpture of Donatello,* p. 201.

7. Janson, *The Sculpture of Donatello,* pp. 198ff., and Seymour, *Michelangelo's David,* pp. 140ff. See, in particular, Agostino Lapini's comment of 1582: "The bronze Judith was installed beneath the arch of the great loggia which faces the new street of the magistrates; there, maybe, she will remain forever, *since she has been moved around so many times. . . .*" (Italics mine.) Published in translation in Janson, *The Sculpture of Donatello,* p. 199.

8. Michael Greenhalgh, *Donatello and His Sources* (New York: Holmes & Meier, 1982), p. 181.

9. Seymour, *Michelangelo's David,* pp. 140ff.

10. ". . . e' non sta bene, havendo noi la + per insegnia e el giglio, non sta bene che la donna uccida lhommo . . ." (sic). For the bibliographical reference see n. 5.

11. Michael Gill's comment in *Images of the Body; Aspects of the Nude* (New York: Doubleday, 1989), pp. 192–93, is revealing: "Not so large as the *David,* [*Judith*] is quite as stern and confident. Moreover, she is in the act of lopping off the head of Holofernes, *with whom she has just spent a torrid evening.* Opposite, under the arch of the Loggia dei Lanzi, *the male gets his own back.*" (Italics mine.)

12. Carroll, "The Erotics of Absolutism," p. 6. See also n. 2.

13. John Pope-Hennessy, *Cellini* (New York: Abbeville Press, 1985), pp. 165, 168. See also n. 18.

14. In *Monuments and Maidens; The Allegory of the Female Form* (New York: Atheneum, 1985), pp. 108–14, Marina Warner studies the myth of Medusa in relation to

that of Athena. Her analysis includes summaries and citations from Sigmund Freud's, Robert Graves's, and Catherine Gallagher's respective examinations of the subject.

15. Ibid., p. 111.

16. Mary D. Garrard, *Artemisia Gentileschi; The Image of the Female Hero in Italian Baroque Art* (Princeton, N.J.: Princeton University Press, 1989), pp. 285–86. For Garrard's comprehensive review and analysis of the iconography of Judith, see pp. 286ff. See also Greenhalgh, *Donatello and His Sources,* p. 182.

17. In addition to the Etruscan bronze statuette reproduced in fig. 6, see Francesco del Prato's medal for Alessandro de' Medici, Cosimo I's predecessor, reported to have inspired the latter's plans for Cellini's *Perseus and Medusa* in Pope-Hennessy, *Cellini,* fig. 52.

18. F. Tassi, *Vita di Benvenuto Cellini . . .* (Florence, 1929), pp. 3, 334–42: "Eccellentissimo Signor Duca mi commisse, che io gli facessi una Statua di un Perseo . . . colla testa di Medusa in mano, e non altro. Io lo feci . . . con la detta testa in mano . . . e *di piu con il corpo tuto di Medusa sotto i piedi*" (sic; italics and translation mine). See also Pope-Hennessy, *Cellini,* p. 306 n. 9.

19. Pope-Hennessy, *Cellini,* pp. 168–69.

20. Warner (*Monuments and Maidens,* p. 109) mentions a metope from the temple of Selinus in Sicily (sixth century B.C.; fig. 30) that displays the figure of Medusa kneeling, as if about to flee, at Perseus' feet.

21. In "The Erotics of Absolutism," p. 6, Carroll quotes a passage from Machiavelli's *The Prince* of 1513, part of which bears repetition here: "Fortune is a woman and if you wish to keep her *under* it is necessary to beat and ill use her" (italics mine).

22. According to Giorgio Castelfranco in "Il Perseo da vicino," *Emporium* 43 (1939): 119, Medusa's body is "un nudo bellissimo, ancora respirante" (a most beautiful nude, still breathing).

23. Warner, *Monuments and Maidens,* p. 108.

24. Cellini's rendition of the decapitated Medusa violates Mannerist decorum. In the "more cultured age" of the sixteenth century, public executions—such as those of Anne Boleyn, Mary Queen of Scots, and Charles I—were staged as artful performances where the scaffold resembled an altar and the victim a dignified Christian martyr. See S. Y. Edgerton, Jr., "*Maniera* and *Mannaia:* Decorum and Decapitation in the Sixteenth Century," in *The Meaning of Mannerism,* eds. F. W. Robinson and S. G. Nichols, Jr. (Hanover, N.H.: University Press of New England, 1982), pp. 67ff.

25. Pope-Hennessy, *Cellini,* p. 178.

26. Ibid., pp. 180 and 172. Italics and translation mine.

27. Ibid., pp. 182–83 and fig. 61.

28. See Liana Cheney, "Disguised Eroticism and Sexual Fantasy in Sixteenth- and Seventeenth-Century Art,"

Eros in the Mind's Eye, ed. D. Palumbo (Westport, Conn.: Greenwood Press, 1986), pp. 24–29.

29. I am grateful to Mary Garrard for sharing this observation with me.

30. See, for example, Charles Avery (*Giambologna: The Complete Sculpture* [Mt. Kisco, N.Y.: Moyer Bell, 1987], p. 114), who comments that the *Rape of a Sabine*'s substitution for the *Judith and Holofernes* "destroys the visual harmony that had existed since 1554 between the Quattrocento bronze group and Cellini's counterpart . . . which had been conceived from the start as its Cinquecento pendant."

31. Greenhalgh, who states that even at the back of the ceremonial parapet, the impact that the *Judith and Holofernes* had on travelers was often greater than that of the *David* (*Donatello and His Sources*, p. 182), cites a comment by an anonymous Frenchman at the beginning of the nineteenth century: "Under the same portico there is a statue of David triumphing over Goliath."

32. Greenhalgh, *Donatello and His Sources*, pp. 181ff.

33. Ibid., pp. 182ff.; see also Garrard's comment in *Artemisia Gentileschi*, p. 286: "The *Judith* of Donatello could fill, as did other Quattrocento *Davids*, a metaphoric role first conceived for an ancient chosen people, the Israelites, and now suited to a Renaissance city-state in its struggle against modern political tyrants."

34. John Shearman, *Mannerism* (Middlesex, England: Penguin Books, 1967), p. 162. Avery, *Giambologna*, p. 109.

35. Shearman, *Mannerism*, p. 162.

36. Carroll, who refers to the subject of Giambologna's sculpture as "a *generic* rape scene," points out that it "is only ambiguous if one tries to link it to a particular historical narrative." See her "The Erotics of Absolutism," p. 7.

37. Shearman, *Mannerism*, p. 163.

38. Avery, *Giambologna*, p. 112. Moryson's comment is typical of the kind of outlook that, in Duncan's words, "masculinize[s] the . . . space [of the Loggia dei Lanzi] with great efficiency." See Duncan, "The MoMA's Hot Mamas," p. 173.

39. Carroll, "The Erotics of Absolutism," p. 5.

40. Walter Friedlander (*Nicolas Poussin: A New Approach* [New York: Harry N. Abrams, n.d.], p. 142), who describes the *Rape of a Sabine* as the "strongest, most popular representation [of] the much admired patriotism . . . in early Rome that permitted . . . even a ruthless and barbarous [act] which would assure the future of the nation," remains one of the few art historians who has commented that "it shows . . . the struggle of women against masculine brutality, with a sexual connotation."

41. Giambologna's Samson, who slays a Philistine (1561–62, Victoria and Albert Museum, London; Avery, *Giambologna*, fig. 10), and his Hercules, who slays a centaur (1595–1600, Loggia dei Lanzi, Florence; ibid., fig. 110), are both armed.

42. Susan Brownmiller, *Against Our Will: Men, Women and Rape* (New York: Simon & Schuster, 1975), p. 289.

43. Avery, *Giambologna*, fig. 141.

44. Diane Wolfthal, who is currently writing a book entitled *Images of Rape: The "Heroic" Tradition and Its Alternatives*, addressed this issue in the paper "Renaissance Images of Rape: Some Considerations," presented at the Sixteenth-Century Studies Conference in 1988.

45. Germaine Greer, "Seduction Is a Four-Letter Word," *Rape Victimology*, in ed. L. G. Schultz (Springfield, Ill.: Charles C. Thomas, 1975), p. 374.

46. Brownmiller, *Against Our Will*, p. 289.

47. Carroll, "The Erotics of Absolutism," pp. 3–4.

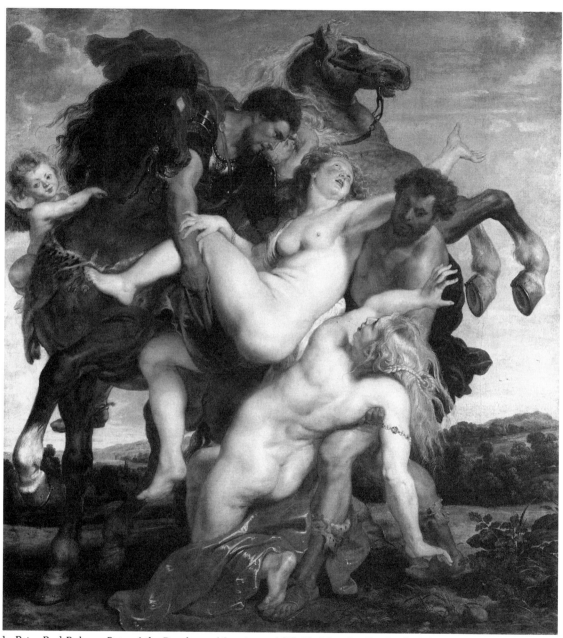

1. Peter Paul Rubens, *Rape of the Daughters of Leucippus*, 1615–18. Munich, Alte Pinakothek.

8

THE EROTICS OF ABSOLUTISM

Rubens and the Mystification of Sexual Violence

MARGARET D. CARROLL

Rubens's *Rape of the Daughters of Leucippus* confronts its viewers with an interpretative dilemma [1].[1] Painted about 1615 to 1618, the life-size composition illustrates the story recounted by Theocritus and Ovid of how the twin brothers Castor and Pollux (called the Dioscuri) forcibly abducted and later married the daughters of King Leucippus.[2] Rubens's depiction of the abduction is marked by some striking ambiguities: an equivocation between violence and solicitude in the demeanor of the brothers, and an equivocation between resistance and gratification in the response of the sisters. The spirited ebullience and sensual appeal of the group work to override our darker reflections about the coercive nature of the abduction. For these reasons many viewers have wanted to discount the predatory violence of the brothers' act and to interpret the painting in a benign spirit, perhaps as a Neoplatonic allegory of the progress of the soul toward heaven, or as an allegory of marriage.[3] Although I agree that a reference to marriage may be at play here, I also believe that any interpretation of the painting is inadequate that does not attempt to come to terms with it as a celebratory depiction of sexual violence and of the forcible subjugation of women by men.

Intimations of violence are embedded in the composition of the painting, which is modeled on an earlier drawing Rubens made after Leonardo da Vinci's *Battle of Anghiari* [2].[4] Rubens appropriates Leonardo's device of the parallel bodies of horses in the battle scene to align the women's bodies along parallel axes in the abduction, and Rubens inverts Leonardo's arrangement of facing warriors placed above converging horses' heads by placing matched horses' heads above converging human heads in the *Leucippus*. Rubens even takes up the lozenge design of Leonardo's group, though drawing it now into a more tightly packed equilateral diamond. Rubens's interlocking figures are patterned after the *Battle of Anghiari* in such a way as to charge the erotic action with the clashing energies of Leonardo's battle scene, even though the warriors' grimaces of rage and horror are replaced in the later canvas by a register of more tender expressions. The effect is to suggest to the viewer the violence and the pleasurability of rape at the same time.

The pleasures of sexual violence had long been championed in Ovid's *Art of Loving*, where in-

From *Representations* 25 (Winter 1989): 3–29. Copyright © 1989 by Margaret D. Carroll. Reprinted by permission of the author and the University of California Press.

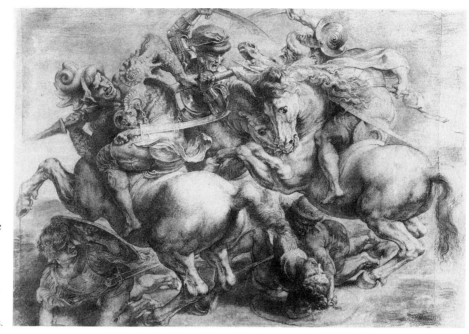

2. Peter Paul Rubens, copy of the *Battle of Anghiari* by Leonardo da Vinci. Pen and wash with gray and white body color on paper, ca. 1615. Paris, Louvre, Cabinet des Dessins.

deed this particular rape—by the Dioscuri of the sisters Phoebe and Hilaira—was cited as an example of how a lover might conquer the object of his desire by using force:

Though she give them not, yet take the kisses she does not give. Perhaps she will struggle at first and cry, "You villain!" Yet she will wish to be beaten in the struggle. . . . He who has taken kisses, if he take not the rest beside, will deserve to lose even what was granted. . . . You may use force; women like you to use it. . . . She whom a sudden assault has taken by storm is pleased. . . . But she who, when she might have been compelled, departs untouched . . . will yet be sad. Phoebe suffered violence, violence was used against her sister: each ravisher found favour with the one he ravished.[5]

In applying this passage from Ovid to Rubens's painting, one art historian draws the conclusion that Rubens is celebrating the triumph of natural impulse over conventional inhibition: "The battle of the sexes is a necessity of nature. With Rubens it is a primal impulse of life, a fight for unification. . . . In being raped Phoebe discovers her destiny as a woman. Her rape reveals and enhances her nature."[6] In claiming something like a truth value

for Rubens's celebratory depiction of this rape, this scholar mystifies it in terms of a misguided notion of what is natural in human sexuality. My position is that we must consider Rubens's painting not as a revelation of primal human nature but as a phenomenon of sixteenth- and seventeenth-century European culture.[7] In particular we may view Rubens's painting as issuing from a tradition that emerged among princely patrons at the time, of incorporating large-scale mythological rape scenes into their palace decorations. With fundamental shifts in political thinking and experience in early sixteenth-century Europe, princes came to appreciate the particular luster rape scenes could give to their own claims to absolute sovereignty.

For one thing, with the rise of absolutist political theory in the sixteenth century, it was claimed that princely rulers were like Jupiter and stood above human law.[8] For another thing, the experience of war and politics in the early sixteenth century was such that rulers and theoreticians alike came to believe, in Felix Gilbert's words, that "force, which had previously been thought to be just one of several factors which determined politics, now came to be regarded as the decisive

factor."[9] This point of view gave rise to political theory that not only recognized the necessity of violence but indeed valorized it.[10] Of particular interest here are instances in which evocations of princely power and dominance are given a distinctly sexual coloration.[11] The best known of course is in chapter 25 of *The Prince* (1513), where Machiavelli urges the Prince to use force in contending with adverse circumstances:

Fortune is a woman and if you wish to keep her under it is necessary to beat and ill use her; and it is seen she allows herself to be mastered by the adventurous rather than by those who go to work more coldly. She is, therefore, always woman-like, a lover of young men, because they are less cautious, more violent, and with more audacity to command her.[12]

Princely claims to Jove-like sovereignty, to the right to subjugate by force both subjects and adversaries, and to sexual mastery over unconsenting partners are boldly intermingled in the decorative program of Federigo Gonzaga's Palazzo del Te in Mantua of around 1530.[13] To take one room, the Sala del'Aquile, as an example, we find three *stuccho* reliefs depicting rapes—or more precisely the forcible abduction of unconsenting sexual partners: Jupiter taking Europa, Neptune taking Amymone, and Pluto carrying Proserpina into the un-

derworld [3].[14] Combined with a fourth relief, of the enthroned Jupiter conferring with the gods, the three rape scenes thematize the rights of dominion each god enjoys in his respective region— earth, sea, and underworld—analogous to the rights of dominion enjoyed by Federigo Gonzaga and other princely rulers in the empire of Charles V.[15] Placed between a centauromachy and an amazonomachy below, and Jupiter destroying Phaeton in the vault above, these scenes of rape contribute to the ceiling's central theme of displaying the manifold aspects of Federigo's personal and political power.

The none-too-subtle implicit claims of Federigo's Mantuan program are made pedantically explicit in Vasari's decorative program for the Sala di Giove in Florence's Palazzo Vecchio. As Vasari explains in the *Ragionamenti* (written in 1558), each of the depicted scenes from the life of Jupiter corresponds to a parallel accomplishment or attribute of Duke Cosimo de' Medici.[16] Thus, for example, Jupiter's rape of Europa comes to stand for Cosimo's conquest of Piombino and establishment of a naval base on Elba.[17]

Only in the rape of Ganymede is Cosimo not identified with Jupiter. In that scene, Vasari tells us, Jupiter, appearing as an eagle, represents the emperor Charles V, while the boy Ganymede

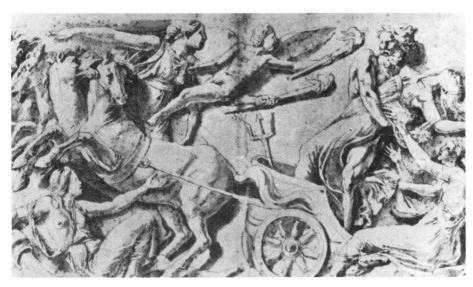

3. Giulio Romano, *Rape of Proserpina*, preparatory drawing for *stuccho* relief in the Palazzo del Te, pen and wash on paper, ca. 1530. Paris, Ecole des Beaux-Arts.

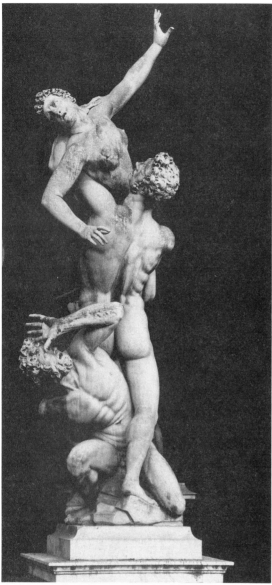

4. Giovanni da Bologna, *Rape of a Sabine,* marble, 1581–83. Florence, Loggia dei Lanzi.

tract or the prior consent of his subjects.[19]

In this absolutist conception of political rule the relationship between a prince and the state is less in the figure of the prince as the head of the single (male) body of the republic than in the figure of two bodies: the prince taking forcible possession of a (usually) female body, the latter having no power to resist or make claims upon him.[20]

Once this refiguration of the prince's relation to his subjects is understood, it becomes readily apparent why, in 1583, Cosimo's son, Francesco de' Medici (Vasari's interlocutor in the *Ragionamenti*), would have found it appropriate to install Giovanni da Bologna's so-called *Rape of a Sabine* in the Loggia dei Lanzi on Florence's Piazza della Signoria [4].[21] Apparently Giovanni da Bologna (also called Giambologna) composed the group without any particular story in mind.[22] But that is not to say that the action here is ambiguous. The sculpture's subject is only ambiguous if one tries to link it to a particular historical narrative. As a *generic* rape scene, its meaning is perspicuous: that of a victory monument to Medicean success in subjugating the citizens and subject territories of Florence.[23] The inclusion of a defeated rival in the group suggests that the young man's triumph is not only over the woman but also over the man at his feet. In political terms, the monument would appear to commemorate the success of the Medici dukes in wresting control of Florence away from rival factions over the course of the sixteenth century.[24]

In contrast to earlier allegories of the city, here the personified Florence is not an active subject but a passive object; not the victor but the victor's possession, the trophy in a contest between men. Indeed a contemporary poem about the sculpture likens Florence to the Sabine woman and praises Francesco, "who with such valor, with such wisdom possesses her."[25] In some respects the woman's function as an attribute of her captor's identity is suggested formally by the way in which we read her flailing body as an extension of his own: a contemporary description of the standing man as a burning, or ardent, youth was no doubt suggested by the flamelike shape of the composition, which, rising through his body, tapers to a

represents Cosimo, who in his youth "was carried into heaven by the emperor and confirmed duke."[18] But even in this exception to the programmatic identification of the duke with Jupiter, the interpretative principle remains the same: the sovereign, in this case Charles V, is one who, like Jupiter, conquers and rules without regard for con-

flickering point in the woman's upraised arm.[26]

Much has been made of the way in which the sculptor makes the viewer want to walk around the sculpture to take in what one critic describes as "the multiple . . . views that are predicated by the spiraling composition."[27] Yet the main view of the group from the front does yield a more or less coherent view of the bodies of both men. It is the woman's body that we see only as a fractional part, which lacks integrity and has become fetishlike.[28] The fetishistic display of the Sabine woman's body effectively complements the display of the head of Medusa in Cellini's *Perseus*—the sculpture with which Giovanni da Bologna's group was paired in the Loggia dei Lanzi [5].[29] In each work the virile hero holds aloft part of a woman's body as evidence of his capacity to dispossess and incapacitate his enemies.[30] Each work plays upon the thematics of sexual prowess and disempowerment as a way of establishing the hero/ruler's *virtù* in facing down opposition.

The concept of *virtù* surmounting difficulty through the use of force is of course central to Machiavelli's delineation of the ideal prince and is a recurrent theme in subsequent Florentine political rhetoric.[31] The gendered signification of the word *virtù* in particular (meaning, literally, manliness) surely underlies the sexual innuendo in Machiavelli's endorsement of princely violence, quoted above.[32] The convergence of the sexual and political meanings in the concepts of force and *virtù* help clarify why this rape group could be taken as a fitting embodiment of those values and serve as a daunting public affirmation of Medicean princely prowess.[33]

A curious point to note is the way in which these same terms—*virtù, forza, difficultà*—were applied not only to sexual and political experience in sixteenth-century Florence but to artistic experience and theory as well. Poems and texts written after the sculpture was unveiled in 1583 take up precisely those terms in lauding the sculptor's accomplishment. Raffaello Borghini asserts that Giambologna made the group to prove to jealous rivals that he could produce large figures in marble. "Goaded by the spur of *virtù*, he arranged to show the world that he could not only make ordi-

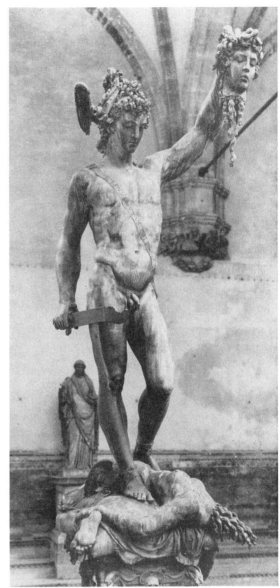

5. Benvenuto Cellini, *Perseus*, bronze, 1545–54. Florence, Loggia dei Lanzi.

nary marble statues, but also many together, and the most *difficult* that could be made."[34] It has long been recognized how central these terms are to Renaissance and particularly mannerist artistic theory.[35] However, by translating *virtù* as "virtuosity," for example, art historians have neglected to consider how sixteenth-century writers used the

terms to claim for artistic achievement the glory of sexual and political conquest.[36]

According to contemporary accounts, it was only after Giambologna completed the marble figures that the subject of the group was established as the rape of a Sabine woman.[37] This incident from Rome's founding history was thought to have made possible the creation of a Roman "people." Lacking women to bear them sons, the first settlers of Rome asked neighboring tribesmen for their daughters in marriage. When their neighbors refused, the Romans forcibly seized the women of the Sabine tribe and made them their wives, thus ensuring the perpetuation of the Roman line.[38] The genealogical import of the narrative explains how this scene of violent conflict between two men carries within it the germ of their reconciliation. After all, the offspring that the Sabine woman bears the Roman youth will be the old man's descendants as well. Her passage from one man to the other establishes a familial bond between the two that will ultimately occasion their political unification.[39]

If one of the manifest historical benefits of the Sabine rape is to draw victor and vanquished into a propitious alliance, a latent benefit of the episode is to affirm a consensual tenet that underlies the rivals' antagonism: the concept that women are the property of men. The ancient sources specify that the Romans put their marriage requests to the neighboring tribesmen, not to the women themselves.[40] To reinforce the principle that a woman was the property of one man or another, early Roman marriage ceremonies—in which the bride, as the possession of the father, was "handed over" to the husband—often incorporated ritual practices recalling the original Sabine rape.[41] Not surprisingly, when sixteenth-century family and political theorists attempted to revive Roman family law and the absolute control of husbands and fathers over their womenfolk, they invoked the rape of the Sabines as an exemplary tale. Thus in 1500 Marcantonio Altieri recommends that his contemporaries include ritual allusions to the rape of the Sabines in their marriage ceremonies as a way of underscoring the husband's coercive power over his wife.[42]

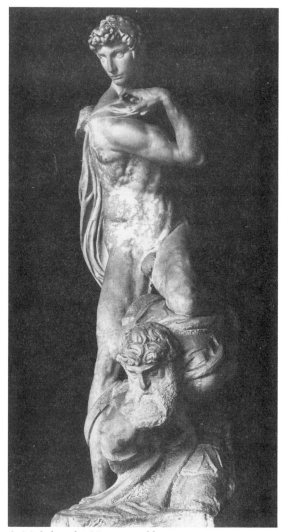

6. Michelangelo, *Victory*, marble, 1527–28. Florence, Palazzo Vecchio.

The domestic significance of the Sabine rape helps us appreciate how Giambologna's public monument at once thematizes the grand duke's dominion over his subjects and rivals, and at the same time thematizes the dominion those male subjects may have hoped to enjoy over the women in their own homes. In so doing, the *Rape of a Sabine* could have helped create an empathetic bond between ruler and ruled that spans divisions of class and wealth by affirming their commonly held values in the domain of gender.[43]

The Sabine narrative also gives pointed signification to the work as a demonstration of the sculptor's claims to artistic sovereignty. As has often been noted, the composition takes up the challenge laid down by Michelangelo that an artist should make his figures "pyramidal, serpentine, and multiplied by one, two, and three."[44] Michelangelo's *Victory* fulfills these precepts in a group of two large-scale serpentine figures: an old man and a youth [6]. But it was left to Giambologna to multiply the *figura serpentinata* in a large-scale group of three.[45] By this feat he not only vanquished his living rivals but also surpassed Michelangelo and made claim to be recognized as Michelangelo's worthiest successor.[46] Viewing the sculpture as Giambologna's bid to outstrip his rivals and Michelangelo, perhaps it was inevitable that his contemporaries should have invoked the imagery of the Sabine rape to liken the young sculptor to the youthful victor in his group, triumphant over and establishing filial ties with the father at his feet.[47]

This brief overview of the multifold significations of Giambologna's *Rape of a Sabine* suggests that its virtuosity resides not only in the serpentine arrangement of the figures but also in the way in which the group gives visible expression to the intertwined values and aspirations of patron, public, and artist at once.

It has been suggested that Rubens's *Rape of the Daughters of Leucippus* could be seen as a pictorial variant of Giambologna's sculptural group.[48] Rivaling Giambologna's spiraling triad on a pyramidal base, Rubens sets four figures in pinwheel rotation on the point of a diamond. By devising this swirling arrangement of four serpentine figures, however, Rubens has done far more than display his own virtuosity in taking up the challenge laid down by Michelangelo and Giambologna. He has transformed a figural tradition thematizing competition between men into a scene of fraternal cooperation. His male protagonists are no longer rivals but brothers, legendary for their mutual devotion.[49] Avoiding competition over a single woman, they undertake a joint sexual conquest in which each is allotted his prize.

Lacking all information about who first owned this canvas, one can only speculate about what prompted Rubens to paint it.[50] But because large-scale depictions of Castor and Pollux are a tradition peculiar to French monarchical imagery, it is worth considering that when Rubens painted this, shortly after 1615, he did so with the French court in mind. In France, too, after all, it was traditional to incorporate rape imagery into princely programs as a means of affirming the ruler's sovereignty in private and public life.[51] Thus, for example, the verses accompanying a *Rape of Europa* on one of the triumphal arches for the entry of King Charles IX and his queen into Paris in 1571 cast Jupiter's rape of Europa as a figure both of the king's marriage to Isabel of Spain and of his prospective dominion over Asia [7]: "Par le vieil Jupi-

7. Arch with the *Rape of Europa*, woodcut from Simon Bouquet, *Bref et Sommaire Recueil de ce qui a este faict et de l'ordre tenue a la ioyeuse et triomphante entree de . . . Prince Charles IX de ce nom roy de France en sa bonne ville et cité de Paris*, Paris, 1572 *(Houghton Library, Harvard University)*.

ter Europe fut ravie: / Le ieune ravira par Isabel l'Asie" (As the old Jupiter ravished Europa, the young one, through Isabel, will ravish Asia).[52] The use of a rape scene to celebrate Charles's acquisition of both a wife and subject territory attests to the eclipse in France, as in Italy, of medieval consensual notions of marriage and political contract by the absolutist insistence upon the unfettered powers of husbands and rulers alike.[53]

The figures of Castor and Pollux make their appearance atop another arch in these same royal entry decorations [8].[54] The ship flanked by Castor and Pollux is based on Alciati's emblem, *Spes proxima*, first published in 1531.[55] The emblem depicts the ship of state on a storm-tossed sea, with the constellation Gemini—identified with the twins Castor and Pollux—in the upper-right-

hand corner. Alciati's epigram explains: "Our state, like a ship, is buffeted by countless storms, and there is only one hope for its future safety. . . . If the shining stars, the twin brothers, appear, good hope will restore our sinking spirits."[56] Alciati's foundering vessel has no evident captain or navigator: in keeping with absolutist theory, the prince is not "in the same boat" as his subjects. Rather he is their shining hope for salvation.[57] In the 1571 adaptation of Alciati's emblem, the ship of state is again saved by Castor and Pollux, who appear not only as stars but also in their human aspect—now identified with the young King Charles IX and his brother, the duc d'Anjou.[58]

It seems possible that Rubens was familiar with this image, particularly the way in which the two brothers incline toward the ship in the center, reaching out as if, in the words of the entry planner, "to touch the ship and to save it."[59] It seems additionally likely that even while drawing inspiration from the image, Rubens would have transformed it, going one step further than the inventor of 1571 toward enlivening this political allegory with animated figures—by replacing the bridles on the ground with rearing horses and by replacing the foundering ship of state with the abjectly disempowered, incipiently grateful figures of the daughters of King Leucippus.[60]

Although it was an established panegyric tradition in the early seventeenth century to compare the French king and his younger brother to Castor and Pollux, it is highly unlikely that the painting by Rubens alludes to Louis XIII and his brother by birth, since the king's brother, the duc d'Orleans, had just died in 1611.[61] Rather, it seems plausible to me that the Dioscuri here refer to Louis XIII and his new brother-by-marriage: the future King Philip IV of Spain. In 1612 a treaty was signed between France and Spain whereby it was agreed that in 1615 the future Philip IV of Spain would marry Louis's sister, Elisabeth, and that Louis XIII would marry Philip's sister, Anne.[62] Marie de Médicis, the mother of Louis XIII, had negotiated the treaty with King Philip III of Spain, and she considered this marriage alliance to be the crowning achievement of her regency.[63] The actual exchange of princesses and

8. Arch with *Castor and Pollux Saving the Ship of State*, woodcut from Simon Bouquet, *Bref et Sommaire Recueil . . . (Houghton Library, Harvard University)*.

9. Anonymous, *Allegory of the Marriage Alliance Between France and Spain*,
engraving, 1615. Paris, Bibliothèque Nationale, Cabinet des Estampes.

dual marriages took place in the fall of 1615, when Louis XIII and his bride were aged fifteen and Philip of Spain and his bride were aged eleven and thirteen, respectively.[64] Most likely, these events would have come to Rubens's attention in his capacity as court painter to the governors of the Spanish Netherlands, since we know that his patrons in Brussels, the Archduke Albert and the Infanta Isabella, had a friendly relationship with Marie de Médicis and endorsed strengthening the bonds between France and Spain.[65]

Imagining that Rubens's painting does commemorate this nuptial alliance makes it possible to appreciate the appropriateness of Rubens's erotic transformation of the triumphal arch decoration of 1571. In fact, the step of likening Louis and Philip to Castor and Pollux had been taken during festive celebrations that accompanied the signing of the treaty in the summer of 1612. A contemporary pamphlet describing the festivities mentions that the mounted figures of Castor and Pollux surmounted one of the stage sets in Paris's Place Royale. The pamphlet explains that the pair was meant to convey the expectation that, like the twins Castor and Pollux, the two monarchs, once united by familial bonds, would banish the tem-

pests of war from Europe.[66] The fact that the "union" between the monarchs would be consummated when they married each other's sisters surely justifies Rubens's decision to represent the twin deities at the moment they take possession of their future brides.

If we provisionally grant that the "exchange of princesses" that took place between France and Spain in 1615 was the occasion for Rubens's painting, and if we compare it to a contemporary print that also refers to these marriages, we can appreciate what an astute and at the same time disturbing commentary upon the nuptials Rubens's version would have been [9].[67] We could say that both the print and the painting forego an attempt to record the historical marriage ceremonies in favor of trying to impart their underlying significance. In a curious confirmation of Claude Lévi-Strauss's explanation of the social value of marriage and the incest taboo, each work indicates that the primary bond being forged is not the bond between husband and wife but the bond between two men who, by exchanging sisters, become brothers-in-law, thereby bringing themselves and their nations into familial and political alliance.[68] The print shows the two couples flanking the marriage god

Hymen, who, in the appended verses, applauds the union not between spouses but kings. Hymen says:

> Scepters and crowns I bring into accord,
> Through marriage, love and concord,
> Conjoining divided kings.[69]

Rubens, dispensing with labored abstractions, conveys the character of the new relationship between Louis and Philip by casting them as actual brothers and by representing their acquisition of wives as a joint sexual adventure, which at once consolidates the fraternal bond and at the same time serves the familiar function of demonstrating their princely *virtù*.[70]

A further point that contemporary encomiasts underscored was the effect the dual marriages had of transforming a former relationship of war between France and Spain into one of peace.

War is dead, and those who carried the torch of division within the state are those who now carry the torch of love. They sacrifice all their enmities on the altar of faith and make a victim without bile for the happy alliance of their scepters.[71]

Whereas this passage relies upon the rather contrived image of bearers of torches of war now becoming bearers of torches of love, who make sacrifices on the altar of faith, Rubens effects the same conversion of imagery of war into imagery of peace by patterning his composition after the *Battle of Anghiari*. Deadly warfare is converted into erotic conquest. The violent impulses of antagonists are not eliminated so much as redirected against women. The dangers of combat are exchanged for the thrill of rape. Violence is absorbed into sexuality.

The strategy of eliminating violence between

10. Rogier van der Weyden, *Escorial Deposition*, panel, ca. 1438. Madrid, Prado.

11. Peter Paul Rubens, *Exchange of Princesses at Hendaye*, ca. 1622–25. Paris, Louvre.

men by redirecting it against women calls to mind René Girard's analysis of sacrifice as violence performed on designated victims for the sake of mitigating conflict and rivalries within a community—that is to say, for the sake of preserving bonds of alliance between men.[72] His analysis helps us understand why the text just quoted uses the imagery of sacrifice and of "victims without bile." It also helps elucidate a point noted by Svetlana Alpers: the impression one has of suspended action in the painting by Rubens. The stilled action calls to mind certain deposition scenes (such as the *Escorial Deposition* by Rogier van der Weyden) in which the figures are arranged not to demonstrate how, logistically, Christ's body was lowered from the cross but to hold up Christ's body as a sacrifi-

cial display to the viewer [10].[73] Similarly, in the *Rape of the Daughters of Leucippus* the figures are arranged less to clarify how the Dioscuri will get the women up onto their horses than to display the bodies of women who are offered in a rite of marriage. Indeed the near reverential gazes of the brothers are curiously consonant with the tender pathos of the companions of Christ and the Virgin (compare, in particular, the mounted rider with Rogier's John the Evangelist). As does the pamphlet, then, the painting alludes to the sacrificial nature of the nuptials, but Rubens is far bolder than the encomiast in suggesting that the victims in these rites are none other than the brides themselves.

The sacral import of these nuptials is also

12. Dirk Bouts, *Visitation,* panel, fifteenth century. Madrid, Prado.

evoked in Rubens's later commemoration of the *Exchange of Princesses,* which he painted in around 1622–25 as part of his series commemorating the life of Marie de Médicis [11].[74] The meeting of the two princesses on the border between France and Spain, as each is about to pass into the other's country, is patterned after traditional Visitation scenes, which represent the momentous encounter between the pregnant mothers of Christ and John the Baptist [12].[75] By implicitly identifying the royal brides with these holy mothers, Rubens turns our attention away from the violence of the brides' induction into sexuality and toward their future maternity and the birth of divinely favored heirs for the French and Spanish thrones.[76]

In the earlier canvas, however, Rubens adverts not to the new roles that await the princesses as mothers but to the traumatic moment in which, as brides, they are forcibly uprooted, seized upon by strangers, and launched into the unknown.[77] While the struggles of the lower sister convey her anguish and impotence against the overbearing force of her captor, the laxness of the higher sister suggests that she is about to abandon resistance altogether. Her limp hand and gratified expression signal her final acquiescence to her powerlessness and to the pleasurability of being desired.[78] The subtle play upon violence and reverence, anguish and acquiescence in this scene suggests that Rubens sentimentalizes sexual difference and presents the brides as sacrificial victims, not so much to arouse our pity and indignation as to intimate the sacred importance of these nuptials and the sovereign powers of the brides' quasi-divine spouses. Thus the *Rape of the Daughters of Leucippus* succeeds at once in making manifest the latent function of the royal marriages and in glamorizing them at the same time.

If we compare the painting to documentary records of the nuptials, we can appreciate what a mystification of those events Rubens's painting would have been. The exchange of sisters never had the effect of cementing a fraternal bond between Philip and Louis. Indeed they never met. Endless wrangling about precedent at the exchange ceremonies and all the ensuing diplomatic tensions between France and Spain indicate that no spirit of concord emerged to bind the two nations into a harmonious alliance. As for the bridal couples themselves, all the pleasures of sexual conquest and capitulation intimated by Rubens are signally uncorroborated by contemporary accounts.

The diary of Louis XIII's physician, Jean Héroard, provides a sobering narrative of how the fifteen-year-old Louis and his thirteen-year-old sister, Princess Elisabeth, experienced the events.[79] On the day Elisabeth left to join her eleven-year-old husband in Spain, she and her brother spent the entire morning and a good part of the afternoon together, crying, sobbing, and clinging to each other, until the Spanish ambassador finally drew her away, exclaiming, "Allons, princesse d'Espagne." Louis continued to weep after she left, finally complaining to his physician of the headache that all his crying had given him.

Louis was equally pained by the requirement that he consummate his marriage with his bride, Anne of Austria. Héroard's journal entry for 25 November 1615 gives reason to doubt that the consummation was successfully accomplished. Indeed the entire performance—and that it was, since witnesses and a written narrative of the consummation were required to establish the legality of the marriage—seems to have been a miserable ordeal for the fifteen-year-old spouses. Héroard records: at 4:00 P.M. the couple goes to mass. At 5:30 Louis takes Anne to her bedroom. He feels "disinclined," goes to his own room, and gets into bed. He eats supper in bed; then several young gentlemen come into his room and tell him ribald stories. Louis feels ashamed and greatly afraid. Finally they reassure him. At 8:00 he returns to his bride's chamber, where he is "put into bed with the queen his wife in the presence of the queen his mother"—who stays in the room the whole time. At 10:15 he emerges from the bed and displays his bloodied member, claiming to have "done it" twice. Héroard marks his skepticism by adding, "so it would seem." In any case, it appears Louis did not resume sexual contact with his wife for at least another four years.[80]

Setting the physician's narrative of this nuptial union against Rubens's Ovidian scenario allows us to measure the gap between the actual experience of at least one bridal couple in 1615 and the fantasy purveyed by the painter. It leads us to recognize how violently, then as now, such mystifications of sexuality, with their seductive fictions of conquest and capitulation, can misrepresent the lived experiences of men and women alike.

NOTES

For their good counsel at various stages of the research, writing, and revision of this paper, I'd like to thank Svetlana Alpers, Harry Berger, Beverly Brown, Howard Burns, Caroline Bynum, Julius Held, Rachel Jacoff, Constance Jordan, Thomas Kaufmann, Miranda Marvin, Katherine Park, Loren Partridge, Seth Schein, Laura Slatkin, and Natasha Staller.

1. Max Rooses, *L'Oeuvre de P.P. Rubens* (Antwerp, 1886–92), no. 579; Rudolph Oldenburg, *P.P. Rubens: Des Meisters Gemälde (Klassiker der Kunst),* 4th ed. (Stuttgart, 1921; hereafter *KdK*), no. 131; catalogue entry (with bibliography) by Arthur K. Wheelock, Jr., in Beverly Louise Brown and Wheelock, *Masterworks from Munich: Sixteenth- to Eighteenth-Century Paintings from the Alte Pinakothek,* National Gallery of Art (Washington, D.C., 1988), pp. 105–8, no. 23.

2. Theocritus *Idylls* 22.137; Ovid *Fasti* 5.699 and *Artis amatoriae* 1.679-80; Apollodorus 3.11.2; Hyginus *Fabulae* 80. Among Renaissance mythographies, see Natalis Comes, *Mythologiae* (Venice, 1567; reprint ed., New York, 1976), book 8, pp. 247–50. Rubens appears to be the first artist since antiquity to have depicted this abduction. For an exhaustive review of ancient literary and visual representations of the Dioscuri, see articles in *Lexikon Iconographicum Mythologiae Classicae* (hereafter *LIMC*), vol. 3 (Zurich, 1986), part 1, pp. 567–635, and part 2, pp. 456–503.

Today the word *rape* is taken to denote sexual intercourse with an unconsenting partner. Evidence of phallic penetration and the emission of semen is crucial to the legal determination of whether or not a rape has occurred. According to current usage Rubens has not depicted a rape but an abduction. In antiquity and the Renaissance, however, it was the use of violence against a sexual partner that was taken as the incontrovertible evidence of a rape. The issue of whether phallic penetration actually occurred seems to have been considered a minor issue (or more frequently a foregone conclusion) once it had been established that the perpetrator had used force against his unwilling partner. In Renaissance Venice, for example, a man could be prosecuted for the crime of rape (legally defined as *carnaliter cognovit per vim*) if he "is found to have committed any molestation or violence against any woman with a desire to commit fornication, whether or not he succeeds in that fornication"; quoted and discussed in Guido Ruggiero, *The Boundaries of Eros: Sex, Crime, and Sexuality in Renaissance Venice* (New York, 1985), 89 and 90. Indeed, although most rape narratives specify that violence was used against an unconsenting partner,

rarely if ever do they mention the moment of physical penetration. However, that by no means leaves any doubt that a rape has actually occurred. For these reasons, I find it appropriate to adhere to Renaissance tradition and retain the word *rape* for the titles of the scenes of sexual violence discussed in this paper.

3. Hans Gerhard Evers, *Rubens und sein Werk: Neue Forschungen* (Brussels, 1943), 253; Svetlana Alpers, "Manner and Meaning in Some Rubens Mythologies," *Journal of the Warburg and Courtauld Institutes* 30 (1967): 285–89; Martin Warnke, *Peter Paul Rubens,* trans. Donna Pedini Simpson (New York, 1980), 62; Wheelock, in *Masterworks from Munich,* 107–8. Both Warnke and Wheelock suggest that the allegory may be political in nature (referring to Spain's dominion over her Netherlandish provinces). I will propose a different complex of political allusions below.

4. See Julius S. Held, *Rubens: Selected Drawings,* 2nd ed. (Oxford, 1986), 85–88, for a discussion of the complex relationship between Rubens's drawing and Leonardo's lost design.

5. Ovid *Artis amatoriae* 1.664–80; in *The Art of Love and Other Poems,* trans. J.H. Mozley, rev. ed., Loeb Classical Library (Cambridge, Mass., 1939), 59.

6. Reinhard Liess, *Die Kunst des Rubens* (Braunschweig, 1977), 382 (my translation).

7. On the social determinants of "rape culture" generally, see Peggy Reeves Sanday, "The Bases for Male Dominance," in her *Female Power and Male Dominance: On the Origins of Sexual Inequality* (Cambridge, England, 1981), 163–83; and "Rape and the Silencing of the Feminine," in *Rape,* ed. Sylvana Tomaselli and Ray Porter (London, 1986), 84–101.

8. In his commentary on Roman law published in 1508, Guillaume Budé likens the king to Jupiter, quotes Ulpian's dictum that a prince is above the law, not bound by it, and endorses Aristotle's fifth type of monarchy—in which the ruler has the same absolute dominion as that of a father in his home—as an ideal model; Guillaume Budé (Budaeus), *Annotationes in pandectas* (Paris, 1508), in *Operum,* vol. 3 (Basel, 1557; reprint ed., Westmead, England, 1966), 68.

On the humanist revival of Roman law and its relationship to absolutist theory, see Myron Gilmore, *Argument from Roman Law in Political Thought: 1200–1600* (Cambridge, Mass., 1941); and Nannerl O. Keohane, *Philosophy and the State in France: The Renaissance to the Enlightenment* (Princeton, N.J., 1980), 57–61. On Budé's importance for Italian absolutist theory, see Nicolai Rubinstein, "Dalla repubblica al principato," in *Firenze e*

la toscana dei Medici nell'Europa del '500, ed. Furio Diaz et al. (Florence, 1983), 165.

9. Felix Gilbert, *Machiavelli and Guicciardini: Politics and History in Sixteenth-Century Florence* (New York, 1984), 118 and 129.

10. J.R. Hale, "War and Public Opinion in Renaissance Italy," in Hale, *Renaissance War Studies* (London, 1983), 359–87.

11. The intermingling of claims of sexual and military prowess characterizes a number of the princely *imprese* published by Paolo Giovio in his *Dialogo dell'imprese militari e amorose* (Rome, 1555), ed. Maria Luisa Doglio (Rome, 1978). The most egregious is the "comic" *impresa* of the condottiere Giovanni Chiucchiera, which represents a wolf, unabashed by two dogs at his heels, poised to take sexual advantage of a ewe knocked onto her back. The image recalls Ovid's image of Lucretia at the moment she is about to be raped by Tarquin: "She trembled, as trembles a little lamb that, caught straying from the fold, lies low under a ravening wolf"; *Fasti* 2.799–800, trans. James George Frazer, Loeb Classical Library (Cambridge, Mass., 1967), 115. Giovio explains that the condottiere's *impresa* was meant to convey the "ardent nature" of his valor in cavalry engagements (147).

After the Medici returned from exile to Florence in 1512, it seems their supporters used sexual imagery to celebrate the Medici's resumption of power. In 1514, Richard Trexler tells us, the *festaioli* of the hunt "put an estrous mare into the ring of the Piazza della Signoria with stallions, 'so that anyone who didn't know how to, learned' the sexual act"; *Public Life in Renaissance Florence* (New York, 1980), 509. When Giuliano di Lorenzo di Medici was elected pope in 1513, "The simplest citizens demonstrated their allegiance to the Medici by placing the family's coat of arms over their front doors. Public officials followed suit, covering the civic coat of arms with the Medici balls [*palle*]. . . . The Medicean cry of *Palle!* was on every lip, Cambi noted, and the traditional civic cry of *Marzocco!* could scarcely be heard, its utterance almost a challenge to the new Medicean order" (496–98). The sexual connotations of the word *palle* were not lost on contemporary Florentines. "The Medici 'had the balls' *(palle)* to make the Florentines' testicles hurt, a contemporary pun ran, if the citizens could not accept a sweeter yoke" (509).

12. Niccolò Machiavelli, *The Prince,* trans. W.K. Marriott (London, 1958), 143.

13. Egon Verheyen, *The Palazzo del Te in Mantua: Images of Love and Politics* (Baltimore, 1977); Frederick Hartt, "Gonzaga Symbols in the Palazzo del Te," *Journal of the Warburg and Courtauld Institutes* 13 (1950): 151–88; Hartt, *Giulio Romano,* 2 vols. (New Haven, 1958), 1:105–60.

14. Verheyen, *Palazzo del Te,* 28–29; and Hartt, "Gonzaga Symbols," 178–80. The subject of Neptune abducting Amymone is unusual (Neptune with Amphitrite, which is not a rape scene, is far more common). A literary source for Neptune and Amymone may be Lucian's *Dialogues of the Sea-Gods,* 8.

15. Scholars have expressed uncertainty about the precise subject of the fourth *stuccho* with the enthroned Jupiter, Juno, Neptune, Mercury, and, I believe, Ceres. My guess is that it depicts Mercury (with pomegranate or pomegranate rind in hand) approaching Jupiter, while Jupiter deliberates on Ceres' demand that her daughter Proserpina be returned to her from the underworld. Not only does the narrative in Ovid's *Fasti* (4.585–614) accord with this scene of Olympian deliberation, but also Jupiter's speech in the *Fasti* defending Pluto enunciates the principle of territorial division implied by the rapes on the other three *stucchi*: "He is not a son-in-law to put us to shame. I myself am not more noble: my kingdom is in the sky, another possesses the waters, and another, empty chaos"; 11.599–600.

16. Giorgio Vasari, *Ragionamenti* (Florence, 1558), trans., with commentary, in Jerry Lee Draper, *Vasari's Decoration in the Palazzo Vecchio* (Ph.D. diss., University of North Carolina, Chapel Hill, 1973), 164–77 and 434–37, also 28–37. See also Ettore Allegri and Alessandro Cecchi, *Palazzo Vecchio e i Medici* (Florence, 1980), 92–95; and more generally, Scott Schaefer, *The Studiolo of Francesco I de' Medici in the Palazzo Vecchio* (Ph.D. diss., Bryn Mawr College, 1976), 227–32.

17. Draper, *Vasari's Decoration,* 174–75 and 437.

18. Ibid., 176–77. For a discussion of the rape of Ganymede as a figure of Cosimo's ascendency under Charles V, in Battista Franco's *Allegory of the Battle of Montemurlo* (ca. 1555), see James M. Saslow, *Ganymede in the Renaissance: Homosexuality in Art and Society* (New Haven, 1986), 166–67.

19. On the association of Charles V with Jupiter in the palace decorations of other princes dependent upon the emperor's patronage, see William Eisler, "Patronage and Diplomacy: The North Italian Residences of the Emperor Charles V," in *Patronage, Art, and Society in Renaissance Italy,* ed. F.W. Kent and Patricia Simons (Oxford, 1987), 269–82. On the palace of Charles's Genoese client, Andrea Doria (which included frescoes of Jupiter's rapes of Europa and Io), see also Elena Parma Armani, *Perin del Vaga: l'annello mancante* (Genoa, 1986), 73–152 and 263–81. The guiding spirit of Paolo Giovio (see note 11 above) behind the decorative programs of Andrea Doria, Federigo Gonzaga, and Cosimo de' Medici—all of whose palaces incorporated eroticized affirmations of princely and imperial sovereignty—is a matter deserving closer investigation.

20. Figurations of the Florentine republic as a male body in fifteenth-century political theory were analyzed by John Najemy in a symposium on "The Body in the Renaissance" held at Brown University, spring 1986.

21. Charles Avery, *Giovanni da Bologna* (New York, 1987), 109–14 and 254.

22. Raffaello Borghini, *Il Riposo* (Florence, 1584; reprint ed., Hildesheim, 1964), 72–74; also Avery, *Giovanni da Bologna*, 109–10.

23. As a poem written upon the unveiling of the sculpture indicates, the *Sabine* joined a sequence of sculptures in the piazza that were recognized as Florentine political allegories; Sebastiano SenLeolini, in *Alcune composizioni di diversi autori in lode del rittratto della Sabina*, ed. Bartolomeo Sermartelli (Florence, 1583), 46. On Donatello's *Judith and Holofernes*, see H.W. Janson, *Donatello*, 2 vols. (Princeton, 1957), 2:198–205. On Michelangelo's *David*, see Charles Seymour, Jr., *Michelangelo's David: A Search for Identity* (New York, 1967), 55. On Baccio Bandinelli's *Hercules and Cacus*, and Benvenuto Cellini's *Perseus with the Head of Medusa*, see John Pope-Hennessy, *Cellini* (New York, 1985), 168.

It seems likely that Francesco installed the *Sabine* in the Loggia dei Lanzi as an emblem of dynastic, not personal, political achievement, since it was really Francesco's father, Cosimo I (1519–74), who had consolidated Medicean rule over Florence and Tuscany in the course of the sixteenth century; Eric Cochrane, *Florence in the Forgotten Centuries* (Chicago, 1973), 3–92; and note 31 below. Notwithstanding the political and military tranquility of Francesco's reign (1574–87), he persisted in commissioning art that celebrated the imposition and extension of Medici rule—for example: Giambologna's sculpture of *Florence Triumphant over Pisa* for the Salone dei Cinquecento in Francesco's residence, the Palazzo Vecchio (Avery, *Giovanni da Bologna*, 77–78; on the Salone dei Cinquecento, see Schaefer, *Studiolo of Francesco I*); and the equestrian monument of Cosimo I, which, though installed in the Piazza della Signoria after Francesco's death, had been proposed by him as early as 1581 (letter dated 27 October 1581 from Simone Fortuna to the duke of Urbino in Avery, *Giovanni da Bologna*, 251; discussed pp. 157–64).

24. On the history of the Medici family's struggles for control of Florence in the sixteenth century, see Cochrane, *Florence in the Forgotten Centuries*. In 1574 Francesco foiled a plot for his assassination by Orazio Pucci and a "blueblood gang" of Florentine youths (100).

25. Cosimo Gaci describes the Sabine as the "altera praeda/Ond'al Seme Roman Sabina terra/Produsse quella pianta eccelsa e grande/Che stese un tiempo i gloriosi rami" (the exalted prize, the Sabine earth, where Roman seed produced that lofty and great plant, which in time grew glorious branches) and then proceeds to the following passage:

Quanto è ricca Fiorenza, che di tanti
Nobili ingegni e chiari spirti è madre?
E quanto è ricco e degno il gran Francesco,
Che con tanto valor, con tanto senno
La possiede . . .
[How rich is Florence, mother of so many geniuses and bright spirits? And how rich and worthy is the great Francesco who, with such valor and such wisdom, possesses her . . .]

Eclogue, in *Alcune composizioni*, 29 and 43 (my thanks to Rachel Jacoff for her help with these translations). Francesco also referred to Florence as "the state I . . . possess"; Cochrane, *Florence in the Forgotten Centuries*, 101. Elsewhere Cochrane explains, "In the sixteenth century the word 'state' or *Stato* was usually used in a passive sense, as something that was possessed, acquired, or dominated"; 53.

26. Bernardo Davanzatti describes the youth as a "giovine ardente" in *Alcune composizioni*, 7.

27. Avery, *Giovanni da Bologna*, 114; see also John Shearman, *Mannerism* (Harmondsworth, England, 1967), 81–88.

28. On the fetish as "a token of triumph over the threat of castration and a safeguard against it," and on "the impulse to execute [upon women] the castration which [fetishists] deny," see Sigmund Freud, "Fetishism," in *The Standard Edition of the Complete Psychological Works*, trans. and ed. James Strachey, 24 vols. (London, 1953–73), 21:152–53. For application of the term to artistic representation, see, among others, Laura Mulvey, "Visual Pleasure and Narrative Cinema," *Screen* 16 (1975): 6–18, reprinted in Brian Wallis, ed., *Art After Modernism* (New York, 1984), 361–73; Rosalind Krauss, "Corpus Delicti," in *L'Amour Fou: Photography and Surrealism* (New York, 1985), 95; and Carol Armstrong, "The Reflexive and the Possessive View: Thoughts on Kertesz, Brandt, and the Photographic Nude," *Representations* 25 (Winter 1989): 57–70. Krauss's characterization of fetishism as a "refusal to accept sexual difference" strikes me as a simplification, as does her assertion that "characterizations of surrealism as antifeminist [are] mistaken."

29. Pope-Hennessy, *Cellini*, 163–86.

30. On the gendered signification of the head of Medusa, see Freud, "The Medusa's Head," *Standard Edition*, 18:253; and Neil Hertz, "Medusa's Head: Male Hysteria Under Political Pressure," *Representations* 4 (1983): 27–54.

31. Machiavelli, *The Prince*, chaps. 6 and 25 in particular. Note the thematization of violence and victory in the decorations of the Sala dei Cinquecento (Draper, *Vasari's Decoration*, 370–407) and the explanation Vasari gives to Francesco de' Medici in *Ragionamenti*:

By reading the ancient and modern histories of the city, I was continually confronted with the troubled times and various misfortunes which led to so many changes of government, the rise and fall of innumerable citizens, sedition and civil discord, even the rebellion of her citizens with great bloodshed. I also considered the conflicts and wars suffered by the republic in subjugating the most noble and renowned cities nearby. . . . Similarly I deliberated upon the difficulties and suffering endured by your most illustrious house when Florence had a popular government and how, more recently, your father had to maintain at incalculable expense an army and a war in enemy territory before Siena surrendered with all her states. (403)

32. The complexities of Machiavelli's use of the word *virtù* should not be underestimated. See Leslie J. Walker, "Machiavelli's Concept of Virtue," in *The Discourses of Niccolò Machiavelli*, trans. and introduced by Walker, 2 vols. (New Haven, 1950), 1:99–102; and, more recently, Victoria Kahn, "*Virtù* and the Example of Agathocles," *Representations* 13 (1986): 63–83. It is not that Machiavelli recommends rape as an actual practice. On the contrary, he urges princes to forebear from raping their subjects—not in consideration for the women, but to avoid incurring the hatred of the men in their families, for "when neither their property nor honour is touched, the majority of men live content"; *The Prince*, chap. 19, p. 101.

33. The same may be said of Cellini's, which, as a sequel to Donatello's *Judith* marks a relocation of power from the corporate body of the republic (identified with Judith) to the singular body of the duke (identified with Perseus); Pope-Hennessy, *Cellini*, 168. On the motif of *virtù* in encomia for Duke Cosimo, see Draper, *Vasari's Decoration*, passim; and Karla Langedijk, *The Portraits of the Medici*, 3 vols. (Florence, 1981), 1:84–85; see also Rudolf Wittkower, "Chance, Time, and Virtue," *Journal of the Warburg and Courtauld Institutes* 1 (1938–39): 318–20.

34. "Per la qual cosa Giambologna punto dallo sprone della *virtù*, si dispose di mostrare al mondo, che egli non solo sapea fare le statue di marmo ordinarie, ma etiando molto insieme, e le piu *difficile*, che far si potessero" (emphasis added); Borghini, *Il Riposo*, 72. My translation.

35. Shearman, *Mannerism*, 21 and 41; also David Summers, *Michelangelo and the Language of Art* (Princeton, N.J., 1981), 177–85.

36. The close identification of artistic with political glory is evident in several poems lauding Giambologna's sculpture. In one, his triumph over ancient sculptors is lauded as bringing to Florence the glory of Rome; *Alcune composizione*, 31. The imagery of force, victory, and, of course, rape itself is invoked repeatedly to characterize the sculptor's achievement:

La gloria dell'intera arte divina
Espressa nel triforme simulacro

Idea e norma a tutti grandi artisti
È, Gian Bologna mio la tua Sabina.
Di quella ardesti; il longo studio, e macro
È il vecchio padre a cui tu la rapisti.
—Bernardo Davanzati
[The glory of all divine art is in this triform image—the ideal and standard for all great artists. This, my Giambologna, is your Sabine, for whom you burned with desire. Long and wearing study (studio work) is the old father from whom you raped her. Ibid., 7]

L'arte, che mai non feo, com'or sì note
Le forze sue, per se lo mostra à pieno,
Ne dirlo è d'huopo a chi ben fisso 'l mira.
Che chi non sà, che 'l marmo venir meno,
Infiammarsi d'amor, rodersi d'ira,
Altri che Gianbologna far non puote?
—Lorenzo Franceschi
[Art, which had never done so before, now displays its force in the open. This need not be said to one who gazes well upon it. Who does not know who it is who could make marble swoon, be enflamed with love, or be eaten away by rage, other than Giambologna? Ibid., 8]

Indeed not only is the creation of the work likened to an act of rape, but also its effect upon the viewer:

Rapir sentì 'l pensier soura misura,
E restai come immobile, in astratto
Quando mirai della Sabina il ratto,
Ove Arte vince supera Natura.
—Francesco Marchi
[You feel your thoughts raped, carried out of bounds, and you remain immobile and abstracted when you gaze at the Rape of the Sabine, in which art conquers proud nature. Ibid., 20]

My thanks to Rachel Jacoff for her help with these translations.

In principle, art historians would be inclined to read these lines as Neoplatonic allegories of spirit and matter. But Neoplatonic readings by now strike me as a way of evading the overt references to sex, gender, and violence that are central to the poems' (and sculpture's) argument.

37. Borghini, *Il Riposo*, 72. Avery, *Giovanni da Bologna*, 109–10. The evolution of the design from a small two-figure group executed in 1579 to the monumental triad of 1583 is considered in Charles Avery and Anthony Radcliffe, eds., *Giambologna: Sculptor to the Medici* (Edinburgh, 1978), 105–8 and 219–20.

38. Livy 1.9–13; Ovid *Fasti* 3.180–232; Plutarch *Life of Romulus* 14–15.

39. Livy 1.13. This is particularly stressed in Plutarch, who explains, "They did not commit the rape out of wantonness, nor even with a desire to do mischief, but with the fixed purpose of uniting and blending the two peoples in the strongest bonds"; *Life of Romulus* 14.6, in *Plutarch's Lives*, trans. Bernadotte Perrin, Loeb Classical Li-

brary, 11 vols. (Cambridge, Mass., 1914–21), 1:131. The women persuade the Sabines to end their war with the Romans by reminding their fathers that, as fathers-in-law and grandfathers of Romans, they have family ties among their enemies; *Life of Romulus* 19. On rivalry over women as a means of establishing social bonds between men, see also Eve Kosofsky Sedgwick, *Between Men: English Literature and Male Homosocial Desire* (New York, 1985).

40. Livy 1.9.2.

41. In fact, Plutarch tells us that this is the origin of the custom of the groom carrying his bride over the threshold (*Life of Romulus* 15.5); see also Catullus *Carmina* 61, 162–63. On Roman marriages and the power of the *pater familias* over the women in his household, see Jane Gardner, *Women in Roman Law and Society* (Bloomington, Ind., 1986), 5–14; and Eva Cantarella, *Pandora's Daughters: The Role and Status of Women in Greek and Roman Antiquity,* trans. Maureen B. Fant (Baltimore, 1982), 113–18.

42. Discussed in Christiane Klapisch-Zuber, "An Ethnology of Marriage in the Age of Humanism," in her *Women, Family, and Ritual in Renaissance Florence,* trans. Lydia Cochrane (Chicago, 1985), 247–60, esp. 255. See also Juan Luis Vives, *De institutione foeminae christianae* (Basel, 1523), in *Vives and the Renascence Education of Women,* ed. Foster Watson (New York, 1912), 110. It is this interest in reenacting the ancient drama in contemporary marriages that I think explains Rubens's decision to dress the Sabine women in contemporary Flemish dress in his 1638 depiction of the *Rape of the Sabines* (National Gallery, London, *KdK* 370).

43. For the theoretical principle, see Heidi Hartmann, "The Unhappy Marriage of Marxism and Feminism: Towards a More Progressive Union," in *Women and Revolution,* ed. Lydia Sergent (Montreal, 1981), 14–15. For its application to the analysis of works of art, see Griselda Pollock, *Vision and History: Femininity, Feminism, and the Histories of Art* (London, 1988), 32–34.

44. Gian Paolo Lomazzo (1584), in Shearman, *Mannerism,* 81; quoted more extensively (with Michelangelo's further recommendation that the figure have a flamelike shape to convey "the *furia* of the figure") in Summers, *Michelangelo,* 81ff.

45. Michelangelo only realized his design for the three-figured Samson and the Philistines in a small-scale model; Shearman, *Mannerism,* 83.

46. "All that he wants is glory, and his greatest ambition is to rival Michelangelo. Many connoisseurs—including the Grand Duke himself—think that Giambologna is already on a par with Michelangelo, and so long as he goes on living he will gradually outstrip him"; Simone Fortuna to the Duke of Urbino, 1581, quoted in Avery, *Giovanni da Bologna,* 251.

47. See poems using rape imagery to praise the sculptor, cited in note 36 above.

48. E.H. Gombrich, as mentioned in Alpers, "Manner and Meaning," 289n. Julius S. Held notes that E. Dhanens proposed that the composition of the *Leucippus* makes use of Giambologna's bronze relief of the *Rape of a Sabine,* affixed to the base of the freestanding group; *The Oil Sketches of Rubens: A Critical Catalogue* (Princeton, N.J., 1980), 380.

49. As evidence of their fraternal love, when Castor was fatally wounded in fighting against the two men to whom King Leucippus had promised his daughters, the immortal Pollux prayed to Jupiter to share his immortality with his dying brother; Ovid *Fasti* 5.715–19. See also Plutarch, "On Brotherly Love," *Moralia* 478, 484, and 486. Plutarch commends the twins not only for sharing immortality but also for avoiding rivalry by seeking honors and power in different fields, so that they could "mutually assist and cheer for each other." See also *LIMC,* 3:567–68.

50. The painting is first recorded in the collection of the Johann Wilhelm, Elector of the Palatinate, in Düsseldorf, in the mid-eighteenth century; Johann van Gool, *De nieuwe schouwburg der nederlantsche kunstschilders,* 2 vols. (1751), 2:530–31 and 544. The first paintings by Rubens entered the Düsseldorf collections under the Elector's grandfather, Wolfgang-Wilhelm, duke of Neuberg and Count Palatine (1578–1653). On his relations with Rubens and other patrons of the artist in the years 1610–20, see Max Rooses and Charles Ruelens, *Correspondance de Rubens et documents epistolaires,* 6 vols. (Antwerp, 1887–1909), 2:95 and 227–30. The Elector Johann Wilhelm expanded the Rubens holdings he had inherited, and bought more paintings by the artist, particularly at the Arundel sale in 1684; Barbara Gaehtgens, *Adriaen van der Werff* (Munich, 1987), 59–60. When the *Rape of the Daughters of Leucippus* first entered the Pfalz-Neuberg collections is not known, although it would not surprise me if it were even in the lifetime of Duke Wolfgang-Wilhelm, whose claims to Jülich Berg were effectively secured by the French-Spanish alliance of 1615 (discussed below). I am presently conducting more research on this matter.

51. For the intertwined erotic and political imagery in the *Galerie François Ier* at Fontainebleau (ca. 1540–50), see the special issue of *Revue de l'art* 16–17 (1972), especially essays by André Chastel, W. McAllister Johnson, and Sylvie Beguin (which nonetheless leave many interpretative problems unresolved).

52. Simon Bouquet, *Bref et Sommaire Recueil de ce qui a esté faict et de l'ordre tenue à la ioyeuse et triomphante Entrée de . . . Prince Charles IX de ce nom Roy de France en sa bonne ville et cité de Paris* (Paris, 1572), "Queen's Entry," p. 6; the entry is discussed by Frances Yates in

Astraea, The Imperial Theme in the Sixteenth Century (London, 1985), 127–48.

53. Following Guillaume Budé (above, note 8), the most important proponent of this theory in the later sixteenth century is Jean Bodin; Keohane, *Philosophy and State in France,* 67–82; R.W.K. Hinton, "Husbands, Fathers, and Conquerors," *Political Studies* 15 (1967): 295; and Gordon J. Schochet, *Patriarchalism in Political Thought* (Oxford, 1975), 18–36. Bodin endorses the coercive powers of husbands and fathers, as well as kings, in *Les Six Livres de la république* (Paris, 1576), esp. book 1, chaps. 3, 4, and 5. See also Sarah Hanley, "Family and State in Early Modern France: The Marriage Pact," in *Connecting Spheres: Women in the Western World, 1500 to the Present,* ed. Marilyn J. Boxer and Jean H. Quatert (New York, 1987), 53–63.

54. Bouquet, *Recueil,* 33–34; Yates, *Astraea,* 135–37.

55. Andrea Alciati, *Emblemata* (Augsburg, 1531), facsimile reprint in Andreas Alciatus, *The Latin Emblems Indexes and Lists,* ed. and trans. Peter M. Daly et al. (Toronto, 1985), no. 43.

56. Trans. Daly, *Latin Emblems,* n.p. On the Dioscuri as the constellation Gemini and their cult as patrons of seafarers, see *LIMC,* vol. 3, part 1, pp. 567 and 610. The constellation Gemini was thought to be particularly propitious for sailors in calming storms at sea.

57. On Alciati's interest in Roman law and his relations with Budé, see David O. McNeil, *Guillaume Budé and Humanism in the Reign of François I* (Geneva, 1975), 21; and Paul Emile Viard, *André Alciat* (Paris, 1926), passim.

58. Pierre Ronsard, "Sur le navire de la ville de Paris protegé par Castor et Pollux, ressemblants de visage au Roy et à Monseigneur le Duc d'Anjou" (On the ship of the city of Paris protected by Castor and Pollux, whose faces resemble the king and monseigneur the duke of Anjou), quoted in Yates, *Astraea,* 136:

Quand le Navire enseigne de Paris
(France et Paris n'est qu'une mesme chose)
Estoit de vents et de vagues enclose,
Comme un vaisseau de l'orage surpris,
Le Roy, Monsieur, Dioscures esprits,
Frères et Filz du ciel qui tout dispose,
Sont apparus à la mer qui repose
Et le Navire ont sauvé de perilz.
[When the ship, insignia of Paris (Paris and France are one and the same), was engulfed by winds and waves like a vessel caught in a storm, the king and monseigneur—spirits of the Dioscuri, brothers and sons of heaven which disposes of all—appeared above the sea, it subsided, and they saved the ship from peril. My translation]

59. Instructions by Ronsard in Paul Guerin, ed., *Registres des délibérations du bureau de la ville de Paris,* vol. 6 (Paris, 1892), 242–43.

60. That Rubens was familiar with the emblematic association of the Dioscuri with the French royal family is further indicated by his allegory for the Medici Series of the *Majority of Louis XIII,* in which the Dioscuri/Gemini are again presented as the protectors of France. In the Medici canvas the twins, pictured as the constellation Gemini, shine down on the ship of state, with Louis XIII at the tiller; *KdK,* 258. See Jacques Thuillier and Jacques Foucard, *Rubens' Life of Marie de' Medici,* trans. Robert Eric Wolf (New York, 1970), 89.

61. An emblem on the birth of Louis's younger brother in 1607 shows the ship of France sailing beneath the adult figures of Castor and Pollux, who recline on clouds, with a star over each of their heads; anonymous engraving in the Cabinet des estampes, Histoire de France no. 88625, Bibliothèque nationale, Paris.

62. On the marriage negotiations, see René Zeller, *La Minorité de Louis XIII,* 2 vols. (1892–97), 1:311–38, 2:1–62. The festivities of 1612 were designed to present the alliance as a personal triumph of Marie de' Medici and to suggest the superiority of her nuptial strategies to the bellicose policies of her predecessors:

O qu'il nous eust cousté de morts
O que la France eust faict d'efforts
Auant que d'auoir par les armes
Tant de Prouinces qu'en un iour,
Belle Reine, auecques vos charmes
Vous vous acquerez par amour!
[Oh, how many deaths it has cost us; oh, how France made efforts to acquire by war so many provinces, which you with your charms, beautiful queen, acquire by love in a day. My translation]

Laugier de Porchères, *Le Camp de la place royale, où ce qui s'y est passe . . . pour la publication des mariages du Roy et de Madame avec l'Infante et le Prince d'Espagne* (Paris, 1612), 60.

63. Zeller, *La Minorité de Louis XIII,* 2:12; Thuillier and Foucard, *Rubens' Life of Marie de' Medici,* 24. Rubens referred to the double marriages in two subsequent commissions connected with the French royal house: the *Marriages of Constantine and Fausta and of Constantia and Licinius* for the tapestry cycle on the life of Constantine for (or at least referring to) Louis XIII (ca. 1622), and the *Exchange of Princesses* for the Medici cycle (discussed below). On the Constantine cycle, see John Coolidge, "Louis XIII and Rubens," *Gazette des beaux-arts,* ser. 3, 67 (1966): 271–85; and Held, *Oil Sketches,* 65–72. According to Thuillier and Foucard, originally four paintings in the Medici series were to be dedicated to the marriages (23). See also note 70 below.

64. *La Royale Reception de leurs maiestez très-chrestiennes en la ville de Bordeaux, ou le siècle d'or ramené par les alliances de France et d'Espagne* (Bordeaux,

1615); Otto Von Simson, *Zur Genealogie der weltlichen Apotheose im Barock* (Strasbourg, 1936), 352–56; Thuillier and Foucard, *Rubens' Life of Marie de' Medici,* 23–24 and 87–88.

65. On Rubens and his patrons, Albert and Isabella, see Christopher White, *Peter Paul Rubens* (New Haven, 1987), 55; and on the friendship between the Infanta Isabella and Marie de' Medici, see L. Klingenstein, *The Great Infanta Isabel* (London, 1910), 157 and passim. Rubens's diplomatic activity in Paris in the early 1620s involved advancing Isabella's policy of preserving the Franco-Hispanic alliance, and of dissuading the French from supporting the Dutch Republic in its war against Spain; C.V. Wedgewood, *The Political Career of Peter Paul Rubens* (London, 1975), 29.

66. Laugier de Porchères, *Le Camp de la place royale,* 15:

Pollux et Castor dont les Mariniers prenoyent jadis augre de bonasse, s'ils les voyoyent tous deux ensemble, & de la tempête quand l'un se montroit tout seul comme nous prenons l'union de ces deux grands Monarques, pour presage de la tranquilité de toute l'Europe.
[Sailors used to take Pollux and Castor as an omen of smooth sailing if they appeared together, and of a storm if one appeared alone. So do we take the union of these two great monarchs as a presage of tranquility for all of Europe. My translation.]

In a later passage in this same book, a poem compares the eyes of Marie to the Dioscuri, and here with unmistakable erotic innuendo (65):

Vos yeux (par qui l'amour plus fort que le respect
Faict dessus tant de coeurs de secrettes conquestes)
Sont des Astres iumeaux de qui le seul aspect
Des tumultes Francois appaise les tempestes.
[Your eyes (by which a love that is stronger than respect makes a secret conquest of so many hearts) are the twin stars, which, at their sole appearance, appease the storms of French tumults. My translation]

67. The print, attributed to Jan Ziarnko, is discussed in Thuillier and Foucard, *Rubens' Life of Marie de' Medici,* 23 and n. 58.

68. Claude Lévi-Strauss, *The Elementary Structures of Kinship,* trans. James Harle Bell et al. (Boston, 1969). For an illuminating précis and critique of Lévi-Strauss's argument, see Gayle Rubin, "The Traffic in Women: Notes on the 'Political Economy' of Sex," in *Toward an Anthropology of Women,* ed. Rayna B. Reiter (New York, 1975), 157–210.

69. My translation of the legend on fig. 9.

70. It is worth recalling Held's commentary on Rubens's arrangement of pairs of figures in his canvas for the Medici series, *The Council of the Gods for the Reciprocal Marriages Between France and Spain:* "Since its central theme

is that of union between two great countries, symbolized by the two joined halves of the globe itself, it is surely a striking feature of the composition that it is made up (except for the 'dark' side) of pairs of figures in various degrees of friendly association. . . . One of the basic themes of the work is union—established on many levels and in many different forms—between two peaceful partners"; *Oil Sketches,* 114. An early instance of this pairing strategy may well be the foursome in the *Leucippus,* even if one hesitates to claim that Rubens intended the circularity of the composition to intimate global union.

71. *La Réponse de Guerin à M. Guillaume et les resiouissances des Dieus sur les heureuses alliances de France et d'Espagne* (Paris, 1612), 49 (my translation).

72. René Girard, *Violence and the Sacred,* trans. Patrick Gregory (Baltimore, 1977), 1–38.

73. Alpers, "Manner and Meaning," 286. On the *Escorial Deposition,* see Martin Davies, *Rogier van der Weyden* (London, 1972) 223–26.

74. *KdK,* 256; Thuillier and Foucard, *Rubens' Life of Marie de' Medici,* 87–88; and Susan Saward, *The Golden Age of Marie de' Medici* (Ann Arbor, Mich., 1982), 137–42. For the historical background, see note 64 above.

75. On the *Visitation* by Dirk Bouts, see Max J. Friedlander, *Early Netherlandish Painting,* vol. 3, *Dieric Bouts and Joos van Gent,* trans. Heinz Norden, commentary by Nicole Veronée Verhaegen (Leyden, 1968), 22 and 59.

76. A recurrent theme in the marriage festivities and epithalamia was the expectation of the royal offspring who would issue from the marriages (see note 77 below).

77. At least one marriage poem that foretells the satisfactions that await the brides as mothers does so by way of consoling them for the pain that, it acknowledges, they will initially suffer (even addressing them at one point as "Sabinoises").

Celles pour qui se fait tant de resiouissance
Feront souspirs de coeur: ietteront larmes d'oeil:
Psyche l'ame d'amour à son Hymen en deuil:
C'est grand deuil de quitter le lieu de sa naissance.

Filles, voyez, oyez: pour vostre cognoissance
Vous trouuerez Maris demy-Dieus trionfans,
Pour vos soupirs, suiets & royalle puissance:
Bref, pour vos pleurs & fleurs, ris & beau fruit d'enfans.

[Those for whom there is so much rejoicing will sigh in their hearts, and tears will gush from their eyes. Psyche, the soul of love, entered marriage in mourning. It is a great bereavement to leave the place of one's birth. Girls, look, listen: for your understanding, you will find husbands who are triumphant demigods; for your sighs, subjects and royal power; in brief, for your tears and marriage-flowers, laughter and the beautiful fruit of children. My translation.]

Alaigres de Navières, *Les Alliances royales et reiouissances publiques précédentes les solennitez du mariage des enfans*

des plus célebres et augustes Roys de l'Europe (Lyons, 1612), 30.

The undress of the daughters of Leucippus is of course entirely appropriate in a mythological scene, and particularly an erotic one. But in contrasting the nude women to the attired men, perhaps Rubens also meant to call to mind ancient and traditional marriage customs wherein the bride is stripped of the clothes she brings from her parents' home before donning new garments provided by the husband. As marriage ethnologists have shown, the bride's divestiture of her old garments signifies her divestiture of her old roles as daughter and sister in her family of birth, prior to her induction into her new roles of wife and mother in the household of her husband. Christiane

Klapisch-Zuber, "The Griselda Complex," in *Women, Family, and Ritual*, 225.

78. The pose of the higher sister duplicates the coital pose of Michelangelo's Leda (as Arthur K. Wheelock, Jr., notes, in *Masterworks from Munich*, 107), thereby heightening the sense of the erotic expectation of the moment.

79. Jean Héroard, *Journal de Jean Héroard sur l'enfance et la jeunesse de Louis XIII*, ed. E. de Soulié and E. de Barthélemy, 2 vols. (Paris, 1868), 2:183–86.

80. It was not until 25 January 1619 that he ventured to bed with his wife again (and this time, as well, with great reluctance); ibid., 2:229–30. See discussion in Pierre Chevallier, *Louis XIII: Roi cornelien* (Paris, 1977), 101.

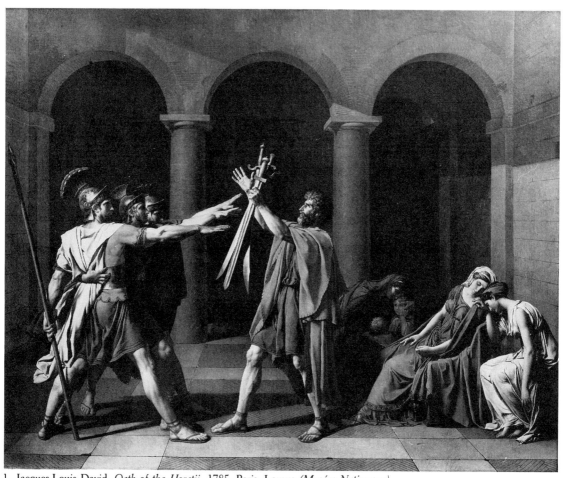

1. Jacques-Louis David, *Oath of the Horatii*, 1785. Paris, Louvre *(Musées Nationaux)*.

THE MUTED OTHER

*Gender and Morality in Augustan Rome
and Eighteenth-Century Europe*

NATALIE BOYMEL KAMPEN

Classicizing art has often expressed political values, but its role in the service of gender ideology has rarely been explored. The goal of this essay is to develop a gender-based interpretation of several works of classicizing public art and to show how they communicated ideas about social order through their representation of female sexuality.[1] The themes and styles taken from an ideal Greek or Roman past function in certain public reliefs of the late first century B.C. and history paintings of the late eighteenth century as a prescription for relationships between men and women. Their method, one among a number visible in these two periods, is to mute difference and alterity. Whether the cultural opposition is between male and female, public and private, or culture and nature, the muting of the Other implies power unequally divided, value unequally apportioned. In patriarchal cultures in the West, this means privileging the male insider and his values.[2] Classicizing art can make this cultural model visible in a special way. Its stories and its idealizations may

be used to give form to the conflict between oppositions and at the same time attempt to mediate that conflict in two ways: first, by demonstrating the moral and physical superiority of male Self over female Other; second, by convincing the Other that it is possible to become like Self.

The classical rhetoric of gender under consideration here establishes norms of moral behavior based on the authority of a better past in which roles and conduct were seen as clear and correct. Normative actions could be chosen by anyone, male or female; to make the correct moral choice was to become an insider, ennobled by the best of tradition. The golden age from which my late-first-century B.C. Roman and eighteenth-century European examples take their themes is pre-Imperial Rome; as it was an ideal time to the Roman authors of the late Republic and Empire, so it became for many in the eighteenth century. For both periods, early Rome meant a certain kind of virtue, based on a simple but rigorous and ordered society that contrasted both with barbarism and with decadence. In that ideal time, men were men and women were under their control. Thus, the classical rhetoric of gender in works of art is, like the choice of the period deemed classic, the staking out of an ideological position.

Published as "The Muted Other," *Art Journal* 47, no. 1 (Spring 1988): 15–19. Copyright © 1988 by the College Art Association of America. Reprinted by permission of the author and the College Art Association of America.

The frieze of the Basilica Aemilia in the Forum Romanum has a classicizing style that has permitted scholars to date it anywhere from about 60 B.C. to about A.D. 60. I believe, however, that its programmatic concerns require its dating to the same time as the Ara Pacis Augustae—that is, after 14 B.C., when Augustus helped the Aemilii restore the Basilica after a fire in the Forum damaged it.[3] The frieze, which ran around the interior of the building, told the story of the foundation of Rome, a favorite theme in the time of Augustus— as the Ara Pacis, the Esquiline tomb paintings, and the work of Virgil and contemporary historians all attest.[4] In addition to locating the emperor in Rome's legendary history by presenting stories of his ancestors and his people, parts of the frieze gave specific expression to Augustus's ideas about the restoration of traditional family and morality. The two scenes that are most important for this discussion of gender ideology represent the Rape of the Sabine Women and the Punishment of Tarpeia, the only known monumental images of these central themes in Roman art.

The story of the Sabines [2] helps to explain the role of female conduct in the revival of Augustus's ideal Roman family.[5] Since the early Romans had no wives, they saw the rape of their neighbors' daughters as a necessity. The rape, in which two Romans carry off two Sabine women, gives form to the issues of exogamy and the social need for reproduction. The later intervention of the women between their Sabine fathers and their Roman husbands, implied and perhaps once part of the frieze but now untraceable, would have illustrated Rome's relationship to its Italian neighbors at the same time that it revealed the correct behavior of women in their roles as daughters, wives, and mothers—symbols of social mediation.

The frieze contrasts the Sabine women, outsiders whose conduct makes them perfect insiders, with the insider, Tarpeia [3], the Roman maiden who, bribed by their gold, opened the gates and let the Sabine warriors into Rome to avenge the rape.[6] Tarpeia's seduction—turning her from insider to outsider—is punished by the Sabines, whom we see as they crush her beneath their shields. The Sabine women thus demonstrate the merits of correct female behavior and cease to be outsiders, whereas Tarpeia stands for the way unregulated female conduct, proof of alterity, can endanger the whole of society.

In both stories the classicizing form alerted the audience to the value of the program as cultural artifact and also to its authority, based on the styles, however eclectic, of the past. Like the frieze of the Temple of Apollo at Bassae, also ranged around the inside of a building, the figures are distributed without crowding in a single layer.

2. Rome, Basilica Aemilia, frieze, detail: Rape of the Sabine Women, after 14 B.C. *(Fototeca Unione, Rome)*.

3. Rome, Basilica Aemilia, frieze, detail: Punishment of Tarpeia *(Fototeca Unione, Rome).*

The outstretched arms of the captive women, the idealized proportions of the bodies, the patterns of drapery all contribute to the evocation of the style of later fifth- and early-fourth-century sculpture well known among patrons and artists in Rome in the later first century B.C.

The frieze of the Basilica Aemilia expresses an ideologically motivated program within which gender functions both as immediate moral lesson and as metaphor for the normative relationship between Self and Other. The program is part of the Augustan response to the chaos of rapidly changing upper-class mores at the end of the Republic. Roman writers such as Cicero and Polybius repeatedly lament the decline of morality in the late Republic, and condemn aristocratic women who care more about staying young and entertaining lovers than for bearing and nursing babies.[7] In place of this perceived decadence, conservative thinkers offered an earlier age of correct conduct, of wives and daughters who, like Lucretia or Verginia, were silent, strong, and obedient, of husbands and fathers whose word was law.[8] That era had a kind of enduring attraction to

many Romans, and Augustus used it to construct his social program. The revival of the family, based in large part on the regulation of female sexuality, was to be accomplished by religious revival and by laws that controlled marital conduct and penalized the unmarried and the childless.[9] Notoriously unsuccessful, the Augustan social program was nonetheless a serious and conservative attempt to stabilize society after the Civil War years and to establish a vigorous Roman population with a sense of its own historic responsibility.

Like the Basilica Aemilia friezes, the reliefs of the Ara Pacis Augustae, of 13–9 B.C., are to be seen against this background of perceived social instability and of Augustan attempts at moral and social *renovatio* [4]. As Diana Kleiner has most recently shown, the Ara Pacis is very much a family monument.[10] Its program illustrates the consequences of Augustan peace in terms that encompass the fertility of the earth, the Romans, and the Imperial family itself [5]. The presence of the Imperial family not only demonstrates dynastic aspirations but also reminds the populace of its duty of responsible sexuality; the court is the ultimate model of this responsibility, which was

4. Rome, Ara Pacis Augustae, front, 13–9 B.C. *(Fototeca Unione, Rome)*.

5. Rome, Ara Pacis Augustae, detail: Imperial Family frieze *(Fototeca Unione, Rome)*.

framed in the Augustan marital laws and sanctions of the period.[11] The panels rephrase the same themes in allegorical form, playing Roma, woman as moral state at peace, against Tellus, woman as nature at peace. Even the sow of Aeneas [6] and the wolf of Romulus and Remus continue this theme of the tamed female in the service of the healthy state. The Ara Pacis program thus includes a consistent use of gender and combines female fertility with female morality. The whole is placed in a form that the educated viewer of the time, familiar with Greek statues and their history, could recognize as worthy of honor. Using restrained movement and emotion, compositions reminiscent of those on the Parthenon and earlier altars, and figure types with the proportions and monumentality of fifth-century Attic sculpture, the style is the signal of a moral past, which the content then explains.[12]

The Ara Pacis and the Basilica Aemilia friezes incorporate the same kinds of gender messages into their programs, and they use similar techniques—muting the danger of the female outsider through demonstrations of normative conduct and through style as signal of the moral and worthy past. A comparable case exists in some of the history painting of the late eighteenth century, particularly in that type which Robert Rosenblum has called "neoclassic stoic."[13] Again, classicizing public works of art may serve to demonstrate the idealized relationship between men and women in the interests of social ideology.

In both David's *Oath of the Horatii* [1] and Angelica Kauffmann's *Cornelia, Mother of the Gracchi* [7], didactic Roman republican stories are combined with that classicizing style which the educated audience associated not just with archaeology but also with reform and morality.[14] Different as their themes are, both pictures share a political vision of gender that depends on woman to be Other; in this vision, women start out as embodiments of emotionality and lack of control, cast as outsiders in relation to the public

6. Rome, Ara Pacis Augustae, detail: Aeneas panel (*Deutsches Archäologisches Institut, Rome*).

7. Angelica
Kauffmann, *Cornelia,
Mother of the Gracchi,*
1784–85. Richmond,
Virginia Museum.

and valued world of men. Only through noble behavior—in other words, behavior based on patriarchal norms—can such alterity be overcome. And that, ultimately, is the message of this classicizing gender program.

The *Oath of the Horatii* offers a patriotic story in which women fail to conduct themselves properly, in the sense that they fail to live up to male codes of behavior; beneath the theme of the oath taken by the brothers to defend Rome lurks the fact that a brother will kill his own sister. She will die for mourning the fiancé whom her brother has killed as an enemy of Rome. Through the form chosen to represent the story, the contrast of weak, weeping, marginal women with muscular, architectonic, and central men, woman is shown to be Other and is thus devalued.[15] Kauffmann's Cornelia is, in contrast, able to overcome the alterity of her sex by her exemplary behavior.[16] Standing between her sons—future virtuous men—and the two female figures toying with jewelry, she

rejects the latter and points to the boys, saying, "These are my jewels." Cornelia's virtue resides, of course, in her *explicit* rejection of the trivial; but in Kauffmann's picture with its simple forms and emotional restraint, the *implicit* choice is between men and women, moral self and problematic Other.

The late-eighteenth-century discussion of women's roles and conduct was in part a reaction to the perceived license of upper-class women and the degeneracy of the family, and it offered a variety of plans for reform.[17] Like the classical program, that of Rousseau was based on the idea of woman as Other, problematic and in need of regulation. What made the two points of view so different, of course, was that one saw the transforming possibilities of moral behavior, whereas the other sought to understand and make the most of nature's laws. J-M. Moreau le jeune's *Les Délices de la maternité* [8] and Benjamin West's *Agrippina with the Ashes of Germanicus* [9] exem-

8. J.-M. Moreau le jeune, *Les Délices de la maternité*, engraving after Helman, 1777.

9. Benjamin West, *The Arrival of Agrippina at Brundisium with the Ashes of Germanicus*, 1768. New Haven, Yale University Art Gallery, Gift of Louis M. Rabinowitz *(Joseph Szaszfai)*.

plify the two points of view. At the same time they demonstrate an essential difference between the women being discussed and perhaps being addressed. As one is an utterly domestic being, the other, no less mother and wife, is a heroic figure capable of public action. It would appear that the classical gender ideology both in Augustan Rome and the eighteenth century spoke in terms that educated, powerful, and independent women could understand. Rather than asking such women simply to become domestic blissful creatures, this classical position permitted them to purify their own recent history of its irresponsibilities and false values and thus to become heroic— not mere women, but moral women. History and the classical style were the vehicles for communication of those messages to the women of the Augustan upper classes and the educated women of eighteenth-century Europe.

The classicizing imagery of gender is functional not only because it describes the socialization of women to moral conduct but also because it explains the relations between Self and Other, be-

tween insider and outsider, between ruler and ruled. The desire to control difference through the application of behavioral norms and the playing down of essence and nature in favor of conduct and civilization function to tame both women and imperialized peoples, to win them or to disarm them. Gender becomes a symbol and model for a larger world of idealized class and international relations.

Classicizing form is essential to this rhetoric of gender because it too mutes alterity. It not only sets norms for figures and compositions but removes emotional and physical eccentricity and abnormality. If woman is nature, the irrational, the abnormal—as Greek and Roman philosophers and doctors suggested—then classicism, as a style, subdues her.[18] Woman becomes like man in the sense that her chaotic and irregular essence is controlled by her absorption into the civilized and rational world. Classicism is, thus, much more than a value-free matter of taste or visual ideals; it may become the instrument of a wide-ranging ideology, a device and a metaphor for social control.

NOTES

1. My discussions with the Providence Women-and-Architecture Group and with Anne Weis and John Dunnigan provided important ideas for this paper.

2. For this set of ideas, see Sherry Ortner, "Is Female to Male as Nature is to Culture?" in Michelle Z. Rosaldo and Louise Lamphere, *Women, Culture, and Society*, Stanford, 1974, pp. 67–88; and Michelle Z. Rosaldo, "The Use and Abuse of Anthropology: Reflections on Feminism and Cross-Cultural Understanding," *Signs*, 5 (1980), pp. 389–417.

3. The dating runs from the earliest, 87–78 B.C., in Filippo Coarelli and Ranuccio Bianchi Bandinelli, *Etruria-Roma: L'Arte dell'Antichità classica*, II, Turin, 1976, #49, to the latest, Neronian, in Erika Simon, in Wolfgang Helbig, *Führer durch die öffentlichen Sammlungen klassischer Altertümer in Rom* (4th ed. by Hermine Speier), II, Tübingen, 1966, #2062, p. 842. Most scholars date the monument to 34 B.C.: e.g., Gianfilippo Carrettoni, "Il Fregio figurato della Basilica Emilia," *Rivista del Istituto Nazionale d'Archeologia e Storia dell'Arte*, n.s. 10,

19(1961), pp. 5–78. Dating of 55–34 is repeated in the most recent work on the Basilica Aemilia's archaeology, reported by Heinrich Bauer in *Kaiser Augustus und die verlorene Republik* (Berlin, 1988), pp. 200–11. Mario Torelli, in Coarelli and Bianchi Bandinelli, suggests that cuts on the backs of some of the blocks indicate their reuse from an earlier monument; the cuts can, however, be interpreted in a variety of other ways—e.g., from a later restoration.

The reasons for a date contemporary with the Ara Pacis include textual references in Dio, 54.24.2–3, to reconstruction work on the Basilica, funded by Augustus and other friends of L. Aemilius Lepidus Paullus after the fire of 14 B.C. Donald Strong in *Roman Art*, Harmondsworth, 1976, pp. 78–79, used style and the Augustan popularity of representations of Roman foundation legends to suggest a date about 14. In addition, the date is appropriate in light of Augustus's interest in Rome's legendary history during the decade of the *Ludi Saeculares* of 17 B.C.

4. The Esquiline tomb connected with the Statilii is

normally dated to the early Augustan period; see: Bernhard Andreae in Helbig (cited n. 3), III, #2489, p. 463.

5. On the Sabine women, see: Livy 1.9ff.; Cicero *de re publica* 2.7.12–13; and also Pierre Lambrechts, "Consus et l'Enlèvement des Sabines," *L'Antiquité Classique*, 15 (1946), pp. 61–82; and Otto Seel, "Der Raub der Sabinerinnen: ein Livius-Interpretation," *Antike und Abendland*, 9 (1960), pp. 7–17. Most recently, see Eva Stehle, "Venus, Cybele, and the Sabine Women: The Roman Construction of Female Sexuality," *Helios*, 16:2 (Autumn 1989) pp. 143–64, and also Norman Bryson, "Two Narratives of Rape in the Visual Arts: Lucretia and the Sabine Women," in *Rape*, ed. S. Tomaselli and R. Porter (Oxford, 1986), pp. 152–73. On the rape as symbolic rite of passage, see: Mario Torelli, *Lavinio e Roma*, Rome, 1984, esp. ch. 3–4.

6. For the story of Tarpeia and its meaning, see: Livy 1.xi.6–9; and Ovid *Fasti* 1.261–2, where he calls her *levis custos*, fickle guardian. For *custos* applied to housewives in praise of their guardianship of the family and its property, see: T.E.V. Pearce, "The Role of the Wife as Custos in Ancient Rome," *Eranos*, 72 (1974), pp. 16–33. Note as well the use of *levis*, which also may be used for the arms of soldiers.

7. See especially: Cicero, *Pro Caelio* 13–16; Polybius 31.23–26; as well as Sallust 24–5; and Horace *Ode* 3.6. On women as uncontrollable: Livy 34.1–8, on the repeal of the Oppian Law.

8. For the *topos* of the good woman in this period, see especially: the Laudatio Murdiae, *Corpus Inscriptionum Latinarum* VI.10230, and Laudatio Turiae, *CIL* VI.1527. On patriarchal power, see, for example: Valerius Maximus 6.3.9–12; Dion. Hal. *Ant. Rom.* 2.25.4; or Aulus Gellius, *Attic Nights* 10.23.

9. Paulus, *Sententiae* 2.26.1–17, and Justinian, *Codex* 9 and 48.5. Pál Csillag, *The Augustan Laws on Family Relations*, Budapest, 1976; Leo Raditsa, "Augustus' Legislation Concerning Marriage, Procreation, Affairs, and Adultery," *Aufstieg and Niedergang der römischen Welt*, ed. Hildegard Temporini, Tübingen, 1980, II.13, pp. 278–339; and Karl Galinsky, "Augustus' Legislation on Morals and Marriage," *Philologus*, 125 (1981), pp. 126–44.

10. Diana E. E. Kleiner, "The Great Friezes of the Ara Pacis Augustae," *Mélanges de l'École Français à Rome*, 90:2 (1978), pp. 753–85. For literature on the Ara Pacis, see: Simon in Helbig (cited n. 3), II, #1937, pp. 673–95.

11. Kleiner (cited n. 10), p. 776.

12. See Paul Zanker, "Zur Funktion und Bedeutung griechischer Skulptur in der Römerzeit," *Le Classicisme à Rome aux 1. siècles avant et après J.-C.*, ed. Hellmut Flashar (*Entretiens sur l'Antiquité Classique: Fondation Hardt* XXV), Geneva, 1979, pp. 283–306, esp. pp. 293–97.

13. Robert Rosenblum, *Transformations in Late-Eighteenth-Century Art*, Princeton, 1970, p. 28.

14. For the David, see: Thomas Crow, "The Oath of the Horatii in 1785," *Art History*, 1:4 (December 1978), pp. 424–71; Norman Bryson, *Word and Image*, Cambridge, 1981, ch. 8, esp. p. 268, n. 36; and idem, *Tradition and Desire*, Cambridge, 1984, pp. 70–76. Stefan Germer and Hubertus Kohle in their discussion of the privatized psychology of the male protagonist ("From the Theatrical to the Aesthetic Hero: On the Privatization of the Idea of Virtue in David's *Brutus* and *Sabines*," *Art History*, 9:2 [June 1986], pp. 168–84) point up the problem of uneven development in the thought of the period; at the same moment that the *Brutus* probes the private psychology of Brutus, the females are still isolated, restricted to the domestic side of the house, and presented as uncontrolled in their emotionality. The private is, thus, perceived with a mixture of yearning and disrespect, and the question of relationship between public and private remains unresolved but also, in its patriarchal character, fundamentally unchallenged. For the relationship between devalued feminine and the private realm, see also: Yvonne Korshak, "*Paris and Helen* by Jacques Louis David: Choice and Judgment on the Eve of the French Revolution," *Art Bulletin*, 69:1 (March 1987), pp. 102–16.

On the Kauffmann, see: Ann Sutherland Harris and Linda Nochlin, *Women Artists: 1550–1950*, exh. cat., New York, 1978, p. 178, #50 (entry by Peter Walch); and Wendy Wassyng Roworth, "Biography, Criticism, Art History: Angelica Kauffmann in Context," in Frederick M. Keener and Susan E. Lorsch, eds., *Eighteenth-Century Women and the Arts* (Greenwood Press, 1988), pp. 209–23.

15. The sources for the *Oath of the Horatii* are to be found in Livy 1.24–26; see: Edgar Wind, "The Sources of David's *Horaces*," *Journal of the Warburg and Courtauld Institutes*, 4 (1940–41), pp. 24–38.

16. For the story of Cornelia, see: Valerius Maximus 4.4 pr.

17. On the ideology of maternity and the point of view of Rousseau, see: Carol Duncan, "Happy Mothers and Other New Ideas in Eighteenth-Century France," in *Feminism and Art History*, ed. Norma Broude and Mary Garrard, New York, 1981, pp. 200–19.

18. For the abnormality and alterity of women in Greek and Roman thought, see: Paola Manuli, "Fisiologia e patologia del femminile negli scritti ippocratici dell'antica ginecologia greca," *Hippocratica: Colloques Internationaux du CNRS*, #583 (1980), pp. 393–408; Mary Beard, "The Sexual Status of Vestal Virgins," *Journal of Roman Studies*, 70 (1980), pp. 12–27, esp. pp. 19–27; and Danielle Gourvitch, *Le Mal d'être Femme*, Paris, 1984, passim.

1. Delsart studio, *Portrait of a Woman with an Album,*
carte-de-visite photograph, about 1865. Private collection.

SECLUDED VISION

Images of Feminine Experience in
Nineteenth-Century Europe

ANNE HIGONNET

Women have many traditions of self-expression; the least known may be their albums and amateur painting. In countless pictures of family, friends, homes, and travels, as well as in self-portraits, middle- and upper-class women all over Europe, throughout the nineteenth century, painted or drew a domestic existence. The few of these pictures that survive now molder in drawers, attics, or flea markets. Yet, like their literary counterparts, the diary and the sentimental novel, they represent the way in which many women understood themselves and their femininity. Women's albums and amateur paintings constitute a widespread, self-conscious, and imaginative interpretation of femininity as a crafted social role. Out of this self-conception came a pictorial practice whose values and achievements have remained obscure.

A reconstruction of nineteenth-century feminine pictorial traditions encounters some basic difficulties, both material and theoretical. Most albums and amateur paintings find no place in public domains. Museums, libraries, academics,

and publishing houses ignore them.[1] This neglect can be partially attributed to the images' own seclusion in the private worlds of women's lives. But in a larger sense, amateur images remain unknown because we do not fit them into the category of representations we call "art." The images of feminine culture are unlike the paintings we associate with nineteenth-century European culture; in an aesthetic comparison with professional painting, they often seem feeble. Such a comparison, however, avoids the real issue, which is that feminine images do not fail to meet aesthetic criteria, but rather obey other criteria altogether. The images of albums and amateur painting are not pictures that happen to be made by women. Nor would it be entirely accurate to say they represent women's lives. Rather, they represent women's definition of themselves as it was structured by gender conventions. Femininity shaped the practice of album-making and amateur painting, and set it apart from the norms of high art.

It would be unfair to treat the images belonging to a feminine pictorial culture, however, by merely stating difference. The difference between these images and those of high art is not just a difference, but also a power relationship. The norms of high art—basically of painting—still control our

From *Radical History Review* 38 (1987): 16–36. Copyright © 1987 by MARHO: the Radical Historians' Organization. Reprinted by permission of the author and MARHO.

2. Princess Eugenie of Sweden,
On the Balcony, Tullgarn,
watercolor, 1853. Collection of
His Majesty King Oscar II.

interpretations (or rather inhibit any interpretation) of a feminine visual culture. When women's albums or amateur paintings have been noticed, they have been condescended to as, at best, quaint illustrations of charming trivialities or, at worst, evidence of women's pictorial incompetency.

In this essay, then, I try to consider the subject from both within and without. I first describe the forms of visual expression practiced by middle- and upper-class women in nineteenth-century Europe, and then suggest what role these images may have played in definitions of femininity. I next observe the inability of feminine imagery to assert itself outside a domestic world, and go on to explain that inability by defining the differences between feminine imagery and painting. Finally, I seek to understand how the characteristics of feminine imagery have worked against its recognition.

Albums and Amateurs

Women throughout nineteenth-century Europe drew and painted. Only the rare middle- or upper-class family did not include at least one serious amateur woman artist every few generations. While exact figures cannot be computed, a wealth of literary sources—novels, biographies, family histories, journals, etiquette manuals, pedagogic treatises, political commentaries, and magazine stories—provides some measure of the phenomenon. The heroine of Wilkie Collins's 1860 *Woman in White,* for instance, meets her hero when he comes to supervise her outdoor afternoon watercolor sessions; Ibsen's 1890 Hedda Gabler disguises her reunion with her former lover by innocuously leafing through her album of honeymoon photographs; Jane Austen's 1816 Emma has a fine but undisciplined talent for "figure-pieces," landscapes, flowers, and especially "likenesses." Over and over again the motif of a woman sketching appears in contemporary painting and in fashion illustration especially. Many women who became famous for other reasons turn out to have been dedicated amateur picture makers: reigning women like Princess Eugenie of Sweden (1830–1889) [2], professional women such as George Sand (1804–1876), and the wives of emi-

3. Adèle Hugo, *Page with Portraits of Her Sons Charles and François Victor*, pencil, 1838. Paris, Maison Victor Hugo *(Photographie Bulloz)*.

nent men, among them Victor Hugo's wife, Adèle (1806–1868) [3].

A pedagogic curriculum emphasizing the fine arts gave women basic expressive means. Most middle- and upper-class girls learned rudimentary drawing and watercolor techniques, and occasionally even oil-painting skills. Artistic proficiency counted among the feminine accomplishments attractive to suitable husbands. Early exercise provided a technical basis for later work. While many women abandoned hobbies after the first years of marriage, some women went on painting or sketching for the rest of their lives—for instance, Louise de Broglie, Comtesse d'Haussonville (1819–1882), better known as the subject of an Ingres portrait than as a dedicated amateur artist. Queen Victoria (1819–1901) painted her last picture at the age of seventy-one. Virtually all the images discussed in this essay were made by adults or young adults who independently chose visual means to express themselves. Descendants or family chronicles describe such women frequently spending many hours making pictures. Consider the case of the Belgian Duchesse de Vendôme,

who in 1920 recorded the scenes of her twenty-fifth wedding anniversary trip through North Africa in four volumes of watercolors and notes; during her one-hundred-and-twenty-day trip she produced an average of three watercolors and seven manuscript pages a day.[2] Mary Ellen Best (1809–1891), an Englishwoman who worked also in Holland, Belgium, and Germany, left a list of 651 portraits made between 1828 and 1849; her biographer estimates a lifetime total of about 1,500 pictures.[3]

Above all, women made albums. Albums lent themselves to a wide range of skill and means. Initially a volume of blank pages, the album could contain whatever its maker chose. Albums ranged from tooled, leather-bound, gold-stamped books with ornamental clasps to cardboard-covered tablets, measured between twelve by eighteen to two by four inches, and contained somewhere between twelve and a hundred sheets. Some albums were filled by one person; others were collective efforts.

Many kinds of pictures fill album pages. Delicate watercolors or pencil sketches of landscapes and interiors hover on the surface of the page,

4. Henrietta Thornton, *Thornton Sisters and Brothers with Nurse Hunter in the Library,* pen and pencil, about 1825. Whereabouts unknown.

fading off at the edges, images of a cozy sitting room [4], the view from home windows [5], or a picturesque vista. With technical difficulties cheerfully bypassed, lively little pen-and-ink figures engage in household occupations [4], relax [2], or travel together. More careful studies, usually in pencil, gouache, or watercolor, portray family [3], friends, and self [6]. Beneath the images in albums, spidery captions tell a story, identifying places and people [5,3].

Although many album pictures were made with pencil or brush, just as many others were found, collected, or assembled. Marie de Krüdener (1823–1910), the Swiss-raised daughter of a Russian diplomat, put both kinds of pictures in her album: penned caricatures and watercolor landscapes, but also lithographs of favorite pianos, maps charting trips, photographs of family homes and family [5], pressed flowers, and butterflies.[4] Other albums turn pictures into words. In "keepsake books" or "albums amicorum," friends and

family members each contributed a page of their own design, combining sketches, prints, proverbs, witticisms, poems, advice, or messages of friendship however they chose, usually uniting the page with decorative borders and ornaments. This type of album ranged from formal volumes like Maria de Marches's tooled blue leather album, including dedications by Alfred de Vigny, Victor Hugo, and Alexandre Dumas, as well as watercolors by Baron Tyler and Isabey,[5] to young Hedwige Oppell's tiny cardboard album in which one friend neatly inscribed next to a poem, "Chère et bien aimée Hedwige quand vous feuilleterez votre Album rappelez vous votre amie Suzanne," and stuck on a color lithograph for emphasis.[6]

The practice of album-making seems to have begun in England and Germany toward the end of the eighteenth century. It has its origins in Romanticism's cult of the outdoor sketch, and in concurrent concepts of leisure. A new perception of the countryside brought women and men out-

side to commune with nature through the medium of art. An intellectually sanctioned form of art-making had developed that women could master, in the most basic logistic sense. Women rarely had access to studios, academic courses, large canvases, and paid human models—the expensive and cumbrous equipment of professional art. Many, though, could obtain paper, pencil, or watercolors and sit outside, their work balanced on their knees. Inside, a small table in the parlor sufficed. Henrietta Thornton, a young Englishwoman (1807–1853), showed herself at such a table in the library her family used as a sitting room, working no more conspicuously than the two sisters who sew nearby [4].[7]

At the same time, a legitimation of leisure allowed women time to spend sketching. Amateur artistic pursuits were becoming a defining feature of femininity as it was conceived of by the middle classes. Earlier in the eighteenth century women had sometimes become accomplished amateur artists, like Mrs. Delany in England, whose paper cutouts of flowers were widely known and praised;

but, if they resembled Mrs. Delany, they thought of their work as a way to prevent idleness, a way they feared might not be as valuable as housekeeping or charity.[8] These negative connotations did not entirely disappear in the next century, but were mitigated by an increased approval of individualistic self-expression. From England and Germany album-making spread throughout the Continent, and has persisted in some form until the present.[9] As long as women made albums, their themes remained remarkably consistent. Only the representation of maternity evolved significantly, tending increasingly to images of mothers holding very young children, signs of a more exclusive and physically bonding conception of the subject.

Albums grouped images together into structured units. Domestic journals recorded scenes of everyday life, of places and people so familiar to their original audiences that they required only the briefest captions. Short descriptions recalled amusing incidents and special occasions, or referred to family jokes and rituals. Domestic jour-

5. Marie de Krüdener, *Album Page with Photographs of a Home*, stereoscopic photographs and ink, 1863. Private collection.

nals sometimes concentrated on a particular family theme, most commonly a mother's experience of a new child's development, and a family tradition of entertainment. Between 1803 and 1810, for example, the English Wynne-Williams family recorded each of their plays or pantomimes, with cast lists and watercolor illustrations.[10]

Other albums commemorate special times: a trip, for instance, or the months between engagement and marriage. In these albums, which we might call souvenir albums, the text tends to be longer, to weave itself around pictures and to make the depicted events into a self-contained story. One woman—remembered in her family only as the aunt of another album maker—put together an album in the 1860s that took her family from English train station to English train station, via boat, barge, and donkey peregrinations in the Middle East. The laconic irony of the captions contrasts humorously with the spontaneous verve of the images, which show three women cousins and their male chaperones dashing about in comic states of high spirits, earnest exertion, and exhaustion.[11]

Paintings by the same women who made albums, or the same sort of women, might seem to be isolated objects, but should be thought of as if they were detached album pages. While of course many amateur pictures were not made for albums, they were conceived of as if they were to be included in albums. Julia Margaret Cameron (1815–1879), for example, produced artistically ambitious and ostensibly separate photographs, but when she presented them to friends and family, she assembled them into albums that revealed her work's conceptual origins in a feminine amateur tradition.[12]

Women's amateur paintings reiterate album themes. Marguerite de Krüdener (1818–1911, sister of Marie de Krüdener) produced a significant number of both separate paintings and albums that, exceptionally, have been kept together. In both her paintings and her albums she represented vacations in the Alps, her home on Lake Geneva, each of her sisters, brothers, nephews, nieces, and many of her numerous friends. Her paintings by their repetitions demonstrate which were her fa-

6. Marguerite de Krüdener, *Self-Portrait*, gouache and pencil, about 1846–48. Private collection.

vorite subjects: her home, her sisters, her mother, and herself [6].

The common belief that the woman amateur painted only pictures of flowers is a myth. Some amateur women did restrict themselves to plant subjects, but more often as a chosen specialization than because they could do nothing else. Women whose painting provided an outlet for extensive botanical knowledge devised particularly ingenious reconciliations of their intellectual inclinations with femininity's exigencies. Marianne North (English, 1830–1890), for example, painted pictures of plants and landscapes around the world that won the respect of contemporary botanists. When she donated her works to Kew Gardens, she requested that they be assembled into an environment she would design as a homelike refuge for visitors to the gardens, complete with live-in couple, tea, and light refreshments.[13]

Representations of Social Experience

Women presented in their albums and amateur paintings their version of what bourgeois feminin-

ity should be. Album imagery is highly selective and coherent. Each individual picture works toward the meaning of the album as a whole. Each album adds its part to an overarching pictorial structure. No one image or one album provides a key, but taken together and considered contextually, amateur images show us how women visualized themselves.

Women's albums and amateur paintings cleave to values professed by the bourgeoisie. Their pictures focus on places and activities with which the middle class identified itself. The travel scenes in albums record middle-class leisure: earned, no doubt, and seriously spent. Images of relaxation and tourism balance images of labor and office. Landscapes catalogue middle-class vacation spots: beaches, lakes, spas, country houses, or the more exotic Alps, Middle East, and North Africa, sometimes adorned with picturesque peasants. Souvenirs of theater performances and scenes from novels or poetry illustrate genteel amusements.

As rest was to work, so was private to public, feminine supposedly to masculine. The bourgeoisie tried to polarize its experience into separate spheres, ideally finding shelter in the one and purpose in the other. New living patterns decreed new spaces, the sacrosanct spaces of home. Femininity belonged to the home, in the home. Men of course occupied and needed home, but home was a world to be invented and managed by women.

Women's album pictures accept the domain allotted to women—indeed, they insist on it. The outside world in albums reaches only as far as families went on vacations or unmarried women could go unchaperoned—not as far as cafés, boulevards, or professional studios, let alone the realms of erudition, politics, or history. Even within these boundaries only women's places are represented: the park or garden, the ballroom, the parlor—not the office, the billiard room, or the stables. Virtually all albums that are not travel souvenirs focus on the maker's home, and on women's occupation within the home (whereas men's albums only occasionally do). At home, in twos or threes, women were most often shown reading or playing the piano, sometimes posing or drawing, occasionally

dancing. Princess Eugenie chose to paint three women together on their balcony [2], Henrietta Thornton grouped her entire family inside their home [4], Marie de Krüdener selected photographs of her family both in front and in back of their house [5]. Men make rare appearances in women's albums, and then as family members, and only in women's home territory [4,5]. The objects that recur throughout amateur imagery belong to women: porcelains, fans, knick-knacks, small pets, and, above all, needlework.

Amateur images assertively emphasize the signs of femininity. Etiquette books of the period, novels, moralistic tracts, and sociological essays all agree in assigning a gender connotation to the places and objects depicted with such insistent frequency. Women certainly spent time in other places, handled other objects; the ones they chose to use as visual self-expression were ones that stood for their roles as daughters, sisters, wives, mothers, and homemakers. The objects of album imagery—the fans, the flowers, the caskets, the needlework, the little pet, the drapery—were so resonant that France's best-selling women's magazine, the *Petit Echo de la mode*, intertwined them into its decorative masthead. The place so often returned to in feminine images, the small worktable in the parlor, by the window or the hearth, was designated a center of feminine gravity, the spot from which the values of home and family emanated. A particularly blunt story, signed by Emmeline Raymond and published in the popular women's magazine *La Mode illustrée* in 1871, articulates the worktable's significance. A concerned husband chastises his heedless wife: "The most important of all duties, because it subsumes all her obligations, is to know how to stay at home."[14] How shall she learn, the wife inquires. He answers: "Have, I beg of you, a worktable, at which you will acquire the habit of sitting for a few hours each day."[15]

Amateur artists edit the variety of female experience into feminine self-representations. What they depict is a social role, not a biological condition. They sedulously avoid the female body itself. Here class distinctions that disembodied bourgeois women and animalized lower-class women

make themselves forcefully felt. Two kinds of women populate feminine imagery: working-class and middle-class (or upper-class identifying with middle-class values). Working-class women virtually all appear as domestic servants performing the kinds of household chores from which middle-class women would like to distance themselves. Images of bathrooms and bedrooms that do not double as parlors are rare, and tend to be relegated to caricatures, disclaimed thereby with pictorial irony. Servants are represented as members of extended families, and only the mother-substitute nurse gains pride of place, as she does in Thornton's image [4].

Amateur imagery represents only the most social aspects of domestic life. Middle- and upper-class apartments had their public and their private areas; amateur women's pictures concentrate on the public. They avoid whatever is solitary and intimate, and contain almost none of the introspective musing or personal reactions more common in verbal diaries or journals.

Women were performing in their images; the images themselves were their performance. They played a role onstage that succeeded inasmuch as it built on, but concealed, the efforts and conditions of its creation. Women presented a crafted vision of themselves from which all preparations and underpinnings had been pruned away.

Yet these women brought to the making of images underlying values of their own. In their pictures they asserted femininity not merely as a subject but as a way of perceiving, which informed the intentions, practice, and destination of their imagery. Only as a complete activity can albums and amateur paintings be understood or contrasted with other kinds of images. Approached picture by picture, feminine imagery yields little, nor can albums and amateur pictures be well understood on opposed terms of public and private, society and individual, despite their adherence to an initial bourgeois polarization of masculine and feminine. Rather, feminine imagery is structured according to beliefs in which public, private, self, and other are less easily distinguished.

Feminine imagery works not just with objects or settings, but through them to depict, cultivate,

and perpetuate ideals of social harmony and emotional bonding. Amateur pictures represent shared experience, just as Princess Eugenie's women share their balcony and Thornton's sisters and brothers gather in their library [2, 4]. Adèle Hugo thanked her sons' tutor in 1838 with two signed and dated portraits of the children assembled into the equivalent of an album page with a commemorative caption: "offert à Monsieur Marin en souvenir des bons soins qu'il a eu pour mes enfants." Travel souvenir pictures include pure landscapes, but also many images of companionship and social events. Often images and especially captions recall the interaction, serious or comic, between travelers and local inhabitants.

Self is understood as it affects others. Women dwell on their presentation of themselves to mutual scrutiny. At resorts, at balls, in the loges of respectable theaters, on balconies [2] (the domestic equivalent of the theater loge) women go on display to arrange marriages, conduct personal business, introduce their children, or engage in the critical occupation of seeing and being seen.

At times in their images women submit passively to public opinion, but just as often with their images they cultivate private relationships. Women who made albums and amateur paintings did not hide themselves or their works from a male audience; a number of nineteenth-century paintings by men represent women sketching out-of-doors, and women artists used male family members as subjects. Women preferred, however, to represent each other, their times together, and their meeting places. Many women's inscriptions address each other. Their pictorial work celebrates the bonds between artist and subject, especially those between the artist and her mother, sisters, daughters, nieces.

Album pictures dwell on the places of feminine sociability—above all the parlor and its outdoor equivalents, the veranda or private garden. Marie de Krüdener used six images to represent her home in Petropolis: one of the building, one of the street in front of it, two views from it, and two of its garden in back [5]. Seated in the parlor next to the chimney or the window, surrounded by flowers or house plants, the mistress of the house re-

ceived and paid calls. There women met friends, maintained family ties, paid deference to social superiors, cultivated their husbands' colleagues through their wives, exchanged information, forged alliances, and conducted business. There mothers trained their daughters in the graces, disciplines, and rituals of their condition.

In their albums, women assembled images that seemed pertinent to a sense of social self. In 1854, A.-A.-E. Disderi introduced the *carte-de-visite,* a type of very small portrait priced significantly lower than its competitors because multiple exposures were grouped on a single photographic plate, printed on paper, and mounted on cardboard. As its name implies, the *carte-de-visite* (calling card) introduced a visual component into existing social rituals; women incorporated it into their album practice. Women exchanged and collected *carte-de-visite* portraits of friends and family, making their albums microcosmic versions of their social networks.[16]

The social orientation of feminine imagery extended to the conditions of its creation and presentation. Women rarely painted or drew alone, tending instead to work in the presence of female friends and relatives, most often a sister. Sometimes two sisters painted or drew together; more often one would sketch while the other played an instrument or sewed [4]. Women transmitted skills across generations, from mother to daughter or from aunt to niece.

Amateur paintings were hung in family rooms, given as tokens of friendship, exchanged as talismans against separation. From the richness of their covers, which make of them display objects rather than ordinary books, and from literary descriptions or other images, we know that albums were usually presented on a table or console in the parlor, where they could be perused or added to by callers. Henrietta Thornton shows one of her sisters, Lucy, who was also an amateur artist, leafing through an album with one of their brothers [4]. Occasionally women would even have themselves photographed with an album [1], indicating the degree to which albums could constitute a part of their willed self-image.[17]

Many albums and amateur paintings are dated, and usually some biographical information about their makers survives. It seems, on the basis of this evidence, that a large majority of album makers and amateur painters were young women, between the ages of about sixteen and thirty-five. Of the women who continued to paint and draw for the rest of their adult lives, a majority seem to have been single. Most exceptions are women who started an album or a series of pictures during a trip or at the birth of a child.

If the subject matter, the emphasis on social role-playing, and the author's age are considered together, it becomes possible to understand the motivation of feminine imagery. In some sense, the motivation for any act of visual self-representation is the basic desire to express oneself. But what triggers that desire? What configuration of circumstances produces a particular kind of self-representation? And how does a particular situation enable and affect the forms self-representation will take?

The majority of women made albums and amateur paintings at transitional moments in their lives, especially just before or after marriage and motherhood. Many started making pictures during adolescence, when they left school, fell in love, or gave birth to their children. Interludes marked by travel also spurred picture-making: "finishing" trips after school and before coming out, for instance, or honeymoon trips. Women actively represented feminine conventions during phases in which they had to redefine themselves and their social role. Picture-making rehearsed feminine obligations and privileges. Feminine imagery acted as self-representation in the sense that it was a means both to learn and to perform an identity.

Ironically, the most telling, because least rewarded, tribute to the adjustment provided by visual self-expression came from unmarried adult women seemingly released from feminine obligations. While a few exceptional women used their positions outside normative feminine roles to achieve in public domains, many more used their time to celebrate and reaffirm the domestic roles they observed without playing. Spinsters remained in a state of liminal femininity—neither children nor mothers—all their adult lives. Yet

they devoted their pictures primarily to their mothers, to their sisters as mothers, and to their sisters' daughters.

Women's amateur pictures demonstrate pride taken in the accomplished performance of a role, but that pride reached its culmination in self-effacement. The final purpose of feminine imagery was dissolution into a family context. Many young women took up drawing and painting to navigate their passage toward a married life whose obligations would preclude picture-making. Small in size, rapid in execution, women's painting was squeezed in between more imperative domestic or emotional preoccupations. These little pictures were integrated into domestic surroundings or closed between book covers. Gradually they merged into a family's sense of self, of its homes, characters, kinship networks, amusements—of its history. As long as family memory endures, the pictures remain within its embrace. Still today, virtually all of the pictures that survive do so in private homes, accessible only through contact with family members.

Feminine Imagery in a Commercial World

Feminine imagery did not survive outside the home. Either it simply disappeared from sight or it succumbed to the forces of commodity marketing. In the 1840s feminine imagery developed a public and professional avatar in the form of fashion illustration. With tragic rapidity, fashion illustration turned on its progenitor, as the tool of forces that would exhaust feminine visual culture's energies by the end of the century.

From the 1830s through the 1890s, magazines targeting a female audience printed several black-and-white engravings on almost every page, and the expensive magazines (or the more expensive editions of a magazine) included two or three full-page, hand-colored plates in every issue. For obvious reasons, fashion illustration detailed clothing more precisely than did women's albums or amateur painting. Otherwise, the images share the same themes and to some extent the same types of composition. They have in common the same middle-class women, the same pairing or grouping

of figures, the same emblematic objects, settings, and occupations—and the same concentration of vision on a domain both social and intimate, selfless and selfish. The figures of fashion illustration, like most figures in albums and amateur paintings, hover large and flat in the foreground, accompanied by a few delineated objects and pieces of furniture placed well in front of a vague background, which itself floats nimbuslike on a small sheet of paper.

Fashion illustration developed a distinctive style of its own in the 1840s, with the influential work of Jules David, Comte Calix, and three sisters: Heloïse Leloir (1820–1873), Anaïs Toudouze (1822–1899), and Laure Noël (1827–1878), all born Colin. For decades the Colins counted among the dominant artistic forces in fashion illustration, especially Anaïs, who outdistanced all the others in sheer output. The Colins' work clearly demonstrates the connection between early nineteenth-century amateur imagery and fashion illustration, for in addition to their professional work, the Colins maintained a private, more traditional, practice, creating pictures for themselves and their families, with images much like those by other album makers and amateurs.

Fashion illustration answered women's images of themselves. The financial interests of women's magazines—sales—dictated a product with which women could identify. The enormous consumption of women's magazines and the iconographic stability of fashion plates over more than a half century suggest that women saw what they wanted to see. In France, center of fashion production, *La Mode illustrée*, whose plates set the highest standards, enjoyed a circulation of 40,000 in 1866, and 100,000 in 1890. The *Moniteur de la mode* had 200,000 subscribers in 1890, as did the *Petit Echo de la mode*. For each subscriber, there were almost certainly several readers.

What happened to feminine imagery like the Colins' when it was bought by the fashion and publishing industries and transformed into a consumer product? In 1866 Anaïs Toudouze designed a fashion illustration for *La Mode illustrée* [7] that shows one woman leafing through an album and another, formally dressed, checking her appear-

7. Design by Anaïs Toudouze in *La Mode illustrée,* fashion plate, engraving and watercolor, 1866. Private collection.

ance in a mirror. The picture, consciously or unconsciously, reveals the vulnerability of feminine self-expression in a capitalist culture. One woman looks at a social portrait of herself that she has assembled. The other looks at a reflection of herself in a costume she has bought. The difference is between a personally produced self-image and one that is purchased. Yet the fashion illustration equates its two sides.

The fashion illustration has no fixed center. Each woman, echoing the other, turns toward her mirror, whether of glass or photographs. The entire image reflects the self-image of *La Mode illustrée*'s audience. An "original" self is everywhere, and consequently nowhere. Ideals reflect back and forth, visions women had of what they wanted to be, of what they thought they should be, of how they hoped to please others. In this hall of mirrors, the only constant is the desire to please.

Femininity demanded a self-effacement that the fashion industry converted to its own purposes. Women rigorously projected signs of their emotional and physical availability. Those signs interwove themselves into a system of appearances we still think of as "feminine." The intention of those appearances was opposed to the values of a capitalist economy inasmuch as they stressed personal relationships and family nurture or, to put it another way, an altruism diametrically opposed to opportunism. Yet the means by which feminine

intentions made themselves manifest proved highly susceptible to market forces.

Feminine visual culture led a fragile existence exposed to an inclement economic environment. Industrialization and fashion chased each other toward ever more rapid production, coupled with ever more rapid consumption. This rhythm threatened to turn feminine appearances into spectacles. What had been extensions of a feminine sense of self easily became ephemeral displays of purchaseable goods. In a studio photograph [1], the woman in a day dress holding an album valorizes herself and her social situation; she poses for the public eye, presenting to the camera textures and emblems that will convey an aura of bourgeois femininity: straight back, graceful gesture, clear skin, silk dress, family album. In the fashion plate [7], her confident outward gaze and inviting gesture have disappeared—only the dress and the album remain. The subject no longer exchanges gazes with a spectator but instead turns toward an image of itself.

The woman in the photograph relies on surfaces to represent herself, yet her individual and social presence still generate the image's message. She manipulates her stance and her accessories, she seeks out the photographer whose style flatters her preconceptions of herself. No individual presence emanates from within the fashion plate. All sense of self has vaporized into a promise that hovers somewhere between costume and caption. "Buy these outfits," it intimates, "and this social situation with all its connotations might be yours." Album pages used captions, descriptive, humorous, or fond, to explain the relevance of the image to its maker. The fashion plate used captions to list where both magazine and outfit could be bought. Women's album captions close the small gap between image and intimate viewer by situating the image in the viewer's personal memory. Fashion print captions do the opposite: they keep image and viewer apart by diverting identification with the feminine subject toward the channels of commodity consumption. Fashion prints hold personality forever hostage against a limitless ransom.

Feminine visual culture steered perilously close to consumer culture. Nineteenth-century industrialization spun femininity centrifugally outward into objects: costume, accessories, interior decoration. Every virtue had its dress, every affection its token, every body its corset. Acceleration of industrial cycles shrank the life span of femininity's representations. Appearances had to be ceaselessly reconstructed, new defenses thrown up around a social sense of self continually menaced by relentlessly novel market directives. Some women recouped faster than others; a few ignored or disdained the world around them.

By the end of the century, though, feminine visual culture and consumer culture had merged almost entirely. Postcards of celebrities replaced family photographs in albums, department store bonuses succeeded watercolors, snapshots taken like trophies supplanted the mixed-media narratives of earlier voyages. The renewal of femininity's representations often became an end in itself.

Marginal Status

Economic and gender constructions interacted to limit the means of women's self-representation. While high art did not escape the mechanisms of consumer culture, it managed to dominate them or, at least, profit from them. Painting used its aura to win for itself not only money but intellectual breathing space. Belief in innate genius and in transcendental beauty enabled some painters to distance their pictures from cultural and economic forces without sacrificing the advantages of those forces. Their work could both partake of privilege and comment on it. Even if it was imaginary, painters' cultural isolation gave them a sustained energy to develop ideas and to perfect techniques with which to express those ideas. In feminine visual culture there was never time for the unfolding of resources. Painting protected itself with a powerful profession and an elaborate body of theory. Women had a pictorial tradition and feminine values, but no institutional protection.

Most of the women who made albums and amateur paintings believed that their work was less

meaningful and worthwhile than the professional painting they saw exhibited in galleries and museums, and even in their own homes. Women faced nearly insuperable external obstacles when they chose to join the profession of painting. Fundamental obstacles also lurked within which kept women from even wanting to confront external impediments. Women must have believed that their experience and their values were worth representing. Their albums and amateur paintings, as well as fashion illustration, show that they did believe this to some extent—to a greater extent than we have perhaps been aware of. But marginality weighed against a belief in their work, and restricted its scope. The reader may be wondering why feminine imagery has been contrasted with "high art" rather than with "masculine" imagery. High art is "high"—that is, dominant—precisely because it so completely denies alternatives that it becomes normative even for those it excludes.

Women may have believed their images were inferior as art, but they adamantly adhered to their values. Feminine visual culture resisted the isolation and self-promotion that granted painting its margin of freedom. Feminine art did not just look different; it obeyed fundamentally different conceptions of meaning and purpose.[18] Albums and amateur paintings were small images perused in intimate settings; ambitious paintings were so large they could hang only in institutions or in the public rooms of large homes. Feminine picture makers tended to work with delicate, evanescent materials like paper, pencil, and watercolor; high-art painters made their finished works in oil and canvas and framed them with carved wood. Amateur pictures were destined for a secluded family life, within which they would be understood as memorials to emotional bonds and private history. Professional paintings were meant for public exhibition and sale, for interpretation by art critics who would extend their significance as far abroad as possible. Album makers and amateur painters shunned the market and its values; professional painters sought the market as an objective indicator of worth. Feminine imagery showed the social situations women hoped to perpetuate, while pro-

fessional painters aspired to transcend social situations and create ideals.

The essential difference is between contextual private objects and autonomous public ones. Feminine pictures are saturated with their social and affective functions; their meaning comes from their setting, from the conditions of their creation and a knowledge restricted to those who knew the maker personally or to her descendants. Album makers and amateur painters make no pretense of an aesthetic or intellectual self-sufficiency. No one album picture makes much sense by itself—its meaning emerges only in its relationship to other pictures in the same album, and from the situation of the album in the life cycle of its maker and her family. Easel paintings signify as autonomously as possible, which enables them theoretically to function in any setting, for any audience. Paintings, more than any other kind of art object, are divorced from their context; whether or not the goal is possible, paintings imply an intellectual and formal self-sufficiency. Amateur feminine imagery takes aesthetic considerations into some account but sustains itself through affective relationships or external social situations; painting may or may not demonstrate social concerns but almost always strives for internal aesthetic coherency.

Unfortunately for feminine imagery, art historians understand that difference in terms of inferiority and superiority. Only one kind of standard is applied, the standard of internal aesthetic excellence. Since the Renaissance the characteristics of painting have become the criteria of artistic judgment. The hegemony of painting has been so complete that its characteristics not only define norms of formal quality, but even norms of visual meaning. All kinds of visual expression have come to be solipsistically measured against the qualities of painting. Those that cannot fit the norms are simply dismissed.

Ironically, that dismissal of marginality seeps even into sympathetic evaluation of women's images. Of women's many visual self-representations, only their painting has really won its way into the purview of art history. No one reasonably argues against the importance of reintegrating women into a history of painting. But that recu-

peration may miss the point of gendered image-making. The challenge may now be not to locate women's images that approximate men's and then measure them on some normative scale of greatness, but to consider whether women may not have made images that are different from men's, to investigate the power of gender in visual culture, and then to ask whether, after all, a feminine vision may not have something of its own to teach us.

From women's amateur picture-making we learn that during the nineteenth century a great number of women all over Europe engaged in self-representation of their own. Though restricted to a domestic sphere, within that sphere they re-created social values, adjusted boundaries between public and private, and found an alternative to the elite art from which they were excluded.

Feminine imagery shows that throughout the century radically different kinds of visual representation did coexist, each with its own economy of creation and exchange. Not everyone made pictures to sell them, justify them theoretically, and define a pictorial "real." The women who made the albums and amateur paintings discussed in this essay made pictures as integral parts of family life and emotional bonds.

Lastly, the fate of feminine images demonstrates the frailty of marginal visual culture. Mary Ellen Best made hundreds of pictures of her family, her travels, and the homes she lived in, mounted them in albums, and left them to her family.[19] Decades passed, family memory faded. Two heirs inquired whether Sotheby's would be willing to auction Best's watercolors. At first, "expecting a sheaf of amateur doodlings," Sotheby's hesitated.[20] Then, seemingly convinced of the particular meaning of the albums as a whole, they accepted them. Howard Rutkowski of Sotheby's wrote: "There was more to these charming views of early nineteenth-century life than immediately met the eye. Indeed the watercolours themselves were a diary, a chronicle of the life of a young woman of the previous century." But the apparent recognition of Best's work proved to be only a marketing ploy. Rutkowski continued: "Promoted as such, these watercolours proved a tremendous success, not only in the salesroom, but in the public's mind as well."[21] Sotheby's broke up the albums and sold Best's work as individual paintings.

NOTES

1. England provides some exceptions to the rule. English definitions of professional and amateur art have long been less rigid than others. Consequently, museums and publishers have brought the work of several women amateurs into the public sphere. See J.P.M. Brenan, Anthony Huxley, and Brenda Moon, *A Vision of Eden: The Life and Work of Marianne North* (New York, 1980); Betty Bright-Low and Jacqueline Hinsley, *Sophie Du Pont: A Young Lady in America. Sketches, Diaries, and Letters, 1823–1833* (New York: Harry N. Abrams, 1987); Stefan Buczacki, *Creating a Victorian Flower Garden: Original Flower Paintings by Alice Drummond-Hay* (New York: Weidenfeld & Nicolson, 1988); Caroline Davidson, *Women's Worlds: The Art and Life of Mary Ellen Best, 1809–1891* (New York, 1985); Mariana Davydoff, *Memoirs of a Russian Lady: Drawings and Tales of Life Before the Revolution* (London and New York, 1986); Robert Fairley, ed., *Jemima: The Paintings and Memoirs of a Victorian Lady* (North Pomfret, Vt.: Trafalgar Square Publishing, 1989); Flora Fraser, ed., *Maud: The Diaries of Maud Berkeley*, introduction by Elizabeth Longford (London: Secker and Warburg, 1985); Ruth Hayden, *Mrs. Delany: Her Life and Her Flowers* (London, 1980); Gordon Mingay, *Mrs. Hurst Dancing and Other Scenes from Regency Life, 1812–1823: Watercolors by Diana Sperling* (London, 1981); Marina Warner, *Queen Victoria's Sketchbook* (New York, ca. 1979).

2. S.A.R. Madame la Duchesse de Vendôme, *Notre Voyage en Afrique* (Paris, 1928). The duchess had her travel journal printed in order to share it with the many members of her family.

3. Davidson, pp. 9, 148.

4. Private collection, France.

5. Bibliothèque de l'Arsenal, Paris.

6. Private collection, France.

7. On the English case, see Michael Clarke, *The Tempt-*

ing Prospect: A Social History of Watercolors (London: Colonnade, 1981), pp. 90–102.

8. See Hayden.

9. On the origins and definitions of "album" in the Romantic period, see Segolène Le Men, "Quelques définitions romantiques de l'album," *Art et métiers du livre,* January 1987, pp. 40–47. While amateur sketching seems to have developed fastest in England, some evidence suggests that albums containing material other than pictures originated in Germany. See Henry Monnier, "La manie des albums," *Paris, ou le livre des cent-et-un* (Paris: Ladvocat, 1832), vol. V, pp. 199–200. Victor-Joseph de Jouy proposes either a German or a Russian source. (*L'Hermite de la Chaussée d'Antin.*) "Des albums," "Recherches sur l'album et le chiffonier sentimentale," *Observations sur les moeurs et usages parisiens au commencement du XIXe siècle* (Paris: Pillet, 1811), vol. 1, p. 145.

10. Victoria and Albert Museum, London.

11. Private collection, England.

12. Helmut Gernsheim, *Julia Margaret Cameron: Her Life and Photographic Work* (Millerton, N.Y., 1975), pp. 175–77. Harry H. Lunn, Jr., *Julia Margaret Cameron: An Album* (Washington, D.C., 1975).

13. See Brenan et al.

14. Ibid., p. 214.

15. Ibid., p. 215.

16. This point has been made by two authors. See André Rouillé in *L'Empire de la photographie* (Paris, 1982); and Caroline Chotard-Lioret, who in her unpublished dissertation, "La Société familiale en province; une correspondance privée entre 1870 et 1920" (Université de Paris V, 1983), shows that a specific series of albums were constituted by exchange of photographs among women, and contained images only of family and friends.

17. Private collection, France.

18. The relationship between professional and amateur art changed with the advent of Impressionism, which brought into the domain of high art some, though by no means all, aspects of the feminine pictorial tradition. My study of women's albums and amateur painting began, in fact, as part of my dissertation on the Impressionist Berthe Morisot (1841–1895), whose paintings were shaped by her feminine heritage. Here may also be the place to note that men, too, made albums and amateur paintings; these are far fewer in number than women's, and conform quite closely to professional high-art models.

19. Davidson, p. 9.

20. Ibid., p. 7.

21. Ibid., p. 7.

1. Rosa Bonheur, *The Horse Fair*, detail, 1853. New York, Metropolitan Museum
of Art, Gift of Cornelius Vanderbilt, 1887 *(James M. Saslow)*.

11

"DISAGREEABLY HIDDEN"

Construction and Constriction of the Lesbian Body in Rosa Bonheur's Horse Fair

JAMES M. SASLOW

The celebrated French animal painter Rosa Bonheur (1822–1899) was long dismissed as one of the legion of conservative Victorian painters who failed to register much conscious awareness of the dramatically changing society around them, either iconographically or stylistically. Over the last decade and a half, evaluation of Bonheur has grown more nuanced in the wake of both an increased scholarly appreciation for academic painting and the development of gender as a fundamental category of analysis in art history and related disciplines.[1]

Analysis of several related paintings, principally her oversized masterpiece *The Horse Fair* of 1853 [2], in conjunction with the artist's biography, will demonstrate that Bonheur's art offers, more than has previously been understood, a radical intervention in the visual and cultural construction of nineteenth-century femininity and masculinity. Her "style," both in her work and her life, represented an alternative vision of the modern female body, and specifically the lesbian body, as a social

This article was developed from papers presented at Yale University's Lesbian and Gay Studies Center, at Swarthmore College's Sager Fund Symposium, and at the 1989 College Art Association Annual Meeting. Copyright © 1991 by James M. Saslow. By permission of the author.

and visual entity. This embryonic self-formulation was necessarily limited in scope and self-consciousness during a period that spanned a major change in the social discourse about women, homosexuality, and gender difference. But her contemporaries, both sympathetic and hostile, read its subversive import clearly; and subsequent developments, both historical and theoretical, permit that novel image to be read even more clearly than she would (or could) have articulated at the time.

Bonheur was the most successful both of nineteenth-century women artists and of *animaliers*. She was well qualified to excel in this popular genre, having shown a special affinity for animals since her numerous childhood pets. Daughter of the painter Raimond Bonheur, whose radical political beliefs embraced the feminist socialism of the Saint-Simonian sect, Bonheur had received prestigious awards and state patronage by her mid-twenties. In 1859 she purchased a country estate at By in the forest of Fontainebleau, where she exchanged visits with her neighbors, the Emperor Napoléon III and his family, and enjoyed the patronage of the Second Empire aristocracy, with whom she shared a love of country life as well as many political sympathies. The Empress Eugénie

2. Rosa Bonheur, *The Horse Fair*, 1853. New York, Metropolitan Museum of Art, Gift of Cornelius Vanderbilt, 1887.

personally conferred the Légion d'honneur on Bonheur, the first female painter to receive this honor.[2]

In contrast to her professional respectability, however, Bonheur led a highly unconventional personal life, which at times conflicted awkwardly with the expectations placed on women, particularly "masculine" women. As an art student committed to direct observation of animals, Bonheur began frequenting stockyards, livestock markets, and slaughterhouses. Because these were all-male enclaves, she dressed in men's clothes to gain access, avoid harassment, and move more easily. Thereafter, she affected a masculine style of dress and grooming, which occasioned much public comment. She cut her hair in a short bob and wore pants and a fedora on all but formal public occasions, when she donned severely tailored black suits. Although she always insisted that this gender-deviant costume was chosen only to facilitate her work, the fact that she wore it for many other activities for which it was neither necessary nor accepted suggests that it had a meaning for her transcending the merely utilitarian.[3]

Bonheur's emotional life was as unorthodox as her fashion. She lived for forty years with another woman, Nathalie Micas, whom she referred to as "my wife." After Micas's death, her final companion and ultimately heiress was a younger American artist, Anna Klumpke. Although it is notoriously difficult to discern sexual expression and self-image within the many such "Boston marriages" of the nineteenth century, and since Bonheur made no direct statements on the subject, her recorded comments leave little doubt of her great love for these women, which both modern definitions and the suspicions of her contemporaries would label lesbian.[4]

However fascinating Bonheur's private life may be to historians of sex and gender, the conventional wisdom among art historians has been, to quote Emmanuel Cooper, that "few of these ideas are immediately apparent in her paintings, which are, to all intents, powerful and competent pictures of animals." While scholars such as Albert Boime and Dore Ashton paint a more complex picture of the relations between Bonheur's art and life, the most recent assessment, by Whitney Chadwick, maintains the accepted view that Bonheur "was radical in her personal life, but artistically and politically conservative."[5] All subsequent critics have agreed with her contemporary,

the English art critic John Ruskin, that she was indifferent to any human-centered narrative that might offer a ground for biographical interpretation. As he wrote in reference to *The Horse Fair*, "No painter of animals ever yet was entirely great who shrank from painting the human face; and Mdlle. Bonheur clearly *does* shrink from it. . . . In the 'Horse Fair' the human faces were nearly all dextrously, but disagreeably, hidden, and the one chiefly shown had not the slightest character."[6]

However, Bonheur's avoidance of human representation was not simply, as Ruskin and his successors have interpreted it, a matter of clumsiness or disinterest. Two factors call for a more inclusive interpretation of her work. First, although the human and personal element is indeed "disagreeably hidden," it is not suppressed as completely as previously assumed. Second, to the extent that such hiding was forced upon her by social conventions over which she had little control, we have evidence that it was disagreeable to Bonheur herself, that she sought to envision alternative models of culture, and that the limited self-revelation she did manage was later received with appreciative enthusiasm by activists who were working more overtly to change cultural attitudes.

Bonheur's most famous picture is *The Horse Fair*, a mural-size genre scene of the Paris animal market. The horses being led in display, barely tamed by their brawny handlers and prancing in a great curve with almost Baroque vitality, bear the stamp of her favorite predecessors, especially Géricault.[7] It has not been previously noticed that the central horse tamer, whose head is next to the rearing white horse [1], is a self-portrait of Bonheur, who confronts the viewer with the male guise she adopted for her sketching forays in these very stockyards. Although dressed in the same blue robe as worn by the other handlers, this figure, who lies close to the picture's central axis, is one of only two among all these ostensible males not sporting any of the customary mid-Victorian facial hair. Moreover, she is the only figure who looks out at the viewer: her three-quarter pose (derived from looking in a mirror while painting) is the traditional indicator of a self-portrait.

The round, smooth face is nearly identical to R.

3. W. H. Mote, *Rosa Bonheur, the French Landseer*, engraving after R. Buckner, 1856. New York Public Library, Picture Collection *(James M. Saslow)*.

Buckner's portrait of Bonheur, engraved about the time of her tour of Britain with *The Horse Fair* in 1856 [3], and to a painting of Bonheur at age twenty-two (1844) by her brother Auguste [4].[8] Other portraits of Bonheur from these years show the same round, soft face; full, slightly puckered lips; and short, bobbed hairstyle that also appear on the horse tamer. The tamer's hair protrudes noticeably from beneath her cap; although shorter than customary for a female at the time, it is longer than that of any man in the picture. It suggests some special fondness for this group that Bonheur repeated it forty years later with slight variations in the mount and androgynous rider of *Two Horses*, 1893.[9]

Similarly ambiguous figures reappear twice in Bonheur's oeuvre around this time, and may also be self-portraits. The more convincing of these occur in *Gathering for the Hunt* of 1856 [5]. The

4. Auguste Bonheur, *Rosa Bonheur at Twenty-two*, 1844. T. Stanton, *Reminiscences of Rosa Bonheur (James M. Saslow).*

uninterested in human subjects. To understand these infrequent but unique self-portrayals, as well as their general absence, her work and life must be interpreted together within a wider context of sex, gender, and power. That interpretation must embrace both the nature of her unorthodox inclinations and the severe limitations that the dominant discourses of art and society placed on her potential for self-understanding and self-expression. Bonheur lived in a period of transition during which limitations on women, especially lesbians, remained strong, and the intellectual framework for modern gay and lesbian identity and the subculture aimed at justifying its expression were just beginning to be constructed. Consequently, her work and life present a series of overlapping discrepancies arising from the dialectic between her desires and the fragmentary opportunities for realizing them.

This analysis of Bonheur's attempts at self-portraiture will suggest three principal themes. First, that her masculine attire was an attempt to claim male prerogatives and create an androgynous and proto-lesbian visual identity that would embody, literally and figuratively, her social and sexual views. Second, that her coded representation of this identity in her pictures reveals her work as more socially engaged, and subversive, than had been thought. And finally, that the relative absence of human subjects from her work can be read as a displacement of interest from what could not then be fully "image-ined" in public onto an alternative subject matter that, while socially acceptable and even popular, provided some scope for symbolizing nonconformist ideas about nature that justified Bonheur's own sexual and gender identity.

The meanings of Bonheur's masculinized self-images with animals are embedded in at least four social and artistic discourses of the time: images of ideal womanhood; the tradition of equestrian portraiture; official strategies for control of deviant gender behavior, along with the resultant conflicts and anxieties of those so labeled and their search for alternative self-formulations; and the genre of animal painting, which must be viewed from within the contemporary discourse that drew par-

subject is, again, a male group outdoors with animals. The three-quarter face of the standing figure holding several dog leashes is the same as that of the central figure in *The Horse Fair,* as is the blue smock (now worn with a hunting cap), and the figure is again emphasized by its location on the picture's center axis. And once again, most of the other figures have some facial hair. The only other one who is clean shaven is the mounted rider, whose face is in fact almost indistinguishable from the leash holder's and may also be based on the painter herself.[10] *Returning from the Fields* of 1851 had earlier featured an androgynous, unbearded figure in trousers seated on an oxcart, though the resemblance to Bonheur in this case is perhaps more generic.[11]

These self-presentations in masculine guise necessitate a revision of the view that Bonheur was

allels between the plight of animals, the condition of women, and the nature of homosexuality.

The first two of these meanings, which proceed from established feminist art-historical analysis, can be briefly summarized by comparing Bonheur's images with pictures of and for two of her most significant female contemporaries, made by artists whom Bonheur knew. Both the Empress Eugénie and Queen Victoria, who much admired *The Horse Fair*, patronized such popular artists among the trans-Channel upper classes as England's Sir Edwin Landseer (1802–1873) and the German Franz Xavier Winterhalter (1805–1873). The works created within this circle of power and influence reveal the sharp contrasts in outlook between Bonheur and the class that both dictated socially acceptable gender behavior and, through its patronage of her, strongly influenced her representation of such behavior.

Insofar as *The Horse Fair* can now be seen as a portrait of a woman, it is embedded within the long tradition of female portraiture, so freighted with assumptions about gender. The dominant pictorial construction of aristocratic femininity at

this period may be typified by Winterhalter, who served as court portraitist to both Victoria and Eugénie. There are striking similarities of composition and the feminine ideal in his *Florinda* (1853), given by the queen to the prince consort, and his group portrait *Empress Eugénie Surrounded by her Ladies-in-Waiting* of 1855 [6]. The subject in *Florinda* is Romantic and medievalizing, illustrating Southey's poem *Don Roderick*, while the empress, though a real contemporary figure, sits in a Rococo grove holding a bouquet of violets, like Sappho among the Muses. In both scenes, the open circle of beautiful and idle young women surrounding the gentle, fluttery heroine is the same.[12]

Although these portraits are exactly contemporary with *The Horse Fair*, their presentation of women obviously opposes Bonheur's in dress, ideals of deportment, and the erotic autonomy of the female body as radically as the court's aristocratic life-style differed from Bonheur's semipublic bohemianism. No matter that both of Winterhalter's patrons wielded enormous power in real life: in the public fantasy of art they supported

5. Rosa Bonheur, *Gathering for the Hunt*, 1856. Stockton, Calif., Haggin Museum.

6. Franz Xavier Winterhalter, *Empress Eugénie Surrounded by Her Ladies-in-Waiting,* 1855. Compiègne, Musée National du Château *(Musées Nationaux).*

images that idealized women of their class as passively secluded from the hurly-burly of male pursuits and implied that women's prime function was to serve as alluringly delicate objects for the male gaze.

Second, and more specifically, Bonheur's self-representation is an anomaly within the tradition of equestrian portraiture. Comparison of *The Horse Fair* with pictures of Victoria on horseback, for example, reveals obvious differences in their ideals of femininity and the gaze. In Landseer's sketch *Queen Victoria on Horseback,* painted shortly before her marriage in 1840 [7], the young monarch is presented fashionably clad, riding side-saddle, with her gaze directed downward, away from the viewer. By contrast, Bonheur always wore pants when riding so she could straddle the horse in male fashion, and she looks boldly out of *The Horse Fair,* confronting us with a gaze equal in power to our own. The contrasting settings of both pictures are further revealing. The queen rides out before a medieval castle, her guards bearing knightly pennons; the reference is backward to a vanished but idealized world of the demure, courtly lady of chivalry. Bonheur, on the other hand, prefers to set herself in the thick of contemporary life, the only world whose rough and un-

idealized vitality offers some scope for her active, modern persona.[13]

Recent scholarship has called attention to the ways in which visual images construct an imaginative social space, an arena whose map opens certain roads of individual action and closes others.[14] Hence the use in my title of *constriction,* a term that connotes both spatial and social limitation. *The Horse Fair* represents a male space, from which Bonheur was excluded by law and custom, and to which she gained admission by subterfuge (Stanton noted that when she first experimented with transvestism while painting *The Horse Fair,* she was delighted that she "was everywhere taken for a young man and no attention was paid to her comings and goings"[15]). Belying her true power, the queen's movement through space remains "ladylike," while Bonheur's exemplifies the lengths to which an ordinary woman had to go to achieve freedom of movement in a male-defined space. Being unable to challenge directly the ideal represented by Victoria, Bonheur not only had to disguise herself, but she then had to relegate her image of that disguised self to the background of her picture—leaving its subversive message to be read only, perhaps, by a few friends who were in on the joke.

The third factor that bears on interpreting *The Horse Fair* is the discourse and practices of social control over deviant gender behavior. In her attempts to circumvent social norms and forge a more androgynous persona, Bonheur's primary and best-known vehicle was cross-dressing, the symbolic and heavily gendered "arts" of clothing, grooming, and social deportment. In negotiating this public arena, conflicts were inevitable, and the consequences were many and varied—from petty bureaucratic obstacles to amusing misunderstandings to deep embarrassment. She was forced to walk a continual tightrope, with explicit frustration, between self-assertion and conformity.[16]

Transvestism was illegal, and to avoid prosecution Bonheur had to procure an official "permit for transvestism" from the Paris police every six months. This document assumes that there exist strictly polarized norms of gender and dress, that the state must and can regulate the "problem" of individual deviations, and that these are essentially *medical* problems requiring a doctor's signature. At the same time, however, it implicitly acknowledges that there are enough women who require exemptions from these supposedly universal norms to justify printing a standardized form to accommodate them. Through what amounts to sociological plea bargaining, this procedure earned Bonheur the right to dress as she pleased, but only at the price of being officially defined as a medical anomaly in need of treatment and supervision.[17]

This compromise kept Bonheur acutely aware of the disjunction between her desire to create a suitable self-image and the need to avoid social disapproval. When invited to an imperial reception, she felt the need to request advance permission not to wear formal female décolletage, and on two occasions when Eugénie arrived unannounced at By, Bonheur barely managed to hold off her guest's entrance long enough to slip a robe over her pants. Ironically, it was on the second of these visits, when Eugénie personally awarded Bonheur the Légion d'honneur, that the empress repeated a well-known feminist slogan, "Genius has no sex." No doubt she meant to declare an opening up of greater possibilities; but the remark carries the unfortunate double meaning that, in order to be publicly *recognized* as a genius, Bonheur had to downplay or deny much of her own proscribed sexual identity. It is revealing that her memoir of the episode uses the French phrase "dissimuler mes vêtements masculins"—not, that is, to *change* her masculine clothes, but rather to conceal or cover them up.[18]

Social control also operated through the medium of the popular press, which satirized all public deviations with relish. Bonheur admired George Sand, another transvestite creative artist of the time, who was caricaturized for her mannish appearance and pseudonym, which rumor associated with an irregular sexual life. Bonheur was subject to the same treatment in the press (1899) [8] and to similar rumors, which she occasionally denied scornfully. Such caricatures exemplify the scrutiny to which her puzzling persona was constantly subjected and the attempt to defuse its radical implications through humor.[19]

7. Edwin Landseer, *Queen Victoria on Horseback*, 1839. Copyright reserved. Reproduced by gracious permission of H. M. Queen Elizabeth II *(Rodney Todd-White & Son).*

8. Guillaume, "Le Bouguereau des vaches," *Le Monde illustré,* 1899 (*James M. Saslow*).

9. Anonymous, *Rosa Bonheur and Solferino,* photograph, 1887. A. Klumpke, *Rosa Bonheur (James M. Saslow).*

In view of such constraints on public expression, more research is needed on the strategies used to carve out a private sphere exempt from surveillance; as Bonheur insisted, "My private life is nobody's concern."[20] One factor that facilitated subcultural self-representation was the advent of amateur photography in the second half of the century. This new medium greatly expanded opportunities for individual image-making, thus opening a gap between public and private artistic arenas and providing an escape valve for imagery not yet permissible in the public sphere. Whereas Bonheur's self-portrayals in *The Horse Fair* and other public paintings necessarily remained unobtrusive, her private photographs offer more overtly deviant images, which corroborate her underlying agenda.

Bonheur and her companions took many photographs that are among the earliest known survivors of what might be called "lesbian genre scenes." In informal snapshots set in the garden and forest at By, Bonheur was captured in male attire sketching, playing with her pets, or, in an image that shows her living out the activity she had fantasized in *The Horse Fair,* leading her horse Solferino (1887) [9].[21] A photograph of Bonheur smoking a cigarette similarly exposes in private imagery an activity that, as a woman, she was unable to engage in on the street, to her great annoyance.[22]

Klumpke posed a more formal photograph of Bonheur in her studio, wearing her signature smock and pants and crowned with a laurel wreath, and titled it *Old Europe Crowned by Young America* (1898) [10].[23] As with Bonheur's self-portrait in *The Horse Fair,* the contrast to Winterhalter's model woman is obvious not only in dress and action but also, more subtly, in the implied exchange of gazes between sitter and subject, with all that that suggests about power, autonomy, and eroticism. In place of the traditional public image of woman, presented by a male artist to an unnoticed and superior male eye, this homespun allegory privately deifies an active, "masculine" career woman who is gazed at by another female artist and reciprocates the observation with an alert gaze of equal interest and power. Bonheur returned the compliment in an even more densely layered image. Her photograph of Klumpke at work on a painting of Bonheur *en travesti* (1898) [11] is an exquisitely symmetrical expression of the couple's mutual regard, in both the emotional and the optical senses of the terms: it represents one

woman gazing at the androgynized image of another who is gazing at her, each simultaneously making an image of the beloved other.[24]

A strikingly similar instance of such private documentation of female intimacy and cross-dressing occurred at about this same time in New York. Alice Austen (1866–1952), who like Bonheur lived with a lifelong companion, photographed among other subjects the life of her close female friends, who formed a social club that excluded men. A self-portrait [12] shows Austen at the left with two of these friends, all dressed in men's clothes, complete with mustaches and cigars. Austen was financially independent and, like Bonheur, never exhibited or sold her photographs. The two women's oeuvres are concurrent but independent manifestations of the emerging power of a relatively inexpensive and rapid pictorial technology. It made possible private images, created outside traditional public structures of patronage, audience, and criticism, in which their makers were free to envision alternative roles.[25]

Finally, a fourth level of comparison between Bonheur and her contemporaries involves a more complex and speculative level of iconographic analysis: the interlocked nineteenth-century discourses about animals, women, and sex-gender deviance. If Bonheur's occasional self-images attest to efforts to circumvent social constrictions, the general absence of human subjects from her work—her displacement of the aesthetic gaze onto nonhuman creatures, whom she viewed as extensions of herself—attests to an attempt to transcend those constrictions. Alone among recent critics, Boime rightly emphasizes that there was "a profound connection between her lifestyle, mystical beliefs and fascination for animals." However, it is necessary to revise his denial that

10. Anna Klumpke, *Old Europe Crowned by Young America*, photograph, 1898. A. Klumpke, *Rosa Bonheur (James M. Saslow).*

11. Rosa Bonheur, *Anna Klumpke at Work*, photograph, 1898. A. Klumpke, *Rosa Bonheur (James M. Saslow).*

12. Alice Austen, *Julia Martin, Julia Bredt and Self Dressed Up as Men*, photograph, 1891. New York, Staten Island Historical Society *(Alice Austen)*.

these animal subjects served her "as metaphors for the human predicament."[26]

The remainder of this study will outline how, when viewed together, Bonheur's masculinized self-portrayals with animals, her sympathetic portrayals of animals alone, and her own statements and actions suggest that her animal subjects functioned as a vehicle for abstract concepts that could be publicly visualized at the time only in compromised or coded forms. For her, as for many of her contemporaries, animals figured simultaneously as symbols of freedom in their own right; as surrogates for the desire for an equivalent social freedom on the part of women in general; and as surrogate for a parallel desire on the part of gender-deviant women (and men) in particular for release from constricting norms of masculinity and femininity.

To begin on the fundamental level of visual and iconographic analysis, Bonheur's treatment of her subjects differs sharply from the mainstream tradition of animal painting. Several contemporaries noted approvingly the same qualities identified by

Boime, Ashton, and others: her rejection of anthropomorphization and sentimental narrative in favor of depicting her subjects "mainly for themselves rather than as accessories to people."[27] This contrast can be briefly illustrated by comparison with Landseer, whose popularity rested on his tendency to humanize domestic animals and highlight their subservience to their masters. In his portrait of Queen Victoria at Windsor Castle with her husband and infant daughter, he sentimentalized the royal pet dogs as domesticated adjuncts to cozy heterosexuality, equating them with lovable but bumptious children, and he also presented animals as objects of human sport—the dead game birds that Prince Albert displays on the carpet. Although Bonheur admired Landseer, she most often portrayed animals alone and independent in their natural habitat. When she titled one watercolor study of lions *Royalty at Home* [13], she meant the animals' own home, in which *they* ruled, not the human world to which they sometimes had to submit. Even when her animals are under human control, as in *The Horse Fair*, she is

more interested than Landseer in the horses' almost untameable strength and individuality.[28]

The same contrast can be seen in portrayals of single creatures. The identity and value of Landseer's sheepdog is summed up in the title of his 1837 picture *The Old Shepherd's Chief Mourner* [14]: dog as "Fido," the faithful companion who loves its owner even in his uncomprehended absence. On the other hand, Bonheur, in choosing subjects like *The Wounded Eagle*, followed earlier artists such as Stubbs and Barye, who exalted wild creatures' fierce and courageous survival in their own habitat. Ruskin captured the essence of Bonheur's approach, though he did it by way of a criticism of her for failing to realize that "there is in every animal's eye a dim image and gleam of humanity . . . through which their life looks out and up to our great mystery of command over them."[29]

Ruskin's perceptive but value-laden comment suggests that Bonheur's characterization of animals rested on a radically different conception of the relationship between animal and human or, more broadly, between nature and culture. This polarity, which preoccupied the century of Darwin and Mendel, constituted the overarching metaphor in a heated discourse about several interrelated oppositions: male-female, heterosexual-homosexual, individual-society, private-public, androgyny-differentiation, and authority-liberty.[30] The key to this nexus of relationships lies in Whitney Chadwick's observation that Bonheur's paintings "emphasize the animals' freedom and uncorrupted nature. . . . In the words of one critic they were 'like nature.'" As Chadwick explains, "It was the search for expressions of feeling unencumbered by social constraints that underlay both the embrace of animal imagery . . . and the fame enjoyed by Rosa Bonheur. . . ."[31]

Operating along this nature-culture axis, nineteenth-century discourse about animals, women, and gender variance constituted a dialectic between those authoritarian and scientific forces that sought to extend human, male, heterosexual hegemony over the natural world, and the liberal humanitarians who strove to preserve and augment the freedom of creatures unjustly subjugated by cultural intervention. The rise of Britain's Society for the Prevention of Cruelty to Animals (founded in 1824), for example, paralleled an in-

13. Rosa Bonheur, *Royalty at Home*, watercolor, 1885. Minneapolis Institute of Arts, Gift of Funds from the Ziegler Corporation.

14. Edwin Landseer, *The Old Shepherd's Chief Mourner*, 1837. London, Victoria and Albert Museum.

creasing reduction in wildlife habitats and the enclosure of both domestic and wild animals within the discourse and praxis of taxonomy, systematic breeding, and zoos.[32] Simultaneously, the rise of the women's movement was accompanied by the medical establishment's efforts to increase control over women in gynecology, obstetrics, and psychiatry. Similarly, *homosexual* and other terms were coined in the 1860s as conceptual alternatives to the emerging psychiatric model of homosexuality as a mental disorder; their invention was explicitly linked to the first agitation for legal emancipation of homosexuals, focused on repeal of the Prussian law prohibiting sodomy, the "crime against nature."[33]

All of these contested social relations were of great importance to Bonheur as an animal lover and a cross-dressing lesbian woman seeking masculine independence and prerogatives. She did not, then, turn to animal imagery simply *faute de mieux;* she was also tapping an established discourse that offered a symbolic arena for her personal concerns. Her statements on animals and gender, as well as her actions and her paintings, indicate that her sympathies in these controversies

were clearly with the libertarian camp. Although the connections she drew between these discourses are at times only indirectly evident, it is not surprising that she seldom theorized directly about such charged topics. In addition to the general social pressure toward public conformity, Bonheur was temperamentally disinclined to abstraction. Her friend Prince Georges Stirbey remembered that although Bonheur was deeply spiritual, "If you spoke to her of complex dogmas, she was no longer able to follow you. It was her heart rather than her mind that governed her in these matters."

Nonetheless, there is ample evidence of Bonheur's irreverent distrust of traditional religion, social custom, and secular authority, veering between bemusement and contempt. She read widely (if intermittently) in science and considered herself a pantheist. She believed in the androgynous God-Goddess of Saint-Simonians, and "was not a member of the Church, never attended mass and probably inherited from her father her thoroughly independent attitude toward Catholicism." The Princess Stirbey recalled that Bonheur "did fulminate against many tenets" of the

church. Although scholars often point to Bonheur's increasing political conservatism, this charge applies only to her sympathy for her Bonaparte supporters after their dethronement in 1870. Reared among socialist-feminist utopians, she was less a conservative than a disillusioned skeptic. As early as 1867 she termed the state of society "almost always sad or entirely comic," and later wrote sarcastically, "I look out of my rat's hole to see how the humanitarian geniuses arrange together again the systems which they have pulled down. Let us hope they will make the universe perfect."[34]

On a first level, then, Bonheur's legendary love for animals "reflects her anti-social attitudes." She believed that animals had souls and she shared the viewpoint of many contemporaries that they were "symbolic of uncivilized nature." What they enjoyed, although it was increasingly threatened, was a primeval liberty that she too sought from cultural domination.[35]

Bonheur's home was a virtual menagerie of species, many of which were allowed to run free. She and Micas took motherly care of their brood, and Bonheur was active in the Society for the Prevention of Cruelty to Animals. Her love of hunting earned her the sobriquet "The Diana of Fontainebleau," after the unmarried goddess who roamed the woods with bow and arrow; but she seldom actually participated in the kill, and her woodland walks were as often with sketch pad as rifle. She wrote a long poem on the myth of Actaeon, whom Diana turned into a stag for intruding on her all-female world. In that poem, significantly, she identifies with the male victim, focuses on the stag's predicament, and fantasizes that he will escape from the hunters.[36]

Animals were not targets for her so much as spiritual surrogates. In correspondence, she identified herself with numerous species, from wrens to boars to fish, turtles, and donkeys. She wrote her sister after a riding accident that "I had a narrow shave of breaking my fore-paw," and signed a letter to a brother, whom she once addressed as "my fellow-horse," "your old animal of a sister."[37] On the most direct level, then, her self-portrait in *Gathering for the Hunt* [5] represents the image of a woman who sought through adopting masculine garb both to lay claim to, and facilitate, the adventurous outdoor life of Diana and its opportunity for communing on largely peaceable terms with her beloved natural creatures in a shared liberty.

More profoundly, she also saw, as did many others at the time, significant connections between the plight of animals and the oppression of women. The ideology that sought to restrict women's freedom to a narrowly defined and powerless domestic sphere was couched, like the ideology of animal control, in terms of nature. Relying on the Darwinian-scientificist theory that "biology dictated destiny," male theorists held that "a woman's nature . . . anchor[ed] her to the home." As Chadwick has outlined, the popular novel *Black Beauty* (1877) drew a parallel between the arbitrary and sometimes cruel control over animals and the powerlessness of women against male social theorists, legislators, and doctors, and "by 1900 women supported the antivivisection movement in numbers exceeded only by their numbers in suffrage societies."[38]

Bonheur was outspokenly aware that assertions about female limitations ascribed to nature qualities that were defined and enforced by culture. Her pointed comments on the superiority of women are epitomized by her well-known remark, "In the way of males, I like only the bulls I paint." She viewed traditional female occupations as imprisoning, using an animal metaphor when explaining to Klumpke her good fortune at being able to "free myself" from "the fetters that weigh on [young women] in Europe." Her account of Bonheur's statement that "the horse is but a slave" abused by mankind is followed immediately by Klumpke's own rhetorical question, "Will anyone be surprised that a frequent subject of Rosa Bonheur's conversation was the place given to women in contemporary society?" Of her abortive apprenticeship to a dressmaker she explained, "Above all, I preferred my liberty." Marriage, the sole alternative to such employment, also reduced women to prisoners of men. Bonheur wrote to the Princess Stirbey regarding her daughter's career choice, "She's right to prefer art to marriage,

which more often than not takes a woman in," adding sarcastically, "however, I don't despise this *natural* institution among all animals, and so useful to men, who would mope to death without wives" (my emphasis).[39]

When speaking specifically of her cross-dressing, animals again provided Bonheur with an image of both social constraint and imagined freedom. She felt herself imprisoned by conventional female clothing, just as animals are bound by human control, complaining in a jocular letter of 1864 that she was "tethered" to By awaiting a visit from the emperor, and "I have to endure the trying on of a dress with a train, and to be alert lest I am surprised in trousers and blouse. . . . I indulge in serious meditations on liberty. . . . So you can imagine . . . how fine I must be in harness." Thirty years later, forced into similarly formal costume for a family wedding, she described it as "my gala harness."[40] Given Bonheur's repeated expressions about embodiment as an animal struggling to break free, it is tempting to read the rearing white horse in the exact center of *The Horse Fair,* who champs at the male-held bridle, as a dramatic double for Bonheur, who sits just to the right of this horse, with her face and eye turned toward us at the same angle.

In the last three decades of the century, theories of homosexuality and gender variance that were not yet formulated at the time of *The Horse Fair,* and which remain largely implicit in Bonheur's own imagery, were explicitly articulated by others. If Bonheur's photographs of her masculine persona were part of a first stage in carving out a private space for alternative identities, a second and more self-consciously political phase shifted its interventions from the private to the public sphere. The homosexual emancipation movement that began in Germany demanded not merely a right to privacy but full legal acceptance—a right, as with animals and women, to "expressions of feeling unencumbered by social constraints."

Although the Judeo-Christian moral code that condemned homosexuality and gender deviance (in Aquinas's terms) as "against nature" began to lose force during the Enlightenment, similar presuppositions underlay the emerging medical-scientific discourse, which treated these phenomena as a disease or developmental abnormality.[41] The legions of women who cross-dressed in the eighteenth and early-nineteenth centuries, whether heterosexual or lesbian, framed their self-concepts within and against this discourse. Deborah Sampson Garnett, an American who had masqueraded as a man to fight in the Revolutionary War, recalled that by so doing she had

grasped an opportunity which custom and the world [i.e., culture] seemed to deny, as a natural privilege. . . . A new world now opened to my view, the objects of which seemed as important as the transition before [to male attire] seemed unnatural.

As late as 1879, in her study of cross-dressing or Amazon-like *Female Warriors,* the English suffragist Ellen Clayton still had to "criticize the notion that any woman who refused an identity as a passive and subservient female was 'masculine' and therefore unnatural."[42]

The emergence of a radical alternative paradigm for this debate occurred too late to have any formative effect on Bonheur's life or imagery, but it followed logically from her own ideas. Moreover, the leaders of this movement were well aware of her and eager to claim this prominent and successful figure as a personification of their theories. Figure 15 shows an engraving of Bonheur taken, as the caption notes, "from the last photograph" of her. A memorial tribute to the recently deceased artist, it was published in 1900 as the frontispiece to an annual journal of homosexual research, the *Jahrbuch für sexuelle Zwischenstufen,* edited by Dr. Magnus Hirschfeld. The legend calls her a "mentally and physically pronounced example of a sexual intermediate [Zwischenstufe]."[43]

Hirschfeld, a sexologist and early homosexual rights advocate, founded the activist Scientific-Humanitarian Committee in Berlin in 1897, as well as a pioneering research center later destroyed by the Nazis, the Institute for Sexual Science (a forerunner to the Kinsey Institute). *Zwischenstufe* was his coinage for homosexual; countering the prevailing medical-legal view that homosexuality was a deviation from bipolar gen-

Rosa Bonheur (nach der letzten Photographie), berühmte französische Tiermalerin, verstorben im Mai 1899, seelisch und körperlich ausgesprochener Typus einer sexuellen Zwischenstufe.

15. Anonymous, *Rosa Bonheur*, engraving. *Jahrbuch für sexuelle Zwischenstufen*, 1900 (James M. Saslow).

der norms, Hirschfeld proposed that such persons were a biologically determined "third sex," with an "intermediate," essentially androgynous personality. His was one of several related terms, such as *Urning*, current in progressive late-century models for the psychophysiological bases of homosexuality (both male and female). This terminology attempted to construct homosexuality (or, as one of Hirschfeld's titles put it, "the feminine man and the masculine woman") as a naturally occurring variation in human behavior rather than a matter of moral choice, and hence not properly subject to cultural proscriptions. Gender variance, in this model, was not a crime against "nature" but an inherent character trait whose rightful expression involved merely a transgression of an arbitrarily rigid social code of gender expectations.[44]

It is not known whether Bonheur had any knowledge of Hirschfeld's activities or ideas. But similar concepts and images had already been current among her Saint-Simonian family, whose sect developed androgynous clothing styles and sex roles and believed that Christ had both male and female personas. Her own language bespeaks parallel assumptions about a "man within a woman": in correspondence she referred to herself playfully as "brother" and "grandson," and commented on the ambiguity of her public gender identity: "It amuses me to see how puzzled the people are."[45]

In conclusion, it is now possible to draw together the threads of Bonheur's implicit alternative vision as it pertained to herself, her beloved animals, and her social conflict as a woman and a gender deviant. To her, nature, in all its diversity and spiritual beauty, transcended any attempt by human culture to categorize and control it. Animals are ideally free from such constraint, and she herself is, like all animals, a part of nature, not an anomaly worthy of ridicule and surveillance. Her distinctive portrayal of the animal kingdom—her sympathy for its intrinsic nobility independent of human terms of reference—was as far as she could go in the 1850s toward articulating an embryonic conception of the natural in which lesbianism and cross-dressing, too, would be explicable and hence acceptable.

The fact that Bonheur's self-portraits in male disguise among the animals remained unnoticed for well over a century attests to the persistence of the dominant nineteenth-century construction of the lesbian body as socially and artistically invisible. That she painted even a few such discreet but subversive self-images testifies to her desire to construct an alternative reality, one toward which Hirschfeld and others were soon to move more consciously. Given the limited development and scope of this creative strategy prior to the emergence of an activist community, it is not surprising that she largely displaced her aesthetic gaze onto nonhuman subjects, which served her as surrogates for a fantasy of liberty that could not yet be fully conceived or publicly represented.

Ruskin found Bonheur's tendency to background the human figure "disagreeable," but I

think we can conclude that Bonheur herself found the *necessity* of doing so even more disagreeable. *The Horse Fair, Gathering for the Hunt,* and their penumbra of biographical images constitute a document of struggle, ambivalence, and compromise: between an emerging feminist and lesbian identity and the artist's dependence on popular approval, state control, and aristocratic support. To claim, as Ruskin did, that Bonheur was not a great painter because she "shrank from painting the human face," without examining what faces she was permitted to show the world and to look at, in her life and her art, is inadequate either as art criticism or history.

The modern homosexual emancipation movement was just beginning in Bonheur's old age. We can only speculate how this august yet embattled woman, who had lived half her life before the term "homosexual" was coined, may have reacted to the news of a movement like Magnus Hirschfeld's, which held out hope of a legitimacy and tolerance she had never dreamed fully possible. But whatever Bonheur's level of conscious motivation in 1853, her self-portrait in *The Horse Fair* now provides visual testimony both to the first steps toward the construction of a public lesbian identity and to how narrow was the path those first steps had to tread.

NOTES

1. Special thanks to Professor William Clark of Queens College, the City University of New York, for encouraging me to pursue this research, and to Eunice Lipton, Linda Nochlin, Pamela Parker, and Carol Zemel for their encouragement and helpful criticism at various stages.

2. The basic sources for Bonheur's life are the memoirs by her companion Anna Klumpke, *Rosa Bonheur: Sa Vie, son oeuvre* (Paris: Flammarion, 1908), and her friend Theodore Stanton, *Reminiscences of Rosa Bonheur* (New York: Appleton, 1910; repr. New York: Hacker, 1976). The sole modern biography is by Dore Ashton and Denise Browne Hare, *Rosa Bonheur: A Life and a Legend* (New York: Viking, 1981).

3. On Bonheur's (and occasionally Micas's) cross-dressing, as early as 1850, see Klumpke, pp. 203, 256–65, 308–11, 338, and photographs, pp. 1, 7, 129, 281, 369; Stanton, pp. 16, 23–24, 36, 63, 105–10, 195, 362–67, and photograph, p. 297; Ashton, pp. 52–56; Albert Boime, "The Case of Rosa Bonheur: Why Should a Woman Want to Be More Like a Man?" *Art History* 4 (1981): 384–85, 400–2.

4. On Bonheur's relationships with Micas and Klumpke, see Klumpke, passim, esp. pp. 113 ("Rosa Bonheur m'aime beaucoup"), 293, 419; Stanton, pp. 122 (reprinting a letter of 1850 implying that Bonheur and Micas shared a bed), 187–88, 269; Ashton, pp. 47–59, 171, 177–82. Klumpke, pp. 354–60, recounts several crucial, and deeply touching, statements by Bonheur about the economic and emotional intertwining of her and Micas's lives and her grief at Nathalie's death; Bonheur adds defensively that, despite the "purity" of their relationship, "people looked for something suspicious in [*on a cherché à rendre suspecte*] the

affection that we felt for each other. If I had been a man, I would have married her and people could not have invented all those ridiculous [*sottes*] stories." Boime, p. 386, expresses doubts about any genital expression between Bonheur and Micas but insists that they were lesbian in orientation. For an overview of lesbian relationships, eroticism, and self-image in the eighteenth and nineteenth centuries, see Lillian Faderman, *Surpassing the Love of Men: Romantic Friendship and Love Between Women from the Renaissance to the Present* (New York: Morrow, 1981), pp. 74–294, esp. 284–85 on Bonheur. Many women lived together without any suspicion of sexual impropriety, and indeed the assumption that such relationships were inherently sexual only gradually took hold between 1850 and 1920 (ibid., introduction). Toward the end of her life, Bonheur did anticipate protests about her relationships from her own family and Klumpke's: Ashton, pp. 177–82; Klumpke, p. 419 (Bonheur's last will). Cross-dressing was commonly assumed to be a sign of lesbianism only after World War I, but was so named as early as 1886 by the psychologist Richard von Krafft-Ebing: Julie Wheelwright, *Amazons and Military Maids: Women Who Dressed as Men in Pursuit of Life, Liberty and Happiness* (London: Pandora, 1989), pp. 12–13, 152–54.

5. Emmanuel Cooper, *The Sexual Perspective: Homosexuality and Art in the Last 100 Years in the West* (London: Routledge and Kegan Paul, 1986), p. 49; Whitney Chadwick, *Women, Art, and Society* (London: Thames and Hudson, 1990), p. 180.

6. *The Works of John Ruskin*, ed. E. T. Cook and Alexander Wedderburn, 39 vols. (London: G. Allen, and New York: Longmans, Green, 1903–12), vol. 14, pp. 172–

73; quoted by Boime, p. 397, and Cooper, p. 51.

7. Charles Sterling and Margaretta Salinger, *Catalogue of French Paintings in the Collection of the Metropolitan Museum*, 3 vols. (Cambridge, Mass.: Harvard University Press, 1955–67), vol. 2, pp. 161–64. For the history of replicas and engravings see also Stanton, pp. 379–85; on Bonheur's models, Klumpke, p. 332.

8. The caption beneath the engraving reads: "R. Buckner [painter] W. H. Mote [engraver]—Mlle. Rosa Bonheur, The 'French Landseer' . . ."; reproduced in Ashton, p. 107; New York Public Library, Picture Collection. Auguste Bonheur's study of Rosa's head was preliminary to the full-length portrait now in Bordeaux, Musée des Beaux-Arts; photograph, New York Public Library, Picture Collection, no. 1099; illustrated in Stanton, p. x and facing p. 20; Ashton, pp. 60–61.

9. Other portraits of Bonheur with similar features include Edouard-L. Dubufe, *Rosa Bonheur at 34*, 1857, and engraved copies, reproduced by Klumpke, p. 219; Ashton, p. 74; Boime, p. 387. Photograph at age sixteen, reproduced in Klumpke, p. 166, and Ashton, p. 32. Photograph of Bonheur and family in 1852, reproduced by Ashton, p. 101. Lithograph by Soulange-Teissier, reproduced by Klumpke, p. 263. Pierre-Jean David D'Angers, medallion portrait, 1856, reproduced by Klumpke, p. 217; Ashton, p. 91. Photograph of 1864, Klumpke, p. 254. For *Two Horses* (Philadelphia Museum of Art), see Rosalia Shriver, *Rosa Bonheur, with a Checklist of Works in American Collections* (London and Toronto: Associated University Presses, 1982), p. 57, ill. p. 102.

10. Stockton, California, Pioneer Museum and Haggin Galleries; Ann Sutherland Harris and Linda Nochlin, *Women Artists, 1550–1950* (exh. cat., Los Angeles County Museum of Art; New York: Knopf, 1977), no. 80, p. 225, color plate p. 87. Harris and Nochlin hypothesized that the figures in this painting "were undoubtedly studied and sketched in individual studies." Their hunch is borne out by Bonheur's *Study of Two Male Figures* (Fine Arts Museums of San Francisco), on which see Shriver, p. 52, ill. p. 75.

11. Columbus, Ohio, Museum of Art; Shriver, p. 56, ill. p. 99; also ill. in Klumpke, p. 189, with the title *Les Charbonniers*.

12. *Florinda* (London: Buckingham Palace, Collection of Her Majesty Queen Elizabeth II; reproduced in Oliver Millar, *The Queen's Pictures* (New York: Macmillan, 1977), p. 172, no. 198. *Empress Eugénie* (Compiègne: Musée National du Château), no. MMPO 941; *The Second Empire, 1852–70: Art in France Under Napoléon III* (exh. cat., Philadelphia Museum of Art, 1978), p. 359, no. VI–110.

13. Millar, p. 170, no. 195. Cf., among other similar portraits, Francis Grant, *Queen Victoria with Lord Melbourne, the Marquess of Conyngham and Others*, ibid., p. 168, no. 192. The radical significance of Bonheur's gaze may also be gauged by comparison with the outrage that attended the alert, blunt stare of Manet's *Olympia* more than a decade later (Salon of 1865). Although the present comparisons focus on high-born women, similar analysis could be made of bourgeois ideals of femininity or the male gaze vis-à-vis working women; for the most comprehensive recent overview of feminist art-historical methods and themes, see Lisa Tickner, "Feminism, Art History, and Sexual Difference," *Genders* 3 (1988): 92–129.

14. See, for example, Griselda Pollock, *Vision and Difference: Femininity, Feminism, and the Histories of Art* (London and New York: Routledge, 1988), and Lisa Tickner (n. 13), with further bibliography.

15. Stanton, p. 363.

16. On Bonheur's cross-dressing, see Stanton, pp. 14, 23, 63, 195–99, 362–66; Klumpke, pp. 7, 256–65, 309–11, 338; Ashton, pp. 52–59.

17. The permit for May 1857 is reproduced by Stanton, p. 364, and Ashton, p. 57. It refers to a certification by a Doctor Cazalin, and in the blank space for justification is written "for reasons of health"; the printed text then specifies that this permission does not extend to appearance at "spectacles, balls, and other meeting places open to the public." Numerous nineteenth-century examples from Europe and America of "the pressure exerted on cross-dressing women to resume a 'feminine' role" (p. 86) are given by Wheelwright (n. 4), passim; see below, n. 33. See also Rudolf Dekker and Lotte van de Pol, *The Tradition of Female Transvestism in Early Modern Europe* (New York: St. Martin's Press, 1989); Peter Ackroyd, *Dressing Up: Transvestism and Drag; The History of an Obsession* (London: Thames and Hudson, 1979).

18. For accounts of these visits, see Klumpke, pp. 256–65; Stanton, pp. 95–97; Ashton, pp. 123–29. An engraving by Charles Maurand after a sketch by Isidore Deroy, *The Empress Eugénie Visiting the Rosa Bonheur Atelier*, is reproduced in Klumpke, p. 257, and Ashton, p. 122 (originally from *Le Monde illustré*, June 1864). In her study of cross-dressing female soldiers, Wheelwright observes that "the female warrior's acceptance was often based on denial of her sexuality" (p. 12).

19. Alcide Lorentz's caricature of George Sand (1842) is illustrated and discussed by Ashton, p. 54. On Bonheur's admiration for Sand, see Klumpke, pp. 198–200. Figure 8, a press caricature of Bonheur as "Le Bouguereau des vaches" by Guillaume (*Le Monde illustré*, May 27, 1899), is reproduced by Klumpke, p. 369; see also Ashton, p. 170. Another newspaper cartoon accompanied an amused report of Bonheur's appearance in 1896 at a state reception for the tsar and tsarina of Russia. Her short hair could not support the large hats, held by long hairpins, that were

expected of women on formal occasions. When she appeared wearing a small bonnet of her own design that was tied under the chin, an embarrassed pall fell over the assemblage until the sympathetic painter Carolus-Duran escorted her to her place: Klumpke, pp. 308–11; also reproduced by Ashton, p. 163. When Bonheur's masculine appearance gave rise to rumors about her sexuality and relationship with Micas, she called the questioners "silly, ignorant, low-minded people": Stanton, pp. 187–88, quoted by Cooper, p. 48.

20. Stanton, pp. 42–43.

21. The photograph is reproduced by Klumpke, p. 49, and Ashton, p. 170. For additional photographs, see Klumpke, pp. 1, 61, 71, 129, 281, 303; Ashton, pp. 137, 165; Stanton, facing p. 296 (taken by a male friend). Bonheur wrote about her photography expeditions in the countryside and spending evenings touching up her own paper proofs: Stanton, pp. 202–6.

22. Reproduced in Klumpke, p. 93; Boime, p. 386; cf. another image of Bonheur smoking outdoors, Ashton, p. 165. For Bonheur's desperately humorous strategy to smoke while in a public carriage, see Stanton, p. 367.

23. Reproduced in Klumpke, p. 75; for Bonheur's use of a similar phrase regarding Klumpke's pictures of her (in a letter of August 1898), see Stanton, p. 214. Klumpke, pp. 68–70, recounts the touching story of how she braided the laurel crown and Bonheur tearfully placed this gift next to her souvenirs of Micas.

24. Reproduced by Klumpke, p. 71, and Ashton, p. 178. Both Klumpke and an artist friend, Achille Fould, portrayed Bonheur wearing pants in oil paintings, which indicates that such images were not entirely banished from public media. The issue here, however, is primarily self-portrayal rather than pictures by others, and in any case these pictures date from the last years of her life, when her official standing presumably permitted somewhat more license.

25. On Austen see Ann Novotny, *Alice's World: The Life and Photography of an American Original* (Old Greenwich, Conn.: Chatham, 1976); the self-portrait is reproduced on p. 49. Another photographer caught Austen, camera in hand, at an early automobile speed trial, claiming the same freedom of artistic movement in the male world of racing as Bonheur had, less overtly, in the stockyards: reproduced by Novotny, p. 163. See further, Tessa Boffin and Jean Fraser, eds., *Stolen Glances: Lesbians Take Photographs* (London: Pandora Press, 1991).

26. Boime, pp. 393, 395; see pp. 393–401 for a sensitive and extensive discussion of the meaning of animals for Bonheur.

27. Boime, p. 395. For comments by Bonheur's artist contemporaries on her "unexaggerated" and non-narrative approach, see Stanton, pp. 136–42.

28. Landseer, *Queen Victoria and Prince Albert at Windsor Castle (Windsor Castle in Modern Times), 1841–45*: Collection of Her Majesty Queen Elizabeth II; Millar, *The Queen's Pictures*, p. 172, color plate XL; Richard Ormond, *Sir Edwin Landseer* (exh. cat., Philadelphia Museum of Art and Tate Gallery, 1981), pp. 150–52. *Royalty at Home*, watercolor, 1885, Minneapolis Institute of Arts: Ashton, p. 137. For Bonheur's opinion of Landseer, see Stanton, p. 136.

29. Ruskin, *Works*, vol. 14, p. 173. Thirty years later, explicitly comparing her unfavorably to Landseer, Ruskin summed up his view that "her feelings for animals . . . were more akin to the menagerie keeper's love": ibid., vol. 34, p. 641; cited by Boime, p. 393, and Ashton, p. 112. *The Old Shepherd's Chief Mourner:* London, Victoria and Albert Museum; see Kenneth Bendiner, *An Introduction to Victorian Painting* (New Haven, Conn.: Yale University Press, 1985), pp. 7–25, and Ormond, *Landseer*, pp. 110–11. *The Wounded Eagle*, ca. 1870: Los Angeles County Museum of Art; reproduced by Ashton, p. 140 (see also p. 111).

30. For the significance of this duality as a conceptual model for social relations, see A. J. Greimas (with François Rastier), "The Interaction of Semiotic Constraints," *Yale French Studies* 41 (1968); reprinted in *Du Sens* (Paris: Seuil, 1970). This study is cited and discussed with particular reference to sexual politics by Christine Brooke-Rose, "Woman as a Semiotic Object," in Susan Rubin Suleiman, ed., *The Female Body in Western Culture: Contemporary Perspectives* (Cambridge, Mass.: Harvard University Press, 1986), pp. 305–16.

31. Chadwick, pp. 177, 181. On the ideological implications underlying the work of nineteenth-century *animaliers*, see Alex Potts, "Natural Order and the Call of the Wild: The Politics of Animal Picturing," *Oxford Art Journal* 13, no. 1 (1990): 12–33.

32. See most recently Harriet Ritvo, *The Animal Estate: The English and Other Creatures in the Victorian Age* (Cambridge, Mass.: Harvard University Press, 1987), esp. chap. 3 on humanitarianism, chap. 5 on zoos; also Keith Thomas, *Man and the Natural World: A History of the Modern Sensibility* (New York: Pantheon, 1983); James Turner, *Reckoning with the Beast: Animals, Pain, and Humanity in the Victorian Mind* (Baltimore: Johns Hopkins Press, 1980).

33. For an introduction to the growing literature on both women and homosexuals in this period, see Jeffrey Weeks, *Sex, Politics and Society: The Regulation of Sexuality Since 1800*, second ed. (London: Longman, 1989), with a detailed bibliographical essay; Catherine Gallagher and Thomas Laqueur, eds., *The Making of the Modern Body: Sexuality and Society in the Nineteenth Century* (Berkeley: University of California Press, 1987); Faderman

(as in n. 4); and below, nn. 42, 44.

34. Stanton, pp. 80–81 (on her Catholicism, and quote from Princess Stirbey), 188 (Bonheur's own confirmation of this stance), 244, 246–7 (Bonheur's comments on society), 319 (on her "capriciousness . . . humorousness . . . levity"), 371, 375. She warmly approved, when it was translated for her, Tennyson's assertion that "it is inconceivable that the whole universe was merely created for us who live in this third-rate planet of a third-rate sun": Stanton, 82. See also Klumpke, pp. 11, 158 (on her reading), 159 (on her adolescent initiation by her father into the Order of the Templars, a progressive political association, with a photograph of her in their androgynous costume), 321–22 (androgynous religious beliefs); Ashton, pp. 139–40; Boime, pp. 393, 396 n. 52.

35. Boime, p. 395; Ritvo, p. 285; Klumpke, p. 307.

36. Stanton, pp. 233, 270–75 (the full poem is on 270–73), 338–61; Boime, pp. 385–89, 400–1; Ashton, pp. 135–43.

37. Stanton, pp. 159–60, 181, 211; for other examples see the chapters in Stanton publishing Bonheur's letters, esp. 164–68, 172, 205, 243, 277–79; Ashton, p. 143; Boime, p. 395.

38. Chadwick, pp. 181–86; Wheelwright, p. 15. Boime, p. 403, notes that for Saint-Simonians and other social reformers "the unity of all species and the dissolution of rigid sexual stereotypes were part of the same philosophical outlook." See further Whitney Chadwick, "The Fine Art of Gentling: Horses, Women, and Rosa Bonheur in Victorian England," in Kathleen Adler and Marcia Pointon, eds., *The Body and Representation* (Cambridge: Cambridge University, in press).

39. Stanton, pp. 36, 366 (bulls); Klumpke, pp. 7, 10 ("affranchir . . . les entraves"), p. 308 ("Sera-t-on surpris?"), pp. 311–12 (feminist statements); Ashton, pp. 55–60; Boime, p. 386.

40. Stanton, pp. 161, 211. On her cross-dressing, see further Stanton, pp. 14, 23, 63, 195–99, 362–86; Klumpke, pp. 7, 308–11. Bonheur was not without ambivalence about her masculine public persona; her occasional protestations that she retained "feminine" interests such as embroidered decoration are analyzed by Linda Nochlin, following Betty Friedan, as an example of the "frilly-blouse syndrome"; see her pioneering article, "Why Have There Been No Great Women Artists?" in Thomas Hess and Elizabeth Baker, eds., *Art and Sexual Politics* (New York: Collier, 1973), pp. 1–43. A home photograph of Bonheur in pants lying next to her pet lioness Fathma (Klumpke, p. 281) epitomizes the links in Bonheur's private life between animal freedom and freedom of dress.

41. On "the scientization of the homosexual" as "a late nineteenth-century development grounded in post-Darwinian zoology," see George S. Rousseau, "The Pursuit of Homosexuality in the Eighteenth Century: 'Utterly confused category' and/or Rich Repository?" in Robert Maccubbin, *'Tis Nature's Fault: Unauthorized Sexuality During the Enlightenment* (Cambridge: Cambridge University Press, 1985), p. 140. For additional sources for the history of homosexuality, see nn. 33, 44. For the origins of this debate in the eighteenth century, see Maccubbin, passim.

42. Wheelwright, pp. 132–33 (Gannett), 119–20 (Clayton), with original sources.

43. *Jahrbuch für sexuelle Zwischenstufen*, vol. 2 (Leipzig, 1900), frontispiece. The photograph upon which this engraving was based had been published elsewhere; it appears on an unidentified printed page preserved in the New York Public Library, Picture Collection, no. 2046. This picture, backed by a reproduction of one of her paintings, would seem to be from a magazine article about her in later life or perhaps from an obituary. For other similar photographs of Bonheur in later years, see Ashton, pp. 133, 178.

44. On Hirschfeld, see James Steakley, *The Homosexual Emancipation Movement in Germany* (Salem, N.H.: Ayer, 1982); and further on the roots of the homosexual liberation movement, Hubert Kennedy, *Ulrichs: The Life and Works of Karl Heinrich Ulrichs, Pioneer of the Modern Gay Movement* (Boston: Alyson, 1988); Jeffrey Weeks (as in n. 33). Other significant titles by Hirschfeld include *Sexuelle Zwischenstufen: Das männliche Weib und der weibliche Mann* (Bonn: Marcus & Webster, 1918) and *Les Homosexuels de Berlin: Le troisième sexe* (Paris: Rousset, 1908).

45. For the letters, see Stanton, pp. 193–94, 199, 220, 256–69 passim, and Klumpke, pp. 46–47 (calling her kisses "fraternel"); on her androgyny, Boime, pp. 401–5, and Klumpke, pp. 112, 288. Secondary sources have mistakenly repeated that Bonheur contributed a written account of her life to Hirschfeld's research project on homosexual identity in which she described herself as a "contrasexual" or "third sex": see Alison Hennegan, "Here, Who Are You Calling a Lesbian?" in *Homosexuality: Power and Politics* (London: Gay Left Press, 1980), p. 193; cited by Cooper, p. 49. This misconception arose from a poor English translation of a passage in Iwan Bloch, *Das Sexualleben unserer Zeit in seinem Beziehungen zur modernen Kultur* (Berlin: Marcus, 1907), p. 580; English trans., *The Sexual Life of Our Time* (New York: Falstaff, 1937), p. 528 n. 1. Bloch referred to two confessional articles by lesbians in Hirschfeld's *Jahrbuch* 3 (1901): 292–307, 308–12, but neither author is Bonheur as the English version implies. Special thanks to Alison Hennegan, Debbie Cameron, Manfred Herzer, and Ilse Kokula for their assistance in tracking this longstanding red herring.

15ᶜ le Nᵒ

LA FAMILLE

13ᵉ Année. 11 Janvier 1891 Nᵒ 588

PARIS — 5, RUE DE LA PERLE, 5 — PARIS

Abonnement : Un an, 8 fr.; Six mois, 4 fr.

Avec une gravure coloriée chaque mois

UN AN 10 FR. — SIX MOIS 5 FR.

Étranger : Un franc en plus pour chaque abonnement

AVANT LA SÉANCE, tableau de Mˡˡᵉ M. CARPENTIER (Phot. BLOCK).

1. Mlle M. Carpentier, *Avant la Séance,* cover of *La Famille,* 11 January 1891. Paris, Bibliothèque Nationale.

"L'ART FÉMININ"

The Formation of a Critical Category in Late Nineteenth-Century France

TAMAR GARB

An important element of recent feminist scholarship has been to uncover and affirm the hitherto undervalued but rich visual culture evolved by middle- and upper-class women within the domestic sphere in nineteenth-century Europe. Such inquiries are valuable not only for the provision of a relevant and accurate contextualization of much visual production in the nineteenth century, but also because of their capacity to dislodge fixed oppositions such as "art" and "craft" which underpin Western assumptions about the nature of the material we study.[1] But it would be wrong to assume that all nineteenth-century women were content to define their artistic practices within the boundaries deemed most appropriate to the cultivated *bourgeoise.* Indeed, in late nineteenth-century France, at least, there were many women who saw their involvement in art as both professional and public, who strove for representation in prestigious exhibition forums, for admission to State art schools, for favorable reviews in the general press, for rewards from official bodies and sales

on the open market. Such women would not have been content with the construction of albums, amateur painting and elaborate needlework, however skilled, for consumption within the domestic sphere alone. They wanted public display and professional recognition. They saw themselves within the wider context of the Paris art world, and it was there that they wanted to be assessed and recognized, both as artists and as women. It is with the discursive framework within which such a group of women's professional initiatives were situated that this article is concerned.

On 3 March 1888 and 29 March 1890 the respected art weekly *L'Art français,* a journal which was avowedly eclectic in taste but which still retained a preference for academic and traditional modes of working, reproduced art works by women artists on its front covers. One of them was a portrait by Mlle Josephine Houssay, the other the then much acclaimed sculpture *Psyché sous l'empire du mystère* by the renowned Mme Léon Bertaux, founder and president of the *Union des femmes peintres et sculpteurs* [2,3].[2]

The covers reveal an interesting and perhaps unexpected conjunction between three terms: first Art, embodied in each case in the word and the reproduced image; then Frenchness, as a means of

Tamar Garb, " 'L'Art féminin': The Formation of a Critical Category in Late Nineteenth-Century France," *Art History* 12, no. 1 (March 1989): 39–65. By permission of the author and Basil Blackwell, Inc.

2. Mlle Josephine Houssay, *Portrait de Mme Marie P...*, cover of *L'Art français,* 29 March 1890. Paris, Bibliothèque Nationale.

3. Mme Léon Bertaux, *Psyché sous l'empire du mystère,* cover of *L'Art français,* 3 March 1888. Paris, Bibliothèque Nationale.

qualifying the art with which the newspaper was concerned, and premised on the idea that such an adjective was meaningful; and Womanhood, indicated through the labeling of the reproduced works, through the texts accompanying them, with their allusions to the *Exposition des femmes peintres et sculpteurs,* and that which the reproduced images represent, a bourgeois lady model, on the one hand, a mythic female figure on the other. Of course the relationship between these terms would have been read and understood simultaneously and unconsciously by their contemporary audiences. They would have made sense. Mediated as they were by the context of *L'Art français,* the works came to represent, or to be significant of, a certain relationship between these terms, a relationship of compatibility. In this context the works signified in relation to these

terms. In different contexts they could have signified differently.

By prizing apart these elements and destabilizing their easy coexistence, it is possible to suggest that behind the apparently unproblematic juxtaposition of such terms on one page lies a complex institutional and discursive history. For the conjunction encoded in these covers is not necessarily as seamless and straightforward as the editorial policy of *L'Art français,* with its extensive illustrated coverage of the exhibitions organized by the now well established *Union des femmes peintres et sculpteurs,* formed in 1881, would lead us to believe.[3] The resolution offered by *L'Art français*—that is, of the happy coexistence of Art, Frenchness and Womanhood, in the interests of the Nation and its Culture—can be read as one response to the highly threatening potential for

conflict between the very elements which the front covers so neatly juxtaposed.

L'Art français was not the only establishment journal to promote the interests of the professional woman artist. The conservative weekly women's magazine *La Famille* saw fit to use engravings of art works by women artists on its covers on a number of occasions. These sometimes took the form of works which had been acclaimed at the Salon, and on two occasions they were paintings by women which portrayed women *as* artists. The issue of 11 January 1891 featured the assertively declared self-portrait by Mlle Carpentier [1], with her signature and the date of the painting clearly indicated on the canvas within the canvas so that the viewer is left in no doubt as to who the artist is; the issue of 9 February 1890 reproduced a painting by Mlle Besson, of the woman artist at her easel surrounded by her friends[4].

How did the figure of the woman artist come to be seen as compatible with the interests that *La Famille* promoted? Or, more to the point, what kind of woman artist would fit into *La Famille's* program for a stable social order? How could *La Famille* and *L'Art français* be seen to inhabit the same sphere, at least where the relationship between Woman and Art is concerned? *La Famille* was dedicated in all ways to the promotion of traditional family life; it was targeted at women as the accepted guardians of the family. It promoted the centrality of women's role in the home, published articles generally hostile to the idea of women pursuing careers, and set out to provide information and entertainment which was suitable to the domestic life of its readers.[4] Like many women's magazines, it provided information on fashion, sewing patterns, embroidery motifs, snippets of cultural information, advice on household management and social gossip suitable for the well-groomed middle-class woman. In addition, it occasionally ran "do-it-yourself" guides and discussions on drawing and painting designed for the accomplished *femme au foyer,* who could thereby acquire skills in the seclusion of her own home.[5] It is not, therefore, surprising to see that when the figure of the woman artist is shown in these pages, it is often with studio equipment op-

4. Mlle Besson, *Les Bonnes Amies,* Salon of 1889, cover of *La Famille,* 9 February 1890. Paris, Bibliothèque Nationale.

erating as a background for the display of new sewing patterns or embroidery motifs, as in a typical image from March 1889.[5] Alternatively, the activity of painting is represented in the familiar guise of refined accomplishment, akin to visits to the theater and piano playing, as in a contemporary cover from the *Gazette des femmes* [6].[6] Studio paraphernalia is repeatedly used as a suitable backdrop for the display of ladies' fashions in journals like these where the easel, the palette and the brush function merely as props. On some occasions the ostensible painter's brush is easily replaced by a fan [7]. In images such as these, brush and fan are interchangeable, since both can function as emblems of an appropriately classed femininity. The threat to the woman artist in such circles was more trivialization than outright hostility.

5. Fashion plate from *La Famille*,
10 March 1889. Paris, Bibliothèque Nationale.

6. Cover from *La Gazette des femmes*,
10 November 1886. Paris, Bibliothèque Nationale.

7. Fashion plate from *La Gazette des
femmes*, 1880s. Paris, Bibliothèque Nationale.

Magazines like *La Famille* and the *Gazette des femmes,* particularly in the latter's later phase, were openly hostile to political feminism, to the tiny but vocal group of French suffragettes, to agitation for women to work outside the home, to campaigns for women's rights as wage earners, or many of the other reforming or revolutionary programs which sought to alter women's social and political position, then at their height in Paris.[7] But, despite its avowed hostility to political feminism, for *La Famille* at least the figure of the woman artist did not remain, exclusively, the caricature of the fashion illustration. As the reproduction of women's work on its covers testifies, there was a serious level on which the professional woman artist could be accommodated.[8] The operative word here is professional. As is clear from the innocuous images from the *Gazette des femmes,* it was not the act of producing art which was threatening to the social order. As is by now well documented, painting (though not, of course, sculpture) was widely regarded as a suitable and necessary accomplishment for the appropriately "feminine" upper-middle-class woman.[9] Watercolor, like weaving, fan decoration and embroidery, to mention only a few artistic practices, had been promoted throughout the nineteenth century as an activity suited to the female temperament and level of skill.[10]

But it is not only at the level of the suitably domesticated and accomplished lady, or as the intuitively skilled craftswoman, that *La Famille* and *L'Art français* represented the woman artist. It was as the professional that she found her place on their covers. What is interesting is the way that the image of the professional woman artist came to be seen as compatible with traditional values, with the importance of home, family and patriotism promoted by such journals. We are forced to question what the role of Art was in such a scenario and what kind of Art and Artist such a vision necessitated. How, we must ask, did such a construction constitute a response to a set of debates about the nature of Art and its responsibilities, the nature of the "Fatherland" or *Patrie* and its demands, and the nature of Woman and her function as guardian of Home, State and Heritage?

How could it be that in the 1890s the elements encoded by the covers of *L'Art français* read as compatible to so many women artists and their defenders, both men and women?

While *La Famille* reproduced women's paintings exhibited at the annual Salons, *L'Art français* was more eclectic in its coverage, still giving a large proportion of space to the Salons but also including reproductions from the many smaller exhibitions which characterized the Paris art world of the 1880s and 1890s. Among these was the *Salon des femmes,* amply covered in *L'Art français* during this period.[11] By this time, the centrality of the Paris Salon was under threat from a number of new exhibition initiatives. These had been growing for decades and had expanded rapidly in the early 1880s, at a time when the Republican State withdrew its control over the Salon in order to foster a more diverse and market-oriented artistic field on the one hand, and a more considered form of state patronage through commissions on the other.[12] Not all critics, administrators or even artists were in favor of the State relinquishing control over the Salon. There were those like the Marquis de Chennevières, erstwhile Director of *beaux-arts,* who had dreamt of a *corporation aristocratique,* an élite body of artists, elected by an exclusive and recognized group, not of an organization which was democratically elected by all artists who had exhibited at least once at the annual Salon.[13] There were those who believed that relinquishing the Salon to a committee of artists over whom the State had no control would lead to a drop in standards and the transformation of this ancient national institution into a vulgar commercial enterprise.

Defenders of the Salon as the primary showcase for contemporary French art saw it and associated institutions, such as the Ecole des Beaux-Arts and the Academy at Rome, as the forums which could best protect the traditional skills and values of French culture, identified as the striving toward the Ideal and embodied in elaborate subject pictures which displayed the academic skills of subtle tonal modelling, accurate drawing, balanced composition and a high degree of surface finish.[14] The French national tradition was threatened from

without, they believed, by foreign advances in art and industry, and from within by "modern" pictorial practices, which sacrificed enduring values for a superficial interest in capturing surface appearance and a slavish attachment to representing the imperfections of nature.[15] In such circles, represented by figures like Delaborde, who was for twenty-four years *secrétaire perpétuel* of the Académie des Beaux-Arts, or the artist Henri Lehmann, the intransigent defender of tradition, "naturalism" could be constructed as an abdication of the ability to abstract, to reason, to order the chaos of the perceived world by means of time-honored rules which stood as the highest expression of Art.[16] Sophisticated powers of reason, together with a suitably noble capacity for sentiment, thought to be rooted in France's racial heritage and physical and psychological adaptability, were some of the qualities which were said to have marked the French Christian sensibility from that of other "races" and to have accounted for France's past supremacy in the visual arts.[17]

Anxiety over the loss of superiority in the fine arts and associated industrial fields was symptomatic of wider social fears of France's moral and national degeneration, to which the defeat of 1870 remained a humiliating reminder. The idea of national degeneration, which by the late nineteenth century had entered into popular parlance and become a cultural catchphrase in the *belle époque*, originated in the theories of *transformisme* of the eighteenth-century naturalist Jean-Baptiste Lamarck which were revised in mid-nineteenth-century France. For neo-Lamarckians, unlike Darwinians, the species survived and adapted itself to changing environmental conditions by learning behavior which established an "equilibrium" between itself and its new environment. This resulted in the transformed internal organization of the organism which could then be passed on to its offspring. Degeneration theory centers on the notion that the short-term adaptive functions of the organism can be those which will become ultimately dysfunctional to the organism itself. So the organism develops a "pathology" which can be said to be hereditary. As Robert Nye has shown, neo-Lamarckian heredity and degener-

8. Elizabeth Jane Gardner, *Deux Mères de famille*, 1888 Salon. Whereabouts unknown.

ation theory functioned paradigmatically in fin de siècle Paris, providing an ostensibly scientific range of concepts with which to explain all France's contemporary "social ills," ranging from the depopulation crisis to alcoholism, the "decline" in moral standards as exemplified in the pornography trade and licensed prostitution to the potential dangers of feminism and the behavioral patterns of the working classes.[18] So whilst the defenders of France's traditional artistic practices and institutions (themselves never as homogeneous as the claims of nostalgic mythology would have us believe) might not have been consciously drawing on biological theory in their attack on "modernity" and its representatives, they operated within a discursive field in which a fear of national degeneration had currency, and provided the framework for a counterattack.

The defenders of the academic tradition in French art would have had little difficulty in choosing between a painting by an artist such as Berthe Morisot, who, by this stage, chose to exhibit only at independent or dealer exhibitions, and Elizabeth Jane Gardner, who was to become an honorary Frenchwoman through her marriage with the much acclaimed William-Adolphe Bouguereau, who chose the Salon as her preferred forum for exhibition. While Morisot's *Wet Nurse and Julie* of 1879 [ch. 13, fig. 1] would have been seen as lacking finish and skill in drawing, Gardner's *Deux Mères de famille,* exhibited at the Salon of 1888 [8], would have fulfilled the demands for a highly contrived, well delineated and convincingly illusionistic pictorial space, with its solid draftsmanship and skilful creation of volume through appropriately subtle tonal modeling. What is more, the Gardner would have been seen as making a moral statement about the healthy young mother's instinctive and entirely wholesome attitude to her child, inscribed as natural by finding its echo in the hen and her chicks. But the moral overtones of the Gardner would not have been restricted to the overt "message" in the work. Indeed, despite its apparently secular theme, the Morisot too could have been read as an interpretation of the modern Madonna, particularly in late nineteenth-century Catholic France. Even though we know the work to be a representation of Morisot's daughter Julie and her nurse, the picture's format suggests Madonna imagery through the subtle promotion of the "natural" closeness of woman and infant.[19]

So it was not only the overt nature of the moral encoded in the Gardner which made it acceptable. It was the formal elements themselves which became tinged with moral associations, signifying Purity, a striving for the Ideal, a belief in the power of Beauty, and a respect for Tradition and enduring values. These characteristics in turn came to be associated with the finest attributes of French Culture. For its detractors, the apparent formlessness of the Morisot signified materialism, an attachment to this world at the expense of a more spiritual one, an attachment to the present at the expense of the past and with no due regard

to the future, a capacity for being seduced by surface pleasure rather than uplifted by enduring moral virtues.[20] We see, therefore, within those artistic circles in Paris who saw themselves as defenders of "ancient" institutions and practices, the formulation of a set of theories which sought to connect conservative pictorial practices with traditional social values. As an anonymous commentator writing in the *Journal des femmes artistes* put it in a virulent attack against the call for contemporaneity and immediacy in recent French art,

. . . "one must be of one's time" so be it, but in what way? He is also of his time who is a prey to his prejudices, who takes his uniform from fashion, who lives entirely in the present; . . . The true artist freely and bravely faces the enticements of fortune, he does not compromise with the demands of his religion, he does not place the cares of the body above the pure joys of the ideal, he dreads that his work should become an object of consumption rather than the manifestation of an idea.[21]

But such criteria for judging art works could have been used irrespective of the female identity of their creators. And lest we think that interpretation is as simple and univocal as this analysis implies, it is salutory to remember the complexity of competing forms of interpretation which exist contemporaneously within a culture. Indeed, in some circles the attention to surface and the interest in color and facture, rather than draftsmanship and careful compositional structure, would have inscribed the Morisot as a truly "feminine" painting. In a culture which overridingly believed in women's innate superficiality and incapacity for rational thought, the surface nature of the Morisot was used by some of its defenders to prove its authenticity as an expression of an appropriately "feminine" spirit. Her work was praised in this manner even by critics who were generally hostile to Impressionism.[22] For such critics, it was deemed appropriate for women artists alone to practice "impressionism" as it was capable of so directly expressing their facile and superficial natures, their excitability and innate propensity toward "nervousness."[23] The implication was that for men to work within an "impressionist" mode

was an abdication of their natural gifts, their innate powers of reason and intellectual abilities, which carried with them a duty to a more restrained and deliberate art.

The debate over an appropriately "feminine" art was to surround the work of professional women artists irrespective of the context in which they exhibited. From the women impressionists to successful decorative artists like Louise Abbema, from popular heroines like Marie Bashkirtseff to Sarah Bernhardt, from watercolorists like Madeleine Lemaire to sculptors like Mme Léon Bertaux, the question of the artist's gender identity as evidenced in her art was always at stake although, as we have seen, not always in the same way.[24] This was equally the case with the first collective initiative on the part of women artists to supplement existing forums of display and to create their own separate artist's organization with its annual exhibitions, institutional infrastructure and public voice. An examination of the discourses which surrounded such an unprecedented institutional intervention may throw some light on the willingness of socially and artistically conservative organs like L'Art français and La Famille to promote the interests of the professional woman artist.

There can be no doubt that the institutional provision for women artists in late nineteenth-century Paris was far inferior to that which existed for men. It was the recognition of these very real disadvantages in educational provision, exhibition facilities and efforts rewarded, not to mention the prejudices which circumscribed women's practices in so many ways, that led a group of women to form their own exhibition society to represent their professional interests, to agitate on their behalf and to provide a forum for the display of women's work which could rival the small clubs and exhibition societies then emerging in Paris, many of which were closed to women. For the growing number of women who sought to make their living out of art, any exclusion from existing forums was a real practical disadvantage.[25]

The moving spirit behind the formation of the Union des femmes peintres et sculpteurs in May 1881 was Mme Léon Bertaux, born Hélène Pilate. Mme Bertaux ran a sculpture studio for women

and was the creator of the sculpture Psyché sous l'empire du mystère, which L'Art français featured on its cover some years later.[26] The first exhibition of the Union was held in January 1882, and annually thereafter, growing from a small show representing only thirty-eight artists in its first year, to 176 works on display by the second exhibition, nearly 300 by the fourth exhibition of 1885 and as many as 942 by 1897. By 1890, the Union had approximately 500 members and had received official sanction. Its exhibitions were regularly housed in the Palais de l'Industrie, its openings were attended by government ministers, and in 1892 it was recognized as a utilité publique by the President of the Republic.[27] Rather than restricting its activities to the organization of exhibitions alone, the Union functioned as a body which could represent the interests of women artists across the profession. It was active in government commissions on women's education, it was instrumental in agitating for the opening of the Ecole des Beaux-Arts to women, it campaigned to get women onto the Salon juries and into the exclusively male Institut Français, and campaigned to end the male monopoly on the competition for the Prix de Rome. In all senses it was devoted to the promotion of art for women as a professional practice rather than as an accomplishment or an activity which was based in the domestic sphere alone.[28] Although the decorative arts began to be represented at the exhibitions in the early 1890s, the main focus for the leadership of the Union had always been and continued to be the promotion of women's involvement in "grand art," with all the connotations that the phrase possessed.[29]

Reactions to the foundation of the Union were mixed. There was the usual misogynistic jeering from some quarters, bemused scepticism or ironic condescension from others, and cautious words of support from a few. Facile flattery of the shows could come from all sides. Unconditional support, if only of the exhibitors' intentions rather than the quality of the works on show, came from the rapidly expanding feminist press. The art press generally offered encouragement, although this was often overlaid by expressions of anxiety at the

explosion of activity in the arts which character-ized this period.[30]

In keeping with the conservative tradition of much socialist thought in nineteenth-century France, dominated as it was by Proudhonian so-cial theory, some of the most hostile coverage of the women's exhibitions came from anarchist and some socialist critics.[31] Many socialists were in any case sceptical of feminist agitation for equal professional rights, seeing these as a manifestation of bourgeois social reformism which would deflect from their real project of socialist revolution. The urban campaigns of the professional woman could not, therefore, be central to the socialist project.[32] Much criticism across the board reproduced cur-rent medical assumptions. Extrapolating from bi-ologists' claims, such as that of the passivity of the ovum and the activity of the sperm, it was widely assumed that action was an intrinsically masculine characteristic while passivity and the power to fas-cinate/attract were innately feminine. It was not part of woman's role to enter the fray of public life nor to be a creative or active initiator.[33] In the words of one critic writing in an anarchist paper on the eighth exhibition of the *Union des femmes peintres et sculpteurs,*

Woman is the ideal which dominates art, the eternal source of inspiration, but just as the artist could not aspire to attain this ideal—that is, supreme perfection in his reproduction—woman herself is not able to de-scend into the arena of the fight. She inspires, she encourages; she dominates, that is her role—but she cannot execute.[34]

For critics such as this, there was little chance of responding charitably to the women's exhibitions, which in their view had no right to exist in the first place. All observations would serve only to under-line the writer's suspicions, any apparent weak-nesses would act as confirmation of the artist's inherent unsuitability to the task, any demonstra-tion of strength and skill would be seen as an abdication of the artist's "femininity" and, there-fore, as an unnatural aberration, worthy only of scorn or lamentation.

Support for the formation of the exhibitions came from unlikely quarters. Albert Wolff, critic

for the conservative *Le Figaro,* saw the point of women forming their own exhibiting organization as he acknowledged the extent to which they were sacrificed by the all-male organizing committees and juries of the annual Salons.[35] But Wolff was no friend to political feminism. Indeed, he was taken to task by Louise Koppe, editor of the mod-erately feminist newspaper *La Femme dans la fa-mille et dans la société,* for his views on women, which were not dissimilar to those held by the anarchist critic quoted above, a man who could not have been further removed from Wolff on wider political issues. Wolff acknowledged that it was men who had constructed the legal code by which both men and women lived but he argued that it was women who benefited from this as much as men. Having fewer rights than men, they also had fewer responsibilities. Echoing the senti-ments of thinkers like Jules Michelet, he held that "it is in the inferiority of her situation that the source of woman's grandeur resides."[36]

It was the same Wolff who was the mildly flat-tering, if patronizing, critic of the women's exhibi-tions. Certainly, he displayed none of the open hostility and venomous antagonism of some of his colleagues. Once again we are faced with an inter-esting juxtaposition. A hostility to political femi-nism and to the campaign for women's political rights did not necessarily entail a hostility to the existence of the professional woman artist, al-though it could in some quarters.[37] There were, on the other hand, those who agitated on behalf of women artists in the name of "feminism," but there were also those who did not regard their hostility to women's social and political advance-ment as incompatible with the campaigns for the rights of the woman artist. For some of her sup-porters, the professional woman artist came in fact to represent one of the types of the socially ad-justed woman, the suitably womanly woman who would not threaten the social fabric or the natural order but who, through her art, could be called upon further to inscribe it.

Works shown at the *Salons des femmes* in-cluded portraits, flower paintings, landscapes, ani-mals and genre scenes, as the published criticism and the illustrated pages of *L'Art français* testify.

Religious and history paintings were rare, as were representations of the nude, although these were occasionally present and then always in the idealized mode. The works did not differ markedly from most of the exhibits that would have been on view at the societies and *cercles* increasingly used to show works of art during this period. What was noticeably different was the abundance of flower painting at the women's exhibitions, though this in itself is unsurprising in view of the popularly held assumptions of the appropriateness of flower painting to women's skill and sensibility. But the demands made of the women's exhibitions both by critics and artists were illuminatingly different from those made of men-only or mixed exhibitions, and an examination of these will help to reveal the climate of possibility within which the woman artist operated. The *Salons des femmes* were expected to be different from "ordinary" exhibitions. They were expected to signify "sexual difference," to represent "femininity" in a tangible form.

"Femininity" was one of the terms which was most struggled over in fin-de-siècle Paris. There was general consensus that it existed, that women possessed it, and that much of what they did or said could be seen to originate in their "feminine" natures. Whether people believed that sexual characteristics were the result of centuries of adaptation and evolution like the followers of Darwin, or the result of "evolutionary transformism" in a neo-Lamarckian sense, or whether they believed that they were inherent and preordained characteristics which were biologically determined, for the most part there was agreement about what constituted appropriate "masculine" and "feminine" behavior. It is not surprising, therefore, that the women's shows would be expected to differ from general exhibitions (here explicitly seen to represent the "masculine" rather than the "sexually indifferent" or neutral) and that the sex of the creators should infuse the work on show. As Dargenty, critic for the *Courrier de l'art,* put it,

I would have hoped on entering the hall of the Palais de l'Industrie, to have felt a special impression, a slight shock, something finally which corresponds to Don Juan's *l'odor di femina.* I had allowed myself to expect that the bosom of this exclusive exhibition would have exhaled an artistic scent *sui generis* [all its own], a particular demonstration deriving neither from knowledge nor genius, but of that complex entity, so subtle, so astute, so fugitive, so interesting, feminine emotion. Bitter disillusionment. There was nothing like this. All these works, quite mediocre for the most part, smell of the masculine force to which the brains of their authors have been subjected.[38]

Dargenty demanded of the exhibitions that they display what he chose to call a *féminisme,* an interesting appropriation of this most promiscuous of terms. He used the word advisedly. He defused it of its strongly political connotations by making it signify "femininity" or the veil of appropriate social behavior that the culture defines as intrinsic to women and which women live out unconsciously as "masquerade."[39] Interestingly, the word *féministe* was later used by Virginie Demont-Breton, second president of the *Union,* for much the same purpose. In the name of a reconciliation of what she saw as the unnecessary divisiveness between men and women which feminist debates had provoked, she called all men *féministes,* by virtue of their affection for women, thus depriving the term of its political dimension.[40]

Dargenty was not the only critic to be disappointed at finding no evidence of the feminine spirit made concrete in the works on show at the *Salons des femmes.* He accused the artists of "masculinization," saw their work as derivative of male models and styles, and called for a feminine art in which women would rid themselves of that which they had gleaned from men and learn to become more fully "themselves." Since he was unconvinced of the need for the shows in the first place, the only justification which he could see for their existence was that they should offer a tangible demonstration of the "femininity" of their participants.

Allied to this disappointment, which was shared by many, came the widespread allegation from all quarters that women artists were too dependent on their teachers, who were usually male, that they lacked originality, that they displayed an unfortunate propensity for imitation, and that their work

was derivative. Indeed, women's imitativeness and lack of originality were constructed through popular psychological discourses as physiologically determined. It was generally believed that the male and female brain and nervous system had developed differently and that this was partially responsible for the difference of "masculine" and "feminine" behavior. Whilst the capacities for reason, analytical thinking and mental synthesis were widely thought to be facilitated by the size, weight and structure of the male brain, together with the nature of the irrigation and nervous systems, the female was seen as being adapted for intuitive, imaginative and imitative functions. In contrast to men's capacity for originality and "genius," women were thought to have a well-developed memory and a heightened capacity for feeling.[41] Women's alleged dependence on their teachers was, therefore, expected, and was seen to have produced an art which was not only dull and unoriginal, but which also reneged on their own natural propensities. Even those critics like Emile Cardon of the *Moniteur des arts* who were on the whole complimentary and encouraging of the women's exhibitions, lamented what he saw as the lack of originality in the shows and the too obvious evidence of the teacher's hand.[42] This was also true for feminist critics. As one writer for *La Revue féministe* put it, "nous aurions préféré voir moins de talent et plus d'originalité."[43]

With historical hindsight, it is possible to see that the demand made of women that they display their "difference" in their art was an impossible one. Women were asked, and asked themselves, to occupy the space of the fantasized Other. They were measured not only in terms of a difference from "masculinity," conceived as normative, but also in terms of their difference from a fantasy of "femininity," constructed in relation to "masculinity." The demand made of women's art was that it be adequate not only to current stylistic notions of good drawing, design, imaginative composition and so on, but also to a more particular test of adequacy, that it express an essential "femininity." An art which was seen not to fulfill each of these criteria could be regarded as both weak in terms of quality and mendacious in nature. And

an art which might demonstrate certain skills, for example in draftsmanship (regarded as the most rational and intellectual of artistic skills, and, therefore, appropriately "masculine"), could simultaneously be seen as reneging on women's innate and necessary incapacity to draw (their skills being more intuitive) and thereby be construed as transgressing its natural boundaries.

Ideas about women's innate lack of originality, incapacity for rigorous thinking and propensities toward the superficial were balanced by a belief in their receptiveness and powers of assimilation, their developed capacities for feeling and appreciation, and their natural sensitivity. For Henry de Varigny, writing in the *Grande Encyclopédie*, it was biology that determined women's developed *sensibilité* in contrast to men's advanced intellectual capacities:

Amongst the latter, the frontal lobes—where it is agreed that the organ of intellectual operations and superior psychic functions is situated—are dominant; they are much more beautiful and voluminous amongst the most civilised races. With women, it is the occipital lobes which are the most developed and have more importance and it is in them that physiology situates the emotive and sensitive centres. This, moreover, corresponds well with the psychological characters of the two sexes, the masculine sex having more intelligence whilst women are gifted with a great sensibility.[44]

Women were widely thought to be endowed with fertile imaginations and intense emotions. Indeed, their alleged capacity to feel was essential to their social role as mother and nurturer. Women were capable of profound *sentiments*, defined in the *Grande Encyclopédie* as intuitive and instinctive intellectual phenomena, sometimes associated with a profound and direct appreciation of the "beautiful," the "spiritual" and the "good."[45] Woman's psychological characteristics were, it was believed, adapted to suit her role in the family as its affective center and in society as its moral conscience.[46] Some defended women's moral superiority by quoting criminal statistics, others their attachment to the church and their involvement in charitable works. Even such figures like the Republican feminist Maria Deraismes argued that women were by nature an *agent moral*, "un

agent pacifique et conservateur de l'humanité."[47] Such ideas, promoted across the board in the Third Republic, with dissension only from a tiny group of anti-essentialist feminists, were rooted in nineteenth-century philosophy from Catholic doctrine to Comteian positivism. It was women who were responsible for the preservation and re-generation of the race. As the *Grand Dictionnaire universal du XIXe siècle* put it, "La dégéneration comme l'amélioration des races commence tou-jours par le sexe féminin."[48] It was women's bod-ies which had been adapted to bear and rear chil-dren, and their natures which were formed to conserve that which was "good" and necessary for the survival of the species. As Auguste Comte put it earlier in the century,

It is indisputable that women are, in general, as superior to men in a spontaneous expansion of sympathy and sociality, as they are inferior to men in understanding and reason. Their function in the economy of the fam-ily, and consequently of society, must therefore be to modify by the excitement of the social instinct the general direction necessarily originated by the cold and rough reason which is distinctive of Man. Apart from all consideration of material differences, and contem-plating exclusively the noblest properties of our cerebral nature, we see that, of the two attributes which separate the human race from the brutes, the primary one indi-cates the necessary and invariable preponderance of the male sex, while the other points out the moderating function which is appropriate to Woman.[49]

Women's special capacities (and these were often alleged to be manifest in their "natural" taste for home decoration, fashion and flower arranging) could be seen to enable them to contribute in unique ways to current artistic practice. Whilst for some critics their allegedly impulsive natures and their sensitivity to surface appearance was as-sociated with an appropriate lightness of touch and tone, for others their natural "tenderness" and heightened capacity to feel emotions, exem-plified in their maternal instincts, could be drawn upon to produce an art which was profound, mor-ally uplifting and highly emotionally charged. It was in these terms that Roger Ballu, *Inspecteur des beaux-arts,* could praise women's involvement in art in his speech at a banquet of the *Union des*

femmes peintres et sculpteurs in 1893. In women he saw ". . . un coeur d'où naît une tendresse pour le beau, une âme qui perçoit l'éternelle grandeur de la nature . . . comme une lyre au souffle des beautés qui passent!"[50]

The foundation of the *Union des femmes pein-tres et sculpteurs* might have intensified the de-bate on what intrinsic characteristics women could bring to art by offering a focus for such speculations, but these ideas certainly did not orig-inate here. Critical accounts of women's work tapped assumptions which were deeply embedded in the culture and encoded in its institutions, from educational provision, the legal code and the orga-nization of the family, to the planning of the city and the structure of the church. Nor, of course, was the debate restricted to women artists exhibit-ing at the *Salons des femmes.* It can, as we have seen, be traced in the critical reception of works by contemporary artists like Berthe Morisot, who was thought by some to have outstripped her col-league Mary Cassatt in "femininity," the work of the latter being dependent on a linearity and planned compositional structure regarded as "manly." Her art was accused of "masculiniza-tion."[51]

Yet the figure on whom the issue of "masculini-zation" turned was Rosa Bonheur, renowned not only for her vigorous animal paintings but for her transgressive adoption of masculine working at-tire, for which she had to receive police permis-sion.[52] For many critics, Bonheur became the car-icature of the professional female artist who had in all ways reneged on her natural attributes and laid claim to gestures and modes of behavior which were beyond her sphere. At best she was seen as an admirable artist and an eccentric, some-times a lovable caricature, at worst the butt of malicious humor, a woman "unsexed."[53] For the members of the *Union des femmes peintres et sculpteurs,* however, she became a symbol of what women could achieve. She was the subject of a portrait exhibited at the Salon of 1893 by Mlle Achille Fould, a staunch member of the *Union,* who represented her complete in working gear and in the context of her own studio, which was filled with allusions to hunting and wild animals

9. Mlle Achille Fould, *Rosa Bonheur in Her Studio,* Salon of 1893.

deemed far beyond the domestic concerns to which women were destined [9]. Bonheur occasionally exhibited at the *Salon des femmes* and in 1896 was elected honorary life president of the *Union.*[54] It was as a *woman* that the "sociétaires" of the *Union* admired Bonheur, it was as a *woman* that they asked for her support, and they refused to see her strength and talent as a function of a deviant sexuality, of a cloaked "masculinity." In order to claim her as a "real" woman though, complex textual acrobatics were required. When Mme Virginie Demont-Breton, second president of the *Union,* paid tribute to her female mentor in an obituary published in the *Revue des revues* in 1898, she was anxious to assure her readers that Bonheur had fulfilled her true female destiny. Although she had never married and had no children of her own, Bonheur, claimed Demont-Breton, viewed her animals with the tenderness of maternal love and would have made an outstanding mother and wife because of the profundity of her feelings. She was like a mother to her animals and in turn became like a mother to women artists.[55]

As is apparent, a complex interaction of terms is at play in the criticism of women artists and their work at this time. When the work of male artists is in question, there is no discussion of sexual difference, no quest for the work to embody the sexuality of its author, as it is "masculinity" which is the norm against which an oppositional "femininity" is constructed. The apparent sexual neutrality of art is revealed to be gender specific only when it is women's work that comes into question.[56] The implications of this for the woman artist who self-consciously operated within this discursive field were vast and the competing demands placed on her impossible to fulfil. She had to answer to a number of requirements: that she be a skilled artist, that she be a womanly woman and that her art be infused with her womanliness. And this in a society which made little institutional provision for her right to be an artist at all and made very specific demands on her identity as a French woman and hence guardian of the home, reproducer of the "race" (in these anxious times once again haunted by the spectre

of falling birth rates) and educator of the Nation's children.[57]

These demands were intercepted and brought into dialogue with another voice, the increasingly insistent voice of political feminism, represented by a small but active group of men and women who set out to question the received wisdom which was presented as the natural order of things. It was this voice which most disturbed so many middle-class women with professional aspirations, for they saw it as threatening to deprive them of their mark of pride and the source of their strength, their true womanliness. It was the prospect of being lumped together with what they saw as the extremes of political feminism, represented particularly by the suffrage campaign, which contributed strongly to the formation of a rhetoric of disavowal of "feminism" even while women artists campaigned furiously for institutional and professional rights.[58]

It is in response to and as constituted within this discursive field of conflicting strands and voices which speak to and past one another, of competing claims and definitions struggling to maintain or to threaten existing relations of power, that the discourse of *l'art féminin* was formulated. And here a distinction must be made between the "feminine art" demanded by the critics, and the utopian dream of a flowering of female culture, of an infusion of French art with the "feminine" spirit, which was formulated by the members of the *Union des femmes peintres et sculpteurs* and came to be known as *l'art féminin.*

Through an examination of the speeches delivered and articles written by Mme Bertaux, her successor Mme Virginie Demont-Breton and their colleagues we can gain an insight into the complex textual field into which the activities of the *Union,* and the self-justifying narratives which surrounded it, can be situated. It was the Russian literary critic Mikhail Bakhtin who taught us that any utterance must be perceived as a response to another utterance, that texts are constructed within contexts as dialogues with that which has already been voiced.[59] And the sense that we get from these texts is that they are offered in response both to the dominant claims of the culture

and to those who would seek to challenge it. The discourse on women's mission in art, *l'art féminin,* generated by the members of the *Union* can be seen as a response to current debates within the art world, as a riposte to the prevailing notion that a professional woman was a desexed woman, as a rejoinder to the radical demands of feminists that women fight publicly for their political rights, as a refusal to accept women's alleged intellectual incapacities and as an answer to critics who demanded that women infuse their art with all their "femininity."

That Mme Bertaux had a utopian dream is already evident from her early claims for the *Union.* She had never seen it as a facilitating institution alone, but had always regarded it as a force through which women's intrinsic powers for the Good could be channeled in the name of the redemption of an ailing and threatened French Culture. As she put it in a speech to a group of women on the founding of the *Union* in 1881: "Est-ce un rêve, mesdames, est-ce une utopie de croire que notre rôle est immense dans l'avenir de l'Etat?"[60] For Mme Bertaux this role involved fighting the forces of corruption which would lead art, following in the steps of literature, to a "mauvaise époque, une époque de décadence," in which its true goals would be forgotten. In her words, art's primitive goal was to

charm the heart through the sight of beautiful forms and at the same time to develop the most noble feelings by the representation of heroic or tender actions.[61]

In order for women to be seen as the redeemers of French culture some of the assumptions about their capacities would have to be turned on their heads. To take the example of the gendering of the genres, it had always been maintained that if women were to excel in art, it would have, by necessity, to be in the lesser genres—in still life, genre painting and perhaps portraiture.[62] In the context of the rise of naturalism and realism, these genres, together with landscape, had gained a new authority in the diverse and multifarious artistic field of the Third Republic. But it was not with them that Mme Bertaux and the protagonists of *l'art féminin* were concerned. Mme Bertaux saw

the tendencies of the new schools of painting as profoundly threatening. They represented the passing of the old order identified with the great French cultural tradition. For conservative forces within the art world, their rise to dominance in the period just after France's worst military humiliation and during a period of great political and economic instability, made them come to represent much that was ailing about modern France. They could, as we have seen, be emblematic of national degeneration. Among the leadership of the *Union,* as among the die-hard Academics who still administered the Prix de Rome and on whose principles the curriculum of the Ecole des Beaux-Arts continued to be based, it was feared that the growth of "naturalism" and "realism" would lead to the destruction of the nobility of the French tradition which, in their view, had always been based on a reverence for the Ideal, associated with Purity and Truth. Too strong an adherence to naturalism would lead to a sacrifice of the rational and imaginative elements of "style," "taste" and "sentiment," all of which were essential for a "high aesthetic concern."[63] As an anonymous *sociétaire* put it in 1892,

We are living in an epoch of doubt which has thrown its shadow over the artistic and literary ideals of all nations. At such a time, stronger and more believing in our art, let us take a grip of ourselves in the face of all these new sects: decadents, "intransigeants," incoherents, independents, etc. but let us nevertheless thank them for having taught us what we must avoid.[64]

"To be of one's time," argued this *sociétaire,* could also mean to reflect its prejudices, to be a slave to fashion, to drift with the current rather than to elevate it. To be truly "of one's time" was to know what to preserve, and to work toward progress through the cherishing of valuable customs and traditions. Women's natural conservatism, it was felt, could be called upon to lead the way in the preservation and revalorization of time-honored values. It was this which was at the heart of the *Union*'s project. In keeping with such views, writing about art, both contemporary and of the past, published in the *Journal des femmes artistes* broadly reflected the most conservative

elements of late nineteenth-century French criticism. The furious debate, for example, which raged over the Caillebotte donation of Impressionist and naturalist paintings to the State, was recorded in the journal, with support given to artists like Gérôme, who issued a vehement attack against the bequest. For Gérôme the acceptance by the State of paintings by the likes of Manet and Pissarro was evidence of great moral decline. In his words it meant "anarchie," "décadence" and ultimately "la fin de la Nation, de la France."[65]

Although anxiety about the "new tendencies" was widespread, there were not many critics in the general press who argued that the threat to Academic standards and priorities posed by avant-garde tendencies and the popularity of a form of "genre naturalism" at the Salons could be assuaged by the collective efforts of women artists.[66] But it was to women that the members of the *Union* and their supporters ascribed the salvation of French culture. In the words of Mme Bertaux, ". . . il n'est pas peut-être téméraire de supposer que l'idéal féminin rendra à l'art ce que le monde lui demandait à son origine."[67] Women's capacity for sentiment, their imaginations and aspirations toward the Ideal were produced as the corrective to the cry "il faut être de son temps," characterized as mere opportunism, passing fashion, ignorance.

But if the redemption of French culture was to be achieved by "women who remained women," who "were themselves," "who remained true to their natures," to use the rhetoric of the women themselves, it had to be achieved without upsetting the sanctity of the discourse of the separate spheres, which divided sexual roles in terms of the public arena of masculinity and the private, or domestic, domain of femininity. So the *sociétaires* of the *Union* had to answer in their rhetoric to the claims that professionalization would take women from their domestic duties, would necessitate their entry into the public domain, would result in the neglect of their maternal responsibilities and the destruction of the natural order. Art had to be produced within this discourse as compatible with women's domain without thereby becoming trivialized. One of the ways in which this was done was

to challenge the terms of feminist rhetoric by reinvesting traditional social roles with value, insisting on the compatibility of art with women's nature and function within society and indeed on proclaiming this as necessary if women artists were to fulfil their roles as people and artists. As Mme Bertaux put it in one speech to the members of the *Union*,

You see, mesdames, our domain does not have restrictions. Let us be great artists; we would still remain within our roles in a manner perfectly in accord with the laws which nature, society and the family impose on us. The cult of art leaves us within our sphere; it is men who make the laws and, when necessary, fight wars to defend them; public life belongs to them; it is they who defend it. In the certainty of being in our rightful places, let us enrol all our living strength, our beautiful passions in the divine cult of art. We will find there bread, sometimes fortune, and, according to our destinies, joys and consolations. Woman will gain from it and the whole of society with her.[68]

Mme Bertaux sought to turn the "separate spheres" argument to her own advantage by accepting its validity but changing its parameters. Art is seen to belong legitimately to the sphere of Woman, the conserver, both socially—that is, in the preservation of family and traditional structures—and artistically, in the promotion of traditional skills and subjects.

It was in the name of women's mission that the institutional campaigns of the *Union* were conducted. Responding to current fears that professionalization would take women away from their traditional roles, they argued that women had been impeded from living out their true womanly destinies by educational disadvantage. If women had not fulfilled their mission, it was because they had never been given the opportunity to develop their skills. At the time that the struggle for women's entry into the Ecole des Beaux-Arts became most concentrated, so a rhetoric evolved which sought to fight the campaign within the terms of the dominant order. It was as women who wished to remain women that the *sociétaires* canvassed support. In a speech delivered in 1891 Mme Bertaux appealed to them in these terms:

Let us remain women . . . in society, in the family, showing that one can be an artist and even a great artist without ceasing to fulfil the duties which are our glory and our honour.[69]

There were those *sociétaires* who prided themselves on being able to reconcile the task of being artists with fulfilling all the socially inscribed tasks of womanhood. In the pages of the *Journal des femmes artistes*, individual women were regularly praised for being great artists without abdicating their domestic responsibilities. The development of women's intellectual capacities, for which the *Union* campaigned so tirelessly, was defended in terms of what it could contribute to domestic harmony and thereby to society as a whole. According to Virginie Demont-Breton, the development of women's faculties, far from turning them from their duties, would serve to complete their unions with their husbands through the exchange of ideas. It was not for women's happiness alone that they wished to participate in progress, but in order to be worthy confidantes for their husbands, and to ensure the future of their children:

The development of our faculties, far from turning us from our duties, would only strengthen and complete our union with man through the exchange of ideas; it is not therefore only for our happiness that we want our part of progress, it is more for the happiness of he who, whilst remaining our protector, must be able to confide in us all his thoughts and aspirations; it is for the future of our children of whom we are the first guides and whom we must be able, at the same time, to direct well in life. It is to enrich the fatherland as much as to aid the development of the forces which we feel inside ourselves and which for so long have been neglected. . . .[70]

What was at stake was the health of the Nation and women were biologically determined and psychologically equipped to preserve it. They did so in society through their charitable works and philanthropic endeavors. Given the means, they would do so in art through their "feminine" sensibility and natural caution.

How the discourse of *l'art féminin* fits into broader discursive structures is, by now, apparent.

10. Anna Elizabeth Klumpke, *Portrait of Rosa Bonheur*, 1898. New York, Metropolitan Museum of Art.

How it affected the works produced by the *sociétaires* of the *Union* is more difficult to assess. Certainly the exhibitions were not full-blown paeans to the "grand style" as the rhetoric would have us assume. As has already been claimed, a variety of styles was evident at the exhibitions, even if "extreme" avant-gardist tendencies were not represented. There were some idealized subject pictures on show which were much praised, but for the most part, rather than serving as the determining aesthetic of the majority of works at the exhibitions, the discourse of *l'art féminin* seems to have remained a fantasy based on a projected future time when society would allow for the flowering of feminine sensibilities and skills. For this to happen, according to the members of the *Union*, women would need to have access to the State's ancient institutions, to be eligible to benefit from a close study of the "old masters" at the State's expense, to be trained in the disciplines of figure painting and to be educated in history and the classics.

But the elaboration of the discourse does allow us to view the works in a new light. In terms of the rhetoric of *l'art féminin* we would not look in the traditional places for the marks of femininity in the exhibitions, that is, in the decoration of fans, the proliferation of flower painting, the celebration of womanly subjects, in delicate brushwork or gentle coloration, although all these may certainly have been present.

L'Art féminin was a grander vision, a vision,

embodied for the members of the *Union* in some of the ambitious works of a figure like Rosa Bonheur, presented in a portrait by her devoted companion Anna Klumpke at her easel, clad in military jacket, wearing her Legion of Honor medal, and imbued with an impressive dignity and presence [10]. The painting that Bonheur is executing in the portrait is no conventional "womanly" subject. It is large, impressive and imposing. It signifies power—that of the horses, but that, too, of the artist herself and of the national tradition of which she was a part. For the artists of the *Union des femmes peintres et sculpteurs,* this was no deviation from woman's true destiny. This was work truly worthy of a woman's strength and a woman's mission.

For the members of the *Union* such strength was embodied in the work of the highly acclaimed Virginie Demont-Breton, daughter of Jules Breton, successor as president of the *Union* to Mme Bertaux, tireless campaigner for the advancement of the woman artist and fierce defender of traditional aesthetic values in art. The second woman painter in France to be awarded the Legion of Honor, Mme Demont-Breton was widely recognized as an important artist by her contemporaries. Already in 1889, when she was thirty, a biographer in the *Moniteur des arts* recommended that she (together with Mme Léon Bertaux) be awarded the Legion of Honor, which was given to her in 1894.[71] For critics, both during her lifetime and afterward, Mme Demont-Breton represented the woman artist who had best managed to reconcile her professional life as an artist with that of being a wife and mother. They dwelled on her apparently happy marriage to Adrien Demont, the painter, on her relationship to her daughters and the way in which she framed her campaigns for women artists in terms of women's traditional social roles.[72]

Mme Demont-Breton was a revered member of the *Union,* imprinting it with her own personality after she was elected with an almost unanimous vote as its president in 1894. Committed to making the *Salon des femmes* a showcase for the best of women's art, she directed the *Union* away from the more inclusive membership policy, based on ideas of solidarity and mutual support, which had been the hallmark of Mme Bertaux's presidency.[73] For Mme Demont-Breton the function of the *Union* was to attract the best works from women who were seriously committed to the promotion of *l'art féminin.* In her own representations of powerful women, of family groups and of religious subjects, executed in terms of the conventions of academic painting with its smooth surfaces, illusionistic devices and overtly self-conscious compositional arrangements, she herself was seen by her colleagues to be defending all that should be cherished in the national tradition.

For some of those who were anxious about the state of contemporary culture and mortality, therefore, it was fitting to promote the interest of the professional woman artist, at least of the type that identified with the ideas circulated by the members of the *Union des femmes peintres et sculpteurs.* For these women it was French Art that was at risk and it was "feminine art" that could save it. For members of conservative circles in the Paris art world who took women seriously at all, and who, like the editors of *La Famille,* regarded themselves as the guardians of traditional moral values, the idea of *l'art féminin* would not have posed a threat. Indeed, in the face of the demands of "extremist" feminists on the one hand, and avant-garde artists on the other, the efforts of professional women artists like those who joined the *Union des femmes peintres et sculpteurs,* could be welcomed. Traditionalists could endorse their campaigns, secure in the knowledge that these women, at least, would neither place their "heritage" at risk nor seek to destroy time-honored social relationships.

NOTES

Notes to this essay have been abridged by permission of the author. For the full notes, see Art History *12, no. 1 (March 1989): 57–65.*

1. See, for example, A. Higonnet, " 'Secluded Vision,' Images of Feminine Experience in Nineteenth-Century Europe," *Radical History Review*, no. 38, 1987, pp. 16–36; R. Parker, *The Subversive Stitch*, London, 1984, pp. 147–88.

2. In an editorial of 1888, the aims of *L'Art français* are spelled out: ". . . de vulgariser (dans le sens le plus noble du mot) les travaux les plus remarquables de nos maîtres contemporains," "A nos lecteurs," *L'Art français*, no. 53, 28 April 1888, p. 1. For a summary of the activities of the *Union des femmes peintres et sculpteurs*, see C. Yeldham, *Women Artists in Nineteenth-Century France and England*, New York and London, 1984, vol. 1, pp. 98–105. For a contextual analysis of the formation of the *Union* see T. Garb, "Revising the Revisionists; Writing in a Space for the *Union des femmes peintres et sculpteurs*," *The Art Journal* (Spring/Summer 1989).

3. In 1890, for example, they repeatedly featured reproductions of works shown at the *Salon des femmes*, as the annual exhibition of the *Union des femmes peintres et sculpteurs* came to be called. See, for example, the issues of 8 March 1890, no. 150, 15 March 1890, no. 151, and 22 March 1890, no. 152, in which full-page illustrations are devoted to works shown at the women's exhibitions. Exhibitions were covered extensively throughout the 1890s. In 1896, *L'Art français* devoted a whole issue of the journal to the *Salon des femmes*, with pages of illustrations and accompanying critical comments. See *L'Art français*, 4th year, no. 459, 8 February 1896.

4. See, for example, B. de Beauchamp, "Les Carrières féminines," *La Famille*, no. 498, 21 April 1889, p. 246.

5. For discussions of the feminine press in late nineteenth-century France see P.F.S. Langlois, *The Feminine Press in England and France, 1875–1900*, Ph.D. dissertation, University of Massachusetts, 1979; D. Flamant-Paparatti, *Bien-pensantes, cocodettes et bas-bleus; la femme bourgeoise à travers la press féminine et familiale, 1873–1887*, Paris, 1984; L. Dzeh Djen, *La Press féministe en France de 1869 à 1914*, Paris, 1939.

6. By the mid-1880s the *Gazette des femmes* had changed from being an earnest cultural journal for serious women to becoming a typical fashion/recipe magazine, complete with cut-out patterns, fashion plates and household hints.

7. For accounts of late nineteenth-century French feminism see P. Bidelman, *The Feminist Movement in France: The Formative Years 1858–1889*, Ph.D. dissertation,

Michigan, 1975; M.J. Boxer, *Socialism Faces Feminism in France, 1879–1913*, Ph.D. dissertation, University of California, 1975; S.C. Hause and A.R. Kenney, *Women's Suffrage and Social Politics in the French Third Republic*, New Jersey, 1984; R.J. Evans, *The Feminists, Women's Emancipation Movements in Europe, America and Australasia, 1840–1920*, London, 1977; C. Goldberg Moses, *French Feminism in the Nineteenth Century*, Albany, 1984; J. Rabaut, *Histoire des féminismes françaises*, Paris, 1978; M. Albistur, D. Armogathe, *Histoire du féminisme français*, Paris, 1977.

8. *La Famille* also published reviews of the exhibitions of the *Union des femmes peintres et sculpteurs*. See, for example, the comments made by the reviewer of the 1890 exhibition, *La Famille*, no. 545, 16 March 1890, p. 167.

9. Despite the widely held view that sculpture was inappropriate to "feminine" skills and propensities, there were a number of nineteenth-century women like Sarah Bernhardt, Marcello, "la duchesse de Colonna de Castiglione," and Mme Léon Bertaux who chose to become sculptors. Mme Bertaux's biographer, E. Lepage, stressed the difficulties for women in becoming sculptors and outlined the qualities they needed to succeed in this profession: *Une Conquête féministe; Mme Léon Bertaux*, Paris, 1911, p. 24.

10. Contemporary accounts abound endorsing the suitability for women of accomplishment art or work in the "lesser genres." For a representative example of the construction of art for the "bourgeoise" see the comments made by Berthe Morisot's teacher Guichard to her mother: "Considering the character of your daughters, . . . my teaching will not endow them with minor drawing room accomplishments; they will become painters. Do you realise what this means? In the upper-class milieu to which you belong, this will be revolutionary, I might almost say catastrophic." D. Rouart, *The Correspondence of Berthe Morisot*, newly edited and introduced by K. Adler and T. Garb, London, 1986, p. 19. For a typical nineteenth-century account of appropriate art activities for women in the nineteenth century, see L. Lagrange, "Du rang des femmes dans les arts," *Gazette des beaux-arts*, vol. 8, 1860, pp. 30–43. Many of these attitudes are summed up in E. Muntz's comments: ". . . les femmes, fidèles à leurs instincts, s'attachent de préférence aux genres faciles, exigeant de l'élégance plutôt que de l'énergie et de l'invention: l'aquarelle, la miniature, la peinture sur porcelaine etc. . . ." *Chronique des arts*, no. 22, 31 May 1873, p. 215.

11. The first *Salon des femmes* was held in February 1882 at the salle Vivienne. For an account of this event, see E. Lepage, ibid., pp. 64–65.

12. For a discussion on the changes within the Paris art world in the context of Republican policy see M.R. Levin,

Republican Art and Ideology in Late Nineteenth-Century France, Ann Arbor, Michigan, 1986. After 1881, State involvement in the Salons was focused on acquisitions. For a detailed discussion of the withdrawal of State control over the Salon in the context of an exhaustive analysis of the relationship of painting to the State, see P. Vaisse, *La Troisième République et les peintres; recherches sur les rapports des pouvoirs publics et de la peinture en France de 1870 à 1914*, Paris-Sorbonne, 1980, pp. 258–346. In 1889, the Salon itself was split when a group of artists led by Meissonier broke away to form their own organization, the *Société nationale des beaux-arts*. See A. Boime, *The Academy and French Painting in the Nineteenth Century* (orig. publ. 1971, refs. here to 1986 ed., New Haven and London), p. 17.

13. See P. Vaisse, op. cit., pp. 282–86.

14. See A. Boime, op. cit., pp. 18–20. As Vaisse has shown, the Salon after 1881 could not be seen to represent either "official" or "academic" tastes, words which are often confused in the literature. See P. Vaisse, op. cit., pp. 169–257.

15. Such views were often expressed in *L'Art français* during the 1890s.

16. For a discussion of Delaborde's position within aesthetic debates of the late nineteenth century, see P. Vaisse, op. cit., p. 186.

17. It was partly the feeling that France's supremacy was threatened by outside forces (industrial competition, Germany's proven military superiority) which induced such a virulent defence of the notion of "Frenchness" in the later years of the nineteenth and beginning of the twentieth centuries. Notions of racial superiority were manifested in extreme xenophobic anxiety, centering at home on the growth of organized anti-Semitism and providing justification for France's consolidation of its Empire abroad. For accounts of the rise of the French right in the fin-de-siècle period see R. Magraw, *France 1815–1914, The Bourgeois Century*, London, 1983, pp. 260–84; W.C. Buthman, *The Rise of Integral Nationalism in France*, New York, 1939; H. Tint, *The Decline of French Patriotism, 1870–1964*, London, 1964. Philosophical respectability for such theories was drawn from the environmental determinism of thinkers like Taine. Theorists from Alfred Fouillée, in his *Psychologie du peuple français*, Paris, 1898, to popularizers like Gustave Le Bon, in many articles published in philosophical and scientific journals, gave pseudo-scientific legitimation to theories of the historic racial and sexual supremacy of the white French male. See, for example, G. Le Bon, "La Psychologie des femmes et les effets de leur éducation actuelle," *Revue scientifique*, vol. 46, no. 15, 11 October 1890, pp. 449–60.

18. For an account of degeneration theory see R. Nye, *Crime, Madness and Politics in Modern France: The Med-* ical Concept of National Decline, New Jersey, 1984.

19. A contemporary critic claimed that every mother would want a reproduction of the Gardner painting in which the baby resembled "un petit saint Jean Baptiste." As he put it, "Tout ce qu'elle peint est du domaine de la femme et elle a mille fois raison de rester sur ce terrain." F. Bournand, "Mlle. E. Gardner," *Paris—Salon*, vol. 1 (no pagination). For a discussion of the imagery of the "modern madonna" in late nineteenth-century France, especially in relation to the work of Mary Cassatt, see N. Mowll Mathews, *Mary Cassatt and the "Modern Madonna" of the Nineteenth Century*, Ph.D. dissertation, New York University, 1980.

20. That the Gardner image was much admired is indicated by the fact that one artist, Mlle Augusta Beaumont, exhibited a porcelain copy of it at the 1889 "Salon des femmes." See catalogue for the 8th exhibition of the *Union des femmes peintres et sculpteurs*, 1889, no. 41.

21. Une Sociétaire, "Causerie," *Journal des femmes artistes*, no. 23, 12 February 1892, p. 1.

The *Journal des femmes artistes* was the official publication of the *Union*. It first appeared on 1 December 1890 and, for its first few years, offered comprehensive coverage of the activities of the *Union*.

22. See, for example, Camille Mauclair's assertion, made in 1896, that Impressionism was dead: "il a vécu de son sensualisme, et il en meurt." While denigrating "Impressionism" at large, Mauclair called it a "feminine art," with its legitimate protagonist as Berthe Morisot: "Il a été, cet impressionnisme chatoyant, cet art si féminin qu'une femme admirable, Mme Berthe Morisot, pourrait par son oeuvre seule en résumer l'effort. . . ." See C. Mauclair, "Les Salons de 1896," *La Nouvelle Revue*, vol. 100, May–June 1896, pp. 342–43. Mauclair was only one of a number of critics who thought that Impressionism was best suited to a woman's temperament. For a brief discussion of this see the introduction to Rouart, *The Correspondence of Berthe Morisot*, pp. 6–8, and K. Adler and T. Garb, *Berthe Morisot*, London, 1987, pp. 57–65. See also G. Pollock and R. Parker, *Old Mistresses, Women, Art and Ideology*, London 1981, pp. 41–44.

23. Such constructions of femininity were consistent with ideas being promulgated in medical and the new psychological discourses. See D. L. Silverman, *Nature, Nobility, and Neurology: The Ideological Origins of "Art Nouveau" in France, 1889–1900*, Ph.D. dissertation, Princeton University, 1983, p. 155. For an example of an influential construction of "femininity" in terms of the new psychological theories, see A. Fouillée, *Woman: A Scientific Study and Defence*, trans. Rev. T.A. Seed, London, 1900, which is extracted from Fouillée's *Tempérament et caractère selon les individus, les sexes et les races*, Paris, 1895.

24. For a brief contextual discussion of the women associated with Impressionism, see T. Garb, *Women Impressionists,* London, 1986. For biographical accounts of selected late nineteenth-century French women artists, see C. Yeldham, op. cit., pp. 337–79. For discussions of Marie Bashkirtseff's position within late nineteenth-century art, see R. Parker and G. Pollock's new introduction to *The Journal of Marie Bashkirtseff,* London, 1985, pp. vii–xxx, and T. Garb, " 'Unpicking the Seams of her Disguise'; Self-Representation in the Case of Marie Bashkirtseff," *Block* 13, Winter 1987/88, pp. 79–86.

25. For an articulation of such feelings, see the inauguration speech made by Mme Léon Bertaux at a gathering of women to mark the founding of the *Union des femmes peintres et sculpteurs.* Reprinted in E. Lepage, op. cit., pp. 47–51.

26. For a biography of Mme Bertaux, see E. Lepage, op. cit.

27. See the catalogues for the exhibitions, which were published annually. Art journals like the *Courrier de l'art,* the *Journal des artistes* and the *Moniteur des arts* published agendas of forthcoming meetings, financial reports, accounts of the annual general meetings and lists of committee members.

28. A critic for the *Journal des artistes* summed up, albeit in a somewhat ironic tone, the pressures on women to confine their work to the private sphere, and praised the *Union*'s recognition of women's need of a forum for public display. See the comments of P. Dupray, "Les Salons," *Journal des artistes,* 14th year, no. 11, 17 March 1895, p. 966.

29. For a discussion of the debates which Mme Bertaux's promotion of "grand art" provoked at one of the meetings of the *Union* see *Journal des artistes,* no. 50, 15 December 1889, p. 395.

30. One critic declared that, in the midst of this "débordement de peinture," journalists did not know where to turn their heads. De Thauriès, "L'Exposition du Cercle des arts libéraux," *Bulletin hebdomadaire de l'Artiste,* no. 2, 19 March 1882.

31. For a discussion on the predominance of Proudhonian theories in the French left and its effect on their attitude toward feminism, see M. Jacoby Boxer, *Socialism Faces Feminism in France, 1879–1913,* Ph.D. dissertation, University of California, 1975, and C. Sowerwine, *Sisters or Citizens? Women and Socialism in France since 1876,* Cambridge, England, 1982. Some notice of the shows did come from socialist feminists like the Guesdist Aline Valette, whose journal, *L'Harmonie sociale,* covered the shows. See, for example, the issues of 31 December 1892, no. 12, p. 1; 25 February 1893, no. 20, p. 2 and 25 March 1893, no. 24, p. 1.

32. As socialists became more interested in establishing themselves via existing political channels in the 1890s and campaigning for votes, they did not want to be associated in the public mind with something as unpopular as feminism. Women artists were, for the most part, drawn from the bourgeoisie, although the *Union des femmes peintres et sculpteurs* encouraged participation of women from all social classes and offered scholarships to poorer women. The fact that private art education was very expensive, and therefore not open to working women who needed to develop marketable skills in order to support themselves, was used as an argument for the opening up of State art schools to women. The failure of the French left, with the notable exception of socialist *députés* like René Viviani, to take on the woman question in any sustained way has been attributed to the dominance of the Proudhonian faction within socialist groups and workers' organizations in France, and the failure of the majority of the French left to take on board the potentially radical ideas of Engels and Marx. The lack of willingness of socialists to take on women's issues was challenged by feminists like Hubertine Auclert. See, for example, H. Auclert, "Lutte de classes, lutte de sexes," *La Citoyenne,* no. 96, March 1885, p. 1. For a discussion of the relationship between bourgeois feminism and socialism in the 1890s, see M. Jacoby Boxer, op. cit., pp. 182–221. Publications like the socialist feminist *L'Harmonie sociale* did try to bridge this gap and participated in such campaigns as the struggle for women's entry into the Ecole des Beaux-Arts.

33. For a well-known medical and psychological text which put forward such views, see H. Campbell, *Differences in the Nervous Organization of Men and Women,* London, 1891, which is widely quoted in French texts. Such ideas are contested and debated in J. Lourbet, *Le Problème des sexes,* Paris, 1900. The debate over women's mental and psychic formation and their consequent social roles is discussed in many popular scientific journals. See, for example, G. Richard's review of Lourbet's earlier *La Femme devant la science contemporaine,* Paris, 1896, published in the *Revue philosophique,* vol. 43, 1897, pp. 434–35. In this review Richard claims that, in his defense of women's intellectual capacities, Lourbet does not take sufficient account of the "law of regression," that is, the way that pregnancy and menstruation in women have their consequences in inevitable mental regression. See also H. Thulié, *La Femme, essai de sociologie psychologique,* Paris, 1885 for a typical view.

34. C. Bonheur, "Art: la huitième exposition de l'Union des femmes peintres et sculpteurs," *La Chronique moderne,* no. 5, March 1889, p. 25.

35. Wolff wrote: "Les femmes ont raison de se coaliser de la sorte, car on les sacrifie vraiment trop dans les Salons organisés par les hommes." In A. Wolff, "Peinture et peintres," *Le Figaro,* 16 February 1883, p. 1.

36. Louise Koppe, "La Femme et M. Albert Wolff," *La Femme dans la famille et dans la société*, no. 22, p. 2. Michelet idealized women's alleged physical and mental frailty, believing that it was up to men to be women's guide, teacher, protector and worshiper. See his *Woman*, originally published in 1860 as *La Femme*, quoted in S. Groag Bell and K. M. Offen, *Women, the Family and Freedom*, vol. 1, pp. 341–42.

37. See, for example, the response of many artists to the survey conducted by *L'Art français* on the entry of women to the Ecole des Beaux-Arts. The majority were against women's admission. H.G., "Les Femmes artistes," *L'Art français*, no. 316, 13 May 1893, p. 34.

38. G. Dargenty, "Chronique des expositions," *Courrier de l'art*, no. 9, 1 March 1883, p. 102.

39. See J. Riviere, "Womanliness as Masquerade" (1929) and S. Heath, "Joan Riviere and the Masquerade," in V. Burgin, J. Donald and C. Kaplan (eds.), *Formations of Fantasy*, London 1986, pp. 35–44 and 45–61.

40. A speech delivered by Mme Demont-Breton at the annual fête of the *Union* on 16 May 1898, published in *Journal des femmes artistes*, no. 77, p. 2.

41. For a summary of popular assumptions about male and female mental and emotional capacities based on "scientific" claims, see H. de Varigny, "Femme," *La Grande Encyclopédie*, vol. 17, pp. 143–48. For an assertion of women's innate imitativeness, see C. Turgeon, *Le Féminisme français*, Paris, 1907, pp. 169 and 180.

42. E. Cardon, "Causerie," *Moniteur des arts*, 1 March 1889, no. 1819, p. 65. The teachers whose influence he "notices" are Chaplin, Bonnat, Henner, Lefebvre, Bouguereau and Rivoire.

43. Trans. "We would have preferred to see less talent and more originality." J. Chanteloze, "L'Art féminin," *La Revue féministe*, 1896, p. 151.

44. Quoted in J. Lourbet, *Le Probléme des sexes*, Paris, 1900, p. 44. Here, de Varigny's claim is placed in the context of conflicting views on women's emotional capacities. Although controversy over women's allegedly greater *sensibilité* did exist in the scientific and philosophical community, it was widely regarded to be true that women were more sensitive and capable of greater feeling than men. For a summary of some of the contemporary arguments, see ibid., pp. 43–56.

45. See the entry for *sentiment, La Grande Encyclopédie*, vol. 29, p. 1013.

46. For a typical argument on the above lines, see views of the popular and widely quoted Republican philosopher Alfred Fouillée in *Woman: A Scientific Study and Defence*, trans. Rev. T.A. Seed, London, 1900.

47. For a discussion of Maria Deraismes's views on women's moral superiority see Jean Rabaut, *Féministes à la belle-époque*, Paris, 1985, p. 39. For a representative

defense of women's moral superiority, see C. Turgeon, op. cit., p. 331. Few thinkers followed Proudhon's assertion that women were morally inferior beings. For an elaboration of his ideas on the physical, intellectual and moral inferiority of women, see P. J. Proudhon, *De la justice dans la révolution et dans l'église*, 1858, in *Oeuvres complètes de P. J. Proudhon*, new ed., C. Bouglé and H. Moysset (eds.), Paris, 1935.

48. Trans. "The degeneration like the amelioration of races always begins with the feminine sex." Quoted in R. Bellet, "La Femme dans l'idéologie du Grand Dictionnaire universel de Pierre Larousse," in *La Femme au XIXe siècle; littérature et idéologie*, Lyons, 1979, p. 23.

49. A. Comte, "Social Statistics; or, Theory of the Spontaneous order of Human Society" (1839). Quoted in S. Groag Bell, K.M. Offen, op. cit., p. 221.

50. Trans. ". . . a heart from which is born a tenderness for the beautiful, a soul which perceives the eternal grandeur of nature . . . like a lyre in the breathing of passing beauties." Toast delivered by Roger Ballu, reprinted in the *Journal des femmes artistes*, no. 40, June 1893, p. 3.

51. While Berthe Morisot's so-called intuitive handling of paint, her lack of finish, sketchy handling and alleged attachment to the rendering of surface appearance alone was attributed to a suitably unmediated expression of her "femininity," as indicated above, Mary Cassatt's interest in pictorial construction, her linearity, and her skilled draftsmanship were used as evidence of her reneging on her "feminine" nature. As one critic in a general essay on women and art put it, "L'esthétique masculine est une esthétique de forme, l'esthétique féminine est une esthétique de mouvement." C. Dissard, "Essai d'esthétique féminine," *La Revue féministe*, vol. 1, 1895, p. 41.

52. See D. Ashton, *Rosa Bonheur*, London, 1981, p. 57.

53. It is the tendency to see all strong women artists as "men in disguise" which is commented upon by Olivier Marthini in "Nos Sculpteurs en robe de chambre," *Moniteur des arts*, no. 1970, 14 August 1891, p. 734.

54. See the *Journal des femmes artistes*, March 1896, no. 62, p. 1. The editor wrote of Bonheur's acceptance of this role that it placed the *Union* "sous le patronage de la plus illustre des femmes peintres de notre époque. . . ." In the following year Bonheur donated 1000ff for *sociétaires* who might be in financial difficulties. See *Journal des femmes artistes*, no. 68, February 1897, p. 1. Her death was reported in the journal with the words "Elle a été la gloire féminine en notre siècle et en notre pays"; see *Journal des femmes artistes*, no. 86, January 1900, p. 1.

55. V. Demont-Breton, "Rosa Bonheur," *La Revue des revues*, 15 June 1899, pp. 604–19.

56. For a discussion of what she calls the "sexual indifference that underlies the truth of any science, the logic of every discourse," see L. Irigaray, "The Power of Dis-

course and the Subordination of the Feminine," in *This Sex Which Is Not One*, New York, 1985, pp. 68–85.

57. Feminism was, in some quarters, thought to be a force which would be detrimental to the "racial" quality of future Frenchmen. See C. Turgeon, op. cit., p. 315. For one feminist response to current "depopulation" rhetoric, see M. Martin, "Dépopulation," *Le Journal des femmes*, no. 54, June 1896, p. 1.

58. See, for example, J. Gerbaud, "Le Groupe de la solidarité des femmes," *Journal des femmes artistes*, no. 17, October 1891, p. 3.

59. M. Bakhtin, "Discourse in the Novel," printed in M. Holquist (ed.), *The Dialogic Imagination*, Austin, 1981, p. 280.

60. Trans. "Is it a dream, mesdames, is it a Utopia to believe that our role is immense in the future of the State?" E. Lepage, op. cit., p. 48.

61. E. Lepage, ibid., p. 48.

62. For an assertion of women's innate suitability for the lesser genres, see L. Lagrange, op. cit., p. 42.

63. See an article by B. Prost, written for *L'Art français* but reprinted and endorsed in the *Journal des femmes artistes*, September 1893, p. 4.

64. *Journal des femmes artistes*, no. 23, 12 February 1892, p. 1.

65. These remarks were made in response to a survey conducted by the *Journal des artistes*, 8 April 1894, reprinted in *Journal des femmes artistes*, no. 48, May 1894, p. 4.

66. The move away from naturalism can be situated within a broader rejection of science and positivist forms of explanation which characterized the 1890s. See H.W. Paul, "The Debate over the Bankruptcy of Science in 1895," *French Historical Studies*, vol. 5, no. 3, 1968, pp. 299–327.

67. Trans. "it would not perhaps be rash to suppose that the feminine ideal will give back to art what the world has demanded of it from its origin." From a toast given by Mme Léon Berteaux at the tenth anniversary celebrations of the *Union*. Reprinted in the *Journal des femmes artistes*, no. 13, June 1891, p. 3.

68. Reprinted in E. Lepage, op. cit., p. 50.

69. Printed in *Journal des femmes artistes*, no. 13, 1 June 1891, p. 3.

70. From a speech delivered at a banquet of the *Union*, published in the *Journal des femmes artistes*, no. 57, June 1895, p. 1.

71. See the *Moniteur des arts*, 26 July 1889, p. 270. The award was announced in *Le Figaro*, 1 August 1894. See this, together with other articles, in the Dossier Virginie Demont-Breton, Bibliothèque Marguerite Durand, Paris.

72. See, for example, an article in *L'Europe artiste*, 12 August 1899, which asserts that, despite her great combative energy and her feminist campaigning, she could never be seen as a "frondeuse masculinisée." In Dossier Demont-Breton, Bibliothèque Marguerite Durand, Paris.

73. See her letter of acceptance of election as president, reprinted in the *Journal des femmes artistes*, no. 51, December 1894, pp. 1–2.

1. Berthe Morisot, *The Wet Nurse and Julie,* 1879. Washington, D.C., private collection.

13

MORISOT'S *WET NURSE*

The Construction of Work and Leisure in Impressionist Painting

LINDA NOCHLIN

Tant de clairs tableaux irisés, ici, exacts, primesautiers. . . .
—Stéphane Mallarmé[1]

Berthe Morisot's *Wet Nurse and Julie* [1] of 1879 is an extraordinary painting.[2] Even in the context of an oeuvre in which formal daring is relatively unexceptional, this work is outstanding. "All that is solid melts into air"—Karl Marx's memorable phrase, made under rather different circumstances, could have been designed for the purpose of encapsulating Morisot's painting in a nutshell.[3] Nothing is left of the conventions of pictorial construction: figure versus background, solid form versus atmosphere, detailed description versus sketchy suggestion, the usual complexities of composition or narration. All are abandoned for a composition almost disconcerting in its three-part simplicity; a facture so open, so dazzlingly unfettered as to constitute a challenge to readability; and a colorism so daring, so synoptic in its rejection of traditional strategies of modeling as to be almost Fauve before the fact.[4]

Morisot's *Wet Nurse* is equally innovative in its subject matter. For this is not the old motif of the Madonna and Child, updated and secularized, as

it is in a work like Renoir's *Aline Nursing* or in many of the mother-and-child paintings by the other prominent woman member of the Impressionist group, Mary Cassatt. It is, surprisingly enough, a work scene. The "mother" in the scene is not a real mother but a so-called *seconde mère*, or wet nurse, and she is feeding the child not out of "natural" nurturing instinct but for wages, as a member of a flourishing industry.[5] And the artist painting her, whose gaze defines her, whose active brush articulates her form, is not, as is usually the case, a man, but a woman, the woman whose child is being nursed. Certainly, this painting embodies one of the most unusual circumstances in the history of art—perhaps a unique one: a woman painting another woman nursing her baby. Or, to put it another way, introducing what is not seen but what is known into what is visible, two working women confront each other here, across the body of "their" child and the boundaries of class, both with claims to motherhood and mothering, both, one assumes, engaged in pleasurable activity which, at the same time, may be considered production in the literal sense of the word. What might be considered a mere use value if the painting was produced by a mere amateur, the milk produced for the nourishment of one's own child,

From Linda Nochlin, *Women, Art, and Power and Other Essays* (New York: Harper & Row, Publishers, 1988), pp. 37–56. Copyright © 1988 by Linda Nochlin. Reprinted by permission of the author and HarperCollins.

is now to be understood as an exchange value. In both cases—the milk, the painting—a product is being produced or created for a market, for profit.

Once we know this, when we look at the picture again we may find that the openness, the disembodiment, the reduction of the figures of nurser and nursling almost to caricature, to synoptic adumbration, may be the signs of erasure, of tension, of the conscious or unconscious occlusion of a painful and disturbing reality as well as the signs of daring and pleasure—or perhaps these signs, under the circumstances, may be identical, inseparable from each other. One might say that this representation of the classical topos of the maternal body poignantly inscribes Morisot's conflicted identity as devoted mother and as professional artist, two roles which, in nineteenth-century discourse, were defined as mutually exclusive. *The Wet Nurse*, then, turns out to be much more complicated than it seemed to be at first, and its stimulating ambiguities may have as much to do with the contradictions involved in contemporary mythologies of work and leisure, and the way that ideologies of gender intersect with these paired

notions, as they do with Morisot's personal feelings and attitudes.

Reading *The Wet Nurse* as a work scene inevitably leads me to locate it within the representation of the thematics of work in nineteenth-century painting, particularly that of the woman worker. It also raises the issue of the status of work as a motif in Impressionist painting—its presence or absence as a viable theme for the group of artists which counted Morisot as an active member. And I will also want to examine the particular profession of wet-nursing itself as it relates to the subject of Morisot's canvas.

How was work positioned in the advanced art of the later nineteenth century, at the time when Morisot painted this picture? Generally in the art of this period, work, as Robert Herbert has noted,[6] was represented by the rural laborer, usually the male peasant engaged in productive labor on the farm. This iconography reflected a certain statistical truth, since most of the working population of France at the time was, in fact, engaged in farm work. Although representations of the male farm worker predominated, this is not to say

2. Giovanni Segantini, *The Two Mothers*, detail, 1868. Milan, Galleria d'Arte Moderna.

that the female rural laborer was absent from French painting of the second half of the nineteenth century. Millet often represented peasant women at work at domestic tasks like spinning or churning, and Jules Breton specialized in scenes of idealized peasant women working in the fields. But it is nevertheless significant that in the quintessential representation of the labor of the female peasant, Millet's *Gleaners,* women are represented engaged not in productive labor—that is, working for profit, for the market—but rather for sheer personal survival—that is, for the nurturance of themselves and their children, picking up what is left over after the productive labor of the harvest is finished.[7] The *glaneuses* are thus assimilated to the realm of the natural—rather like animals that forage to feed themselves and their young—rather than to that of the social, to the realm of productive labor. This assimilation of the peasant woman to the position of the natural and the nurturant is made startlingly clear in a painting like Giovanni Segantini's *Two Mothers* [2], which makes a visual analogy between cow and woman as instinctive nurturers of their young.

Work occupies an ambiguous position in the representational systems of Impressionism, the movement to which Morisot was irrevocably connected; or one might say that acknowledgment of the presence of work themes in Impressionism has until recently been repressed in favor of discourses stressing the movement's "engagement with themes of urban leisure."[8] Meyer Schapiro, above all, in two important articles of the 1930s, laid down the basic notion of Impressionism as a representation of middle-class leisure, sociability, and recreation depicted from the viewpoint of the enlightened, sensually alert middle-class consumer.[9] One could contravene this contention by pointing to a body of Impressionist works that do, in fact, continue the tradition of representing rural labor initiated in the previous generation by Courbet and Millet and popularized in more sentimental form by Breton and Bastien-Lepage. Pissarro, particularly, continued to develop the motif of the peasant, particularly the laboring or resting peasant woman, and that of the market woman in both Impressionist and Neo-Impressionist vocabularies,

right down through the 1880s. Berthe Morisot herself turned to the theme of rural labor several times: once in *The Haymaker,* a beautiful preparatory drawing for a larger decorative composition; again, in a little painting, *In the Wheat Field,* of 1875; and still another time (more ambiguously, because the rural "workers" in question, far from being peasants, are her daughter, Julie, and her niece Jeanne picking cherries) in *The Cherry Tree* of 1891–92.[10] Certainly, one could point to a significant body of Impressionist work representing urban or suburban labor. Degas did a whole series of ironers;[11] Caillebotte depicted floor scrapers and house painters; and Morisot herself turned at least twice to the theme of the laundress: once in *Laundresses Hanging Out the Wash* [3] of 1875, a lyrical canvas of commercial laundresses plying their trade in the environs of the city, painted with a synoptic lightness that seems to belie the laboriousness of the theme; and another time in *Woman Hanging the Washing* [4], of 1881, a close-up view where the rectangularity of the linens seems wittily to reiterate the shape and texture of the canvas, the laundress to suggest the work of the woman artist herself. Clearly, then, the Impressionists by no means totally avoided the representation of work.

To speak more generally, however, interpreting Impressionism as a movement constituted primarily by the representation of leisure has to do as much with a particular characterization of labor as with the iconography of the Impressionist movement. In the ideological constructions of the French Third Republic, as I have already pointed out, work was epitomized by the notion of rural labor, in the time-honored, physically demanding, naturally ordained tasks of peasants on the land. The equally demanding physical effort of ballet dancing, represented by Degas, with its hours of practice, its strains, its endless repetition and sweat, was constructed as something else, something different: as art or entertainment. Of course this construction has something to do with the way entertainment represents itself: often the whole point of the work of dancing is to make it look as though it is not work, that it is spontaneous and easy.

3. Berthe Morisot,
*Laundresses Hanging Out the
Wash*, 1875. Washington,
D.C., National Gallery,
Mellon Collection.

But there is a still more interesting general point to be made about Impressionism and its reputed affinity with themes of leisure and pleasure. It is the tendency to conflate *woman's* work—whether it be her work in the service or entertainment industries or, above all, her work in the home—with the notion of leisure itself. As a result, our notion of the iconography of work, framed as it is by the stereotype of the peasant in the fields or the weaver at his loom, tends to exclude such subjects as the barmaid or the beer server from the category of the work scene and position them instead as representations of leisure. One might even say, looking at such paintings as Manet's *Bar at the Folies-Bergère* or his *Beer Server* from the vantage point of the new women's history, that middle- and upper-class men's leisure is sustained and enlivened by the labor of women: entertainment and service workers like those represented by Manet.[12] It is also clear that these representations position women workers—barmaid or beer server—in such a way that they seem to be there to be looked at—visually consumed, as it were—by a male viewer. In the *Beer Server* of

1878, for example, the busy waitress looks out alertly at the clientele, while the relaxed male in the foreground—ironically a worker himself, identifiable by his blue smock—stares placidly at the woman performer, half visible, doing her act on the stage. The work of café waitresses or performers, like those represented by Degas in his pastels of café concerts, is often connected to their sexuality or, more specifically, the sex industry of the time, whether marginally or centrally, full time or part time. What women, specifically lower-class women, had to sell in the city was mainly their bodies. A comparison of Manet's *Ball at the Opera*—denominated by the German critic Julius Meier-Graefe as a *Fleischebörse,* or flesh market—with Degas's *Cotton Market in New Orleans* makes it clear that work, rather than being an objective or logical category, is an evaluative or even a moral one. Men's leisure is produced and maintained by women's work, disguised to look like pleasure. The concept of work under the French Third Republic was constructed in terms of what that society or its leaders stipulated as good, productive activity, generally conceived of

4. Berthe Morisot,
*Woman Hanging the
Washing*, 1881.
Copenhagen, Ny
Carlsberg Glyptotek.

as wage-earning or capital production. Women's selling of their bodies for wages did not fall under the moral rubric of work; it was constructed as something else: as vice or recreation. Prostitutes (ironically, referred to colloquially as "working girls" today), a subject often represented by Degas, like the businessmen represented in his *Members of the Stock Exchange,* are of course engaging in a type of commercial activity. But nobody has ever thought to call the prints from Degas's monotype series of brothel representations "work scenes," despite the fact that prostitutes, like wet nurses and barmaids and laundresses, were an important part of the work force of the great modern city in the nineteenth century, and in Paris, at this time, a highly regulated, government-supervised form of labor.[13]

If prostitution was excluded from the realm of honest work because it involved women selling their bodies, motherhood and the domestic labor of child care were excluded from the realm of work precisely because they were unpaid. Woman's nurturing role was seen as part of her natural function, not as labor. The wet nurse [5],

then, is something of an anomaly in the nineteenth-century scheme of feminine labor. She is like the prostitute in that she sells her body, or its product, for profit and her client's satisfaction; but, unlike the prostitute, she sells her body for a virtuous cause. She is at once a mother—*seconde mère, remplaçant*—and an employee. She is performing one of woman's "natural" functions, but she is performing it as work, for pay, in a way that is eminently not natural but overtly social in its construction.

To understand Morisot's *Wet Nurse and Julie,* one has to locate the profession of wet-nursing within the context of nineteenth-century social and cultural history. Wet-nursing constituted a large-scale industry in France in the eighteenth and nineteenth centuries. In the nineteenth century, members of the urban artisan and shopkeeping classes usually sent their children out to be nursed by women in the country so that wives would be free to work. So large was the *industrie nourricière* and so patent the violations of sanitation, so high the mortality rate and so unsteady the financial arrangements involved that the gov-

5. Anonymous photograph, wet nurses in a public park about 1900.

ernment stepped in to regulate the industry in 1874 with the so-called Loi Roussel, which supervised wet nurses and their clients on a nationwide basis.[14] Members of the aristocracy or upper bourgeoisie such as Berthe Morisot, however, did not have to resort to this "regulated" industry. They usually hired a *nourrice sur lieu,* or live-in wet nurse, who accompanied the infant, took it to the park, and comforted it—but was there mainly to provide the baby with nourishment.[15] The omnipresence of the wet nurse in the more fashionable purlieus of Parisian society is indicated in Degas's *Carriage at the Races* [6], where the Valpinçons, husband and wife, are accompanied by their dog, by their son and heir, Henri, and by the veritable star of the piece, the wet nurse, depicted in the act of feeding the baby.[16] A foreign painter like the Finnish Albert Edelfelt, when depicting the charms of Parisian upper-class life, quite naturally included the wet nurse in his *Luxembourg Gardens,* a painting of 1887 now in the Antell Collection in Helsinki; and Georges Seurat incorporated the figure, severely geometrized, into the cross section of French society he represented in *A Sunday on the Island of La Grande-Jatte.*

The wet nurse was, on the one hand, considered the most "spoiled" servant in the house and, at the same time, the most closely watched and supervised. She was in some ways considered more like a highly prized milch cow than a human being. Although she was relatively highly paid for her services, often bringing home 1,200 to 1,800 francs per campaign—her salary ranked just under that of the cordon bleu chef[17]—and was often presented with clothing and other valuable gifts, her diet, though plentiful and choice, was carefully monitored and her sex life was brought to a halt; and of course, she had to leave her own baby at home in the care of her own mother or another family member.[18]

The wet nurse was always a country woman, and generally from a specific region of the country: the Morvan, for instance, was considered prime wet-nurse territory.[19] Wet-nursing was the way poor country women with few valuable skills could make a relatively large sum of money: selling their services to well-off urban families. The analogy with today's surrogate mothers makes itself felt immediately, except that the wet nurse was not really the subject of any moral discourse about exploitation; on the contrary: although some doctors and child-care specialists complained about the fact that natural mothers refused to take nature's way and breast-feed their children them-

selves, in general they preferred a healthy wet nurse to a nervous new mother. Few upper-class women in the later nineteenth century would have dreamed of breast-feeding their own children; and only a limited proportion of women of the artisan class, who had to work themselves or who lived in crowded quarters, had the chance to do so. If Renoir proudly represented his wife nursing their son Jean, it was not because it was so "natural" for her to do so, but perhaps because, on the contrary, it was not. Renoir's wife, in any case, was not of the same social class as Berthe Morisot; she was of working-class origin. Berthe Morisot, then, was being perfectly "natural" within the perimeters of her class in hiring a wet nurse. It would not be considered neglectful and certainly would not have to be excused by the fact that she was a serious professional painter: it was simply what people of her social station did.

The wet nurse, in various aspects of her career, was frequently represented in popular visual culture, and her image appeared often in the press or in genre paintings dealing with the typical trades or professions of the capital. A forgotten painter of the later nineteenth century, José de Frappa, in his *Bureau de Nourrice* [7] depicted the medical examination of potential wet nurses in an employment bureau. Husband, mother-in-law, and doctor evidently participated in the choice of a candidate. Wet-nursing was frequently the subject of humorous caricatures right down to the beginning of the twentieth century, when sterilization and pasteurization enabled mothers to substitute the newly hygienic bottle for the human breast—and thereby gave rise to cartoons dealing with the wet nurse attempting to compete with her replacement.[20] With her ruffled, beribboned cap and jacket or cape, she was frequently depicted in illustrations of fashionable parks, where she aired her charges, or in those of upper-class households. Her characteristic form could even serve to illustrate the letter *N*—for *nourrice*—in a children's alphabet. Degas, like Seurat, was evidently struck by the typical back view of this familiar figure and sketched it in one of his notebooks.

Morisot is not, of course, in her paintings of her

6. Edgar Degas, *Carriage at the Races,* 1869. Boston, Museum of Fine Arts.

7. José de Frappa, *Bureau de Nourrice.*

daughter and her wet nurse[21] creating a sociological document of a particular kind of work or even a genre scene of some engaging incident involved in wet-nursing. Both Julie and her wet nurse serve as motifs in highly original Impressionist paintings, and their specificity as documents of social practice is hardly of conscious interest to the creator of the paintings, who is intent on creating an equivalent for her perceptions through visual qualities of color, brushwork, light, shape—or the deconstruction of shape—and atmosphere. Nor do we think of Morisot as primarily a painter of work scenes; she was, indeed, one of those artists of the later nineteenth century—like Whistler and Manet, among others—who helped construct a specific iconography of leisure, figured by young and attractive women, whose role was simply to be there, for the painter, as a languid and self-absorbed object of aesthetic contemplation—a kind of human still life. Her *Portrait of Mme Marie Hubbard* of 1874 and *Young Girl Reclining* of 1893 are notable examples of this genre. Morisot

is associated, quite naturally, not with work scenes, however ambiguous, but rather with the representation of domestic life, mothers, or, more rarely, fathers—specifically her husband, Eugène Manet—and daughters engaged in recreation [8]. This father-and-daughter motif is, like the theme of the wet nurse, an unusual one in the annals of Impressionist painting, and one with its own kinds of demands. Male Impressionists who, like Morisot, turned to the domestic world around them for subject matter, painted their wives and children as a matter of course. Here is a case where being a woman artist makes an overt difference: Morisot, in turning to her closest relatives, paints a father and child. She depicts her husband and daughter doing something concrete—playing with a boat and sketching or playing with toy houses—and with a vaguely masculine air.

Despite the fact that scenes of leisure, languor, and recreation are prominent in Morisot's oeuvre, there is another way we might think of work in relation to her production. The notion of the work

of painting itself is never disconnected from her art and is perhaps allegorized in various toilette scenes in which women's self-preparation and adornment stand for the art of painting or subtly refer to it.[22] A simultaneous process of looking and creating are prime elements of a woman's toilette as well as picture-making, and sensual pleasure as well as considerable effort is involved in both. One could even go further and assert that in both—maquillage and painting—a private creation is being prepared for public approbation.

Painting was work of the utmost seriousness for Morisot. She was, as the recent exhibition catalogue of her work reveals to us,[23] unsparing of herself, perpetually dissatisfied, often destroying works or groups of works that did not satisfy her high standards. Her mother observed that when-

ever she worked, she had an "anxious, unhappy, almost fierce look," adding, "This existence of hers is like the ordeal of a convict in chains."[24]

There is another sense in which Morisot's oeuvre may be associated with the work of painting: the way in which the paintings reveal the act of working which creates them, are sparkling, invigorating, and totally uneffortful-looking registers of the process of painting itself. In the best of them, color and brushstroke are the deliberately revealed point of the picture: they are, so to speak, works about work, in which the work of looking and registering the process of looking in paint on canvas or pastel on paper assumes an importance almost unparalleled in the annals of painting. One might almost say that the work of painting is not so strongly revealed until the time of the late

8. Berthe Morisot, *Eugène Manet and His Daughter, Julie, in the Garden*, 1883. Private collection.

Monet or even that of Abstract Expressionism, although for the latter, of course, looking and registering were not the issue.[25]

Even when Morisot looked at herself, as in her 1885 *Self-Portrait with Julie,* boldly, on unprimed canvas, or in her pastel *Self-Portrait* [9] of the same year, the work of painting or marking was primary. These are in no sense flattering or even conventionally penetrating self-portraits: they are, especially the pastel version, working records of an appearance, deliberate in their telling asymmetries, their revelation of brushwork or marking, unusual above all for their omissions, their selective recording of a motif that happens to be the author's face. The pastel *Self-Portrait* is almost painfully moving. It is no wonder that critics sometimes found her work too sketchy, unfinished, bold to the point of indecipherability. Referring to two of her pastels, for example, Charles Ephrussi declared: "One step further and it will be

9. Berthe Morisot, *Self-Portrait,* 1885. Art Institute of Chicago.

10. Berthe Morisot, *Girl with a Greyhound (Julie Manet),* 1893. Paris, Musée Marmottan.

impossible to distinguish or understand anything at all."[26]

In her late *Girl with a Greyhound* [10], a portrait of Julie with a dog and an empty chair, painted in 1893, Morisot dissolves the chair into a vision of evanescent lightness: a work of omission, of almost nothingness. Compared with it, Van Gogh's famous *Gauguin's Chair* looks heavy, solid, and a little overwrought. Yet Morisot's chair is moving, too. Its ghostliness and disembodiment remind us that it was painted shortly after her husband's death, perhaps as an emblem of his absent presence within the space of his daughter's portrait. And perhaps for us, who know that she painted this at the end of her life, it may constitute a moving yet self-effacing prophecy of her own impending death, an almost unconscious means of establishing—lightly, only in terms of the work itself—her presence within an image representing, for the last time, her beloved only child.

In insisting on the importance of work, specifically the traces of manual activity, in Morisot's production, I am not suggesting that Morisot's work was the same as the onerous physical labor involved in farm work or the routine mechanical efforts of the factory hand—nor that it was identical with the relatively mindless and constricted duties of the wet nurse. We can, however, see certain connections: in a consideration of both the work of the wet nurse and that of the woman artist the element of gender asserts itself. Most critics both then and now have emphasized Morisot's gender; her femininity was constructed from an essentialist viewpoint as delicacy, instinctiveness, naturalness, playfulness—a construction implying certain natural gendered lacks or failures: lack of depth, of substance, professionalism or leadership, for instance. Why else has Morisot always been considered as somehow a secondary Impressionist, despite her exemplary fidelity to the movement and its aims? Why has her very flouting of the traditional "laws" of painting been seen as a weakness rather than a strength, a failure or lack of knowledge and ability rather than a daring transgression? Why should the disintegration of form characteristic of her best work not be considered

a vital questioning of Impressionism from within, a "making strange" of its more conventional practices? And if we consider that erosion of form to be a complexly mediated inscription of internalized conflict—motherhood versus profession—then surely this should be taken as seriously as the more highly acclaimed psychic dramas of male artists of the period: Van Gogh's struggle with his madness; Cézanne's with a turbulent sexuality; Gauguin's with the countering urgencies of sophistication and primitivism.

I would like to end as I began, with Karl Marx's memorable phrase: "All that is solid melts into air." But now I would like to consider the whole passage, from the *Communist Manifesto*, from which I (and Marshall Berman, author of a book titled by that passage) extracted it. Here is the whole passage: "All fixed, fast-frozen relations, with their train of ancient and venerable prejudices and opinions, are swept away, all new-formed ones become antiquated before they can ossify: All that is solid melts into air, all that is holy is profaned, and men at last are forced to face . . . the real conditions of their lives and their relations with their fellow men."[27]

I am not in any sense suggesting that Morisot was a political or even a social revolutionary—far from it. But I am saying that her strange, fluid, unclassifiable, and contradiction-laden image *Wet Nurse and Julie* inscribes many of those characteristic features of modernism and modernity that Marx is of course referring to in his celebrated passage—above all, modernism's profoundly deconstructive project. Sweeping away "all fixed and frozen relations with their accompanying prejudices and opinions"—this is certainly Morisot's project as well. And in some way too, she is in this picture, being forced to face, at the same time that it is impossible for her fully to face, the real condition of her life and her relations with a fellow woman. Thinking of Marx's words, looking at Morisot's painting, I sense these real conditions hovering on the surface of the canvas, a surface as yet not fully explored, untested but still potentially threatening to "ancient and venerable prejudices and opinions"—about the nature of work, about gender, and about painting itself.

NOTES

1. Preface to the catalogue of the posthumous exhibition of Berthe Morisot's paintings, Durand-Ruel Gallery, Paris, March 5–23, 1896.

2. The painting was exhibited under the title *Nourrice et bébé* (Wet Nurse and Baby) at the Sixth Impressionist Exhibition of 1880. It is also known under the title *La Nourrice Angèle allaitant Julie Manet* (The Wet Nurse Angèle Feeding Julie Manet) and *Nursing*. See the exhibition catalogue *The New Painting: Impressionism, 1874–1886,* Fine Arts Museums of San Francisco and National Gallery of Art, Washington, D.C., 1986, No. 110, p. 366, and Charles F. Stuckey and William P. Scott, *Berthe Morisot: Impressionist,* exhibition catalogue, National Gallery of Art, Washington, D.C.; Kimball Art Museum, Fort Worth, Texas; Mount Holyoke College Art Museum, 1987–88, Fig. 41, p. 89 and p. 88.

3. Karl Marx's statement may be found in Robert C. Tucker, ed., *The Marx-Engels Reader* (New York: Norton, 1978), p. 476.

4. The critic Gustave Geffroy responded to the *Wet Nurse*'s unique qualities when he reviewed Morisot's work from the Sixth Impressionist Exhibition in *La Justice* of April 21, 1881, by waxing lyrical: "The forms are always vague in Berthe Morisot's paintings, but a strange life animates them. The artist has found the means to fix the play of colors, the quivering between things and the air that envelops them. . . . Pink, pale green, faintly gilded light sings with an inexpressible harmony." Cited in *The New Painting: Impressionism, 1874–1886,* p. 366.

5. Indeed, one might suspect that the unusual sketchiness and rapidity of the brushwork may have had something to do with Morisot's haste to complete her painting within the course of a single nursing session. Nevertheless, she obviously did not consider the painting a mere preparatory study, since she exhibited it in public as a finished work.

6. Robert Herbert, "City vs. Country: The Rural Image in French Painting from Millet to Gauguin," *Artforum* 8 (February 1970): 44–55.

7. See Jean-Claude Chamboredon, "Peintures des rapports sociaux et invention de l'éternel paysan: Les deux manières de Jean-François Millet," *Actes de la recherche et sciences sociales,* Nos. 17–18 (November 1977): 6–28.

8. Thomas Crow, "Modernism and Mass Culture in the Visual Arts," in *Modernism and Modernity: The Vancouver Conference Papers,* ed. Benjamin H. D. Buchloh, Serge Guilbaut, and David Solkin, Nova Scotia, The Nova Scotia College of Art and Design, 1983, p. 226.

9. See Meyer Schapiro, "The Social Bases of Art," in *Proceedings of the First Artists' Congress against War and Fascism,* New York, 1936, pp. 31–37, and "The Nature of Abstract Art," *The Marxist Quarterly* I (January 1937): 77–98, reprinted in Schapiro, *Modern Art: The Nineteenth and Twentieth Centuries* (New York: George Braziller), especially pp. 192–93.

10. For an illustration of *The Haymaker,* see *Berthe Morisot: Impressionist,* colorplate 93, p. 159; for *In the Wheatfield,* Kathleen Adler and Tamar Garb, *Berthe Morisot* (Ithaca, N.Y.: Cornell University Press, 1987), Fig. 89; and *The Cherry Tree, Berthe Morisot: Impressionist,* colorplate 89, p. 153.

11. For a detailed discussion of Degas's ironers and laundresses, see Eunice Lipton, *Looking into Degas: Uneasy Images of Women and Modern Life* (Berkeley: University of California Press, 1986), pp. 116–50.

12. For the role of the barmaid in French nineteenth-century society and iconography, see T. J. Clark, *The Painting of Modern Life: Paris in the Art of Manet and His Followers* (Princeton, N.J.: Princeton University Press, 1984), pp. 205–58, and Novalene Ross, *Manet's "Bar at the Folies-Bergère" and the Myths of Popular Illustration* (Ann Arbor: University of Michigan Press, 1982).

13. For information about government regulation of prostitution, see Alain Corbin, *Les Filles de noce: Misère sexuelle et prostitution aux 19e et 20e siècles* (Paris, 1978); for the representation of prostitution in the art of the later nineteenth century, see Hollis Clayson, *"Avant-Garde* and *Pompier* Images of 19th Century French Prostitution: The Matter of Modernism, Modernity and Social Ideology," in *Modernism and Modernity,* pp. 43–64. Meier-Graefe uses the term "Fleischbörse" in *Édouard Manet* (Munich: Piper Verlag, 1912), p. 216.

14. For the Roussel Law of December 23, 1874, see George D. Sussman, *Selling Mothers' Milk: The Wet-Nursing Business in France: 1715–1914* (Urbana: University of Illinois Press, 1982), pp. 128–29 and 166–67.

15. For an excellent examination of the role of the wet nurse in the nineteenth century, focusing on the *nourrice sur lieu* and including an analysis of the medical discourse surrounding the issue of maternal breast-feeding, see Fanny Faÿ-Sallois, *Les Nourrices à Paris au XIXe siècle* (Paris: Payot, 1980).

16. I am grateful to Paul Tucker for pointing out the presence of the wet nurse in this painting.

17. Faÿ-Sallois, *Les Nourrices à Paris aux XIXe siècle,* p. 201.

18. For the figures of the wages cited, see Sussman, *Selling Mothers' Milk: The Wet-Nursing Business in France: 1715–1914,* p. 155, and for the salary of the live-in wet nurse and her treatment generally, see Faÿ-Sallois, *Les Nourrices à Paris aux XIXe siècle,* pp. 200–39.

19. Sussman, *Selling Mothers' Milk: The Wet-Nursing*

Business in France: 1715–1914, pp. 152–54.

20. See, particularly, the vicious cartoon depicting a wet nurse attempting to boil her breast in emulation of bottle sterilization, published by Faÿ-Sallois, *Les Nourrices à Paris au XIXe siècle,* p. 247. Other interesting cartoons featuring wet-nursing and the practices associated with it appear on pp. 172–73, p. 188, and p. 249 of this work, which is amply illustrated.

21. There are at least two other works by Morisot representing her daughter, Julie, and her wet nurse: an oil painting, *Julie with Her Nurse,* 1880, now in the Ny Carlsberg Glyptotek, Copenhagen, reproduced as Fig. 68 in Adler and Garb, *Berthe Morisot;* and a watercolor entitled *Luncheon in the Country* of 1879, in which the wet nurse and baby are seated at a table with a young boy, probably Morisot's nephew Marcel Gobillard, reproduced as Colorplate 32, p. 77, in Stuckey and Scott, *Berthe Morisot: Impressionist.*

22. See, for example, *Woman at Her Toilette,* ca. 1879, in the Art Institute of Chicago or *Young Woman Powdering Her Face* of 1877, Paris, Musée d'Orsay.

23. Charles Stuckey and William Scott, *Berthe Morisot: Impressionist,* National Gallery of Art, Washington, D.C.; Kimbell Art Museum, Fort Worth, Texas; Mount Holyoke College Art Museum, 1987–88.

24. Stuckey and Scott, *Berthe Morisot: Impressionist,* p. 187.

25. See, for example, Charles Stuckey's assertion that, in the case of *Wet Nurse and Julie,* "it is difficult to think of a comparably active paint surface by any painter before the advent of Abstract Expressionism in the 1950s." *Berthe Morisot: Impressionist,* p. 88.

26. Cited in Stuckey and Scott, *Berthe Morisot: Impressionist,* p. 88.

27. Cited by Marshall Berman in *All That Is Solid Melts into Air: The Experience of Modernity* (New York: Simon & Schuster, 1982), p. 21.

1. Mary Cassatt, *At the Opera*, 1879. Boston, Museum of Fine Arts, The Hayden Collection.

14

MODERNITY AND THE SPACES OF FEMININITY

GRISELDA POLLOCK

*Investment in the look is not as privileged in women as in men. More than other senses,
the eye objectifies and masters. It sets at a distance, and maintains a distance. In our culture the
predominance of the look over smell, taste, touch and hearing has brought about an impoverish-
ment of bodily relations. The moment the look dominates, the body loses its materiality.*

<div align="right">

—Luce Irigaray (1978). Interview in M.-F. Hans and G. Lapouge, eds.,
Les Femmes, la pornographie et l'érotisme (Paris), p. 50.

</div>

Introduction

The schema which decorated the cover of Alfred H. Barr's catalogue for the exhibition *Cubism and Abstract Art* at the Museum of Modern Art, New York, in 1936 is paradigmatic of the way modern art has been mapped by modernist art history [2]. All those canonized as the initiators of modern art are men. Is this because there were no women involved in early modern movements? No.[1] Is it because those who were, were without significance in determining the shape and character of modern art? No. Or is it rather because what modernist art history celebrates is a selective tradition which normalizes, as the *only* modernism, a particular and gendered set of practices? I would argue for this explanation. As a result any attempt to deal with artists in the early history of modernism who are women necessitates a deconstruction of the masculinist myths of modernism.[2]

These are, however, widespread and structure the discourse of many counter-modernists, for instance in the social history of art. The recent pub-

lication *The Painting of Modern Life: Paris in the Art of Manet and His Followers,* by T. J. Clark,[3] offers a searching account of the social relations between the emergence of new protocols and criteria for painting—modernism—and the myths of modernity shaped in and by the new city of Paris remade by capitalism during the Second Empire. Going beyond the commonplaces about a desire to be contemporary in art, "il faut être de son temps,"[4] Clark puzzles at what structured the notions of modernity which became the territory for Manet and his followers. He thus indexes the Impressionist painting practices to a complex set of negotiations of the ambiguous and baffling class formations and class identities which emerged in Parisian society. Modernity is presented as far more than a sense of being "up to date"—modernity is a matter of representations and major myths—of a new Paris for recreation, leisure and pleasure, of nature to be enjoyed at weekends in suburbia, of the prostitute taking over and of fluidity of class in the popular spaces of entertainment. The key markers in this mythic territory are leisure, consumption, the spectacle and money. And we can reconstruct from Clark a map of Impressionist territory which stretches from the new boulevards via Gare St-Lazare out on the suburban train to La Grenouillère, Bougival or

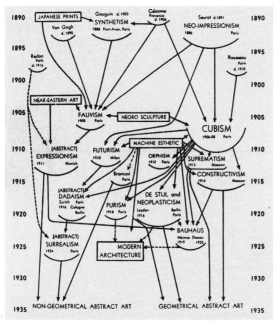

2. Cover design of the catalogue for the exhibition *Cubism and Abstract Art*, 1936, New York, Museum of Modern Art.

Argenteuil. In these sites the artists lived, worked and pictured themselves.[5] But in two of the four chapters of Clark's book, he deals with the problematic of sexuality in bourgeois Paris, and the canonical paintings are *Olympia* (1863, Paris, Musée du Louvre) and *A Bar at the Folies-Bergère* (1881–82, London, Courtauld Institute of Art) [3].

It is a mighty but flawed argument on many

levels, but here I wish to attend to its peculiar closures on the issue of sexuality. For Clark the founding fact is class. Olympia's nakedness inscribes her class and thus debunks the mythic classlessness of sex epitomized in the image of the courtesan.[6] The fashionably blasé barmaid at the Folies evades a fixed identity as either bourgeois or proletarian but nonetheless participates in the play around class that constituted the myth and appeal of the popular.[7]

Although Clark nods in the direction of feminism by acknowledging that these paintings imply a masculine viewer/consumer, the manner in which this is done ensures the normalcy of that position, leaving it below the threshold of historical investigation and theoretical analysis.[8] To recognize the gender-specific conditions of these paintings' existence one need only imagine a female spectator and a female producer of the works. How can a woman relate to the viewing positions proposed by either of these paintings? Can a woman be offered, in order to be denied, imaginary possession of Olympia or the barmaid? Would a woman of Manet's class have a familiarity with either of these spaces and its exchanges which could be evoked so that the painting's modernist job of negation and disruption could be effective? Could Berthe Morisot have gone to such a location to canvass the subject? Would it have entered her head as a site of modernity as she experienced it? Could she as a woman have experienced modernity as Clark defines it at all?*

*While accepting that paintings such as *Olympia* and *A Bar at the Folies-Bergère* come from a tradition which invokes the spectator as masculine, we need to acknowledge the way in which a feminine spectator is actually implied by these paintings. Surely one part of the shock, of the transgression effected by the painting *Olympia* for its first viewers at the Paris Salon was the presence of that "brazen" but cool look from the white woman on a bed attended by a black maid in a space in which women, or to be historically precise, bourgeois ladies, would be presumed to be present. That look, so overtly passing between a seller of woman's body and a client/viewer signified the commercial and sexual exchanges specific to a part of the public realm which should be invisible to ladies. Furthermore its absence from their consciousness structured their identities as ladies. In some of his writings T. J. Clark correctly discusses the meanings of the sign woman in the nineteenth century as oscillating between two poles of the *fille publique* (woman of

the streets) and the *femme honnête* (the respectable married woman). But it would seem that the exhibition of *Olympia* precisely confounds that social and ideological distance between two imaginary poles and forces the one to confront the other in that part of the public realm where ladies do go—still within the frontiers of femininity. The presence of this painting in the Salon—not because it is a nude but because it displaces the mythological costume or anecdote through which prostitution was represented mythically through the courtesan—transgresses the line on my grid derived from Baudelaire's text, introducing not just modernity as a manner of painting a pressing contemporary theme, but the spaces of modernity into a social territory of the bourgeoisie, the Salon, where viewing such an image is quite shocking because of the presence of wives, sisters and daughters. The understanding of the shock depends upon our restoration of the female spectator to her historical and social place.

For it is a striking fact that many of the canonical works held up as the founding monuments of modern art treat precisely with this area, sexuality, and this form of it, commercial exchange. I am thinking of innumerable brothel scenes through to Picasso's *Demoiselles d'Avignon* or that other form, the artist's couch. The encounters pictured and imagined are those between men who have the freedom to take their pleasures in many urban spaces and women from a class subject to them who have to work in those spaces often selling their bodies to clients, or to artists. Undoubtedly these exchanges are structured by relations of class but these are thoroughly captured within gender and its power relations. Neither can be separated or ordered in a hierarchy. They are historical simultaneities and mutually inflecting.

So we must inquire why the territory of modernism so often is a way of dealing with masculine sexuality and its sign, the bodies of women—why the nude, the brothel, the bar? What relation is there between sexuality, modernity and modernism? If it is normal to see paintings of women's bodies as the territory across which men artists claim their modernity and compete for leadership of the avant-garde, can we expect to rediscover paintings by women in which they battled with their sexuality in the representation of the male nude? Of course not; the very suggestion seems ludicrous. But why? Because there is a historical asymmetry—a difference socially, economically, subjectively between being a woman and being a man in Paris in the late nineteenth century. This difference—the product of the social structura-

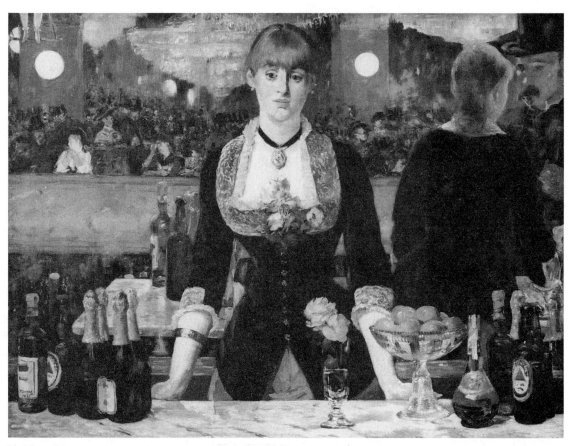

3. Edouard Manet, *A Bar at the Folies-Bergère*, 1881–82. London, Courtauld Institute Galleries, Courtauld Collection.

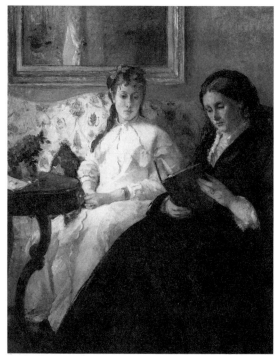

4. Berthe Morisot, *Two Women Reading*, 1869–70. Washington, D.C., National Gallery of Art, Chester Dale Collection.

tion of sexual difference and not any imaginary biological distinction—determined both what and how men and women painted.

I have long been interested in the work of Berthe Morisot (1841–1896) and Mary Cassatt (1844–1926), two of the four women who were actively involved with the Impressionist exhibiting society in Paris in the 1870s and 1880s who were regarded by their contemporaries as important members of the artistic group we now label the Impressionists.[9] But how are we to study the work of artists who are women so that we can discover and account for the specificity of what they produced as individuals while also recognizing that, as women, they worked from different positions and experiences from those of their colleagues who were men?

Sexuality, modernism or modernity cannot function as given categories to which we add women. That only identifies a partial and mascu-

line viewpoint with the norm and confirms women as other and subsidiary. Sexuality, modernism or modernity are organized by and organizations of sexual difference. To perceive women's specificity is to analyze historically a particular configuration of difference.

This is my project here. How do the socially contrived orders of sexual difference structure the lives of Mary Cassatt and Berthe Morisot? How did that structure what they produced? The matrix I shall consider here is that of space.

Space can be grasped in several dimensions. The first refers us to spaces as locations. What spaces are represented in the paintings made by Berthe Morisot and Mary Cassatt? And what are not? A quick list includes:

dining rooms
drawing rooms
bedrooms
balconies/verandas
private gardens (See figs. 4, 5, 7.)

The majority of these have to be recognized as examples of private areas or domestic space. But there are paintings located in the public domain— scenes, for instance, of promenading, driving in the park, being at the theater, boating. They are the spaces of bourgeois recreation, display and those social rituals which constituted polite society, or Society, *Le Monde*. In the case of Mary Cassatt's work, spaces of labor are included, especially those involving child care. In several examples, they make visible aspects of working-class women's labor within the bourgeois home.

I have previously argued that engagement with the Impressionist group was attractive to some women precisely because subjects dealing with domestic social life hitherto relegated as mere genre painting were legitimized as central topics of the painting practices.[10] On closer examination it is much more significant how little of typical Impressionist iconography actually reappears in the works made by artists who are women. They do not represent the territory which their colleagues who were men so freely occupied and made use of in their works—for instance, bars, cafés, backstage

and even those places which Clark has seen as participating in the myth of the popular—such as the bar at the Folies-Bergère or even the Moulin de la Galette. A range of places and subjects was closed to them while open to their male colleagues, who could move freely with men and women in the socially fluid public world of the streets, popular entertainment and commercial or casual sexual exchange.

The second dimension in which the issue of space can be addressed is that of the spatial order within paintings. Playing with spatial structures was one of the defining features of early modernist painting in Paris, be it Manet's witty and calculated play upon flatness or Degas's use of acute angles of vision, varying viewpoints and cryptic framing devices. With their close personal contacts with both artists, Morisot and Cassatt were no doubt party to the conversations out of which these strategies emerged and equally subject to the less conscious social forces which may well have conditioned the predisposition to explore spatial ambiguities and metaphors.[11] Yet although there are examples of their using similar tactics, I would like to suggest that spatial devices in the work of Morisot and Cassatt work to a wholly different effect.

A remarkable feature in the spatial arrangements in paintings by Morisot is the juxtaposition on a single canvas of two spatial systems—or at least of two compartments of space often obviously boundaried by some device such as a balustrade, balcony, veranda or embankment whose presence is underscored by facture. In *The Harbor*

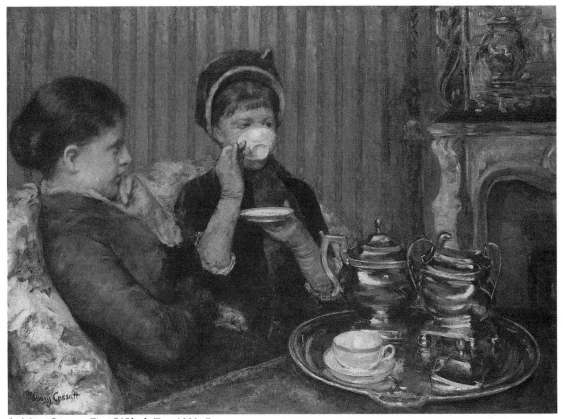

5. Mary Cassatt, *Five O'Clock Tea*, 1880. Boston, Museum of Fine Arts, M. Theresa B. Hopkins Fund.

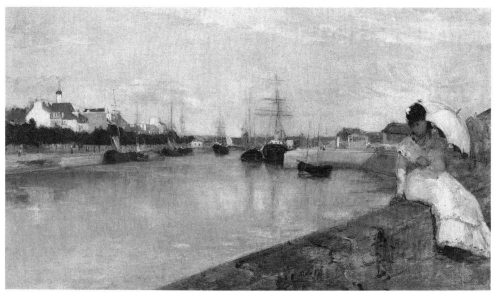

6. Berthe Morisot, *The Harbor at Lorient,* 1869. Washington, D.C.,
National Gallery of Art, Ailsa Mellon Bruce Collection.

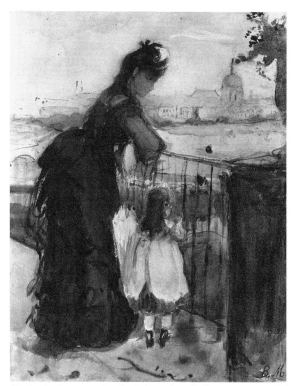

7. Berthe Morisot, *On the Balcony* (overlooking Paris near the
Trocadéro), 1872. Art Institute of Chicago, Gift of
Mrs. Charles Netcher in memory of Charles Netcher II, 1933
(Courtesy of the Art Institute of Chicago).

8. Claude Monet, *The Garden of the Princess, Louvre,*
1867. Oberlin, Ohio, Allen Memorial Art Museum,
Oberlin College, R. T. Miller, Jr., Fund.

at Lorient, 1869 [6], Morisot offers us at the left a landscape view down the estuary represented in traditional perspective while in one corner, shaped by the boundary of the embankment, the main figure is seated at an oblique angle to the view and to the viewer. A comparable composition occurs in *On the Terrace,* 1874, where again the foreground figure is literally squeezed off-center and compressed within a box of space marked by a heavily brushed-in band of dark paint forming the wall of the balcony, on the other side of which lies the outside world of the beach. In *On the Balcony,* 1872 [7] the viewer's gaze over Paris is obstructed by the figures who are nonetheless separated from that Paris as they look over the balustrade from the Trocadéro, very near to Morisot's home.[12] The point can be underlined by contrasting a painting by Monet, *The Garden of the Princess,* 1867 [8], where the viewer cannot readily imagine the point from which the painting has been made, namely a window high in one of the new apartment buildings, and instead enjoys a fantasy of floating over the scene. What Morisot's balustrades demarcate is not the boundary between public and private but between the spaces of masculinity and of femininity inscribed at the level of both what spaces are open to men and women and what relation a man or woman has to that space and its occupants.

In Morisot's paintings, moreover, it is as if the place from which the painter worked is made part of the scene, creating a compression or immediacy in the foreground spaces. This locates the viewer in that same place, establishing a notional relation between the viewer and the woman defining the foreground, therefore forcing the viewer to experience a dislocation between her space and that of a world beyond its frontiers.

Proximity and compression are also characteristic of the works of Cassatt. Less often is there a split space but it occurs, as in *Susan on a Balcony,* 1883. More common is a shallow pictorial space which the painted figure dominates, as in *Young Woman in Black: Portrait of Mrs. Gardner Cassatt,* 1883 [9]. The viewer is forced into a confrontation or conversation with the painted figure while dominance and familiarity are denied by the

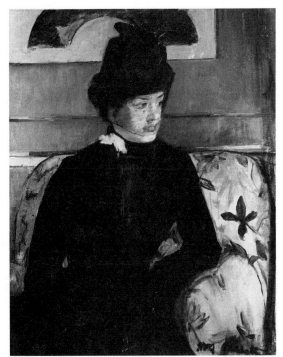

9. Mary Cassatt, *Young Woman in Black: Portrait of Mrs. Gardner Cassatt,* 1883. Baltimore Museum of Art, on loan from the Peabody Institute of the City of Baltimore.

device of the averted head of concentration on an activity by the depicted personage. What are the conditions for this awkward but pointed relation of the figure to the world? Why this lack of conventional distance and the radical disruption of what we take as the normal spectator-text relations? What has disturbed the "logic of the gaze"?

I now want to draw attention in the work of Mary Cassatt to the disarticulation of the conventions of geometric perspective which had normally governed the representation of space in European painting since the fifteenth century. Since its development in the fifteenth century, this mathematically calculated system of projection had aided painters in the representation of a three-dimensional world on a two-dimensional surface by organizing objects in relation to each other to produce a notional and singular position from which the scene is intelligible. It establishes the viewer as both absent from and indeed independent of the scene while being its mastering eye/I.

It is possible to represent space by other conventions. Phenomenology has been usefully applied to the apparent spatial deviations of the work of Van Gogh and Cézanne.[13] Instead of pictorial space functioning as a notional box into which objects are placed in a rational and abstract relationship, space is represented according to the way it is experienced by a combination of touch, texture, as well as sight. Thus objects are patterned according to subjective hierarchies of value for the producer. Phenomenological space is not orchestrated for sight alone but by means of visual cues refers to other sensations and relations of bodies and objects in a lived world. As experiential space this kind of representation becomes susceptible to different ideological, historical, as well as purely contingent, subjective inflections.

These are not necessarily unconscious. For instance, in *Young Girl in a Blue Armchair*, 1878 [10] by Cassatt, the viewpoint from which the room has been painted is low so that the chairs loom large as if imagined from the perspective of a small person placed among massive upholstered obstacles. The background zooms sharply away, indicating a different sense of distance from that a taller adult would enjoy over the objects to an easily accessible back wall. The painting therefore not only pictures a small child in a room but evokes that child's sense of the space of the room. It is from this conception of the possibilities of spatial structure that I can now discern a way through my earlier problem in attempting to relate space and social processes. For a third approach lies in considering not only the spaces represented, or the spaces *of* the representation, but the social spaces from which the representation is made and its reciprocal positionalities. The producer is herself shaped within a spatially orchestrated social structure which is lived at both psychic and social levels. The space of the look at the point of production will to some extent determine the viewing position of the spectator at the point of consumption. This point of view is neither abstract nor exclusively personal, but ideologically and historically construed. It is the art historian's job to re-create it—since it cannot ensure its recognition outside its historical moment.

The spaces of femininity operated not only at the level of what is represented, the drawing room or sewing room. The spaces of femininity are those from which femininity is lived as a positionality in discourse and social practice. They are the product of a lived sense of social locatedness, mobility and visibility, in the social relations of seeing and being seen. Shaped within the sexual politics of looking they demarcate a particular social organization of the gaze, which itself works back to secure a particular social ordering of sexual difference. Femininity is both the condition and the effect.

How does this relate to modernity and modernism? As Janet Wolff has convincingly pointed out, the literature of modernity describes the experience of men.[14] It is essentially a literature about transformations in the public world and its associated consciousness. It is generally agreed that modernity as a nineteenth-century phenomenon is a product of the city. It is a response in a mythic or ideological form to the new complexities of a social existence passed among strangers in an atmosphere of intensified nervous and psychic stimulation, in a world ruled by money and commodity exchange, stressed by competition and formative of an intensified individuality, publicly defended by a blasé mask of indifference but intensely "expressed" in a private, familial context.[15] Modernity stands for a myriad of responses to the vast increase in population leading to the literature of the crowds and masses, a speeding up of the pace of life with its attendant changes in the sense and regulation of time and fostering that very modern phenomenon, fashion, the shift in the character of towns and cities from being centers of quite visible activities—manufacture, trade, exchange—to being zoned and stratified, with production becoming less visible while the centers of cities such as Paris and London become key sites of consumption and display producing what Sennett has labeled the spectacular city.[16]

All these phenomena affected women as well as men, but in different ways. What I have described above takes place within and comes to define the modern forms of the public space changing as Sennett argues in his book significantly titled *The*

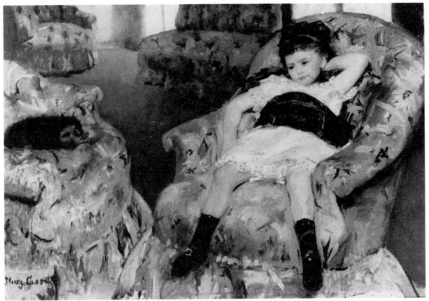

10. Mary Cassatt, *Young Girl in a Blue Armchair*, 1878. Washington, D.C., National Gallery of Art, Collection of Mr. and Mrs. Paul Mellon.

Fall of Public Man from the eighteenth-century formation to become more mystified and threatening but also more exciting and sexualized. One of the key figures to embody the novel forms of public experience of modernity is the flâneur, or impassive stroller, the man in the crowd who goes, in Walter Benjamin's phrase, "botanizing on the asphalt."[17] The flâneur symbolizes the privilege or freedom to move about the public arenas of the city observing but never interacting, consuming the sights through a controlling but rarely acknowledged gaze, directed as much at other people as at the goods for sale. The flâneur embodies the gaze of modernity which is both covetous and erotic.

But the flâneur is an exclusively masculine type which functions within the matrix of bourgeois ideology through which the social spaces of the city were reconstructed by the overlaying of the doctrine of separate spheres on to the division of public and private, which became as a result a gendered division.

As both ideal and social structure, the mapping of the separation of the spheres for women and men on to the division of public and private was

powerfully operative in the construction of a specifically bourgeois way of life. It aided the production of the gendered social identities by which the miscellaneous components of the bourgeoisie were helped to cohere as a class, in difference from both aristocracy and proletariat. Bourgeois women, however, obviously went out in public, to promenade, go shopping, or visiting or simply to be on display. And working-class women went out to work, but that fact presented a problem in terms of definition as woman. For instance, Jules Simon categorically stated that a woman who worked ceased to be a woman.[18] Therefore, across the public realm lay another, less often studied map which secured the definitions of bourgeois womanhood—femininity—in difference from proletarian women.

For bourgeois women, going into town and mingling with crowds of mixed social composition was not only frightening because it became increasingly unfamiliar, but because it was morally dangerous. It has been argued that to maintain one's respectability, closely identified with femininity, meant *not* exposing oneself in public. The public space was officially the realm of and for

men; for women to enter it entailed unforeseen risks. For instance, in *La Femme* (1858–60) Jules Michelet exclaimed,

How many irritations for the single woman! She can hardly ever go out in the evening; she would be taken for a prostitute. There are a thousand places where only men are to be seen, and if she needs to go there on business, the men are amazed, and laugh like fools. For example, should she find herself delayed at the other end of Paris and hungry, she will not dare to enter into a restaurant. She would constitute an event; she would be a spectacle: All eyes would be constantly fixed on her, and she would overhear uncomplimentary and bold conjectures.[19]

The private realm was fashioned for men as a place of refuge from the hurly-burly of business, but it was also a place of constraint. The pressures of intensified individuality protected in public by the blasé mask of indifference, registered in the equally socially induced roles of loving husband and responsible father, led to a desire to escape the overbearing demands of masculine domestic personae. The public domain became also a realm of freedom and irresponsibility if not immorality. This, of course, meant different things for men and for women. For women, the public spaces thus construed were where one risked losing one's virtue, dirtying oneself; going out in public and the idea of disgrace were closely allied. For the man going out in public meant losing oneself in the crowd away from both demands of respectability. Men colluded to protect this freedom. Thus a woman going out to dine at a restaurant even with her husband present was scandalous, whereas a man dining out with a mistress, even in the view of his friends, was granted a fictive invisibility.[20]

The public and private division functioned on many levels. As a metaphorical map in ideology, it structured the very meaning of the terms masculine and feminine within its mythic boundaries. In practice as the ideology of domesticity became hegemonic, it regulated women's and men's behavior in the respective public and private spaces. Presence in either of the domains determined one's social identity and therefore, in objective terms, the separation of the spheres problematized women's relation to the very activities and experiences we typically accept as defining modernity.

In the diaries of the artist Marie Bashkirtseff, who lived and worked in Paris during the same period as Morisot and Cassatt, the following passage reveals some of the restraints:

What I long for is the freedom of going about alone, of coming and going, of sitting in the seats of the Tuileries, and especially in the Luxembourg, of stopping and looking at the artistic shops, of entering churches and museums, of walking about old streets at night; that's what I long for; and that's the freedom without which one cannot become a real artist. Do you imagine that I get much good from what I see, chaperoned as I am, and when, in order to go to the Louvre, I must wait for my carriage, my lady companion, my family?[21]

These territories of the bourgeois city were, however, gendered not only on a male/female polarity. They became the sites for the negotiation of gendered class identities and class gender positions. The spaces of modernity are where class and gender interface in critical ways, in that they are the spaces of sexual exchange. The significant spaces of modernity are neither simply those of masculinity, nor are they those of femininity, which are as much the spaces of modernity for being the negative of the streets and bars. They are, as the canonical works indicate, the marginal or interstitial spaces where the fields of the masculine and feminine intersect and structure sexuality within a classed order.

The Painter of Modern Life

One text above all charts this interaction of class and gender. In 1863 Charles Baudelaire published in *Le Figaro* an essay entitled "The Painter of Modern Life." In this text the figure of the flâneur is modified to become the modern artist while at the same time the text provides a mapping of Paris marking out the sites/sights for the flâneur/artist. The essay is ostensibly about the work of a minor illustrator Constantin Guys, but he is only a pretext for Baudelaire to weave an elaborate and impossible image of his ideal artist, who is a passion-

ate lover of crowds and, incognito, a man of the world.

The crowd is his element as the air is that of birds and water of fishes. His passion and profession are to become one flesh with the crowd. For the perfect flâneur, for the passionate spectator, it is an immense joy to set up house in the heart of the multitude, amid the ebb and flow of movement, in the midst of the fugitive and the infinite. To be away from home and yet feel oneself everywhere at home; to see the world and to be the centre of the world and yet remain hidden from the world—such are a few of the slightest pleasures of those independent, passionate, impartial natures which the tongue can but clumsily define. The spectator is a *prince* and everywhere rejoices in his incognito. The lover of life makes the whole world his family.[22]

The text is structured by an opposition between home, the inside, the domain of the known and constrained personality and the outside, the space of freedom, where there is liberty to look without being watched or even recognized in the act of looking. It is the imagined freedom of the voyeur. In the crowd the flâneur/artist sets up home. Thus the flâneur/artist is articulated across the twin ideological formations of modern bourgeois society—the splitting of private and public with its double freedom for men in the public space, and the preeminence of a detached observing gaze, whose possession and power is never questioned as its basis in the hierarchy of the sexes is never acknowledged. For as Janet Wolff has recently argued, there is no female equivalent of the quintessential masculine figure, the flâneur; there is not and could not be a female flâneuse. (See note 14.)

Women did not enjoy the freedom of incognito in the crowd. They were never positioned as the normal occupants of the public realm. They did not have the right to look, to stare, scrutinize or watch. As the Baudelairean text goes on to show, women do not look. They are positioned as the *object* of the flâneur's gaze.

Woman is for the artist in general . . . far more than just the female of man. Rather she is divinity, a star . . . a glittering conglomeration of all the graces of nature, condensed into a single being; an object of keenest admiration and curiosity that the picture of life

can offer to its contemplator. She is an idol, stupid perhaps, but dazzling and bewitching. . . . Everything that adorns woman that serves to show off her beauty is part of herself. . . .

No doubt woman is sometimes a light, a glance, an invitation to happiness, sometimes she is just a word.[23]

Indeed woman is just a sign, a fiction, a confection of meanings and fantasies. Femininity is not the natural condition of female persons. It is a historically variable ideological construction of meanings for a sign W*O*M*A*N, which is produced by and for another social group, which derives its identity and imagined superiority by manufacturing the specter of this fantastic Other. WOMAN is both an idol and nothing but a word. Thus when we come to read the chapter of Baudelaire's essay titled "Women and Prostitutes," in which the author charts a journey across Paris for the flâneur/artist, where women appear merely to be there as spontaneously visible objects, it is necessary to recognize that the text is itself constructing a notion of WOMAN across a fictive map of urban spaces—the spaces of modernity.

The flâneur/artist starts his journey in the auditorium, where young women of the most fashionable society sit in snowy white in their boxes at the theater. Next he watches elegant families strolling at leisure in the walks of a public garden, wives leaning complacently on the arms of husbands while skinny little girls play at making social class calls in mimicry of their elders. Then he moves on to the lowlier theatrical world, where frail and slender dancers appear in a blaze of limelight admired by fat bourgeois men. At the café door, we meet a swell while indoors is his mistress, called in the text "a fat baggage," who lacks practically nothing to make her a great lady except that practically nothing is practically everything for it is distinction (class). Then we enter the doors of Valentino's, the Prado or Casino, where against a background of hellish light, we encounter the protean image of wanton beauty, the courtesan, "the perfect image of savagery that lurks in the heart of civilization." Finally by degrees of destitution, he charts women, from the patrician airs of young and successful prostitutes to the poor slaves of the filthy stews.

Baudelaire's essay maps a representation of Paris as the city of women. It constructs a sexualized journey which can be correlated with Impressionist practice. Clark has offered one map of Impressionist painting following the trajectories of leisure from city center by suburban railway to the suburbs. I want to propose another dimension of that map, which links Impressionist practice to the erotic territories of modernity. I have drawn up a grid using Baudelaire's categories and mapped the works of Manet, Degas and others onto this schema.[24] From the loge pieces by Renoir (admittedly not women of the highest society) to the *Musique aux Tuileries* of Manet, Monet's park scenes and others easily cover this terrain where bourgeois men and women take their leisure. But then when we move backstage at the theater, we enter different worlds, still of men and women but differently placed by class. Degas's pictures of the dancers on stage and rehearsing are well known. Perhaps less familiar are his scenes illustrating the backstage at the Opéra where members of the Jockey Club bargain for their evening's entertainment with the little performers. Both Degas and Manet represented the women who haunted cafés, and as Theresa Ann Gronberg has shown, these were working-class women often suspected of touting for custom as clandestine prostitutes.[25]

Thence we can find examples sited in the Folies and cafés-concerts as well as the boudoirs of the courtesan. Even if *Olympia* cannot be situated in a recognizable locality, reference was made in the reviews to the café Paul Niquet's, the haunt of the women who serviced the porters of Les Halles and a sign for the reviewer of total degradation and depravity.[26]

Women and the Public Modern

The artists who were women in this cultural group of necessity occupied this map but partially. They can be located all right but in spaces above a decisive line. *Lydia at the Theater*, 1879, and *The Loge*, 1882 [11], situate us in the theater with the young and fashionable but there could hardly be a greater difference between these paintings and the work by Renoir on this theme, *The First Outing*, 1876 (London, National Gallery of Art), for example.

The stiff and formal poses of the two young women in the painting by Cassatt were precisely calculated, as the drawings for the work reveal. Their erect postures, one woman carefully grasp-

GRID I

	Ladies		
theater (loge)	debutantes; young women of fashionable society	RENOIR	CASSATT
park	matrons, mothers, children, elegant families	MANET	CASSATT MORISOT
	Fallen Women		
theater (backstage)	dancers	DEGAS	
cafés	mistresses and kept women	MANET RENOIR DEGAS	
folies	The courtesan: "protean image of wanton beauty"	MANET DEGAS GUYS	
brothels	"poor slaves of filthy stews"	MANET GUYS	

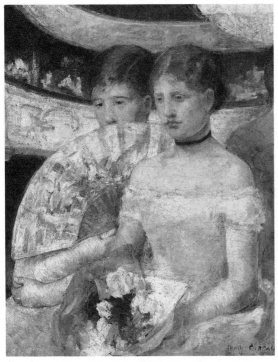

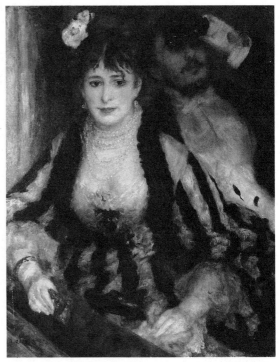

11. Mary Cassatt, *The Loge*, 1882. Washington, D.C., National Gallery of Art, Chester Dale Collection.

12. Auguste Renoir, *The Loge*, 1874. London, Courtauld Institute Galleries, Courtauld Collection.

ing an unwrapped bouquet, the other sheltering behind a large fan, create a telling effect of suppressed excitement and extreme constraint, of unease in this public place, exposed and dressed up, on display. They are set at an oblique angle to the frame so that they are not contained by its edges, not framed and made a pretty picture for us as in *The Loge* [12] by Renoir, where the spectacle at which the scene is set and the spectacle the woman herself is made to offer merge for the unacknowledged but presumed masculine spectator. In Renoir's *The First Outing* the choice of a profile opens out the spectator's gaze into the auditorium and invites her/him to imagine that she/he is sharing in the main figure's excitement while she seems totally unaware of offering such a delightful spectacle. The lack of self-consciousness is, of course, purely contrived so that the viewer can enjoy the sight of the young girl.

The mark of difference between the paintings by Renoir and Cassatt is the refusal in the latter of that complicity in the way the female protagonist is depicted. In a later painting, *At the Opera*, 1879 [1], a woman is represented dressed in daytime or mourning black in a box at the theater. She looks from the spectator into the distance in a direction which cuts across the plane of the picture, but as the viewer follows her gaze another look is revealed steadfastly fixed on the woman in the foreground. The picture thus juxtaposes two looks, giving priority to that of the woman, who is, remarkably, pictured actively looking. She does not return the viewer's gaze, a convention which confirms the viewer's right to look and appraise. Instead we find that the viewer outside the picture is evoked by being as it were the mirror image of the man looking in the picture.

This is, in a sense, the subject of the painting—the problematic of women out in public being vulnerable to a compromising gaze. The witty pun

GRID II

Ladies

		MANET CAILLEBOTTE	MORISOT CASSATT	bedroom
		RENOIR CAILLEBOTTE	MORISOT CASSATT	drawing room
		BAZILLE CAILLEBOTTE	CASSATT MORISOT	veranda
		MONET	CASSATT MORISOT	garden
theater (loge)	debutantes	RENOIR	CASSATT	theater
park	elegant families	MANET	CASSATT MORISOT	park

Fallen Women

theater (backstage)	dancers	DEGAS		
cafés	mistresses and kept women	MANET RENOIR DEGAS		
folies	The courtesan: "protean image of wanton beauty"	MANET DEGAS GUYS		
brothels	"poor slaves of filthy stews"	MANET GUYS		

on the spectator outside the painting being matched by that within should not disguise the serious meaning of the fact that social spaces are policed by men's watching women and the positioning of the spectator outside the painting in relation to the man within it serves to indicate that the spectator participates in that game as well. The fact that the woman is pictured so actively looking, signified above all by the fact that her eyes are masked by opera glasses, prevents her being objectified and she figures as the subject of her own look.

Cassatt and Morisot painted pictures of women in public spaces but these all lie above a certain line on the grid I devised from Baudelaire's text. The other world of women was inaccessible to them while it was freely available to the men of the group and constantly entering representation as the very territory of their engagement with modernity. There is evidence that bourgeois women did go to the cafés-concerts but this is reported as a fact to regret and a symptom of modern decline.[27] As Clark points out, guides for foreigners to Paris such as Murray's clearly wish to prevent such slumming by commenting that respectable people do not visit such venues. In the journals, Marie Bashkirtseff records a visit she and some friends made to a masked ball where behind the disguise daughters of the aristocracy could live dangerously, playing with sexual freedom their classed gender denied them. But given both Bashkirtseff's dubious social position, and her condemnation of the standard morality and regulation of women's sexuality, her escapade merely reconfirms the norm.[28]

To enter such spaces as the masked ball or the café-concert constituted a serious threat to a bourgeois woman's reputation and therefore her femininity. The guarded respectability of the lady could be soiled by mere visual contact, for seeing

was bound up with knowing. This other world of encounter between bourgeois men and women of another class was a no-go area for bourgeois women. It is the place where female sexuality or rather female bodies are bought and sold, where woman becomes both an exchangeable commodity and a seller of flesh, entering the economic domain through her direct exchanges with men. Here the division of the public and private mapped as a separation of the masculine and feminine is ruptured by money, the ruler of the public domain, and precisely what is banished from the home.

Femininity in its class-specific forms is maintained by the polarity virgin/whore which is mystifying representation of the economic exchanges in the patriarchal kinship system. In bourgeois ideologies of femininity the fact of the money and property relations which legally and economically constitute bourgeois marriage is conjured out of sight by the mystification of a one-off purchase of the rights to a body and its products as an effect of love to be sustained by duty and devotion.

Femininity should thus be understood not as a condition of women but as the ideological form of the regulation of female sexuality in a familial, heterosexual domesticity ultimately organized by the law. The spaces of femininity—ideologically, pictorially—hardly articulate female sexualities. That is not to accept nineteenth-century notions of women's asexuality but to stress the difference between what was actually lived or how it was experienced and what was officially spoken or represented as female sexuality.[29]

In the ideological and social spaces of femininity, female sexuality could not be directly registered. This has a crucial effect with regard to the use artists who were women could make of the positionality represented by the gaze of the flâneur—and therefore with regard to modernity. The gaze of the flâneur articulates and produces a masculine sexuality which in the modern sexual economy enjoys the freedom to look, appraise and possess, in deed or in fantasy. Walter Benjamin draws special attention to a poem by Baudelaire, "A Une Passante" (To a Passerby). The poem is written from the point of view of a man who sees in the crowd a beautiful widow; he falls in love as she vanishes from sight. Benjamin's comment is apt: "One may say that the poem deals with the function of the crowd not in the life of a citizen but in the life of an erotic person."[30]

It is not the public realm simply equated with the masculine which defines the flâneur/artist but access to a sexual realm which is marked by those interstitial spaces, the spaces of ambiguity, defined as such not only by the relatively unfixed or fantasizable class boundaries Clark makes so much of but because of cross-class sexual exchange. Women could enter and represent selected locations in the public sphere—those of entertainment and display. But a line demarcates not the end of the public/private divide but the frontier of the spaces of femininity. Below this line lies the realm of the sexualized and commodified bodies of women, where nature is ended, where class, capital and masculine power invade and interlock. It is a line that marks off a class boundary but it reveals where new class formations of the bourgeois world restructured gender relations not only between men and women but between women of different classes.*

*I may have overstated the case that bourgeois women's sexuality could not be articulated within these spaces. In the light of recent feminist study of the psychosexual psychology of motherhood, it would be possible to read mother-child paintings by women in a far more complex way as a site for the articulation of female sexualities. Moreover in paintings by Morisot—for instance, of her adolescent daughter—we may discern the inscription of yet another moment at which female sexuality is referred to by circling around the emergence from latency into an adult sexuality prior to its strict regulation within marital domestic forms. More generally it would be wise to pay heed to the writings of historian Carroll Smith-Rosenberg on the importance of female friendships. She stresses that from our post-Freudian vantage point it is very difficult to read the intimacies of nineteenth-century women, to understand the valencies of the terms of endearment, often very physical, to comprehend the forms of sexuality and love as they were lived, experienced and represented. A great deal more research needs to be done before any statements can be made without the danger of feminists merely rehearsing and confirming the official discourse of masculine ideologues on female sexualities. (C. Smith-Rosenberg, "Hearing Women's Words: A Feminist Reconstruction of History," in her book *Disorderly Conduct: Visions of Gender in Victorian America*, New York, Knopf, 1985.)

Men and Women in the Private Sphere

I have redrawn the Baudelairean map to include those spaces which are absent—the domestic sphere, the drawing room, veranda or balcony, the garden of the summer villa and the bedroom (Grid II). This listing produces a markedly different balance between the artists who are women and men from that on the first grid. Cassatt and Morisot occupy these new spaces to a much greater degree while their colleagues are less apparent, but importantly, not totally absent.

By way of example, we could cite Renoir's portrait *Madame Charpentier and Her Children,* 1878 (New York, Metropolitan Museum of Art), or Bazille's *Family Reunion,* 1867 (Paris, Musée d'Orsay), or the painting of Camille in several poses and different dresses painted by Claude Monet in 1867, *Woman in the Garden* (Paris, Musée d'Orsay).

These paintings share the territory of the feminine but they are painted from a totally different perspective. Renoir entered Madame Charpentier's drawing room on commission; Bazille celebrated a particular, almost formal occasion and Monet's painting was devised as an exercise in open-air painting.[31] The majority of works by Morisot and Cassatt deal with these domestic spaces: for instance, *Two Women Reading,* 1869–70 [4], and *Susan on a Balcony,* 1883 (Washington, D.C., Corcoran Gallery of Art). These are painted with a sureness of knowledge of the daily routine and rituals which not only constituted the spaces of femininity but collectively trace the construction of femininity across the stages of women's lives. As I have argued previously, Cassatt's oeuvre may be seen to delineate femininity as it is induced, acquired and ritualized from youth through motherhood to old age.[32] Morisot used her daughter's life to produce works remarkable for their concern with female subjectivity, especially at critical turning-points of the feminine. For instance, her painting *Psyché* shows an adolescent woman before a mirror, which in France is named a "Psyché" (1876; Lugano, Thyssen-Bornemisza Collection). The classical, mythological figure Psyche was a young mortal

with whom Venus's son Cupid fell in love, and it was the topic of several paintings in the Neoclassical and Romantic period as a topos for awakening sexuality.

Morisot's painting offers the spectator a view into the bedroom of a bourgeois woman and as such is not without voyeuristic potential, but at the same time the pictured woman is not offered for sight so much as caught contemplating herself in a mirror in a way which separates the woman as subject of a contemplative and thoughtful look from woman as object—a contrast may make this clearer; compare it with Manet's painting of a half-dressed woman looking in a mirror in such a way that her ample back is offered to the spectator as merely a body in a working room, *Before the Mirror,* 1876–77 (New York, Solomon R. Guggenheim Museum).

But I must stress that I am in no way suggesting that Cassatt and Morisot are offering us a truth about the spaces of femininity. I am not suggesting that their intimacy with the domestic space enabled them to escape their historical formation as sexed and classed subjects, that they could see it objectively and transcribe it with some kind of personal authenticity. To argue that would presuppose some notion of gendered authorship, that the phenomena I am concerned to define and explicate are a result of the fact that the authors/ artists are women. That would merely tie the women back into some transhistorical notion of the biologically determined gender characteristics, what Rozsika Parker and I labeled in *Old Mistresses* as the feminine stereotype.

Nonetheless the painters of this cultural group were positioned differently with regard to social mobility and the type of looking permitted them according to their being men or women. Instead of considering the paintings as documents of this condition, reflecting or expressing it, I would stress that the practice of painting is itself *a site for the inscription of sexual difference.* Social positionality in terms of both class and gender determine—that is, set the pressure and prescribe the limits of—the work produced. But we are here considering a continuing process. The social, sexual and psychic construction of femininity is con-

stantly produced, regulated, renegotiated. This productivity is involved as much in the practice of making art. In manufacturing a painting, engaging a model, sitting in a room with someone, using a score of known techniques, modifying them, surprising oneself with novel and unexpected effects both technical and in terms of meanings, which result from the way the model is positioned, the size of the room, the nature of the contract, the experience of the scene being painted and so forth—all these actual procedures which make up part of the social practice of making a painting function as the modes by which the social and psychic positionality of Cassatt and Morisot not only structured their pictures, but reciprocally affected the painters themselves as they found, through the making of images, their world represented back to them.

It is here that the critique of authorship is relevant—the critique of the notion of a fully coherent author subject previous to the act of creation, producing a work of art which then becomes merely a mirror or, at best, a vehicle for communicating a fully formed intention and a consciously grasped experience. The death of the author has involved the emphasis on the reader/viewer as the active producer of meaning for texts. But this carries with it an excessive danger of total relativism; any reader can make any meanings. There is a limit, a historical and ideological limit which is secured by accepting the death of the mythic figure of the creator/author but not the negation of the historical producer working within conditions which determine the productivity of the work while never confining its actual or potential field of meanings. This issue becomes acutely relevant for the study of cultural producers who are women. Typically within art history they are denied the status of author/creator (see Barr's chart, fig. 2). Their creative personality is never canonized or celebrated. Moreover they have been the prey of ideological readings where without regard to history and difference, art historians and critics have confidently proclaimed the meanings of the work by women, meanings which always reduce back to merely stating that these are works by women.

How sexual difference is inscribed will be determined by the specificity of the practice and the processes of representation. In this essay I have explored two axes on which these issues can be considered—that of space and that of the look. I have argued that the social process defined by the term modernity was experienced spatially in terms of access to the spectacular city which was open to a class and gender-specific gaze. (This hovers between the still-public figure of the flâneur and the modern condition of voyeur.) In addition, I have pointed to a coincidence between the spaces of modernity and the spaces of masculinity as they intersect in the territory of cross-class sexual exchange. Modifying therefore the simple conceit of a bourgeois world divided by public and private, masculine and feminine, the argument seeks to locate the production of the bourgeois definition of woman defined by the polarity of bourgeois lady and proletarian prostitute/working woman. The spaces of femininity are not only limited in relation to those defining modernity but because of the sexualized map across which woman is separated, the spaces of femininity are defined by a different organization of the look.

Difference, however, does not of necessity involve restriction or lack. That would be to reinscribe the patriarchal construction of woman. The features in the paintings by Mary Cassatt and Berthe Morisot of proximity, intimacy and divided spaces posit a different kind of viewing relation at the point of both production and consumption.

The difference they articulate is bound to the production of femininity as both difference and as specificity. They suggest the particularity of the female spectator—that which is completely negated in the selective tradition we are offered as history.

Women and the Gaze

In an article entitled "Film and the Masquerade: Theorizing the Female Spectator," Mary Ann Doane uses a photograph by Robert Doisneau titled *An Oblique Look*, 1948, to introduce her discussion of the negation of the female gaze [13]

13. Robert Doisneau, *An Oblique Look*, photograph, 1948. London, Victoria and Albert Museum.

in both visual representations and on the streets.[33] In the photograph a petit bourgeois couple stand in front of an art dealer's window and look in. The spectator is hidden voyeur-like inside the shop. The woman looks at a picture and seems about to comment on it to her husband. Unbeknownst to her, he is fact looking elsewhere, at the proffered buttocks of a half-naked female figure in a painting placed obliquely to the surface/photo/window so the spectator can also see what he sees. Doane argues that it is his gaze which defines the problematic of the photograph and it erases that of the woman. She looks at nothing that has any meaning for the spectator. Spatially central, she is negated in the triangulation of looks between the man, the picture of the fetishized woman and the spectator, who is thus enthralled to a masculine viewing position. To get the joke, we must be complicit with his secret discovery of something better to look at. The joke, like all dirty jokes, is at the woman's expense. She is contrasted icono-graphically to the naked woman. She is denied the picturing of her desire; what she looks at is blank for the spectator. She is denied being the object of desire because she is represented as a woman who actively looks rather than returning and confirming the gaze of the masculine spectator. Doane concludes that the photograph almost uncannily delineates the sexual politics of looking.

I have introduced this example to make somewhat plainer what is at stake in considering the female spectator—the very possibility that texts made by women can produce different positions within this sexual politics of looking. Without that possibility, women are both denied a representation of their desire and pleasure and are constantly erased so that to look at and enjoy the sites of patriarchal culture we women must become nominal transvestites. We must assume a masculine position or masochistically enjoy the sight of woman's humiliation. At the beginning of this essay I raised the question of Berthe Morisot's

relation to such modern sights and canonical paintings of the modern as *Olympia* and *A Bar at the Folies-Bergère*, both of which figure within the sexual politics of looking—a politics at the heart of modernist art and modernist art history's version of it. Since the early 1970s, modernism has been critically challenged nowhere more purposely than by feminist cultural practitioners.

In a recent article titled "Desiring Images/ Imaging Desire," Mary Kelly addresses the feminist dilemma wherein the woman who is an artist sees her experience in terms of the feminine position—that is, as object of the look—while she must also account for the feeling she experiences as an artist occupying the masculine position as subject of the look. Different strategies have emerged to negotiate this fundamental contradiction, focusing on ways of either repicturing or refusing the literal figuration of the woman's body. All these attempts center on the problem: "How is a radical, critical and pleasurable positioning of the woman as spectator to be done?"

Kelly concludes her particular pathway through this dilemma (which is too specific to enter into at this moment) with a significant comment:

Until now the woman as spectator has been pinned to the surface of the picture, trapped in a path of light that leads her back to the features of a veiled face. It seems important to acknowledge that the masquerade has always been internalized, linked to a particular organization of the drives, represented through a diversity of aims and objects; but without being lured into looking for a psychic truth beneath the veil. To see this picture critically, the viewer should neither be too close nor too far away.[34]

Kelly's comment echoes the terms of proximity and distance which have been central to this essay. The sexual politics of looking function around a regime which divides into binary positions, activity/passivity, looking/being seen, voyeur/exhibitionist, subject/object. In approaching works by Cassatt and Morisot we can ask: Are they complicit with the dominant regime?[35] Do they natu-

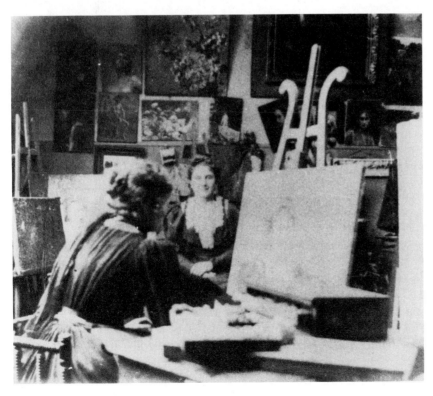

14. Berthe Morisot in her studio, photograph.

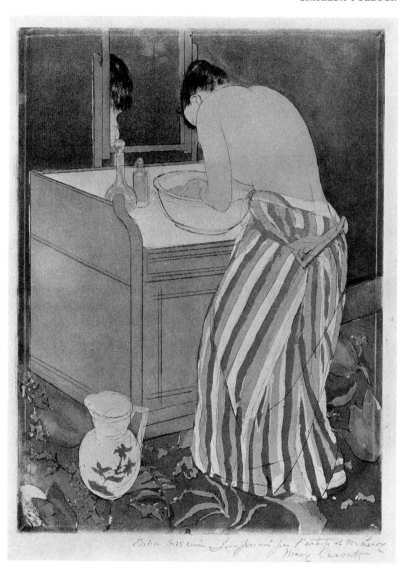

15. Mary Cassatt, *Woman Bathing*, color print with drypoint and aquatint, fifth state, 1891. New York, Metropolitan Museum of Art, Gift of Paul J. Sachs, 1916.

ralize femininity in its major premises? Is femininity confirmed as passivity and masochistic or is there a critical look resulting from a different position from which femininity is appraised, experienced and represented? In these paintings by means of distinctly different treatments of those protocols of painting defined as initiating modernist art—articulation of space, repositioning the viewer, selection of location, facture and brushwork—the private sphere is invested with meanings other than those ideologically produced to

secure it as the site of femininity. One of the major means by which femininity is thus reworked is by the rearticulation of traditional space so that it ceases to function primarily as the space of sight for a mastering gaze, but becomes the locus of relationships. The gaze that is fixed on the represented figure is that of equal and like and this is inscribed into the painting by that particular proximity which I suggested characterized the work. There is little extraneous space to distract the viewer from the intersubjective encounter or to

reduce the figures to objectified staffage, or to make them the objects of a voyeuristic gaze. The eye is not given its solitary freedom. The women depicted function as subjects of their own looking or their activity, within highly specified locations of which the viewer becomes a part.

The rare photograph of Berthe Morisot at work in her studio serves to represent the exchange of looks between women which structure these works [14]. The majority of women painted by Cassatt or Morisot were intimates of the family circle. But that included women from the bourgeoisie and from the proletariat who worked for the household as servants and nannies. It is significant to note that the realities of class cannot be wished away by some mythic ideal of sisterhood among women. The ways in which working-class women were painted by Cassatt, for example, involve the use of class power in that she could ask them to model half-dressed for the scenes of women washing [15]. Nonetheless they were not subject to the voyeuristic gaze of those women washing themselves made by Degas which, as Lipton has argued, can be located in the maisons-closes or official brothels of Paris.[36] The maid's simple washing stand allows a space in which women outside the bourgeoisie can be represented both intimately and as working women without forcing them into the sexualized category of the fallen woman. The body of woman can be pictured as classed but not subject to sexual commodification.

I hope it will by now be clear that the significance of this argument extends beyond issues about Impressionist painting and parity for artists who are women. Modernity is still with us, ever more acutely as our cities become, in the exacerbated world of postmodernity, more and more a place of strangers and spectacle, while women are ever more vulnerable to violent assault while out in public and are denied the right to move around our cities safely. The spaces of femininity still regulate women's lives—from running the gauntlet of intrusive looks by men on the streets to surviving deadly sexual assaults. In rape trials, women on the street are assumed to be "asking for it." The configuration which shaped the work of Cassatt and Morisot still defines our world. It is relevant then to develop feminist analyses of the founding moments of modernity and modernism, to discern its sexualized structures, to discover past resistances and differences, to examine how women producers developed alternative models for negotiating modernity and the spaces of femininity.

NOTES

1. For substantive evidence see Lea Vergine, *L'Autre Moitié de l'avant-garde, 1910–1940,* translated by Mireille Zanuttin (Italian ed. 1980), Paris, Des Femmes, 1982.

2. See Nicole Dubreuil-Blondin, "Modernism and Feminism: Some Paradoxes," in Benjamin H. D. Buchloh (ed.), *Modernism and Modernity,* Halifax, Nova Scotia, Press of Nova Scotia College of Art and Design, 1983. Also Lillian Robinson and Lisa Vogel, "Modernism and History," *New Literary History,* 1971–72, iii (1), 177–99.

3. T. J. Clark, *The Painting of Modern Life: Paris in the Art of Manet and His Followers,* New York, Knopf, and London, Thames & Hudson, 1984.

4. George Boas, "Il faut être de son temps," *Journal of Aesthetics and Art Criticism,* 1940, 1, 52–65; reprinted in *Wingless Pegasus: A Handbook for Critics,* Baltimore, Johns Hopkins University Press, 1950.

5. The itinerary can be fictively reconstructed as follows: a stroll on the *Boulevard des Capucines* (C. Monet, 1873, Kansas City, Nelson Atkins Museum of Art), across the *Pont de l'Europe* (G. Caillebotte, 1876, Geneva, Petit Palais), up to the *Gare St-Lazare* (Monet, 1877, Paris, Musée d'Orsay), to catch a suburban train for the twelve-minute ride out to walk along the *Seine at Argenteuil* (Monet, 1875, San Francisco, Museum of Modern Art) or to stroll and swim at the bathing-place on the Seine, *La Grenouillère* (A. Renoir, 1869, Moscow, Pushkin Museum), or to *Dance at Bougival* (A. Renoir, 1883, Boston, Museum of Fine Arts). I was privileged to read early drafts of Tim Clark's book now titled *The Painting of Modern Life* and it was here that this Impressionist territory was first lucidly mapped as a field of leisure and pleasure on the metropolitan/suburban axis. Another study to undertake this work is Theodore Reff, *Manet and Modern Paris,* Chicago, University of Chicago Press, 1982.

266GRISELDA POLLOCK

6. Clark, op. cit., 146.

7. Ibid., 253.

8. The tendency is the more marked in earlier drafts of material which appears in *The Painting of Modern Life*—e.g., "Preliminaries to a Possible Treatment of *Olympia* in 1865," *Screen*, 1980, 21 (1), especially 33–37, and "Manet's *Bar at the Folies-Bergère*" in Jean Beauroy et al. (eds.), *The Wolf and the Lamb: Popular Culture in France*, Saratoga, Anma Libri, 1977. See also Clark, op. cit., 250–52, and contrast the radical reading of Manet's paintings which results from acknowledging the specificity of the presumed masculine spectator in Eunice Lipton's "Manet and Radicalised Female Imagery," *Artforum*, March 1975, 13 (7), and also Beatrice Farwell, "Manet and the Nude: A Study of the Iconography of the Second Empire," University of California, Los Angeles, Ph.D. dissertation, 1973, published New York, Garland Press, 1981.

9. Tamar Garb, *Women Impressionists*, Oxford, Phaidon Press, 1987. The other two artists involved were Marie Bracquemond and Eva Gonzales.

10. Rozsika Parker and Griselda Pollock, *Old Mistresses: Women, Art and Ideology*, London, Routledge & Kegan Paul, 1981, 38.

11. I refer, for example, to Edouard Manet, *Argenteuil, Les Canotiers*, 1874 (Tournai, Musée des Beaux Arts) and to Edgar Degas, *Mary Cassatt at the Louvre*, 1879–80, etching, third of twenty states (Chicago, Art Institute of Chicago). I am grateful to Nancy Underhill of the University of Queensland for raising this issue with me. See also Clark, op. cit., 165, 239ff., for further discussion of this issue of flatness and its social meanings.

12. See also Berthe Morisot, *View of Paris from the Trocadéro*, 1872 (Santa Barbara, Museum of Art), where two women and a child are placed in a panoramic view of Paris but fenced off in a separate spatial compartment precisely from the urban landscape. Reff, op. cit., 38, reads this division quite (in)differently and finds the figures merely incidental, unwittingly complying with the social segregation upon which the painting's structure comments. It is furthermore interesting to note that both these scenes are painted quite close to the Morisot home in the Rue Franklin.

13. See, for instance, M. Merleau-Ponty, "Cézanne's Doubt," in *Sense and Non-Sense*, translated by Hubert L. Dreyfus and Patricia Allen Dreyfus, Evanston, Illinois, Northwestern University Press, 1961.

14. Janet Wolff, "The Invisible Flâneuse; Women and the Literature of Modernity," *Theory, Culture and Society*, 1985, 2 (3), 37–48.

15. See George Simmel, "The Metropolis and Mental Life," in Richard Sennett (ed.), *Classic Essays in the Culture of the City*, New York, Appleton-Century-Crofts, 1969.

16. Richard Sennett, *The Fall of Public Man*, Cambridge, Cambridge University Press, 1977, 126.

17. Walter Benjamin, *Charles Baudelaire; Lyric Poet in the Era of High Capitalism*, London, New Left Books, 1973, chapter II, "The Flâneur," 36.

18. Jules Simon, op. cit., quoted in MacMillan, op. cit., 37. MacMillan also quotes the novelist Daniel Lesuer, "Le Travail de la femme déclassée," *L'Evolution féminine: ses résultats economiques*, 1900, 5. My understanding of the complex ideological relations between public labor and the insinuation of immorality was much enhanced by Kate Stockwell's contributions to seminars on the topic at the University of Leeds, 1984–85.

19. Jules Michelet, *La Femme*, in *Oeuvres completes* (Vol. XVIII, 1858–60), Paris, Flammarion, 1985, 413. In passing we can note that in a drawing for a print on the theme of omnibus travel Mary Cassatt initially placed a man on the bench beside the woman, child and female companion (ca. 1891, Washington, D.C., National Gallery of Art). In the print itself this masculine figure is erased.

20. Sennett, op. cit., 23.

21. *The Journals of Marie Bashkirtseff* (1890), introduced by Rozsika Parker and Griselda Pollock, London, Virago Press, 1985, entry for 2 January 1879, 347.

22. Charles Baudelaire, "The Painter of Modern Life," in *The Painter of Modern Life and Other Essays*, translated and edited by Jonathan Mayne, Oxford, Phaidon Press, 1964, 9.

23. Ibid., 30.

24. The pictures to fit the schema would include the following examples:

A. Renoir, *La Loge*, 1874 (London, Courtauld Institute Galleries).

E. Manet, *Music in the Tuileries Gardens*, 1862 (London, National Gallery).

E. Degas, *Dancers Backstage*, ca. 1872 (Washington, D.C., National Gallery of Art).

E. Degas, *The Cardinal Family*, ca. 1880, a series of monotypes planned as illustrations to Ludovic Halévy's books on the backstage life of the dancers and their "admirers" from the Jockey Club.

E. Degas, *A Café in Montmartre*, 1877 (Paris, Musée d'Orsay).

E. Manet, *Café, Place du Théâtre Français*, 1881 (Glasgow, City Art Museum).

E. Manet, *Nana*, 1877 (Hamburg, Kunsthalle).

E. Manet, *Olympia*, 1863 (Paris, Musée du Louvre).

25. Theresa Ann Gronberg, "Les Femmes de brasserie," *Art History*, 1984, 7 (3).

26. See Clark, op. cit., 296, n. 144. The critic was Jean Ravenal, writing in *L'Epoque,* 7 June 1865.

27. See Clark, op. cit., 209.

28. The escapade in 1878 was erased from the bowdlerized version of the journals published in 1890. For discussion of the event see the publication of excised sections in Colette Cosnier, *Marie Bashkirtseff: un portrait sans retouches,* Paris, Pierre Horay, 1985, 164–65. See also Linda Nochlin, "A Thoroughly Modern Masked Ball," *Art in America,* November 1983, 71 (10). In Karl Baedecker, *Guide to Paris,* 1888, the masked balls are described but it is advised that "visitors with ladies had better take a box" (p. 34) and of the more mundane *salles de danse* (dance halls) Baedecker comments, "It need hardly be said that ladies cannot attend these balls."

29. Carl Degler, "What Ought to Be and What Was; Women's Sexuality in the Nineteenth Century," *American Historical Review,* 1974, 79, 1467–91.

30. Benjamin, op. cit., 45.

31. The exception to these remarks may well be the work of Gustave Caillebotte, especially in two paintings exhibited at the third Exposition de Peinture in April 1877: *Portraits in the Country* (Bayeux, Musée Baron Gerard) and *Portraits (In an Interior)* (New York, Alan Hartman Collection). The former represents a group of bourgeois women reading and sewing outside their country house and the latter women indoors at the family residence in the Rue de Miromesnil. They both deal with the spaces and activities of "ladies" in the bourgeoisie. But I am curious about the fact of their being exhibited in a sequence with *Paris Street, Rainy Day,* and *The Bridge of Europe,* which are both outdoor scenes of metropolitan life where classes mix and ambiguity about identities and social positions disturb the viewer's equanimity in complete contrast to the inertia and muffled spaces evoked for the enclosed worlds of drawing room and terrace of the family estate in the two portrait paintings.

32. Griselda Pollock, *Mary Cassatt,* London, Jupiter Books, 1980.

33. Mary Ann Doane, "Film and the Masquerade; Theorizing the Female Spectator," *Screen,* 1982, 23 (3–4), 86.

34. Mary Kelly, "Desiring Images/Imaging Desire," *Wedge,* 1984 (6), 9.

35. There are of course significant differences between the works by Mary Cassatt and those by Berthe Morisot which have been underplayed within this text for reasons of deciphering shared positionalities within and against the social relations of femininity. In the light of recent publications of correspondence by the two women and as a result of the appearance in 1987 of a monograph (Adler and Garb, Phaidon) and an exhibition of works by Morisot it will be possible to consider the artists in their specificity and difference. Cassatt articulated her position as artist and woman in political terms of both feminism and socialism, whereas the written evidence suggests Morisot functioning more passively within the haut bourgeois formation and republican political circles. The significance of these political differences needs to be carefully assessed in relation to the texts they produced as artists.

36. For discussion of class and occupation in scenes of women bathing see Eunice Lipton, "Degas's Bathers," *Arts Magazine,* 1980, 54, also published in Eunice Lipton, *Looking into Degas: Uneasy Images of Woman and Modern Life,* University of California Press, 1986. Contrast Gustave Caillebotte, *Woman at a Dressing-Table,* 1873 (New York, private collection), where the sense of intrusion heightens the erotic potential of a voyeuristic observation of a woman in the process of undressing.

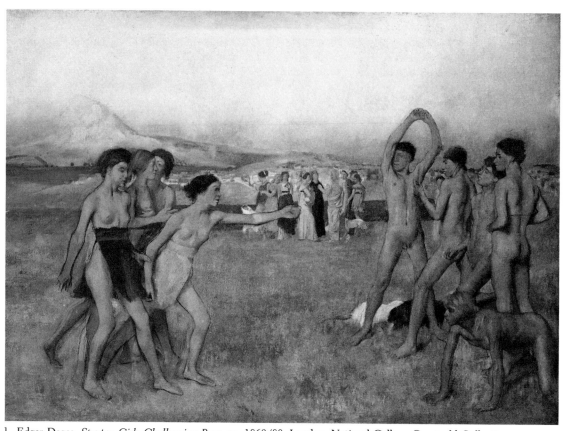

1. Edgar Degas, *Spartan Girls Challenging Boys,* ca. 1860/80. London, National Gallery, Courtauld Collection.

15

EDGAR DEGAS AND
FRENCH FEMINISM, CA. 1880

———

"The Young Spartans," the Brothel Monotypes,
and the Bathers Revisited

———

NORMA BROUDE

Edgar Degas's *Spartan Girls Challenging Boys* [1], begun around 1860, later revised for inclusion (but never shown) at the Fifth Impressionist Exhibition in April of 1880,[1] is a painting whose subject has held considerable fascination for modern scholars, but whose meaning, nevertheless, remains something of an enigma. Once interpreted as an expression of a competitive and unhealthy hostility between the sexes, one that reflected a personal fear and dislike of women on Degas's part, the scene was subsequently described as a natural confrontation among equals and offered in an essay of mine as part of a refutation of the notion of Degas's presumed "misogyny."[2] More recently, Carol Salus has rejected the idea that the picture represents a competition between the sexes and has proposed instead that it is a portrayal of Spartan courtship rites, a subject in which Degas, a young man when he first undertook the painting, would presumably have had a natural interest.[3]

In support of her interpretation, Salus maintains that the group of adolescents at the left, formerly thought to consist only of females, contains within it a male and female couple, who set an example of heterosexual bonding which the youths at the right are being encouraged to emulate. The group at the left, moreover, is said to provide a complete display of the stages of courtship, including "hesitancy on the part of the young woman on the left" (whose long hair, according to Spartan custom, would mark her as a virgin), "aggressive enticement in the lunging figure" (whose cropped hair signals that she is either married or ready to be), and, finally, "bonding in the couple." The so-called male in this couple (who is, by the way, noticeably smaller in size than any of the adolescent boys at the right) is shown fondling the breast of his female companion, and "his gesture," we are told, "indicates that he is male."[4] This assumption, which plays a central role in Salus's argument, is unwarranted, however, both in light of Degas's knowledge of classical culture in general and his literary sources for this painting in particular. For Plutarch, who is recognized as a major source for Degas's understanding of Spartan life and custom,[5] speaks of the practice of taking same-sex lovers as normal for Spartan adolescents of both sexes.[6]

From *The Art Bulletin* LXX, no. 4 (December 1988): 640–59. Copyright © 1988 by the College Art Association of America. Reprinted by permission of the author and the College Art Association of America.

In this article, I shall present a previously over-looked contemporary commentary, which suggests that Degas did regard the action depicted in "The Young Spartans" as a challenge that would lead to an ensuing athletic competition. But this painting and its subject, I will argue, no matter what its original iconographical stimulus may have been, had very different meanings for Degas when he began it in 1860 and when he considered exhibiting it for the first time two decades later in 1880—at a moment when the feminist movement in France (a movement with which Degas can now be shown to have had an important link) had begun to emerge as a significant force in the political life and in the social consciousness of the French people. What may have begun for Degas in 1860, in other words, as a straightforward depiction of the egalitarian training given atypically to young women in Spartan society, may have taken on for him by the late 1870s a more complex and problematic significance—one that might serve as a metaphor and as a reflection of the relationship between the sexes in contemporary European society. The attitudes and influences of the contemporary feminist movement, I will also suggest, may have far broader implications for Degas scholarship than the illumination of a single picture and its iconography; and I will therefore conclude with a reconsideration of Degas's brothel monotypes and bather imagery in the light of this new context.

A new clue to the subject of "The Young Spartans" is provided by the writings of Diego Martelli, the Italian art critic who was a close friend of Degas and of many of the advanced artists in his circle. From April 1878 to April 1879, Martelli spent a year in Paris, and during this period, Degas painted two major portraits of him [2].[7] A precocious and enthusiastic supporter of the Impressionists, Martelli gave a public lecture on the group when he returned to Italy in 1879, and in his discussion of Degas, he singled out for special comment "The Young Spartans," a picture that he must have seen in Degas's studio, probably on several occasions, during the previous year. After describing Degas's admiration for and long ap-

2. Edgar Degas, *Portrait of Diego Martelli,* 1879. Edinburgh, National Galleries of Scotland *(Annan).*

prenticeship in his youth to the artists of the Italian Quattrocento, whom he had studied both at the Louvre and in Florence, Martelli wrote:

Believing that he had found the right path, he sketched out, I know not whether in Italy or in France, one of the most classicizing paintings imaginable: "The Spartan girls who challenge the boys to the race which decided, in accordance with the law of those people, their submission." ["Le giovani Spartane che eccitano i giovani alla corsa, che decideva, com'era legge di quel popolo, della loro sottomissione."] This painting, begun with sincerity and put aside after a certain point, remained abandoned and unfinished because of the same sincerity that had impelled Degas to begin it. A man of the finest education, modern in every aspect of his life, Degas could not fossilize himself in a composite past reconstructed from fragments, which can never be what was or what is, a Chinese puzzle that may yield excellent results for artists like Gérôme, but not for artists who feel the pulse of real life.[8]

Martelli's remarks help to clarify several important issues regarding not only the subject but also the history of "The Young Spartans." They sug-

gest, first of all, that in 1878–79, when Martelli had the opportunity to form his impressions of the picture, Degas apparently considered it to be unfinished. Martelli, perhaps reflecting the current attitude of Degas himself, regards the painting as a relic and document of the artist's early roots in the classical tradition. He describes it as an artificial and unsuccessful attempt to reconstruct the historical past, a work that Degas had long ago decided to abandon, an exercise unworthy of an artist who feels "the pulse of real life."

These comments also suggest that at the time Martelli saw the picture, Degas had not yet carried out the major modifications that X-ray examination of the canvas in its present state has revealed—that is to say, the alteration of the figures from their original classicizing models to the more obviously contemporary types that we see here.[9] Sometime between 1879 and 1880, then, Degas's interest in this picture, begun almost twenty years earlier, was rekindled, enough so that he now planned to show it at the Fifth Impressionist Exhibition in the spring of 1880. It is reasonable to infer that these important expressive changes in the work would have been made just prior to that exhibition, and not in the 1860s, as scholars have previously supposed.[10] It is also reasonable to infer that Degas, the artist who wanted to paint the contemporary world through the lens of the classics, may now have come to feel that this particular painting and its subject did indeed have a message, or at the very least a relevance for his own time. What that relevance may have been I would now like to explore.

Diego Martelli's description of "The Young Spartans" in 1879, based to some extent, we may assume, on conversation with Degas himself, suggests that Degas *did* regard the action depicted here as a challenge that would result in an athletic competition—a race. Martelli describes it as "the Spartan girls who challenge the boys to the race which decided, in accordance with the law of those people, their submission." This description is in general terms consonant with Degas's early statement of intention with regard to this painting, the notebook entry, ca. 1859–60, in which he spoke of "jeunes filles et jeunes garçons luttant

dans le Plataniste sous les yeux de Lycurgue vieux à côté des mères."[11] And, in turn, it would also support, I believe, the traditional reading of the composition as divided into two, gender-defined groups of figures in the foreground, the Spartan girls at the left and the boys at the right. If the "race" newly specified by Martelli was associated with a particular mating practice that went beyond the general opportunity for mate selection afforded by these exercises—as might indeed be inferred from Martelli's description, as well as from the presence of the women and children who accompany Lycurgus the law-giver in the background of the picture—no source from which Degas might have gathered this particular notion about Spartan custom has yet been identified.

But even if Degas did not set out here to illustrate a documentable Spartan mating ritual as Salus has claimed, nevertheless, by the time he showed this picture to Martelli in 1878–79, he appears to have seen the activity it depicts in terms of the larger context of the lives of these Spartan girls—whose unusual training in youth might have suggested a more egalitarian status than the future actually held in store for them as members of a patriarchal society. In the group of Spartan girls at the left Degas has presented the early and natural forms of bonding that occurred among those girls (including sexual bonding), their competitive spirit, and their aggressive group challenge directed toward the wary group of boys at the right. And this, I will now suggest, by the late 1870s, may well have reflected Degas's perception of the situation of *contemporary* European women and men, as that perception would have been stimulated and evoked by the growing feminist movement of his period.

By the middle of the nineteenth century, the "woman question" had become a central issue in French intellectual and political discourse, so much so that during the Second Empire (according to a report issued in 1911), more books on women were published than at any other time in French history.[12] The continuing debate, which focused on the role and status of women within the family as a key to the moral and material

regeneration of the French nation, was fed in the late 1850s and early sixties by the overtly misogynist writings of Pierre-Joseph Proudhon and by the more chivalric ones of Jules Michelet, both of whom argued for restricting the options and rights of women as a means of preserving and strengthening the patriarchal family, and both of whom based their arguments to differing degrees on the notion of the physical, intellectual, and moral inferiority of women.[13] In heated refutation, a spate of newspaper articles, brochures, and books soon appeared by feminist writers, the most influential of whom were Juliette Lamber (Mme Adam) and Jenny d'Héricourt, who set forth their own views on the nature of woman, calling for equality and programs of social and legal reform.[14]

This lively literary debate was the most visible evidence of the survival of feminist activism during the Second Empire, a period during which government controls on the press and on free assembly effectively prevented feminist organization and propaganda in France, and virtually decimated a feminist movement that, before 1850, had been one of the most active in Europe. But with the relaxation of repressive laws and censorship in the last years of the Second Empire, feminist activism reemerged in the late 1860s. In 1869, the liberal journalist Léon Richer founded the newspaper Le Droit des femmes, whose pages, over the next twenty-three years, provide us with an important historical record of the French feminist movement during this period.[15] In the next year, 1870, Richer and Maria Deraismes (a political activist, a woman of independent means, and a brilliant and popular public speaker who could draw large crowds) founded the "Société pour l'Amélioration du Sort de la Femme et la Revendication de ses Droits," and together, over the next decade, these two were the major leaders in organizing and defining the political tactics of the feminist movement in France. Middle-class and republican in their orientation, as distinct from the working class and socialist leaders who had shaped the movement during the first half of the century, Deraismes and Richer worked during the 1870s to make feminism into a respectable political position in France, allying it with, and in some

ways subordinating it to, the survival of the fledgling and at first unstable Third Republic. Linking the emancipation of women to the stability and welfare of the family and the Republic, they held the issue of women's political rights (i.e., the vote) in abeyance, and concentrated their efforts on seeking legislative reforms, particularly in the areas of equal education for women, the reestablishment of a divorce law, women's right to file paternity suits, the abolition of state-supervised prostitution, and the rights of married women to control their own property.

Implementing a strategy of making the movement more visible as well as more respectable by enlisting influential public figures, especially male legislators and writers, in their cause, the Amelioration Society organized a banquet for 150 people at the Palais-Royal in June of 1872. With Edouard Laboulaye of the Institut de France presiding, the assembled group heard an impassioned statement of support sent to them by Victor Hugo. And in his report on the banquet in the 8 July 1878 issue of L'Avenir des femmes, Richer cited a long list of prominent writers and politicians who supported the feminist cause. He proudly declared: "Who now can be afraid of being ridiculed when in the company of Victor Hugo, Louis Blanc, H. de Lacretelle, Naquet, Lemonnier, the director of Opinion nationale, Adolphe Guéroult, and the director of Siècle, Louis Jourdan."

Throughout the seventies, the fortunes of feminism were very closely tied to the republican cause. In the wake of the anti-republican movement that toppled Adolphe Thiers and brought the monarchists' candidate, Marshal MacMahon, to the presidency of the Republic in May of 1873, a ban was placed on public meetings of the Amelioration Society. The Republican victory in the Chamber of Deputies election of 1877 led at last to the lifting of that ban, and enabled the group to proceed, in 1878, with a major international congress, for which plans had been begun earlier in the decade.

The First International Feminist Congress (Congrès International du Droit des Femmes) opened in Paris on 25 July 1878. Eleven foreign countries and sixteen organizations were repre-

sented, and two hundred and nineteen people were on the roster as official delegates. Among the latter were nine members of the Chamber of Deputies, two senators, and such familiar names as Julia Ward Howe and Theodore Stanton from the United States. By the time the Congress closed on 9 August, an additional four hundred people had come to hear the speeches and reports that had been presented during sessions held at the Grand Orient Hall (the major Freemason lodge) in Paris.[16] These sessions, organized broadly around issues of pedagogy, economics, morality, and legislation, produced a series of resolutions calling for reform that had by now become a familiar part of the liberal feminist program: these included equal education for both sexes; "equal pay for equal work" ("à production égale, salaire égal"), and open access to all professions; the abolition of state-regulated prostitution; and the establishment of a divorce law, based not on a double moral standard in regard to adultery, but on the principle of equality between the spouses.[17] Press coverage of the Congress, which was predictably negative in Bonapartist papers and positive in republican ones, was lively, and generated considerable debate over the issues, as the organizers of the Congress had hoped. In response to an article in *Le Gaulois,* for example, that began with the statement "Enfin, nous allons rire un peu!" *XIXe Siècle* published an article in defense of the Congress by Francisque Sarcey, entitled "Il n'y a pas de quoi rire."[18]

The next year, 1879, was a major turning point for the feminist movement in France. In that year, liberal Republicans gained control of the Senate and the presidency, with the result that, for the first time in that decade, considerable legislative progress was made on feminist issues. In 1880, for example, the Camille Sée Law was passed, authorizing the establishment of secondary schools for girls (with a curriculum, however, that would not prepare girls for the *baccalauréat* examinations).[19] And the campaign to reestablish a divorce law in France, which had been begun by Alfred Naquet, a member of the Chamber of Deputies, in 1876, was also now much advanced.[20] After many unsuccessful efforts on Na-

quet's part to win consideration of the issue in the legislature, the Chamber of Deputies voted with a strong majority to debate the proposed measure after Naquet delivered an eloquent speech before it on 27 June 1879.[21] Even though a divorce law would not be passed until 1884, the vote of 1879 was nevertheless a significant victory, for it marked the beginning of vigorous discussion of the issues, both in the legislature and in the press.

The year 1879 also saw the emergence of a radical wing of Republican feminism led by Hubertine Auclert, who took up the issue that had been shelved by Deraismes and Richer, the issue of suffrage. Taking the position that civil reforms for women would follow only in the wake of their political enfranchisement, Auclert, who had been silenced at the Congress of 1878, split from the moderate majority, announcing a new "politics of assault" rather than one of compromise. And in a press release of January 1879 reflecting this new aggressive spirit, she threw down her challenge: "Man makes the laws to his advantage and we [women] are obliged to bow our heads in silence. Enough of resignation. Pariahs of society, stand up!"[22]

Later in the same year, Auclert presented her demand for suffrage at the Congress of the Socialist Workers of France (Congrès Ouvrier Socialiste de France), which convened in Marseilles in 20–31 October 1879. She met with resounding success, for not only was the assembly persuaded to adopt a resolution in favor of women's suffrage,[23] but Auclert herself was elected president of the Congress. In accepting the presidential chair, according to a report published in *Le Figaro,* Auclert thanked the Congress for the honor it had conferred upon her, " 'for,' " she said, " 'in naming me your president, you are acknowledging the equality of man and woman.' "[24] Even in the conservative *Le Figaro,* almost daily reports on the Congress and its sessions were published. These reports, though often mocking and hostile in tone, are relatively lengthy and detailed, and are indicative of the amount of attention that was given to the Congress and to Auclert's part in it by the Parisian press.

In 1879 and 1880, Auclert continued to imple-

ment her strategy of assault both upon the government and upon public opinion with a steadily escalating barrage of press releases and petitions demanding the vote, as well as with increasingly visible and well publicized public demonstrations and acts of protest and resistance.[25] After attempting unsuccessfully to register to vote in February of 1880, for example, Auclert and twenty of her followers staged over the next months a tax strike that drew coverage from the press and elicited new expressions of support, some of it from surprising quarters (it was at this time, for example, that Alexandre Dumas *fils,* whose earlier writings had been vehemently antifeminist, began to reverse his position and endorsed women's suffrage[26]). As usual, Auclert expressed herself forcefully. Having been told "that 'the law confers rights only on men and not on women,' " she informed the prefect of the Seine, "in consequence, I leave to men, who arrogate to themselves the privileges of governing, arranging, and allotting the budgets, I leave to men the privilege of paying the taxes that they vote and divide to their liking. Since I have no right to control the use of my money, I no longer wish to give it.

. . . I have no rights, therefore I have no obligations; I do not vote, I do not pay."[27]

These events, and in particular the active and escalating challenge to male supremacy that was being laid down by the newly radicalized wing of the French feminist movement around 1879–80, are relevant, I believe, to defining the climate in which Degas was inspired to revise and insert contemporary figure types into "The Young Spartans," with the intention of showing the picture to the public at the Fifth Impressionist Exhibition in April of 1880. The original character of the picture before revisions were carried out is best suggested by the thinly brushed and largely tonal version of the subject, today in the Art Institute of Chicago [3], which Degas probably painted in 1860, in the traditional manner, as a large-scale study for the London picture. Here the challenging gesture of the leading Spartan girl at the left can be read (as it can still be read on one level in the London picture), as a straightforward illustration of Degas's original literary sources: these are the Spartan girls of Plutarch or of the Abbé Barthélemy, who exercise publicly with the Spartan boys, taunting them and inciting them to acts of

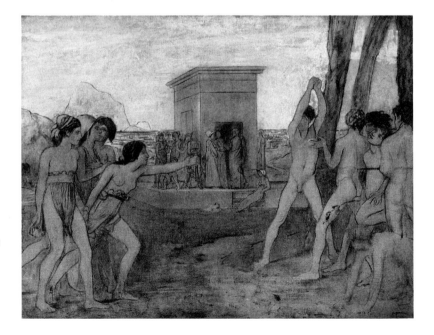

3. Edgar Degas, *Spartan Girls Challenging Boys,* ca. 1860. Art Institute of Chicago, Charles H. and Mary F. S. Worcester Fund, 1961 *(Courtesy of the Art Institute of Chicago).*

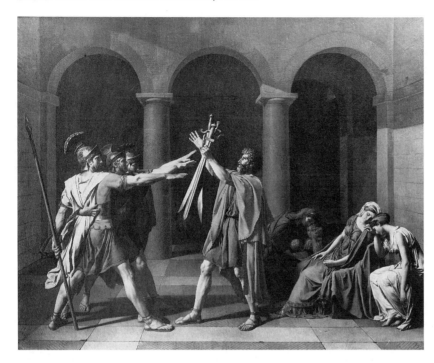

4. Jacques-Louis David, *Oath of the Horatii*, 1785. Paris, Louvre (Musées Nationaux).

greater glory.[28] But in the revised version of 1880, with its explicitly contemporary Parisian types and the newly wary and confrontational stance of the boys on the right, all of whom, in contrast to the Chicago version, now look directly at the group of girls at the left (cf. figs. 1 and 3), these same gestures—as well as the presence of Lycurgus, the male law-giver, surrounded by women and children in the background—take on new meaning. They demand now to be read as well within the context of the contemporary relationship between the sexes—in terms, I believe, of the challenge that was being presented to contemporary men to yield their positions of total legal and political power and to participate in the creation of a more equitable social order. That Degas would have chosen to respond in this instance to topical concerns within the context of a history painting is not altogether surprising nor wholly unprecedented in his practice. For as Hélène Adhémar pointed out some years ago, the subject of Degas's *Scène de guerre au Moyen Age*, a history painting that he exhibited at the Salon of 1865, is likely to have been a response or a reference to specific

events from the American Civil War, events that had had a direct impact upon the lives of the artist's female relatives in New Orleans.[29]

The relationship of Degas's "Young Spartans" to another classic French painting, David's *Oath of the Horatii* [4], in which the artist also addressed the issue of appropriate gender roles for his own period through the model of antique history, provides another revealing reference point for this discussion. It has been pointed out that the active versus passive roles of the women versus the men in Degas's picture, as well as their left versus right compositional placement, present obvious reversals of what is to be found in such traditional history paintings as David's *Oath*.[30] And this, I think we may conclude, was neither accidental nor unselfconscious, for the relationship between the two pictures clearly resonates on more than just the formal level. Originally, Degas had undertaken "The Young Spartans," in part, and not entirely without the spirit of rebellion, as a youthful artist's effort to come to terms with the Neoclassical tradition of history painting, a tradition for which David's painting already stood as

the obvious archetype. But by 1880, in the revised London version, Degas's "Young Spartans" had emerged as a mature artist's fully formed critique and answer to that tradition, painted now not only from a vastly altered aesthetic perspective, but from a vastly altered social one as well—based on the vision and at least the possibility of a more nearly egalitarian relationship between the sexes.

We do not know what Degas thought about feminism, and we have no evidence, beyond what may be inferred from his works, that might permit us to speculate on where he stood in relation to the feminist movement of his period. It can be said, however, that during the 1870s, the increasingly middle-class and republican orientation of that movement would not have been antithetical to Degas's own political position, which had clearly emerged as liberal and republican during the period of the Franco-Prussian War and the siege of Paris (when he and Manet, unlike many of the other artists in their circle, had chosen to remain in Paris).[31] It can also be said with some assurance that Degas would have been exposed to contemporary feminism, and that he must have become aware, at least by the late 1870s, of the debate that it was generating. A link between Degas and contemporary feminist thought is in fact provided, once again, by Diego Martelli, whose friendship with Degas during this period was apparently a close one, and whose activities may further help us to establish the context in which Degas's interest in "The Young Spartans" was renewed during the years between 1878 and 1880.

In addition to his activity as an art critic, Diego Martelli was a respected political and social observer who wrote on a variety of issues for Italian journals.[32] During the year he spent in Paris, from 1878 to 1879, he supported himself in part by acting as correspondent to the Universal Exposition for several of these Italian newspapers, covering not only the Exposition itself, but also related cultural events in the French capital, and, in two articles for *La sentinella bresciana*, the sessions of the First International Feminist Congress.[33]

That the Congress would have been of interest to Martelli's Italian readers is not surprising, given the emphasis that Risorgimento leaders had long placed on the issue of women's emancipation, and the continuing political and legislative struggle among Italian liberals of Martelli's generation to secure equal rights for women. Giuseppe Garibaldi had been an early supporter and adherent of Deraismes's and Richer's Amelioration Society in France, and Italian feminists were active in the planning and organization of the Society's First International Congress.[34] On the roster of official delegates to the Congress were several prominent Italians, including Anna-Maria Mozzoni, Aurelia Cimino-Folliero, and, from Rome, the legislators Mauro Macchi and Salvatore Morelli.[35] Morelli, the author of a law that allowed Italian women to act as legal witnesses for civil and public acts, had only recently introduced a divorce bill into debate before the Italian parliament, an action for which he had been publicly congratulated by Garibaldi.[36] In the 1870s, the international feminist movement had even penetrated to Livorno, in Martelli's native Tuscany, where, in May of 1878, after Martelli's departure for Paris, Julia Ward Howe addressed a meeting of the Circolo Filologico on the subject of women's rights and education in America.[37]

While Martelli's articles on the International Congress reflect to some extent the liberal attitudes of many Italian political leaders on the issue of women's rights, his remarks also reveal considerable ambivalence and anxiety about the feminist movement, reactions that would probably have been quite normal for even some of the most liberal-minded men of his period. Beginning, for example, with the kind of jocular ridicule that was a familiar part of the journalistic response to feminism in the nineteenth century, he observes that out of the approximately four hundred women who attended the congress, no more than two could accurately be described as belonging to "the fair sex."[38] He seems, however, to be genuinely interested in and surprised by Theodore Stanton's description of the indirect political power wielded by female abolitionists in the northern United States during the period of the Civil War, by the educational and professional opportunities open to American women, and by the fact that in some

of the states, women were permitted to sit on juries.[39] But while he expresses the belief that "this tendency of women to change customs is one of the most serious phenomena of our times,"[40] he also expresses fear and concern for the future of marriage and the family as social institutions, predicting that feminist activists, "this legion of grenadiers who have opened the path to attack the edifice of the past, will, in our opinion, be followed by large numbers of an irregular infantry who will sow afflictions upon the thorny field of the home and the marriage bed."[41]

Within a year, however, Martelli had become a committed supporter of the feminist program of social and legal reform, allying himself, as he put it, with "the many men of feeling and intelligence who nowadays raise their voices against the usages of an antiquated constitutional law" and "the many women, cultivated and courageous, who are demanding a broader and less ignoble share in the banquet of life." Among the causes he now championed were women's right to vote, to serve on juries, and to receive equal pay for equal work. Indeed, in many ways, he was now willing to go further than the feminist Congress with which he had been so uncomfortable only a year earlier, and which he now faults for lacking "the courage it should have had to proclaim the absolute vindication of the sacred and natural principle of mother right [la potestà materna]." For this principle, he says, stands "in direct opposition to the principle of father right, just as truth is the opposite of the absurd, and as certainty is the opposite of the conjectural."[42] Although he still remained committed to the primacy of the family, he now saw equality and justice within marriage as the key to the strength and stability of the family unit and of society itself, ideas that were now identical to those of French feminists like Maria Deraismes.[43]

This development in Martelli's thinking is clearly related to his experience in Paris, where he met Maria Deraismes and other feminists, both male and female,[44] and where he seems to have been particularly impressed by Deputy Naquet's campaign for the reestablishment of the divorce law. Inspired by that campaign, either shortly before or after his return to Italy, Martelli wrote

and published an article entitled "Il divorzio,"[45] in which he exposed the illusions and hypocrisies of patriarchal authority in general and decried in particular the subjugation of women under the laws regulating marriage—laws, he said, which have accustomed us to regarding a woman as merely an "instrument of pleasure or as a child-making machine."[46] He argued against several of the more discriminatory provisions of the civil code in this regard. (One of these was a provision that permitted legal separation on the grounds of a husband's adultery only in cases where the husband had maintained his mistress within the family home, a provision that had also been attacked by Naquet and others in France.) And in conclusion, he exhorted his readers "to praise and encourage this first step toward the rationalization of the marriage bond, which is called Divorce, until woman regains her primacy and her liberty completely . . . so that the family at last can become a truth of conscience, and not continue for eternity as a lie of the law and as an illusion of masculine vanity."[47]

Although Degas's decision to revise and exhibit "The Young Spartans" appears to have followed Martelli's return to Italy in April of 1879, it was, significantly, during the year that Martelli spent in Paris, between 1878 and 1879, that Degas is thought to have undertaken his series of more than fifty brothel monotypes, works for which scholars have long cast about in vain for a context.[48] An important part of that context, I believe, can be found in the attitudes and influences of the contemporary feminist movement. And once again, the link between Degas and the feminist position is provided by Diego Martelli, who had had a longstanding interest in prostitution as a social issue. In Martelli's library, in fact, were no fewer than six books published in France and in Italy on the subject of prostitution,[49] a subject to which he had been sensitized on a personal level by his own common-law marriage to a former prostitute.[50]

As images of life within the State-regulated *maison close*, the works that constitute Degas's extensive series of brothel monotypes were

unusual and virtually unprecedented both in their subject and in their form. Most earlier nineteenth-century images of prostitution had dealt with its "unregulated" and more glamorous variety—that is to say, the independent courtesans pictured by artists like Constantin Guys, Manet, and others. The literature of the Second Empire and the early years of the Third Republic is filled with diatribes against the spreading evils of unregulated or "clandestine" prostitution (which, it was feared, would overrun and pollute the moral arrangements and strictures of patriarchal society), as well as with calls for stricter government regulation of prostitutes and their activities. But while much has been made of these documents as interpretative tools in the recent art-historical literature,[51] the "different voice" that was being raised by feminist writers in the nineteenth century on these issues has yet to be admitted into our presently very narrow critical discussion regarding the impact of this social debate on the visual imagery of the period.

T. J. Clark, for example, in attempting to turn the issue of prostitution in nineteenth-century art and society into one of class struggle, has argued for the centrality of class distinctions in the contemporary debates over Manet's *Olympia*, asserting that critics were distressed by this picture of a courtesan, who stares out at the beholder with aggressive insolence, because in it nakedness alone was left to communicate class. "Nakedness," he writes, "is a strong sign of class, a dangerous instance of it. And thus the critics' reaction in 1865 becomes more comprehensible."[52]

What this approach ignores is the feminist position on prostitution that emerged during the nineteenth century, a position that was based on what is for orthodox Marxism the inadmissable assumption that all women—whether single or married, exploited laborer, prostitute, or protected middle-class mother—may be seen to constitute, in fact, a single "class."[53] Increasingly, the liberal feminist movement in the nineteenth century used as part of its rhetoric the metaphor of the prostitute as a symbol for the oppression of all women, for all were forced to sell their bodies for money, whether within the framework of the repressive marriage laws or outside of them. As early as 1840,

the utopian socialist feminist Flora Tristan had written in this vein: "Look at the prostitutes on the street, that lamentable flock marked by shame; if only they had known enough to sell themselves at an earlier age, they would not have fallen to such a low mark, and they would be honorable women."[54] A somewhat different version of the same equation was presented later in the century by Diego Martelli, who condemned marriage as a form of prostitution, describing it as "nothing but a state of subjection and slavery, or, better still, a private form of prostitution for a woman, compared with public prostitution; a condition, in short, equivalent to that of a horse, who whether he pulls a king's coach or is tied to an omnibus, will always remain a beast of burden."[55]

For feminists in the nineteenth century, then, the central issues to be addressed were indeed economic ones—but not the economic exploitation that separated one social class from another, but rather the kind, based on sexual discrimination, that denied to women—all women—control of their own property if married, or, if unmarried, access to the kind of education, range of jobs, and fair pay that would ultimately free them from the necessity of prostitution and subservience, at whatever economic level, to the dominant male "class." Here it would be well to reiterate that the increasingly visible feminist movement of the 1870s was not socialist; it was primarily bourgeois and liberal-republican in its constituency and in its political orientation. While republican and socialist feminists had been allied earlier in the century in opposition to the governments of Louis-Philippe, and later, of Louis Napoléon, with the consolidation of the Third Republic in the 1870s and early eighties, and with the exile after the Commune in 1871 of such socialist feminists as Louise Michel, André Léo, and Paule Mink, the leadership and politics of the French feminist movement were altered and its ties with socialism were gradually cut. Even Hubertine Auclert's alliance with the socialists in 1879 was a pragmatic and a temporary one.[56]

The liberal feminist position on prostitution was clearly enunciated in 1878 at the First International Congress, whose "Section de morale"

passed resolutions calling for the end of State-regulated prostitution and the closing of all government-licensed brothels and separate health facilities for prostitutes, on the grounds that the State was sanctioning and supporting behavior—on the part of men—that was at odds with the ideals of an egalitarian society, behavior that was ultimately injurious to the institution of the family and hence to the moral health and stability of the republic itself. "By converting disorder into the exercising of a regular profession," they asserted, "the state sanctions the immoral prejudice that debauchery is a necessity for man." In an egalitarian society, they believed, there would be no need for regulation, since economic justice and equity for women would automatically eliminate most forms of prostitution. Thus, the report of the "Section economique" of the Congress called vigorously for the principle of "equal pay for equal work," citing insufficient pay for women as "one of the principal causes of prostitution."[57]

A powerful statement of the antiregulatory and feminist point of view during this period is to be found in Diego Martelli's "La prostituzione," an article published in *La lega della democrazia* on 1 August 1880, and written in conjuction with a congress on prostitution that was then being held in Genoa. In Italy, prostitution was regulated by a law that had been promulgated by Cavour in 1860 (and that remained in force until 1958).[58] It was apparently to the dehumanizing aspects of this system and its enforcement, as he could have seen it applied in France as well as in Italy, that Martelli was here responding. Denouncing the system of State regulation and police surveillance of registered prostitutes as a system of persecution that deprived women of their basic human and civil rights, he dismissed as the standard justification for such regulation the right and the duty of government to protect public health and morality. "It seems to me, rather," he wrote, "that this final step in the subjugation of the female, which almost all men take with pleasure, is the last link in a chain of infamies to which woman has been subjected by the bestiality of man." Equating prostitution, in the broadest terms, with the condition of women in contemporary society, he

called it "a state not peculiar to those unfortunate women who sell their mistreated and exhausted flesh for a few pennies in the brothel; but, rather, it is the normal condition of the entire sex which we call gentle, and of which the brothel part is only one variety, perhaps the least significant and the least dangerous."[59]

Among the most extensive recent discussions of Degas's brothel monotypes are those by Hollis Clayson and Charles Bernheimer. Clayson dismisses as methodologically retardataire and as socially irresponsible the analyses of the monotypes that depend on the biographical reconstruction of the artist's viewpoint. Nevertheless, she engages in one of the least productive forms of such analysis when she asserts that "fantasizing and in turn representing prostitution in this way may have had its personal satisfactions" for the artist. Degas, she says, "disparages the working class prostitute," but at the same time was attracted by "the positive aspects" of her obscenity and vulgarity, and he "cloaked [his own] voyeurism in detachment and gentle parody" by depicting the male clients of the brothel as looking "a bit foolish."[60]

Bernheimer, on the other hand, refuses to see Degas's brothels as "a space of self-representation" for the artist. His interpretation of the images still depends, nevertheless, upon the projected reactions of a voyeur—"the would-be voyeur at the brothel threshold," who may further be identified with the viewer of the work. "What," Bernheimer asks, "if the male viewer I have supposed to be made uncomfortably self-conscious about his complicity in the exploitation of women actually felt quite at ease with the marks he sees of her subjugation? Could not the flattening of the prostitute's body into a common-place of male sexual privilege serve to reinforce, rather than subvert, the viewer's satisfaction with patriarchal gender arrangements?" The viewer's response, Bernheimer concludes, oscillates between two perspectives. "In the first, the viewer is made to feel guilt about the ideological impact of his gaze; in the second, the viewer finds his patriarchal prejudice reinforced."[61]

What these writers share, I believe, is a masculi-

nist point of view from which they attempt to interpret Degas's images and his intentions. (I use the terms "masculinist" and "feminist" in this context to describe modes of thought that, in the first case derive from, and in the second case respond to, a patriarchal social structure. The terms are not necessarily predictive of the sex of the observer, for men can hold feminist attitudes and women masculinist ones.) What is essentially at stake in both of the masculinist interpretations presented above is how Degas's images of prostitutes reflect upon or define the psychological position or the economic and social power of the male. Both writers ignore or omit the possibility of a feminist observer. For both, the point of view to be defined and established is assumed to be that of the patriarchal male viewer, and the question to be answered is whether that viewer is easy or uneasy with his point of view.

Proceeding from this masculinist perspective, Clayson has tried to build a social context for the brothel monotypes by establishing partial parallels between what we see in the images and the position held by those who advocated stricter gov-

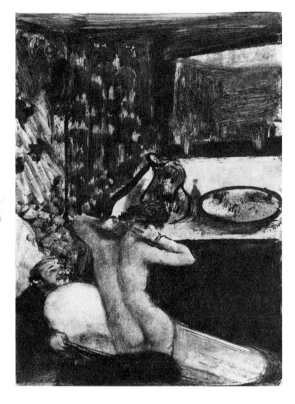

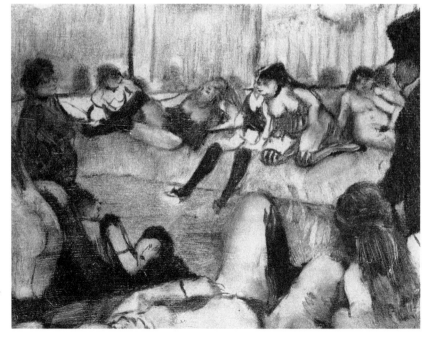

5. Edgar Degas, *Admiration*, monotype in black ink with pastel, ca. 1878–80. Paris, Bibliothèque d'Art et d'Archéologie de l'Université de Paris, Fondation Jacques Doucet *(Société des Amis de la Bibliothèque d'Art et d'Archéologie)*.

6. Edgar Degas, *In the Salon*, monotype in black ink, ca. 1878–79. Paris, Musée Picasso *(Musées Nationaux)*.

ernment regulation and police surveillance of prostitution during this period. Like the "neo-regulationists," who argued that prostitutes were unlike other women and should be kept separated from the rest of society in order to protect public health and morality, Degas, she says, in the monotypes, also presented a view of the debased prostitute as "bestial" and "other" by nature. "The world of the monotypes," she writes, "is shown to be populated by a species which is singularly well adapted for life within its confines: subjective 'selves' transformed into objective commercialized matter; a view with which the neo-regulationists could have heartily agreed."[62]

The overlooked feminist position, however, which countered calls for increased state regulation of prostitutes and their separation from the rest of society, provides a broader context for art-historical analysis, one in which the brothel monotypes can take on new and more plausible meanings. Degas's remarkable series of prints is too extensive and consistent to be dismissed—as there is still an inclination to do—as an expression of personal "voyeurism" or as gratuitous pornogra-phy. It must have been conceived, at least in part, I believe, as an indictment of the system of State-regulated and sanctioned prostitution, a system that, from the feminist point of view, numbered among its victims not only the women themselves, but also their "foolish" clients, and even French society as a whole. In these images of grotesque and dehumanized women and their equally gro-tesque and dehumanized customers, some of whom leer hungrily[5] or stand stiffly in their bourgeois attire[6], Degas brought his talent as a caricaturist to bear as he worked to strip away the myths behind which nineteenth-century society tried to hide and to justify its patterns of exploitation. These women, officially classified as "other," have indeed been debased and commodified by the lives in which they have been economically trapped—they have become what patriarchal society intended them to be used for. Yet it is striking that Degas provides us with images that attest not only to their exploitation but also (in the occasional rendering that is more particularized than caricatured) to their humanity, affection for one another, and solidarity [7, 8].

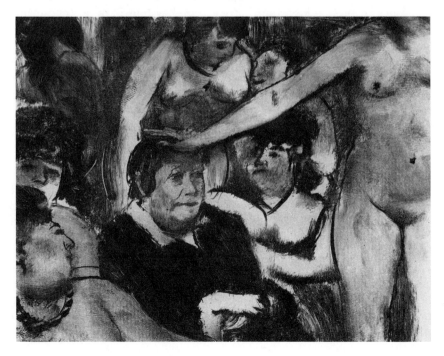

7. Edgar Degas, *The Madame's Birthday Party*, monotype in brown ink, ca. 1878–79. Whereabouts unknown *(Courtesy of the Lefevre Gallery, London).*

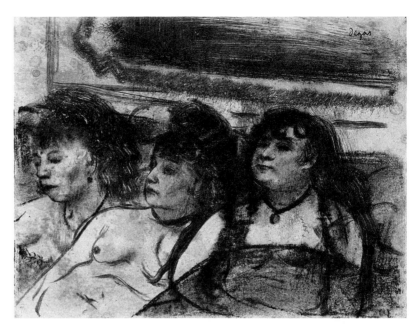

8. Edgar Degas, *Three Seated Prostitutes*, monotype in black ink with pastel, ca. 1878–79. Amsterdam, Rijksmuseum, Rijksprentenkabinet.

Diego Martelli's clearly enunciated statement in 1880 of a passionately held feminist and antiregulationist position on prostitution establishes at last a broader range of social attitudes on this issue to which Degas could have been exposed. In 1877, Degas did a few drawings in one of his notebooks to illustrate Edmond de Goncourt's *La Fille Elisa*, a recently published novel about prostitution [9].[63] The differences in scope, character, and expression between the slightly later series of brothel monotypes and these comparatively mild and decorous drawings of 1877, which show the women talking or playing cards with their soldier-clients, are indeed startling. And they are enough to suggest that the period from 1878 to 1879, when Martelli was in Paris and when many of the brothel monotypes may have been executed, was an important turning point for Degas's perception of the theme and of the issue of prostitution in modern art and life. It was through Martelli, I would suggest, that Degas may have become sensitized to issues and exposed to a point of view about prostitution that had not previously been fully accessible to him through French literary treatments of the subject.[64] And it is through Martelli that we today may be afforded a glimpse of what

the brothel monotypes might have meant to a late nineteenth-century feminist observer of either sex. For from this feminist perspective, the monotypes, as unprecedentedly direct images of female degradation, present an often harrowing vision of the State-regulated system of prostitution, one that accords well with Martelli's view of that system as the "final step in the subjugation of the female . . . the last link in a chain of infamies to which woman has been subjected by the bestiality of man."

Although the brothel monotypes were apparently never exhibited by Degas,[65] the female "bather" compositions (most of them pastels) were; and as manifestations of Degas's earlier and more general interest in the subject of the female nude in modern life, it is significant that many of these works predate the brothel series by several years. At the First Impressionist Exhibition in 1874, Degas showed a drawing entitled *Après le Bain*. The catalogue of the Second Exhibition in 1876 lists a work entitled *Femme se lavant le soir*, as well as the tentative and enigmatic *Petites Paysannes se baignant à la mer vers le soir* (Lemoisne 377), an oil painting that includes a fragment of a woman arranging her hair at the upper right.

The latter work appears again in 1877 in the catalogue of the Third Exhibition, along with two bather subjects, *Femme sortant du bain* (Lemoisne 422) and *Femme prenant son tub le soir*. Also from the show of 1877 is *La Toilette (Femme nue, accroupie de dos)*, a pastel over monotype (Lemoisne 547), which was shown either *hors catalogue* or as one of three untitled monotypes listed in the catalogue. A pastel described as *Toilette* appears in the catalogue of the Fifth Exhibition in 1880; and the catalogue of the Eighth Exhibition in 1886 lists ten pastels, the *Suite de nuds* [sic] *de femmes se baignant, se lavant, se séchant, s'essuyant, se peignant ou se faisant peigner*, which was the largest and most coherent group of bather and toilette subjects by Degas that had been shown publicly to date.[66]

The subjects of Degas's bather and toilette scenes, though more traditional in their art-historical origins and evocations than the brothel scenes, nevertheless caused confusion and controversy among the artist's contemporaries, and they continue to do so today. In recent years, Eunice Lipton has made "the case for realism" in the interpretation of Degas's bathers, asserting that they are really depictions of prostitutes.[67] In support of this, she cites State regulations for cleanliness on the part of registered prostitutes, which would have compelled them to bathe frequently (while the bathing habits of respectable, middle-class women, we are given to understand, were not as regular).[68] Also in support of her contention, she speculates on the question of whether Degas, a bachelor and a "realist," would ever have had the opportunity to see the inside of a respectable, middle- or upper-middle-class woman's bedchamber.[69] Leaving aside the dubious assumption that, as a realist, Degas could work only from the most immediate and personal kinds of real-life experience, it might be recalled, in response to this argument, that throughout his life Degas had occasion to visit and share the homes not only of female relatives but also the homes of many of his married male relatives and friends. While he may or may not have been admitted on an intimate basis into these or other middle-class boudoirs, the general character and physical arrangements of such dwelling spaces would surely not have remained a lifelong mystery to him.

That a few of Degas's contemporaries responded to his female bathers as prostitutes, as Lipton and others have observed, is of course undeniable, and is the principal aspect of this argument that needs to be addressed.[70] As the reviewer Henry Fèvre put it, in response to the *Suite de nus* at the Eighth Impressionist Exhibition (including the works reproduced here below as figs. 14, 16, and 17): "Degas lays bare for us the streetwalker's modern, swollen, pasty flesh."[71] Degas's images of "real" women, whose bodies

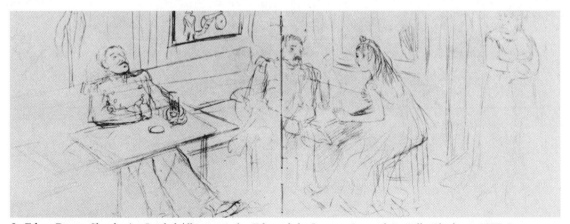

9. Edgar Degas, *Sketch of a Brothel* (illustration for Edmond de Goncourt's novel *La Fille Elisa*), ca. 1877. Paris, formerly Collection of Ludovic Halévy *(from Theodore Reff,* The Notebooks of Edgar Degas, *1976, vol. II)*.

conformed to no ideal standard of feminine beauty, but which were nevertheless not without sensual appeal, were images that proved distasteful and even frightening to many critics and observers of the period, some of whom, like Fèvre, assumed automatically that a nude woman who was not a goddess must be a prostitute. Their reactions were not only understandable but even necessary ones in a society that seems to have been virtually obsessed with the need to regulate "vice" in order to draw clear and recognizable distinctions between "good" and "bad" women.[72] Nineteenth-century male commentators, fixating upon themselves as observers of these images and hence as observers of the women who are depicted in them in private situations, often took the position that these women did not know that they were being observed, thus introducing the factor of male voyeurism—their own and the artist's—into

their interpretative readings of these works, and thereby turning the female subjects of Degas's bather compositions into the passive objects of "the male gaze."[73] But once we succeed in dissociating ourselves from that gaze and that point of view, Degas's bathers, as distinct from his brothel prostitutes, can be seen, unequivocally, as women who are naked for no one but themselves. And therein lay their potential to disturb and repel male audiences. They are among the very few representations of the female nude by male artists in the Western tradition that challenge (albeit mildly and obliquely from our point of view today) the societal assumption that nude women can exist only for the pleasure and the purposes of dominant males.[74]

Thus, even though some of Degas's contemporaries may have responded to his bathers as prostitutes, their responses must be understood in large

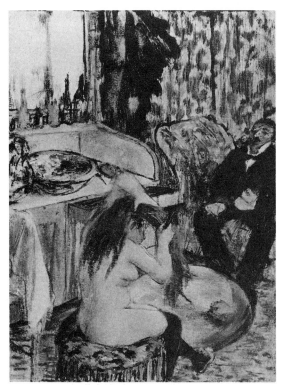

10. Edgar Degas, *Woman Combing Her Hair,* monotype in black ink with pastel, ca. 1878–80. New York, Ittelson Collection *(from E. P. Janis,* Degas Monotypes, *1968).*

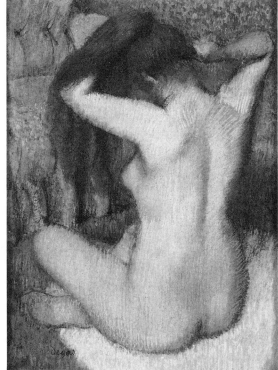

11. Edgar Degas, *Nude Combing Her Hair,* pastel on paper, ca. 1885. New York, Metropolitan Museum of Art, Gift of Mr. and Mrs. Nate B. Spingold, 1956.

part as reflections of personal and societal biases, and cannot be used necessarily to "prove" the artist's intentions. It should be remembered, too, that equally skewed charges of "misogyny" also grew out of contemporary responses to the non-idealized aspects of Degas's bather pictures,[75] as did contemporary efforts to defend the artist from such charges, efforts that were couched in very different terms. The critic Maurice Hermel, for example, wrote of Degas, in response to the *Suite de nus* at the Eighth Impressionist Exhibition in 1886: "He is a feminist . . . and more feminist than the manufacturers of Venuses and Ledas, if one understands by that the gift of seeing and defining woman (a certain type of woman, if you wish) in that which most characterizes her."[76]

Lipton has cogently analyzed and identified some of the broader differences between Degas's brothel and bather images. "The context in the paintings," she writes, "is imprecisely described; gesture and narrative are minimized; the male spectator is removed; and the expressiveness of texture, form, color, space, etc. has increased."[77] Nevertheless, she dismisses all of this to insist that the bathers are in reality prostitutes, reasoning (in a circular manner) that if only the male observers were to be removed from some of the brothel monotypes (e.g., figs. 10 and 11), then "a prevalent Degas bather image" would emerge.[78]

But between Degas's images of prostitutes and his images of bathers, there are clear and often glaring differences that cannot be denied. And these differences are all the more telling and meaningful when works that would appear, superficially, to have much in common are juxtaposed from each category. The woman, for example, in Degas's pastel *Retiring* [12], ca. 1883, who reaches to turn off her bedside lamp as she prepares to retire for the night into the curtained privacy of her bed, seems similar in general posture and situation to the prostitute in the monotype *Waiting*, ca. 1879 [13], who also sits on a bed and twists her body in the direction of a bedside light source. The distinctions between them, and the identification of the latter as a prostitute, despite the absence of the male observer, the client, are clear and unambiguous. The woman in *Retir-*

ing belongs only to herself at this moment: she is totally and unselfconsciously nude, her hair still damp and disarranged from her bath, with one arm, modestly but naturally placed by the artist to shield her genitals. Her counterpart in the brothel monotype, on the other hand, with her genital region fully exposed, her hair ostentatiously coiffed, and with a black ribbon adorning her throat and wrist, is a woman who is displaying her nakedness. The stiffness of her posture and the tense self-consciousness in the arrangement of her limbs bespeak the presence or imminent presence of an observer, the client for whom she waits.

Similarly, the woman in the pastel now known as *The Baker's Wife*, ca. 1886 [14], and the woman in an analogous monotype, *In the Salon of a Brothel*, ca. 1879 [15], are clearly distinguished from each other. Although both are presented from explicit and ungainly rear views, *The Baker's Wife* is at ease in her own space. She stands, stretching slightly and arching her neck; and although she is not classically proportioned, her posture is centered and self-contained, the contours of her body are comfortably smooth and round, and her hands are planted firmly on her buttocks in a gesture of familiarity with her own body that is an entirely natural one. Her brothel counterpart, on the other hand, stands uncomfortably in a public, not a private, space. Her posture is awkward and off balance. Her proportions are ungainly, her silhouette is jagged and angular, and her gesture is unmistakably vulgar, if not obscene.

In the works that he exhibited and designated as having bather or toilette themes, Degas's intention, I believe, was to depict not prostitutes but "respectable" women. And in the *Suite de nus*, the group of pastels that he sent to the Eighth Impressionist Exhibition in 1886, these respectable women, as critics of the period recognized, represented a wide range of age, social condition, and class: from the working-class young woman who bathes in a cheap metal tub in a simple interior, in the Hill-Stead Museum's *The Tub* [16], whose poverty was stereotypically equated by one critic with immorality,[79] to *The Baker's Wife*, described in a review by Paul Adam as a "fat bourgeoise ready for bed,"[80] to the smoothly

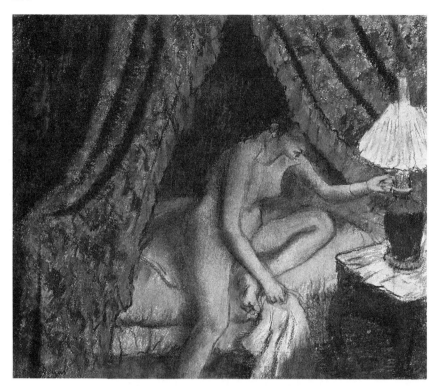

12. Edgar Degas, *Retiring*,
pastel on paper, ca. 1883.
Art Institute of Chicago,
Gift of Mrs. Sterling
Morton, 1969.

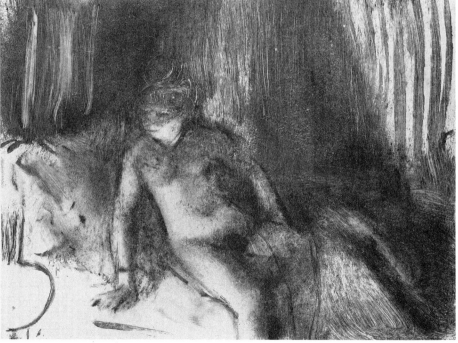

13. Edgar Degas, *Waiting*, monotype in black ink, ca. 1878–79.
Art Institute of Chicago, Gift of Mrs. Charles Glore, 1958.

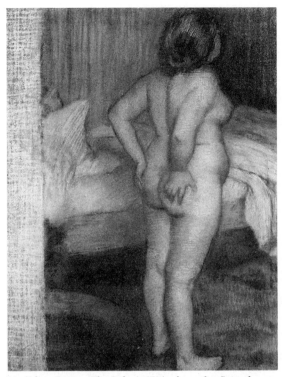

14. Edgar Degas, *The Baker's Wife,* from the *Suite de nus,* pastel on paper, ca. 1885–86. The Henry and Rose Pearlman Foundation *(New York, Metropolitan Museum of Art).*

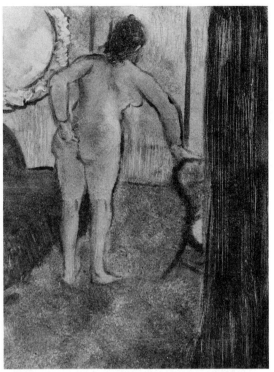

15. Edgar Degas, *In the Salon of a Brothel,* monotype in black ink, ca. 1878–79. Stanford University Museum of Art, The Mortimer C. Leventritt Fund and The Committee for Art at Stanford.

plump and pampered upper-middle-class woman of a certain age, who luxuriates with obvious contentment while attended by her maid in the Metropolitan Museum's *A Woman Having Her Hair Combed* [17]. Whether generalized or, less often, particularized to the point of quasi-portraiture (as in the case of fig. 17), these images of women run the gamut from unidealized and matter-of-fact reportage [14] to lyrical appreciations of the female body and of private moments of female self-absorption and sensual experience [17]. (Feminists of the period, like Maria Deraismes, were openly proclaiming now, for the first time, such experience to be a natural right even of "respectable" women.[81])

One can only speculate on the irony for Degas of contemporary identifications of his bathers with prostitutes, especially in light of opinions like those held by Diego Martelli on the prostituted

state of all women in patriarchal society, and wonder, indeed, if the more ambiguous of the bather images in this regard (e.g., fig. 18, where the black stockings and ornate chandelier suggest a brothel setting) may not have reflected a conscious appreciation of that irony on Degas's part. For while the bather images are for the most part very different in their focus and in their physical expressiveness from the grossly caricatured women of the brothel monotypes, selected pairings, as has been seen, will sometimes reveal startling analogies in posture and behavior between the women who are presented in both genres [12–15]. While one cannot rule out the strong probability that Degas, even though he worked from posed models, was simply drawing repetitively upon a large but not inexhaustible repertoire of stock figure types and poses (as he did in the ballet and racing pictures where figure types also occasionally recur), one also can-

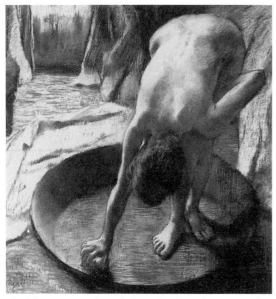

not entirely rule out the possibility that such repetitions and analogies were purposeful ones, made self-consciously for expressive or even ideological reasons. For such visual analogies, certainly, would seem to challenge most effectively (albeit privately and obliquely, since the brothel monotypes were not widely known) the regulationist position that prostitutes were by nature different from "respectable" women, the position that was being used throughout this period to justify the hotly contested segregation, exploitation, and commodification of the registered prostitute.

When Degas was at work on his brothel monotypes, then, there were two sides to the debate over prostitution in France that were being voiced openly in the press; and there is now compelling evidence to suggest that Degas would have been personally exposed to the "other" side of that debate, the feminist side, through his association

16. Edgar Degas, *The Tub*, from the *Suite de nus*, pastel on paper, 1886. Farmington, Conn., Hill-Stead Museum.

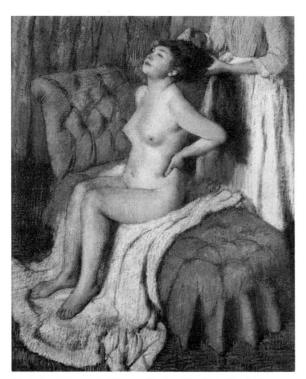

17. Edgar Degas, *A Woman Having Her Hair Combed*, from the *Suite de nus*, pastel on paper, ca. 1885–86. New York, Metropolitan Museum of Art, Bequest of Mrs. H. O. Havemeyer, The H. O. Havemeyer Collection, 1929.

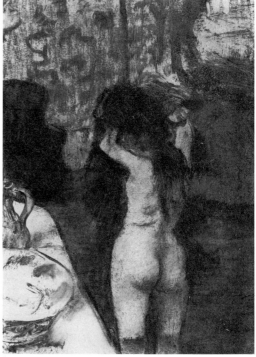

18. Edgar Degas, *Toilette* (?), monotype in black ink with pastel, ca. 1879. Chicago, private collection *(Courtesy of B. C. Holland, Inc.)*.

with Diego Martelli at this time. But even without positing Degas's complete agreement with Martelli's point of view on this or any other feminist issue, in the future, I believe, that point of view must form part of the necessary social context in which not only the brothel monotypes and bather images, but all of Degas's works from this period, including the revised (ca. 1880) version of "The Young Spartans," must be seen if their meanings are to be intelligently explored.

Although I would continue to argue, as I first did more than ten years ago, against the idea that Degas was a "misogynist," my intention now is not to assert that Degas was a "feminist" (as his socially progressive friend Martelli clearly was), but only to establish that feminism and its principles were an increasingly visible part of the modern world that Degas had set himself to interpret.

In this context, then, as I have suggested, the wary response of the young men at the right in Degas's "The Young Spartans" to the aggressive young women at the left may indeed reflect a component of fear and anxiety—not *Degas's* personal fear of women as later writers have claimed, but, rather, his perception of the fears of male society as a whole, as these would have been stimulated and evoked by the growing feminist movement of his period. We need not, in fact, attempt to attribute to Degas himself anything more than the confusion and ambivalence that were probably felt by most men of his generation toward the feminist movement in order for these issues to be relevant to our understanding of the complex and highly charged meanings of Degas's images of contemporary life, both to the artist and to his contemporaries.

NOTES

This article grew out of a paper delivered at the joint meetings of the College Art Association and the Women's Caucus for Art in New York City in February of 1986. I am grateful to The American University for the grant awarded me in the summer of 1987, which permitted me to complete my research, and to the staffs of the Bibliothèque Marguerite Durand in Paris and the Biblioteca Marucelliana in Florence for their generous assistance. My thanks go also to my colleague Mary D. Garrard, who encouraged and assisted the development of this article in many practical and important ways.

1. In the catalogue of the Fifth Impressionist Exhibition, the picture is listed as No. 33, with the title "Petites filles Spartiates provoquant des garçons (1860)." But it was apparently not exhibited. Its absence from the show, which opened on 1 April and closed on 30 April 1880, was specifically noted by Gustave Goetschy in a review that appeared in *Le Voltaire* on 6 April (see C.S. Moffett, "Disarray and Disappointment," in *The New Painting: Impressionism, 1874–1886,* exh. cat., The Fine Arts Museums of San Francisco, 1986, 299, 301, 309, n. 43, and 311).

The verb "provoquer," used by Degas for the title in the catalogue of 1880, can mean, according to Larousse, "to provoke, to incite, to bring on; to instigate; to challenge." Though the term "provoking," with its implication of sexual enticement, is the one most frequently used in English translations of the title, I prefer to translate Degas's "provoquant" instead with the equally correct "challenging," which, as I hope this article will show, more accurately reflects what Degas may have had in mind in 1880.

2. N. Broude, "Degas's 'Misogyny,' " *Art Bulletin,* LIX, 1977, 95–107, and esp. 99–100.

3. C. Salus, "Degas' *Young Spartans Exercising,* " *Art Bulletin,* LXVII, 1985, 501–6.

4. Ibid., 504.

5. See D. Halévy, *Degas parle,* Paris-Geneva, 1960, 14.

6. Plutarch, *Lives,* trans. B. Perrin *(Loeb Classical Library),* 11 vols., London and Cambridge, Mass., 1967, I, 259, 263, 265. On the sexual identity of these figures, see also L. Nochlin, "Letter to the Editor," *Art Bulletin,* LXVIII, 1986, 486–87; and R. Rosenblum, "Letter to the Editor," LXIX, 1987, 298. Although Nochlin appears to accept Salus's identification of Degas's subject as a Spartan courtship rite, she cites elements in the picture that appear to contradict or mask its presumed iconography, and she argues, correctly, I believe, for a more psychologically complex interpretation of the picture's meaning.

7. In addition to the Edinburgh portrait reproduced here, there is another large-scale painted portrait of Martelli by Degas in the Museo National in Buenos Aires. See P.-A. Lemoisne, *Degas et son oeuvre,* Paris, 1946–49, II, cat. 519 and 520. The standard biography on Martelli is by Piero Dini, with the collaboration of Alba del Soldato, *Diego Martelli,* Florence, 1978. Martelli's sojourn in Paris in 1878–79 was the last of four trips that he made to the

French capital (the others were in 1862, 1869, and 1870). He left Italy on 30 March 1878 and was back home again in Castiglioncello on 20 April 1879. On Martelli's trips to Paris, see Dini, chap. IV, 125–56.

8. D. Martelli, "Gli Impressionisti," text of a lecture delivered at the Circolo Filologico in Livorno in 1879 and published as a pamphlet at Pisa in 1880; repr. in *Scritti d'arte di Diego Martelli*, ed. A. Boschetto, Florence, 1952, 98–110; this quotation is on p. 105.

9. See T. Reff, "New Light on Degas's Copies," *Burlington Magazine*, CVI, 1964, 257 and nn. 71–73.

10. See D. Burnell, "Degas and His 'Young Spartans Exercising,'" *Art Institute of Chicago Museum Studies*, IV, 1969, 49–65, for a review of scholarly opinion in regard to the dating of both the London and Chicago versions of the painting and related studies.

11. T. Reff, *The Notebooks of Edgar Degas: A Catalogue of the Thirty-eight Notebooks in the Bibliothèque Nationale and Other Collections*, 2 vols., Oxford, 1976, I, 99–100 (notebook 18, p. 202).

12. P.K. Bidelman, *Pariahs Stand Up! The Founding of the Liberal Feminist Movement in France, 1858–1889*, Westport, Conn., 1982, 63 and 230, n. 114. See also K.M. Offen, "The 'Woman Question' as a Social Issue in Nineteenth-Century France," *Third Republic*, Nos. 3–4, 1977, 238–99. An impressive literature exists to document and analyze the French feminist movement of the 19th century. Among the most helpful of the recent works in English, in addition to Bidelman's book cited above, is C.G. Moses, *French Feminism in the Nineteenth Century*, Albany, 1984. See also L. Abensour, *Histoire générale du féminisme: Des Origines à nos jours* (Paris, 1921) repr., Geneva, 1979; S. Grinberg, *Historique du mouvement suffragiste depuis 1848*, Paris, 1926; and Li Dzeh-Djen, *La Press féministe en France de 1869 à 1914*, Paris, 1934. Essential for research in this field are the holdings of the Bibliothèque Marguerite Durand in Paris. A research library now housed in the *mairie* of the fifth *arrondissement*, it was created in 1897 by Marguerite Durand (1864–1936), who was director of the feminist journal *La Fronde*, and who donated her library to the city of Paris in 1931. In addition to published books and journals of the period, its holdings include thousands of newspaper clippings, pamphlets, and letters, which have been organized into dossiers under the names of feminist leaders, organizations, and congresses.

13. The books in question were: P.-J. Proudhon, *De la Justice dans la Révolution et dans l'église*, 3 vols., Paris, 1858 (which included two chapters on women and the family), and his last work, *La Pornocratie ou les femmes dans les temps modernes*, Paris, n.d., incomplete and published posthumously, in which he devoted himself to combating the feminist position; and J. Michelet, *L'Amour*, Paris, 1858, and *La Femme*, Paris, 1860. (Enormously

popular, both of Michelet's books were published in dozens of editions well into the early part of the 20th century.)

14. J. Lamber (Mme Adam), *Idées anti-proudhoniennes sur l'amour, la femme, et le mariage* (1858), 2nd ed., Paris, 1861; and J. d'Héricourt, *La Femme affranchie; réponse à MM. Michelet, Proudhon, E. de Girardin, A. Comte et aux autres novateurs modernes*, 2 vols., Brussels, 1860 (Eng. ed., *A Woman's Philosophy of Woman; or Woman Affranchised*, New York, 1864).

15. *Le Droit des femmes* was a weekly newspaper until 1876. Then it became a monthly review; and after 1885, it was published biweekly. In September of 1871, Richer changed its name to *L'Avenir des femmes* (in response to the government's contention, during the early days of the Third Republic, that the definition of "rights" was solely its prerogative). But in 1879, after the victories of the republicans at the polls and the subsequent lifting of an earlier government ban on meetings of the Amelioration Society, he restored the journal's original title (see Moses, 186; and Bidelman, 94 and 96).

16. For the announcement of the program and list of delegates, see *Le Droit des femmes*, X, 164, 1878, 97ff. See also the report on the Congress after its opening, ibid., X, 165, 1878.

17. The acts and resolutions of the Congress appear in *L'Avenir des femmes*, X, 166, 1878, 131–33.

18. For a discussion of the press coverage and a reprint of the article by Sarcey, see *L'Avenir des femmes*, X, 165, 1878, 117.

19. See Moses, 32, 209, 210, 233. For a contemporary report on the developing debate, see also J. Mercoeur, "Questions d'enseignement," *Le Droit des femmes*, XI, 174, 1879, 70.

20. A liberal divorce law of 1792, which had granted divorce on demand, was amended in favor of the male partner in 1804, and then repealed in 1816 (see Moses, 18–19).

21. Naquet's proposal for the reestablishment of divorce appears in *Le Droit des femmes*, XI, 174, 1879, 68–70. The June issue (XI, 175) reports Naquet's preliminary victory in the Chamber of Deputies and reprints a recent article from the *Télégraphe* in which arguments in favor of the proposed law had been set forth (pp. 84–85).

22. H. Auclert, *Historique de la société du droit des femmes 1876–1880*, Paris, 1881, 18–19; as quoted and translated by Bidelman, 109.

23. "Le Congrès, partant de ce principe, l'égalité absolue des deus sexes, reconnaît aux femmes les mêmes droits sociaux et politiques des hommes." For the resolutions of the Congress, see *Séances du Congrès Ouvrier Socialiste de France (Troisième session tenue à Marseilles du 20 au 31 Octobre 1879 à la salle des Folies Bergères)*, Marseilles, 1879, 801–5; this quotation is on p. 804. For the report on the session "De la femme," see pp. 145–223.

24. Report on "Le Congrès Ouvrier Socialiste," dated Marseilles, 24 October, in *Le Figaro,* 25 année, 3ᵉ série, n. 298, 25 October 1879, 2. Establishing Auclert as a feminist and a radical, the writer describes her as "la citoyenne Hubertine Auclerc [sic] de Paris, rentière délégué des Sociétés des Droits de Femme et des Travailleuses de Belleville."

25. For details, see Bidelman, 125ff.

26. See Alexander Dumas *fils, Les Femmes qui tuent et les femmes qui votent,* Paris, 1880. For his earlier, antifeminist position, see *L'homme-femme: Réponse à M. Henri Ideville,* Paris, 1872.

27. Bidelman, 126. The women who participated in Auclert's tax strike would have been for the most part single or widowed, since the law gave men complete control over their wives' finances.

28. For a review of the literary sources to which Degas had access, see Salus (as in n. 3), 501–2.

29. H. Adhémar, "Edgar Degas et la 'Scène de guerre au Moyen Age,'" *Gazette des beaux-arts,* LXX, 1967, 295–98.

30. Richard Brettell has written: "Comparison of Degas's composition with that of *The Oath of the Horatii* reveals an element of satire on the part of Degas. Indeed, the gesturing girl at the left is almost a caricature of the young oath-takers in David's famous painting" (R.R. Brettell and S.F. McCullagh, *Degas in The Art Institute of Chicago,* Chicago and New York, 1984, 34–35).

31. See R. McMullen, *Degas, His Life, Times, and Work,* Boston, 1984, 188ff. Suggesting Degas's openness as well to even more radical positions during this period, McMullen writes: "There can be no doubt . . . about Degas's being a republican at this time. Indeed, Madame Morisot, who was herself a very moderate anti-Bonapartist, one day completely lost her always short temper and put him in the same category as the ruffian, wild-eyed radicals of Belleville (one of the most socialist quarters of Paris), which was a gross exaggeration but an enlightening one" (ibid., 189).

32. A selection of Martelli's writings on art have been published as *Scritti d'arte di Diego Martelli,* ed. A. Boschetto, Florence, 1952. Drafts of these and other articles by him, as well as his personal correspondence (most of it unpublished), are preserved in the Biblioteca Marucelliana in Florence.

33. D. Martelli, "La sentinella all'esposizione di Parigi," *La sentinella bresciana,* XX, 214 and 224, Aug. 4 and 14, 1878.

34. See Bidelman, 96–97, and 100. The Italian members of the Congress's Committee of Initiative are mentioned in *L'Avenir des femmes,* X, 163, and X, 164, 1878, 98.

35. A list of registered delegates to the Congress was published in *L'Avenir des femmes,* X, 165, 1878.

36. For a report from Italy on Morelli's legislative initiatives, see ibid., X, 164, 1878, 111.

37. Martelli's mother, Ernesta Martelli, wrote to him about the lecture in a letter of 10 May 1878 (Carteggio Martelli, A XXVI, Biblioteca Marucelliana); cited by E.G. Calingaert, "Diego Martelli, a Man of the Twentieth Century in the 1880s: Art Criticism and Patronage in Florence, 1861–1896," 2 vols., M.A. thesis, The American University, Washington, D.C., 1985, I, 116. On Martelli's attitudes toward women in general, and his relationships with his mother, his wife, and other women in particular, see Calingaert, I, chap. 5, 107–52, for a discussion that is based extensively on Martelli's unpublished correspondence as well as other sources.

38. Martelli, "La sentinella all'esposizione di Parigi," *La sentinella bresciana,* XX, 214, 4 Aug. 1878, 2.

39. Ibid., 2.

40. Ibid.

41. Ibid., XX, 224, 14 Aug. 1878, 2. See also Calingaert, 117–18.

42. See D. Martelli, "Il divorzio," an article written and published in an as yet unidentified Italian newspaper, ca. 1879 (on the date, see below, n. 45). Martelli's original manuscript for this article is preserved along with the rest of his papers in the Biblioteca Marucelliana in Florence (mss Martelli, "Scritti," IV, No. 47, 410–26). An unidentified newspaper clipping of the published version is in Martelli's "Libretto d'appunti," a small pocket notebook also in the Marucelliana. Using the library's pagination for double pages in that notebook, the passages here quoted can be found on p. 15. For a discussion of this article, see also Calingaert, 108.

43. For Deraismes's views on the family, see Moses, 181–84.

44. In a letter to his mother of 12 August 1878, Martelli mentions that he has been invited to meet Deraismes and indicates his eagerness to meet her. He describes her as "a forty year old woman, with a look more fierce and resolute than a gendarme, who possesses a very rare and very original fertility of mind and education" (Carteggio Martelli, A XXI, Biblioteca Marucelliana; as cited by Calingaert, 119 and 147, n. 42).

45. See above, n. 42. "Il divorzio" was probably written and published during the months immediately following Martelli's return to Italy, in May or June of 1879, for at that time a divorce law was in fact before the Italian Senate, and the article would have been a timely and relevant one (on the proposed Italian divorce law, see E. Cérioli, "Letter from Italy," *Droit des femmes,* June 1879, 109–110). Also, Martelli states in the preface to the article that he had been inspired to write it by the campaign being mounted by Deputy Naquet in France to gather popular support for divorce, so that a law might be presented to the Parliament. This too suggests a date around

May or June of 1879 (see above, p. 644 and n. 21), but does not entirely preclude the possibility that Martelli drafted the article during the weeks or months just prior to his departure from Paris. Martelli's own association of the growth of his views on issues like divorce and women's rights with his experiences in Paris is further reflected by the fact that his clippings of this article (and another on prostitution, which can be dated to 1880—see below, n. 59) are pasted onto the pages of his "libretto d'appunti," a small pocket notebook which he had had with him in France and which contains some of his own drawings of Parisian scenes.

46. Martelli, "Il divorzio," clipping from the "Libretto d'appunti," 14.

47. Ibid., 16. Quoted passage, translated by Calingaert, 109.

48. The brothel monotypes have been catalogued by E.P. Janis, *Degas Monotypes, Essay, Catalogue, and Checklist*, Cambridge, Mass., 1968, checklist Nos. 61–118ff.; and by J. Adhémar and F. Cachin, *Degas, The Complete Etchings, Lithographs and Monotypes*, New York, 1975, Nos. 83–123ff. (Both classify images that belong to the brothel category as simple studies of the nude at her toilette: e.g., Janis, Nos. 184 and 185, and Adhémar, Nos. 129 and 130.) Janis speculates that at the time of his death there may have been in Degas's studio perhaps twice as many brothel monotypes than the fifty-odd now extant (p. xix).

The date of ca. 1878–79, traditionally assigned to the brothel monotypes since Lemoisne's catalogue, has been accepted by most subsequent writers on the subject, with the exception of Adhémar, who cited a lack of concrete evidence and asserted that "it is impossible to date them more precisely than between 1876 and 1885" (p. 276). Janis, whose catalogue placed the brothel monotypes within a range of dates between 1878 and 1880, remained closer to the traditional dating. Nevertheless, she examined and dismissed what had heretofore been the major support for this dating: the assumption that the monotypes were part of a project to illustrate recent novels on prostitution, like J.-K. Huysmans's *Marthe, histoire d'une fille*, published in 1876, or Edmond de Goncourt's *La Fille Elisa*, published in 1877 (Zola's *Nana*, which Janis does not mention in this context, appeared in 1880, and Guy de Maupassant's *La Maison Tellier*, which she does consider, was not published until 1881). "Degas' brothels seem related to the contemporary interest in documenting prostitution," Janis wrote, "but no specific literary work has been found to which they might correspond" (p. xxi).

49. The books, which span the literature from the 1830s to the 1890s, are A.-J.-B. Parent-Duchâtelet, *De la Prostitution dans la ville de Paris*, Brussels, 1837; D.J. Jeannel, *Mémoire sur la prostitution*, Paris, 1862; idem, *La Prostitution dans les grandes villes au XIXe siècle*, Paris, 1868;

A. Veronese, *Della prostituzione*, Florence, 1875; *Commissione per la prostituzione*, Florence, 1889; and *Regolamento della prostituzione*, Florence, 1891 (see Calingaert, I, 148, n. 49).

50. Martelli met Teresa Fabbrini in a Florence brothel in 1862 or early 1863, and by January of 1865 had moved her to his home in Castiglioncello. Although she was never fully accepted by his family and some of his friends, she lived with him for some thirty years as his common-law wife. On their relationship, see Dini (as in n. 7), 267–72; also, Calingaert, I, 121–23.

51. Primarily by T.J. Clark, *The Painting of Modern Life: Paris in the Art of Manet and His Followers*, Princeton, 1984, chap. 2; and by S.H. Clayson, "Representations of Prostitution in Early Third Republic France," Ph.D. dissertation, University of California at Los Angeles, 1984.

52. Clark, 146.

53. In recent years, the applicability of strict Marxist methodology to women's history has been widely challenged. For an overview of some of the literature that has been generated by this interdisciplinary debate, see J.W. Scott, "Gender: A Useful Category of Historical Analysis," *American Historical Review*, XCI, 1986, 1059–61.

54. F. Tristan, *Promenades dans Londres*, Paris, 1840, 110; as cited and translated by Moses, 111.

55. Unidentified and undated quotation from Martelli's writings, in Dini (as in n. 7), 287, n. 13.

56. See C.G. Moses, "The Growing Gap between Republican Feminists and Socialists," in *French Feminism in the Nineteenth Century* (Albany, 1984), 223–26; also C. Sowerwine, *Sisters or Citizens? Women and Socialism in France since 1876* (Cambridge, England, 1982).

57. From the report on the Acts and Resolutions of the Congress, published in *Droit des femmes*, X, 166, 1878. The resolutions of the "Section de morale" appear on pp. 132–33; and those of the "Section économique" on p. 132. See also Moses, 208.

58. On government regulation of prostitution in Italy, see M. Gibson, *Prostitution and the State in Italy, 1860–1915*, New Brunswick and London, 1986.

59. Martelli then proceeds to give examples of the prostitution of women at all levels of society—examples that range from the contemporary queen of Spain, who was reportedly subjected to a humiliating "ceremony" in order to prove the legitimacy of her offspring, and was thus prostituted, Martelli says, "neither more nor less than a poor woman of the streets"; to the virginal, middle-class girl, who was neither physically nor emotionally prepared for the marriage into which she was sold by her parents for social or economic gain (D. Martelli, "La prostituzione," *La lega della democrazia*, 1 August 1880. A clipping of the published article is pasted onto the pages of Martelli's Parisian "libretto d'appunti" in the Biblioteca Marucelliana. These quotations are from the clippings on pp.

17–18 of that notebook).

60. Clayson (as in n. 51), 127 and 128.

61. Charles Bernheimer, "Degas's Brothels: Voyeurism and Ideology," *Representations*, XX 1987, 158–186; these quotations are on pp. 176, 177, 178.

62. Ibid., 123–24.

63. Reff (as in n. 11), I, 130, and II, Notebook 28, pp. 26–27, 29, 31, 33, 35.

64. See above, n. 48. For further discussion of Degas's work in relation to contemporary naturalist novels that dealt with the theme of prostitution, see Clayson (as in n. 51), 139–67.

65. It has been suggested that one of the monotypes, *Dans le Salon d'une maison close* [15], may have been a work described by J.-K. Huysmans in his review of the Sixth Impressionist Exhibition of 1881 (*The New Painting*, 363). This suggestion, however, is unjustified and misleading, for this image does not correspond sufficiently to a work that Huysmans praised for its "flight and movement" and the subject of which he described as "a very striking female nude, at the back of a room." Similarly, the pastel over monotype [18] that is offered in *The New Painting* catalogue as the pastel *Toilette* from the Fifth Exhibition does not correspond convincingly to descriptions cited from contemporary reviews (p. 322). Among the more ambiguous and difficult to classify of the so-called bather images, its inclusion in the catalogue as a work exhibited by Degas is again misleading.

66. *The New Painting*, 120, 161, 204, 311, and 444. (The original catalogue numbers, with the exhibitions indicated in roman numerals, are: I-62; II-55, 56; III-45, 46, 51, 58–60; V-39; VIII-19–28.)

67. E. Lipton, "Degas' Bathers: The Case for Realism," *Arts Magazine*, LIV, 1980, 94–97. This article, revised and expanded, is the basis for chap. 4, "The Bathers: Modernity and Prostitution," in Lipton's more recent book, *Looking into Degas: Uneasy Images of Women and Modern Life*, Berkeley and Los Angeles, 1986.

68. Lipton, 1980, 95; and idem, 1986, 168–69.

69. Lipton, 1980, 94; and idem, 1986, 165–67.

70. Lipton, 1980, 96; and idem, 1986, 179. The contemporary criticism is discussed more fully by Martha Ward in her essay on the Eighth Impressionist Exhibition, "The Rhetoric of Independence and Innovation," in *The New Painting*, 430–34. For an extended discussion of J.-K. Huysmans's response to Degas's nudes in the exhibition of 1886, see C.M. Armstrong, "Odd Man Out: Readings of the Work and Reputation of Edgar Degas," Ph.D. dissertation, Princeton University, 1986, chap. IV, 251–346.

71. H. Fèvre, "L'Exposition des Impressionnistes," *La Revue de demain*, May–June 1886, 154; as cited by Ward, "The Rhetoric of Independence and Innovation," in *The New Painting*, 431.

72. As A.-J.-B. Parent-Duchâtelet, author of the author-

itative work on the subject of prostitution in France in the 19th century, put it: "We will have arrived at the limit of perfection, and of the possible, in this regard, if we arrange it so that men, and in particular those who are looking for [prostitutes], can distinguish them from honest women; but that those women, and especially their daughters, cannot make this distinction, or at least can do so only with difficulty" (*De la Prostitution dans la ville de Paris* [1836], 2 vols., 3rd ed., Paris, 1857, I, 363; as cited and translated by Clark, as in n. 51, 109).

73. See, for example, the comments of Gustave Geffroy in *La Justice*, 26 May 1886 ("he wanted to paint a woman who did not know she was being watched, as one would see her hidden by a curtain or through a keyhole"), as cited by Ward, "The Rhetoric of Independence and Innovation," in *The New Painting*, 432.

74. Edward Snow has written of Degas's bathers: "These women are rendered as physical beings in their own right rather than as projected, complicit objects of masculine desire. [They are] delivered not only from the male gaze but from any introjected awareness of it" (E. Snow, *A Study of Vermeer*, Berkeley, 1979, 28). Eunice Lipton has also emphasized the sensuous privacy and self-absorption of the women in these works (Lipton, 1980, as in n. 67, 96–97). For a careful analysis of the ways in which Degas's formal strategies work to externalize the male viewer from the female subject of the bather images, see C.M. Armstrong, "Edgar Degas and the Representation of the Female Body," in *The Female Body in Western Culture: Contemporary Perspectives*, ed. S.R. Suleiman, Cambridge, Mass., 1986, 230–41. On the basis of these readings, Charles Bernheimer has concluded that contemporary critical reactions to the bather pastels, reactions like those of Huysmans, may be regarded as "a defense of the traditional prerogatives of male spectatorship, especially of the voyeur's implied presence in a position of fantasized mastery, mounted in the face of the dislocation and problematization of that position" (Bernheimer, as in n. 61, 163).

75. See Broude (as in n. 2), 95ff., and Ward, "The Rhetoric of Independence and Innovation," in *The New Painting*, 430ff.

76. M. Hermel, "L'Exposition de peinture de la rue Laffitte," *La France libre*, 27 May 1886; as cited and translated by Ward, in *The New Painting*, 433.

77. Lipton, 1980, as in n. 67, 96.

78. Ibid., 95.

79. Fèvre (as in n. 71), 154; as cited by Ward, "The Rhetoric of Independence and Innovation," in *The New Painting*, 431.

80. P. Adam, "Peintres Impressionnistes," *La Revue contemporaine, littéraire, politique et philosophique*, IV, 1886, as cited in *The New Painting*, cat. entry on p. 454.

81. See Moses, 183.

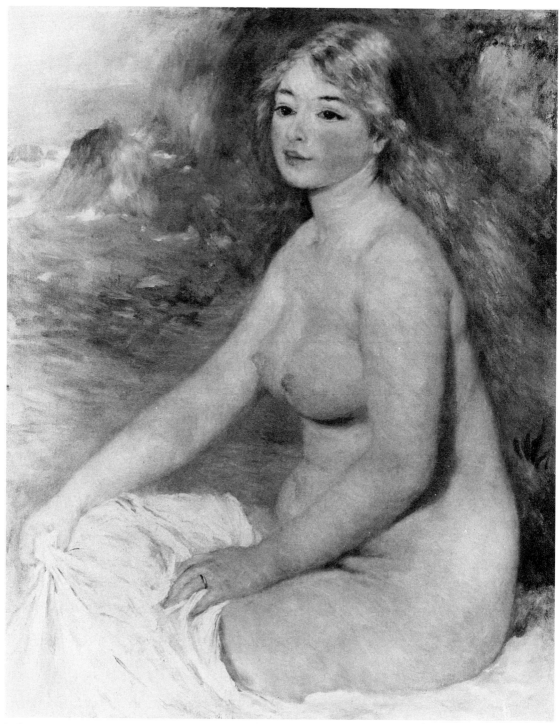

1. Pierre-Auguste Renoir, *Blond Bather I*, 1881. Williamstown, Mass., Sterling and Francine Clark Art Institute.

16

RENOIR AND THE NATURAL WOMAN

—————

TAMAR GARB

Renoir's identification with a tradition in which the idealization of the naked female body is seen as the metaphoric realization of Beauty, Truth and Purity is well documented. In the critical writing he is repeatedly linked to such artists as Titian, Rubens and Boucher in an apparently unbroken tradition of celebration of female beauty through what is called pure painting. In such accounts, the "body of woman" operates as an undeclared extension of matter—earth, nature, pigment—so that the rendering of her flesh is seen to be outside of an ideological construction of womanhood and exists rather as a natural extension of a natural will to form. Renoir's entire painting practice is often accounted for in this light. Paradoxically, critics have repeatedly claimed that his vision was unmediated by the intervention of history, psychology or tradition and unmarred by the barriers of subject matter, while at the same time invoking the tradition in which he should be placed. Joachim Gasquet claimed in 1921 that in Renoir, like Rubens, we love pure painting.[1] Renoir himself is reported by his son Jean as saying that he had no

subject matter, claiming that "what is important is to escape from subject matter, to avoid being literary and so to choose something that everybody knows—still better (to have) no story at all."[2] His friend and dealer Ambroise Vollard recorded that in front of a painting Renoir wanted to experience joy, not search for ideas.[3]

One would have hoped that the 1985 Hayward Gallery Renoir exhibition would have provided an opportunity for a reassessment of the artist in terms which distance themselves from the nineteenth-century categories through which he has traditionally been viewed.[4] An examination of much of the criticism which appeared in the daily and weekly press while the exhibition was on reveals, however, that these categories continue to define the parameters within which debates on Renoir persist.[5] Clive James entitled his review of the Renoir exhibition "Art of an Artless Man," which he accompanied, apparently unproblematically, with the assertion that Renoir "spent a lot of his time in the Louvre soaking up Watteau, Lancret, Boucher and Fragonard."[6] Even more surprising is its juxtaposition on a double-page spread with the artfully contrived image *Gabrielle with Jewelry* [2], in which the flowing transparent robe is deliberately placed to reveal the nipple,

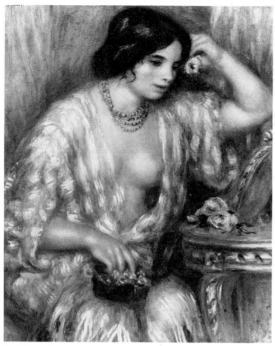

2. Pierre-Auguste Renoir, *Gabrielle with Jewelry,* 1910. Private collection *(Acquavella Galleries, Inc., New York).*

and the hand and jewelry box could not have been more self-consciously arranged, let alone the time-worn conventions of jewelry against flesh, plucked red roses and boudoir mirror.

And yet, while being constructed as the pure painter, Renoir is known, above all, as the painter of women, as though such an enterprise operated on the level of nature, rather than within conventions which must be explained as cultural constructs. Théodore Duret wrote in 1910 that Renoir invested women "with a kind of sensuality, an effect which was by no means deliberately studied but proceeded simply from his immediate perception."[7] Walter Pach, in 1951, claimed that "Above everything else, Renoir is supreme in the history of art as a painter of the female nude."[8] He goes so far as to claim that Renoir's art is a celebration of "the glory and wonder of the female form."[9] Lawrence Gowing's essay in the catalogue for the Hayward exhibition promotes the familiar myth of Renoir as the natural virtuoso painter. "The brush in his hand . . . was part of him; it

shared his faculty of feeling. In Renoir this was more than heroic; it was natural," he writes.[10] Gowing presents Renoir's traditionalism as if it were an extension of his nature, the inevitable result of virtuosity. Rather than overtly stating that his "natural" ability found its expression in the representation of "natural womanhood," Gowing subtly describes Renoir's painting practice in self-consciously phallic terms, so extending Renoir's own ironic assertion that he painted "with his prick."[11] Gowing writes: "An artist's brush had hardly ever been so completely an organ of physical pleasure and so little of anything else as it was in Renoir's hand. Its sensate tip, an inseparable part of him, seemed positively to please itself. In the forms it caressed it awakened the life of feeling and it led them not to a climactic fulfilment but to prolonged and undemanding play without any particular reserve or restraint— or commitment."[12]

In such an account, the very act of painting is male, culture is male, and that which is represented exists in the order of nature so that "woman," Renoir's most frequent subject, is seen to operate on this physical and "primitive" level beyond culture.[13] In this way, the apparent contradiction in the legacy of Renoir criticism between the pure painter capable of spontaneous and intuitive responses on the one hand and the celebrator of female beauty on the other is resolved. For as long as "woman" is seen as an extension of nature, her identity as subject can be erased and she can be subsumed in true modernist fashion into a painting practice which is said to be pure and acutely aware of its own means.

The "silence" over Renoir's subject matter has, therefore, two sources. One is the dominance of modernist perspectives which have characterized the writing of much art history from Renoir's time to our own. The second is the continuation in our own century of a way of seeing women which is compatible with the constructions that Renoir and his contemporaries erected. One of the links here is the highly influential biography of his father by Jean Renoir, so useful not necessarily because of the accuracy of its specific recordings, but because of the lack of ideological distancing be-

tween the writer and his subject. Jean Renoir becomes, by default, a reliable source, because he interposes so little critical distance between himself and his father. The book's usefulness lies in a recognition of its apparent normative authority, which makes it one of the dominant texts which has been instrumental in the construction of the myth of Renoir as the intuitive artist whose responses to nature and therefore to women are unmediated. The practice of painting naked women continues to be seen as an inevitable response to nature and not shaped within deeply rooted ideological assumptions about the nature of "woman" and the nature of "art."

The ostensible lack of subject matter to which Renoir, his biographers and critics allude obscures, therefore, the content of a range of images steeped in nineteenth-century constructions of femininity, the image of "woman," of motherhood and of the family. It is in its evasion of reality that Renoir's enterprise can be located, although much current criticism has subtly invoked its "realism."[14] Terence Brady, for example, titled his *Daily Mail* article "In Praise of *Real* Women" and used the Renoir exhibition as an opportunity to bemoan the state of contemporary womanhood.[15] As no separation seems to exist between Brady's mythology and that of Renoir's, he is unable to distance himself from the level of myth at which Renoir's imagery operates. By obscuring the real relationships between people, classes and genders, Renoir gives form to a fin-de-siècle fantasy which still has currency today.

Renoir's evasion of reality produced an idealized, timeless and therefore mythic vision of women. Such a construction, rather than operating as a hymn of praise as is so often assumed, must ultimately be oppressive because of its inability to engage with the reality of women's lives. Moreover, the obverse side of the myth of ideal womanhood, as propounded by so many thinkers, writers and artists in the nineteenth century, was the denial of women's needs for rights, privileges and responsibilities deemed natural to men, in the name of some essential femininity. Such idealism, coupled with a circumscribing of women's lives, is

typical of writers such as Ruskin in England and Michelet in France.[16] While extolling female purity and grace, they used so-called female weakness to invoke their economic, intellectual and spiritual dependence on men in the name of the salvation of women. The price paid for idealization was recognized by nineteenth-century feminists in Britain and France. Millicent Fawcett in Britain declared: "We talk about 'women and women's suffrage,' we do not talk about Women with a capital W. That we leave to our enemies."[17] Jenny P. d'Héricourt, in her 1860 publication *La Femme affranchie*, wrote: "Woman according to Michelet is a being of nature opposite to that of man, a creature weak, always wounded, exceedingly barometrical and consequently unfit for labour . . . created for man she is the altar of his art, his refreshment, his consolation."[18] Paule Mink, a communarde and an activist in the women's rights and working-class movements in Paris in the 1860s, addressed the public on behalf of women's right to work in July 1868, stating:

Many of you gentlemen recognise no duty for woman other than that of being a wife, no right other than that of being a mother. This is the feminine ideal, so you say. Ah! Let's have less of the ideal, thank you. Let's stay a bit more on practical ground, for these appeals to the ideal tend to destroy the best, the most fruitful questions.[19]

The sphere of practice in which pronouncements on the feminine ideal proliferate is that of "high art." Through its discourses the privileged position of the male artist, critic, collector and historian is legitimized in the conflation of appreciation for "beauty" with the admiration of the female form. Nowhere is this better demonstrated than in Renoir's *Portrait of Ambroise Vollard* [3], where the thick-set balding collector caresses the Maillol statuette of a classical female nude while gazing at it appreciatively. Vollard's discernment as connoisseur is assured not only by his authoritative handling of a miniature objet d'art but in his implicit power over the body of "woman" caught in the firm grasp of his hand and controlled by the power of his gaze. The prerogative of men to *describe* female beauty from the

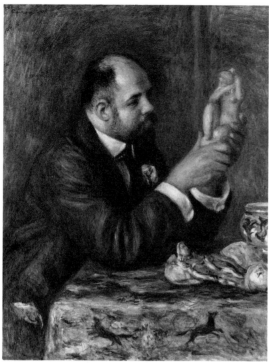

3. Pierre-Auguste Renoir, *Portrait of Ambroise
Vollard*, 1908. London, Courtauld Institute
Galleries, Courtauld Collection.

safe position of the observer is enshrined in that
cultural practice which deems such an apprecia-
tion to be within the province of "aesthetics."

The nineteenth-century worship of a remote,
sanitized female beauty bore little relation to the
way that male artists and writers related to the
actual women with whom they came into contact.
We are even told by Renoir's friend Georges Ri-
vière that Renoir was a misogynist. While he was
charmed by young women and enjoyed their com-
pany, writes Rivière, he found the constant pres-
ence of women around him disagreeable as it
made him feel as though part of his independence
had been stolen.[20] Jean Renoir reports, on the
other hand, that his father bloomed in the com-
pany of women and the family home was always
filled with them.[21] But Renoir ensured that he
was able to keep his distance when he wanted to.
He and his wife adopted the bourgeois practice of
having separate bedrooms, the studio was his own

private haven and models and servants would be
summoned to the "Boss," as they called him,
when needed.

Renoir's professed reasons for enjoying the
company of women indicate how he viewed them.
Rivière recorded that he loved women, children
and cats for the same reason, that is their tena-
cious way of satisfying themselves without regard
for the consequences, their essential amorality;
like children, he believed, they lived impulsively
and according to the "logic of their instincts."[22]
Such a view of women was in no way idiosyncratic.
The belief in the separate spheres of masculinity
and femininity, in women's animal nature and
their rootedness within their own biology was pro-
duced and reproduced through philosophical, reli-
gious, legal, medical and pictorial discourses in the
nineteenth century. Women's very physiology
was seen to be closer to nature than men's. As
Simone de Beauvoir put it, the female seems to be
"more enslaved to the species than the male, her
animality is more manifest. . . . Because of
women's greater bodily involvement with the nat-
ural functions surrounding reproduction, she is
seen as more a part of nature than man is."[23] De
Beauvoir goes on to say that those social and cul-
tural functions that women traditionally perform
in the domestic sphere and in the nurturing and
education of the young come to be seen as an
extension of women's nature rather than as work
or participation in human culture.

Nineteenth-century medical discourses pro-
duced women not only as confined within their
own biology but as permanently in a state of ill-
ness. Woman's nature and her inevitable pathol-
ogy was seen to stem from her womb, and men-
struation ensured that she was in a permanent
state of instability. Both Rousseau and Michelet
wrote that women were ill every month and a
Parisian doctor, Icard, published a book on
women during menstruation in 1890 in which he
claimed that an intellectual education was inap-
propriate to the vocations and aspirations of
women, as intellectual stress in puberty could have
a derogatory effect on the development of
woman's reproductive organs. Women's bodies as
well as their minds were frail and all their strength

had to be conserved for their prime function, reproduction.[24]

Renoir, like many of his contemporaries, believed that women's danger lay in their natural powers of seduction, so that the association of women with nature is not always seen as a benevolent one.[25] The power of women to destroy was symbolized during Renoir's time by the image of the rapacious prostitute who consumes the defenseless male. It is Zola who outlines this aspect of women's nature so graphically in his notes for his "realist" novel *Nana*. He describes her as ending up "regarding man as a material to exploit, becoming a true force of Nature, by means of her sex and her strong female odour, destroying everything she approaches, and turning society sour just as women having a period turn milk sour."[26]

Already in the nineteenth century feminists were contesting the idea that women were weak by nature and rendered invalids by their biology, but their voice was a minority, though a vocal one. Jenny P. d'Héricourt invoked the reality of women's lives to prove that the theory that they are in a permanent state of illness is false and pointed to the diseases suffered by men to expose the lack of logic in this argument.[27] Women worked throughout the nineteenth century, although, because their proper place was believed to be in the home by theorists on both the left and the right, little attention was given to the conditions under which they worked or to the paltry wages which they earned.

The explosion of images of bathing women during this period can be understood within the context of the range of discourses which, as we have seen, placed women in the sphere of nature. It was not so much that such an idea was new in the second half of the nineteenth century, but that it became increasingly vocally challenged and therefore defended. To Renoir, the "nudity of women seemed natural . . . whereas he was embarrassed by the naked male body."[28] Female nudes were shown reclining in the vegetation as in countless Renoir paintings (for example, London's National Gallery's *Water Nymph*) or in Salon nudes such as Wencker's *Bather* [4], shown at the Salon of 1883, or posing by the sea or in watery glades, as in Renoir's *Blond Bather I* of 1881 [1], or Bouguereau's *Bather* [5], or seated drying themselves, displaying themselves for the viewer, arranging their hair, partially covered in ways which juxtapose flesh with drapery, or playing and lying together in ways which invoke the many lesbian images popular in the nineteenth century [6]. The atmosphere evoked is one of calm, languid pleasure. The settings for these scenes are often remote and idealized. Although robbed of her status as goddess or nymph because of the absence of specific anecdotal referents in the Renoir images, the mythic image of woman remains intact, so that while there is indeed no "story" in these paintings, they form part of a deeper level of narrative, produced around the image of woman. "They're trying to do away with Neptune and Venus. But they

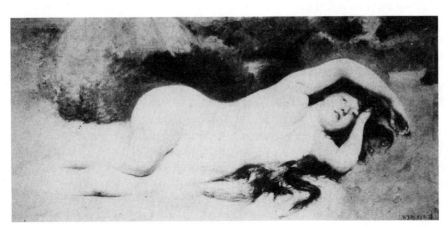

4. Joseph Wencker, *Bather*, 1883 Salon. Whereabouts unknown.

5. William-Adolphe Bouguereau, *Bather*,
1883 Salon. Whereabouts unknown.

other natural phenomenon in a natural paradise. As a being fused with nature, the naked woman provides writers with a symbol of all that is good and wholesome. The body of woman comes to signify renewal, rebirth and hope. It is in this vein that Jean Renoir writes that Renoir's nudes "declared to the men of this century, already deep in their task of destruction, the stability of the eternal balance of Nature." For Jean Renoir and many of Renoir's critics, his nudes function as a reassuring reminder of the stability of the natural universe, an assurance that all is well despite the horrors of twentieth-century reality. It is this idea which characterized so much of the criticism of the Hayward exhibition, with Renoir promoted as the preserver of good old-fashioned values; so for example, Clive James was able to write that "He [Renoir] was strong enough to say that real things included love, desire and fat children."[30]

The retreat to Arcadian nature worship with its nostalgic overtones and the positioning of women within a fantastic natural paradise functions as a resistance to the political and social demands which were being made by feminists, both male and female, during the French Third Republic with unprecedented intensity. Although many crucial feminist texts were published in the 1860s, the Third Republic saw the first sustained and organized feminist movement in France and it was during this period that long-held views were most consistently challenged, so that positions became visibly polarized. Renoir's position on feminism was clear. His frequent allusions to it indicate his awareness of women's growing aspirations. "When women were slaves they were really mistresses. Now that they have begun to have rights, they are losing their importance. When they become men's equals they will really be slaves," he said.[31] Renoir's statements reveal his awareness of the rising dissatisfaction of nineteenth-century feminists with the limited educational and professional opportunities available to women. Jean Renoir writes that Renoir "would punctuate his statements about the superiority of women by a few jibes at their newly acquired desire for independence and education. When someone mentioned a woman lawyer, he shook his

won't succeed. Venus is here for eternity—at least as Botticelli painted her," Renoir is reported to have said.[29] Resting or playing, animal-like in the vegetation, woman exists without thought, conflict or even self-consciousness. There is in these paintings no confronting gaze—at most we feel a coquettish awareness of being surveyed—there is no command of the space occupied. Rarely have women been more available. Content in a state of original innocence, woman is powerless, she exists only for her flesh. Her nakedness is an expression of her submission to the viewer, her body is often twisted to reveal her breasts or thighs and her passivity or harmless playfulness reassures the viewer of his mastery over her.

In Renoir's images of the nude the very painterliness of his technique, with its lack of differentiation of texture, fuses the body of woman with the vegetation that surrounds her. The female body dissolves into the landscape, becoming yet an-

head and remarked, 'I can't see myself getting into bed with a lawyer . . . I like women best when they don't know how to read; and when they wipe their baby's behind themselves.' "[32]

Renoir's statement points to one of the key areas of focus within feminist discourse which challenged the traditionally held belief in the incompatibility between women as rational thinking citizens on the one hand and women's legendary gentle nature and identity as wife and mother on the other.[33] (Of course Renoir adds the dimensions of women's desirability, about which feminists were not concerned.) Renoir's view can be easily located within the debates of the time. It was a typical one and one which was expressed across the political spectrum. As the suffragette Hubertine Auclert stated as late as 1904: "Revolutionaries and reactionaries, believers and atheists, have shown that they are absolutely in agreement to despoil French women of their rights."[34] Most particularly, Renoir's statements echo those of Proudhon and his followers.[35] Proudhon wrote: "Equality of civil and political rights would mean that the privileges and grace that nature has bestowed on women would be bound up with man's utilitarian faculties. The result of this bargaining would mean that women, instead of being elevated, would become denatured or debased. By the ideal nature of her being, woman is . . . of priceless value. If she were to be on an equal footing with man in public life, he would find her odious and ugly."[36]

In keeping with his general prescriptions for women, Renoir's opinion of professional women was very low. "I consider women writers, lawyers and politicians [such as] George Sand, Mme [Juliette] Adam and other bores as monsters and nothing but five-legged calves. The woman artist is merely ridiculous, but I am in favor of the female singer and dancer. In Antiquity and among simple peoples, the woman sings and dances and does not therefore become less feminine. Gracefulness is her domain and even a duty,"[37] he is reported to have said. Renoir's ideas on women and work stem from his adherence to the dominant "femme au foyer" doctrine. He once said to his son Jean: "If you ever marry, keep your wife

at home. Her business is to look after you and your children if you have any."[38] He did not believe, though, that women should become "lazy" at home, as he placed a high premium on exercise "and the best exercise for a woman is to kneel down and scrub floors, light fires or do the washing, their bellies need movement of that sort," he claimed.[39] Without such exercise, he believed, society would produce women who would not be capable of enjoying sexual intercourse to the full.

Many of Renoir's paintings represent women performing domestic chores with apparent ease and enjoyment. This is in keeping with his idea that domestic work was an extension of women's nature. In the *Inn of Mother Anthony at Marlotte* (1866), for example, the men converse while the woman clears the dishes "unobtrusively," and in *Breakfast at Berneval* (1898) the woman stands by the table in the interior space attending to the demands of the young child, while the older male child reads just outside the space. In the washerwomen series an image of harmonious commu-

6. Pierre-Auguste Renoir, *Seated Bather*, 1914. Art Institute of Chicago.

7. Pierre-Auguste Renoir,
Washerwomen at Cagnes, ca.
1912. Private collection *(Eileen
Tweedy).*

nion with nature is conjured up by the flowing
rhythms of the women's bent bodies performing
their daily rituals in a sun-filled paradise, as in the
Washerwomen at Cagnes (ca. 1912) [7]. The
overall paint surface, the undifferentiated facture,
the echoing of the rhythms of bodies and land-
scape and the apparent ease with which the
women perform their work construct the vision of
a natural unity in which everything is in its right-
ful place.

For Renoir, true women were not intellectually
aware. Jean Renoir recalled that he often men-
tioned the "gift women have of living for the
moment," although he restricted such praise for
women who "do housework or other kinds of
work. The lazy ones get too many notions into
their heads. They become intellectuals; lose their
sense of eternity, and are no good to paint any
more."[40] Renoir's aversion to models who
thought is legendary. His son recalled his anger
when a painting of his was sold at Sotheby's in
London with the title *La Pensée.* "My models
don't think at all," he is reputed to have said, and
a glance at any of his monumental late nudes with
their tiny heads and glazed eyes is evidence that

any thoughts which might have existed in the
minds of his actual models have been erased in the
process of creating the mythic painted image of
women. Renoir hated "les modèles expressifs."
Vollard describes his frustration with a certain
model who, although pretty, always looked as
though she had a world of thoughts in her head.
One day, in exasperation, he is said to have asked
her what she was thinking. She answered that she
was "worried whether the food in the kitchen had
burnt." As the wife of a hotel keeper, this was
obviously an important concern, but Vollard sup-
plies this information as if to demonstrate the
triviality of her concerns.[41] Indeed the idea of
women thinking at all was often thought inappro-
priate in Renoir's time. George Moore described
George Eliot as "one of those women who so
entirely mistook her vocation as to attempt to
think. . . ." Such a woman in Moore's view is
"sexless" and her works are therefore flawed.[42]

Michelet was convinced of women's inability to
abstract and of their innate weakness. Proudhon
and Michelet's writings stimulated an explosion of
response by feminists denouncing their views. The
term "proudhonien" became synonymous with

misogynist in the feminist press. Initial feminist reaction was stimulated by the publication of Proudhon's *La Justice dans la révolution et dans l'eglise,* in which he outlined his belief in women's inferiority and on chaste marriage as the only fulfillment appropriate to their natures. Michelet and Proudhon extolled women's domestic virtues and Proudhon argued that the only way to stop the ravages of capitalist industry on the female sex was to ban women's work altogether so that they would remain entirely in the home. Proudhon's famous *Pornocratie* was written in response to a number of feminist critiques of his earlier pronouncements.[43] These were by Juliette Lambert (later Mme Adam, one of the women to whom Renoir referred as a "five-legged calf"), who wrote *Ideés anti-Proudhoniennes sur l'amour, la femme et le mariage* (1858) and Mme Jenny P. d' Héricourt's two publications, the first "Proudhon and the Woman Question," published in the *Revue philosophique* in 1856, the second *La Femme affranchie: résponse à MM Michelet, Proudhon, E. de Girardin, A. Comte et autres novateurs modernes.* [44] In his answer to their challenges, Proudhon presented his critics as unnatural imbeciles, calling them the "dames patronesses" of "cette pornocratie" which France had, in his opinion, become. This terminology relates to the only legitimate options which Proudhon allowed for women in his philosophy, that of "ménagère" or "courtisane." The intellectual woman, having abdicated from her "true" vocation, becomes associated with the prostitute. Proudhon believed that women who worked deprived men of their jobs and should, therefore, be considered as thieves.[45]

It is "nature," then, that is repeatedly invoked as the originator of the separate spheres of masculinity and femininity. Proudhon had claimed that if "you alter this system you alter the natural order of things."[46] The extremes to which such a view can be taken is demonstrated in Vicomte Louis de Bonald's views:

Look at nature and admire how it distinguished the sex that it calls to exercise public functions from that which it destines to the cares of the family: it gives to the one from the most tender age, the taste for political and even religious *action,* the taste for arms, for religious ceremonies; it gives to the other the taste for sedentary and domestic works, for household cares, for dolls.[47]

The extent to which such demarcations of the natural spheres of men and women existed across the political spectrum is demonstrated by the way that the doctrine of the "femme au foyer," championed by the Catholic church, was promoted with almost equal zeal by the leadership of the Third Republic. Jules Simon wrote: "What is man's vocation? It is to be a good citizen. And woman's? It is to be a good wife and a good mother."[48]

Debates around the separate spheres became central in the feminist publications of the Third Republic. Hubertine Auclert was one of the most vocal challengers of this doctrine, claiming that to be a man or woman has as little importance in the distribution of social functions as to be tall or short, fat or thin, blond or brunette. "Moral and intellectual qualities are absolutely independent of the individual who possesses them," she wrote.[49] Such a proposition, however, was so much of an anathema within the nineteenth-century context that support for Auclert's political program was minuscule. Her most radical insight was that women's responsibilities as mothers did not render them incompatible with the right to vote and her understanding that female emancipation would not come automatically with republicanism.

There is no doubt that Renoir came into contact with independent and powerful women and that he was aware of current debates on the "woman question." Mme Adam, whom he so denigrated, was one of France's foremost political journalists and a regular frequenter of the republican salon of Mme Charpentier. It was she who had termed Proudhon and men like him "quintessential abstractors" who "want to return us to patriarchy by imprisoning women in the family."[50] The year 1878, during which Renoir painted the portrait of Mme Charpentier and her children (New York, Metropolitan Museum of Art) and when he must have been a frequent visitor at the Charpentier salon, was also the year of the first French Congress for Woman's Rights

convened by Maria Deraismes and Léon Richer.[51] It was only in 1878 that French feminists felt that the republic was secure enough to bear the divisions which debates on feminism would provoke and there can be little doubt that it stimulated at least some discussion in the Charpentier salon, which attracted leading republican figures.[52] It was at this congress that a sizable number of people demanded, for the first time, reform in women's education, employment and civil rights and urged the republic to eliminate all discrimination. The "threat" posed by the intellectual woman was widely felt. The image of the woman artist and of the emancipated woman had conjured up a vision of an unnatural species which would threaten the very fabric of society long before Renoir harbored such views. In his own time, Barbey d'Aurevilly wrote that "women who write are no longer women, they are men"; Goncourt described a woman of "genius" as a man and Octave Uzanne, the late nineteenth-century moralist and commentator, wrote that emancipation would make women into men.[53]

What threatened stability even more than this unnatural transmogrification of women into men was the fear that the emancipation of women would mean that the sanctity of the home would be broken and would endanger the authority of the husband guaranteed by religion and law. The use of art to promote the ideology of the separate spheres and to warn against the dangers of emancipation is demonstrated by the existence of a painting at the Salon of 1880 on which were enscribed the words "L'Emancipation de la Femme." It was spotted by a feminist critic, writing under the initials L.G., who described it in detail. The picture was divided into two parts, "Avant" and "Après." "Avant" showed a well-ordered home with happy children who hang adoringly on their father's neck as he returns from work to a "foyer délicieux." "Après" showed a room in disarray, the husband cuddling the children while the wife dreams, pen in hand, and studies a page of literature.[54] Precedents for such images were set by Daumier in another period of concentrated, although this time short-lived, feminist activity, the 1840s, in his series of caricatures

published in *Le Charivari* in 1844 on "Les Bas bleus" and in 1849 on "La Femme socialiste."

Renoir's close friendship with Berthe Morisot belies his vehement antagonism toward the woman artist. It is interesting, though, that when he painted Morisot, it was in her role of mother and not artist. (See the Barnes Foundation portrait of Berthe Morisot with her daughter, Julie, of 1894.) Renoir's relationship with Morisot was complicated by his own consciousness of the class differences which separated them. Proud as he was of his artisan origins and contemptuous as he remained of bourgeois customs, he was nevertheless reluctant to let Morisot know of his association with a peasant woman, Aline Charigot. When he showed her the drawings of Aline and their son, Pierre, he did not tell her that these were of his common-law wife and child.[55] It is possible, therefore, that Renoir's narrow prescriptions for women's sphere were suspended in relation to certain women of the haute-bourgeoisie on whom he depended for patronage and support. In the case of Morisot, whom he admired for her "femininity," there was consequently a space for a warm friendship to emerge. Morisot's position on women, despite her own lifelong commitment to a professional practice, was moreover, fairly conservative and would not have offered a threat to Renoir's views.

The confining of women's sphere to the domestic, the limiting of her role in productive life and the increased focus on her function as reproductive agent emerges within educational, political and pictorial discourses in France in the late eighteenth century. Rousseau had perceived women as depraved beings whose primary duty consisted of service to the sex they had originally wronged. Rousseau saw Sophie's role (his ideal woman and the female counterpart to Emile) as that of being "the object of Emile's pleasure and the faithful mother of his children."[56] As such she needs no intellectual education, her true sphere of interest being children rather than books. "All education of women should be relative to men. To please them, to console them, to render their lives agreeable and sweet; these are the duties of women at all times."[57] Interestingly, Renoir's own views on

education echo Rousseau's very closely and testify to the continuing power of such views. "Why teach women such boring occupations as law, medicine, science and journalism which men excel in when women are so fitted for a task which men can never dream of attempting and that is to make life bearable?" he asks.[58]

As Carol Duncan has argued, the image of the happy family and the contented fecund mother bore little relation to the reality of family life in the eighteenth century.[59] She explains that the family traditionally implied the line, a chain of descendants who each in turn held title to estates, properties and privileges in the family name, with marriage operating as a legal contract between heads of families in the interests of finance and property. In such extended households there was no governing paradigm of domestic harmony or romantic attachment between husband and wife. Yet the promotion of the nuclear family as an intimate and harmonious social unit became one of the keynotes of Enlightenment philosophy and pivoted on the image of the "happy mother," often represented pictorially as surrounded by her contented offspring. Images of the "good mother" reinforced through visual signification the message of the joy of motherhood.

Ironically, although women's fecundity and innate domesticity were extolled, their legal power was severely limited even with regard to children. It was Napoleon who, in his renowned exchange with Mme de Staël, had argued that female greatness had only one dimension, fecundity, and it was the Napoleonic Code which legitimized the absolute authority of the husband by according no financial independence to wives, by allowing mothers no legal authority over children during the father's life, by severely punishing female adultery while condoning that of males, by ruling out all possibilities of women filing paternity suits, by forbidding women to be legal witnesses, and so on.[60] Women were, for the most part, regarded as if they were not adults by law. Women's role as mother was restricted to the biological functions of reproduction and the caring for children, which was thought to be a natural extension of that.

The image of domestic harmony and maternal bliss as promoted through both "high art" and popular prints was fundamentally disturbed during the period of 1830–50, a time when feminism became a powerful, albeit sporadic, political issue in France. Michel Melot has argued that the emergence of the image of the "bad mother," "la mauvaise mère," as a popular theme in visual representation as well as in literature in, for example, Flaubert's *L'Education sentimentale* and Stendhal's *Le Rouge et le noir,* is a result of the inability of society to pose the problem which women faced—that is, of being caught between the new responsibilities and freedom which they sought and the fact that they were tied to their maternal roles.[61] Thus the image of the bad mother who abandons her children for her lover emerges. The inscription of a lithograph entitled *La Mauvaise Mère* (1840) by Devéria reads: "Débaressez-moi de ces enfants, ils me gênent." The meretriciousness of the woman is indicated by her rejection of her children.

This representation of the "bad mother" was replaced during the Third Republic by an explosion of images once more representing the joys of motherhood, and much of the rhetoric of this period centers on the importance of good mothering to produce a healthy society. There was some degree of alarm during this period caused by falling birthrates in France throughout the nineteenth century, exacerbated by the severe losses suffered by France during the Franco-Prussian war. Eighty-two books were published on the subject in Paris between 1890 and 1914, with many manuals for mothers and occasionally fathers being published in the 1880s to encourage good parenting.[62] The ideological focus centered on "motherhood," though, and the responsibilities of women as breeders, homemakers and to some extent educators were widely proclaimed. The role of the mother was increasingly idealized in visual representations, focusing repeatedly on the pseudo-religious relationship between mother and child, and the image of the breast-feeding mother became very popular.

The ideal of the *mère éducatrice* was one that could be comfortably contained within the ideology of domesticity which surrounded women's

306 TAMAR GARB

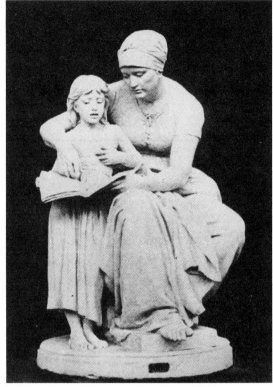

8. Elisabeth Jane Gardner, *Deux Mères de famille*, 1888 Salon. Whereabouts unknown.

9. Eugène Delaplanche, *Education maternelle*, 1873 Salon. Whereabouts unknown.

lives, and the image of *éducation maternelle* was widely promoted. In the Salons of the 1870s and 1880s there are numerous examples of paintings in which the woman provides a powerful enfolding presence for the child behind whom she sits or crouches as she gently guides her. Elizabeth Gardner's *Deux Mères de famille* [8] situates the figures together with a family of chickens (mother hen in control) in a domestic interior complete with kitchen equipment, and the parallel set up between the two "mothers" fixes the woman firmly within her prescribed "natural" role. Works such as Delaplanche's *Education maternelle* show the monumental mother figure teaching her daughter from a book in a formal arrangement which is reminiscent of Renaissance "mother and child" imagery [9]. Renoir often showed women teaching small children, as in *Woman and Child Playing Dominoes* (1906), which shows the model in

the mythic maternal role with one of his sons dressed in girl's clothing with long hair, as was the custom until boys were old enough to go to school, where they would receive a boy's education and dress as boys. A boy's education, after a certain age, was deemed too important to be left to women. Although many girls of the middle classes did go to convents, it was felt to be appropriate for girls to be educated at home by their mothers. "To educate a daughter is to educate society itself. Society proceeds from the family, of which the wife is the living bond," wrote Michelet.[63] Indeed, it was to prevent women from passing on ideas contrary to those believed in by men, rather than to assure women's independence, that education reform was sought by the young deputy Camille Sée in a debate in the Chambre des Députés in December 1880: "It is not prejudice, but nature herself that confines women to the family circle,"

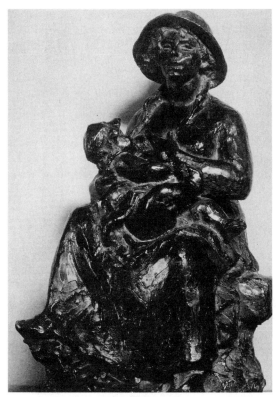

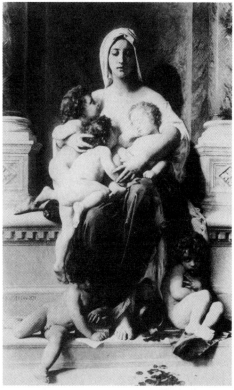

10. Pierre-Auguste Renoir, *Maternité.*
Lyon, Musée des Beaux-Arts.

11. William-Adolphe Bouguereau, *Charity*, Exposition Universelle, 1878. New York, Private collection.

he declared. "It is in their interest, in our interest, in the interest of the entire society that they remain at home. The goal of the schools we want to found is not to tear them away from their natural vocation but to render them more capable of fulfilling their obligations as wives, mothers and mistresses of households."[64]

Images of motherhood were not confined to those promoting *éducation maternelle.* Generalized mythic mother-and-child images became very popular, with certain artists like Hughes Merle specializing in them. Renoir's own involvement with the *maternité* image of his wife Aline and son Pierre is curious. Pierre was born in March 1885. Two sanguine drawings of Aline suckling him appear from this period, as well as three oil paintings and several drawings. It is this image of Aline which Renoir wished to preserve in his initial idea for her memorial sculpture [10] and he made yet

another version of this image in a work of 1918, some years after her death. These images clearly belong to the genre of *maternité* paintings, in which the individual sitters become irrelevant, so that they operate not as portraits but as types within accepted conventions of representation. The image invoked is that of the breast-feeding Madonna who represents motherhood in all its fullness and perfection, the woman who though denied sex is permitted suckling, for her milk is symbolic of healing, preservation, charity.[65] The religious association was intentional. Humbert even used the triptych format for his heroic glorification of motherhood in the *Maternité* shown at the Salon in 1888. In Pelez's *Sans Asile,* shown at the Salon of 1883, the desperate situation of the down-and-out family is rendered poignant by the monumental central figure of the breast-feeding mother. The celebration of moth-

erhood reached absurd proportions in Bougue-
reau's *La Charité,* exhibited at the Salon of 1878
[11], where woman as a symbol of fecundity is
expressed through the sheer number of children
gathered around her monumental form and naked
breast.[66] The presence of Renaissance prototypes
for these paintings is evident and the centrality of
the image of the Madonna in constructing an
ideal of motherhood in French nineteenth-cen-
tury culture cannot be underestimated. Nor was
this identification limited to the profoundly reli-
gious. During his travels to Italy, Renoir had com-
mented: "Every woman nursing a child is a Ra-
phael Madonna."[67]

The eighteenth-century practice of wet-nursing
was, by the late nineteenth century, considered
dangerous for the well-being of the child and psy-
chologically harmful for the mother, who, it was
believed, would not bond sufficiently with her
child without breast-feeding it. Rousseau had al-
ready urged mothers to feed their children them-
selves, but the practice of employing wet nurses
continued to the end of the nineteenth century,
when improved hygiene made it possible to use
animal's milk. Breast-feeding was widely ad-
vocated in manuals on child rearing. Lloyd de
Mause writes of the resurgence of wet-nursing at
the end of the nineteenth century, attributing this
to growing middle-class affluence and increased
women's independence.[68] An exploitative trade in
young wet nurses grew, a phenomenon which was
exposed in Brieux's drama *Les Remplacantes,* in
which the fate of the nurses is seen to be depen-
dent on the modish life of the Parisian mother
with her teas, her cycling around in culottes, her
attending lectures at the Collège de France. An
interesting polarity between the "good mother"
who fulfils her "natural" functions and the "bad
mother," characterized by the "new woman," is
set up, cycling and intellectual pursuits being
identified with the neglect of maternal duty.

Although breast-feeding had never been legally
binding in France (as it had been in Prussia, with
the right to decide the length of time that a
woman should breast-feed residing with the fa-
ther), it was widely advocated throughout the
nineteenth century.[69] Michelet declared that the

"nursing baby experiences the dawn of tenderness
when he tries to offer himself entire to his mother
by contracting his small body."[70] In his language
is revealed an interesting sexual polarity where the
male child is seen to respond to the powerful
mother. A similar eroticization of the relationship
is apparent in Renoir's advocacy of breast-feeding.
He was against artificial feeding of infants "not
only because mother's milk has been invented, but
because a child should bury its nose in its mother's
breast, nuzzle it, and knead it with its chubby
hands."[71] He feared that "bottle-fed babies grew
up into *men* [my emphasis] lacking all of the gen-
tler feelings" and believed that mother's milk was
what gave children healthy, glowing cheeks.[72] In
his opinion, a mother who did not breast-feed
deserved the worst sort of punishment and he
described such a mother as "no better than a
whore" before recalling that he had known prosti-
tutes who were excellent mothers.[73] In the many
maternité images of Aline and Pierre, the sexual
identity of the male child is proudly displayed and
the eroticization of the relationship is central to
the image.

Ideologies surrounding motherhood were not
promoted unchallenged in the nineteenth century
and this became one of the central areas of debate
for feminists in the Third Republic. Juliette Adam
had already proclaimed in the 1850s that it was
the confining of women's role to reproduction
which impeded their emancipation. Adam, like
many of the women of her time, believed that
women's role in the family was crucial but did not
believe that this was enough to justify their lives.
"I maintain," she wrote, "that family life does not
suffice for the physical, moral and intellectual ac-
tivity of woman. The role of broody hen is, no
doubt, most respectable, but it is not suited to
everyone; nor is it so absorbing as has been repre-
sented."[74]

The promotion of motherhood as the ideal ex-
pression of femininity occurred (simultaneously
with the image of idealized female beauty as em-
bodied in the nude) in a society in which little
support existed for women outside of their pre-
scribed roles as homemakers. Moreover, the visual
representation of ideal motherhood reached its

most popular moment at a time when established ideas about women's roles were being threatened by new and increasingly vocal definitions of womanhood. Although the intensity of the debate was significantly heightened during the Third Republic, many of the terms of the debate had already been laid out in earlier periods. It was the very strength of the attack by feminists against widely held beliefs which made women's issues more visibly discussed during this period than ever before. While feminists rejected traditional roles, symbols and even, in some cases, fashion, artists promoted with unprecedented intensity the myth of natural womanhood. Symbolized as the physical "source of life," "Woman" was promoted through the image of the secular Madonna on the one hand and in a state of primitive "naturalness" on the other. The popular title *La Source* had long evoked the life-giving woman who is more elemental than human. Compared by Michelet to the "flux and reflux of [the] . . . ocean" and as "very

regular, and submissive to the laws of nature," woman is produced through verbal and visual representations as removed from the sphere of culture and intellect.[75]

Renoir's image of woman can therefore be seen in the context of the most pervasive, dominant and reactionary nineteenth-century constructions of womanhood. As part of the debates around the "woman question," so heated during his lifetime, his paintings can be seen to reinforce the dominant Proudhonian construct with which, we know, he felt most comfortable. His paintings operate not as a reflection of social attitudes but as a powerful nonverbal promoter of an identifiable political position. It was through the discourses and practices of "high art" that the myth of ideal womanhood could achieve its highest expression and through the power of art's apparent political neutrality that its centrality is obscured in the promotion of the nineteenth-century category "Woman."

NOTES

This paper was originally presented under the title "Renoir's Image of Woman" for a series of lectures organized by the University of London, Department of Extra-Mural Studies, to coincide with the Renoir exhibition at the Hayward Gallery.

1. J. Gasquet, "Le Paradis de Renoir," *L'Amour de l'art,* 1921, p. 62.

2. J. Renoir, *Renoir, My Father,* p. 65 (hereafter cited as J. Renoir).

3. "Moi, devant un chef d'oeuvre, je me contente de jouir," Renoir is reported to have said. A. Vollard, "Renoir et l'Impressionisme," *L'Amour de l'art,* 1921, p. 51.

4. Hayward Gallery, London, *Renoir,* 30 January–21 April 1985.

5. Critical accounts which attempt to come to terms with the cultural and political implications of the show include K. Adler, "Reappraising Renoir," *Art History,* vol. 8, no. 1, and L. Nead, "Pleasing, Pretty and Cheerful, Sexual and Cultural Politics at the Hayward Gallery," *Oxford Art Journal,* vol. 8, no. 1, pp. 72–74.

6. "Clive James on Renoir," *Observer Colour Supplement,* 27 January 1985, p. 17.

7. T. Duret, *Manet and the French Impressionists,* p. 168.

8. Pach quotes Renoir's own defense of Boucher: "A painter who has the feel for breasts and buttocks is saved," W. Pach, *Renoir,* p. 86.

9. Ibid., p. 86.

10. L. Gowing, "Renoir's Sentiment and Sense," Hayward Gallery, *Renoir,* pp. 30–35. See particularly p. 31.

11. J. Renoir, p. 195.

12. L. Gowing, "Renoir's Sentiment and Sense," Hayward Gallery, *Renoir,* p. 32.

13. For an account of the relationship of women to the nature/culture polarity, see S.B. Ortner, "Is Female to Male as Nature Is to Culture?" in Rasaldo and Lamphere (eds.), *Woman, Culture, Society,* 1974.

14. Edwin Mullins's article in the *Telegraph Colour Supplement,* no. 431, January 27, 1985, is billed on the cover as "The Women in Renoir's Life," while the inside article is titled "A Dream of Fair Women." Renoir's vision is subtly misread as a realist one, with the artist being produced as the macho hero. Even his assertion that Renoir created a "feminine dreamland" in which his "nudes float dreamily in a mist of flowers and foliage" is balanced with factual information on Renoir's models Lise and Gabrielle and his wife Aline Charigot as actual people, and so distinctions between the mythic and the real become

blurred (see p. 27).

15. *Daily Mail*, 1 February 1985, p. 13.

16. Michelet's views on women appear in his books *La Femme; L'Amour;* and *Le Prêtre, la femme et la famille.* For a brief account of his attitude to women see T. Zeldin, *France 1848–1945, Ambition, Love and Politics.* Ruskin writes on women in *Of Queen's Gardens* in *Sesame and the Lilies.* For an account of Ruskin's views on women see "The Debate over Women" in *Suffer and Be Still, Women in the Victorian Age*, ed. M. Vicinus (1972).

17. Millicent Fawcett, cited in R. Parker, *The Subversive Stitch* (1984), p. 4.

18. J.P. d'Héricourt, *La Femme affranchie* (1860), partially translated as *Woman Affranchised* in S.G. Bell and K.M. Offen (eds.), *Women, the Family, and Freedom* (1983), pp. 342–43 (hereafter cited as *Women, the Family, and Freedom*).

Patrick Bidelman claims that, more so than men, women were measured against abstract ideas and myths. He cites Simone de Beauvoir's analysis of woman as the negative sex where man is the "subject," woman is the "other." Bidelman claims that prior to the nineteenth century the extreme images of ideal womanhood remained on the level of myth while the real conditions of existence imposed parameters of behavior removed from these images. Woman's daily existence could take advantage of this gap and attain a relative degree of freedom. But in the nineteenth century new mythic images and new objective conditions evolved where women were expected to measure their lives in relation to mythic constructions of, for example, the "mère éducatrice." P. Bidelman, *The Feminist Movement in France: The Formative Years 1858–1889*, Ph.D. dissertation, University of Michigan, 1975, p. 118 (hereafter cited as Bidelman).

19. P. Mink, "Le Travail des femmes," partially reprinted in *Women, The Family, and Freedom*, p. 470.

20. G. Rivière, *Renoir et ses amis* (1912), p. 88.

21. Jean Renoir reports that his father wanted all his female servants to sing and laugh and feel at ease around him. "The more naive and even stupid their songs were, the more pleased he was." J. Renoir, p. 84. Clive James engages in a curious inversion of this idea when he claims that it was women who bloomed in Renoir's company rather than the other way around. "If the painting of his marvellous first period seem idyllic, it is because he inspired an idyll. People, and especially women, were at their best around him," he writes. James promotes the idea that the world that Renoir created was in fact the recording of a real world, rendered perfect because of his ability to inspire it. C. James, "The Art of an Artless Man," *Observer Colour Supplement*, 27 January 1985, p. 19.

22. G. Rivière, "Les Enfants dans l'oeuvre et la vie de Paul Cézanne et de Renoir," *L'Art vivant*, September 1928, pp. 673–77.

23. S. de Beauvoir, *The Second Sex*, quoted in S.B. Ortner, "Is Female to Male as Nature Is to Culture?" p. 74.

24. S. Icard, *La Femme pendant la période menstruelle*, Paris, 1890. Icard quotes Rousseau's and Michelet's statement: *"la femme est malade tous les mois,"* p. 28. His views on women's education are on pp. 113–14.

25. G. Rivière, "Les Enfants dans l'oeuvre et la vie de Paul Cézanne et de Renoir," *L'Art vivant*, 1 September 1928. Rivière quotes Renoir as saying "ce qui les rend dangereux c'est le pouvoir de séduction dont ils disposent," pp. 673–77.

26. E. Zola, *Nana*, Harmondsworth, p. 12.

27. *La Femme affranchie* in *Women, the Family and Freedom*, pp. 342–49.

28. J. Renoir, p. 335.

29. Ibid., p. 139.

30. Ibid. p. 421, and C. James, "The Art of an Artless Man," *Observer Colour Supplement*, p. 19.

31. Ibid., p. 86.

32. Ibid., p. 85. It is comments like this one that Edwin Mullins cites, stating that "It is not entirely fair to select from Renoir's utterances only the reddest rags to a feminist bull," although he himself adds that it is hard to imagine Renoir, painting women as he did, did he not have such views. E. Mullins, *Telegraph Colour Supplement*, no. 431, January 27, 1985, p. 26.

33. For accounts of feminism in the Third Republic, I have used: R.J. Evans, *The Feminists, Women's Emancipation Movements in Europe, American and Australasia 1844–1920* (1977); T. Stanton, *The Woman Question in Europe* (1884); S.C. Hause and A. R. Kenny, *Woman's Suffrage and Social Politics in the French Third Republic* (1984) (hereafter cited as *Woman's Suffrage*); and P. Bidelman (cited above).

34. H. Auclert, *La Patrie*, January 1904, quoted in *Woman's Suffrage*, p. 13.

35. I am not of course claiming that Renoir had read Proudhon. Rather I am identifying him with a very powerful strain of French thinking for which Proudhon was the most articulate spokesperson. Proudhon's ideas on women are to be found in *La Justice dans la révolution et dans l'église* (1858) and *La Pornocratie de la femme dans les temps moderne* (1875). For a discussion on Proudhon's ideas on women see R.J. Evans, *The Feminists*, pp. 155–58.

36. *Selected Writings of Pierre-Joseph Proudhon*, p. 256.

37. Quoted in B. Ehrlich White, *Renoir, His Life, Art and Letters*, p. 202.

38. J. Renoir, p. 202.

39. Ibid., p. 86.

40. Ibid., p. 110.

41. A. Vollard, "Renoir et l'Impressionisme," *L'Amour de l'art*, 1921, p. 50.

42. G. Moore, *Modern Painting* (1898), p. 227.

43. He did not finish it before his death but his notes were collated and published in 1875.

44. D'Héricourt claimed that the revolutions of both 1789 and 1848 had abandoned women and that a third betrayal seemed imminent. She went beyond an analysis of Proudhon to show that the apparent sweetness of other writers in fact perpetuated male domination. In comparing Michelet and Proudhon she claimed that they differed only in style, "the first is as sweet as honey, and the second as bitter as wormwood . . . we shall therefore castigate him [Michelet] over the shoulders of M. Proudhon, who may be cannonaded with red hot shot." Cited in Bidelman, p. 73. D'Héricourt challenged the belief that a political, economic and social program for France would automatically benefit women. She was, therefore, isolated from most Republican feminists, who believed that women's emancipation could be realized through the Republic. *La Femme affranchie* was initially banned by the French authorities but the Emperor lifted the ban after a personal appeal by d'Héricourt. See Bidelman, pp. 76–78.

45. Proudhon's writings had an enormous influence on workers in France. In 1866, a year after his death, the French section of the International Working Man's Association paid tribute to his ideas by passing a resolution barring women from working outside the home. See Bidelman, p. 72.

46. *Selected Writings of Pierre Joseph Proudhon*, S. Edwards (ed.), p. 256.

47. Cited in Bidelman, p. 15.

48. Cited in J.F. McMillan, *Housewife or Harlot: The Place of Women in French Society 1870–1914* (1981), p. 12.

49. H. Auclert, "La Sphère des femmes," *La Citoyenne*, 19–25 February 1882. Reprinted in *Hubertine Auclert*, E. Taieb (ed.), p. 85.

50. J. Lambert (Adam), "Idées anti-Proudhoniennes sur l'amour, la femme et le mariage," (orig. published in 1858) in *Woman, the Family, and Freedom*, p. 332.

51. For information on the Congress see Bidelman, pp. 171–79.

52. Mme Adam had by this stage renounced her earlier feminism and, in the wake of the Franco-Prussian war, became committed to Republicanism and patriotic moves to achieve revenge against Germany for the humiliation suffered by the French after their defeat.

53. See O. Uzanne, *The Moderne Parisienne*, pp. 134, 128, 224.

54. L. G. "Souvenir du Salon de 1880," *La Citoyenne*, no. 9, 10 April 1881.

55. Discussed by B. Ehrlich White in *Renoir, His Life, Art and Letters*, p. 158.

56. V.G. Wexler, "Made for Man's Delight: Rousseau as Anti-feminist," *American Historical Review*, no. 81, 1976, p. 273.

57. J.-J. Rousseau, *Emile*, quoted in Bidelman, p. 44.

58. J. Renoir, p. 85.

59. C. Duncan, "Happy Mothers and Other New Ideas in Eighteenth-Century French Art," in *Feminism and Art History*, N. Broude and M. Garrard (eds.), pp. 201–19.

60. For two discussions on the implications for women of the Napoleonic Code, see Bidelman, pp. 10–12, and T. Stanton, *The Woman Question in Europe*, pp. 239–61.

61. M. Melot, "La Mauvaise mère: Etude d'un thème romantique dans l'estampe et la littérature," *Gazette des beaux-arts*, vol. 79, 1972, pp. 167–76.

62. One book which was aimed at encouraging fathers to be good parents was Gustave Droz's *Monsieur, madame et bébé*, Paris (1886).

63. J. Michelet, *La Femme*, partially reprinted in *Women, the Family and Freedom*, p. 341. Michelet characterizes the difference between boys' and girls' education as follows: "The education of boys . . . aims to organise a force, an effective and productive force, to create a creation which is the modern man. The education of the girl is to produce harmony, to harmonize a religion. Woman is a religion" (p. 340).

64. Camille Sée, speech delivered on 19 January 1880, Sénat et Chambre de Députés. I pt. I 1880, Chambre des Députés, pp. 89–90; reprinted in *Woman, the Family and Freedom*, pp. 443–44.

65. For a discussion of the changing symbolism of the breast-feeding Madonna, see M. Warner, *Alone of All Her Sex—the Myth and Cult of the Virgin Mary* (1976).

66. I am acutely aware here of the necessity to examine contemporary criticism in order to establish to what extent these images were seen at the time of their production to be instrumental in the construction of definitions of femininity. Unfortunately such a task is beyond the scope of this paper.

67. J. Renoir, p. 220.

68. L. de Mause, *The History of Childhood*, p. 410.

69. *Allgemeines Landrecht für die preussischen Staaten* (1794), article 67, C.F. Koch (ed.), Berlin (1862), Part II, Title I, pp. 1, 75, 77, 80, and Title II, p. 248. Partially reprinted in *Woman, the Family and Freedom*, pp. 38–39.

70. Quoted in L. de Mause, *The History of Childhood*, p. 410.

71. J. Renoir, p. 285.

72. A. Vollard, *La Vie et l'oeuvre de Pierre Auguste Renoir* (1919), p. 166.

73. The invocation of the Proudhonian paradigm of mother/whore is interesting here.

74. J. Lambert (Adam), "Idées anti-Proudhoniennes sur l'amour, la femme et le mariage" in *Women, the Family and Freedom*, p. 333.

75. J. Michelet, "L'Amour in *Women, the Family and Freedom*, pp. 337 and 338.

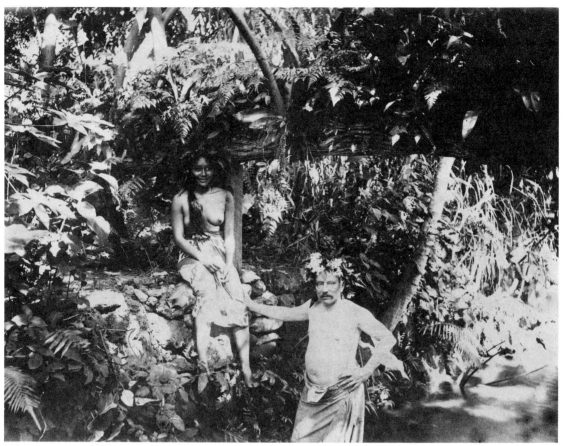

1. A French colonial with a Polynesian woman, photograph from P. Godey, *Album des photos venant de Monsieur P. Godey, Commissaire de la Marine, lors de ses campagnes,* ca. 1880. Paris, Bibliothèque Nationale, Cabinet des Estampes.

17

GOING NATIVE

———

Paul Gauguin and the Invention of Primitivist Modernism

———

ABIGAIL SOLOMON-GODEAU

The massive 1988 Gauguin exhibition which debuted at the National Gallery of Art in Washington, D.C., traveled to the Art Institute of Chicago, and ended its run at the Grand Palais in Paris, is perhaps most interestingly considered as an exemplum not only of museological blockbusterism but, as well, of the construction of the (male) artist as promethean and agonistic hero. In the Parisian incarnation, the weeks before the opening witnessed Gauguin as the cover story in mass-media publications such as *Telerama* and *Figaro,* displacing more familiar cultural icons such as Princess Di or Johnny Halliday. From the moment the exhibition opened, lines routinely stretched from the entrance of the Grand Palais to the Métro station; I was told that an average of 7,000 people saw the show each day. The accompanying scholarly apparatus conformed equally to the now-familiar terms of these kinds of exhibitions: a seven-pound, 300-franc catalogue produced by a Franco-American *équipe,* brimming with facts and factoids; a three-day symposium uniting scholars from several countries; blue-chip

corporate sponsorship on both sides of the Atlantic—Olivetti in France, AT&T in the States; and satellite exhibitions of both the graphic work of the Pont-Aven school and historical photographs of Polynesia. Also attendant upon the show were disputes, if not polemics, concerned with problems of dating in publications such as *The Print Collector's Newsletter,* and the reissue of numerous older Gauguin monographs.

Consistent with this discursive presentation of the artist and his work—a presentation which, for short, may be designated business as usual—the physical presentation of the exhibition and the catalogue were insistently concerned with a certain inscription of the artist. In the Grand Palais, for example, at various strategic points, the viewer was confronted with over–life–size photographic blowups of Gauguin. And departing from the overall stylistic/chronological organization of the show, the very last room was consecrated to a medley of Gauguin's self-portraits, revealing a progression (if that is the right term) from the rather louche *Autoportrait avec chapeau* (1893–94) to the lugubrious *Autoportrait près de Golgotha* (1896). In other words, there were at least two narratives proposed by this exhibition; one structured around a temporal, formal trajectory (the

From *Art in America* 77 (July 1989): 118–29. Copyright © 1989 *Art in America.* Reprinted by permission of the author and *Art in America.*

stylistic evolution and development of the artist's work), and the other around a dramatized and heroicized presentation of the artist's life. The former narrative was produced through curatorial strategies of selection and exclusion; the latter, through the interpolation of Gauguin as a biographical subject—for example, the use of text panels chronicling his activities, his travels, his mistresses. These two narratives were unified under the mystic sign of the promethean artist; thus, fully in keeping with the exigencies of secular hagiography that characterizes mainstream, culturally dominant approaches to art, the catalogue offers us a full-page photograph of Gauguin's hand.

This shamanlike image is as good a point of entry as any other into the myth of Gauguin, and by extension, into the discourse of artistic primitivism which Gauguin is taken to exemplify. Gauguin's position is here quite central insofar as he is traditionally cast as the founding father of modernist primitivism. I am less concerned here, however, with primitivism as an aesthetic option—a stylistic choice—than with primitivism as a form of mythic speech. Further, it is one of my themes that the critical interrogation of myth is a necessary part of art-historical analysis. Myth, as Roland Barthes famously defined it, is nothing more or less than depoliticized speech—consistent with the classical definition of ideology (a falsification or mystification of actual social and economic relations). But mythic speech is not only about mystification, it is also, and more crucially, a *productive* discourse—a set of beliefs, attitudes, utterances, texts and artifacts that are themselves constitutive of social reality. Therefore, in examining mythic speech, it is necessary not only to describe its concrete manifestations, but also to carefully attend to its silences, its absences, its omissions. For what is not spoken—what is unspeakable, mystified or occulted—turns always on historical as well as psychic repressions.

Second only to the life of his equally mythologized contemporary Vincent van Gogh, Gauguin's life is the stuff of which potent cultural fantasies are created. And indeed have been.

Preeminently, the myth is associated, in both the popular and the art-historical imagination, with Gauguin's ten years spent in Polynesia and—integrally linked—his assumption of the role of savage. Simultaneously, Gauguin's life is also deemed tragic and accursed. A glance through the card catalogue yields some of the following book titles: *Oviri: The Writings of a Savage; The Noble Savage: A Life of Paul Gauguin; Gauguin's Paradise Lost; La Vie passionée de Paul Gauguin; Poètes et peintres maudit; Les Maudits; Gauguin: Peintre maudit;* and—my personal favorite—*Gauguin: Sa Vie ardente et misérable.*

Even during his lifetime Gauguin was associated with the flight from, variously, bourgeois life and respectability, the wear and tear of life in the cash nexus, a wife and children, materialism, "civilization." But no less mythically important than the things escaped are the things sought—the earthly paradise, its plenitude, its pleasure, its alluring and compliant female bodies. To admirers of Gauguin during his lifetime and the period immediately after—I refer here to such indispensable and powerful promoters as Albert Aurier, Charles Morice, Daniel de Monfried, and most crucially, Victor Segalen[1]—Gauguin's voyage of life was perceived in both the most literal and gratifyingly symbolic sense as a voyage ever further outward, to the periphery and margins, to what lies outside the parameters of the superego and the polis. On a biographical level, then, Gauguin's life provides the paradigm for primitivism as a white, Western and preponderantly male quest for an elusive object whose very condition of desirability resides in some form of distance and difference, whether temporal or geographical.

In the myth of Gauguin "the man," we are thus presented with a narrative (until quite recently, one produced exclusively by men) that mobilizes powerful psychological fantasies about difference and otherness, both sexual and racial. On a formal level—or on the level of Gauguin the artist—another narrativization is at work. Here, the salient terms concern originality and self-creation, the heroism and pathos of cultural creation, a telos of avant-gardism whose movement is charted stylistically or iconographically.

Common to both the embrace of the primitive—however defined—and the celebration of artistic originality is the belief that both enterprises are animated by the artist's privileged access, be it spiritual, intellectual or psychological, to that which is primordially internal. Thus, the structural paradox on which Gauguin's brand of primitivism depends is that one leaves home to discover one's real self; the journey out, as writers such as Conrad have insisted, is, in fact, always a journey in; similarly, and from the perspective of a more formally conceived criticism, the artist "recognizes" in the primitive artifact that which was immanent, but inchoate; the object from "out there" enables the expression of what is thought to be "in there." The experience of the primitive or of the primitive artifact is therefore, and among other things, valued as an aid to creation, and to the act of genius located in the artist's exemplary act of recognition.

Is it the historic Gauguin that so perfectly incarnates this mythology, or is it the mythology that so perfectly incarnates Gauguin? Did Gauguin produce this discourse, or did the discourse produce him? From whichever side we tackle this question, it must be said that Gauguin was himself an immensely persuasive purveyor of his own mythology. But the persuasiveness of Gauguin's primitivism—both as self-description and as aesthetic project—attests to the existence of a powerful and continuing cultural investment in its terms, a will to believe to which 100 years of uncritical commentary bears ample witness. Mythic speech cannot be dispelled by the facts it ignores or mystifies—the truth of Brittany, the truth of Polynesia, the truth of Gauguin; rather, it must be examined in its own right. And because myth's instrumentality in the present is of even greater moment, we need to attend to its avatars in the texts of contemporary art history. Thus, while it is fruitless to attempt to locate an origin of primitivist thought, we can at any point along the line attempt to unpack certain of primitivism's constituent elements, notably the dense interweave of racial and sexual fantasies and power—both colonial and patriarchal—that provides its raison d'être and which, moreover, continues to inform its articulation. Insofar as Gauguin is credited with the invention of modernist primitivism in the visual arts, such an investigation needs to reckon both with Gauguin's own production—literary as well as artistic—and with the successive levels and layers of discourse generated around it.

For my purposes here, it is sufficient to begin in 1883, when, at the age of thirty-five, Gauguin makes his decisive break with his previous life as a respectable bourgeois and paterfamilias; terminated from the investment firm of Bertin in the wake of the financial crash of 1882, he resolves to become a full-time artist. Three years later he leaves his wife, Mette Gad Gauguin, and his five children in Copenhagen and returns to Paris. Then begins his restless search for "luxe, calme et volupté," a troubled quest for another culture that's purer, closer to origins and—an equally insistent leitmotif—cheaper to live in.

By July 1886, he is installed at Pont-Aven, at the Pension Gloanec. It is during this first Breton sojourn that he begins to present himself, quite self-consciously, as a savage. Simultaneously, and in concert with other artists—notably Emile Bernard—he begins to specifically adumbrate the goals and intentions of a primitive art. Brittany is thus presented in Gauguin's correspondence, and in the subsequent art-historical literature, as the initial encounter with cultural Otherness, a revivifying immersion in a more archaic, atavistic and organic society. Such a view of Brittany is exemplified by Gauguin's often quoted comment, "I love Brittany: there I find the wild and the primitive. When my wooden shoes ring on this stony soil, I hear the muffled, dull, and mighty tone I am looking for in my painting." Daniel de Monfried, Gauguin's close friend and subsequent memorialist, tied the move to Brittany specifically to Gauguin's ambitions for his art: "He hoped to find a different atmosphere from our exaggeratedly civilized society in what, he thought, was a country with archaic customs. He wanted his works to return to primitive art."[2]

Since the publication of Fred Orton and Griselda Pollock's important essay of 1980, "Les Données Bretonnantes," which significantly does

2. Javanese village at the 1889 Exposition
Universelle in Paris *(Roger-Viollet)*.

not even appear in the Grand Palais catalogue's
bibliography, this conception of Brittany as some-
how primitive, severe and eminently folkloric has
been revealed as itself a mythic representation.
Indeed, Pollock and Orton's evocation of Pont-
Aven in the late 1890s suggests nothing so much
as Provincetown in the 1950s—an international
artists' colony, and a popular site for tourism, co-
existing with, and forming the economy of, a rela-
tively prosperous and accessible region whose
diversified economy was based on fishing (includ-
ing canning and export), agriculture, kelp harvest-
ing and iodine manufacturing.

Far from constituting the living vestiges of an
ancient culture, many of the most visually distinc-
tive aspects of Breton society (preeminently the
clothing of the women) postdated the French
Revolution; they were, in fact, as Orton and Pol-
lock demonstrate, aspects of Breton *modernity.*[3]
But from the perspective of an inquiry into the
terms of a nascent primitivism, what needs be
emphasized is the construction of Brittany as a
discursive object; in keeping with analogous con-
structions such as Orientalism, we might call this
construction "Bretonism." Accordingly, the dis-

tance between the historical actuality of Brittany
in the later 1880s and the synthetist representa-
tion of it is not reducible to a distance from or a
distortion of an empirical truth, but must be ex-
amined as a discursive postulate in its own right.
Of what, then, does this postulate consist?

On a formal level, the developments one ob-
serves in Gauguin's work of 1886–90, and indeed
in the work of the Pont-Aven circle as a whole,
have little to do with Brittany, whether real or
imagined. These years encompass the first two
Breton sojourns, punctuated by the 1887 trip to
Panama and Martinique, and the crucial encoun-
ter with tribal arts and culture at the 1889 Univer-
sal Exhibition [2, 3] Gauguin's jettisoning of
phenomenological naturalism with respect to
color, atmosphere and perspective, and his assimi-
lation of, variously, Japonisme, French popular
imagery and Emile Bernard's cloisonnisme, all of
which had long since been discursively constituted
as the primitive, did not require Brittany for its
realization.

On the level of motif, however, Bretonism sig-
nals a new interest in religious and mystical ico-
nography—Calvaries, self-portraits as Christ,
Magdalens, Temptations and Falls. To be sure,
this subject matter is not separable from the
emerging precepts of Symbolism itself, any more
than Gauguin's self-portraiture as Christ or magus
is separable from his personal monomania and
narcissism. In this respect, Synthetism, cloison-
nisme, primitivism and the larger framework of
Symbolism all represent diverse attempts to nego-
tiate what Pollock and others have termed a crisis
in representation—a crisis whose manifestation is
linked to a widespread flight from modernity,
urbanity and the social relations of advanced capi-
talism.

To commentators such as Camille Pissarro,
Symbolism was itself a symptom of bourgeois re-
trenchment in the face of a threatening working
class:

The bourgeoisie, frightened, astonished by the im-
mense clamor of the disinherited masses, by the insis-
tent demands of the people, feels that it is necessary to
restore to the people their superstitious beliefs. Hence

the bustling of religious symbolists, religious socialists, idealist art, occultism, Buddhism, etc., etc.[4]

And he reproached Gauguin for "having sensed this tendency" and, in effect, pandering to it. But from either perspective, it seems clear that Bretonism fulfills a desire for the annihilation of what is deemed insupportable in modernity, which in turn requires that the Brittany of Bretonism be conceived as feudal, rural, static and spiritual—the Other of contemporary Paris.

Stasis—being outside of time and historical process—is particularly crucial in the primitivizing imagination, insofar as what is required is an imaginary site of psychic return. The "return to origins" that Gauguin claimed as his artistic and spiritual trajectory is emblematized in another frequent quotation: "No more Pegasus, no more Parthenon horses! One has to go back, far back . . . as far as the dada from my childhood, the good old wooden horse."[5] Gauguin's words limn an atavism that is anterior to and more profound in its implications than the search for a kind of ethno-graphic origin in either Brittany or the South Seas.

This atavism has its lineage in Rousseauist thought, in various kinds of temporal exoticism, in certain currents in Romanticism, and—closer to Gauguin's own time—in a new interest in the child and the child's perception. While it might be possible to argue that Gauguin's numerous images of children—Breton girls and adolescents, naked little boys (some of them quite strikingly perverse)—themselves constitute an element of Bretonism[4, 5], it is also possible that the prevalence of children, like that of unindividuated Breton women, masks something largely absent from the Bretonist vision—namely, adult men and their activities. Why should the character—physiognomic, sartorial or spiritual—of Breton men be of no interest? While there is no simple answer to this question, I would like to suggest that the absence of men from Bretonism may be structurally similar to the absence of men in the nineteenth-century *discours prostitutionelle*. In other words, in the same way that discussions of *proxénètisme* and other forms of male entre-

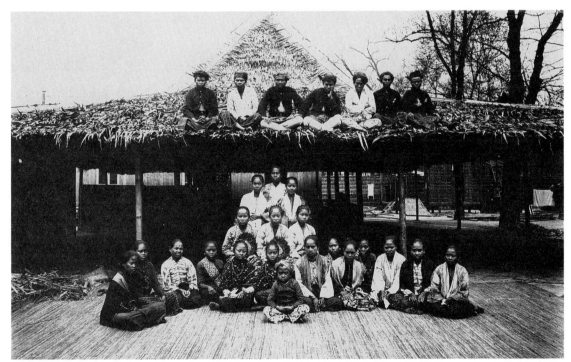

3. A group of Javanese participants at the 1889 Exposition Universelle in Paris *(Roger-Viollet)*.

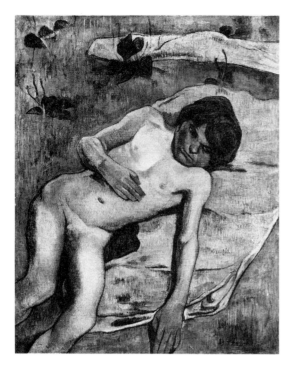

preneurial relations to prostitution are elided, it may well be that what is at work in these discourses is a fantasmatic construction of a purely feminized geography. In this respect, Bretonism thus supplies a vision of an unchanging rural world, populated by obliquely alien, religious women and children, a locus of nature, femininity and spirituality. And as the Grand Palais catalogue so ingenuously puts it, "In the artistic itinerary of Gauguin, le Pouldu would remain as 'the first of his Tahitis,' his 'French Tahiti.' "[6] And lest we think that Bretonism is a late nineteenth-century phenomenon, here is a description of Breton women written in 1971: "The feminine population of Brittany was both earthy and undifferentiated, the women possessing a shared character which took form in a sort of animal nature, the result of centuries of ritualized response to an established role."[7]

In any event, the appearance of female nudes in Gauguin's work during the first stay in Brittany

4. Paul Gauguin, *Nude Breton Boy*, 1889. Cologne, Wallraf-Richartz Museum *(Rheinisches Bildarchiv)*.

5. Paul Gauguin, *Breton Girls Dancing, Pont-Aven*, 1888. Washington, D.C., National Gallery of Art, Collection of Mr. and Mrs. Paul Mellon.

(the only ambitious female nude anterior to the Brittany work is the "realist" *Suzanne Coussant* of 1881) participates in many of the same structures of desire as does Bretonism itself. Significantly, during the Breton period Gauguin elaborated his peculiar mythology of the feminine—a hodgepodge of Wagnerian citations, fin-de-siècle *idées reçues* about woman's nature, Strindbergian misogyny, French belles-lettriste versions of Schopenhauer and so forth. Modern art-historical literature abounds in grotesquely misogynist exegeses of the meanings in Gauguin's representations of women.[8] In terms of my larger argument, it is enough to note that like the putatively archaic, mysterious and religious Bretonne, the deflowered maiden, the naked Eve and the woman in the waves (all from the Breton period) alike reside in that timeless and universal topos of the masculine imaginary—femininity itself.

Unmistakably, in Gauguin's writing and in his art, the quest for the primitive becomes progressively sexualized, and we must ask if this is a specific or a general phenomenon. From 1889 on, there is an explicit linkage of the natural and Edenic culture of the tropics to the sensual and the carnal—nature's plenitude reflected in the desirability and compliance of "savage women." "The first Eves in Gauguin's Eden," as one art historian refers to them, appear in 1889 (the two versions of *Eve bretonne, Ondine, Femmes se baignent,* and, in the following year, *Eve exotique*). Much psychobiographic ink has been spilled over the fact that the head of the *Eve exotique* derives from a photograph of Gauguin's mother—Aline Chazal. But if we recall that Eve means mother to begin with, and that, biblically speaking, Eve is the mother of us all, Gauguin's use of his mother's photograph could mean any number of things. Given the ultimate unknowability of an artist's intentions, motivations and psychic structures, there seems little point in psychoanalyzing the subject through the work. Of far greater importance to my mind is an analysis of the availability and indeed the self-evidence of the constellation Eve/Mother/Nature/Primitive to the patriarchal imaginary as a cultural and psychic construction.

Again, we are confronted with a form of mythic speech that can by no means be historically relegated to the era of Symbolism. I quote a contemporary art historian:

What better symbol for this dream of a golden age than the robust and fertile mother of all races? . . . Gauguin's Eve is exotic, and as such she stands for his natural affinity for tropical life. His was more than a passing taste for the sensuality of native women; of mixed origin—his mother had Peruvian as well as Spanish and French blood—he was deeply aware of his atavism, often referring to himself as a pariah and a savage who must return to the savage.[9]

And from another art historian:

Although Gauguin's imagery clearly emerges out of the 19th-century tradition of the fatal woman, it rejects the sterility of that relationship. On the contrary, the ceramic [the *Femme noire*] suggests a fruitful outcome to the deadly sexual encounter by representing the Femme Noire as full-bellied and almost pregnant: the female uses the male and kills him, but she needs the phallus and its seed to create new life. So the fated collaboration is productive, even though fatal for the male. Gauguin's imagery is basically an organic and natural one.[10]

The leitmotifs that circulate in these citations (chosen fairly randomly, I might add)—strange references to mixed blood, persistent slippages between what Gauguin said or believed or represented and what is taken to be true, the naturalizing of the cultural which, as Barthes reminds us, is the very hallmark of mythic speech—all these suggest that Gauguin's mythologies of the feminine, the primitive, the Other, are disturbingly echoed in current art-historical discourse. Furthermore, insofar as femininity is conventionally linked, when not altogether conflated, with the primitive (a linkage, incidentally, that reaches a delirious crescendo in the fin-de-siècle), is there, we might then ask, a mirror version of this equivalence in which the primitive is conflated with the feminine? Is primitivism, in other words, a gendered discourse?

One way to address this question is by tracking it through Gauguin's own itinerary. By 1889, he

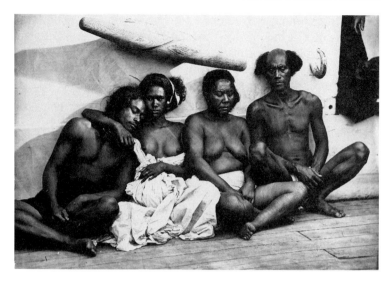

6. Paul-Emile Miot, *The Royal Family of Vahi-Tahou from the Marquesas, Photographed on Board the French Frigate* Astrée, 1869–70. Paris, Musée de l'Homme.

had already resolved to make his life anew in Tahiti. Significantly, he had also considered Tonkin and Madagascar; all three were French colonial possessions. Tahiti, the most recent of these, had been annexed as a colony in 1881 (it had been a protectorate until then). Gauguin's primitivism was not free-floating, but followed, as it were, the colonizing path of the *tricouleur*. From Brittany he wrote to Mette Gauguin the following:

May the day come soon when I'll be myself in the woods of an ocean island! To live there in ecstasy, calmness and art. With a family, and far from the European struggle for money. There in Tahiti I shall be able to listen to the sweet murmuring music of my heart's beating in the silence of the beautiful tropical nights. I shall be in amorous harmony with the mysterious beings of my environment. Free at last, without money trouble, I'll be able to love, to sing, to die.[11]

In this as in other letters, Gauguin makes very explicit the equation tropics/ecstasy/amorousness/native. This was mythic speech at the time Gauguin articulated it, and it retains its potency to this day; one has only to glance at a Club Med brochure for Tahiti to appreciate its uninterrupted currency.

Insofar as we are concerned with Polynesia as a complex and overdetermined representation as well as a real place in time and history, we may start by asking what kinds of associations were generated around it in nineteenth-century France. From the moment of their "discovery"—a locution which itself demands analysis—by Captain Samuel Wallis in 1767, the South Sea Islands occupied a distinct position in the European imagination. Renamed La Nouvelle Cythère shortly after by Louis-Antoine de Bougainville, Tahiti especially was figured under the sign of Venus: seductive climate, seductive dances, seductive (and compliant) women.

In the expeditionary literature generated by Captain Cook, Wallis, Bougainville and the countless successive voyagers to the South Seas, the colonial encounter is first and foremost the encounter with the body of the Other. How that alien body is to be perceived, known, mastered or possessed is played out within a dynamic of knowledge/power relations which admits of no reciprocity. On one level, what is enacted is a violent history of colonial possession and cultural dispossession—real power over real bodies [6]. On another level, this encounter will be endlessly elaborated within a shadow world of representations—a question of imaginary power over imaginary bodies.

In French colonial representation, the nonreciprocity of these power relations is frequently disavowed. One manifestation of this disavowal

can be traced through the production of images and texts in which it is the colonized who needs and desires the presence and the body of the colonizer. The attachment of native women—often the tragic passion—for their French lovers becomes a fully established staple of exotic literary production even before the end of the eighteenth century [7].

The perception of the Maori body—entering European political and representational systems much later than the black or Oriental body—can be seen to both replicate and differ from the earlier models for knowing the Other's body. Like that of the African, the body of the South Sea Islander is potentially—and simultaneously—monstrous and idealized. In the Polynesian context, these bodily dialectics were charted on a spectrum ranging, on the one hand, from cannibalism and tattooing to, on the other, the noble savage (usually given a Grecian physiognomy) and the delightful *vahine*. It is the fantasmatic dualism of cannibalism and *vahine* which alerts us to the central homology between the Polynesian body and the African body in European consciousness. For as Christopher Miller has pointed out in relation to Africanist discourse, "The horror of monstrousness and the delight of fulfillment are counterparts of a single discourse, sharing the same conditions of possibility: distance and difference. . . ."[12] The Maori body has its own specificity; it did not conform altogether to the model of the black African body. On the contrary, eighteenth- and nineteenth-century images of the Maori—and they are overwhelmingly of women—work to produce a subject who, if not altogether "white," is certainly not inscribed within the conventional representational schema for "black." This in turn may account for the perpetual problem posed by the "origin" of the Maori. If neither Black, White nor Yellow (the overarching racial categories systematized in such summas of racialism as Joseph Gobineau's *Essai sur l'inégalité des races humaines*), the Maori race, along with its placelessness, was clearly disturbing for nineteenth-century racial theory. In this respect, it would be amusing to think that the "problem" of Maori origins was unconsciously al-

legorized in Gauguin's *D'où venons-nous, Que sommes-nous, Où allons-nous?*

The Polynesian body had another specific valence, which was structured around the perception of its putative androgyny, androgyny here understood in a morphological sense. As Victor Segalen, following countless previous descriptions, specified: "The woman possesses many of the qualities of the young man: a beautiful adolescent [male] comportment which she maintains up to her old age. And diverse animal endowments which she incarnates with grace."[13] Conversely, the young male Maori was consistently ascribed feminine characteristics. This instability in gendering was given explicit expression in the encounter Gauguin described in *Noa Noa* which hinged on his "mastery" of homosexual desire for a young Maori who trekked for him in search of wood to make his carvings.

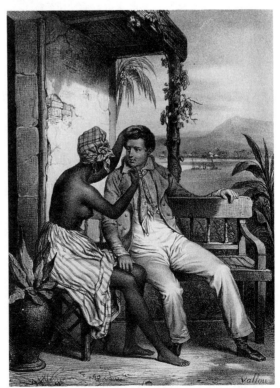

7. Julien Vallou de Villeneuve, *Petit Blanc que j'aime*, lithograph, ca. 1840s. Paris, Bibliothèque Nationale, Cabinet des Estampes.

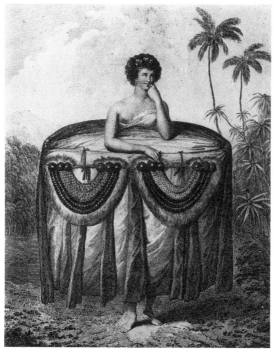

8. J. Webber, *A Young Woman of Otaheete Bringing a Present,* early nineteenth-century British print, after a French original *(Roger-Viollet).*

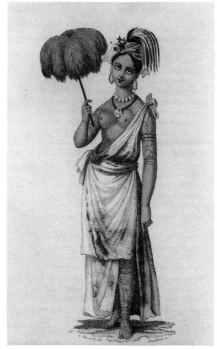

9. L. Massard, *Femme tatouée de l'Ile Madison, Océanie,* ca. 1820 *(Roger-Viollet).*

The logic at work in the literary and iconic production of La Nouvelle Cythère was explicitly structured by the erotic fascination organized around the figure of the young Polynesian woman. "There should be little difficulty," wrote one frigate captain in 1785, "in becoming more closely acquainted with the young girls, and their relations place no obstacles in their way."[14] We may recall too that the mutiny on the Bounty was in part a consequence of the crew's dalliances with the native women. In any case, from the eighteenth century on, it is possible to identify various modalities in which the South Sea Islands are condensed into the figure of the *vahine* who comes effectively to function as metonym for the tropic paradise *tout court.* Indeed, Maori culture as a whole is massively coded as feminine, and glossed by constant reference to the languor, gentleness, lassitude and seductiveness of "native life"—an extension of which is the importance in Polynesian culture of bathing, grooming, perfuming, etc.

By the time the camera was conscripted to the discursive production of the Maori body (in the early 1860s, a good twenty years before Gauguin's arrival), these conventions of representation were fully established [8, 9].

In examining popular representational modes —whether graphic or photographic—one can situate them with respect to the high-cultural forms to which they relate as iconographic poor relations. Hence, we move from Rococo *vahines* to "naturalist" or academic representations of unclothed Tahitians in the later nineteenth century, underpinned, as they clearly are, by the lessons of academic painting and its protocols of pose and comportment [10].

There was, as well, a fully developed literary tradition concerning Tahiti and to a lesser extent the Marquesas, ranging from what are now deemed high-cultural productions such as Herman Melville's *Typee* and *Omoo,* to enormously successful mass-cultural productions such as the

Marriage of Loti by Pierre Loti (the pen name of Julien Viaud). "Serious" primitivists such as Gauguin and Victor Segalen dismissed books such as the *Marriage of Loti* as sentimental trash—*"proxynètes de divers,"* Segalen called them—but to read Segalen's *Les Immemoriaux* or to contemplate Gauguin's strangely joyless and claustral evocations of Tahiti and the Marquesas is to be, in the final instance, not at all far from Loti.

In short, the "availability" of Tahiti and the Marquesas to Gauguin was as much a function of 100 years of prior representation as was its status as French possession, which additionally entitled Gauguin to a 30 percent reduction on his boat ticket and a spurious mission to document native life. Both forms of availability are eloquently symbolized in the 1889 Universal Exhibition, whose literal center was composed of simulacra of native habitations, imported native inhabitants and tribal objects. William Walton, a British journalist, indicated the scale and ambition of this colonial Disneyland in his "Chefs d'oeuvre de l'Exposition Universelle": "The colonial department includes Cochin Chinese, Senegalese, Annamite, New Caledonian, Pahouin, Gabonese and Javanese villages, inhabitants and all. Very great pains and expense have been taken to make this ethnographic display complete and authentic."[15]

In addition to these villages, there was a model display of forty-odd dwellings constituting a "History of Human Habitation" as well as a display of "The History of Writing," including inscriptions taken from Palenque and Easter Island. The importance of this lexicon of exoticism for Gauguin should not be—but usually is—underestimated. Over a period of several months, Gauguin was frequently within the precincts of the exhibition (the Synthetist exhibition at the Café Volponi ran simultaneously). Thus, the experience of the primitive "framed" within the Pavilion of the Colonies or the History of Human Habitation is analogous to the primitivist discourse "framed" by the imperialism that is its condition of existence and the context of its articulation.

To acknowledge this framing is but a first step in demythifying what it meant for Gauguin to "go native." There is, in short, a darker side to primi-

10. Lithograph after drawing by E. Ronjat, *Indogènes des Iles Tubuai,* ca. 1875 *(Roger-Viollet).*

11. Paul-Emile Miot, *Two Tahitian Sisters in Missionary Garb*, 1869–70. Paris, Musée de l'Homme.

tivist desire, one implicated in fantasies of imaginary knowledge, power and rape; and these fantasies, moreover, are sometimes underpinned by real power, by real rape. When Gauguin writes in the margin of the *Noa Noa* manuscript, "I saw plenty of calm-eyed women. I wanted them to be willing to be taken without a word, brutally. In a way [it was a] longing to rape,"[16] we are on the border between the acceptable myth of the primitivist artist as sexual outlaw, and the relations of violence and domination that provide its historic and its psychic armature.

In making an argument of this nature, one can also make reference to the distinction between the Polynesian reality and Gauguin's imaginary reconstruction of it. In 1769, the population of Tahiti was reckoned at about 35,000 persons. By the time of Gauguin's arrival in Papeete in 1891, European diseases had killed off two thirds of the population. Late nineteenth-century ethnographers speculated that the Maori peoples were destined for extinction. The pre-European culture had been effectively destroyed; Calvinist missionaries had been at work for a century, the Mormon and Catholic missionaries for fifty years. The hideous muumuus worn by Tahitian women were an index of Christianization and Western acculturation [11, 12]. According to Bengt Danielsson, the only Gauguin specialist who diverges from mythic speech, "virtually nothing remained of the ancient Tahitian religion and mythology . . . ; regardless of sect, they all attended church—at least once a day. Their Sundays were entirely devoted to churchgoing."[17]

Not only had the indigenous religion been eradicated, but the handicrafts, barkcloth production, art of tattoo and music had equally succumbed to the interdiction of the missionaries or the penetration of European products. The bright-colored cloth used for clothing, bedding and curtains that Gauguin depicted was of European design and manufacture.

Gauguin did, of course, indicate his dissatisfaction with Papeete as a provincial town dominated by colonials and demoralized and deracinated *indigènes*. In later years, in the Marquesas, he saw fit to regularly (and publicly) denounce the practice of intermarriage between the resident Chinese and the Polynesians. But the tourist/colonialist lament for the loss of the authentic, primitive culture it seeks to embrace is itself a significant component of the primitivist myth. For within

this pervasive allegory, as James Clifford points out, "The non-Western world is always vanishing and modernizing. As in Walter Benjamin's allegory of modernity, the tribal world is conceived as a ruin."[18]

In France, Gauguin had imagined Tahiti to be a sensual land of cockaigne where a bountiful nature provided—effortlessly—for one's needs. This was also what the colonial pamphlets he had read told him. In fact, installed in his house thirty miles from Papeete, Gauguin was almost entirely reliant on the extremely expensive tinned food and biscuits from the Chinese trading store. Bananas and breadfruit, a staple of the Tahitian diet, were gathered by the men once a week on excursions to the highlands. Fishing, which provided the second staple food, was both a collective and a skilled activity. Ensconced in his tropical paradise, and unable to participate in local food-gathering activities, Gauguin subsisted on macaroni and tinned

beef and the charity of Tahitian villagers and resident Europeans. Throughout the years in Tahiti and later in the Marquesas, Gauguin's adolescent mistresses were not only his most concrete and ostentatious talisman of going native, they were also, by virtue of their well-provisioned extended families, his meal tickets.

There are, of course, as many ways to go native as there are Westerners who undertake to do so. Gauguin scrupulously constructed an image of himself as having a profound personal affinity for the primitive. The Polynesian titles he gave most of his Tahitian works were intended to represent him to his European market, as well as to his friends, as one who had wholly assimilated the native culture. In fact, and despite his lengthy residence, Gauguin never learned to speak the language, and most of his titles are either colonial pidgin or grammatically incorrect.[19] His last, rather squalid years in the Marquesas included

12. Engraving by Patas, illustration from *Les Voyages de Capitaine Cook* (vol. III, pl. 6), 1774. *Vue de l'intérieur d'une maison dans l'île d'Uhetea, représentation d'une danse à la mode de pays (Roger-Viollet)*.

stints as a journalist for a French newspaper and a series of complicated feuds and intrigues with the various religious and political resident colonial factions.

It is against this background that we need to reconsider the text of *Noa Noa*. It has been known for quite a long time that much of the raw material of the text—notably that pertaining to Tahitian religion and mythology—was drawn from Gauguin's earlier *Ancien Culte mahorie,* of which substantial portions were copied verbatim from Jacques-Antoine Moerenhout's 1837 *Voyages aux îles du grand océan.* [20] Thus, when Gauguin writes in *Noa Noa* that his knowledge of Maori religion was due to "a full course in Tahitian theology" given him by his thirteen-year-old mistress Teha'amana, he is involved in a double denial; his avoidance of the fact that his own relation to the Maori religion was extremely tenuous, merely the product of a text he had just appropriated, and his refusal to acknowledge that Teha'amana, like most other Tahitians, *had* no relation to her former traditions.

I will return to this paradigmatic plagiarism shortly, but first I want to say a few more words about what we might call Teha'amana's structural use value for the Gauguin myth. Certainly, and at the risk of stating the obvious, it is clear that Teha'amana's function as Gauguin's fictive conduit to the ancient mythologies is entirely overdetermined. No less overdetermined is the grotesque afterlife of Gauguin's successive *vahines* in the modern art-historical literature. Conscientiously "named," their various tenures with Gauguin methodically charted, their "qualities" and attributes reconstituted on the "evidence" of his paintings and writing, their pregnancies or abortions methodically deduced, what is at work is an undiminished investment in the mythos of what could be termed primitivist reciprocity. This is a form of mythic speech that Gauguin produces effortlessly in the form of the idyll or pastorale, as in the following passage from *Noa Noa:*

I started to work again and my house was an abode of happiness. In the morning, when the sun rose the house

was filled with radiance. Teha'amana's face shone like gold, tinging everything with its luster, and the two of us would go out and refresh ourselves in the nearby stream as simply and naturally as in the Garden of Eden, *fenua nave nave.* As time passed, Teha'amana grew ever more compliant and affectionate in our day to day life. Tahitian *noa noa* imbued me absolutely. The hours and the days slipped by unnoticed. I no longer saw any difference between good and evil. All was beautiful and wonderful.[21]

The lyricism of Gauguin's own idealized description of life in Tahiti with its piquant allusions to the breaking of bourgeois norms and strictures—most spectacularly in the vision of a fifty-year-old man frolicking with his thirteen-year-old mistress—is one of the linchpins of the Gauguin myth. All the more necessary to instate less edifying perspectives on Eden, as in Gauguin's 1897 letter to Armand Seguin:

Just to sit here at the open door, smoking a cigarette and drinking a glass of absinthe, is an unmixed pleasure which I have every day. And then I have a 15-year-old wife [this was one of Teha'amana's successors] who cooks my simple every-day fare and gets down on her back for me whenever I want, all for the modest reward of a frock, worth ten francs a month.[22]

Such oppositions give some notion of the rich range of material available to the Gauguin demythologizer. More pointedly still, they call attention to one of the particularly revealing aspects of what I may as well now call Gauguinism—namely, the continuing desire to both naturalize and make "innocent" the artist's sexual relations with very young girls, as symptomatically expressed in René Huyghe's parenthetical assurance in his essay on Gauguin's *Ancien Culte mahorie* that the thirteen-year-old Tahitian girl is "equivalent to 18 or 20 years in Europe."[23]

Huyghe's anodyne assurance that the female Maori body is *different* from its Western counterpart is paradoxically motivated by the desire to normalize a sexual relationship which in Europe would be considered criminal, let alone immoral. But the paradox is fundamental, for what is at stake in the erotics of primitivism is the impulse to domesticate, as well as possess. "The *body* of

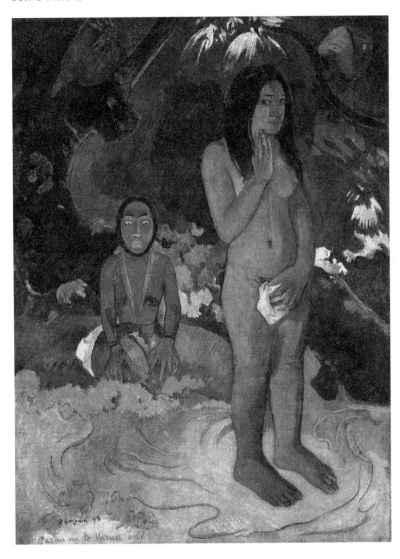

13. Paul Gauguin, *Parau Na Te Varua Ino* (Words of the Devil), 1892. Washington, D.C., National Gallery of Art, Gift of the W. Averell Harriman Foundation in memory of Marie N. Harriman.

strangeness must not disappear," writes Hélène Cixous in *La Jeune Née*, "but its strength must be tamed, it must be returned to the master."[24] In this respect, the image of the savage and the image of the woman can be seen as similarly structured, not only within Gauguin's work, but as a characteristic feature in the project of representing the Other's body, be it the woman's or the native's. Both impulses can be recognized in Gauguin's representational practice.

In the Polynesian pictures as in the Breton work, images of men are singularly rare. Fre-quently, and in conformity with the already-represented status of the Maori, they are feminized. Nothing suggests that there is anything behind the men's pareros, while Gauguin is one of the first European artists to depict his female nudes with pubic hair. In this regard it is interesting to note that Gauguin's supine nude Breton boy (male nudes appear only in the Breton period) has had his penis strangely elided. But while there is nothing quite comparable to this odd avoidance of masculine genitalia in his images of women, and although they are figured with all the conventional

tropes of "natural" femininity—fruits with breasts, flowers and feathers with sex organs—there is nonetheless something in their wooden stolidity, their massive languor, their zombielike presence that belies the fantasy they are summoned to represent [13].

What lies behind these ciphers of femininity? By way of approaching this question, I want to reintroduce the issue of Gauguin's plagiarisms. For the scandal of the appropriation of Moerenhout may be seen to have broader implications. Copied for use in *L'Ancien Culte mahorie*, it resurfaces in the later *Noa Noa*. Parts of the same text reappear in *Avant et après*. A paragraph from the French colonial office pamphlet touting Tahiti for colonial settlement appears in a letter to Mette Gauguin.

In addition to the appropriation of others' texts, Gauguin tends to constantly recycle his own. Bits and pieces of *The Modern Spirit and Catholicism* surface in letters and articles. In his personal dealings with artists during his years in France, there is another kind of appropriation: Emile Bernard, for example, claimed that Gauguin had in effect "stolen" his Synthetism, and there is no question that Bernard's work comprised a far more developed and theorized Symbolism when the two artists first became friends in Brittany. From 1881 through the 1890s, one can readily identify a Pissarroesque Gauguin, a van Goghian Gauguin, a Bernardine Gauguin, a Cézannian Gauguin, a Redonian Gauguin, a Degasian Gauguin and, most enduringly and prevalently, a Puvisian Gauguin. And as for what is called in art history "sources," Gauguin's oeuvre provides a veritable lexicon of copies, quotations, borrowings and reiterations.

Drawing upon his substantial collection of photographs, engraved reproductions, illustrated books and magazines and other visual references, Gauguin, once he jettisoned Impressionism, drew far more from art than from life. Consider, for example, Gauguin's repeated use of the temple reliefs from Borobudur and wall paintings from Thebes. His borrowings from the Trocadéro collections, and from the tribal artifacts displayed at the Universal Exhibition, are obvious. In certain cases, he worked directly from photographs to depict Maori sculptures that he never saw; photographs were often the source of individual figures as well. The Easter Island inscription from the Universal Exhibition appears in *Merahi Metue No Tehamana*. Manet's *Olympia* and Cranach's *Diana* are reworked as *Te Arii Vahine*. A double portrait of two Tahitian women comes directly from a photograph. Certain of Gauguin's ceramic objects are modeled on Mochican pottery. Woodcuts by Hiroshige provide the motif for a Breton seascape.

For some of Gauguin's contemporaries, this bricolage was the very essence of what they understood to be Gauguin's brand of Symbolism, as in Octave Mirbeau's description of Gauguin's "unsettling and savory mingling of barbarian splendor, Catholic liturgy, Hindu meditation, Gothic imagery and obscure and subtle symbolism."[25] For less sympathetic observers, such as Pissarro, "All in all . . . it was the art of a sailor, picked up here and there."[26]

All of which suggests that in Gauguin's art the representation of the feminine, the representation of the primitive, and the reciprocal collapse of one into the other, has its analogue in the very process of his artistic production. For what is at issue is less an invention than a reprocessing of already constituted signs. The life of Gauguin, the art of Gauguin, the myth of Gauguin—approached from any side we confront a Borgesian labyrinth of pure textuality. Feminine and primitive, Breton and Maori, are themselves representable only to the extent that they exist as already-written texts, which yet continue to be written. "When myth becomes form," cautioned Barthes, "the meaning leaves its contingency behind, it empties itself, it becomes impoverished, history evaporates, only the letter remains."[27] In contrast to the recent and elaborate rehabilitation of the primitivizing impulse, Pissarro, closer to the history that the Gauguin myth occludes, always retained his clarity of judgment: "Gauguin," he wrote, "is always poaching on someone's land; nowadays, he's pillaging the savages of Oceania."[28]

NOTES

1. By profession a doctor in the French navy, and by avocation a diarist and writer, Victor Segalen (1878–1919) was an influential producer of toney literary exotica. His first naval tour of duty was in Oceania, and he arrived in Tahiti a few months after Gauguin's death. Subsequently, he purchased many of Gauguin's effects, including manuscripts, art works, photographs, albums, etc. Segalen's essays on Gauguin are anthologized in the posthumous collection *Gauguin dans son dernier décor et autres textes de Tahiti*, Paris, 1975. Upon Segalen's return to France, he wrote his novel *Les Immemoriaux* (1905–6), an imaginary reconstruction of Maori life which he characterized as attempting "to describe the Tahitian people in a fashion equivalent to the way Gauguin saw them." Subsequently, Segalen was posted to China for four years (1909–13), a sojourn that resulted in the novel *René Leys*, as well as two collections of essays, *Steles* and *Briques et tuiles*. His *Essai sur l'exoticisme*, published posthumously, is a meditation on the nature of [Western] exoticism—a desire for the Other.

2. Cited in John Reward, *Gauguin*, New York, 1938, p. 11.

3. Fred Orton and Griselda Pollock, "Les Données Bretonnantes: La Prairie de la Representation," *Art History*, Sept. 1980, pp. 314, 329.

4. *Camille Pissarro: Letters to His Son Lucien*, ed. John Rewald, New York, 1943, p. 171.

5. Cited in Robert Goldwater, *Primitivism in Modern Painting*, New York, 1938, p. 60.

6. Claire Frèches-Thory, "Gauguin et la Bretagne 1886–1890," *Gauguin* (exhibition catalogue), Paris, Grand Palais, 1989, p. 85.

7. Wayne Andersen, *Gauguin's Paradise Lost*, New York, 1971, p. 53.

8. Examples are legion, but Wayne Andersen's book, cited above, is one of the worst offenders. Its central thesis is that Gauguin's work is unified around the theme of the woman's life cycle, wherein the crucial event is the loss of virginity, which, as Andersen has it, may be understood as homologous to the Crucifixion of Christ. Not surprisingly, this theory promotes a fairly delirious level of formal and iconographical analysis.

9. Henri Dorra, "The First Eves in Gauguin's Eden," *Gazette des beaux-arts*, Mar. 1953, pp. 189–98, p. 197.

10. Vŏjtech Jirat-Wasiutynski, "Paul Gauguin's Self-Portraits and the Oviri: The Image of the Artist, Eve, and the Fatal Woman," *The Art Quarterly*, Spring 1979, pp. 172–90, p. 176.

11. *Lettres de Gauguin à sa femme et ses amis*, ed. Maurice Malingue, Paris, 1946, p. 184.

12. Christopher L. Miller, *Blank Darkness: Africanist Discourse in French*, Chicago, 1985, p. 28.

13. Victor Segalen, "Homage à Gauguin," *Gauguin dans son dernier décor*, p. 99 [my translation].

14. C. Skogman, *The Frigate Eugenie's Voyage Around the World*, cited in Bengt Danielsson, *Love in the South Seas*, London, 1954, p. 81.

15. Cited in Christopher Gray, *Sculpture and Ceramics of Paul Gauguin*, Baltimore, 1967, p. 52.

16. Paul Gauguin, *Noa Noa*, ed. and intro. Nicholas Wadley, trans. Jonathan Griffin, London, 1972, p. 23. There are a number of editions of *Noa Noa* in keeping with its complicated production and publication history. Originally planned by Gauguin as a collaboration between himself and Charles Morice, he later declared himself dissatisfied with the literary improvements and narrative reorganization that Morice had imposed. At least three different versions are in print, not counting translations.

17. Bengt Danielsson, *Gauguin in the South Seas*, London, 1965, p. 78.

18. James Clifford, "Histories of the Tribal and the Modern," *Art in America*, April 1985, pp. 164–72, p. 178.

19. See in this regard, Bengt Danielsson, "Les Titres Tahitiens de Gauguin," *Bulletin de la Société des Études Oceaniennes*, Papeete, nos. 160–61, Sept.–Dec. 1967, pp. 738–43.

20. See René Huyghe, "Le Clef de Noa Noa," in Paul Gauguin, *Ancien Culte mahorie*, Paris, 1951. Gauguin's spelling of *mahorie* is incorrect in any language.

21. Gauguin, *Noa Noa*, p. 37.

22. Letter to Armand Séguin, Jan. 15, 1897. Cited in Danielsson, *Gauguin in the South Seas*, p. 191.

23. Huyghe, "La Clef de Noa Noa," p. 4.

24. Cited in Josette Féral, "The Powers of Difference," in *The Future of Difference*, eds. Hester Eisenstein and Alice Jardine, Boston, 1980, p. 89.

25. Octave Mirbeau, "Paul Gauguin," *L'Echo de Paris*, Feb. 16, 1891. Reprinted in Mirbeau, *Des Artistes*, Paris, 1922, pp. 119–29.

26. *Camille Pissarro*, p. 172.

27. Roland Barthes, "Myth Today," *Mythologies*, ed. and trans. Annette Lavers, New York, 1978, p. 139.

28. *Camille Pissarro*, p. 221.

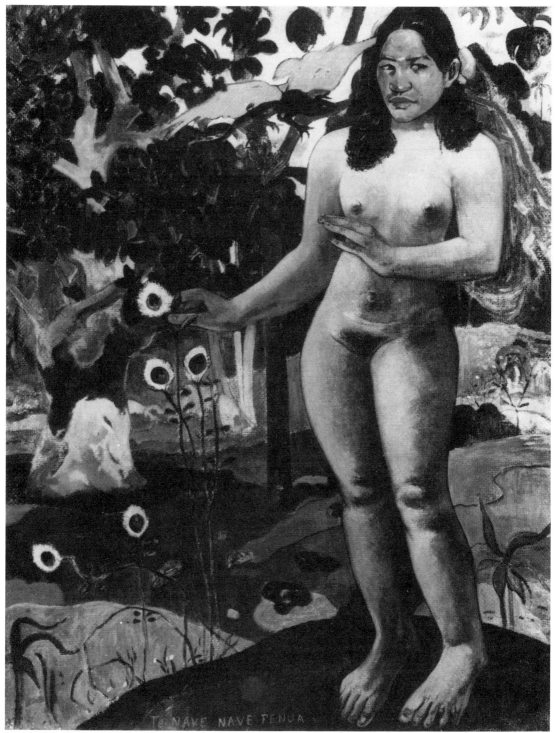

1. Paul Gauguin, *Te Nave Nave Fenua (Delightful Land),* 1891. Chuo Kurashiki, Japan, Ohara Museum of Art.

18

GAUGUIN'S TAHITIAN BODY

PETER BROOKS

Gauguin's version of the myth of Tahiti, gleaned from guidebooks to Oceania, from Pierre Loti's insufferable Tahitian romance *Le Mariage de Loti,* and perhaps especially from the Colonial Exhibits in the Exposition Universelle of 1889, does not differ in essence from that which exercised its fascination in the European imagination from the very moment of the discovery of the island in the eighteenth century.[1] Especially in France, from the moment Louis-Antoine de Bougainville returned in 1769 from his voyage around the world to report his discoveries, Tahiti was "l'Ile de Cythère," the new abode of Venus. If Tahiti appeared to many as the realization of Rousseau's speculations about the earliest forms of social organization, a primitive utopia which had instituted harmony and order but not succumbed to the division of property and the twin despotisms of church and state, it was most remarkably a sexual paradise, a place where the surplus repression that had created the discontents of European civilization simply had no currency, and the plea-

sure principle dominated without censorship.

Bougainville's arrival in Tahiti saw his two ships, *Boudeuse* and *Etoile,* surrounded by native canoes, filled with men, and, especially, women. "Most of these nymphs were naked, for the men and the old women who accompanied them had taken off the wrap that they normally wear."[2] It was quickly evident that the men were offering these nymphs—*why* they were doing so is a question that will need some attention in a moment— and indeed in "unequivocal gestures" demonstrated how the sailors were to make the nymphs' acquaintance. One of them even managed to reach the deck, "where she negligently let fall the wrap that covered her, and appeared to the eyes of all in the manner that Venus showed herself to the Phrygian shepherd: she had the same celestial form." Thus are the French sailors convoked to a reenactment of the Judgment of Paris.

The moment and the style are quintessential Bougainville. In the following chapter, he recounts his first visit on shore, and how, on his return to his launch, he was invited to sit down with a handsome islander who then, accompanied by a flutist, "slowly sang for us what was no doubt an Anacreonic song: a charming scene, worthy of the paintbrush of Boucher" (p. 191). *Et in Ar-*

This essay was presented as a paper at the College Art Association Annual Meeting, 1990. A fuller version was published in *Yale Journal of Criticism* 3, no. 2 (Spring 1990): 51–90. Copyright © by Peter Brooks. Reprinted by permission of the author and *Yale Journal of Criticism.*

cadia ego. Bougainville—a man who can cite his Virgil from memory—consistently chooses a tropological frame of reference that situates Tahiti as a classical golden age, as reinvented by the eighteenth-century artists of *la volupté:* he and his men have wandered into a *fête galante* which has embarked them for the Isle of Cythera:

Venus is here the goddess of hospitality, her worship admits of no mysteries, and every moment of bliss is a festival for the nation. They were surprised at the embarrassment that we displayed; our manners have proscribed such publicity. However I cannot guarantee that none of the French was able to overcome his repugnance in order to conform to the local customs (pp. 194–95).

Bougainville has discovered not the anarchic "state of nature" but what Rousseau in his *Discours de l'inégalité parmi les hommes* of 1754 called "la société naissante": a people emerged from barbarism, and entered into a social compact which has not yet been adulterated—"the happiest and most enduring state." Here, as Rousseau puts it, is "the true youth of the world."[3] Diderot will epigrammatically make the application to Tahiti in his *Supplément au voyage de Bougainville:* "The Tahitian borders on the origin of the world, and the European on its old age."[4] Tahitian primitivism is conceived to be consubstantial with primal innocence, an admirable naiveté, lack of the corruption inevitable in old civilizations. This version of the exotic is both spatially and temporally removed from contemporary Europe. The voyage out to the South Pacific is thus also a voyage back, to a time before.

Even the thievery of the Tahitians is merely a sign of their innocence in regard to the notion of private property, which is of course for Rousseau the beginning of the end, an usurpation that leads inevitably to a society of masters and slaves, and to the destruction of human felicity. The most patent disciple of Rousseau on board the *Boudeuse,* its physician and naturalist, Philibert de Commerson, at once equated Tahiti with Thomas More's *Utopia,* and claimed that the Tahitians lived in a kind of harmonious communism, without any sense of exclusive property rights—a

misinterpretation of Tahitian social structure which is revealing of certain Enlightenment requirements for utopia. The lack of a sense of exclusive possession included persons as well as things: women were free to circulate, the fundamental law was that of desire, without any of the artificial prohibitions and inhibitions that European civilization had invented to promote what Freud would call "instinctual renunciation." "They know no other god than Love," writes Commerson. Arcadia is above all the unrestricted exercise of the pleasure principle, which shows itself to be in harmony with the principle of utility.

As for Commerson, for Diderot the free sexuality of the Tahitians is based on their understanding that the production of children is an ultimate natural good; and the moral restrictions paraded by Diderot's fictive chaplain—including prohibitions on fornication, incest, adultery, and prescriptions of monogamy and eternal fidelity—only pervert and inhibit the realization of this good. Jealousy, coquetry, infidelity, false modesty—all these attributes of European sexuality derive from a history which has turned women into men's property. Sexual liberty in Tahiti is for Diderot more than anything else a powerful source of illumination for European sexual servitude. The discovery of Tahiti thus stands as a confirmation of Rousseau's *Discours,* and a source of Choderlos de Laclos's argument, in his *Sur l'Education des femmes,* that there is no way of perfecting the nature of women in the present state of European society, since woman's natural wants and needs have been thoroughly adulterated by her enslavement to men.

Bougainville's presentation of Tahiti under the aegis of the Judgment of Paris from among the naked Graces stands in some contrast to the account given by his predecessor, the first European to discover the island, Captain Samuel Wallis of H.M.S. *Dolphin.* Wallis's arrival in Tahiti apparently did not produce boatloads of naked nymphs, but rather some tense trading encounters, the firing of warning rounds of cannon, and then a full-fledged combat, with Tahitian stone-throwing quickly overmastered by English cannonades and

grapeshot. Several Tahitians had been slaugh-
tered, probably without sufficient provocation,
before the English established their beachhead.
And when the English did come ashore, it was to
establish a trading post, under the watchful eye
and the sole authority of the gunner, alongside a
river which served as a closely guarded frontier
between the natives and the English. With the
English, it was not the gift of sex but its barter
that characterized the relations of female natives
to male visitors. Wallis comments: "While our
people were on shore, several young women were
permitted to cross the river, who, though they
were not averse to the granting of personal fa-
vours, knew the value of them too well not to
stipulate for a consideration."[5] Or as George Rob-
ertson, master of the *Dolphin,* puts it in his jour-
nal for 7 July 1767: "I was told by one of the
Young Gentlemen that a new sort of trade took
up most of their attention this day, but it might
be more properly called the old trade."[6] The cur-
rency of the trading was quickly established in
nails. Wallis claims that the "fathers and broth-
ers" who brought young women to the trading
area were "conscious of the value of beauty, and
the size of the nail that was demanded for the
enjoyment of the lady, was always in proportion to
her charms" (Hawkesworth, 1: 181). Yet Wallis's
neat economy may be faulty, since in fact he spent
much of the Tahitian stay sick in his cabin. Rob-
ertson reports a simpler and perhaps more accu-
rate progressive inflation of prices: on 21 July he
notes, "Some of the Young Gentlemen told me,
that all the Liberty men carried on a trade with
the Young Girls, who had now raised their price
for some Days past, from a twenty or thirty-penny
nail, to a forty-penny, and some was so Extrava-
gant as to demand a Seven or nine Inch Spike"
(Robertson, p. 104). In fact, the *Dolphin* had by
this point been rendered almost unseaworthy by
the carnal trade: Robertson discovered that the
seamen had been pulling nails and spikes from the
ship's cleats, and that two-thirds of the hammock
nails had disappeared, with the result that the
men were sleeping on the deck. Thus it became
necessary for Wallis and Robertson to impose
draconian regulations on trade.

The nails of the *Dolphin* give a version of sexual
commerce between Europeans and Tahitians
somberly at odds with the Arcadian tropes of Bou-
gainville. One notes that the Tahitians seem to
have responded eagerly to the introduction of iron
into their society—they had none before the ar-
rival of the Europeans, and it must have appeared
an exotic and marvelous substance, immediately
suitable for making fishhooks and, when it took
the form of ax heads, other tools and weapons.[7] If
this were the case, they would be behaving in the
manner imposed upon many colonized peoples,
offering their natural resources in exchange for
"modernization." Gauguin will regularly describe
the Tahitian body as "golden"—"Et l'or de leur
corps" (And the gold of their bodies), he lyrically
entitled one of his paintings. In the commerce of
the *Dolphin,* the golden body of pleasure is the
natural resource exchanged—at bargain rates—
for grim, utilitarian English iron. Complicit with
the commercial exchange is a tropology: the pre-
cious but primitive "found" resource, belonging
to an economy of abundance, enjoyment, and
waste, set against the manufactured commodity,
belonging to an economy of scarcity, capitaliza-
tion, and repression. The Golden Age perceived
by the French captain and crew was already,
thanks to the English, on the way to its degrada-
tion, into an Iron Age.

Thus Bougainville's belief that he and the Tahi-
tians were freely offering gifts to one another—as
in the ceremony of the potlatch—may mark an
ideological blindness that did not let him see the
underlying terms of exchange. But the history of
the *Dolphin*'s stay in Tahiti, and the armed en-
counter and slaughter of an undetermined num-
ber of natives by the mysterious and potent fire-
arm, suggests still another interpretation of the
facility with which women were offered up to the
visitors. It may have been in propitiation to outsid-
ers who, the Tahitians recognized, had the power
to destroy them all. Once you discover that your
stones are no match for their cannon and musket
balls, try to seduce them. Make love, not war.

And yet: even if one suspects that there was a
measure of calculation in the presentation of those
naked nymphs to sexually deprived sailors, one

cannot wholly dismiss Bougainville's Arcadian vision, which seems in fact to be substantiated by modern ethnological work on Maori culture, particularly that of Douglas Oliver and Marshall Sahlins.[8] Sahlins in particular—who is discussing Hawaii, not Tahiti, but the societies had much in common—makes the point that sexual relations were to a large extent creative of social relationships in Maori culture, that sex was pragmatic, and performative, creating structure and patterning kinship. That is, sexual relations between a man and a woman were considered properly foundational for other relations, rather than vice-versa.

The Tahitian sexual body in any event demands interpretation, from the moment of the discovery onward. On the one hand, we have the view sententiously summarized in Hawkesworth's *Account* that in Tahiti "there is a scale in dissolute sensuality, which these people have ascended, wholly unknown to every other nation whose manners have been recorded from the beginning of the world to the present hour, and which no imagination could possibly conceive" (Hawkesworth, 2: 207). On the other hand, there is Diderot's attempt to reconstruct Tahitian sexuality on the model of utility, as the most basic of natural laws. "There is almost nothing in common between the Venus of Athens and that of Tahiti; the first is a galant Venus, the second a fecund Venus" (Diderot, p. 470). The debate is still with us today, even if its ethnological terms have changed: we still are not entirely sure what to make of the apparent free circulation of sexual bodies in the Tahitian social economy, and we will never quite be sure, since the observed phenomena were irretrievably altered by the introduction of the first observers.[9]

Gauguin went to Tahiti in large part because of the attraction of a sexuality ostensibly free of European conventions and repressions, and this meant that he, too, would have to ask questions about the meaning of the Tahitian sexual body. What he found in the Tahitian capital, Papeete, was not the Golden Age or even the nascent Iron Age, but the grim results of a century of efforts by Protestant, Catholic, and Mormon missionaries, and the disintegration of traditional social structure at the hands of the colonial powers. Papeete

was an ugly town of concrete houses with tin roofs, and the women were fully covered with shapeless sack dresses. Arriving on the eve of the death of King Pomaré V—after which, by prior agreement, rule passed directly to France, which in reality had been in control for decades—Gauguin chose in *Noa Noa,* his book about his first Tahitian stay, to see the passing of this monarch as the final extinction of Maori culture: "With him disappeared the last traces of Maori customs. It was completely finished; nothing left but civilized people."[10] This is inaccurate, in that Maori culture had been pretty well eradicated long before the death of the decadent and drunken Pomaré V—in fact, there had been no kings in Tahiti until the Europeans set up one family of chiefs in this role—but the event is useful for Gauguin's mythological narrative. His text continues: "Will I succeed in finding a trace of this so distant and so mysterious past? And the present didn't say anything worthwhile to me. To rediscover the ancient hearth, to revive the fire in the midst of all these ashes."

Like a number of other travel books, including Claude Lévi-Strauss's *Tristes Tropiques, Noa Noa* from the outset establishes itself as a quest, a journey back from a rotten civilization toward the savage state, which is also the place of a lost Maori culture. And in this quest, the Tahitian woman will naturally—as if predetermined by the prehistory of European contact with Tahiti—play a central role, as the literal point of entry into the Maori soul. Gauguin's first woman, in Papeete, is the half-caste Titi, all he can find for the moment but clearly unsuitable for his larger purposes. Ridding himself of the inhibiting vestiges of civilization must wait upon his discovery of Tehamana, the golden body encasing the Maori soul.

To understand the importance of this Tahitian body for Gauguin, we ought properly to review his earlier artistic versions of the woman's body, especially in his nudes, of which there are relatively few before his Tahitian stay, and which tend to be rather grim. But let me move immediately to his "Tahitian Eve," painted during the year following his arrival in the island, the well-known *Te Nave Nave Fenua* [1], or *Delightful Land.* Here, Eve has become frankly "native," her setting exotically

and fantastically paradisiacal and sensuous, and her nudity presented boldly, without coyness, to the viewer.

The figure of Eve is in fact the focal point for many of Gauguin's reflections on art, woman, and civilization. The most important statement to consider here is the letter he wrote to August Strindberg, during the year he spent in France between his two trips to Tahiti. Couched as an opposition between Strindberg's "civilization" and his own "barbarousness," the letter then focuses on Eve:

Before the Eve of my choice, whom I have painted in the forms and the harmonies of another world, your chosen memories perhaps evoked a painful past. The Eve of your civilized conception makes you, and makes almost all of us, into misogynists; the ancient Eve, who frightens you in my studio, might some day smile on you less bitterly. . . . The Eve I have painted (she alone) logically can remain nude before our eyes. Yours in this simple state couldn't walk without shame, and, too beautiful (perhaps) would be the evocation of an evil and a pain.[11]

What is perhaps most interesting here is what Gauguin says about *looking* at the two Eves naked. It evokes a problem that posed itself acutely to late nineteenth-century painters: how to look at nudity (which essentially meant female nudity) in a naturalizing way. The classical tradition as embodied in Beaux-Arts practice and the innumerable nudes exhibited at the Paris Salons had clearly become decadent, the nudes themselves both erotic and prettified, a kind of Second Empire and Third Republic pinup art that excused what it was doing through worn-out references to classical motifs: endless births of Venus, *bacchantes,* and artificial bathing scenes, which I will illustrate through only one example: Eugène-Emmanuel Amaury-Duval's *La Naissance de Vénus* of 1862 [2]. Following the revolutionary gesture of his *Baigneuses* in 1853, Courbet in the 1860s had produced a series of nudes that for the most part seemed to make considerable concessions to commercial taste, such as the *La Femme au perroquet* of 1866 [3].[12] The Impressionists, with their desire to render modern life, and to

2. Eugène-Emmanuel Amaury-Duval, *La Naissance de Vénus,* 1862. Lille, Musée des Beaux-Arts *(Lauros-Giraudon).*

place their paintings outdoors—"en plein air"— faced the difficulty of finding plausible and picturable settings for the nude—and in fact, there are not that many nudes in Impressionist painting, with the exception of the later Renoir. The triumphant nude of Gauguin's time was of course Manet's *Olympia* [4], a painting that Gauguin worshiped: he took the trouble to copy it, and he had a photograph of it with him in Tahiti. But *Olympia,* and the scandal it provoked, points the problem: the naturalization of nudity in this case

3. Gustave Courbet, *La Femme au perroquet,* 1866. New York, Metropolitan Museum of Art, Bequest of Mrs. H. O. Havemeyer, 1929. The H. O. Havemeyer Collection.

takes the form of showing up the artificiality of the Neoclassical nude by displaying the nude as prostitute, as a clearly sexualized body offered to the spectator's glance in the same manner she is offered to paying customers. Gauguin wants something else, something that would remain fully erotic but without the connotations of shame, scandal, and exposure. That he repeatedly insisted on the figure of Eve—rather than, in the manner of Bougainville and nineteenth-century Salon painters, moving back into classical mythology and the evocation of Venus—indicates a stubborn and no doubt accurate perception that Venus was no longer the point, no longer what nakedness was all about in the Western imagination. It is precisely Eve, with all the connotations of sin and shame, and the complex entry into knowledge of good and evil, that is central to our perception of nudity, and that thus must be reconceived. As Gauguin stated in an interview in 1895, in response to the question why he had gone to Tahiti, "To do something new, you have to go back to the beginning, to the childhood of humanity. My cho-

sen Eve is almost an animal; that's why she is chaste, although naked. All those Venuses exhibited at the Salon are indecent, odiously lubricious. . . ."[13]

Thus Gauguin takes on the almost impossible challenge of revising Eve, of creating a nude in paradise whose nakedness is meant to be looked at in joy and erotic pleasure without the sense that her evident sexuality is connected to evil and pain. His success in this revision is of course dependent on a certain depersonalization of his Eve: in praising her "animality," he removes her from traditional cultural constraints and brackets her own subjectivity, in gestures that could be considered typical of both patriarchy and colonialism. One could indeed argue, as Abigail Solomon-Godeau has forcefully done, that Gauguin's primitivism is a "gendered discourse" that inscribes itself directly in a colonialist "dynamic of knowledge/ power relations which admits of no reciprocity."[14] But such a claim does not do justice to the disruptive, interrogative force of Tahitian sexuality in Western discourse: Tahiti was not, at the outset,

in the first debates its social arrangements provoked, a simple object of colonial rape, but a cultural problem. If one views (as I do) Gauguin's Tahitian painting with sympathy—as marking a decisive break from current European representations of the nude—one may want to counter with the argument that Gauguin produced new and compelling art even while his discourse remained hostage to primitivist myths because he turned this discourse to other uses, made his objects of representation call into question traditional kinds of looking. His construction of "the natural," in *Te Nave Nave Fenua,* for instance, is a matter of the utmost artifice, aimed at disarming our traditional view of the nude and of the primitive, revising the space of our observation and the context of our looking. Gauguin's "exotic" continually refers us back—and is meant to refer us back—to

the problem of the nude in Western art. In this sense, his flight to Oceania is less escapist than it might at first appear, and the art created there is constantly antithetical, using the Tahitian body as a commentary on the civilization that produced Eve. Gauguin implicitly reached back beyond the simpler forms of colonial domination, to participate, at a distance, in the earlier debate—that of Bougainville and Cook—about how the Tahitian sexual body problematizes our standard versions of the body.

Noa Noa is very much the record of Gauguin's construction of a primitive paradise, indeed it is itself part of that construction, conceived as a kind of *vade mecum* for Gauguin's Tahitian paintings, attempting to control the way in which they are to be read through a narrative of the shedding of civilization, a progress back to primitivism, a

4. Edouard Manet, *Olympia,* 1863. Paris, Musée d'Orsay *(Musées Nationaux).*

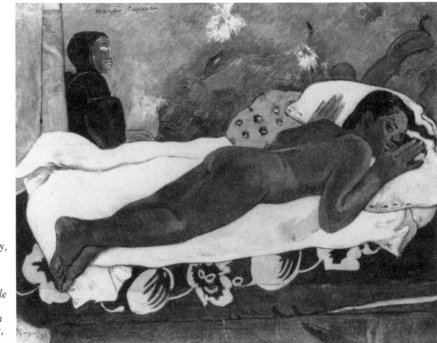

5. Paul Gauguin, *Manao Tupapau*, 1892. Buffalo, Albright-Knox Art Gallery, A. Conger Goodyear Collection, 1965.

6. François Boucher, *Mlle O'Murphy (L'Odalisque)*, 1743. Paris, Louvre *(from Georges Brunel,* Boucher, *1986).*

becoming savage. A crucial passage from *Noa Noa*, revelatory of both Gauguin's project and his confusions, concerns the discovery of Tehamana (in more accurate Tahitian, Teha'amana), the thirteen-year-old girl who is offered to him as a bride by a woman at whose house he is lunching during his exploratory trip around the island. Suddenly, Bougainville's Arcadian Tahiti has come to life again. Gauguin brings this girl—whom he describes as simultaneously "melancholy and mocking"—back to his house in a largely silent journey. "Each of us observed the other; she was impenetrable; I was quickly beaten in this contest" (p. 73). Once again, as in the letter to Strindberg, Gauguin's relation to the female body is presented within a problematics of looking, where the male attempt to penetrate an impassive exterior reaches an impasse that can be resolved only in physical penetration. But after Tehamana has gone to visit her mother, and then returns a few days later, her cultural impenetrability is progressively breached by physical intimacy. Now the true Tahitian idyll begins:

Each day at sunrise the light was radiant in my hut. The gold of Tehamana's face illuminates everything around it and the two of us go to refresh ourselves in a nearby stream, naturally, simply, as in Paradise. . . . [I skip over some ecstatic paragraphs here.]

In bed, at night: conversations. The stars interest her greatly; she asks me the name in French of the morning star, the evening star. She has trouble understanding that the earth turns around the sun. In her turn she tells me the names of the stars in her language (p. 75).

At this point, Gauguin opens a passage on Maori cosmology: not only the names of the stars but the myths of creation associated with them. The passage is lifted from Gauguin's notebook entitled *Ancien Culte mahorie*, which itself, scholars have discovered, is essentially a transcription of parts of a book which Gauguin had discovered in Papeete called *Voyages aux îles du grand océan*, by J. A. Moerenhout, a Belgian who was American consul in Oceania and one of the first serious ethnographers of the region.[15] It is unlikely, to say the least, that Gauguin could have learned Maori cosmology from the thirteen-year-old Tehamana, since a century of Christian missionary work had virtually extirpated traditional Polynesian customs, beliefs, and mythology. By the time Gauguin reached Tahiti, at most a few Tahitian elders could recollect native traditions. They survived at all only in books written by Europeans, and what Gauguin attributes to his child bride is demonstrably book learning.

At this central moment of *Noa Noa*, then, Gauguin's search for the savage state leads him to the gift of the body of a Tahitian girl, who at first appears to be impenetrable golden surface, and in bed with her he finally discovers the long-gone and mysterious Maori past, and indeed the key to Maori beliefs and ways. So he would have us believe. He wants us to understand that it is the very golden body of this silent girl which holds the key to what he has been looking for, that entering her body opens his way to primitivism as a coherent and totalized world view, and its symbols which—reformulated with all the fictional revision that characterizes this moment of *Noa Noa*—would become part of his art.

An indispensable painting in this context is *Manao Tupapau* [5], from late 1892, which in fact "illustrates" the next episode of *Noa Noa*, which recounts how Gauguin, delayed on a trip to town, comes home late at night, to find the lamp in the hut extinguished from lack of fuel and Tehamana lying awake on the bed, staring in wide-eyed terror in fear of the legendary evil spirits of the night, the *tupapau*. Gauguin described the scene and the painting several times: in a letter to his wife, in the notebook dedicated to his daughter, *Cahier pour Aline*, and in later versions of *Noa Noa*, insisting alternately on its Tahitian symbolism and on its pictorial qualities, on its nature as a vision of Maori superstitions, and on its generic nature as a nude study in which the Maori elements are simply a context to display Tehamana's body. He thus thoroughly covers his tracks, and eludes any single interpretive intention. Alfred Jarry in a poem of 1894 described the nude as "brown Olympia," and a number of commentators have subsequently noted Gauguin's evident ambition to rephrase Manet's painting—a photograph of which was tacked on the wall of Gauguin's hut—in Tahitian terms. Like the body of Olympia, that

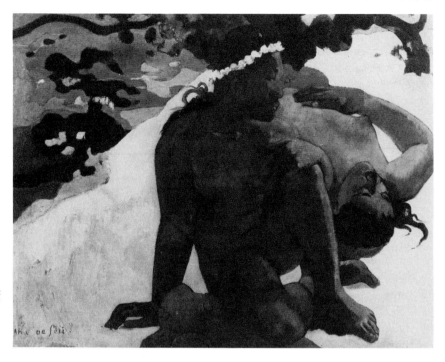

7. Paul Gauguin, *Aha Oe
Feii? (Are You Jealous?),*
1892. Moscow, Pushkin
Museum *(from* The Art of
Paul Gauguin, *ed. Richard
Brettell et al., National
Gallery of Art,
Washington, D.C., 1988).*

in *Manao Tupapau* is offered to the spectator's gaze, though not frontally this time—rather, in a pose that refuses to be a pose, refuses the sense of self-display that one finds in *Olympia* and the distinct impression given by Manet's girl that she is available, for a price. Gauguin's nude is also available, but in a more unself-conscious way, and without connotations of venality. As an Olympia turned over, the nude of *Manao Tupapau* may suggest a comment on the problematics of penetrability and impenetrability posed by Gauguin—may suggest, to use his term, a greater "animality" than that evoked by the classic poses of the nude.

The naked female form, slipping forward toward the frontal plane of the canvas, dislodges the viewer from his traditional space of visual dominance. It is offered to the spectator's gaze in such a way that its nakedness, conceived as natural to the woman herself, without overtones of sin or commerce, is made both natural as an object of vision, and a challenge to standard prettified eroticism. (One could contrast here some of Boucher's rear views of naked women—for instance, his *Mlle O'Murphy* [6].) In contrast to the attributes

of Olympia that betoken her exchange value—the pose, the bold gaze, the black servant bearing flowers sent by an admirer or a keeper—those of *Manao Tupapau* suggest an economy of the gift, as it would be defined by Marcel Mauss: the free and generous offering, which must be responded to by a corresponding gift—which may here be the painting itself. And the gift of the potlatch, as Georges Bataille points out, is related to the creation of sacred objects: objects that have no use value, that belong not to an economy of exchange and accumulation but to an economy of waste, glorious expenditure.[16] Gauguin, one might say, is attempting to reach back beyond the economy of exchange to that of the gift—as it were, denying Wallis's version of Tahiti in order to resurrect Bougainville's vision.

The result is achieved in part, I think, by Gauguin's decorative treatment of the setting and the vaguely symbolic elements—which are perhaps signs of "primitiveness" more than anything else—and also by the sculptural weight and volume of the body itself. Other paintings of the same moment, such as *Aha Oe Feii? (Are You*

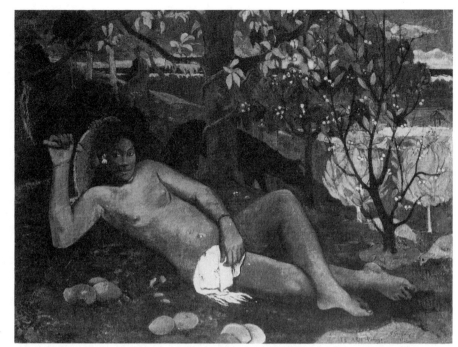

8. Paul Gauguin, *Te Arii Vahine (The Noble Woman)*, 1896. Moscow, Pushkin Museum (*from* The Art of Paul Gauguin).

9. Titian, *Venus of Urbino*, 1538. Florence, Uffizi *(from Charles Hope,* Titian, *1980)*.

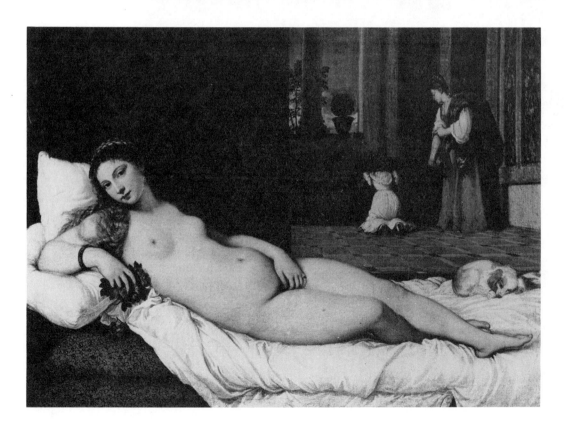

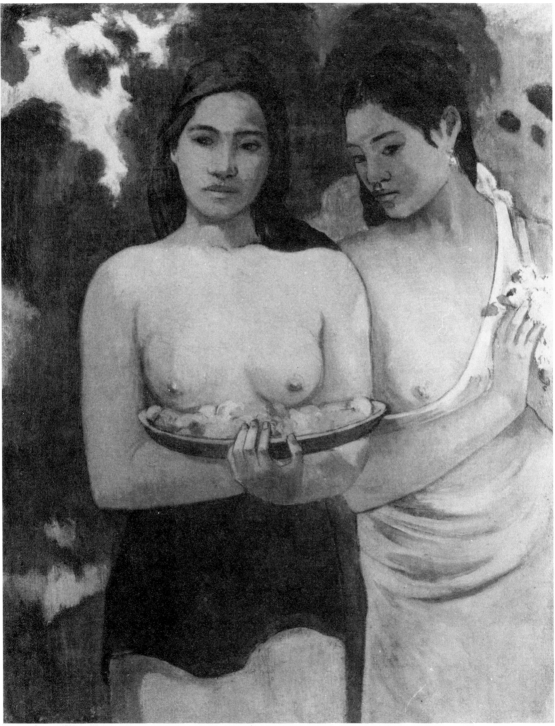

10. Paul Gauguin, *Two Tahitian Women*, 1899. New York,
Metropolitan Museum of Art, Gift of William Church Osborn, 1949.

Jealous?) [7] could help to make the point, but I want in brief space to mention two others, from the second Tahitian stay. The first is *Te Arii Vahine* of 1896 [8]—*The Noble Woman*—which clearly alludes to a long tradition of Western nudes, very much including Manet's *Olympia* and its own prototype, Titian's *Venus of Urbino* [9]. (Another source mentioned is Cranach's *Diana Reclining,* of which Gauguin may also have owned a photograph.[17]) *Te Arii Vahine* evidently suggests the nymphs and Dianas and Venuses of Western art, perhaps even Eve, since the vine wrapped around the tree trunk evokes the serpent wrapped around the tree of knowledge in a number of Renaissance paintings, the pieces of mango evoke the forbidden fruit, and the fan held behind her head by the Tahitian woman almost suggests a halo, triggering responses within the biblical tradition. But all these allusions must be seen almost as comic, as citations from a tradition that has been made irrelevant by a place and a person so clearly unconcerned with Western allegories of the *locus amoenus* and its loss. Especially when one considers the somewhat absurd cloth covering the figure's loins—held almost as if she didn't know its purpose—one has the sense of a Tahitian figure consciously posed by the artist within a Western iconographical tradition of which she is unaware and which doesn't concern her. She appears simply content to display her body, and all the elements of the storybook paradise landscape concur in its display.

The other painting is the *Two Tahitian Women* [10] of 1899, with its almost classical ease in the presentation of this full, strong body that emerges into the sunlight to confront the viewer in full erotic beauty, without any coyness or indeed any self-consciousness. Her face is impassive, neither soliciting nor refusing our gaze. It is a body full of both strength and repose. The unidentified flowers or fruits offered on the tray become a simple metonymy of the body offered as such. One can,

to be sure, simply stigmatize the painting as one more example of a male gaze taking woman as its sexual object. It is this, of course. But we may also find it moving and persuasive as a painting *about* looking: about the positive, guilt-free invitation to take pleasure in the gaze directed to the body.

If Gauguin began as a deluded participant in the myth of Tahiti—on the very banal level of the Colonial Exhibition and the travel brochure—he managed to supplant, or perhaps more accurately to supplement, that myth with one of his own (which thereafter becomes part of our myth of Tahiti).[18] While his thought was limited by colonialist polarities—"civilized" and "primitive," "culture" and "nature"—his attempt to reverse their valorizations may be said to have had an animating effect in his art. I would claim that he did achieve a kind of solution to the persistent problem of the body in nineteenth-century art and culture. It is a "solution" that remains bounded by the ideology of the male gaze on the female body—even as they border on androgyny, his bodies remain resolutely female—and, in its interpretive mythology of the Maori world opened and retrieved by way of the body, stands within an old tradition of allegorization of the woman's body. Nonetheless, everything in Gauguin's performance sets a challenging standard for all later artists who would attempt to rethink the tradition of the nude. I find myself in this inconclusive conclusion thinking back to an anonymous chronicler of Cook's first voyage who, after describing the Tahitians' practice of tattooing their bodies, noted that upon first seeing the Europeans write, the Tahitians dubbed the practice tattoo. Gauguin's effort is a kind of tattoo: not so much a writing on the body—though there certainly are messages inscribed on his nudes—but writing of and with the body, making the body not so much a transcendent signified as the ultimate, irreducible signifier.

NOTES

1. A historical note: The first European to reach Tahiti (so far as we know) was Samuel Wallis, in June 1767; he was followed by Louis-Antoine de Bougainville in April 1768—who didn't yet know of Wallis's visit—and then by James Cook in April 1769.

2. Louis-Antoine de Bougainville, *Voyage autour du monde, suivi du Supplément de Diderot,* ed. Michel Hérubel (Paris: Union Générale des Editions, October 1966), p. 185. This edition also includes excerpts from the journal of Philibert de Commerson, from which I shall quote as well. Subsequent references will be given in parentheses in my text. On the first, brief *Relation* of Bougainville's discovery, see L. Davis Hammond, ed., *News from New Cythera: A Report of Bougainville's Voyage* (Minneapolis: University of Minnesota Press, 1970). For helpful dialogue on this essay, let me thank Natasha Staller, Eliza Nichols, and Abigail Solomon-Godeau.

3. Jean-Jacques Rousseau, *Discours sur cette question proposée par l'Académie de Dijon: Quelle est l'origine de l'inégalité parmi les hommes et si elle est autorisée par la loi naturelle?* in *Du Contrat social . . .* (Paris: Garnier, 1962), p. 72. Bougainville speaks directly to Rousseau's *Discours* in his final journal entry before leaving the island: "Législateurs et philosophes, venez voir ici, tout établi, ce que votre imagination n'a pu même rêver. Un peuple nombreux, composé de beaux hommes et de jolies femmes, vivant ensemble dans l'abondance et la santé, avec toutes les marques de la plus grande union, connaissant assez le mien et le tien pour qu'il y ait cette distinction dans les rangs nécessaires au bon ordre, ne le connaissant pas assez pour qu'il y ait des pauvres et des fripons. . . ." Bougainville, "Journal" (unpublished ms.), quoted in Jean-Etienne Martin-Allanic, *Bougainville navigateur et les découvertes de son temps,* 2 vols. (Paris: Presses Universitaires de France, 1964), vol. 1, p. 683.

4. Diderot, "Supplément au Voyage de Bougainville," in Bougainville, *Voyage,* p. 444.

5. Samuel Wallis, in John Hawkesworth, ed., *An Account of the Voyages Undertaken by the order of his Present Majesty for Making Discoveries in the Southern Hemisphere and successively performed by Commodore Byron, Captain Wallis, Captain Carteret, and Captain Cook. From the Journals that were kept by the several Commanders, and from the Papers of Joseph Banks, Esq.,* 3 vols. (London: W. Strahan and T. Cadell, 1773), vol. 1, pp. 458–59. On the first discoverers of Tahiti, I have consulted with profit Alan Moorehead, *The Fatal Impact: An Account of the Invasion of the South Pacific, 1767–1840* (New York: Harper & Row, 1966); David Howarth, *Tahiti: A Paradise Lost* (New York: Viking, 1983); Bernard Smith, *European Vision and the South Pacific,* second ed. (New Haven and London: Yale University Press, 1985); Michèle Duchet, *Anthropologie et histoire au siècle des lumières* (Paris: François Maspero, 1971).

6. George Robertson, *An Account of the Discovery of Tahiti, from the Journal of George Robertson, Master of HMS Dolphin,* ed. Oliver Warner (London: Folio Press/ J.M. Dent, 1973), p. 73.

7. Compare Rousseau's view: "Pour le philosophe, ce sont le fer et le blé qui ont civilisé les hommes et perdu le genre humain. Aussi l'un et l'autre étoient-ils inconnus aux sauvages de l'Amérique, qui pour cela sont demeurés tels; les autres peuples semblent même être restés barbares tant qu'ils ont pratiqué l'un de ces arts sans l'autre." *Discours . . . ,* p. 73. The Tahitians of course did practice agriculture, and they reared domestic animals. The importance of iron to the Tahitians is confirmed by James Morrison, boatswain's mate on the *Bounty,* who spent nearly two years on the island—August 1789 to May 1791—and left one of the most thorough accounts of Tahitian society: "The grand object of these people is Iron and like us with Gold it matters not by what means they get it or where it comes from if they can but get it." James Morrison, *Journal* (London: The Golden Cockerel Press, 1935), p. 52.

8. See Douglas L. Oliver, *Ancient Tahitian Society* (Honolulu: University of Hawaii Press, 1974), vol. 1, p. 350–74; Marshall Sahlins, "Supplement to the Voyage of Cook; or, *le calcul sauvage,*" in *Islands of History* (Chicago: University of Chicago Press, 1985), pp. 1–31. One should note also that the "calculus" may have had something to do with an apparent Tahitian valuation of light skin. Vivès, the ship's doctor of the *Boudeuse,* reports: "La blancheur de notre peau les enchante, ils témoignent leur admiration à cet égard de la manière la plus expressive" (cit. Martin-Allanic, *Bougainville navigateur,* p. 668); and his report is confirmed by that of the Prince de Nassau-Siegen, who appears to have spent as much time as anybody making love to Tahitian women, and who mentions in the course of an account of an afternoon spent with three of them that "La blancheur du corps européen les ravit" (cit. Martin-Allanic, p. 670).

9. On this point, see the wise comment by James Morrison: "And here it may not be improper to remark that the idea formed of this Society and of the Inhabitants of this Island in general by former Voyagers could not possible extend much farther than their own Oppinion, None having remained a sufficient length of time to know the manner in which they live and as their whole system was overturned by the arrival of a Ship, their Manners were then as much altered from their Common Course, as those of our own Country are at a Fair, which might as well be

given for a specimen of the Method of living in England—which was always their situation as soon as a ship Arrived their whole thought being turned toward their Visitors, & all Method tryd to win their Friendship" (Morrison, *Journal*, p. 235).

10. Paul Gauguin, *Noa Noa*, ed. Pierre Petit (Paris: Jean-Jacques Pauvert et Compagnie, 1988), p. 37. This edition reprints the original Gauguin ms., without the additions made by Charles Morice for the first published edition, and without the later revisions made by Gauguin to the Gauguin/Morice text. Petit's critical edition in my view deserves its billing as the "première édition authentique" of the text.

11. Letter of 5 February 1895, *Lettres de Gauguin à sa femme et à ses amis*, ed. Maurice Malingue (Paris: Grasset, 1946), p. 263.

12. On this question, see my essay "Storied Bodies, or Nana at Last Unveil'd," *Critical Inquiry*, vol. 16, no. 1 (Fall 1989); and also T. J. Clark, "Olympia's Choice," in *The Painting of Modern Life* (New York: Knopf, 1985), pp. 79–146; and Beatrice Farwell, *Manet and the Nude: A Study in Iconography in the Second Empire* (New York: Garland Publishing Company, 1981).

13. Interview with Eugène Tardieu, *L'Echo de Paris*, 13 May 1895, in Paul Gauguin, *Oviri, écrits d'un sauvage*, ed. Daniel Guérin (Paris: Gallimard, 1974), p. 140.

14. Abigail Solomon-Godeau, "Going Native," *Art in America*, July 1989, pp. 123–24. Solomon-Godeau continues: "On one level, what is enacted [in the colonial encounter] is a violent history of colonial possession and cultural dispossession—real power over real bodies. On another level, this encounter will be endlessly elaborated within a shadow world of representations—a question of imaginary power over imaginary bodies." This is true, but I think it fails to take account of the original discursive framework of the European encounter with Tahiti, which was not a simple act of colonial possession—that came later—but rather a problem in Enlightenment philosophy and ethnology. Gauguin, I think, participated in this discourse as well as the simpler, more violent colonialist ideology. But of course one's view here depends very much on how one reacts to his paintings. Solomon-Godeau writes, "To contemplate Gauguin's strangely joyless and claustral evocations of Tahiti and the Marquesas is to be, in the final instance, not at all far from Loti" (p. 125). I cannot agree with this characterization of the painting, nor the implied similarity to Loti's purple prose.

15. See J.-A. Moerenhout, *Voyages aux îles du grand océan* (Paris: A. Bertrand, 1837), vol. 2, pp. 206–11.

16. See Marcel Mauss, "Essai sur le don" [1925], in *Sociologie et anthropologie* (Paris: Presses Universitaires de France, 1968), pp. 145–279; Georges Bataille, "The Notion of Expenditure," *Visions of Excess: Selected Writings, 1927–1939*, ed. Allan Stoekl (Minneapolis: University of Minnesota Press, 1985), pp. 116–29. In my discussion of this painting, I am indebted to the perceptive comments offered by Professor Hilary Schor, of the University of Southern California, when I presented an early version of this paper as a lecture.

17. See Brettell et al., *The Art of Paul Gauguin*, pp. 398–99.

18. The Gauguin-Tahiti myth has, of course, been commercialized in our own time: the recent major retrospective of his work produced in Paris not only a run of Gauguin shopping bags, but Gauguin-inspired bathing suits, lipstick, etc. It is perhaps typical of the postmodern moment that myth almost instantaneously turns into its commercial parody.

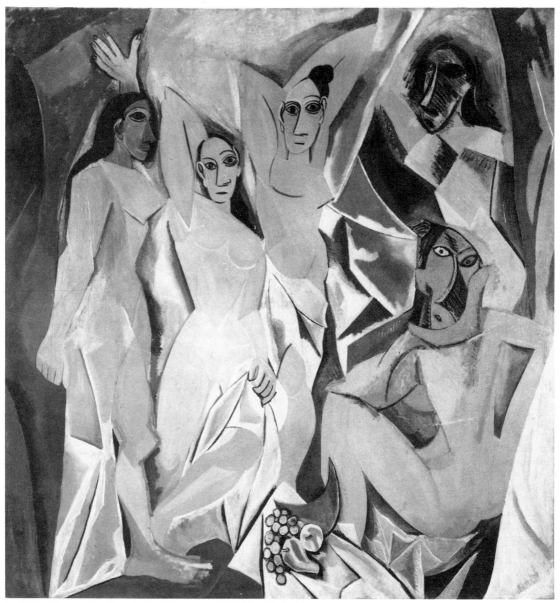

1. Pablo Picasso, *Les Demoiselles d'Avignon,* 1907. New York, Museum of Modern Art, acquired through the Lillie P. Bliss Bequest.

THE MoMA'S HOT MAMAS

CAROL DUNCAN

When the Museum of Modern Art opened its newly installed and much enlarged permanent collection in 1984, critics were struck with how little things had changed. In the new installation, as in the old,[1] modern art is once again a progression of formally distinct styles. As before, certain moments in this progression are given greater importance than others: Cézanne, the first painter one sees, announces modern art's beginnings. Picasso's dramatically installed *Les Demoiselles d'Avignon* [1] signifies the coming of Cubism—the first giant step twentieth-century art took and the one from which much of the history of modern art proceeds. From Cubism unfolds the other notable avant-garde movements: German Expressionism, Futurism, and so on, through Dada-Surrealism. Finally come the American Abstract Expressionists. After purifying their work of a residue of Surrealist representation, they made the final breakthrough into the realm of absolute spirit, manifested as absolute formal and nonrepresentational purity. It is in reference to their achieve-

From *Art Journal* 48 (Summer 1989): 171–78. Copyright © 1989 by the College Art Association of America. Reprinted by permission of the author and the College Art Association of America.

ment that, according to the MoMA (in its large, new, final gallery), all later significant art in one way or another continues to measure its ambitions and scale.

Probably more than any other institution, the MoMA has promoted this "mainstream modernism," greatly augmenting its authority and prestige through acquisitions, exhibitions, and publications. To be sure, the MoMA's managers did not independently invent the museum's strictly linear and highly formalist art-historical narrative; but they have embraced it tenaciously, and it is no accident that one can retrace that history in its galleries better and more fully than in any other collection. For some, the museum's retrospective character is a regrettable turnaround from its original role as champion of the new. But the MoMA remains enormously important for the role it plays in maintaining in the present a particular version of the art-historical past. Indeed, for much of the academic world, as for the larger art public, the kind of art history it narrates still constitutes the definitive history of modern art.

Yet, in the MoMA's permanent collection, more meets the eye than this history admits to. According to the established narrative, the history of art is made up of a progression of styles and

unfolds along certain irreversible lines: from style to style, it gradually emancipates itself from the imperative to represent convincingly or coherently a natural, presumably objective world. Integral to this narrative is a model of moral action, exemplified by individual artists. As they become liberated from traditional representation, they achieve greater subjectivity and hence greater artistic freedom and autonomy of spirit. As the literature of modern art portrays it, their progressive renunciation of representation, repeatedly and minutely documented in monographs, catalogues, and critical journals, is often achieved through painful or self-sacrificing searching or courageous risk-taking. The disruption of space, the denial of volume, the overthrow of traditional compositional schemes, the discovery of painting as an autonomous surface, the emancipation of color, line, or texture, the occasional transgressions and reaffirmations of the boundaries of art (as in the adaptation of junk or non–high-art materials), and so on through the liberation of painting from frame and stretcher and thence from the wall itself—all of these advances translate into moments of moral as well as artistic choice. As a consequence of his spiritual struggle, the artist finds a new realm of energy and truth beyond the material, visible world that once preoccupied art—as in Cubism's reconstruction of the "fourth dimension," as Apollinaire called the power of thought itself; Mondrian's or Kandinsky's visual analogues of abstract, universal forces; Robert Delaunay's discovery of cosmic energy; or Miró's re-creations of a limitless and potent psychic field. Ideally and to the extent to which they have assimilated this history, museum visitors reenact these artistic—and hence spiritual—struggles. In this way they ritually perform a drama of enlightenment in which freedom is won by repeatedly overcoming and moving beyond the visible, material world.

And yet, despite the meaning and value given to such transcendent realms, the history of modern art, as it is written and as it is seen in the MoMA and elsewhere, is positively crowded with images—and most of them are of women. Despite their numbers, their variety is remarkably small.

Most often they are simply female bodies or parts of bodies, with no identity beyond their female anatomy—those ever-present "Women" or "Seated Women" or "Reclining Nudes." Or they are tarts, prostitutes, artist's models, or low-life entertainers—highly identifiable socially, but at the bottom of the social scale. In the MoMA's authoritative collection, Picasso's *Demoiselles d'Avignon,* Léger's *Grand Déjeuner,* Kirchner's scenes of streetwalkers, Duchamp's *Bride,* Severini's Bal Tabarin dancer, de Kooning's *Woman I,* and many other works are often monumental in scale and conspicuously placed. Most critical and art-historical writings give them comparable importance.

To be sure, modern artists have often chosen to make "big" philosophical or artistic statements via the nude. If the MoMA exaggerates this tradition or overstates some aspects of it, it is nevertheless an exaggeration or overstatement of something pervasive in modern art practice. Why then has art history not accounted for this intense preoccupation with socially and sexually available female bodies? What, if anything, do nudes and whores have to do with modern art's heroic renunciation of representation? And why is this imagery accorded such prestige and authority within art history—why is it associated with the highest artistic ambition?

In theory, museums are public spaces dedicated to the spiritual enhancement of all who visit them. In practice, however, museums are prestigious and powerful engines of ideology. They are modern ritual settings in which visitors enact complex and often deep psychic dramas about identity—dramas that the museum's stated, consciously intended programs do not and cannot acknowledge overtly. Like those of all great museums, the MoMA's ritual transmits a complex ideological signal. My concern here is with only a portion of that signal—the portion that addresses sexual identity. I shall argue that the collection's recurrent images of sexualized female bodies actively masculinize the museum as a social environment. Silently and surreptitiously, they specify the museum's ritual of spiritual quest as a male quest, just

as they mark the larger project of modern art as primarily a male endeavor.

If we understand the modern art museum as a ritual of male transcendence, if we see it as organized around male fears, fantasies, and desires, then the quest for spiritual transcendence on the one hand and the obsession with a sexualized female body on the other, rather than appearing unrelated or contradictory, can be seen as parts of a larger, psychologically integrated whole. How very often images of women in modern art speak of male fears. Many of the works I just mentioned feature distorted or dangerous-looking creatures, potentially overpowering, devouring, or castrating. Indeed, the MoMA's collection of monstrous, threatening females is exceptional: Picasso's *Demoiselles* and *Seated Bather* (the latter a giant praying mantis); the frozen, metallic odalisques in Léger's *Grand Déjeuner;* several early female figures by Giacometti; sculptures by Gonzáles and Lipschitz; and Baziotes's *Dwarf,* a mean-looking creature with saw teeth, a single large eye, and a prominent, visible uterus—to name only some. (One could easily expand the category to include works by Kirchner, Severini, Rouault, and others who depicted decadent, corrupt—and therefore *morally* monstrous—women.) In different ways, each of these works testifies to a pervasive fear of and ambivalence about woman. Openly expressed on the plane of culture, this fear and ambivalence, it seems to me, makes the central moral of modern art more intelligible—whether or not it tells us anything about the individual psyches of those who produced these works.

Even work that eschews such imagery and gives itself entirely to the drive for abstract, transcendent truth may also speak of these fears, in the very act of fleeing the realm of matter *(mater)* and biological need that is woman's traditional domain. How often modern masters have sought to make their work speak of *higher* realms—of air, light, the mind, the cosmos—realms that exist above a female, biological earth. Cubism, Kandinsky, Mondrian, the Futurists, Miró, the Abstract Expressionists—all drew artistic life from some nonmaterial energy of the self or the universe. (Léger's ideal of a rational, mechanical

order can also be understood as opposed to—and a defense against—the unruly world of nature that it seeks to control.) The peculiar iconoclasm of much modern art, its renunciation of representation and the material world behind it, seems at least in part based in an impulse, common among modern males, to escape not the mother in any literal sense but a psychic image of woman and her earthly domain that seems rooted in infant or childish notions of the mother. Philip Slater noted an "unusual emphasis on mobility and flight as attributes of the hero who struggles against the menacing mother."[2] In the museum's ritual, the recurrent image of a menacing woman adds urgency to such flights to "higher" realms. Hence also the frequent appearance in written art history of monstrous or threatening women or, what is their obverse, powerless or vanquished women. Whether man-killer or murder victim, whether Picasso's deadly *Seated Bather* or Giacometti's *Woman with Her Throat Cut,* their presence both in the museum ritual and in the written (and illustrated) mythology is necessary. In both contexts, they provide the reason for the spiritual and mental flight. Confrontation and escape from them constitute the ordeal's dark center, a darkness that gives meaning and motive to the quest for enlightenment.

Since the heroes of this ordeal are generically men, the presence of women artists in this mythology can be only an anomaly. Women artists, especially if they exceed the standard token number, tend to degender the ritual ordeal. Accordingly, in the MoMA and other museums, their numbers are kept well below the point where they might effectively dilute the masculinity. The female presence is necessary only in the form of imagery. Of course men, too, are occasionally represented. But unlike women, who are seen primarily as sexually accessible bodies, men are portrayed as physically and mentally active beings who creatively shape their world and ponder its meanings. They make music and art, they stride, work, build cities, conquer the air through flight, think, and engage in sports (Cézanne, Rodin, Picasso, Matisse, Léger, La Fresnaye, Boccioni). When male sexuality is broached, it is often presented as the

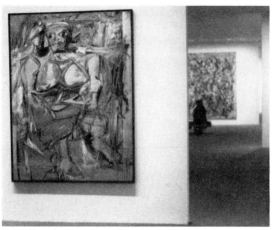

2. Willem de Kooning, *Woman I*, 1952, as installed in 1988. New York, Museum of Modern Art *(Carol Duncan)*.

3. Willem de Kooning, *Woman II*, 1952, as installed in 1978. New York, Museum of Modern Art *(Carol Duncan)*.

experience of highly self-conscious, psychologically complex beings whose sexual feelings are leavened with poetic pain, poignant frustration, heroic fear, protective irony, or the drive to make art (Picasso, de Chirico, Duchamp, Balthus, Delvaux, Bacon, Lindner).

De Kooning's *Woman I* and Picasso's *Demoiselles d'Avignon* are two of art history's most important female images. They are also key objects in the MoMA's collection and highly effective in maintaining the museum's masculinized environment.

The museum has always hung these works with precise attention to their strategic roles in the story of modern art. Both before and after the 1984 expansion, de Kooning's *Woman I* hung at the threshold to the spaces containing *the* big Abstract Expressionist "breakthroughs"—the New York school's final collective leap into absolutely pure, abstract, nonreferential transcendence: Pollock's artistic and psychic free flights, Rothko's sojourns in the luminous depths of a universal self, Newman's heroic confrontations with the sublime, Still's lonely journeys into the back beyond of culture and consciousness, Reinhardt's solemn and sardonic negations of all that is not Art, and so on. And always seated at the doorway to these moments of ultimate freedom and purity, and literally helping to frame them, has been *Woman I* [2]. So important is her pres-

ence just there, that when she has to go on loan, *Woman II* appears to take her place [3]. With good reason. De Kooning's *Women* are exceptionally successful ritual artifacts, and they masculinize the museum's space with great efficiency.

The woman figure had been emerging gradually in de Kooning's work in the course of the 1940s. By 1951–52, it had fully revealed itself in *Woman I* as a big, bad mama—vulgar, sexual, and dangerous. De Kooning imagines her facing us with iconic frontality—large, bulging eyes; open, toothy mouth; massive breasts [4]. The suggestive pose is just a knee movement away from open-thighed display of the vagina, the self-exposing gesture of mainstream pornography.

These features are not unique in the history of art. They appear in ancient and tribal cultures, as well as in modern pornography and graffiti. Together, they constitute a well-known figure type.[3] The Gorgon of ancient Greek art [5], an instance of that type, bears a striking resemblance to de Kooning's *Woman I* and, like her, simultaneously suggests and avoids the explicit act of sexual self-display that elsewhere characterizes the type. An Etruscan example [6] states more of its essential components as they appeared in a wide range of archaic and tribal cultures—not only the display of genitals, but also the flanking animals that point to her origins as a fertility or mother goddess.[4] Obviously, the configuration, with or without ani-

mals, carries complex symbolic possibilities and can convey many-sided, contradictory, and layered meanings. In her guise as the Gorgon witch, however, the terrible aspect of the mother goddess, her lust for blood and her deadly gaze, is emphasized. Especially today, when the myths and rituals that may have suggested other meanings have been lost—and when modern psychoanalytic ideas are likely to color any interpretation—the figure appears especially intended to conjure up infantile feelings of powerlessness before the mother and the dread of castration: in the open jaw can be read the *vagina dentata*—the idea of a dangerous, devouring vagina, too horrible to depict, and hence transposed to the toothy mouth.

Feelings of inadequacy and vulnerability before mature women are common (if not always salient) phenomena in male psychic development. Such myths as the story of Perseus and such visual images as the Gorgon can play a role in mediating that development by extending and re-treating on the cultural plane its core psychic experience and accompanying defenses.[5] Thus objectified and communally shared in imagery, myth, and ritual, such individual fears and desires may achieve the status of higher, universal truth. In this sense, the presence of Gorgons on Greek temples, important houses of cult worship (they also appeared on Christian church walls)[6]—is paralleled by *Woman I*'s presence in a high-cultural house of the modern world.

The head of de Kooning's *Woman I* is so like

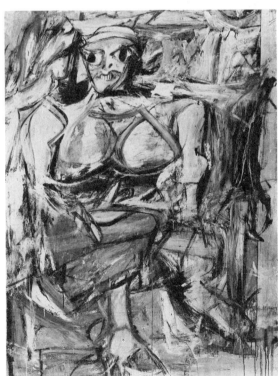

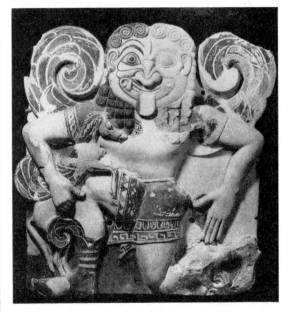

4. Willem de Kooning, *Woman I*, 1952. New York, Museum of Modern Art.

5. *Gorgon*, clay relief. Syracuse, National Museum.

6. Etruscan *Gorgon*, drawing after a bronze carriage front. Munich, Museum Antiker Kleinkunst.

that of the archaic Gorgon that the reference could well be intentional, especially since the artist and his friends placed great store in ancient myths and primitive images and likened themselves to archaic and tribal shamans. Writing about de Kooning's *Women,* Thomas Hess echoed this claim in a passage comparing de Kooning's artistic ordeal to that of Perseus, slayer of the Gorgon. Hess is arguing that de Kooning's *Women* grasp an elusive, dangerous truth "by the throat."

And truth can be touched only by complications, ambiguities and paradox, so, like the hero who looked for Medusa in the mirroring shield, he must study her flat, reflected image every inch of the way.[7]

But then again, the image type is so ubiquitous we needn't try to assign de Kooning's *Woman I* to any particular source in ancient or primitive art. *Woman I* can call up the Medusa as easily as the other way around. Whatever de Kooning knew or sensed about the Gorgon's meanings, and however much or little he took from it, the image type is decidedly present in his work. Suffice it to say that de Kooning was aware, and indeed explicitly claimed, that his *Women* could be assimilated to the long history of goddess imagery.[8] By choosing to place such figures at the center of his most ambitious artistic efforts, he secured for his work an aura of ancient mystery and authority.

The *Woman* is not only monumental and iconic. In high-heeled shoes and brassiere, she is also lewd, her pose indecently teasing. De Kooning acknowledged her oscillating character, claiming for her a likeness not only to serious art—ancient icons and high-art nudes—but also to pinups and girlie pictures of the vulgar present. He saw her as simultaneously frightening and ludicrous.[9] The ambiguity of the figure, its power to resemble an awesome mother goddess as well as a modern burlesque queen, provides a fine cultural, psychological, and artistic field in which to enact the modern myth of the artist-hero—the hero whose spiritual ordeal becomes the stuff of ritual in the public space of the museum. As a powerful and threatening woman, it is she who must be confronted and transcended—gotten past on the

7. Robert Heinecken, *Invitation to Metamorphosis,* emulsion on canvas and pastel chalk, 1975 *(Robert Heinecken).*

way to enlightenment. At the same time, her vulgarity, her "girlie" side—de Kooning called it her "silliness"[10]—renders her harmless (or is it contemptible?) and denies the terror and dread of her Medusa features. The ambiguity of the image thus gives the artist (and the viewer) both the experience of danger and a feeling of overcoming it. Meanwhile, the suggestion of pornographic self-display—more explicit in de Kooning's later work but certainly present here—specifically addresses itself to the male viewer. With it, de Kooning knowingly and assertively exercises his patriarchal privilege of objectifying male sexual fantasy as high culture.

An interesting drawing/photomontage by the California artist Robert Heinecken, *Invitation to Metamorphosis* [7], similarly explores the ambiguities of a Gorgon-girlie image. Here the effect of ambiguity is achieved by the use of masks and by combining and superimposing separate negatives. Heinecken's version of the self-displaying woman is a composite consisting of a conventional pornographic nude and a Hollywood movie-type monster. As a well-qualified Gorgon, her attributes

include an open, toothy mouth, carnivorous animal jaws, huge bulging eyes, large breasts, exposed genitals, and one very nasty-looking claw. Her body is simultaneously naked and draped, enticing and repulsive, and the second head, to the left of the Gorgon head—the one with the seductive smile—also wears a mask. Like the de Kooning work, Heinecken's *Invitation* sets up a psychologically unstable atmosphere fraught with deception, allure, danger, and wit. The image's various components continually disappear into and reappear out of one another. Behaving something like de Kooning's layered paint surfaces, they invite ever-shifting, multiple readings. In both works, what is covered becomes exposed, what is opaque becomes transparent, and what is revealed conceals something else. Both works fuse the terrible killer-witch with the willing and exhibitionist whore. Both fear and seek danger in desire, and both kid the danger.

Of course before de Kooning or Heinecken created ambiguous self-displaying women, there was Picasso's *Demoiselles d'Avignon* of 1907 [1]. The work was conceived as an extraordinarily ambitious statement—it aspires to revelation—about the meaning of Woman. In it, all women belong to a universal category of being, existing across time and place. Picasso used ancient and tribal art to reveal woman's universal mystery: Egyptian and Iberian sculpture on the left, and African art on the right. The figure on the lower right [8] looks as if it was directly inspired by some primitive or archaic deity. Picasso would have known such figures from his visits to the ethnographic art collections in the Trocadero. A study for the work in the Musée Picasso in Paris [9] closely follows the type's symmetrical, self-displaying pose. Significantly, Picasso wanted her to be prominent—she is the nearest and largest of all the figures. At this stage, Picasso also planned to include a male student on the left and, in the axial center of the composition, a sailor—a figure of horniness incarnate. The self-displaying woman was to have faced him, her display of genitals turned away from the viewer.

In the finished work, the male presence has been removed from the image and relocated in the

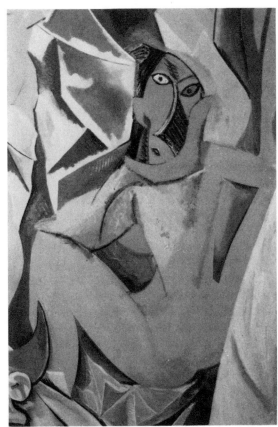

8. Pablo Picasso, *Les Demoiselles d'Avignon,* detail *(Carol Duncan).*

9. Pablo Picasso, study for *Les Demoiselles d'Avignon,* 1907. Paris, Musée Picasso.

10. Wall label, with photograph of the missing *Demoiselles*, 1988. New York, Museum of Modern Art *(Carol Duncan).*

viewing space before it. What began as a depicted male-female confrontation thus became a confrontation between viewer and image. The relocation has pulled the lower right-hand figure completely around, so that her stare and her sexually inciting act, although not detailed and less symmetrical than before, are now directed outward. Picasso thus isolated and monumentalized the ultimate men-only situation. As restructured, the work forcefully asserts to both men and women the privileged status of male viewers—they alone are intended to experience the full impact of this most revelatory moment.[11] It also assigns women to a visitors' gallery where they may watch but not enter the central arena of high culture.

Finally, the mystery that Picasso unveils about women is also an art-historical lesson. In the finished work, the women have become stylistically differentiated so that one looks not only at present-tense whores but also back down into the ancient and primitive past, with the art of "darkest Africa" and works representing the beginnings of Western culture (Egyptian and Iberian idols) placed on a single spectrum. Thus does Picasso use art history to argue his thesis: that the awesome goddess, the terrible witch, and the lewd whore are but facets of a single many-sided creature, in turn threatening and seductive, imposing and self-abasing, dominating and powerless—and always the psychic property of a male imagination. Picasso also implies that truly great, powerful, and

revelatory art has always been and must be built upon such exclusively male property.

The museum's installation amplifies the already powerful meanings of the work. Mounted on a freestanding wall in the center of the first Cubist gallery, the painting seizes your attention the moment you turn into the room—the placement of the doorway makes it appear suddenly and dramatically. Physically dominating this intimately scaled gallery, the installation dramatizes the painting's role as progenitor of the surrounding Cubist works and their subsequent art-historical issue. So central is the work to the structure of MoMA's program that recently, when the painting was on loan, the museum felt compelled to post a notice on the freestanding wall explaining the work's absence—but also invoking its presence. In a gesture unusual for the MoMA, the notice was illustrated by a tiny color reproduction of the missing monument [10].

The works by de Kooning and Heinecken that I have discussed, along with similar works by many other modern artists, benefit from and reinforce the status won by the *Demoiselles*. They also develop its theme, drawing out different emphases. One of the elements they develop more explicitly than did Picasso is that of pornography. By way of exploring how that pornographic element works in the museum context, I want to look first at how it works outside the museum.

Last year, an advertisement for *Penthouse* magazine appeared on New York City bus-stop shelters [11]. New York City bus shelters are often decorated with near-naked women and sometimes men advertising everything from underwear to real estate. But this was an ad for pornographic images as such—that is, images designed not to sell perfume or bathing suits, but to stimulate erotic desire, primarily in men. Given its provocative intent, the image generates very different and—I think for almost everyone—more charged meanings than the ads for underwear. At least one passerby had already recorded in red spray paint a terse but coherent response: "For Pigs."

Having a camera with me, I decided to take a shot of it. But as I set about focusing, I began to feel uncomfortable and self-conscious. As I real-

ized only later, I was experiencing some prohibition in my own conditioning, activated not simply by the nature of the ad but by the act of photographing such an ad in public. Even though the anonymous inscription had made it socially safer to photograph—it placed it in a conscious and critical discourse about gender—to photograph it was still to appropriate openly a kind of image that middle-class morality says I'm not supposed to look at or have. But before I could sort that out, a group of boys jumped into the frame. Plainly, they intended to intervene. Did I know what I was doing? one asked me with an air I can only call stern, while another admonished me that I was photographing a *Penthouse* ad—as if I would not knowingly do such a thing.

Apparently, the same culture that had conditioned me to feel uneasy about what I was doing also made *them* uneasy about it. Boys this age know very well what's in *Penthouse*. Knowing what's in *Penthouse* is knowing something meant for men to know; therefore, knowing *Penthouse* is a way of knowing oneself to be a man, or at least a man-to-be, at precisely an age when one needs all the help one can get. I think these boys were trying to protect the capacity of the ad to empower them as men by preventing me from appropriating an image of it. For them, as for many men, the chief (if not the only) value and use of pornography is this power to confirm gender identity and, with that, gender superiority. Pornography affirms their manliness to themselves and to others and proclaims the greater social power of men. Like some ancient and primitive objects forbidden to the female gaze, the ability of pornography to give its users a feeling of superior male status depends on its being owned or controlled by men and forbidden to, shunned by, or hidden from, women. In other words, in certain situations a female gaze can *pollute* pornography. These boys, already imprinted with the rudimentary gender codes of the culture, knew an infringement when they saw one. (Perhaps they suspected me of defacing the ad.) Their harassment of me constituted an attempt at gender policing, something adult men routinely do to women on city streets.

Not so long ago, such magazines were sold only

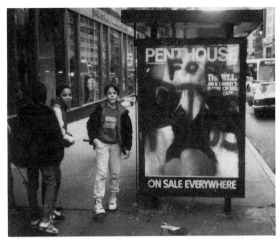

11. Bus-stop shelter on Fifty-seventh Street, New York City, with advertisement for *Penthouse* magazine, 1988 *(Carol Duncan)*.

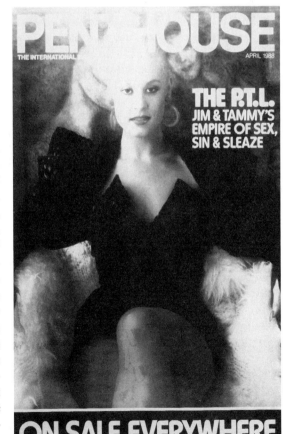

12. Advertisement for *Penthouse,* using a photograph by Bob Guccione, April 1988 *(Penthouse)*.

in sleazy porn stores. Today ads for them can decorate mid-town thoroughfares. Of course, the ad as well as the magazine cover cannot itself be pornography and still be legal (in practice, that tends to mean it can't show genitals), but to work as an ad it must *suggest* it. For different reasons, works of art like de Kooning's *Woman I* or Heinecken's *Invitation* also refer to without actually being pornography—they depend on the viewer "getting" the reference but must stop there. Given those requirements, it shouldn't surprise us that the artists' visual strategies have parallels in the ad [12]. *Woman I* shares a number of features with the ad. Both present frontal, iconic, massive figures seen close up—they fill, even overflow, the picture surface. The photograph's low camera angle and the painting's scale and composition monumentalize and elevate the figures, literally or imaginatively dwarfing the viewer. Painting and photograph alike concentrate attention on head, breasts, and torso. Arms serve to frame the body, while legs are either cropped or, in the de Kooning, undersized and feeble. The figures thus appear powerful and powerless at the same time, with massive bodies made to rest on unstable, weakly rendered, tentatively placed legs. And with both, the viewer is positioned to see it all should the thighs open. And of course, on *Penthouse* pages, thighs do little else but open. But de Kooning's hot mama has a very different purpose and cultural status from a *Penthouse* "pet."

De Kooning's *Woman I* conveys much more complex and emotionally ambivalent meanings. The work acknowledges more openly the fear of and flight from as well as a quest for the woman. Moreover de Kooning's *Woman I* is always upstaged by the artist's self-display *as an artist*. The manifest purpose of a *Penthouse* photo is, presumably, to arouse desire. If the de Kooning awakens desire in relation to the female body, it does so in order to deflate or conquer its power of attraction and escape its danger. The viewer is invited to relive a struggle in which the realm of art provides escape from the female's degraded allure. As mediated by art criticism, de Kooning's work speaks ultimately not of male fear but of the triumph of art and a self-creating spirit. In the critical litera-

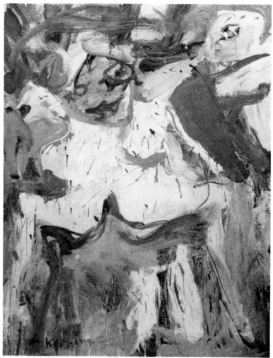

13. Willem de Kooning, *The Visit*, 1966–67. London, Tate Gallery.

ture, the *Women* figures themselves become catalysts or structural supports for the work's more significant meanings: the artist's heroic self-searching, his existentialist courage, his pursuit of a new pictorial structure or some other artistic or transcendent end.[12]

The work's pornographic moment, now subsumed to its high-cultural import, may (unlike the *Penthouse* ad) do its ideological work with unchallenged prestige and authority. In building their works on a pornographic base and triggering in both men and women deep-seated feelings about gender identity and difference, de Kooning, Heinecken, and other artists (most notoriously, David Salle) exercise a privilege that our society has traditionally conferred upon men only. Through their imagery, they lay claim to public space as a realm under masculine control. Transformed into art and displayed in the public space of the museum, the self-displaying poses affirm to male viewers their membership in the more powerful gender

group. They also remind women that their status as members of the community, their right to its public space, their share in the common, culturally defined identity, is not quite the same—is somehow less equal—than men's. But these signals must be covert, hidden under the myth of the transcendent artist-hero. Even de Kooning's later *Women* figures, which more openly invite comparison to pornographic photography and graffiti [13], qualify the reference; the closer to pornogra-phy, the more overlaid they must be with unambiguously "artistic" gestures and philosophically significant impastos.

Nevertheless, what is true in the street may not be so untrue in the museum, even though different rules of decorum may make it seem so. Inside or outside, such images wield great authority, structuring and reinforcing the psychic codes that determine and differentiate the real possibilities of women and men.

NOTES

1. For an analysis of the older MoMA see Carol Duncan and Alan Wallach, "The Museum of Modern Art as Late Capitalist Ritual," *Marxist Perspectives* 4 (Winter 1978): 28–51.

2. Philip Slater, *The Glory of Hera* (Boston, 1968), p. 321.

3. See Douglas Fraser, "The Heraldic Woman: A Study in Diffusion," in *The Many Faces of Primitive Art*, ed. D. Fraser (Englewood Cliffs, N.J., 1966), pp. 36–99; Arthur Frothingham, "Medusa, Apollo, and the Great Mother," *American Journal of Archaeology* 15 (1911): 349–77; Roman Ghirshman, *Iran: From the Earliest Times to the Islamic Conquest* (Harmondsworth, England, 1954), pp. 340–43; Bernard Goldman, "The Asiatic Ancestry of the Greek Gorgon," *Berytus* 14 (1961): 1–22; Clark Hopkins, "Assyrian Elements in the Perseus-Gorgon Story," *American Journal of Archaeology* 38 (1934): 341–58; Clark Hopkins, "The Sunny Side of the Greek Gorgon," *Berytus* 14 (1961): 25–32; and Philip Slater (cited in n. 2), pp. 16–21 and 318ff.

4. More ancient than the devouring Gorgon of Greece and pointing to a root meaning of the image type, a famous Louristan bronze pin in the David Weill Collection honors an older, life-giving Mother Goddess. Flanked by animals sacred to her, she is shown giving birth to a child and holding out her breasts. Objects of this kind appear to have been the votive offerings of women (see Ghirshman (cited in n. 3), pp. 102–4).

5. See Philip Slater (cited in n. 2), pp. 308–36 on the Perseus myth, and pp. 449ff. on the similarities between ancient Greek and middle-class American males.

6. See Fraser, cited in n. 3.

7. Thomas B. Hess, *Willem de Kooning* (New York, 1959), p. 7. See also Hess, *Willem de Kooning: Drawings* (New York and Greenwich, Conn., 1972), p. 27, on a de Kooning drawing of Elaine de Kooning (ca. 1942) in which the writer finds the features of Medusa—a "menacing" stare and intricate, animated "Medusa hair."

8. As he once said, "The *Women* had to do with the female painted through all the ages. . . . Painting the *Woman* is a thing in art that has been done over and over—the idol, Venus, the nude." Quoted in *Willem de Kooning:TheNorthAtlanticLight,1960–1983*, exh. cat., Stedelijk Museum, Amsterdam; Louisiana Museum of Modern Art, Humlebaek; and the Moderna Museet, Stockholm, 1983. Sally Yard, "Willem de Kooning's Women," *Arts* 53 (November 1975): 96–101, argues several sources for the *Women* paintings, including Cycladic idols, Sumerian votive figures, Byzantine icons, and Picasso's *Demoiselles*.

9. *Willem de Kooning: The North Atlantic Light* (cited n. 8), p. 77. See also Hess, *Willem de Kooning*, 1959 (cited n. 7), pp. 21 and 29.

10. *Willem de Kooning: The North Atlantic Light* (cited in n. 8), p. 77.

11. See, for example, Leo Steinberg, "The Philosophical Brothel," *Art News*, September 1972, pp. 25–26. In Steinberg's ground-breaking reading, the act of looking at these female figures visually re-creates the act of sexually penetrating a woman. The implication is that women are anatomically unequipped to experience the work's full meaning.

12. Very little has been written about de Kooning that does not do this. For one of the most bombastic treatments, see Harold Rosenberg, *De Kooning* (New York, 1974).

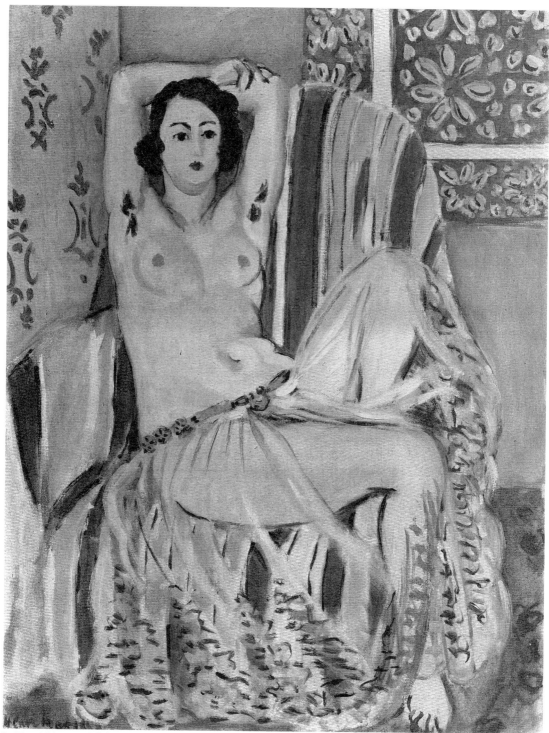

1. Henri Matisse, *Odalisque Seated with Arms Raised, Green Striped Chair*,
1923. Washington, D.C., National Gallery of Art, Chester Dale Collection.

CONSTRUCTING MYTHS AND IDEOLOGIES IN MATISSE'S ODALISQUES

MARILYNN LINCOLN BOARD

It must be acknowledged that Henri Matisse's images of women in Oriental dress are enticingly beautiful [1, 2, 3, 4, 5]. They are flooded with resplendent light that radiates blissful tranquility. On the surface, they seem to represent timeless visions of a pure realm where personal crises, religious anxieties, politics, and questions of ideological hegemony seem to have no relevance. The stunning force of their uncomplicated reductive forms juxtaposed in crystalline patterns of clear, vibrant color makes such an authoritative stylistic statement that, until recently, Matisse's formal mastery has tended almost exclusively to dominate scholarly discussion of his work.[1]

My intention in this paper is to describe some contemporary critical approaches to the odalisques by a selection of major Matisse scholars and to present, by contrast, a case for my own feminist perspective on the paintings. My debts are many. I am, of course, heavily dependent upon the invaluable research of the Matisse scholars whose theoretical approaches I am rejecting or augmenting. I am indebted to several generations

of feminist scholars, only some of whom are cited later in my argument, for giving me the courage to write eccentrically. The marginal position of feminist ideology in twentieth-century bourgeois civilization provides an advantageous Outsider perspective on the dominant phallocentric ideology. In addition to the obvious feminist sources of my thesis, my argument has been shaped by writers such as Jacques Derrida, Claude Lévi-Strauss, Terry Eagleton, and Fredric Jameson, who have contemplated the relationships between texts (visual and otherwise) and society. Derrida observes that the contrast between binary concepts is always a hierarchy and that deconstruction cannot limit itself to neutralization; it requires an overturning of the classical opposition and a general displacement of the system.[2] Lévi-Strauss posits that all cultural artifacts constitute a symbolic (mythic) resolution of political and social contradictions, and that formal patterns are symbolic enactments of the social within the formal and aesthetic.[3] Eagleton defines ideology as "that complex structure of social perception which ensures that the situation in which one social class has power over the others is either seen by most members of the society as 'natural,' or not seen at all."[4] Jameson reflects that analysis of the ideology

From *Genders* 5 (Summer 1989): 21–49. Copyright © 1989 by *Genders.* Reprinted by permission of the author and *Genders.*

of form reveals the persistence of sign systems which give shape to the alienation that results from political domination, commodity reification, and patriarchy. He asserts that a historical text often fails to acknowledge its ideological center, or, on the contrary, it seeks desperately to repress it.[5]

With Jameson's observation in mind, before I proceed to examine the mythological and ideological premises of Matisse's odalisques, I would like to acknowledge my own biases. I recognize that my reinterpretation of the odalisques in terms of an ideological master code that the artist might not recognize is essentially a construction of my own. In fact, I am interested in clarifying the premises of the ideological center that motivates the paintings in order to advocate its replacement by an alternative feminist ideological center that is, in its way, as mythical as Matisse's mental and visual structures were. My assumption is that the human mind cannot function, at least within a social context, without a mythic and ideological structure. My concern is that this structure be conducive to human growth rather than an instrument for domination and oppression. I would argue that feminism does not merely seek to replace patriarchy as the dominant component in a hierarchical duality, but that it constitutes, in Derrida's terms, "a general displacement of the system."

Approaching the Odalisques

Predicated upon Matisse's own formalist statements of intention, the formal focus of traditional Matisse criticism has tended to isolate the odalisques from their political and historical surroundings. The criticism of the prominent Matisse scholar Lawrence Gowing in the late seventies illustrates the stylistic emphasis that characterizes conventional approaches to these sumptuous paintings. Gowing contends that the harem fantasies systematically reinforced Matisse's "faith in painting as a source of undisturbed pleasure."[6] Although he is troubled by the fact that "a species of sexual politics that seems to make chauvinism innocent and beautiful perhaps played some part

in the growth of sympathy for Matisse's achievement," he nevertheless concludes that Matisse's glowing color washes conflicts away.[7]

Writing more recently, Jack Flam and Dominique Fourcade analyze the odalisques with more attention to iconographical issues. Unlike formalist critics, who concentrate on descriptions of Matisse's stylistic virtuosity and his buoyant expression of apparently uncomplicated happiness, both Flam and Fourcade detect unresolved tensions in the pictures. Flam notes a disturbing mood of "boredom, claustrophobia, alienation and sexual yearning" beneath the surface beauties of the odalisques,[8] and Fourcade perceives in them an aura of "waiting . . . sadness . . . heavy eroticism . . . and solitude."[9] But neither Flam nor Fourcade read the odalisques as mythological or ideological statements. Although Flam cites the exacerbating influence of the cultural malaise and general disillusionment that followed upon the trauma of World War I, both critics attribute the tensions in the paintings primarily to Matisse's personal neurotic dissatisfactions.

In a beautifully written analysis of some of the philosophical premises behind Matisse's art, Pierre Schneider also detects subliminal tensions in the odalisques. Schneider argues, however, that the underlying conflicts in the pictures are essentially metaphysical rather than formal or neurotic. Like Gowing, who read the paintings as formal resolutions of conflict, he also sees the luminous harmony of Matisse's revelatory canvases as an abstract indication of the resolution of "inner" tensions. Delving beneath the surface of Matisse's canvases, he interprets them as responses to the waning power of religious faith as a catalyst for artistic vision in the twentieth century. He describes Matisse's career as a subliminal quest for the spiritual redemption of material light and for the creation of divine hieroglyphs manifest in the life of the senses.[10] Schneider's contention that Matisse's art is a modernized nondoctrinal reformulation of art's traditional aspirations toward the sacred is undeniably convincing. But the odalisques function as transcendental icons only from a European male-oriented perspective.

From the viewpoint of the female Outsider, the

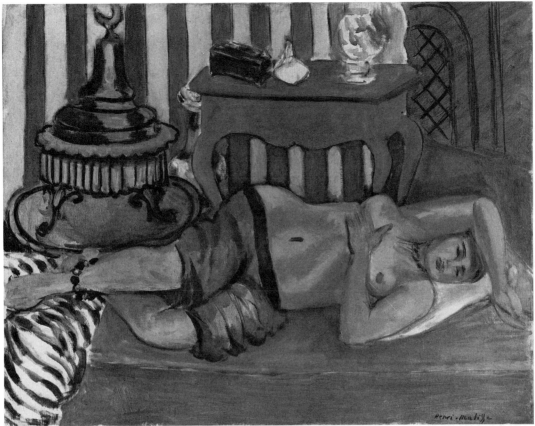

2. Henri Matisse, *Odalisque with Green Sash*, 1927. Baltimore Museum of Art, The
Cone Collection, formed by Dr. Claribel Cone and Miss Etta Cone of Baltimore.

pictures reveal the disturbing presence of sexual myths and ideological shadows submerged beneath the sunny harmonies on the surface of the canvases. I will argue that the odalisques are uncomfortably tense, in spite of their surface harmonies, because they are based on oppositional dynamics that have been fragilely balanced in an attempt to achieve a resolution of conflict that is ultimately unsuccessful. Assumptions of male possessive dominance over the passive female obviously underlie the odalisques. These gender values can be linked to self-oriented European imperialistic attitudes toward the French colonies in Africa. Kenneth Silver's work considerably illuminates the political context of Matisse's harem iconography by locating it solidly within the matrix of historical colonial policies that have ideological

significance beyond the boundaries of Matisse's personal neuroses.[11] But the interdependence of colonialist ideology, sexual chauvinism, and the mythic structure of the artist's psyche that is inherent in the compositions of the paintings has never been clearly articulated. Further, in addition to Matisse's more obviously prejudicial iconography, his stylistic syntax can be demonstrated to constitute an ideological statement that embodies establishment positions on women and empire, as well as assumptions about the dominance of the human intellect over inchoate nature and the dark realm of the unconscious.

I do not intend to imply in my critique of the odalisques that Matisse was personally reprehensible for harboring the phallocentric attitudes that his paintings embody, nor even for perpetuating

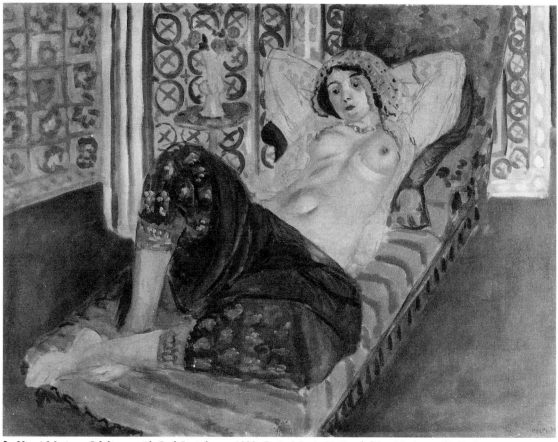

3. Henri Matisse, *Odalisque with Red Pantaloons*, 1922. Paris, Musée National d'Art Moderne *(Bulloz).*

them. Matisse himself acknowledged that "we belong to our time and we share in its opinions, its feelings, even its delusions,"[12] and simply stated, that is the crux of my thesis. I will argue, in fact, that stylistic transformations in Matisse's late-life series of paper cutouts suggest the potential for actually attaining the genuine ideological reconciliation that the odalisques attempt, but fail to achieve. Some of the late cutouts imply that perhaps there is reason for optimism about the possibility of evolving less divisive relationships between man and woman, the West and the Orient, the Self and the Other, the conscious and subconscious mind—more fulfilling myths and ideologies that could facilitate escape from the restrictive mental constructs that confine the odalisques and that have imprisoned us all.

Woman as the Other in the Odalisques

Matisse's harem women are symbols of that which is not man (that is, not entirely *hu*man); they represent alien nature in opposition to culture, a designation that Simone de Beauvoir has christened the "Other." De Beauvoir discusses the origins of the associations between nature and women in biology and in the genderized division of labor in early agricultural societies, observing that both nature and women seemed to incarnate a static principle dedicated to the preservation and perpetuation of the flesh. Woman was doomed to immanence, whereas man alone, through his association with hunting, war, and the expansion of existence, represented transcen-

dence. In her assigned role as Other, woman was condemned to play either slave or idol, but in neither case did she have the power to choose or define her part. De Beauvoir notes that the Other is perceived as inherently dangerous because it is, by definition, a negation of the Self. Yet, according to de Beauvoir, man inevitably seeks union with that which is Other than himself; he desires to possess that which he is not.[13]

Writing in the early seventies, the anthropologist Sherry Ortner establishes that "in reality" women are no closer to nature than men, and that the whole scheme of female associations with nature and male identification with culture is a construct of culture rather than a fact of nature.[14] But the schema has nevertheless persisted as a powerful mythic force in Western culture. In a groundbreaking article on the artistic celebration of primordial stereotypes of virility and domination in early twentieth-century vanguard painting, Carol Duncan argues that the modernist avant-garde continued the tradition of regarding confrontations with women as real or symbolic confrontations with nature. By portraying women as powerless, sexually subjugated beings the artist celebrated his control over them as "merely a means to his own ends, often exploiting them to boast of his virility."[15] The iconography of the odalisques is predicated upon these polarizing conventions that identify civilization and transcendent spirituality with male characteristics and associate raw material nature with female attributes. In describing the artist's need for whatever "will let him become one with nature—identify himself with her, by entering into the things . . . that arouse his feelings,"[16] Matisse's unconscious sexual vocabulary makes his mythological conflation of nature with woman explicit.

Duncan observes of Matisse's pre-odalisque work during the first decade of the century that his female models are distinctly less intellectual types than his male models.[17] Indeed, throughout his career Matisse juxtaposes women with motifs that evoke associations of natural cycles of fertility. The odalisques, for instance, are often shown in conjunction with flowers, the sexual organs of plants [1, 3, 4]. As a group the paintings constitute a symbolic garden of beautifully colored, extravagantly exotic blossoms. Louis Aragon referred to Matisse's models as "the flowers he plucked," and described his oeuvre as a garden "à la française."[18] Bram Dijkstra documents the popular nineteenth-century association between women and flowers, noting the common belief that, in recognition of feminine beauty, fragility, and passivity, "the husband should regard himself as gardener and his wife as his flower."[19] Matisse's chief artistic rival, Picasso, would refer to woman as "la femme fleur," and paint her accordingly, as in the famous portrait of Françoise Gilot. Within the larger symbolic structure of Matisse's oeuvre, the enticing women who constitute his primary subject matter function as signs of an inert yet potentially recalcitrant exterior Other that is placed in antithetical opposition to the artist's interior creative self-consciousness. His ordering intelligence must penetrate and cultivate her passive body in a fertilizing process of self-expressive creation that is an act of domination. A garden, after all, constitutes a section of nature that is regulated and possessed for the purposes of the gardener, not the flowers.

The Orient as Other in the Odalisques

The odalisques are especially vivid emblematic reflections of popular early twentieth-century European cultural attitudes about dominance and submission, because the colonial status of their ostensibly Oriental models clearly links their iconographic assumptions of sexual chauvinism to the wider political context of European imperialism. Matisse was a typical representative of his sex, class, and nationality. Indeed, Kenneth Silver describes him as a "mildly complacent . . . bourgeois postwar Frenchman," and argues convincingly that his Orientalist images were apt reflections of the myths and realities of the French colonial movement.[20] It is a fairly safe assumption that Matisse shared not only the prevalent male sense of intellectual superiority over women but also the general European sense of intellectual superiority over the Orient. With the comment that some of Matisse's ideas "went a bit beyond the realm of

science," the popular novelist and playwright Henry de Montherlant reported the painter's assertion (during an interview in 1938) that "European birds are brighter and more intelligent than those of exotic countries."[21] As Silver has noted, Léonce Bénédite, curator at the Luxembourg Museum and founder and president of the Société des Peintres Orientalistes, purchased the *Odalisque with Red Pantaloons* [3] for the state in 1922, just three weeks before the opening of a colonial exposition designed to promote public enthusiasm for colonial development. This timely official sanction of Matisse's Orientalist work would imply that its political position in support of colonialism was recognized by establishment powers.[22]

In *Orientalism* (1978), a study of European perspectives on the Orient, the literary critic Edward Said documents the fact that the Orient, like woman, has consistently been viewed by the West as inarticulate, enticing, and strange, constituting a passive cultural body to be controlled and acted upon by others. In the European cultural construct of male and female, the West has often been conceived as active and the Orient as a passive reactor. The West was spectator, judge, and jury of Oriental behavior,[23] just as Western men defined and assessed the ideal attributes and functions of femininity. In the imagination of the European scholars who defined it, the Orient, like woman, came to signify an undiscriminating sensual paradise that constituted a revitalizing complement to Western man's divisive analytical compulsions. Said notes that non-European cultures such as those of the Orient did not fragment their view of the world into interior and exterior oppositions and were therefore appropriate ciphers of wholeness within the European context.[24]

Reflecting the attitudes of the turn-of-the-century patriarchal imperialist French culture from which he emerged, Matisse too equated the Orient with woman as an incarnate form of the mythical Other, through possession of which a redemptive unification might be achieved. His odalisques are "pure Eves" on Gauguin's romantic model,[25] representatives of a "primitive" female principle that is untainted by the separation of the physical and spiritual worlds or by the curse of the Fall and European biblical associations of sex with original sin. Matisse was intrigued by the odalisques' apparent combination of flesh and innocence; they represented a paradisical state of harmonious reintegration between the polarized forces of spirit and matter that tantalized and eluded his troubled European psyche. In his paintings of odalisques Matisse attempts to penetrate the mystery of these natural creatures in order to produce a purified art and renew Europe's decaying and corrupt aesthetic and religious traditions. But, I will argue, until he learned to understand *himself* more completely, their essence remained unfathomable, a situation that is reflected in the aura of undefinable alienation that many viewers have sensed in the pictures.

Historical Conflicts in the Odalisques

Within the discourse of modernism the odalisques have sometimes been repudiated for their stylistic conservatism; they have been seen to represent a temporary evasive retreat on Matisse's part from the exigencies of modernism. In their desire to preserve Matisse's reputation as a leader of the avant-garde, scholars such as Fourcade and Catherine Bock would urge that the harem pictures ought to be reassessed as worthy (rather than embarrassing) component elements in the unbroken evolution of Matisse's modernist development.[26] Arguing to the contrary, Silver admits the charm of many of the pictures, but he convincingly demonstrates that they *are* reactionary statements, that they represent a "retour à l'ordre,"[27] and that they define an essentially conservative artistic position—an unfortunate (but not unique) ideological liability within the context of modernism's promotion of the concepts of evolutionary progress and heroic innovation. But, while Matisse *did* clearly seem to back away from radical abstraction and return to conventional techniques of spatial recession during the period of the odalisques, his culturally sanctioned attitudes on women and colonialism were positions that were not often examined by either conservative forces *or* by the

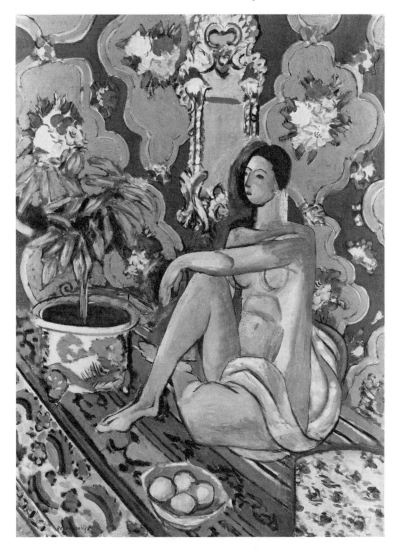

4. Henri Matisse, *Decorative Figure on an Ornamental Ground*, 1927. Paris, Musée National d'Art Moderne *(Bulloz).*

more experimental avant-garde. As Carol Duncan has demonstrated, chauvinism (and one might add colonialism) was not necessarily inconsistent with formal modernism.[28] Nevertheless, of course, Matisse's stylistic conservatism was entirely in harmony with the traditional ideology that permeates the odalisques. Moreover, Matisse was not alone in his retreat from artistic and cultural revolution; the era of the odalisques was a generally reactionary period in French culture.

Matisse's work had always focused on the image of women. But, while earlier paintings such as *The*

Blue Nude of 1910 may have conveyed exotic overtones due to the presence of tropical fauna, more often the surroundings were vaguely universalized. Matisse's apparently sudden compulsion during the immediate postwar years to portray his female models as Orientals in white face surrounded by exotic accessories coincides with the apogee of French colonialism. The decade of the twenties saw a political emphasis on the exotic civilizations of the French colonies in an effort to persuade the French public that the colonies were an asset rather than a burdensome liability. It was

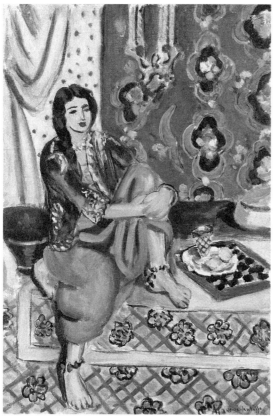

5. Henri Matisse, *Seated Odalisque with Left Leg Bent*, 1926. Baltimore Museum of Art, The Cone Collection, formed by Dr. Claribel Cone and Miss Etta Cone of Baltimore.

suggested that wartime financial losses could be recouped quickly by means of colonial exploitation, and the journal *L'Afrique française* declared that the nation was witness to "a veritable crusade in favor of colonial development."[29] The colonies came to symbolize national pride in French culture and in the mission to civilize the world that victory in the war had mandated. Silver documents the extensive publicity given to colonial decorative arts (the government sponsorship of the *Exposition internationale des arts décoratifs et industriels modernes* in 1925, for example) as part of a patriotic effort to reassert French imperial dominance over German rivals in the production of luxury goods. Matisse's patrons, he notes, were not bohemian collectors but rich and stylish bour-

geois who saw ownership of Matisse's art as a "trophy" of their position in the French social hierarchy.[30]

While this spate of colonialist propaganda may or may not have impressed the Germans, within France the onslaught of information about unfamiliar aesthetic systems and value structures not only confirmed Frenchmen's pride in their possessions but must also have provoked subconscious defensive reactions against disorienting doubts raised by the specter of cultural relativism which had been growing with increasing exposure to the Orient since the Napoleonic wars. Focusing primarily on nineteenth-century examples, Said observes that academic Orientalism served as a structuring system for coming to terms with these alien stimuli; it bolstered the barricades against the threat of the unknown Other by placing Europe firmly and erectly in the privileged center of this enlarged universe.[31] Matisse's odalisques constitute a similar self-aggrandizing response to growing challenges that the Orient posed to the uncontested position of French cultural (if not yet political) supremacy. They are a declaration of European power over the sexual disposition of black women, who are symbolically claimed by the European male as a demonstrable confirmation of Oriental subjugation.

Perhaps it is not too farfetched to suggest that it was more than simply the privileged dominance of French *culture* that was subliminally threatened by influences from the Orient. The odalisque motif had a venerable nineteenth-century tradition in the work of artists such as Delacroix, Ingres, and Renoir, but it is possible to argue that Matisse revived it at a particularly sensitive time when the Orient posed a potential challenge to European sexual prowess with the physical presence of black men on French soil. During the war conscripts from the French colonies in Africa (the so-called *force noire*) had been imported into Europe to augment troops fighting against the ever-ominous Germans. That their mythic sexual potency excited competitive male fantasies and fears among Frenchmen as well as the German enemy is indicated by the anxious speculations of E. D. Morel, a French politician who declared

that "barbarians belonging to a race inspired by Nature with tremendous sexual instincts" had been thrust into the heart of Europe.[32] Within the context of this sort of insecurity Matisse's depictions of a white harem might be reconsidered as statements of indisputable property claims by a middle-aged Frenchman to exclusive possession of white womanhood.[33]

Challenges to the uncontested domination of the European male emanated not only from the exotic Orient but also from the domestic women's movement. Feminism had been burgeoning in France since the revolution of 1789, when women first demanded political rights. By the eve of World War I there were over one hundred and twenty-three feminist organizations and thirty-five feminist newspapers.[34] In World War I, as in World War II, French women became active in many sectors of the economy, as nurses and as farm and factory workers. They were militant unionists, since, unlike their male counterparts, they could not be sent to the trenches as a punishment for organizing.[35] But once the war was over, there was a concerted effort among French*men* to return to the familiar conservative patterns of the prewar years. War casualties had caused a severe drop in population in France and women were encouraged to relinquish other goals to become mothers. As a result of this pressure to reproduce and to return to "normality," the women's movement lost the momentum that had been building for several generations. No women's revolution occurred and women did not receive the vote until 1944. These reactionary pressures were reflected in the work of contemporary painters. Robert Herbert observes that during the decade of the twenties Fernand Léger typically depicted women as emblems of leisure and security in paintings like *Le Grand Déjeuner* of 1921,[36] and a similar iconography can be detected in works by Picasso such as *Woman and Child*, which also dates from 1921. Silver argues that Matisse's odalisques likewise represent women as unthreatening islands of comfort that reflect the desire of Frenchmen for respite upon returning from battle to the safety of the home front.[37] Despite their exotic veneer, the paintings clearly participate in the concerted na-

tionwide campaign during the postwar period to redefine women's place in French culture in domestic terms.

The Central Position in the Odalisques of the European Male Artist as Divine Creator

Matisse's formal language posits an exclusive position of uncontested power for the European male. In a famous statement in *Notes of a Painter* (1908) Matisse unambiguously identified the sex of his intended viewers: the "tired businessman" and "men of letters."[38] Matisse and his assumedly male viewer dominate the space of the odalisque paintings through their central position in the compositional arrangement. Norman Bryson establishes that the Renaissance Albertian convention of perspective locates the body of the viewer outside the picture at a fixed spot which is defined prior to the picture and dematerialized into a single point. The vanishing point within the picture reflects the viewer's gaze back at him and the picture plane becomes a transparent projection of the painter/viewer, a system by which negative space is ordered. Bryson argues that the Albertian regime returns the body to itself in its own image, as a measurable, visible, objectified unit in a state of temporal arrest.[39] Matisse seldom employs a mathematically consistent single-point perspective, yet his compositions during the odalisque period have a significant residue from this traditional spatial system and they usually locate the viewer in a central controlling position that assumes the artist's own pivotal perspective on the subject. The painter/viewer sees himself reflected back upon himself (sic) through the spatial hierarchy of the picture—like a deity who is manifest in the substance of his creation [1, 2, 3, 4, 5].

During and after the Renaissance, the awesome creativity of exceptional artists like Matisse became the revered object of the kind of cultural devotion that had once been reserved solely for sacred figures. The creative artist was conceptualized as a potent white male patriarch on models such as the seminal image of Michelangelo's powerful Old Testament Father-God.[40] Witness, for instance, the worshipful cults that developed

6. Henri Matisse, *Violinist at the Window,*
1917. Paris, Musée d'Art Moderne.

7. Henri Matisse, *Self-Portrait,* 1918. Le
Cateau-Cambresis, Matisse Museum.

around Leonardo and Rodin, who fit the arche-type of creative artist to perfection. Although the authority of the Christian Father-God had waned in early twentieth-century Europe, within the boundaries of his creations Matisse retained the structuring omnipotence of an absent god. He identified the source of his creative prowess as a religious force, an "interior light which transforms objects to make a new world of them—sensitive, organized, a living world which is in itself an infallible sign of the Divinity, a reflection of Divinity."[41] While he rejected conventional religious dogma, his paintings unconsciously retained the mythic structure of Renaissance sacred art, wherein the male creator-deity occupied the center of his creation, much as Michelangelo's God-the-Father-with-the-long-white-beard occupied the conceptual center of the Sistine ceiling.

Violinist at the Window (1917) [6] provides a graphic illustration of Matisse's covert equation between artist and deity. The musician in the painting, who is a signifier for the creator-artist,[42] stands before a cross formed by the window frames at the center of the pictorial construction he has made. The surrogate maestro figure gazes through a window, a symbolic nexus between interior and exterior worlds that marks the plane of critical juncture where subjective interior perception and objective exterior nature meet. His face is turned away from the viewer. He is mysterious and unfathomable, like the miraculous art he creates. His sex, however, is clearly established. That Matisse associated his creative power to embody artistic forms with his male sexual identity is demonstrated in a rather literal manner in the imagery of his 1918 *Self-Portrait* [7], where, as Flam points out, his palette and oversized thumb unequivocally function as a phallic substitute.[43]

The Erotic Dynamic in the Odalisques

Matisse did not systematically analyze the erotic dynamics that motivated his art. He expressed little interest in theory. In fact, in a famous statement he advised the aspiring painter to cut out his tongue in order to paint more purely.[44] When Matisse did write on theoretical issues, he stressed formal differences rather than symbolic relationships. Yet the compositional relationships of his pictures employ a syntax that articulates differences not only between lines and colors but also between the dominant male artist and his submissive female model. Matisse contended that "what is significant is the relation of the object to the artist, to *his personality,* and *his power* to arrange his sensations and emotions."[45] In a well-known letter to Henry Clifford, curator of his Philadelphia exhibition in 1948, he declared that "an artist must *possess* Nature. He must identify himself with her rhythm, by efforts that prepare for the *mastery* by which he will later be able to *express himself* in his own language."[46] Matisse begets art on the female body of his exotic muse in order to domesticate her; he paints woman/nature/the Orient in order to translate her ineluctable (and therefore frightening) mysteries into the possessive idiom of partriarchal and imperialist discourse.

Matisse's famous *The Painter and His Model* (1916) [8] visually articulates the erotic basis of the relationship in his work between the structuring masculine artist and malleable feminine nature. The picture shows the artist contemplating a model who serves as the raw material for his imaginative transformation of nature into art. The scene is situated within a studio enclosure that interiorizes the imagery. Positioned at the fulcrum of the picture, like the musician in *Violinist at the Window,* the painter is seated with his back to the viewer in a manner that allows identification with his central perspective on the room. He occupies a median point between a painting of the model which sits on his easel, the model herself, and an open window. As in *Violinist at the Window,* the surface of the windowpane again suggests a plane of oppositional juncture between exterior nature

8. Henri Matisse, *The Painter and His Model,* 1916. Paris, Musée National d'Art Moderne.

and the interior reformulation of nature that occurs in the artistic process.[47] The suggestion is ironic, since, of course, like the rest of the picture, the natural scene beyond the window, too, is painted. The relationship between passive, feminine nature and the active male painter who recreates her in his art is stated compositionally by the regulation of loosely flowing organic arabesques within the geometric confines of angular rectangles.

The most sensually rounded curves and succulent colors are reserved for the form of the female model, whose undulating body is shaped like a swelling vase. The association of women's bodies with ceramic vessels was, of course, an ancient iconographical tradition that recognized the la-

tent germinative potentiality of both forms through their function as containers of fluid life sources and seed grains. An oval mirror with a spiraling, ornate golden frame is suspended above the model's head. Its shape suggests a vaginal keyhole, a redemptive entryway, a sort of secular, sensual gateway to paradise.[48] This exotic, intriguing form abstractly encapsulates the fascination that the model poses for the artist. Tantalizingly, the mirror does not reflect the contents of the room but mysteriously projects the darkness of the unknown feminine Other for which it is a sign.

The contrasting maleness of the artist, who represents the observing intellect, is abstractly celebrated in the formal properties of the grid-backed chair upon which he sits.[49] It consists of intersecting rectangular elements that visually establish his association with order, increment, balance, and regulation. These are the qualities that the artist has imposed in his painting on an unruly feminine nature. Likewise, in the picture within the picture that sits on the artist's easel the model's powerful physicality has been confined and defined by the rectangular boundaries of the frame, thus providing parameters that indicate its position within a referential framework of artistic discourse. But in the process of transferring the image to the canvas the artist has altered and reduced the form; it has become less massive and formidable, but more orderly, as it is filtered through the artist's imagination. Nature has been tamed and possessed through the creative act.

In a parallel process, the isolated tree seen through the open window, an iconic tree of life that depicts the generative powers of nature in a nonfigurative form,[50] has been cultivated and domesticated through its placement in a definable position within the referential grid of European culture, signified by the geometric masses of the urban architecture that surround it and by the enclosing rectangle of the window frame through which we see it. Once more, the window frame marks Matisse's awareness of a plane of contact between exterior stimulus and interior emotion. The echoing rectangle of the canvas on the easel signals the presence of a second interface between inner experience and its exterior transformation

into art, where the direction of stimulative motion from exterior object to interior emotion is reversed.

The rigid line of the artist's body extends the vertical line of the window frame, subtly identifying him with its delimiting function; as the composer of the painting, he is its framer. This association of the dominating creative intellect with an erect vertical male principle is confirmed by the suggestive position of the artist's arm, which thrusts phallically into the depths of the picture plane in the direction of the model. The figural interplay between artist and model is abstractly reprised in terms of still-life forms in the upper left-center of the painting, where a simple erect rectangular projection from the top of the easel thrusts toward the rococo swirls of the golden vaginal mirror. In theoretical musings Matisse would write cryptically of "marriages among objects," consecrated in the crucible of his imagination.[51]

The Colonialist Dynamic in the Odalisques

Although Matisse does not usually depict himself in the odalisque paintings [1, 2, 3, 4, 5], his controlling presence is understood as the power that situates the female within the frame and establishes the relationships and oppositions which give the pictures their balanced tension. Said describes the categorizing process through which the Orient is "contained" and "represented" by the controlling framework of Orientalism;[52] Matisse likewise "contains" and "represents" his odalisques by establishing a viewpoint from which to see them. Said characterizes Orientalism as "an accepted grid for filtering through the Orient to Western consciousness. . . ." He also observes that European discussions of the Orient have not been directed toward discovering objective truths, but rather toward representing the Orient within an accepted grid for filtering raw data with a selectivity that makes sense within the context of European needs;[53] the Orient is thereby tamed by astutely framing the relationships that surround it. This process of filtration, restructuring, and inten-

sification very much resembles Matisse's creative process. Said argues further that Western Orientalism is a "style"—that is, a formal system—for dominating and exerting authority; it is a method for transforming a distant and often threatening Otherness into a highly artificial mythic formation to serve a network of interests: military, scientific, ideological,[54] or, by extension, imaginative, as in the instance of Matisse's odalisques. It need hardly be pointed out that these interests are entirely European in orientation and that, by the same analogy, Matisse's usage of this exotic material was similarly self-centered.

Matisse's artificial Orient is a world without apparent conflict; it is a tourist's postcard image of a culture,[55] an enchanted vision of a fantasy land where sensual beauty and picturesque charm combine solely for the casual delight of a pleasure-seeking foreign observer. Light in the odalisque paintings is invariably unmodulated; it has been purged of shadows and the dark, disquieting traces of political coercion, poverty, or ordinary human struggle. Matisse's subjects are so accommodating and his formal mastery is so complete that his pictorial control appears effortless. Nothing in this charmed realm suggests discord or resistance. Yet, of course, the actual Orient in the early twentieth century was the site of severe political and cultural repression which created an intense resentment of European presence.[56]

Said identifies the European who tours as a "watcher, never involved, always detached." He describes the Orient as a "watched" source of infinite peculiarity.[57] Reenacting this time-honored European role as uninvolved observer, Matisse cautioned Camoin, his companion on his second trip to Morocco in 1912–13, that on their excursions to brothels in search of models they would "have to go like doctors making a house call."[58] In later life he habitually painted in a white jacket that suggested the sterile purity and objective, analytical detachment toward his subjects that a doctor might exhibit with regard to a patient. Matisse's paintings maintain a careful distance both from the problematic actualities of the lives of his European models and from the disturbing realities of the Orient.

The Psychological Dynamic in the Odalisques

After the breakdown of Matisse's marriage, just prior to the period of the odalisques, he surrounded himself with beautiful, undemanding, supportive women, brightly colored exotic birds, and an indoor garden of potted tropical plants which constituted a private idyllic domain that he could rule as he pleased, like a Persian pasha. His life-style during the twenties and thirties, when he painted most of the odalisques, has an artificial and theatrical quality that matches the mood of the pictures. He had left his wife and family for a vagabond life centered in a sequence of comfortable Nice hotels where he could devote himself untiringly to his art and fantasies undisturbed by mundane and bothersome obligations. In a conversation with Francis Carco in 1941 he reminisced about the pleasure of painting nudes in the old rococo salon of the Hôtel de la Méditerranée, recalling fondly the dramatic way the light came through the shutters "from below like footlights. Everything was fake, absurd, terrific, delicious. . . ."[59] There he dressed his paid and pliant European models in colorful Oriental costumes and surrounded them with exotic paraphernalia, in which, as indicated by titles such as *Odalisque with Green Sash* [2] and *Decorative Figure on an Ornamental Ground* [4], he often seemed more interested than in the models themselves.

Matisse's harem subjects do not function independently; their sole raison d'être is to entice the artist's imagination and to offer themselves unequivocally as catalysts for his sensual and/or aesthetic reveries. Their frequent nudity is a sign of their submission to the artist's (and to the presumably male viewer's) demands. They are invariably alluring, indolent creatures who are content to lie about on overstuffed furniture or languish aimlessly atop magnificent Persian carpets in domestic interiors. They stare blankly into space, suggesting both feminine lassitude and the inertia that Europeans believed to characterize Oriental culture. Louis Aragon, poet, art critic, and Matisse's friend, observed that Matisse had "fixed" his painted world so that women move with a

certain slowness "so as not to disturb *the order of things....*"[60] They represent both the female body and the Orient as passive incubators whose nature it is to await fructification from the European male artist/viewer. The pubic triangle of the *Odalisque Seated with Arms Raised, Green Striped Chair* [1] is hidden beneath a brilliant jewel that promises great reward. The contour lines of the red culottes in *Odalisque with Red Pantaloons* [3] likewise point to the concealed entrance to the model's body which is offered to the artist/viewer. The figure in *Odalisque with Green Sash* [2] touches her breast as a sign of her primitive nurturing function, and the green sash around her belly that calls the viewer's attention to her pregnant womb is the color of vegetation. She is surrounded by receptive vessels like herself and is identified with the mutability of the crescent moon that dominates the upper left-hand corner of the painting. The faces of Matisse's models are empty or impassive; their bodies are motionless; they have neither personalities nor histories of their own. They are, of course, not real women, but mythic products of the artist's fantasy and the collective fantasies of his patriarchal culture. Matisse is interested in his female models only as they signify the polarity of the unknown Other in his interior monologue. His paintings are not about his models; they are about the artist's power to create and about his extraordinary capacity to condense and reformulate his sensations in response to nature. Thus, regardless of their ostensible themes, the odalisques are disguised self-portraits. Matisse's obsessive quest for union with his model is an expression of his aspiration to reunify the interior and exterior, conscious and unconscious fragments of himself. By all accounts he was completely self-absorbed. His obsession with his art and his own personality was so intense that his daughter Marguerite observed that he "could think and talk of nothing else."[61] Ultimately, because Matisse's visions of erotic women are symbolic projections of suppressed aspects of his own psyche, in the process of artistic penetration of his own nature he is consummating an act of metaphorical masturbation.

The Studio Wall as a Symbol of Self

Although Matisse's odalisques are ostensibly foreign flowers, they bloom within the familiar domestic confines of his studio. Like many esoteric species, they have been artificially transplanted and carefully cultivated. Most of them were painted not in North Africa, which the artist visited briefly on three occasions, but in those theatrical hotel rooms in Nice in the south of France. While impressed by the light and color of the Orient, Matisse was uncomfortable with its strangeness and its physical discomforts. He mused, regarding his trip to equally exotic Tahiti in 1930, "Before I left, everyone said to me: 'How lucky you are!' I answered: 'I would love to already be on my way back.'"[62] He preferred armchair travel to the unpredictability of the real thing, just as he preferred the abstract, controllable, and harmonious constructs of art to the vexing demands and unpredictability of real life. "Back home in my slippers," he remarked on another occasion, "I became myself again."[63] Matisse's creative process was self-contained. Remembering the moment of his initial self-discovery as an artist, he recalled that when he started to paint, he had felt "gloriously free, quiet and [most significantly] alone . . ., transported to a kind of paradise. . . . In everyday life I was usually bored and vexed by the things that people were always telling me I must do."[64]

Matisse's redemptive painted paradise during the odalisque period is a walled garden. Pierre Schneider has suggested that the studio enclosure which surrounds the models sustains a high degree of exultation by its exclusionary nature.[65] While this observation is undoubtedly accurate, Matisse's retreat into his studio was not only a spiritual isolation but also a worldly one. Silver's point that Matisse's emphasis on studio iconography during this period was indicative of his withdrawal from modernism is apt, and I would argue that his retreat from the world was a self-protective action on a more profound psychological level as well. The walls of Matisse's studio function as a defensive barricade against the onslaught of the Outside

9. Henri Matisse, *Interior with Phonograph*, 1924. Formerly in New York, Collection of Mrs. Albert D. Lasker.

Other. They nurture the hermetic, self-centered structure of the ethnocentric and patriarchal language in which Matisse's Oriental garden of beautiful painted women is articulated and thereby controlled. De Beauvoir's observation that man perceives the Other as inherently dangerous because it is, by definition, a negation of Self that reminds him of his mortality[66] elucidates, in part, his reluctance to interact with the unknown. He found it safer to examine the threatening Other within the confines of his interior, culturally based reference coordinates. Here any intrusive challenge by an alien system of cognition could be subdued and reframed within a thoroughly French diction. Educated Frenchmen believed unquestioningly in the superiority of the French language over colonial alternatives as the vehicle of precise and logical thought. Matisse's stylistic language described the Orient within the constructs of French discourse. Both through their

succinct, if largely unintentional, statements of a pervasive sexual mythology and imperialistic ideology, as well as through their stylistic mastery, his odalisques reaffirm *French* supremacy.

Matisse acknowledged to the artist André Marchand that "you have one idea, you are born with it, and all your life you develop your fixed idea, you make it breathe."[67] *Interior with Phonograph* (1924) [9], a studio arrangement of fruit and flowers surrounded by Oriental accessories that frame a mirror and a window, reprises the imagery that obsessed Matisse throughout his career. Through compartmentalization and visual oppositions the painting articulates the dichotomizing mental and emotional fragmentations that confined Matisse's art within the restrictive walls of a self-reflexive closed circuit. The modern phonograph on the right suggests the allusions to the musically based metaphor for transcendent harmony which had been evoked by the violin in earlier pictures. Within the grid-enframed depths of the studio the presiding structuring intelligence of Matisse's interior process of conceptualization is represented by the reflected image of his intent, analytical face observing *itself* in the mirror. In immediate proximity to the mirror, forming a sort of diptych, the delimiting rectangular panes of an undraped window frame the world of nature, the exterior Other which is defined in the relative terms of difference. The fruit and flowers in the foreground of the picture are redolent with allusions to a mysterious, fecund, feminine, and Oriental Otherness that surrounds the reflection of the artist implanted in its core like a germinal seed in a receptive womb. The natural Other nurtures the creative seed of the artist who gives birth to an art that is a reincarnated, transcendent form of himself, purged of nature's material encumberments.

Interior with Phonograph is significantly more than an objective description of Matisse's studio space; it is a cryptic cipher that symbolizes the mythic tensions of his interior life and his half-conscious struggle to resolve them by bringing them forth into the dawn of conscious awareness. His light is a healing illumination. Aware that it constituted a revolutionary break from tradition,

his critics, as we have seen, labeled it "emancipated."[68] But while the celestial glow of Matisse's color soothed the eye, I would argue that it failed to wash away the deep-rooted conflict between the Self and Other (creative intellect and nature) that underlay the polarization of male and female, the West and the Orient in his iconography. In a letter written in 1938 Matisse admitted his frustration, complaining, "There are so many things I would like to understand, and most of all myself. After a half century of hard work and reflection the wall is still there. Nature—or rather, *my nature*—remains mysterious."[69]

The Unification of Self and Other: And the Wall Came Tumbling Down

Although the odalisque paintings glow with emancipated color, they remain uncomfortably claustrophobic. Matisse's culturally sanctioned mythological and ideological assumptions about dominance and submission created delimiting parameters and internal divisions that frustrated the achievement of the transcendent wholeness that he so earnestly sought. Without ever consciously probing inherited assumptions about the separation between the Self and the Other that dictated the division of his mental structure into polarized fragments, Matisse nevertheless groped instinctively toward psychic reintegration. Following a major, life-threatening operation in 1941, from which he felt he had arisen to a second life,[70] his work underwent a gradual, but dramatic, transformation.

The changes were tentative and inconsistent, and for a while Matisse wavered on the brink of revelation. *The Sorrows of the King* (1952) [10] is a visualization of his psychological stagnation. The cutout depicts a melancholy king, a musician surrogate for the artist, who holds a guitar in his hand. The shape of the instrument echoes the curves of the female body and it is pierced by a vaginal hole; the female body (mythic nature) is the metaphorical instrument for giving form to the conceptualizations of the artist. Perspective is rudimentary, but the artist-king is compositionally at the center of Matisse's fantasy. Although the

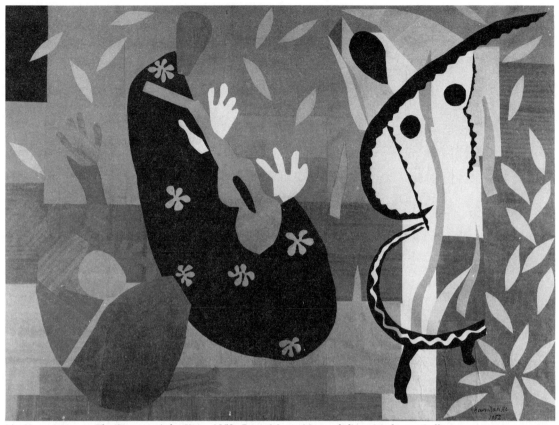

10. Henri Matisse, *The Sorrows of the King*, 1952. Paris, Musée National d'Art Moderne *(Bulloz)*.

confining walls of the setting have lost their solidity, the suggestion of boundaries is retained. With sadness at the passing of life and the elusiveness of beauty, the old king watches the seductive dancing of an erotic odalisque. Although she is his possession, he is not cheered; he seems on the threshold of the perception that his power to control the Other is a vain and ephemeral illusion. The king is as unconsciously oppressed by the relationship of dominance and submission between master and slave, Self and Other, as his powerless subject; he is imprisoned in a psychic state of fragmented isolation that is mythological and ideological in origin.

The most joyful and revolutionary paper cutouts dating from Matisse's late career are based on radically different premises from those that motivated the odalisques. Matisse did not consciously

articulate the internal alterations in mythological and ideological perspective that are responsible for the changes that occurred in his work. Perhaps he was not fully aware of the psychological forces that inspired them. And yet, the radical alterations in format and composition in the cutouts confirms beyond a doubt that they did occur. After 1950 images begin to float in open, undefined space. Often there is no longer a privileged central position from which the viewer can command the picture space; traditional spatial recession, which is organized around the exclusive, centrally located position of an assumed (male) viewer is eliminated in favor of a more inclusive, all-over compositional organization.

If Matisse was not entirely cognizant of the causes of the changes in his work, he nevertheless sensed them. On a conscious level he seemed to

11. Henri Matisse, *The Wave*, 1952. Nice, Musée Matisse.

attribute them solely to formal considerations, but subconsciously he alludes to the process of breaking down the walls of Self. In 1947 he wrote to Rouveyre that he had undergone "a sort of crisis of conscience and it's possible that a major upheaval in my work is under way. I see the necessity of getting away from all constraints, from all theoretical ideas so that I can reveal myself utterly and freely by *placing myself outside* current preoccupations. . . ."[71] By 1952 the studio walls that formerly constrained Matisse's models had disappeared from his oeuvre; the confining boundaries between Self and Other had disintegrated.

Some of the late cutouts, such as *The Wave* (1952) [11] convey an unprecedented sensation of harmonious confluence that implies a lack of oppositional conflict between the controlling intellect of the artist and nature (his model). They seem implicitly to acknowledge that transcendent "masculine" potency and "feminine" immanence are two aspects of a single sacred creative force. If Matisse's need to possess the material, feminine, and alien Other had been an expression of his desire to possess the whole of himself, I would suggest the possibility that as the result of his failing physical health, he had been confronted with his mortality and had slowly learned to accept the inevitability of change. The antagonism between Mind and Body that is implicit in the separation of the spiritual and physical worlds, another aspect of the mythological and ideological dualism that permeates the odalisques, was resolved. Having recognized "feminine" imma-

nence within himself, Matisse no longer feared the threatening Other, and his compulsion to control it, to keep it separate from himself at a safe distance, disappeared.

Cutouts such as *The Wave* seem to breathe and move as the earlier odalisques, for all their sensuous beauty, did not. Although more abstract than the odalisques, the imagery of the ocean wave still symbolizes nature in a nonfigurative form, like the iconic tree of life in *The Painter and His Model* [8] or the fruit and flowers in *Interior with Phonograph* [9]. But in *The Wave* Matisse no longer compositionally defines nature in terms of difference as the external Other; the traditional rectangular boundary of the canvas and the structuring perspective of the enclosing French windowpane have been eliminated, allowing the wave to break out of established frames of discourse and be experienced by the viewer without cultural preconceptions about its relative hierarchical position in relationship to culture.

Fresh, luminous color floats freely in a primeval, indivisible space that implies an altered concept of deity. Unlike the odalisque pictures, *The Wave* does not exalt the artist's omnipotent mastery over his subject through his control of the artistic process; rather, it extols the creative act itself. The sacred is no longer conceived as a possessive noun (of male gender), but as a verb form in which mind and matter, male and female, Self and Other, are inseparable in a perpetual cycle of becoming. It is somewhat startling to realize how closely this description of the space in *The Wave*

corresponds to the feminist philosopher Mary Daly's definition of the nondualistic deity which she believes will emerge from the application of the feminist ideal of sexual equality.[72] Matisse's cutouts imply the resacralization of (supposedly) feminine nature. In fact, the cutouts have been a major source of inspiration for contemporary pattern painters, a movement that has been heavily influenced by feminist thought.[73]

For all the misguided frustration that is revealed by a close inspection of the odalisques, Matisse's artistic development encourages optimism for the future. Not simply because of the stylistic success of the late cutouts, but more importantly because of the dramatic mental breakthrough that they represent. The mythic ideologies of sexual and cultural hegemony that structured early twentieth-century European thought had been so deeply rooted in Matisse's odalisques that they were, for the most part, unquestioned by the painter or his public. As long as possession and domination were perceived as the only options for relating to difference, a redemptive unification of mind and matter, male and female, West and Orient, the Self and Other, the conscious and unconscious mind, remained an unattained

paradisical fantasy. Matisse's evolution not only demonstrates that change is possible, it suggests that it is a psychic necessity, not only for those who must submit, but also for those who dominate.

The change in consciousness represented by *The Wave* is, of course, only a beginning in a complex struggle to transform an entire social system and its human and ecological interrelationships. But it is a crucial step. Unfortunately, the mythological and ideological formulas that are crystallized in the odalisques are still so deeply imbedded in contemporary Western culture that, as the failure of traditional Matisse scholarship to acknowledge them indicates, they have often remained unrecognized. The present phase of feminist scholarship, which is largely dedicated to exposing the dark conflicts that linger on the underside of the serene surface of patriarchal and imperialist culture, will soon complete its task. Like Matisse's odalisques, in retrospect it will constitute a necessary preliminary period dedicated to coming to terms with submerged tensions. With luck, it too will lead to a liberating release from the restrictive premises that have framed and colored our past.

NOTES

1. For Matisse's own formalistic descriptions of his creative concerns see *Matisse on Art*, ed. Jack Flam (New York: Phaidon, 1973), pp. 36, 47, 60, and 116. Typical examples in secondary sources of stylistic emphasis in discussions of Matisse are: John Russell's *Meanings of Modern Art* (New York: Museum of Modern Art and Harper & Row, 1981), in which the chapter on Matisse is titled "The Emancipation of Color"; or Raymond Escholier's *Matisse: A Portrait of the Artist and the Man* (New York: Praeger, 1960), in which the initial chapter is called "The Pure Act of Painting," and a later chapter is titled "Music in Color."

2. Jacques Derrida, "Signature, Sign and Play in the Discourse of the Human Sciences," *Writing and Difference*, trans. Alan Bass (Chicago: University of Chicago Press, 1978), pp. 280–81.

3. Claude Lévi-Strauss, "The Structural Study of Myths," *Structural Anthropology*, trans. C. Jacobson and

B. G. Schoepf (New York: Basic Books, 1963), pp. 206–31.

4. Terry Eagleton, *Marxism and Literary Criticism* (Berkeley: University of California Press, 1976), pp. 5–7.

5. Fredric Jameson, *The Political Unconscious* (Ithaca, N.Y.: Cornell University Press, 1981), pp. 100 and 49.

6. Lawrence Gowing, *Matisse* (New York and Toronto: Oxford University Press, 1979), pp. 143, 154–56.

7. Ibid., p. 93.

8. Jack Flam, *Matisse: The Man and His Art, 1869–1918* (Ithaca, N.Y., and London: Cornell University Press), 1986, p. 480.

9. Dominique Fourcade, "An Uninterrupted Story," in Jack Cowart and Dominique Fourcade, *Henri Matisse: The Early Years in Nice, 1916–1930* (Washington, D.C., National Gallery of Art, and New York, Harry N. Abrams, 1986), pp. 56–57.

10. Pierre Schneider, *Matisse*, trans. Michael Taylor and Bridget Stevens Romer (New York: Rizzoli, 1984), pp.

13, 10, and 24. Jack Flam refers to Matisse's *Zorah* (1912) as a "paradoxical combination of the vividly sensual and the intensely spiritual . . . that Matisse was so drawn to in Morocco" ("Matisse in Morocco," *Connoisseur* 211 [August 1982]; 84).

11. Kenneth Silver, "Matisse's *Retour à l'ordre*," *Art in America*, June 1987.

12. "Notes of a Painter," Jack Flam, *Matisse on Art* (London: Phaidon Press, 1973, and New York, 1978), p. 39.

13. Simone de Beauvoir, *The Second Sex*, trans. and ed. H. M. Parshley (New York: Alfred A. Knopf, 1968), pp. 69, 77, 79, and 73–74.

14. Sherry Ortner, "Is Female to Male as Nature Is to Culture?" *Woman, Culture and Society*, ed. Michelle Zimbalist Rosaldo and Louise Lamphere (Stanford, Calif.: Stanford University Press, 1974), pp. 67–88.

15. Carol Duncan, "Virility and Domination in Early Twentieth-Century Vanguard Painting," *Artforum*, December 1973, pp. 30–39; reprinted in *Feminism and Art History: Questioning the Litany*, ed. Norma Broude and Mary D. Garrard (New York: Harper & Row, 1982), p. 311.

16. Jack Flam, "Letter to Henry Clifford, 1948," in *Matisse on Art*, p. 121.

17. Duncan, "Virility," p. 304.

18. Louis Aragon, *Henry Matisse: A Novel*, trans. Jean Stewart (New York: Harcourt, Brace & Jovanovich, 1972), vol. II, pp. 109, 67.

19. Bram Dijkstra, *Idols of Perversity: Fantasies of Feminine Evil in Fin-de-Siècle Culture* (New York and Oxford: Oxford University Press, 1986), pp. 14–15.

20. Silver, "Matisse's *Retour à l'ordre*," pp. 169, 188.

21. Flam, *Matisse on Art*, p. 79.

22. Silver, "Matisse's *Retour à l'ordre*," p. 122.

23. Edward Said, *Orientalism* (New York: Pantheon Books, 1978), p. 109. Said does not treat Orientalism in the visual arts, however; Linda Nochlin discusses Said's relevance for Oriental imagery in nineteenth-century painting in "The Imaginary Orient," *Art in America*, May 1983, pp. 119–31 and 186–91, where she also remarks upon its touristic appeal. For a discussion of the sexual and political implications of the odalisque theme in the work of Ingres, see Marilyn Brown, "The Harem Dehistoricized: Ingres' *Turkish Bath*," *Arts Magazine* 61, no. 10 (Summer 1987): 58–68, and see n. 8 (p. 67) for a bibliography on Orientalism in the visual arts.

24. Ibid., p. 47.

25. According to Gertrude Stein (in her *Autobiography of Alice B. Toklas*, p. 37), during a period of poverty Matisse bought one of Gauguin's paintings with his wife's engagement ring. Matisse, however, denied the accuracy of her story in his *Testimony Against Gertrude Stein*

(Flam, *Matisse on Art*, pp. 88 and 168).

26. Catherine C. Bock, "*Woman Before an Aquarium* and *Woman on a Rose Divan*: Matisse in the Helen Birch Bartlett Memorial Collection," *Museum Studies* (Art Institute of Chicago), 1986, pp. 203–4 n. 2, and Fourcade, "An Uninterrupted Story," p. 47.

27. Silver, "Matisse's *Retour à l'ordre*," p. 112.

28. Duncan, "Virility," p. 311.

29. Christopher M. Andrew and A. S. Kanya—Forstner, *France Overseas: The Great War and the Climax of French Imperial Expansion* (London: Thames and Hudson, 1981), p. 210, and Silver, "Matisse's *Retour à l'ordre*," p. 121.

30. Silver, "Matisse's *Retour à l'ordre*," pp. 117, 111.

31. Said, *Orientalism*, p. 87.

32. Andrew and Kanya-Forstner, *France Overseas*, p. 211.

33. Sally Stein suggested this possibility in response to an early version of this paper, which I presented at the 1988 College Art Association meeting in Houston as part of Eunice Lipton's panel "Discussing the Other: Possessing the Outsider."

34. Jean Rabaut, *Histoire des féminismes français* (Editions Stock, 1978).

35. Douglas and Madeleine Johnson, *The Age of Illusion: Art and Politics in France, 1918–1940* (New York: Rizzoli, 1987), "Verdun," n.p.

36. Robert L. Herbert, *Léger's "Le Grand Déjeuner,"* Minneapolis Institute of Arts, 1980, p. 27; cited by Silver, "Matisse's *Retour à l'ordre*," p. 122.

37. Silver, "Matisse's *Retour à l'ordre*," p. 122.

38. Matisse, "Notes of a Painter," in Flam, *Matisse on Art*, p. 38.

39. Norman Bryson, *Vision and Painting: The Logic of the Gaze* (New Haven, Conn.: Yale University Press, 1983), "The Gaze and the Glance," pp. 87–131.

40. Mary Daly's *Beyond God the Father* (Boston: Beacon Press, 1973) is among the earliest and most articulate feminist discussions of the relationships between patriarchal religion and sexual hierarchy. Others include Naomi Goldenberg, *Changing of the Gods: Feminism and the End of Traditional Religions* (Boston: Beacon Press, 1979), and Rosemary Ruether, *Sexism and God-Talk: Toward a Feminist Theology* (Boston: Beacon Press, 1983), which has an excellent bibliography.

41. "Statements to Teriade, 1929," in Flam, *Matisse on Art*, p. 61.

42. Although Matisse's son, Pierre, served as a model for the painting (Nicholas Watkins, *Matisse* [New York and Toronto: Oxford University Press, 1979], p. 13), the figure represents the artist's capacity to perform the sacred act of distilling harmony from nature through the creative act.

43. Matisse's obsessive devotion to the subjects of the

odalisque and the female nude during the following decades has sometimes been attributed to Renoir's example (Gowing, p. 121, and Flam, *Matisse: The Man and His Art*, p. 473). The day before beginning the 1918 self-portrait Matisse paid a series of visits to the elderly and ailing Renoir at Cagnes. Perhaps his association of the painterly act with the act of sexual appropriation was also reinforced by Renoir. When Renoir was asked by a journalist how he painted with his crippled, arthritic hands, he replied that he painted "with my prick" (Jean Renoir, *Renoir, My Father* [Boston and Toronto: Little, Brown & Company, 1962], p. 205). Leo Steinberg suggests that Picasso too intended to draw his model "as if to possess . . . like the global ruler in the Age of Discovery whose *mappa mundi* unfurls a circumnavigated world" ("The Algerian Women and Picasso at Large," *Other Criteria* [New York: Oxford University Press, 1972], pp. 222, 174, and 192).

44. Flam, "Jazz, 1947," *Matisse on Art*, p. 111.

45. Ibid., p. 73, italics mine. "I don't paint things, I only paint differences between things," Matisse told Louis Aragon (*Henri Matisse: A Novel*, trans. Jean Stewart [New York: Harcourt, Brace & Jovanovich, 1972], vol. I, p. 140).

46. Matisse, "Letter to Henry Clifford, Vence, February 14, 1948," in Flam, *Matisse on Art*, p. 121, italics mine.

47. Schneider interprets Matisse's work as an effort to make the transparency between interior and exterior worlds visible. Schneider sees the flatter, more decorative handling of the world beyond the windowpane as a sign of its sacred nature, as opposed to the more three-dimensional handling of the secular interiors (pp. 452–55). But, if the window is a metaphor for the canvas, it does not sanction nature but rather enshrines the process of dominating and harmonizing nature through the creative will of the artist.

48. Bram Dijkstra discusses nineteenth-century precedents for the iconography of the oval mirror as a representation of the primal mysteries of nature in *Idols of Perversity;* see especially pp. 132–52.

49. Watkins suggests that Juan Gris's theories on the mathematical basis of pictorial harmony and Henri Bergson's description of the human mind as "a net" influenced Matisse's frequent employment of the grid structure (p. 127). Flam also cites parallels between Matisse's ideas and Bergson's ("Matisse on Art," pp. 159–160). In *Jazz* (1947) Matisse declares that his curves are not mad, because they relate to his verticals and that the verticals are an abstraction in his mind (Flam, *Matisse on Art*, p. 112). Because he identifies curves with nature, he implies that nature acquires meaning through her relationship to the structuring process of the human mind.

50. Matisse's awareness of traditional fertility iconography in conjunction with the tree is suggested by his later reference to it in his depiction of the Tree of Life in the Vence Chapel windows in the early fifties.

51. Aragon, *Matisse-en-France*, p. 33, cited by Schneider, *Matisse*, p. 316.

52. Said, *Orientalism*, p. 40.

53. Ibid., p. 6.

54. Ibid., p. 3.

55. See n. 14.

56. For the details of North African resentment against European rule see Edmund Burke III, *Prelude to Protectorate in Morocco: Precolonial Protest and Resistance, 1860–1912* (Chicago and London: University of Chicago Press, 1976); and Douglas Porch, *The Conquest of Morocco* (New York: Alfred Knopf, 1983).

57. Said, *Orientalism*, p. 103.

58. Flam, *Matisse on Art*, pp. 84–86.

59. Ibid., p. 89.

60. Aragon, *Henri Matisse*, vol. II, p. 138.

61. Watkins, *Matisse*, pp. 22 and 10.

62. Flam, *Matisse on Art*, p. 62.

63. Schneider, *Matisse*, p. 158.

64. Gowing, *Matisse*, p. 9.

65. Schneider, *Matisse*, p. 430.

66. De Beauvoir, *The Second Sex*, p. 79.

67. "André Marachand: The Eye, 1947," in Flam, *Matisse on Art*, p. 114.

68. See n. 1.

69. Jack Cowart and Dominique Fourcade, *Henri Matisse*, p. 57.

70. Letter to Simon Bussey, April 13, 1941, quoted by Schneider, *Matisse*, p. 778.

71. Ibid., p. 739, italics mine.

72. Daly asks: "Why indeed must 'God' be a noun? why not a verb—the most active and dynamic of all? . . . Women in the process of liberation are enabled to perceive this because our liberation consists in refusing to be 'the Other' " (pp. 33–34).

73. Tracing the roots of Miriam Schapiro's "Femmage" to Matisse and Kandinsky, Norma Broude contends that Matisse achieves "a critical balance between the sensory and cerebral which he acknowledges as two equally valid, rather than conflicting, demands of his artistic sensibility" ("Miriam Schapiro and "Femmage": Reflections on the Conflict Between Decoration and Abstraction in Twentieth-Century Art," *Arts Magazine*, February 1980, pp. 83–87; reprinted in Broude and Garrard, *Feminism and Art History*, 1982). I would agree that on the whole Matisse does balance these conflicts, although rarely equally. But only in some of the late cutouts, which were, after all, the source of Schapiro's inspiration, does he finally succeed in transcending them.

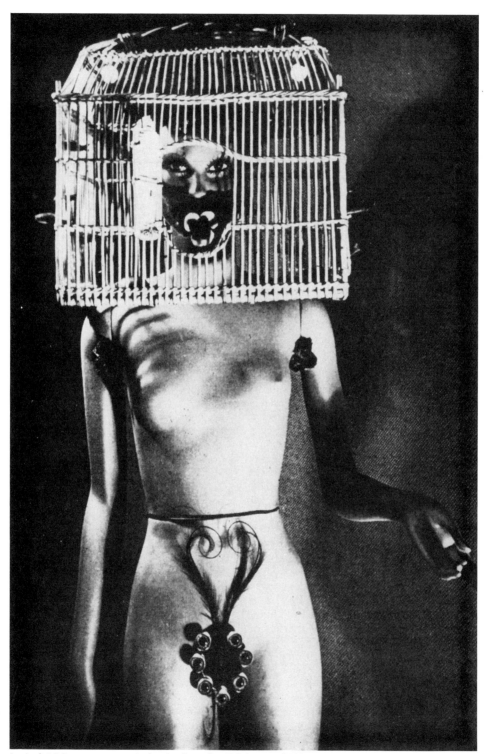

1. André Masson, mannequin for the Surrealist Exhibition of 1938.

21

LADIES SHOT AND PAINTED

———

Female Embodiment in Surrealist Art

———

MARY ANN CAWS

I think that is absolutely amazing, really phenomenal. Talk about complications!
—André Breton, to Pierre Unik

Conspicuous Consumption: Caging In and Out

When Pierre Unik told Breton that he consulted, in lovemaking, his partner about what she enjoyed, Breton was amazed. Why not? asked Unik. Because, replied Breton, her likes and dislikes "have nothing to do with it."[1] Indeed. Breton's attitude may strike *us* as phenomenal, given our present assumptions about an egalitarian society, about an equal ardor consuming both and all members of unions—but of course, talk about complications, Surrealism had a few.

I want to reflect on some problems in the representation of female bodies in Surrealist photography and painting, touching first their canonization, their consecration, and the laying on of hands, and then the relation of this representation to the supposed consumer, for his or her conspicuous or clearly visible consumption. Since, in the latter concern, *we* are plainly concerned when we look (whoever we are assumed to be), just as where

we speak or write, we may be assumed to be looking at our own gaze (*con-spicere,* to look intensively). Problematic above all is the notion of our own consuming of what we see as if in collusion with the artist or photographer.[2] For both the representation as produced by the agent or manager or mediator of the reading—artist or photographer—and the reactions of the onlooker or reader of the image must be re-exposed in the light of a certain recent criticism putting into question the whole binary system of subject and object. This is a revision overdue and all the more problematic in Surrealism, which already wanted to overcome the split between seer and seen, visionary and view: thus, a problematics of the problematic, and how it is received.

I see this, speaking from the point of view of onlooker, as a tripartite problem: our view of the object, in this case, the woman portrayed in whole or part (of which more later); our view of the agent or mediator or middle-person; and our view of ourselves as consumers of the object as mediated and managed. To talk, again, about complications: insofar as it is a question of women's bodies, the female onlooker is—willing or not, partially or wholly—identified with the body under observation and under the rule of art. Her reaction to the

From *The Female Body in Western Culture,* Susan R. Suleiman, ed. (Cambridge, Mass.: Harvard University Press, 1986), pp. 262–87. Copyright © 1985, 1986 by the President and Fellows of Harvard College. Reprinted by permission of the author and Harvard University Press.

middle term or the management will be colored by that identification, her consuming function modified by the pleasure or anger with which she differentially views what I have been calling the laying on of hands (*management,* from "hand," like mannerism, and—of course—like "handling").

For how could we possibly think that a seeing woman writing about women being touched with the brush, perfectly *captured* in paint, or accurately shot by a camera's eye, about these artistically ogled and consumed beings, would have an "objective" point of view? Her lens will be at least set with an angle to it, since there is no stranger's summit on which to stand aside and above. She, we are bound to think and say, is implicated, heavily.

Implication is nervously involved in looking at André Masson's rendering, for the Surrealist Exhibition of 1938, of a mannequin at once painted, caged, and captivated [1]. Her head is imprisoned in a bird cage, her face caught exactly within the cage door and her mouth masked, with a pansy directly over the opening. Under her arms, pansies match that one, so that neither in speaking nor in making gestures is she able to present herself unmediated or untouched, unornamented. The cage is not domestic but rather of the jungle variety— thus her presentation as vaguely exotic, beflowered. Over the join of her thighs is a complicated decoration for a double thrust of hiding and priding, as we might read in the peacock eyes (or, reread, the evil eyes) with the curving plumes in the form of fallopian tubes.

A found object, severed in the middle as mannequins may often be, she is set up with odd lighting so that one breast seems larger than the other: it is marked above by lines of shadow, significantly in the form of a spider, as if entrapment were to be in fact the key to the reading of the object. The shadows under the left eye and the dark circlet just below the neck stress the embattled nature of the shady and shiny lady with her jungle hat. She cannot speak; she is entrapped even as she is decorated, wearing at once too much and too little, dressed up and dressed down, naked and rendered mute, added to and subtracted from,

but most of all entrapped. We've come a long way, baby, from the fig leaf to the chastity belt to this prize covering flower.

As for the head so encaged, it calls strongly to mind another female entrapment, this one the capturing by Man Ray of a live female model whose torso is bare and whose head is perfectly netted in a wire mesh hat, through which her eyes look out, as unsmiling as her mouth[2]. Is this a reflection on hat styles, on consumerism as negative display, or on capturing a prey who is rendered simultaneously mute and speaking of objecthood? The slope of her shoulders denotes a submission to the netting and the capture, and the caption is a quote from Breton's piece "Il y aura une fois," which the photo illustrates: "These girls being the last ones to point themselves out in a haunted house scandal . . ." The haunting, I submit, is more than a little sexually oppressive and less than innocent.

Xavière Gauthier's attack, in her *Surréalisme et sexualité* (1971),[3] on the male Surrealist artist and writer's point of view regarding the female sex object has often come under attack itself for its "reductionism" and its "simplifications." A contemporary reexamination of the issue—of which this can only be a preliminary sketch—might well want to take into account two more recent works, neither directly concerned with the male-female issue, but both of indirect and yet certain relevance. The first is that of Rosalind Krauss, in her chapter entitled "The Photographic Conditions of Surrealism" in *The Originality of the Avant-Garde and Other Modernist Myths,* where she examines the techniques with which Surrealist photographers rob—by their spacing and delays and doublings—the image of the sense of presence. Quoting Jacques Derrida on the split between the time of the meaning of the sign and that of the mark or sound as its vehicle ("The order of the signified is never contemporary, is at best the subtly discrepant inverse or parallel— discrepant by the time of a breath—from the order of the signifier"), Krauss explains how, for Derrida, this spacing can be "radicalized as the precondition for meaning as such, and the outsideness of spacing . . . revealed as already con-

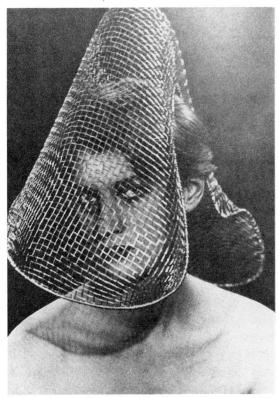

2. Man Ray, nude in head cage of wire, photograph in *Le Surréalisme au service de la révolution*, no. 1 (July 1930).

stituting the condition of the 'inside.' "[4] Thus "spaced," she continues, the photographic image is deprived of the sense of presence which—since it is the mark of the object—we have counted on. Doubling, or the showing of this spacing by a double imprint, is the most important strategy in Surrealist photography for letting the sense of difference and deferral penetrate the image (and so, we might want to add, the imagination). "For it is doubling that produces the formal rhythm of spacing—the two-step that banishes the unitary condition of the moment, that creates *within* the moment an experience of fission."[5] Doubling destroys the impression of singularity, of the original.

Since, as Krauss says, Surrealist convulsive beauty depends on the belief in *"reality as representation,"* and since "Surreality *is,* we could say, nature convulsed into a kind of writing,"[6] her discussion is crucial to the points I want to make about the representation of the female image, as I consider the writing of the female into the making and the seeing of Surrealist art. The denial of presence is exactly the problem with such photography, as we see ourselves seeing ourselves in it. In the image by Man Ray, *Monument to de Sade,* which Krauss takes as one of her two initial examples, a woman's posterior is seen rotated to the left and up, to echo a simple cruciform design imposed upon it: "Never could the object of violation be depicted as more willing."[7] So the issues of depiction, collusion, and consumption are massively complicated even by the formal echoes, as we read them.

If we consider the point of view of a leading modern female exponent of Surrealist views, looking at the identical posterior and the identical cruciform shape as they fit each other, the difference in interpretation takes on its complicated colors to color our own text. Annie Le Brun, reading the same image of the *Monument to de Sade,* finds it the supreme example of revolutionary eroticism, the very illustration of the nudity of loves, and gives it the caption: "this condemned part of our history, the splendid return of the flame of human freedom against the idea of God"; and for the blurb of Jean-Jacques Pauvert's volume *L'Anthologie de lectures érotiques,* she comments: "Whether we like it or not, the body remains our only means of transportation, body of the other, body towards the other, body neither of one nor the other, body always other."[8]

I have worried before, in the case of modernism, about representing a body as if speaking before some parliament and about some body that should speak for itself, yet finds itself, instead of representative, just represented.[9] I have tried, elsewhere, to consider the images repeated and even integral in a series of representations of the fragmented body as a piece of the whole body of art.[10] She who would understand that body, in its own figure and embodiment, is obligated to *take it up,* and this taking-it-up is already taking a position, this position taken already implying its own struggle, hoping to find therein its own strength.

The body laid flat to be exposed, the body bedded and eaten by the eyes after the camera or the

brush—this body demands, it would seem, a completely other point of view from the body sighted in the polite nineteenth-century garden picking fruit, or cuddling a child, or simply and politely seated or tabled, as in Mary Cassatt's women taking tea, chatting and consuming, as if the proper response there were to be a tabling and a sipping, a gentle consuming of impressions as opposed to the more violent Surrealist mode.

But the artist's point of view is of necessity manipulating, and not just in Mannerism: all art is derived from the hand, after the eye. By the hand this model is treated and seated, tabled and bedded. Linda Nochlin has shown us convincingly (and graphically) how, since the nineteenth century, the woman's body has been presented for the man's erotic pleasure, rarely the man's body for the woman's.[11] Commenting on the woman's nudity as she has been traditionally exposed before the eyes of all, John Berger contrasts, quoting Kenneth Clark's *The Nude* as his source, nakedness (the state of being unclothed) with nudity (a conventionalized way of seeing), summarizing the argument as "Nakedness reveals itself. Nudity is placed on display." He then points out that the display is always for the male spectator.[12] The woman's exposure is not—and Breton would surely agree—a matter of her own sexuality, but of the sexuality of the observer, whose monopoly of passion is such that bodily hair (assumed to represent sexual power and passion) is not ordinarily placed on *her* objectified body.[13] Alienated from her body and from its probable representation, present and future, the model suffers in fact the destiny that René Char predicted at the end of his own classic Surrealist text of 1930, *Artine:* "The painter has slain his model."[14] Char refers here to an interior model as replacing the exterior one: we who have been the model so often exterior may learn at least to exteriorize our anger over some of the manhandling.

Pleasurable Fictions of Presence

But back to the binary. The idea of a union, so desired, between painter and object of gazing and creation, fictional as it is, and of a specific problematic, may suffice to create a general fable which can so depart from the apparent realm of fiction as to become real. These are fictions indeed, these unions of body and brush or sight, but real fictions, sustaining as they can—and only they—the object of art as the representation of any onlooker's desire. The problem is, of course, the "any." Whose *is* the body of this art, and whose the fiction? Whose is the pleasure, where is it taken, and from whom? And, apart from the commercial *gain* of the management, what is its fruit? Who consumes what, however surreptitiously, and who is consumed, even by a glance?

It is, true enough, just as we are often told, a privilege to be photographed by, to be *captured so well by,* the camera or the brush of a great artist. How could we ever, either as model models or as model onlookers, have thought that any model would refuse to bear or enjoy the fruit of the entrails of mother art itself, at the hands or through the lens of its most celebrated representatives? We have then, it is supposed, to give credit, photographic and artistic, to the great mediators of the image as they pass it on to us; since they are also, in this cycle as I see it, the mediators of us to ourselves, we might want to pause before giving entire credit to the entire story, or to their descriptions as our story.

Narrative always fecundates; more stories are ceaselessly produced for us to live and read them, for them to efface our critical doubt, however dubiously we first begin to participate in bearing and having and seeing. Are we to refuse looking as part of being looked at? The whole issue of looking at ourselves as looked at calls into question how and where we may be thought to possess ourselves, within this fiction of painless consuming of images-as-other. They are not, in this case, entirely other, nor can we pretend to see them as such. We are folded up in and into—implicated—and even tied up in and by our seeing.

Implications: Taking Our Place, and Whose Pleasure?

Are we obliged to be represented by, to participate in such problematic representations as that of a

body offered in a caged display? What of a woman looking at an Other Woman clothed or caged, naked and yet neat and perhaps even integral, or dismembered like a doll of Hans Bellmer, untidily lying somewhere on some stair or floor, or then stretched out and spread out even more awkwardly like Marcel Duchamp's nude half-body with her legs wide apart, hidden and revealed behind his wooden door with its peephole in his construction called, aptly enough, and in the plural because, in fact so much is given, *Etant donnés* . . . or *Given . . . ?* Does the woman looking take the stance of another or of a same, and what pleasure does she take in spying? Is the prey *taken* or the likeness perfectly *caught* in art *given* to her too, only as she can be co-opted into spying?

Only in utopia, some might say, would spying on the other have no place, whichever other we are not the same as. But the pleasures of participating and showing, modeling and making, consuming and enjoying the other—all these would seem to depend on a binary system. Michael Fried's examination of Diderot's attitude in front of Tintoretto's *Susannah and the Elders* is one of the most relevant texts in relation to such spying, for the Tintoretto renderings pose a special problem about a gaze seen as illicit. "The canvas," says Diderot, "encloses all of space, and no one is beyond it. When Susannah exhibits herself bare before my look, opposing to the stares of the old men all the veils in which she is swathed, Susannah is chaste and the painter too; neither one nor the other knew I was there."[15] John Berger points out about the version Tintoretto made of Susannah looking at herself in the mirror that she joins the spectators of herself, whereas in the other rendering, as she looks at us, we are the obvious spectators and she judges us as such, as female nudes usually do.[16] In either case the spectator is committed, along with the old men, to gazing at Susannah.

Is there some way of looking that is not the look of an intruder, some interpretation from which we could exempt ourselves as consumers? Julia Kristeva reminds us how the verbal play of debt, of nearness and presence, is found from the beginning implicated in the notion of interpretation

(*interpretare,* to find oneself indebted toward someone, based on *praesto,* meaning "near at hand"—*praesto esse,* present, *praestare,* to present, like some object, money in particular). But, she says, "the modern interpreter avoids the presentness of subjects to themselves and to things. For in this presentness a strange object appears to speaking subjects, a kind of currency they grant themselves—interpretation—to make certain they are really there. . . . Breaking out of the enclosure of the presentness of meaning, the *new* 'interpreter' no longer interprets; he speaks, he 'associates,' because there is no longer an object to interpret."[17] Here the dimension of desire appears, and interpretation as desire returns the contemplator and participator in Surrealist art back to the very subject: how might we desire to function so as not to be implied in the *incorporation* and *embodiment* of the desire of another, when our body is interrogated, subjected to the act of painting as to the act of love, but without choosing our partner?

There again, difference sets in, between the gaze and the glance, for example, the latter implying less presence to the painting or photograph, the former requiring a lengthy implication in the folds of the scene or portrait. Norman Bryson, in his remarkable study *Vision and Painting: The Logic of Gaze,* examines the distinction between two aspects of vision, the gaze or look he calls vigilant, dominating, and "spiritual," and the glance we could think of as subversive, random, lacking a principle of order.[18] The look, as he explains, implies an act always repeated, an impulse that would want to contain what is about to escape, as in the expression *reprendre sous garde = regard.* This gaze gone hard, this stare, tends toward a certain violence, a will to penetrate, to pierce, to fix in order to discover the permanent under the changing appearances, which implies a certain anxiety in the relation between spectator and object seen. The glance, on the contrary, creates an intermittence in vision, an attack, as in music, which withdraws afterwards into the calm of non-seeing; this would be the plebeian aspect in contrast with the aristocratic nature of the gaze, visible to the gaze of the other.[19]

The gaze fixed into a stare would not permit the other thus transfixed to leave the battlefield or the pleasure-bed, or the canvas. It would hold the other there, at the table of consummation and consuming. In contrast, the glance inflicts its momentary violence, and sometimes on the slant, with no return permitted, leaving to the other a certain freedom. In Surrealist painting and photography, I would submit, the gaze or the stare and the glance seem often to be called for as if simultaneously, summoned and as it were renewed: "Always for the first time," as in the Breton poem of that title. The sustained gaze will then be subject to momentary impulses of the glance as violent assault, under which the model will be obliged to sustain the onlooker's spontaneous desire in a paradoxical permanence.

The Surrealist body represented, taken (in) by the gaze and glance of the spectator, presents no margin of interpretation. By the desire of Breton as critic, all distance is to be suppressed between seeing and the object seen, between the look of desire and the prey, between two objects imagined or seen together.[20] Unless the female—for it is usually *she*—submits actively to such a stare, giving what is in any case taken by the male, she will have no role except enforced submission. The *prise de vue*, that expert taking of the view, that shooting of the model, is a one-way venture, far from the erotics of exchange, open only to a willing relation of dominator and dominated.

Translating Business

What is rendered by Surrealist art is rarely qualifiable as totalization. More frequently than not, only a fragment of the body is exposed to brush or lens, as in Mannerist emblematics: an eye for Magritte, either seen in the crack of a door *(The Eye)* or in sublime solitude, divorced from its other and with clouds floating across it *(The False Mirror)*, or (in *The Portrait*) delicately placed in a slice of ham upon the plate; a breast for Duchamp or Eluard, sometimes ornamenting a book cover slyly enjoining us to *Please Touch;* a series of clasped hands or wide-open eyes for Ernst (to illustrate Eluard's *Répétitions*); a photograph of legs

repeated, or of one glove, for Breton's *Nadja.* This process, by metonymy and synecdoche referring to the whole body by the handling and exhibition of one part, can of course be considered celebratory, as in Breton's famous poem called "Free Union" in which each part of the woman loved is chanted in turn. This would be a traditional translation according to a mode now classic, no more troublesome than the instant interpretation of such famous lines as Ronsard's "A ce bel oeil dire adieu," which we read as saying farewell not just to one gorgeous orb, not even to both, not even just to the face, but to the whole being, in a crescendo which has—by the time we get there— lost all shock value, to become a standard reference point.

But modern views about translation, such as those expressed in the volume *Difference in Translation*,[21] teach us about mis-use as being more creative than standard use, about mis-translation as a possible challenge to a too simply $A = B$ relation by exercise on the pressure points of textuality, in which a relation of surface is also kept, and not just a relation of substance to substance as ordinary useful merchandising.[22] The *business* of translation as textual business too puts a new light on the light put on the Surrealist body and its polyvalent representations. We cannot just refer the fragmentation of the Surrealist body back to Mannerism with a good conscience, but must see it with the *presentness* demanded by modern art and theory. Thus, the female body seen by Hans Bellmer as a lifeless rag doll, rounded and thrown down like some castoff propped up for the picture, may enrage as it enlightens us; the double exposure of one pair of breasts above another in a photograph in the *Minotaure,* one of each pair larger and in profile, the other smaller and pointing the other way, like four eyes unwilling to meet the observer's stare, may send us back to the vertical superpositioning of many pairs of eyes in *Nadja* as well as to the other repetitions of fragments of females, but it will not add up, however we calculate, to wholeness. In each pair there is visible difference, which the repetition only aggravates. Horizontal opposition plays against vertical sameness in an image contrary to all intuition. This is

a perfect image of delay and spacing, as in the analysis done by Krauss, wherein presence is abolished from the photograph.[23]

Parts and the Politics of the Whole

When a fragmented image is said to represent us, as we are supposed to represent woman, we may either refuse such synecdochic enterprises of representation or demand, if not totalization of the model, then at least reintegration, according to terms both private and public. To be sure, being partial prevents our being seen as homogeneous, and thus acts against the exclusion or appropriation of "all of us," all of our mind and body, since we are seen only in part.[24] We learn our politics in various ways, and these displacements and impositions may lead to rebuttal, or then to a demand for differentiation between the brilliant and revelatory, and the simply deforming and defaming. What we see as we are stared at may inform our own returning stare, or our own newfound anger, or help us to see something about ourselves, to accept it, refuse it, or change it.

One of Magritte's images, *Les Liaisons dangereuses* [3], playing on Laclos's novel of the same name, shows a woman down to her ankles, her head bent down in profile. A mirror is located exactly in the middle of her body, with the middle part—that portrayed in the mirror—reversed in the center of the image. It is also reduced and raised, so that the parts—upper, central, and lower—have no way of matching. The deformation can be read as central to the self, for the woman divided is also watching herself—without seeing us see her from behind. The mirror she holds is, as traditionally, the sign of "vanitas," which, as John Berger points out, condemns her and has her connive in "treating herself as first and foremost, a sight."[25] Not a pleasant sight, and conducive rather to self-loathing.

The awkwardness invades every inch of what is presented as vision on the interior of the frame. Never, in this body pictured and centrally interrupted, is the center to be either focused in the right sense or beautiful; never is the flow of vision to be integral; never is grace to visit this figure,

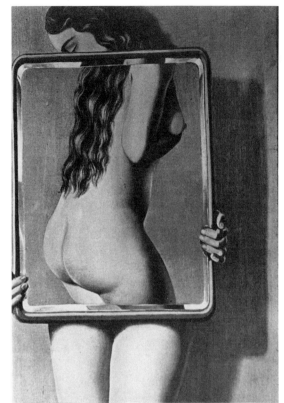

3. René Magritte, *Les Liaisons dangereuses*, 1936.

from which the middle is forever excluded. Beneath her chin runs the hair continued, seen from the back, like the beard of some Slavic god; and more mythical figures are called in to help us read the picture, which is never satisfactory, and from which we are always shut out. Turning away, her posture resembles that of Cranach's Eve, with her back forever framed, her belly lit by a thin lighted line. Her head droops like that of a dead woman, or the bent head of a Madonna. She refuses to meet our eyes, as if desperately seeking the privacy she is supremely denied. This enormously pessimistic picture, with which—strangely, and perhaps because of the echoes—it is hard to empathize, into which we cannot enter, might be read as *Woman reading woman*.

This negative view is forever bound to be that of Magritte's self-regarder as she fails to locate her image in the mirror image, an image as reversible

4. Man Ray, *Retour à la raison*, photograph in *La Révolution surréaliste*, no. 1 (December 1924).

5. Man Ray, photograph, 1920s.

as it is inescapable. Self-loathing is presented as part of female presence. Now to this image such contemporary reflections as those we might make upon the pride and glory of the naked state (from Eve to photographic models) are totally foreign: the picture, as picture, makes no room for pride— only heavy astonishment at there being no frontal state to observe, for either insiders or outsiders. Deprived of natural frontal beauty, seen only askance and from the side, completely under the domination of the male painter, the model simply exhibits the shame of self and the difficulty of self-reading.

Quite to the contrary of such formulations— baldly categorizable as the nude ashamed and self-concealing, the fragmented doll, and so on, images setting up the display of the female, reading herself or as she is read, for the delectation or violent pleasure of male eyes—would be the free exchange of the ideas of possible images, between sexes as between persons and nature, all these translations at once erotic and artistic, the translations of difference which we could freely enjoy under the light of the narrative fecundated by a couple or many. I want to examine in particular a few images of the positive, or then of the double-edged or ambivalent, in photographs by Man Ray and in two paintings by Magritte.

Man Ray's extraordinary image of a female torso called *Retour à la raison,* reprinted in *La Révolution surréaliste* (no. 1, 1924) [4], is a film still from his three-minute film of the same title. Made by the capture of a female body moving behind a striped curtain, this torso appears with stripes of shadow across the bare flesh like those of a tiger, one snaking up the center, all like some elaborate body painting. The torso, leaning slightly backwards, inviting the gaze, is posed against the rectilinear form of a window, so that the curves of animal and human play out their contrast. Nature is brought to the human, and the curved to the straight. The diagonal stripe across the torso echoes the window line, whereas the slightly fuzzy or at least irregular shadow to the right echoes, as if with human hair, the subjective statement of the photograph itself. This is, it seems to me, a positive image, adding to the

beauty of the female form. This imposition is quite unlike the imposition of the penis against a woman's nose in a photomontage by Wilhelm Freddie called *Paralysexappeal,* in which the addition can only insult and enrage a female observer. The Man Ray imposition of the natural on the human can be read only as beautiful; in no way is the body deformed, it is rather augmented by its natural possibilities. Thus do we learn about merging the one with the other, as in the Surrealist game of "l'un dans l'autre," the one in the other, where one object is considered as augmented by the other and each rendered more interesting: their union is not forced but imaginative, and multiple in its possibilities.

In another but frontally posed torso [5], the imprint of the curtain with its meshing pattern over the bareness works a strange and convincing convergence. The bare body behind the grill, or its representation, is nevertheless liberated as it is, precisely, baring its breasts; the baring is all the more emphasized in relation to what appears to be a binding corset, dropped to expose the navel, thus creating a double liberation, above and below. That the face of the woman is seen in only some versions, not in *Retour à la raison* nor in many of the other Man Ray photographs with the bare torso striped or bound, permits the body's presentation as emblematic, and as emblematic of beauty itself, in all its splendid convergence of the bound and the free. The protrusion of the breasts balancing the indentation of the navel is marked as the other, and natural, opposition, whereas the body exposed by the side of the curtain which would be thought to cover and to veil makes the drama of the whole presentation. This, like *Erotique-voilée,* celebrates a complicated ambivalence in paying homage to simple unadorned beauty, celebrates the art of photography in paying homage to nature, and, in encouraging the juxtaposition of the notions of superimposed pattern and evident freedom, celebrates the play of the intellect in relation to the body.

To this union of possibilities, human and artistic, we might compare, for the blend of figure and nature held in exchange, the extraordinary photograph by Brassai [6] which appeared in the Sur-

realist journal *Minotaure* (no. 6, 1934) of part of a naked woman's body from shoulder to buttocks, seen from behind as she lies stretched out with her ridges and furrows and monumental beauty responding to the long body of a mountain's profile, matching curve to curve beyond her, and above it the sky, as if reclining in like pose above the mountain, its bright curves mirroring the light body of the woman against the darker ground, like two female bodies stretched out to hold between them all the earth and its own full and swelling beauty. Surrealism's flexible and often sentimental vision serves to encourage such harmony between natural landscape and the culture of art, holding in poetic embrace contrary elements past their binary opposition, as in Breton's memorable and significant expressions "the air of water" and "the flame of sea." These expressions illustrate the Surrealist basis of convulsive beauty, the reading of one thing into another. The image can in fact be read equally well from the top and from the bottom, in perfect figural harmony.

6. Brassai, photograph in *Minotaure,* no. 6 (December 1934).

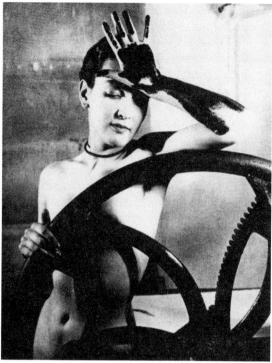

7. Man Ray, *Erotique-voilée,* photograph
in *Minotaure,* no. 5 (May 1934).

Breton's statement, in *Nadja* and elsewhere,
that "beauty will be convulsive or not be" is illus-
trated by Breton's own choice of an image by Man
Ray to accompany his essay on this subject in the
Minotaure. The image [7] is full-page and striking,
called *Erotique-voilée,* thus marked by being at
once open and secret. Méret Oppenheim is pic-
tured leaning on a gigantic and complicated
wheel, nude and facing us, with her left hand and
arm raised, imprinted with grease, while her right
hand presses on the metal. In the upper right-
hand space between the outer rim and the spokes,
chosen elements of her body are as if *caught:* the
hair under her raised arm, appearing just under
the rim, and her right nipple, appearing just over
the spoke. This image is emblematic, I think, of
the double reading of Surrealism's celebrations of
blasons or separate body parts, for the elaborate
divisions of the wheel stress, above all else, the
disjunction of parts.

According to a first and positive reading, all the

pressure here can be seen as light—the eroticism
also, even as it is veiled. The interaction between
machine and woman is entered into with com-
plicity and elegance, as Méret looks down with a
slight smile at the wheel itself, which, although it
could be seen to interrupt her body quite as defi-
nitely as the Magritte mirror interrupts the self-
reflective woman, is also the instrument of her
willing revelation—in parts—and the object of
her admiration. She has no shame about her body
and no fear of the wheel: around her neck is a
simple black circlet, like a visual echo of the wheel
shape, and her lips are closed over her teeth, while
the wheel has toothlike notches on one of its verti-
cal spokes. In a visible yet subtle complementarity,
the wheel reveals what she conceals; it both adds
and subtracts.

In this upbeat reading, the medieval spinning
wheel brings its long tradition to the song of the
body, spinning out the tale of how woman harmo-
nizes with her partner, the object, from ancient to
Modern Times. She is in complete understanding
with her mechanical lover, so that even the orifices
of her body (her navel, her ear) rhyme with the
openings of the wheel; the elements are strength-
ened each by the other, force without forcing.
The woman shot is here celebrated by both wheel
and camera, to both of which she may seem to
give, smiling and thus as if freely, her bare form
to be caressed and pictured, with no intrusion
upon her intimate secret. Art and mechanics wed
the modern female form, which learns to reread
itself as if by a printing press, the wheel replacing
for us the spinning out of our tale. The woman
awakens in her new image against the traditional
rhythm to be hummed or sung, now to be printed
against the background of the past. Here the prim-
itive strength of the domestic meets a more con-
temporary magic of imprinting and metallic repro-
duction: woman in the round, we might read, and
about to be multiplied in so many images.

An opposite reading is equally possible. Here
the wheel allies itself with the grease marked upon
the body as referring to a torture wheel, for Saint
Catherine or any other woman foolish enough,
unfortunate enough, to be caught by it. In this
grim tale the potential violence of convulsive

beauty remains implicit, as does the reflection of the wheel upon her body; the aggression of the metallic form, that deliberately segmenting master, is as divisive—she will be, like us, torn apart—as it is permanently imprinting for the Surrealist design. This reading joins the photograph of what is both openly erotic and openly veiled to the stance of those other Man Ray photographs, where cages are placed over the woman's head (bodyless in the photo) and body, metallic over living. Here the living weds the metallic, only to reinforce the latter.

But the photograph published in *Le Minotaure* is a cropped version, and the longer original says still other things in this second reading [8]. The etching wheel is moved by handles, and the handle of the outer and smoother wheel now appearing makes a definitely phallic protuberance above the intimate region formerly cropped from the photograph. Adding this reading is like adding an appendage, an appurtenance, to the photograph and the female form within it. Already, as we know, in the 1950s and 1960s the printmaking tradition, or the lithographic revival, inspired the rolling of models in printer's ink to inscribe their *real traces* as art. Here, the model, having become a partner of the printmaking process, still suggests her own implication, by the ink upon her arm and hand (she, the artist Méret, after all) which was already visible in the cropped version, and by the smile now seen as even more complicitous even in the act of photography. The two photographs make an odd doubling, for the smile seems somehow to change its focus, as she looks down at her exposure, the handling of it, and the *handle* to it. At this point, and in this rereading, we think back to the Magritte rendering of *Les Liaisons dangereuses,* as the woman closes her eyes to her own exposure in the mirror and behind: these relations in their accent on process involve a still other danger and, I would submit, the viewer is far more involved. Even the act of second reading is a confession of further involvement—for otherwise, why would we feel the need to look again? *In what process are we indeed involved?*

An equally ambivalent reading can be made or *taken* of Magritte's painting called *Représentation*

[9], a painting seen as a mirror, or a mirrored form painted as a painted form, showing quite simply the mirrored form of a woman from her lower stomach to her thighs, with the heavy frame around it shaped to its outline, as if deliberately keeping and holding just that part of the woman, metonymic of the way she is seen, with the mirror object as discreet and appealing as a statue, and not much more lifelike. What represents here, and what is represented? the reader is bound to ask. Is it the self-reflexivity of the form looking at itself as framed, by itself, as a mirror? Does the title indicate that to represent is to mirror, that to frame is to wed outline to form, that to look at ourselves framed up is already to represent ourselves? More than any of Magritte's other works, this one is surely about how the metaphor of representation works, how it makes a whole from what would seem a most partial part, a public

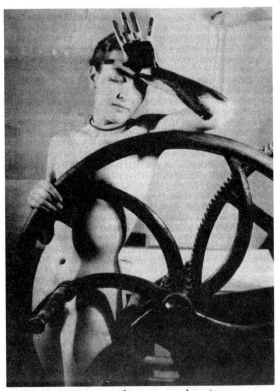

8. Man Ray, *Erotique-voilée,* uncropped version (© *ADAGP, Paris, and DACS, London, 1989*).

9. René Magritte, *Représentation*, in
Alain Robbe-Grillet, *La Belle Captive*.

these genres for an odd reflection on representing. A statue is painted as a statue in a painting about painting: the mixing of genres, of conceptions, adds to our own perception of what representation is, what painting may be, and how complicated a simple form can become. Like the *Représentation* of representation just commented on as emblematic of how we look at looking, this picture is about seeing, enframing, and models in their treatment as parts and as wholes.

Here the frame and the included statue are *tabled* and *set up* for our own illumination, surely, while the raised stumps of the statue seem to summon help and love, or at least our willing perception of the summons. As is proper for a *vanitas*, the shadow of the statue within the box is reflected on the wall, while the front table, tipped up, intersects with the box, until the objects in the painting and their harmonies of dark and light are doubly boxed in and framed, until containing and self-containment seem to reach perfection in their very shadowing. Nothing here is cut off by its intersection; nothing feels lost even as it is severed; nothing feels merely painted or merely caged. The substance is adequate to the meditation, uninterrupted and profoundly lit, poetic as it is erotic, contemplative and profound. This we are given; how we interpret it depends on our relation to meditation and to its partial giving, its partial concealing and its partial lighting.

Ambivalent or monovalent in the reading, stuffed, shot, and shown, in our dismemberment and our displacement, captured and presented to the gaze or the glance, aging into observers of ourselves as object, we can still hope that past the fragments of our exposed individual bodies there may be imagined, in all its deepest integrity, our own representing body. Our interpretation must move past the easily assimilable and its confines as just *Représentation*, to incorporate our delight in the modern as we imagine it and our refusal of dumb mastery.

Giving Credit and Giving the Lie

To what might we choose to give ourselves and our being seen, and, more especially, why, and to

artistic statement about what would seem the most private form. This is *representation* itself, and how we react to its selection out from the rest, to its enframing in its fragmentation, may depend on what credit we give to the representers of representation, as well as on what credit we think they give to us.

The final image I wish to comment on is itself of a complication worthy of mirroring the spoken complications with which I began. ("Talk about complications!") Perhaps the most captivating and most complicated of all the representations of the female body that Magritte is responsible for is *La Lumière des coincidences* [10]. Upon a table stands a frame, in which there is pictured a statue of a female torso, stumps marking the arms and legs, while upon another table nearer to the observer there stands a candle, burning like the famous candle in de La Tour's Repentant Magdalene pictures, with its very substance lit by the flame. The heavy metaphysical light of a *vanitas*, of a memento mori shines here, and the implicit weight of the statue, representing female form in massive beauty, sculpted instead of painted, mixes

what end? The gift, Marcel Mauss reminds us, must circulate, and in its interior country. What interior country has the artist's model, real or painted or shot, that naked lady in the iron cage? In Robert Desnos's great novel *La Liberté ou l'amour!* Louise Lame (the Lady Blade, as it were, Jack the Ripper's rival) is naked under her leopard-skin coat. She has, however, the privilege of laying it down, and takes that privilege, giving it as a leopard would his spots. But the caged lady, not measured here against some beast as in the celebrated story "The Lady or the Tiger?" has little privilege and no choice. To be able to give or to give oneself, one must know oneself to be free. To be given in free exchange, to be willingly kept in ocular circulation, to serve as object for readerly and visual reception, not to hold out on the viewer, is already surely an act of generosity, if not forced. We have to be able to refuse it; and the portrayal of the bare self as caged even if smiling, even if the cage is chosen as a fashion, should make us grit our teeth, and, more properly, arm our wits and tongues.

Lewis Hyde's recent book entitled *The Gift: Imagination and the Erotic Life of Property,* which takes its point of departure from Mauss in order to apply his theories on the gift to poetry as a human (and therefore giving) relationship, rede-

10. René Magritte, *La Lumière des coincidences, Minotaure,* no. 8 (June 1936).

fines the word *erotic* under this angle. To the theories of Mauss, Hyde adds emotion in the place of economics: what cannot be given does not exist as a gift, including the gift of talent, or a body and spirit of lyricism. A gift, he says, is anarchist property, "because both anarchism and gift exchange share the assumption that it is not when a part of the self is inhibited and restrained, but when a part of the self is given away, that community appears."[26] The fragmented self—even a part of us—thus given away uninhibitedly, after Mannerism into Surrealism, and to all observers equally, may redeem—should we acquiesce in it—the sort of communal vision that a more classic holistic tradition was not able to save. Rather than yielding our minds up with our modeled and remodeled bodies, we must give our readings of our representations, and our opinions as to which deserve anger and which, celebration. We must, in short, read freely and choose how we are to read our representing. Good and true reading is a gift, one we must hope to develop, and one on whose exchange we must work.

This indeed is what giving is about. "A gift that cannot be given away is not a gift. . . . *The gift must always move.*"[27] To *contribute,* says Hyde, "one's ideas to a journal, or a colloquium, or a book and thus to *share* them, is the mark of a gift which has learned to circulate."[28] We are creating, then, a network of giving by this circulation, giving a part of ourselves to the community of readers. The more a gift is shared, the more it is sacred; what is given leaves a free place, so that energy accrues in the procedure of free circulation.

In the major images I am presenting or *giving* of ourselves as *taken,* painted, and shot, our individual and collective interpretations must move past the paralysis that might set in from too prolonged and too accepting a stare at those fragments of our exposed bodies. We must at least glance beyond the "imposing" *Paralysexappeal* of Wilhelm Freddie as well as the conforming and constraining frame for our confinement that Magritte presents as *Représentation* itself; beyond the mechanics of our delight in our own modernness, as in Man Ray's picture of Méret Oppen-

heim and the printing press, a contemporary celebration of the textual in which the nude is seen in (sadomasochistic) textual and visual collusion, replacing both the torture wheel and the only seemingly innocuous spinning wheel of an earlier age.

Collective Integrity

In networks and interpretive communities, to use Stanley Fish's term,[29] in their embodiments of our imaginations, our desires, and our truths, we would find an integration of ourselves, not just represented by representing. Refusing totalization as a *masterly* concept and preferring integration in its place, we are already making a strong statement about how we can deal with fragments and how we do not have to deal with tyranny and its currency of forced consumption. Giving credit where credit can be read as deserved, if it is not always necessarily and truly due, our free reading of images positive or even ambivalent makes its generosity out of sharing what it feels and sees.

This reconstruction of us all—of these bodies dismembered, violated, and undone on the one hand, of these bodies harmonious and celebrated and supplemented by nature, art, and even the machine on the other—cannot take place until the very speaking core of our interpretive community takes its truest pleasure and deepest joy in the exchange of our ideas taken up and understood together, in our essential difference and in our common comprehension, in our joint understanding and speech and work—in short, in our equivalent of the philosophical *conversation*.[30] We would put our ideas in common for a free exchange of views, the ideas of all those "whose Ideas are Eaten in Conferences."[31] Our will to discussion as to art, not just as passive models and dolls gone to pieces, but as inducers of the circulation of ideas as of talent, turns us from consumer and consumed to creator and life-giver, after all that labor. "In a modern, capitalist nation," Hyde concludes his chapter called "A Female Property," "to labor with gifts (and to treat them as gifts, rather than exploit them) remains a mark of the female gender."[32] Our true labor may be working out the greatest possible realization of some conversation about sharing and female networking, developing it toward a collective wholeness that our final gift to each other may represent.

From our free reading of the renderings we encounter, from our discussions there may develop—in time as in our texts and those we contemplate—the collective integrity we would most want, as a body, to work toward: *beyond* the traditional candle and mirroring frame, as a reminder of our deaths and of the life of our art, in their marvelous coincidence and their unequaled flame. Modern, like the wheel, striking, like the straight-on stomach shot, old-timey, like the candle, representation—with its complications mirroring and complicating our own—is our recurring concern. Our willingness to share in it and discussions that include our part in it, partial but shared, prove our strength abiding and most whole.

NOTES

1. See *La Révolution surréaliste*, no. 11 (1928).
2. As for the painter or the photographer, he can keep himself at a certain distance from his creation or then enter it: he manipulates, that is, his stance. Michael Fried, in examining the ways in which Courbet represented himself in a painting by a woman's gesture which would seem to repeat the very gesture of painting, absorbing himself corporally within it, undoing his pose as a simple observer before the painting conceived as a spectacle, describes Courbet as putting into question "the ontological impermeability of the bottom framing-edge—its capacity to contain the representation, to keep it in its place, to establish it at a fixed distance from both picture surface and beholder"—Michael Fried, "Representing Representation: On the Central Group in Courbet's *Studio*," in Stephen Greenblatt (ed.), *Allegory and Representation* (Baltimore: Johns Hopkins University Press, 1980), pp. 100–101. Some of the techniques Courbet uses to reduce

his own separation to undercut the territory of the one who would be looking from the outside, to abolish any possibility of an objective or impersonal point of view—these techniques are not neutral or neutered, but often serve, in *Les Baigneurs (The Bathers),* for example, through the use of a feminine body and a female gesture, to affirm the corporality of the link between the painting and the one who looks at it as the object of desire and union, corporality affirmed as natural and also cultural, as if nature were to take pleasure in her representation in art.

3. Xavière Gauthier, *Surréalisme et sexualité* (Paris: Gallimard, 1971).

4. Rosalind E. Krauss, *The Originality of the Avant-Garde and Other Modernist Myths* (Cambridge, Mass.: MIT Press, 1985), p. 106.

5. Ibid., p. 109.

6. Ibid., p. 112.

7. Ibid., p. 88.

8. Annie Le Brun, *A Distance* (Paris: Jean-Jacques Pauvert, aux Editions Carrière, 1985), pp. 183, 185.

9. See Mary Ann Caws, *The Art of Interference: Stressed Readings in Visual and Verbal Texts* (Princeton, N.J.: Princeton University Press, 1990), chapter 3.

10. Ibid., chapter 5.

11. Linda Nochlin, "Eroticism and Female Imagery in Nineteenth-Century Art," in Nochlin (ed.), *Woman as Sex Object: Studies in Erotic Art, 1730–1970* (New York: Newsweek, 1973).

12. John Berger, *Ways of Seeing* (Harmondsworth, England: Penguin, 1972), p. 54.

13. Ibid., p. 55.

14. René Char, "Artine" (1930), *Selected Poems,* ed. and trans. Mary Ann Caws and Jonathan Griffin (Princeton, N.J.: Princeton University Press, 1976), p. 13.

15. Michael Fried, *Absorption and Theatricality: Painting and Beholder in the Age of Diderot* (Berkeley: University of California Press, 1980), p. 96.

16. Berger, *Ways of Seeing,* p. 47.

17. Julia Kristeva, "Politics and the Polis," in W. J. T. Mitchell (ed.), *The Politics of Interpretation* (Chicago: University of Chicago Press, 1983), p. 80.

18. Norman Bryson, *Vision and Painting: The Logic of the Gaze* (New Haven, Conn.: Yale University Press, 1983), p. 93.

19. Ibid., p. 99.

20. André Breton, *Le Surréalisme et la peinture* (Paris: Gallimard, 1928), pp. 199–200.

21. Joseph Graham (ed.), *Difference in Translation* (Ithaca, N.Y.: Cornell University Press, 1985), pp. 142–48).

22. See in particular the essay by Philip Lewis on "misusing" ("The Measure of Translation Effects"), in Graham (ed.), *Difference in Translation,* pp. 31–62. Barbara Johnson uses the term "pressure points" for the moments when an ambivalence in sense is sensed as necessary ("Taking Fidelity Philosophically," ibid., pp. 142–48).

23. Krauss, *The Originality of the Avant-Garde,* p. 109.

24. Gayatri Chakravorty Spivak, writing on the "politics of interpretation," points out the hidden marks of ideology at work, such as "excluding or appropriating a homogeneous woman," and points out the totalizing appropriations of the "masculist" critic in relation to feminist criticism and to Third World criticism. But, it is clear, "Male critics in search of a cause find in feminist criticism their best hope. . . . Feminism in its academic inceptions is accessible and subject to correction by authoritative men; whereas for the bourgeois intellectual to look to join other politico-economic struggles is to toe the line between hubris and bathos"—"The Politics of Interpretation," in Mitchell, *The Politics of Interpretation.*

25. Berger, *Ways of Seeing,* p. 51.

26. Lewis Hyde, *The Gift: Imagination and the Erotic Life of Property* (New York: Vintage Books, 1979), p. 92.

27. Ibid., pp. xiv, 4.

28. Ibid., p. 77.

29. Stanley Fish, *Is There a Text in This Class? A Theory of Interpretive Communities* (Baltimore: Johns Hopkins University Press, 1983).

30. Richard Rorty, *Philosophy and the Mirror of Nature* (Princeton, N.J.: Princeton University Press, 1980), p. 318.

31. Hyde, *The Gift,* p. 79.

32. Ibid., p. 108.

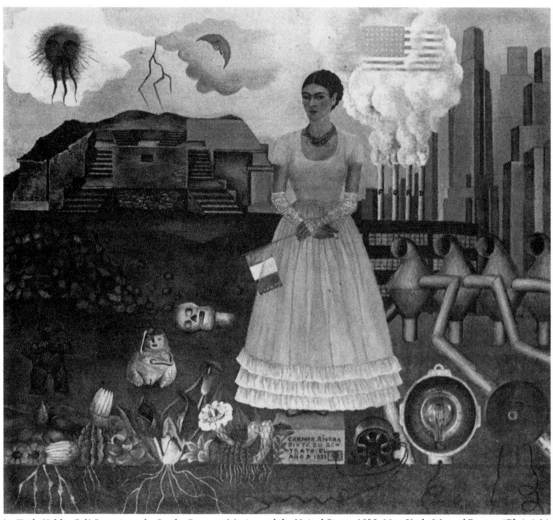

1. Frida Kahlo, *Self-Portrait on the Border Between Mexico and the United States,* 1932. New York, Manuel Reyero *(Christie's).*

CULTURE, POLITICS, AND IDENTITY IN THE PAINTINGS OF FRIDA KAHLO

JANICE HELLAND

Frida Kahlo used the often traumatic and harrowing iconography of her Mexican heritage to paint herself and the pain which had become an integral part of her life after, at age eighteen, a streetcar accident left her crippled. From then on she underwent a series of operations and, because of her severely injured pelvis, a number of miscarriages and abortions. Her physical disability never inhibited Kahlo's flair for theatrics, and this, combined with a tempestuous relationship with her philandering husband, the mural painter Diego Rivera, established her as a tragically romantic and exotic figure. As a result, Kahlo's works have been exhaustively psychoanalyzed and thereby whitewashed of their bloody, brutal, and overtly political content. Kahlo's personal pain should not eclipse her commitment to Mexico and the Mexican people. As she sought her own roots, she also voiced concern for her country as it struggled for an independent cultural identity. Her life and even her death were political.

Kahlo died eleven days after participating in a

Published as "Aztec Imagery in Frida Kahlo's Paintings," *Woman's Art Journal* 11 (Fall 1990/Winter 1991): 8–13. Copyright © by Janice Helland. Revised by the author for this edition. Reprinted by permission of the author and *Woman's Art Journal.*

public protest opposed to American intervention in Guatemala. On 14 July 1954, her body lay in state in the magnificent foyer of the Palace of Fine Arts in Mexico City. Much to the chagrin of Mexican officials, her coffin was draped with a large flag bearing the Soviet hammer and sickle superimposed upon a star. With her love of the unconventional and her talent for black humor, Kahlo, in all likelihood, would have enjoyed the uproar caused by this spectacle.[1]

Kahlo, like many other educated young people during the tumultuous era between the world wars, joined the Communist Party in the 1920s. In the early part of the century, the intellectual atmosphere in Mexico was charged with cosmopolitan European ideologies, most prominently Marxism tempered with Mexican nationalism. Renewed interest in Mexico's culture and history began in the nineteenth century, and in the early twentieth century, Mexican *indígenista* tendencies ranged from a violently anti-Spanish idealization of Aztec Mexico to a more rational interest in the "Indian question" as the key to a truly Mexican culture.[2]

Mexican nationalism, with its anti-Spanish anti-imperialism, identified the Aztecs as the last independent rulers of an indigenous political unit.

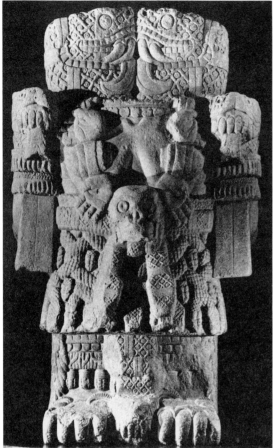

2. *Coatlicue,* late fifteenth century. Mexico City, Museo Nacional de Antropología *(Ignacio Bernal).*

However, by the early twentieth century, the United States had replaced Spain as the intrusive foreign power. The threat became particularly evident to the Mexican left when the United States interfered in internal political struggles between capital and labor. The most romantic of the anti-imperialists continued to idealize the self-control and governing power of the Aztecs, who, according to some prominent late nineteenth-century intellectuals, could trace their roots to an early civilization based upon a combination of communism and labor leading to fraternity and virtue.[3] Allegedly, from this early simplified society grew the complex structure of Aztec society.

Alfredo Chavero, a nineteenth-century Mexi-

can intellectual and a leading supporter of Aztec eminence, was one of the first to describe as beautiful the awesome, fearful goddess figure *Coatlicue* [2], now on view in the Museo Nacional de Antropologia in Mexico City. This serpent-skirted goddess, adorned with a necklace of skulls that rests upon her breasts and enhances her severed neck, is a favored motif in Kahlo's work. Although she seldom represents the deity in her complete sculpted form, she nevertheless repeatedly refers to the severed neck and skull necklace. In addition to Coatlicue imagery, Kahlo also uses images of the heart and the skeleton in her paintings. All three are important symbols in Aztec art as well as in Kahlo's *Mexicanidad.*

In Kahlo's particular form of *Mexicanidad,* a romantic nationalism that focused upon traditional art and artifacts uniting all *indígenistas* regardless of their political stances, she revered Aztec traditions above and beyond those of other pre-Spanish native cultures. She expressed her deeply felt nationalism by favoring in art the representation of the powerful and authoritarian pre-Columbian society that had united a large area of the Middle Americas through force and conquest. This emphasis upon the Aztecs, rather than the Mayan, Toltec, or other indigenous cultures, corresponds to Kahlo's demand for a unified, nationalistic, and independent Mexico. Unlike her husband, she disapproved of Trotsky's internationalism. She was drawn, rather, to Stalin's nationalism, which she probably interpreted as a unifying force within his own country. Her anti-imperialism had a distinctly anti-U.S. focus.

Her repeated use of often bloody Aztec imagery is an intrinsic part of her social and political beliefs and derives much of its power from the depth of her convictions. Thus, the skeletons, hearts, and Coatlicue, images relating to the emanation of light from darkness and life from death, speak not only to Kahlo's personal struggle for health and life but to a nation's struggle. It is this intense interest in her homeland that is behind her transformation into a mythological or cult figure by the Mexican people.[4]

For a time, Frida Kahlo was also the "darling" of New York and Paris art circles. She was courted

by the "pope of Surrealism," André Breton, who in 1938 described her as a "ribbon around a bomb" in his glowing brochure for her exhibition in New York at the Julien Levy Gallery.[5] However, Kahlo never saw herself as a Surrealist and became thoroughly disillusioned with the movement and with Breton after a trip to Paris early in 1939. By the mid-1940s, Kahlo was rarely mentioned north of the border or in Europe, although her popularity and influence remained undiminished in Mexico.

Only since the late 1970s, with the increased interest in women artists and feminist scholarship, has Kahlo re-emerged as an international figure. Because of her large number of self-portraits, many of which reveal her physical and psychic pains, her art is often subjected to psychological analysis. Harris and Nochlin write that "she turned to herself and her own peculiarly feminine obsessions and dilemmas for subject matter."[6] Herrera believes that "Kahlo has become something of a heroine to U.S. feminists who admire the devastating frankness with which she recorded specifically female experiences—birth, miscarriage, unhappiness in love."[7]

Certainly, as the French theorists Hélène Cixous and Luce Irigaray have suggested, women must "speak" and "write" their own experiences,[8] but the speaking must also be related to the context. Kahlo's "speaking" herself encompasses her political self and her love for her country. For example, in *Self-Portrait on the Border Between Mexico and the United States,* 1932 [1], Kahlo stands on the border between the highly industrialized, robotlike United States and agricultural, pre-industrial Mexico. In this painting, as in other works of hers, she evokes past cultures while, at the same time, she comments on modernity; although she sometimes suggests modernization for Mexico, this is never at the expense of cultural identity. The sculpture on the Mexican side of the picture is typically pre-Columbian. In fact, the standing piece at the lower left is like many of the pre-classic sculptures found near Monte Alban in central Mexico (dating from ca. 500 B.C.). The squatting figure to the right is a pastiche of the crouching figures found in Aztec sculpture or of

the kneeling death goddesses who wear skulls or hand trophy necklaces, and the temple in the upper left resembles the main temple area at Tenochtitlan.[9] The temple, the blood-drenched sun, and the moon, all suggesting the Aztec practice of ritual sacrifice, are deliberately rendered in a "primitive" or "naive folkloric style"[10] similar to that found on *retablos,* the traditional Mexican paintings of miracles collected by Kahlo. The pre-Columbian side of the painting, with its rich, lush border of vegetation deeply rooted in the earth, dramatically contrasts with the industrialized United States, represented by skyscrapers, technology, and pollution. The Mexican skull, probably relating to the skulls that often lined the stone walls of Aztec temples, is a life-sprouting-from-death metaphor that appropriately complements the vegetation. The picture effectively contrasts Kahlo's Mexico with Western industrial civilization. Kahlo herself stands in the middle, holding the Mexican flag and wearing a Coatlicue-like necklace with bones. For her, life and death were as intimately related to the earth and the cosmos as they were to her pre-Columbian ancestors. The artist's temple, meant for sacrifice, and the sun dripping with sacrificial blood are included without comment or apology: a concrete visual example of Kahlo's idealization of the Aztec past.

In another painting from her United States sojourn, *My Dress Hangs There,* 1933 [3], Kahlo scourges the United States with representations of the accoutrements of a bourgeois life-style (a toilet, a telephone, and a sports trophy) and indicts its hypocrisy by wrapping a dollar sign around the cross of a church. Her appropriated photographs of Depression-era unemployment, which constitute the lower part of the picture, juxtapose "reality" with the "made-up" painting and thereby highlight the vulgar display of American wealth and well-being as opposed to the poverty and suffering of the lower classes. In the midst of this Kahlo places a pristine image: the Tehuana dress. This traditional costume of Zapotec women from the Isthmus of Tehuantepec is one of the few recurring indigenous representations in Kahlo's work that is not Aztec. Because Zapotec women represent an ideal of freedom and economic inde-

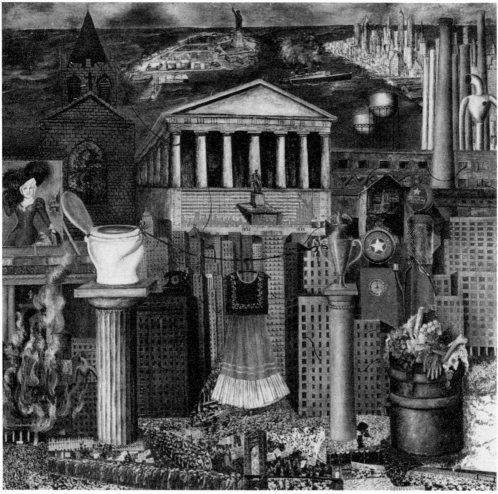

3. Frida Kahlo, *My Dress Hangs There*, 1933. San Francisco, Dr. Leo Eloesser Estate *(Courtesy of the Herbert Hoover Gallery).*

pendence, their dress probably appealed to Kahlo.[11] However, the reference to freedom and liberty is combined with Aztec imagery in at least three of Kahlo's works, thereby uniting the two sources into one statement of cultural nationalism, dominated by the Aztec. This use of the Tehuana dress with Aztec symbols occurs in *Remembrance of an Open Wound* (1938), *The Two Fridas* (1939), and *The Love Embrace of the Universe, the Earth (Mexico), Diego, Me, and Señor Xolotl* (1949).

In *The Love Embrace of the Universe* [4], Tehuana-robed Kahlo holds an infantlike Rivera

on her lap and, in turn, both are encompassed by a large, protective earth goddess sprouting Mexican cacti from her earth-body. The small dog, Señor Xolotl, is Kahlo's pet. However, the representation of a dog with this name in a picture so obviously about life and death (the large goddess is wounded but also sprouts new life from her body) must be considered a play both upon the name and the animal. Señor Xolotl could represent the dog of the Aztec underworld; he could be named after Xolotl, the historic Chichimec chieftain who is considered the progenitor of the Aztecs; or he could be the *nahual,* or alter-ego, of one

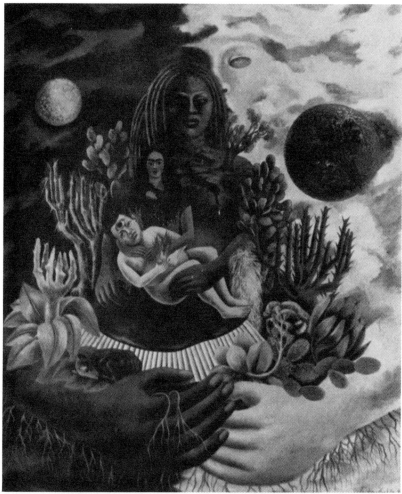

4. Frida Kahlo, *The Love Embrace of the Universe, the Earth (Mexico), Diego, Me, and Señor Xolotl*, 1949. Collection of Mr. and Mrs. Eugenio Riquelme *(from Hayden Herrera*, Frida, *1983).*

of the great gods in Aztec mythology, Quetzal-coatl. If Xolotl were the *nahual*, then he would also represent Venus, the evening star, twin to Quetzalcoatl, the morning star. Perhaps even more appropriate, considering the duality common to Aztec thought, the dog might represent both the warrior Xolotl and the alter-ego of Quetzalcoatl, also named Xolotl.[12] Xolotl the hero may be conquering or protective: Kahlo holds the over-sized infantlike Rivera in her arms. Xolotl the *nahual* may be Venus, the goddess of love in Western tradition: the painting is called *The Love Embrace of the Universe.* Or, because of the earth

goddess's wounded chest and Kahlo's slashed neck, the "love embrace" could mean death. The heart is alluded to by the drops of blood on the breasts of both the goddess and the Tehuana-clad Kahlo. Aztecs often represented the "heart," which they perceived as the life center of a human being, as drops of (or spurting) blood.[13]

The Aztec heart, according to Laurette Sé-journé, "is the place of union where the luminous consciousness is made."[14] She connects the painful spiritual search into one's own "heart" (or psyche) with the iconography of the wounded or bleeding heart in Aztec imagery. This wounded

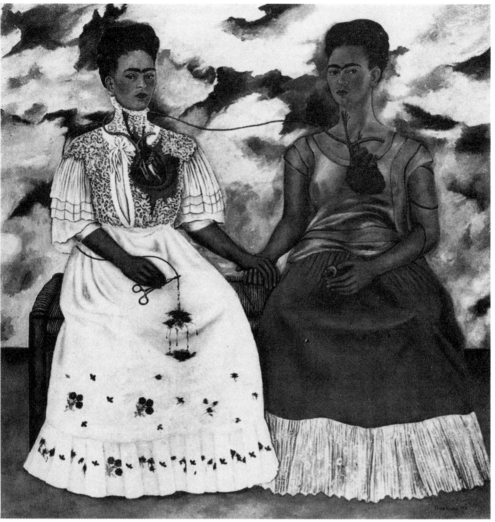

5. Frida Kahlo, *The Two Fridas*, 1939. Mexico City, Museo de Arte Moderno
(from Frida Kahlo and Tina Modotti, *London, Whitechapel Art Gallery, 1982).*

heart with drops of blood, which recurs so frequently in Aztec art, is shown most dramatically in Kahlo's picture *The Two Fridas* [5]. One Frida wears a Tehuana dress and the other a white lace European-style dress. The two women are united by hands and hearts. Like a cord, an artery reaches from one heart to the other, closely joining the two cultures. The "luminous consciousness" emanates from and unites both figures. Although Kahlo's frequent and explicit use of the heart may also relate to her emotional and physical suffering,

the indigenous cultural sources of this symbol cannot be overlooked.

Kahlo wears the Tehuana dress again in *Remembrance of an Open Wound* [6]. Here the artist lifts her skirt to display an open wound on her leg, the result of one of her numerous operations, but there is also symbolic reference to Aztec culture. Lying on her thigh near the wound are spiky plants, which probably refer to the use of thorns for self-mutilation, perpetrated by Aztec priests.[15] Moreover, she has entwined her head

and the upper part of her body with growing roots, once again making the tie between life and death. She playfully told friends that the right hand beneath her skirt near her genitals indicates that she is masturbating.[16] Esther Pasztory in *Aztec Art* explains: "The two basic metaphors for transformation in ancient Mesoamerica were sexuality and death, because both were seen to result in the creation of life."[17] Nowhere in Kahlo's oeuvre is this attitude more strongly expressed than in *Remembrance of an Open Wound,* and nowhere else can such a strong statement be found for her personal identification with her cultural traditions. Within her own body, she explores all the death-life traditions of her past. And although she wears a Zapotec dress in all three paintings mentioned above, it is the brutal, powerful force of the

Aztec imagery that attracts and repels the viewer and creates strong, compelling works.

The intimate relationship between life and death is most obvious in *Luther Burbank,* 1931 [7]. Here the skeleton lies embedded in the earth; roots grow from the skeleton and become a tree, which, in turn, becomes the horticulturist Luther Burbank. From the roots of death, as represented by the skeleton, springs the life-affirming tree.[18] In *The Dream,* 1940, the skeleton rests atop the canopy of a bed that holds a reclining Kahlo entwined by a living plant. The skeleton sleeps above her and, as Herrera suggests, may represent her own dream of death.[19] However, it may also speak of life; the plant grows around Kahlo's sleeping body in much the same way that it twines around Luther Burbank. In another painting, *Roots,*

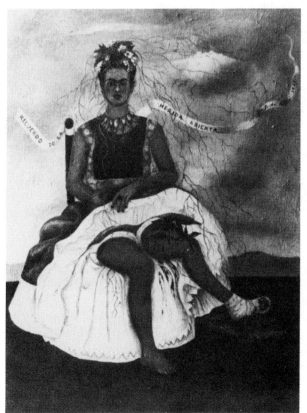

6. Frida Kahlo, *Remembrance of an Open Wound,* 1938, destroyed. Mexico City, photograph owned by Raquel Tibol *(from Hayden Herrera,* Frida, *1983).*

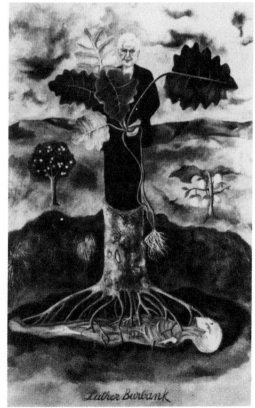

7. Frida Kahlo, *Luther Burbank,* 1931. Mexico City, Collection of Dolores Olmedo *(from Hayden Herrera,* Frida, *1983).*

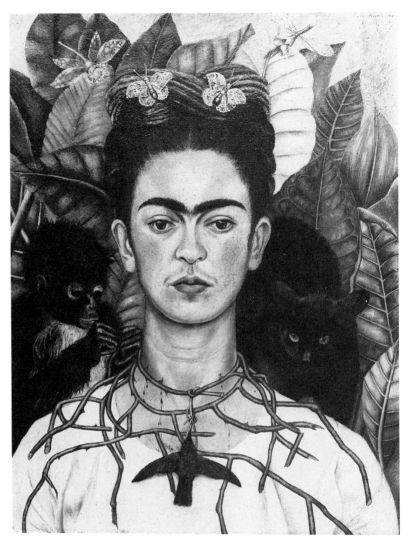

8. Frida Kahlo, *Self-Portrait with Thorn Necklace and Hummingbird*, 1940. University of Texas at Austin *(Harry Ransom Humanities Research Center)*.

1943, Kahlo replaces the supine skeleton sprouting Luther Burbank as tree with her own body, from which grows a lush, rich green foliage veined with red blood. The skeleton is not death; it speaks of life.[20]

Kahlo's representation of the skeletal figure and death can be understood only in relation to their iconography in Aztec work. The Coatlicue sculpture provides a clue to understanding their use in Kahlo's painting. Pasztory writes that Coatlicue "embodies the duality of Mexican consciousness. . . . At the very centre of the figure is a contrast

of quintessential opposites: breasts seen behind a skull, the two images of life and death."[21] Although Kahlo seldom included an actual representation of Coatlicue in her work,[22] the enigmatic goddess recurs in symbolic form in a number of Kahlo's self-portraits. For example, in *Self-Portrait with Thorn Necklace and Hummingbird*, 1940 [8], Kahlo's thorn necklace draws blood from her neck. Aztec priests performed self-mutilation with agave thorns and stingray spines, and Coatlicue's neck also bleeds. The dead hummingbird is sacred to the chief god of Tenochtitlan, Huitzilopichtli,

the god of the sun and of war. It also represents the soul or spirit of the warrior who died in battle or the sacrificial stone. In her *Self-Portrait Dedicated to Dr. Eloesser*, 1940, Kahlo covers her head with flowers, and a necklace of thorns again draws blood from her neck. She also wears a small hand as an earring. Both Coatlicue and the kneeling death goddess sculptures so common in Aztec art wear hands as trophies around their necks The drawing *Self-Portrait Dedicated to Marte R. Gomez*, 1946, shows her wearing a hand earring and, although her neck is not pierced, it is covered with an intricately webbed necklace that zigzags tightly around her neck. The top of the necklace looks precisely like the zigzag lines in Aztec sculpture (these can be seen on Coatlicue's neck) that represent the fatty layer of subcutaneous tissue that would be exposed if the head or a limb were severed.

The psychological reductionism that equates the bloody, brutal imagery in Kahlo's work with a desire to "paint away" her accident, suffering, and pain does little justice to her work. It reduces an important group of paintings done by a deeply intellectual and socially committed artist to simply a visual cry of personal angst. But this was not Kahlo's intention. Since she grew up after the Mexican revolution and reached maturity when indigenity and *Mexicanidad* were strong forces in her country, we should expect to find direct references to romantic nationalism in her work. And since she was a political person, we should expect to find her politics reflected in her art.

Because Rivera supported the internationalist Trotsky, Kahlo agreed to befriend the exile and his entourage, but she never renounced Stalin.[23] In fact, she died with an unfinished portrait of Stalin on her easel. Framed above her bed were pictures of Marx, Engels, Lenin, Stalin, and Mao. In Russian parlance, perhaps *partinost* would not have appealed to her, but *narodnost* would have been preferable to bourgeois cosmopolitanism.[24]

The intense interest in her homeland and her use of indigenous Aztec art for themes and symbols make Kahlo's art at once political and cultural. She painted herself, she painted Mexico, and, as is common among many realists, she painted in such a way as to be understood by the people. Kahlo knew what she wanted her art to be:

Some critics have tried to classify me as a Surrealist; but I do not consider myself a Surrealist. . . . I detest Surrealism. To me it seems a manifestation of bourgeois art. A deviation from the true art that the people hope for from the artist. . . . I wish to be worthy, with my paintings, of the people to whom I belong and to the ideas which strengthen me.[25]

It is probably unfair, even speculatively, to associate Kahlo with the political authoritarianism and artistic didacticism of Stalinism. Far removed from the realities of Socialist Realism, for her, as for many radical Mexican nationalists, Stalin represented anti-capitalism and anti-Americanism, as well as planned economic development in a national setting. Stalin's attraction lay in the positive aspects of a national push for growth and development, supposedly under the auspices of Marxism. Certainly, the dark side of her Aztec symbols and her individualistic imagery would have offended any Stalinist cultural commissar. The idea of developing socialism within one country may have had a romantic appeal similar to that found in the unified realm of the Aztecs. Of course, Kahlo was not painting for a de facto socialist government but from her own consciousness. She was a political radical and a passionate nationalist, whose art was inspired as much by her public beliefs as by her personal suffering. In a feminist art history Kahlo's pictures are interventions that disrupt the dominant discourse *if* we allow her to "speak" herself and refrain from imposing on her work our own Western middle-class values and psychology. She should be seen not as a Surrealist, nor as a member of any other Western modernist movement, nor exclusively as a painter of the female experience, but as a committed Third World cultural nationalist.

NOTES

A brief version of this paper was presented at the Universities Art Association of Canada in Ottawa, November 1985. In addition to faculty members in the Department of History of Art at the University of Victoria, Victoria, who generously offered their time and assistance during the preparation of this paper, I thank S. L. Cline, University of California, Santa Barbara; Ralph Croizier, University of Victoria; and Reesa Greenberg, Concordia University, Montreal, for their critical comments and suggestions.

1. Hayden Herrera provides a vivid description of Kahlo's death and funeral in *Frida: A Biography of Frida Kahlo* (New York: Harper & Row, 1983), pp. 429–40. Bertrand Wolfe, in *The Fabulous Life of Diego Rivera* (New York: Stein and Day, 1963), pp. 402–4, points out that it was in Coyoacan, Kahlo's birth and death place, that the first Aztec ruler, Cuauhtmeoc, was tortured by the Spanish. An altogether appropriate place, from Kahlo's point of view, to die. Wolfe, a friend of both Kahlo and Rivera, claims that Kahlo would have "laughed at the spectacle of her funeral."

2. For further discussion of these ideas, see Benjamin Keen, *The Aztec in Western Thought* (New Brunswick, N.J.: Rutgers University, 1971), pp. 463–508. See Jean Franco, *The Modern Culture of Latin America: Society and the Artist* (Harmondsworth, England: Penguin, 1970), for an analysis of Mexican culture and intellectual history.

3. See Keen, *The Aztec*, pp. 424–32, for a synopsis of Alfredo Chavero, *Historia antigua y de la conquista* (Mexico, 1886). Keen provides a translation of Chavero's comments about Coatlicue, pp. 509–510.

4. Emmanuel Pernoud, "Une Autobiographie mystique: la peinture de Frida Kahlo," *Gazette des beaux-arts* 6 (1983): 43–48, discusses Kahlo's "cultification." He also draws enlightening parallels between Kahlo's self-portraits, 1940–50, and the *Soeurs Couronées*, portraits of Roman Catholic nuns common in Mexico during the eighteenth and nineteenth centuries. Most work on Kahlo, including Raquel Tibol's *Frida Kahlo: Cronica, Testimonies y Aproximaciones* (Mexico City: Ediciones de Cultura Popular, 1977), suggests relationships between Kahlo's imagery and Mexican Catholic imagery. Although these symbols are important in Kahlo's work (she said that Catholic imagery in her work was "part of a memory image, not for symbolic reasons," Herrera, *Frida*, p. 157), it is not my intention to explore them here.

5. See André Breton, "Frida Kahlo de Rivera," reprinted in Breton's *Surrealism and Painting* (London: Macdonald, 1972). For a discussion of "natural affinity"

between Surrealism and pre-Columbian imagery, see Nancy Breslow, "Frida Kahlo: A Cry of Pain and Joy," *Americas,* March 1980, pp. 36–37. Breslow is one of the few Kahlo scholars who writes on her indigenity.

6. Ann Sutherland Harris and Linda Nochlin, *Women Artists; 1550–1950* (New York: Knopf, 1976), p. 59.

7. Herrera, *Frida Kahlo* (Chicago: Museum of Contemporary Art, 1978), p. 4. For a more theoretical (and political) discussion of Kahlo's work, see Laura Mulvey and Peter Wollen in *Frida Kahlo and Tina Modotti* (London: Whitechapel Art Gallery, 1982). See also Terry Smith, "From the Margins: Modernity and the Case of Frida Kahlo," in *Block* 8 (1983): 11–23; and Oriana Baddeley, " 'Her Dress Hangs Here': De-Frocking the Kahlo Cult," *Oxford Art Journal* 14, no. 1 (1991): 10–17. For a brief look at Kahlo's work in its Mexican context see Dawn Ades, *Art in Latin America: The Modern Era, 1820–1980* (London: Yale University Press, 1989).

8. See Hélène Cixous, "Castration or Decapitation?" *Signs,* Autumn 1981, pp. 41–55, and "The Laugh of the Medusa," *Signs,* Summer 1976, pp. 875–93; Luce Irigaray, *This Sex Which Is Not One* (Ithaca, N.Y.: Cornell University Press, 1985).

9. The drawing is like those found in Fray Bernadino de Sahugun's sixteenth-century codices or the drawing of Montezuma's palace in the *Codex Mendosa* (ca. 1541–42, Bodleian Library, Oxford). Illustrations originally done for Fray Bernadino de Sahugun in his sixteenth-century compilation of Mexican history and mythology, *Codex Florentino,* are frequently reproduced in books about Mexican history, where Kahlo could have seen them. Similarly, she would have had access to excerpts from the works of Fray Diego de Duran, another sixteenth-century commentator on New Spain.

10. "Primitivism" or a "naive folkloric" style in Kahlo's paintings has been discussed by Herrera and by Michael Newman. In "Native Roots: Frida Kahlo's Art," *Artscanada,* October/November 1979, Herrera wrote that Kahlo's primitivism, her "naive, folkloric manner . . . camouflaged the awkward technique of an untrained artist" (p. 25). Newman, on the other hand, links primitivism with nationalism in her art and labels it "indigenity." In "The Ribbon Around the Bomb," *Art in America,* April 1983, pp. 160–69, he convincingly suggests that Kahlo's naive style is deliberate and the result of her political commitment. John Berger in "The Primitive and the Professional," *About Looking* (New York: Pantheon, 1980), suggests that professional painting removes lived experience from a work of art. He writes: "The will of primitives derives from faith in their own experience and a profound

scepticism about society as they have found it" (p. 68). I submit that Kahlo's work demonstrates both a "faith in her own experience" and a "profound scepticism about society."

11. See Miguel Covarrubias, *Mexico South: The Isthmus of Tehuantepec* (London: Cassell, 1946), p. 30, for a rather romanticized description of the Tehuanas, and Joseph Whitecotton, *The Zapotecs: Princes, Priests, and Peasants* (Norman: University of Oklahoma, 1977), for information about the women and their life-styles. Breslow, in "Cry of Pain," appropriately suggests that Kahlo's Tehuana dress represents the Zapotec, the "unconquered" people.

12. The *nahual*, often the animal with which people and gods were magically linked or associated, has been described as the "twin" or the alter-ego. Charlotte McGowan in "The Philosophical Dualism of the Aztecs," *Katunob*, December 1977, pp. 37–51, explores this aspect of dualism found in the mythology and life of Aztecs.

13. See Esther Pasztory, *Aztec Art* (New York: Harry N. Abrams, 1983), or *Art of Aztec Mexico: Treasures of Tenochtitlan* (Washington, D.C.: National Gallery of Art, 1983) for comprehensive commentaries on and reproductions of Aztec art.

14. Laurette Séjourné, *Burning Water: Thought and Religion in Ancient Mexico* (New York: Vanguard Press, 1956), p. 119. In Séjourné's highly romanticized discussion, the cult of Quetzalcoatl is the apex of the spiritual side of life during the era immediately preceding Aztec rule. Her suggestion that the cult continued into Aztec times while Aztec society, as a whole, became brutal and militaristic is an attempt to rationalize and relativize the gruesomeness of sacrifice.

15. For further discussion of this phenomena see Fray Diego Duran (trans. and ed. by Fernando Horcasitas and Doris Heyden), *Book of the Gods and Rites, and the Ancient Calendar* (Norman: University of Oklahoma, 1971), pp. 82–84 and 419–20, or Michael Coe, *Mexico* (London: Thames and Hudson, 1984), p. 160.

16. See Herrera, *Frida,* pp. 190–91.

17. Pasztory, *Aztec Art,* p. 57.

18. This kind of imagery is found in the work of many Mexican artists and writers. See Barbara Brodman, *Mexican Cult of Death in Myth and Literature* (Gainesville: University of Florida, 1976), for a discussion of life-from-death metaphors in Mexican literature.

19. Herrera, *Frida,* p. 281.

20. As Pasztory states in her discussion of the skeletal goddesses in *Aztec Art,* "death was chaos, evil, and darkness overcoming the forces of order, good, and light; yet it was also necessary, for without it life could not continue" (p. 220).

21. Pasztory, *Aztec Art,* p. 158.

22. An accurate representation of the goddess appears in the top left corner of *Moses (Nuclear Sun),* 1945. Kahlo demonstrated the "quintessential opposites" of Coatlicue much more dramatically than the original sculpture when she painted the death skull immediately beneath palpable breasts.

23. In *My Art, My Life* (New York: Citadel, 1960), Rivera tells us that "Frida detested Trotsky's politics but, desiring to please me," she met and invited him to stay in Coyoacan. By 1940 political differences existed between Rivera and Trotsky as well (pp. 229–30).

24. *Narodnost* refers to the loosely organized populist ideals growing out of the anarchistic socialism of the nineteenth-century *narodniki. Partinost,* "party consciousness" or "party spirit," implies total dedication to a centralized leadership. See Jerry Hough and Merle Fainsod, *How the Soviet Union Is Governed* (Cambridge, Mass.: Harvard University Press, 1979), pp. 10–16 and 116.

25. In a 1952 letter from Kahlo to Antonio Rodriguez, quoted in Herrera, *Frida,* p. 263. The Mexican art historian Ida Rodríguez-Prampolini in "Remedios Varo and Frida Kahlo: Two Mexican Painters," in *Surréalisme périphérique* (Montreal: University of Montreal, 1984), emphasizes Kahlo's realism.

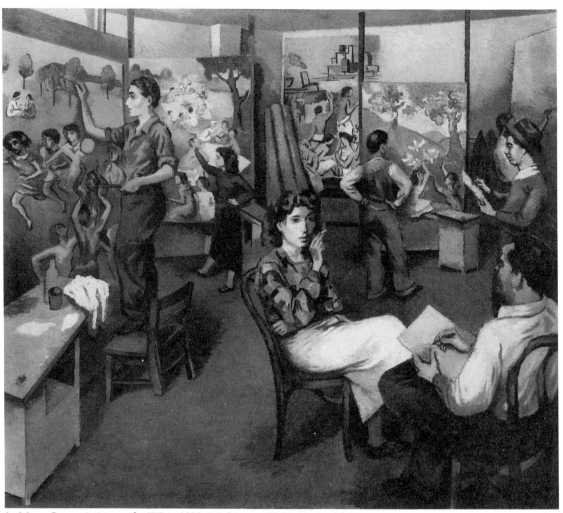

1. Moses Soyer, *Artists on the WPA*, 1935. Washington, D.C., National Museum
of American Art, Smithsonian Institution, Gift of Mr. and Mrs. Moses Soyer.

EGALITARIAN VISION, GENDERED EXPERIENCE:

Women Printmakers and the WPA/FAP Graphic Arts Project

HELEN LANGA

Increasing numbers of women artists had established professional careers in the United States by the early 1930s, but the economic catastrophe of the Great Depression weakened private patronage, and competition for subsistence employment drove many artists out of the secondary jobs on which they depended for support. Women artists, like their male peers, turned to the New Deal federal art programs for survival.[1] These programs were especially helpful to women because hiring decisions primarily addressed artists' professional status and avoided sexual bias through anonymous competitions or emphasis on qualifications for relief; the New Deal art projects therefore offered many women unprecedented opportunities to establish professional camaraderie with their male peers in an egalitarian atmosphere of shared work and shared interests. For women artists on these projects, however, conceptions of gender difference were both expressed and repressed in their working relationships and in the artistic choices that inflected their work. In this article I present

an overview of the tensions between the egalitarian vision that informs artists' memories of this period and the ideological constructions of gender that shaped women's work in relation to stylistic conventions and innovations, the politics of representation, the support or constraint of bureaucratic supervision, and the desire to build a mass audience.

As the Depression deepened in the early 1930s and state-sponsored arts relief projects were seen to be inadequate, Roosevelt's New Deal government established several federal art programs intended to provide assistance for impoverished artists and to utilize artistic expression to enhance democratic values, rebuild national confidence, and promote pride in local and regional identity. These programs offered artists dignified if meager financial sustenance and the opportunity to maintain and develop their professional skills, as well as the challenge of constructing communal visions of American experience and the possibility of working cooperatively with other artists and building a national system of support for the arts.

The first national program, the Public Works of Art project (PWAP), ran from December 1933 to June 1934, and was followed by three major federal arts programs that continued from 1934/35

This essay was given as a paper in the Mid-Atlantic Symposium in the History of Art (the University of Maryland and the Center for Advanced Study in the Visual Arts), National Gallery of Art, 1990. Copyright © 1991 by Helen Langa. By permission of the author.

until the mid-1940s. Two of these, the Treasury Section and the Treasury Relief Art Project (TRAP), were supervised by the Treasury Department, and produced murals, sculpture, and easel paintings for public buildings. The third and by far the largest program was Federal Project Number One, set up under the Works Progress Administration; its mandate was to provide support for artists through work-based relief until economic recovery was achieved.[2] "Federal One" included separate programs for the visual arts, music, theater, and literature; the visual arts sector was simply called the Federal Art Project (FAP).

Both the TRAP and the FAP established group workshops that provided stimulating environments for men and women participants and facilitated the interchange of skills and ideas; Moses Soyer's 1935 painting *Artists on the WPA* [1] suggests the intense but relaxed atmosphere that prevailed in these shared studio spaces. Many artists felt that the camaraderie that characterized their experience on the federal arts projects allowed them to assert a unique degree of creative independence, stimulated by an atmosphere of mutual endeavor that freed them from competitive anxiety.[3] Anton Refregier, who worked on both the FAP Easel Painting and Graphic Arts projects, observed:

There was a close comradeship among the artists, a respect for each other regardless of the direction each of us chose—the Realist painter along with the Abstract and Surrealists felt a common bond. . . . We were not degraded by personal opportunism, we were not manipulated by art entrepreneurs, critics, nor museums. . . . We jealously guarded our freedom of expression.[4]

Women who joined the projects also commended the absence of gender discrimination in working relations as a factor that further enhanced their participation in this comradely ideal. Lee Krasner, for example, noted:

There was no discrimination against women that I was aware of in the WPA. There were a lot of us working then. . . . There was camaraderie not isolation . . . it was a living for us all.[5]

In contemporary interviews, later reminiscences, and on questionnaires developed by Francis O'Connor during his germinal 1960s study of the WPA, other women reiterated this sentiment.

It is therefore very tempting to applaud these Depression years of professional empathy and aesthetic freedom as an ironically utopian moment of equality for women artists. However, as a late twentieth-century feminist, I found myself reading such affirmations of equality with a certain skepticism. While respecting the experience to which they testify, I think we can also question how this conception of equality interacted with prevailing ideologies of gender identity to shape artistic choices. Or, to put it slightly differently, we can ask how women's stylistic and thematic decisions, worked out in a nominally egalitarian setting, resisted or reproduced in their work the patterns of gender difference embedded in 1930s society.

Forty percent of the self-declared artists on the 1930s census were women, and I suspect that the importance many women artists placed on egalitarian comradeship was linked to their ideological positioning as women *and* professionals, a dual identity that differentiated them from most of their female contemporaries.[6] Karal Ann Marling has observed that while certification for relief provides a peculiar reverse standard for assessing women artists' professionalism, acceptance for the relief-based art programs required evidence of both economic eligibility and established professional status.[7] FAP records can therefore be read as further documentation of women's successful careers in the visual arts.[8] In *New Deal for Art*, Marlene Park and Gerald Markowitz estimate that 23 percent of the artists on the New York City FAP in 1936 were women, but this included art teachers; women represented about 18 percent of the easel and graphic artists, and 15 percent of the muralists and sculptors.[9] About 2,000 artists were employed by the FAP in New York in 1936, so we can estimate that approximately 600 women worked on various federal projects.[10]

Women's demonstrated professional experience reflected a "modern" conception of gender equality for women distinct from conventional

stereotypes of womanly virtue, in which tradi-
tional iconographies of woman's feminine identity
as wife and mother were expanded in the 1920s to
include woman as consumer, without any serious
revision of her prevailing domesticity identity.
Contrasting with this conventionalized femininity
was the modern figure of the New Woman, pro-
fessional, independent, sexually liberated, and de-
picted more often in advertising, popular fiction,
and films than in the fine arts. Representing
women as capable of comradely alliances with
men in both work and play, the trope of the New
Woman articulated gender difference in newly
equal terms during the first three decades of the
twentieth century. During the Depression years of
the 1930s, however, women's choice to work out-
side the home was challenged by social values that
posed women's wage work as an obstacle to full
male employment. Under these conditions,
women artists had to renegotiate these competing
codes of gendered female identity; their strategies
are represented in their art as well as in their
personal and professional relationships.[11]

Neither women's participation in the New Deal
art projects nor the coding of gender difference
into visual imagery has received much attention in
the literature of American art history.[12] However,
recent work by the American studies scholar Bar-
bara Melosh has addressed these issues in relation
to 1930s murals and sculpture commissioned by
the Treasury Department under the New Deal
administration.[13] Melosh sees an articulation of
sexual difference taking shape in these works
through an imagery of sexual comradeship sym-
bolized by representations of shared work and
complementary duties. She cites numerous murals
that characterize familial relationships by means
of a complementary, sex-based division of labor,
yet in many of these works women's experience is
relegated to a peripheral supporting role, while
male enterprise in founding frontier settlements,
sustaining agricultural development, or providing
industrial labor is emphasized. Moreover, what
eludes us in even the most egalitarian of these
New Deal representations of picturesque and pa-
triotic America is any account of comradeship be-
tween men and women performing the same kind

of work, as they did on the federal art programs;
that in itself suggests the novelty of such a situa-
tion.

The opportunities for equal access to employ-
ment and equal pay provided by the New Deal art
projects enhanced women's desire for the possibil-
ity of professional comradeship. Most types of
work in the 1920s and 1930s remained sex segre-
gated, and if men and women performed similar
jobs, there was usually a gender-based differential
in their salaries. On the federal art projects, by
contrast, unmarried women and men received the
same level of support.[14] In a 1986 panel discussion
by artists on the WPA, Riva Helfond, who par-
ticipated in the Graphic Arts Division workshop
in New York City, stressed the importance of pay
equity in establishing camaraderie among peers.
She commented:

We were just people. We were getting paid the same
thing the men were. . . . There were many women
artists on the Project, and as raises came up we were
entitled to them just as much as the men. There was
absolutely no discrimination.[15]

The opportunity to portray anything that inter-
ested them was probably another significant factor
in women's experience of equality on the projects.
Helfond observed: "We were simply drawing
from the subject matter that was around us, that
we were affected by, that moved us most. . . ."[16]
Similarly, Elizabeth Olds, who also worked for the
Graphic Arts project, expressed artists' exhilara-
tion at the new breadth of subject possibilities
opened to them even before she joined the work-
shop. In an interview with an Omaha, Nebraska,
newspaper in 1935, she stated:

American artists have lately chosen to portray our own
life. We find our subject on the streets, in the factory,
the machines and workers of industry and on the farm.
We aim to picture truly the life about us as the people
we are in reference to the forces that make us. We
choose all sides of life, searching for the vital and signif-
icant. . . .[17]

While celebrating the breadth of artists' op-
tions, these comments also reveal the particularly
public focus of many New Deal themes; artists

concentrated on the external world, on observation rather than self-revelation, but this does not imply a lack of passion in their works. In a review of a 1933 exhibition at New York's John Reed Club, Anita Brenner observed characteristic values that persisted into the latter part of the decade. She noted:

The shift of interest from things to people is aggressively marked; also the shift from decoration to emotional expression, from sensory pleasure to human anger and pain . . . artists trying, with some self-consciousness and strain, but with all their strength, to be common people.[18]

Shaping the documentary perspective Olds described, these ideals continued to focus artists' choices of subject and presentation through considerations of economic and social empathy and political ideology. Within the parameters of individual interest, women and men constructed a new social vocabulary for American art during the 1930s, a vocabulary often marked by the desire to articulate images with which a mass audience could identify.

The conditions of professional equity and intensified commitment to a broad range of social themes provided a grounding for women's perceptions of employment on the federal art projects as unusually egalitarian in context, but how women proceeded to enact this egalitarian opportunity into art can be determined only by careful study of their work. Women's choices both of style and subject constitute an arena in which they took advantage of new possibilities for equality by sustaining or breaking with prevailing patterns of gender difference. To explore these choices more closely in a somewhat limited context, I have focused on the work of women printmakers who were employed by the WPA/FAP Graphic Arts Division workshop in New York City between 1935 and 1943.

In comparison with the non-relief Treasury Section program or the relief-based TRAP projects whose productions were also intended for public buildings, the relief-oriented FAP programs supervised by the Works Progress Administration allowed artists substantial aesthetic independence.

Unlike Section artists, those on the FAP did not have to accommodate the political values and artistic opinions of both local communities and supervising bureaucrats. Under Holger Cahill's mandate, the primary rationale for the relief projects was support of artists' ongoing work, albeit for eventual public display under government auspices; although some concerns were expressed and some limits set, the FAP relief programs fostered independence in individual expression. Because of this autonomy, the work of women artists who participated in the Graphic Arts workshop allows us a more distinct view of the ways in which, as women, they addressed varied facets of contemporary experience, confronted urgent issues of theme and audience, and broke with conventions about gender-appropriate subjects.

The Graphic Arts workshop was set up in 1936 at the suggestion of New York printmakers with the support of Audrey McMahon, then the director of the FAP in New York City, and usually employed between fifty and sixty artists. Its working atmosphere, as participants described it, replicated the general egalitarian tenor of most FAP programs.[19] Studio facilities and special projects encouraged cooperative technical experimentation, particularly in lithography and the development of silkscreen printing, quickly renamed serigraphy to establish its fine-arts status. Many artists also shared the spirit of democratic idealism that pervaded both the regionalist and social realist schools of 1930s art-making; for printmakers, outreach to a mass audience dictated simple and accessible subject matter and larger print editions.

Artist employees had to conform to basic procedural requirements on the project. They were expected to make at least one print a month and could work either at the workshop or at home, since relief didn't pay them enough to rent studios.[20] Completed etching plates, wood or linoleum blocks, and lithography stones were printed at the workshop by the artist in cooperation with several master printers who were also employed by the project. Although some printmakers advocated larger editions, print runs were usually limited to editions of twenty-five to fifty, of which the artist could keep three; the rest were to be

distributed for exhibition.[21] Within this seemingly flexible framework, however, other bureaucratic restrictions did set significant limits on artists' autonomy; these included required supervisory approval for each print, timekeeping regulations, and the ultimate threat of dismissal from the program, all of which reminded artists that cooperation with the system was mandatory.

Although project supervisors were remembered by most artists as sympathetic to innovation, they had substantial discretion over what constituted acceptable work. The ideal of maintaining deserving artists' skills with as little government censorship as possible was constricted in practice by politically motivated concerns about public accountability. In the workshop, artists' preliminary drawings had to be approved for accessibility of subject and overall artistic value.[22] Before a final printing, each artist had to submit six proofs to a panel of project supervisors, which sometimes included one artist representative from the workshop. Despite the apparent diversity of imagery produced under WPA/FAP auspices, it seems likely that supervisors' preferences produced some unstated conventions of acceptability that affected individual artists' choices.

Artists' daily subordination to bureaucratic control was expressed more directly by timekeeping regulations, intended to assuage public fears that artists might cheat the government of "real" work. During the first years of the FAP program, all artists had to sign in by nine in the morning at a central location in their community before returning home, where they were randomly visited by timekeepers to make sure they were working. The hardship caused by this system is indicated by a sympathetic account in Cahill's letters of Mabel Dwight's sleepless nights of anxiety over not hearing her alarm (she had to commute from Staten Island to the midtown Manhattan office),[23] or, more humorously, by apocryphal stories about Jackson Pollock's running down the street in his pajamas to make the morning deadline.[24]

Ignoring these requirements posed a real threat to artists, whose fears of losing their relief checks were well founded. Despite the FAP's goal of supporting all deserving artists, acceptance onto the New York projects was very competitive. In 1937 and 1938, about 2,000 artists were employed, but as many more, certified as eligible, could not be hired; after a series of quota cuts, Congress ruled in August 1939 that all WPA workers employed for more than eighteen months had to be dismissed.[25] Although artists' organizations protested limitations and layoffs, they were unable to force the federal government to change its policies. Jacob Kainen, in his essay on the Graphic Arts project in *Art for the Millions,* has described the humiliating and difficult process of recertification that artists had to endure if they were laid off.[26]

Artists working under these conditions might well have given some thought to the advantages of conforming to the stylistic and thematic choices that appeared most acceptable in contemporary imagery. For women in particular, work that drew them into prevailing tendencies and replicated the major concerns of outstanding male peers may have seemed most likely to be acceptable.[27] Moreover, themes that paralleled male interests might also have seemed more challenging and innovative, more compelling, even more professional, than images associated with feminine experience. It is within the context of these pressures for conformity to normative male standards of achievement that we have to look more carefully at how gender affected women printmakers' choices.

The formal vocabularies utilized by both male and female artists on the project were very varied and were inflected in part by conventional uses of particular print media—for example, the sharp detail typical of wood engraving or the overlapping of color planes combined with linear emphases in serigraphy. The majority of artists of both sexes worked in various representational modes; only a few explored the expressive distortions of Surrealist imagery or purely abstract compositions, although the development of various realist, expressive, or abstract styles was protected by Cahill's vision of the FAP's goals. Women's innovative use of varied print media probably contributed significantly to their inclusion in the atmosphere of mutual respect and aesthetic independence that characterized various descriptions

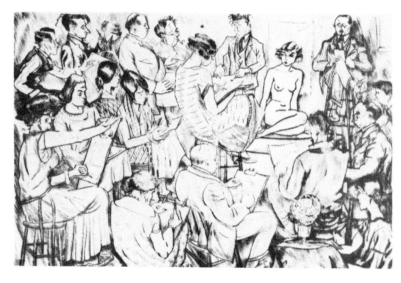

2. Peggy Bacon, *Frenzied Effort,* etching/drypoint, 1925. New York, Weyhe Gallery.

of the FAP workshop. However, in the importance Refregier and other artists placed on aesthetic freedom, we might also discern a subtext of resistance to bureaucratic pressures for conformity and an assertion of project artists' aesthetic integrity.

Artists' thematic choices reveal more clearly the significant role of gender difference in shaping women's work and conceptions of women's equality. While desires for conformity to contemporary values may have influenced their options, the possibilities, as Olds and Helfond have indicated, were ostensibly unlimited. Only one unwritten but pervasive restriction conditioned project artists' choices; sexually suggestive imagery and any depiction of nudes were discouraged to placate the conservative values attributed to the taxpaying public by some WPA supervisors and members of Congress who controlled FAP finances. Today such censorship would be widely protested, but the constraints imposed by this restriction may have significantly enhanced women's perceptions of the comradely atmosphere of the project.

The female nude's erotic objectification poses complex issues for women both as artists and viewers. These issues include women's appropriation or negotiation of codes of visual authority and the fetishization of female bodies as objects of male heterosexual desire.[28] Women artists were eager

to participate in life drawing classes in the 1920s and 1930s. A satiric view of a mixed group of students is shown in Peggy Bacon's 1925 print *Frenzied Effort* [2], but few women continued to depict the nude in their professional work, Isabel Bishop being one notable exception.[29]

Two images of burlesque dancers suggest women artists' resistance to exploitative portrayals of female nudity and offer sharp contrasts in both form and interpretation to such contemporary portrayals of the burlesque theater as those by Reginald Marsh. Marsh frequently played the sensual details of naked strippers' bodies against the working concentration of the orchestra and the mixed emotions of male spectators. In a very different interpretation, Elizabeth Olds, in her lithograph *Burlesque* [3], condensed the physical energy of the women she portrayed into a serial repetition of flattened body contours and satirically emphasized smiles, visually constructing resistance to the row of male viewers rather than enticement of them. Olds made this lithograph during the years that she worked on the Graphic Arts project, but probably on her own time rather than as an FAP print. Kyra Markham similarly rejected sexually suggestive imagery in a print titled *Burlycue* [4]; she portrayed the scantily clad dancers as workers, chatting and resting backstage between acts. In Markham's vision, the women's

costumes and poses can be read as attributes of wage labor; the emphasis is on their interactive camaraderie, not the appropriative milieu beyond the stage. Not many women chose to portray burlesque subjects, and these two works cannot be translated into documentation of women's feelings generally; however, it seems likely that the exclusion of nudity from the canon of acceptable subjects for FAP artists, and therefore the absence of imagery that reiterated gendered inequalities of male voyeurism and female objectification, facilitated both men's and women's perceptions of comradeship in a shared work environment.

If the absence of sexually objectifying imagery allowed women psychic space within which to affirm equality, other subject conventions of 1930s art-making brought gendered valuations of male and female identity into the foreground of artists' choices. In the later 1930s, the focus of political

rhetoric about economic failure, survival, and recovery centered on employment, on the revitalization of industry, and on workers as continuing victims of the Depression or heroes of New Deal recovery. The primary conception of the worker, whether in leftist valorizations of proletarian strength and dignity, or more conservative ideologies of American individual opportunity, was male.[30] For women artists interested in addressing the widespread suffering of the Depression and the possibilities of recovery, depiction of male workers represented the predominant vocabulary in which to frame both concerns. It was a vocabulary they could share with male peers, but it constituted both a challenge to take on unfamiliar subjects, and the acceptance of a normative framework that made the experiences of women themselves less valid and less visible.

Women artists' approaches to industrial sub-

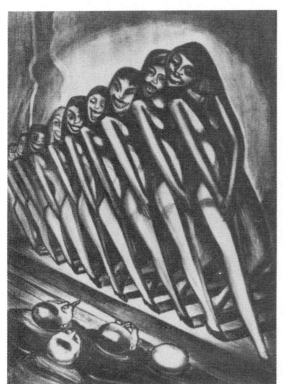

3. Elizabeth Olds, *Burlesque*, lithograph, 1936. Washington, D.C., National Museum of American Art, Smithsonian Institution, transfer from Archives of American Art.

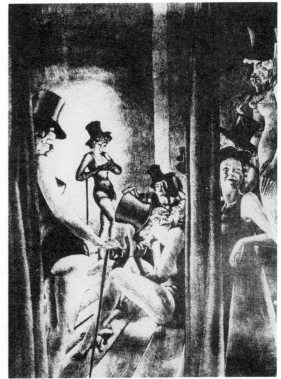

4. Kyra Markham, *Burlycue*, lithograph, n. d. Washington, D.C., National Archives.

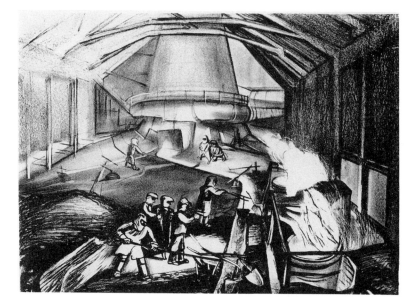

5. Elizabeth Olds, *The Blast Furnace*, lithograph (NYC WPA stamp), n. d. Lexington, University of Kentucky Art Museum.

6. Riva Helfond, *In the Shaft*, silkscreen (NYC WPA stamp), n. d. Lexington, University of Kentucky Art Museum.

7. Mabel Dwight, *Banana Men*, lithograph, n. d. Washington, D.C., National Archives.

jects both paralleled and diverged from the imagery of their male contemporaries. While some representations of male workers emphasized the muscular energy of these figures to epitomize masculine strength and determination as sources of industrial recovery, heroic images of male musculature are rare in the work of women artists, raising questions whether women's work was shaped by gendered conventions of feminine sexual reticence about explicit representation of the male body that were difficult to disregard. Most women artists who took up industrial themes developed documentary overviews that explored the conditions of industrial labor. Elizabeth Olds made numerous serial studies of workers in heavy industry and generally deemphasized the physical attributes of masculinity. She focused instead on contextual aspects of the work environment; her lithograph, *The Blast Furnace* [5] is a typical example of these works. Olds's prints are very similar in style to those of several of her male peers, such as Harry Gottlieb and Chet LaMore; Olds and Gottlieb worked together on illustrations of major industrial complexes, such as the Homestead steel plant in Pittsburgh. Like Olds, Riva Helfond also took up the challenge of entering dangerous areas

8. Minnie Lois Murphy, *Fish Day*, wood engraving (NYC WPA stamp), 1938. Ann Arbor, University of Michigan Museum of Art.

9. Betty Waldo Parish, *Railroad Yard*, lithograph (NYC WPA stamp), n. d. Ann Arbor, University of Michigan Museum of Art.

of male labor as an artist-investigator; her serigraph titled *In the Shaft* [6] was a product of her studies of the mining industry. Except for the explicit heroization of the male body by some male artists, the stylistic conventions developed by both men and women interested in these subjects shared many similarities.

Women printmakers also portrayed the mundane efforts of laboring men from a more distanced and conventional viewpoint, as in Mabel Dwight's lithograph *Banana Men* [7] and Minnie Lois Murphy's wood engraving *Fish Day* [8]. In a catalogue essay for the exhibition *Depression Printmakers as Workers*, Mary Francey argued that many artists on the federal art projects may have identified themselves as workers, affiliating their social concerns with other working people's sense of purpose and practical efficacy in supporting New Deal recovery programs.[31] If their choice of subjects is any indication, a number of women artists shared these attitudes.

The depiction of industrial facilities offered women further possibilities for interpreting male workers' experience; their choice of a critical or celebratory vision would have been influenced both by shifting economic tendencies during the late 1930s and by their political perspectives. Lithographs by Betty Parish and Nan Lurie reveal pessimistic and critical viewpoints that contrast with the optimism of much of Olds's work. In Parish's *Railroad Yard* [9], the unemphatic realism of her technique suggests the gloomy silence that pervaded the drab railroad yards and empty shipping terminals she documented. Lurie, who often portrayed the experience of African-Americans, created a more overtly condemnatory image titled *Technological Improvements* [10], which posed the suffering of African-American workers as a product of their "dumping" by technology's elimination of jobs, suggested metaphorically by the powerless ghostly figures falling from the steam shovel's open maw.

In depicting workers and industrial subjects, all artists were attending to concerns that had not been prevalent in earlier American imagery.[32] But women artists who went out into steel mills, slaughterhouses, and mines to document modern production techniques, the catastrophe of economic upheaval, or the reanimation of American industry were breaking radically with gender con-

ventions about women's proper sphere. Like the photographer Margaret Bourke-White, as heroic exceptions to feminine propriety they were applauded (perhaps by different constituencies) because their causes were heroic: revelation of capitalist failure or validation of American resourcefulness and recovery. Thus women were able to take on subjects distinctly unsuited to prevailing ideologies of gender difference in the larger culture.

At the same time, emphasis on male workers and the industrial economy universalized male achievement and suffering as the symbolic equivalents for New Deal progress or its failure, and this focus also concentrated visual interest on the public, external environment, as did the more traditional landscapes and urban scenes that form the majority of graphic images from the 1930s. Artists of both sexes addressed the domestic realms of women's household work or family survival much less frequently; here again we can trace the working of gender in artists' thematic choices. Home life had been emphatically associated in nineteenth-century America with the idealization and subordination of women, and with reproduction and consumption rather than production; in the 1930s, home was still artistically associated with the sentimental excesses of genre painting rather than the politically conscious observations intended by the social realists.

In fact, comparatively few works of art of any kind from the 1930s portray the household experience or wage work of women as central themes. The mundane domestic struggles of keeping a home together, buying the cheapest food, maintaining worn-out clothes, and rearing hungry children rarely appear in visual imagery; the same is true for working-class women's paid labor in sweatshops and factories, or as secretaries, shop clerks, or cleaners.[33] Women journalists and authors of popular fiction such as Josephine Herbst, Meridel LeSueur, and Tess Slessinger did address these topics during the 1930s, especially in magazines associated with leftist politics. Although a number of printmakers were also affiliated with left-wing publications and produced journalistic illustrations, few focused on such subjects. Two

images by women that do address these issues are Winifred Lubell's undated color woodcut *A Woman's Tools* [11], unusual in its sympathetic heroization of women's unending domestic repair of the world, and Jolan Gross-Bettelheim's 1943 lithograph *Home Front* [12], portraying the women who replaced men in industrial production work during World War II.

For some women artists, whether working on the New Deal art projects or on their own, conflicting feelings of empathy and difference may have operated to make such subjects difficult to approach. To those who came from immigrant families, the domestic struggle for economic survival was all too painful and familiar; for others, professionalism itself set them apart from other

10. Nan Lurie, *Technological Improvements*, lithograph (NYC WPA stamp), n. d. Washington, D.C., National Archives.

women's domesticity or oppressive experiences of waged work. Rather than confront these painful reminders of most women's isolation from the male world of professional achievement, women artists rarely portrayed women's struggles to survive the Depression, except in the contexts of family suffering or cultural ethnicity.

Although there were some exceptions, women's thematic choices seem often to have served to minimize their identity as women and emphasize the interests they shared with male peers; these strategies of assimilating predominant male concerns are particularly noticeable in the work of women on the federal art projects, where they assisted women's claims to professional equality. However, if these claims were respected within the workshop, they were more problematic in other social and political contexts, which at times disclosed the inequalities of gender difference that encoded the egalitarian ideal.

Some sense of women's participation in the American Artists' Congress can be deduced from Matthew Baigell and Julia Williams's republication of the Congress papers in *Artists Against War and Fascism*. The surviving documents suggest that the discrepancies between equality in the workshop and the gendered paradigms of male

and female identity that marked most heterosexual relations also qualified women's experience in art-world politics. Of the 378 artists who signed the Call for a National Artists' Congress in 1936, 61 were women. At the Congress itself, however, only three of thirty-four speakers were women, and there were only three women on the forty-five-member National Executive Committee, two of them from New York.[34] These statistics, compared to the 23 percent of artists on the FAP who were women, suggest that the egalitarian vision concealed gendered boundaries of sexual difference that manifested themselves when women moved beyond the workshop into a more public sphere.

The playing out of gender equality in intimate relations and friendships is more complex to uncover. Women writers and activists associated with radical leftist groups in the 1930s commented that their professional work didn't assure them a hearing in male-dominated intellectual or political discussions. Josephine Herbst complained in a letter to Katherine Anne Porter that she was excluded from a male writers' "talkfest" at a bar because she was a woman, and Esther Allen described shouting at her husband during a political meeting in their living room:

11. Winifred Milius Lubell, *A Woman's Tools*, chiaroscuro woodcut with hand coloring, n. d. Collection Ben and Beatrice Goldstein *(Edward Owen)*.

While you sit on your ass making the revolution, *I'm* out in the kitchen like a slavey. What we need is a revolution in this house [emphasis in original].[35]

Some women artists may have felt similar outrage, but in the second decade after women achieved suffrage, the egalitarian ideal nevertheless offered a conception of professional comradeship that discouraged them from drawing attention to themselves as women. As Marlene Park and Gerald Markowitz have pointed out, women were as militant as men in support of the Artists' Union, and spoke out against discrimination toward African-Americans and immigrants, but they did not want to be seen as a separate category of artists themselves.[36]

The federal art programs allowed many women artists to survive the Depression with a sense of dignity and accomplishment, and most successfully continued their professional careers in the following decades. The innovative stylistic and thematic developments that characterized much of their work during the 1930s, however, were demeaned with Abstract Expressionism's rise to ascendancy. When leading art critics reconstructed painting as an expression of virile passion in the early 1950s, they significantly minimized women's claims to equal creative status by associating art-making with intellectual and emotional traits conceptualized as preeminently male.

Recent research has reevaluated earlier negative attitudes toward the development of both realism and modernism during the interwar decades, and has begun to untangle the complex intermeshings of ideology and practice that characterized American art during the 1930s.[37] The ideal of egalitarian comradeship among workers was one theme that had special significance for artists on the New Deal projects; and it offered a vision of shared experience implicitly helpful to women artists' assertions of professional equality. What this vision dissimulates, however, and what we need to retrieve, is the recognition that equal status depended on a leveling of gender difference that articulated what had formerly been male-identified subjects—the public realms of work and the industrial and urban environment—as well as the bolder techniques that best depicted them, as the

12. Jolan Gross-Bettelheim, *Home Front*, lithograph, 1943. Washington, D.C., Library of Congress, Fine Prints Collection.

focus of socially concerned artistic imagery. Despite occasional expressions of empathy for women's experience, professionalism generally encouraged women artists to remain within gendered conventions of representation that projected themes of male/public experience as more compelling for both artists and for a mass audience than female/private subjects. Women resisted earlier conceptions of feminized propriety by accommodating their imagery to the gendered priorities of contemporary artistic practice, priorities that reproduced masculine values and viewpoints as neutral and universal. While the significance of women's sense of inclusion in the camaraderie of the WPA/FAP projects should not be minimized, closer attention to the contexts in which women artists asserted, retreated from, or were denied equality reveals complex tensions between the egalitarian vision of professional comradeship and the multiple enactments of gendered experience into art during the New Deal era.

NOTES

1. My work on this paper could not have taken shape without the the pathbreaking scholarship on women artists of the New Deal decade produced during the late 1970s and early 1980s by Karal Ann Marling and Helen A. Harrison, and by Marlene Park and Gerald Markowitz. I am especially indebted to Kim Carlton-Smith, "A New Deal for Women: Women Artists and the Federal Art Project, 1935–1939," Ph.D. dissertation, Rutgers University, 1990, for sharing her research with me, and to Barbara Melosh, for letting me read sections of her book *Engendering Culture* (1991) prior to its publication.

2. The Section employed about 1,200 artists, and TRAP employed 446, in contrast to the WPA/FAP, which in 1936 at its most expansive employed about 5,000. Total costs for the Section were $2.5 million, for TRAP about $800,000, and for the FAP $35 million. Figures cited in "Ten Crucial Years: The Development of United States Government Sponsored Artists Programs, 1933–1943. A Panel Discussion by Six WPA Artists," ed. Stephen Neil Greengard. *The Journal of Decorative and Propaganda Arts* 1 (Spring 1986): 57.

3. See also Audrey McMahon's assessment of artistic freedom on the federal art projects despite bureaucratic strictures; cited in Francis V. O'Connor, *Federal Support for the Visual Arts: The New Deal and Now* (New York, 1969), p. 47.

4. Anton Refregier, *New York City WPA Art* (New York: Parsons School of Design, 1977), p. 73. Cited in Patricia Hills, *Social Concern and Urban Realism: American Painting of the 1930s* (New York: American Federation of Arts, 1983), p. 11.

5. Lee Krasner, from an interview in Eleanor Munro, *Originals: American Women Artists* (New York, 1979), p. 108.

6. See O'Connor, *Federal Support for the Visual Arts,* p. 192, for census figures for 1920, 1930, and 1940. The total number of artists for 1930 was 57,265, which included 35,621 men and 21,644 women.

7. Karal Ann Marling, "American Art and the American Woman," *7 American Women: The Depression Decade,"* ed. Karal Ann Marling and Helen A. Harrison (New York, 1976), p. 13. See also Amy J. Wolf, *New York Society of Women Artists, 1925* (New York, 1987), pp. 6–15 for discussion of women artists' participation in professional societies.

8. The FAP established four levels of professional status, but most artists were hired at the top level. Projects were also allowed a percentage of non-relief artists, who were intended to be of highest ability and to raise the overall level of production. The quota of non-relief participants began at 25 percent, but was cut back in 1938 to 5 percent.

See O'Connor, *Federal Support for the Visual Arts,* p. 67.

9. Marlene Park and Gerald Markowitz cite these percentages for New York City and State, where WPA/FAP projects employed about 42 percent of the national total in 1936. See Marlene Park and Gerald Markowitz, *New Deal for Art: The Government Art Projects of the 1930s* (Hamilton, N.Y., 1977), p. 20. The numerical statistics are cited by Francis V. O'Connor, "The New Deal Art Projects in New York," *The American Art Journal* 1, no. 2 (Fall 1969): 76–78.

10. Kim Carlton-Smith has traced the records of women employed on the Federal Art Projects in New York between 1935 and 1939. Her documentation shows about 35 percent of the artists were women; for the maximum year of employment, 1936, this would lead to a total of about 600 women employed on all FAP programs. Carlton-Smith, Appendix I, 305.

11. The identities represented by these two sets of conventions neglected many aspects of women's complex roles in 1930s society, particularly their participation in the lower echelons of waged labor; nor did they adequately reflect differences in women's class, race, or ethnic identities.

12. The work of Francis O'Connor, Richard McKinzie, Belisario Contreras, Karal Ann Marling, Helen A. Harrison, Marlene Park and Gerald Markowitz has been essential in reasserting the importance of the 1930s to the study of American art, but of these scholars only Marling, Harrison, and Park and Markowitz have paid specific attention to women artists. By contrast, studies in American culture have specifically addressed issues of gender difference in the New Deal decade. See, for example, Barbara Melosh, *Engendering Culture* (1991); Molly Haskell, *From Reverence to Rape: The Treatment of Women in the Movies* (1974); Marjorie Rosen, *Popcorn Venus: Women, Movies and the American Dream* (1973); and Janice Radway, *Reading the Romance: Women, Patriarchy, and Popular Culture* (1984).

13. Barbara Melosh, "The Comradely Ideal: Womanhood and Manhood in New Deal Murals and Sculpture," unpublished talk given at a symposium on women artists of the New Deal at the National Museum of Women in the Arts, Washington, D.C. (22 October 1988).

14. See O'Connor, *Federal Support for the Arts,* p. 31, for discussion of pay scales and differential between married men and single men. In *New Deal for Art,* p. 20, Park and Markowitz note that married women often had to conceal their marital status by using their maiden names to gain employment.

15. Riva Helfond, "Ten Crucial Years: The Development of United States Government Sponsored Artists Pro-

grams, 1933–1943. A Panel Discussion by Six WPA Artists," ed. Stephen Neil Greengard. *The Journal of Decorative and Propaganda Arts* I (Spring 1986): 57.

16. Helfond, "Ten Crucial Years," p. 48.

17. Elizabeth Olds, in a 1935 interview with the *Omaha World-Tribune*, quoted in Susan Arthur, "Elizabeth Olds: Artist of the People and the Times," *Elizabeth Olds Retrospective Exhibition: Paintings, Drawings, Prints*, Austin, Texas, 1986, p. 14.

18. Anita Brenner, "Revolution in Art," *The Nation* 8 (March 1933): 268.

19. The comments of Riva Helfond and Elizabeth Olds cited above refer specifically to the WPA/FAP Graphic Arts workshop.

20. See Jacob Kainen, "The Graphic Arts Division of the WPA Federal Art Project," in Francis V. O'Connor, *The New Deal Art Projects: An Anthology of Memoirs* (Washington, D.C., 1972), pp. 158–62, for a detailed description of project organization. Since the workshop lacked proper ventilation for acid fumes, intaglio printmakers had to work at home. Lithographers who wanted to work at home could have their stones delivered and returned to the workshop by a project truck.

21. Kainen, pp. 158ff.

22. Ibid., p. 158.

23. Richard McKinzie, *The New Deal for Artists* (Princeton, N.J., 1973), p. 85.

24. Cited in Mary Francey, *Depression Printmakers as Workers: Re-defining Traditional Interpretations*, exhibition catalogue, Utah Museum of Art, Salt Lake City, (1988), p. 21 n. 19 (from Deborah Solomon, *Jackson Pollock* [1987], p. 80).

25. These figures are cited in "The New Deal Art Projects in New York," pp. 76–78.

26. Also cited in O'Connor, *Federal Support for the Arts*, pp. 69ff.

27. See discussion of women's professionalism in the 1930s in Nancy Cott, *The Grounding of Modern Feminism* (New Haven, Conn., 1987), pp. 225–35.

28. For theorizations of women's fetishization as objects of the male gaze, see, for example, John Berger, *Ways of Seeing* (1972), Laura Mulvey, "Visual Pleasure and Narrative Cinema," *Screen* 16, no. 3 (Autumn 1975); Mary Ann Doane, *The Desire to Desire: The Woman's Film of the 1940's* (Bloomington, Ind., 1987); or Griselda Pollock, "What's Wrong with Images of Women?" *Looking On: Images of Femininity in the Visual Arts and Media*, ed. Rosemary Betterton (London, 1987).

29. Bishop continued to work from nude models in her studio, inspired by the practices of Renaissance drawing that she learned through her studies with Kenneth Hayes Miller at the Art Students League.

30. Union propaganda explicitly masculinized associa-

tions between industrial organizing, worker exploitation, and violent resistance through the exclusion of women's presence as workers or strikers, despite women's active participation in the labor unrest of the 1920s and 1930s. See Elizabeth Faue, " 'The Dynamo of Change': Gender and Solidarity in the American Labour Movement of the 1930s," *Gender and History* 1, no. 2 (Summer 1989): 138–58.

31. Francey, p. 13.

32. Francey, pp. 19–20, suggests that some of the increased interest in industrial subjects among printmakers can be attributed to Joseph Pennell, who was a printmaker and an effective and inspiring teacher at the Art Students League during the 1920s.

33. George Biddle and Don Freeman both included women in their portrayal of family groups suffering the economic deprivation of relief during the Depression era, and Isaac Soyer made a number of prints that sympathetically portrayed women workers as exhausted or unemployed. Isabel Bishop's portrayals of young women who were sales clerks and office workers are well known, but she shows them in moments of relaxation or companionship, outside the work environment.

34. *Artists Against War and Fascism: Papers of the First American Artists' Congress*, ed. Matthew Baigell and Julia Williams (New Brunswick, N.J.: Rutgers University Press, 1986), pp. 49–52.

35. Esther Allen, interview with Vivian Gornick, *The Romance of American Communism* (New York, 1977), p. 133. Both comments cited in Paula Rabinowitz, "Women and U.S. Literary Radicalism," *Writing Red: An Anthology of American Women Writers, 1930–1940*, ed. Charlotte Nekola and Paul Rabinowitz (New York, 1987), p. 5.

36. Park and Markowitz, p. 20.

37. Recent reassessments of American modernism include Susan Noyes Platt, *Modernism in the 1920s* (1985); John Lane and Susan Larsen, *Abstract Painting and Sculpture in America, 1927–1944* (1984); and Virginia Mecklenburg, *The Patricia and Phillip Frost Collection: American Abstraction, 1930–1945* (1989). For a reevaluation of the meanings of regionalist realism, especially important is M. Sue Kendall, *Rethinking Regionalism: John Steuart Curry and the Kansas Mural Controversy* (1986). Important current research on women artists and the representation of women during the 1930s includes Barbara Melosh, *Engendering Culture* (1991); Kim Carlton-Smith, "A New Deal for Women: Women Artists and the Federal Art Project, 1935–1939," Ph.D. dissertation, Rutgers University, 1990; and Ellen Wiley Todd, "Gender, Occupation and Class in Paintings by the Fourteenth Street School, 1925–1940," Ph.D. dissertation, Stanford University, 1988.

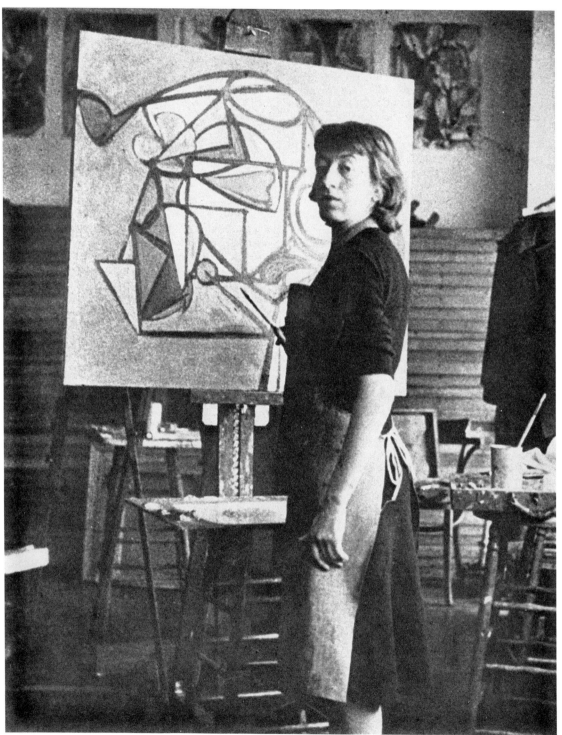

1. Unknown photographer, *Lee Krasner at the Easel in Hofmann's studio, New York,* ca. 1940 *(from Barbara Rose,* Lee Krasner, *1983).*

LEE KRASNER AS L.K.

ANNE M. WAGNER

There is no shortage of material from which to construct an account of Lee Krasner and her art in which gender could figure. Take, for example, one of the earliest of the portraits of the artist [1]: Krasner before the easel in Hans Hofmann's studio, perhaps at work on one of those very pictures about which her teacher would say, "This is so good you would not know it was painted by a woman."[1] This was praise in the early 1940s (at least in the art world), and Krasner formed herself in response to it, in ways that the photograph, with its air of slightly hostile determination, captures well enough. Yet the most vivid indication we have of the outlines, and even the contents, of her selfhood at this time are not so much paintings or photographs as a few lines from Rimbaud's *A Season in Hell*, as translated by Delmore Schwartz in 1939:

To whom shall I hire myself out?
What beast must I adore?
What holy image is attacked? What hearts shall I break?
What lies shall I maintain? In whose blood tread?[2]

From *Representations* 25 (Winter 1989): 42–57. Copyright © 1989 by the Regents of the University of California Press. Reprinted by permission of the author and the University of California Press.

Even on first reading these are violent, leveling demands, the fruits and heritage of Rimbaud's alienation, his *mauvais sang*. They are also the questions that modernism, at its best, has repeatedly asked—and then all too often lost sight of.

In the early 1940s Lee Krasner insisted on facing these questions daily. She wrote them in big black and blue characters on her studio wall, both a private blazon and a self-interrogation. That action is, I think, a measure of her identification with the Rimbaud of *A Season in Hell*—with his dismissal of mere Beauty, with his belief in the absolutely modern, and with his claim that a voyage into the depths can lead to truth. Rimbaud's phrases, and Krasner's use of them to paint by, lay down the first lineaments of a psychological—read gendered—profile; if its outline is not exactly a portrait of the artist as a young man, it certainly involved Krasner, like many women committed to high culture, in adopting the male intellectual world and stance and working in the wake of male-determined models—a kind of work, moreover, that departed, as her self-portrait of ca. 1930 suggests [2], from a fierce, interrogatory scrutiny of oneself, one's physical presence, identity, and means as a painter.[3]

But a view of Krasner alert to issues of gender

2. Lee Krasner, *Self-Portrait,* ca. 1930. New York, Courtesy of Robert Miller Gallery *(Zindman/Fremont).*

might equally logically launch itself into rather different territory, like that suggested by Hans Namuth's portrait of the artist [3], sitting folded up on a stool, a figure for the act of contemplation as she views her husband's art rather than makes her own. In this same vein let me quote the opening lines of a piece entitled "Unframed Space" from a *New Yorker* of August 1950—a month or so after Namuth's photograph.

We improved a shining weekend on Eastern Long Island by paying a call on Jackson Pollock . . . at his home, a big, gaunt white clapboard Ulysses S. Grant Period structure in the fishing hamlet of The Springs. Pollock, a bald, rugged, somewhat puzzled-looking man of thirty-eight, received us in the kitchen, where he was breakfasting on a cigarette and a cup of coffee and drowsily watching his wife, the former Lee Krasner, a slim auburn-haired young woman who is also an artist as she bent over a hot stove, making currant jelly.[4]

Enter Mrs. Jackson Pollock, as Lee Krasner was

legally known from 1945, obligingly bent over the stove, modernist anxieties very much on the back burner, at least for the time it takes currants to jell. The wifely role was one Krasner became familiar with during the eleven years of her marriage, though, despite *The New Yorker,* her version of it was not all canning pots and apron strings. After all, her particular corner of artistic bohemia was well-enough versed in psychoanalytic discourse at least to pretend to a certain irony and scorn where matrimony was concerned, if not actually to avoid it completely: Pollock chose a church wedding, you may remember, and in 1945 Mark Rothko wrote to Barnett Newman, "I want both of us to have the most beautiful wives in captivity, both of us seeming to have an untenably romantic attitude about this shady business."[5] The problem, of course, is that knowing that marriage is a shady business does not stifle the old possessive urge to have a beautiful wife. And ironizing about your wifely role when journalists come to call (after all, why choose that Saturday morning to make jelly instead of a picture?) does not stop the media from turning you into the little missus.

It's hard not to dwell on the fortunes of the former Lee Krasner, from 1945 through the early fifties, partly because their outlines are so classic. Being Mrs. Pollock meant being summoned by Pollock's gallery to stuff envelopes in the pinch before a show. It meant, on a slightly higher plane, keeping the facts straight about one's husband's work: prices, buyers, titles. *The New Yorker* didn't fail to note this role too: " 'What's it called?' we asked. 'I've forgotten,' he said, and glanced inquiringly at his wife, who had followed us in. 'Number Two, 1949, I think,' she said." Such services were the willing contribution of a person with a gift for organization; more notable was the public substitution, in the wake of the marriage, of the person known as Mrs. Pollock for the painter called Lee Krasner. Of course Mrs. P. was acknowledged to paint as well, even well enough to exhibit, once in a while. In 1949 she was invited, along with her husband, to be in a show at Sidney Janis called *Artists: Man and Wife.* Whatever confidence the two of them may have had in exposing, side by side, the complementarity and relatedness of their

work must have evaporated when the reviews came out. Read *Art News* on their contribution: "There is also a tendency among some of these wives to 'tidy up' their husbands' styles. Lee Krasner (Mrs. Jackson Pollock) takes her husband's paints and enamels and changes his unrestrained, sweeping lines into neat little squares and triangles."[6]

Any account of the public retooling of Krasner's identity would not be complete, however, if it failed to notice the process that turned her back into Krasner again. She died in 1984, having been reclaimed as an artist in the late 1960s and 1970s, particularly by feminist art historians who, unlike others in those days, were able to see her as more than the best living source of information about Pollock. Her rehabilitation, interestingly enough, was solidified by media attention as symptomatic of its day and age, as were the first journalistic responses to Pollock of theirs. In 1949 *Life* asked the question, "Jackson Pollock: Is He the Greatest Living Painter in the United States?" In 1972 *Time* declared unequivocally that Krasner was "Out of the Shade." The metaphor was, shall I say, a tested one, though apparently not so stale as to prohibit its repetition. In succeeding years, according to the headlines, Krasner variously "put Mrs. Jackson Pollock in the shade," "showed her true colors," became "an artist in her own right," "found her own voice," came "out of the shadows to gain recognition," moved "out of Pollock's shadow," and graduated "from disciple to individualist."

These epithets, with their pretensions to a heroics of Woman as Survivor, are as much evidence of the construction of Lee Krasner in gendered terms as are any of the details I have so far cited. They could hardly be otherwise, in that gender, as a less-than-stable social phenomenon, is negotiated in social practice, including the feminist kind. We do not yet know enough about the operations of such phenomena—particularly about the

3. Hans Namuth, *Lee Krasner in Jackson Pollock's Studio at The Springs*, 1950. New York, Estate of Hans Namuth (© *Hans Namuth, 1988*).

IRASCIBLE GROUP OF ADVANCED ARTISTS LED FIGHT AGAINST SHOW

The solemn people above, along with three others, made up the group of "irascible" artists who raised the biggest fuss about the Metropolitan's competition (following pages). All representatives of advanced art, they paint in styles which vary from the dribblings of Pollock (Life, Aug. 8, 1949) to the Cyclopean phantoms of Baziotes, and all have distrusted the museum since its director likened them to "flat-chested" pelicans "strutting upon the intellectual waterlands."

From left, rear, they are: Willem de Kooning, Adolph Gottlieb, Ad Reinhardt, Hedda Sterne; (next row) Richard Pousette-Dart, William Baziotes, Jimmy Ernst (with bow tie), Jackson Pollock (in striped jacket), James Brooks, Clyfford Still (leaning on knee), Robert Motherwell, Bradley Walker Tomlin; (in foreground) Theodoros Stamos (on bench), Barnett Newman (on stool), Mark Rothko (with glasses). Their revolt and subsequent boycott of the

show was in keeping with an old tradition among avant-garde artists. French painters in 1874 rebelled against their official juries and held the first impressionist exhibition. U.S. artists in 1908 broke with the National Academy jury to launch the famous Ashcan School. The effect of the revolt of the "irascibles" remains to be seen, but it did appear to have muddled the Metropolitan's juries into turning more than half the show into a free-for-all of modern art.

4. Nina Leen, *The Irascibles*, 1951. Reproduced from *Life*, January 1951 *(Photo Library, University of California, Berkeley)*.

logic that enforces and eases the strictures and prohibitions shaping social identity. And we know equally little about them in their historical dimension, either as a template for *mentalités* or, much less broadly, in the specific instance at hand, in terms of their impact on the construction of a postwar artistic subculture. Let me offer one brief sounding of the depth of our ignorance—the notorious, brilliant photograph of the "Irascibles" taken by Nina Leen for *Life* in 1951 [4]. Once you ask—if you ask—that familiar question, "Who's the woman?"—it's the painter Hedda Sterne— her cultural anonymity, versus the identities allotted Newman or Robert Motherwell or Adolph Gottlieb or Rothko or even James Brooks, is laid bare. The issue here is not only the status of forgotten women artists (though Lord knows I find it hard to claim that their lack of status is *not* an issue).[7] Likewise the tenor of critical response to

their work—Greenberg in 1944 calling Sterne's art "a piece of femininity," for example; or the *Times* critic in 1942 titling his account of the annual exhibition of the National Association of Women Artists "Shall We Join the Ladies?"; or, Greenberg again, in 1947, faintly hoping in print that Gertrude Barrer would not succumb to "the social and cultural handicaps that frustrate female talent"—such critical responses, as I say, are not in and of themselves the issue.[8]

What concerns me in the particular instance of Lee Krasner, and in the general case of artists who are female, is the problem of how an artist's subjectivity, that sense-of-oneself-as-an-artist (a sense inseparable from an idea of one's art) is formed in conditions like the ones I have just outlined. What kind of uneasy peace is made between gender identity and artistic identity? What gender hybrid is the result? How is artistic identity forced to restructure itself in the face of shifts in social status and experience, in the wake of career successes or setbacks, for instance, or of marriage, or birth, or even death? Gender stereotypes hit hard in such circumstances. As social facts that form part of the conditions of production of art, they leave their marks on it, limit and define it, just as they shape the artist, offering materials for hesitation and doubt and strength concerning one's place and identity within contemporary practice. The study of gender is thus meant here as part of a social history of art still in the making, a history whose efforts will not best be spent adjudicating influence, or establishing claims of priority and territory vis-à-vis the various technical and symbolic strategies of Abstract Expressionist painting. Did Bradley Walker Tomlin in fact learn from Krasner when he saw her pictures in the guest bedroom at The Springs? When Krasner employs her technique of controlled drips is this evidence of—horrors—dependence on Pollock? Or vice versa? If these are not to my mind the important questions, however, I find it equally fruitless to make an effort to move Krasner "out of Pollock's shadow" onto her own, sunny, heroic little patch of turf. Just as the Rimbaud quote says something about her private self, the documents about Krasner's life married to Pollock insist that, as a

painter and a person, she was more or less obliged to fit herself into a socially prescribed role. Rewriting history around issues of gender is not about reversing the "facts," whatever they may be; it is about taking both public and private representations and estimations of women's place in art as among the determinants both of the artist's self, and of her art.

In Krasner's case that effort first involves attention to a phenomenon that might be called "the myth of L.K." The phrase is meant to invoke not only Krasner's habitual neutered signature of the 1940s and 1950s but also her androgynous *nom de guerre* (she was born Lenore in 1908), and in even more general terms, her self-consciousness about her name and the stereotypes it might automatically call into play. Witness a story she told more than once, in which the initials are the figure of her lack of a name in the art world of dealers and critics. After Pollock bungled the arrangements for one of Peggy Guggenheim's visits to his studio, the pair met her steaming down the stairs as they came up. She was in a stew, muttering, "L.K., who is this L.K.? I didn't come to see L.K.'s work." Now Krasner: "She damn well knew at that point who L.K. was and that was really like a hard thrust."[9] Signing L.K., or not signing at all (Pollock once did it for her when she refused), or signing so her name was camouflaged as part of the painting's figuration—these stratagems are, on one level, a resistance to her art being identified and thus seen "as that of a woman"—a reluctance that went hand in hand with her refusal in 1945 to take part (at Guggenheim's request, no less) in a group show of artists who were women.[10]

Of course Krasner knew she was a woman and, I think, sometimes viewed that fact with horror, but both the knowledge and the horror were militantly kept out of her art. She was schooled to do so, for one thing, by more lessons than Hofmann's hackneyed comments. Her training took place in the art classes of the 1930s, which whether traditional or modernist functioned in the belief that art could be taught; that no matter what its procedures, its logic and language were knowable, open to analysis and definition and fruitful repetition, even by a woman, if she just painted like a man—

that is if she didn't make any moves that could be called delicate or pretty and did things the way they should be done. In *Blue Square* [5] Krasner was doing just that: insisting that she was not other, therefore painting like a man—like Arshile Gorky, to name one—in a way that bespeaks less a lack of originality than a certain confidence, inherited from Cubism, in a shared and usable abstract style uniting a community of practitioners. The credo of a painting like *Blue Square* might go something like this: I believe, like my European painter fathers, in form—line, plane, color in the service of geometry—as an available vocabulary, a positive diction whose parsing makes a painted metaphor that is a picture. Amen. Such a faith was clearly enabling for Krasner; so was the fact that she came to it in the New York of the 1930s, where for a few crucial years, as a result of government intervention, men and women worked as artists outside the confines of the dealer/critic system.

After meeting Pollock, Krasner lost her faith.

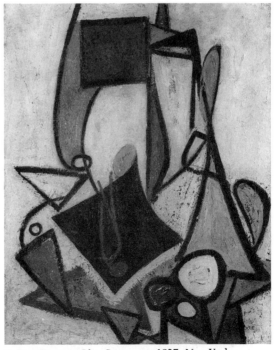

5. Lee Krasner, *Blue Square*, ca. 1937. New York, Courtesy of Robert Miller Gallery *(eeva-inkeri)*.

6. Lee Krasner, *Abstract No. 2*, 1946–48.
New York, Courtesy of Robert Miller Gallery.

She stopped painting for at least a year, and then when she began again in 1944 she could produce only thick, encrusted gray skins of paint—gray slabs, she called them. The image refused to surface, she complained, and when it did emerge it was clear that the doctrine by which it was conceived and asked for judgment had been rewritten [6, 7]. By the later 1940s, in works like *Abstract No. 2* and *Night Light,* the territory had been ceded to Pollock, the strategy apparently as well, above all in the two related but separable matters of art's sources and its metaphors. Pollock's notion of an abstract art working against nature and out of the self was now Krasner's, bringing with it benefits but also dangers for the person called L.K. Can painting out of the self—inventing a picture out of response and risk and accident—actually be done when your previous operations have been all intellect and control? Is not leaving signs and clues to the self (not only its unconscious but its bodily actions) a dangerous thing to do—might they not take the viewer back to an identity that one had made it one's business to hide? Would not such an art, like Pollock's, be open to the charge of merely arising from the emotions, from the psy-

che? In response to such risks, I believe, Krasner rewrote a Pollock-derived conception to embrace a series of strategic omissions; above all she avoided all the evocations of myth and shamanism and kabbala, as well as all the flirtations with figuration, incipient and actual, then current on the scene and perfected in Pollock's hands. In *Krasner's* hands Pollock's techniques are chastened, made anti-rhetorical, almost erased by devices imposed like a baffle before the pictures' surfaces—devices like the black network or the overlay of white flicks, which in different ways silence and repress the energy of the pours. Once in place, as in the Museum of Modern Art's untitled picture of 1949 [8], these prohibitions mean that her work simply will not coalesce into imagery, even the imagery of action. Its measure stays even-grained; its marks, though separable, are equivalents of each other; they seem, if not exactly anxious not to mean, then at least reluctant to do so. This is not to say that they are not involved with ideas of order, or even, as in this instance, with promises of writing; there is in them nothing as blatant as a pictograph or a hieroglyph—more like a letter or a number or two. But this promise

is refused, thwarted, deflected into signs at the edge of resolution. Meaning remains at the level of a resemblance approached, then skirted, once and for all.

In fact, the essence of Krasner's art, as she worked through the implications of Pollock's break with Cubism, seems to me its refusal to produce a self in painting. I am not offering this refusal as yet another high-handed modernist negation, though to my mind it helps to name the achievement of the best of her paintings in the late 1940s and early 1950s. It is more useful to recognize, I think, that this was quite simply an answer in paint—hard won, intellectually rigorous—to the most problematic issue she faced: establishing an otherness to Pollock that would not be seen as the otherness of Woman. Its urgency was only heightened by social circumstance—by being a wife.

These issues of artistic selfhood came to a head for Krasner at the moment of her first solo show at Betty Parsons late in October 1951. She had not exhibited in New York since the fiasco of "Artists: Man and Wife" two years earlier; she wouldn't show again in the city until 1955. The gallery put into motion its usual operations: ads in the *Times* and the *Herald Tribune*, announcements, an opening, a man on duty at the elevator who cleared $2.50 for his pains, a price list, of course, and though no catalogue, a brief biography.[11] The fact sheet gave her age as thirty-nine, ten days short of forty and three years younger than the truth. A telling fiddle for a first exhibition: an effort, by all appearances, to mark publicly a symbolic cultural milestone, just in the nick of time. Such symptoms of anxiety were only redoubled after the show, when Krasner destroyed or reused all but two of the fourteen paintings she

7. Lee Krasner, *Night Light*, 1949. New York, Courtesy of Robert Miller Gallery *(Zindman/Fremont)*.

8. Lee Krasner, *Untitled*, 1949. New York, Museum of Modern Art, Gift of Alfonso A. Ossorio.

had put on view: one survivor went to the Museum of Modern Art in 1969 [9]; the other, a huge canvas, is at the Miller Gallery [10].[12] Photographs of two others—numbers 4 and 12 on the price list—exist as well [11, 12]. Not much to go on, but enough to recognize that one aim of the show was certainly to measure publicly and in paint the distance between herself and Pollock, whose own annual show was due to open at Parsons twenty-three days later.

And in one sense, the strategy was successful, in that this time reviewers kept their minds on Krasner. They made it clear that all fourteen canvases manipulated finely adjusted planes of color—muted yellows, grays, and mauves, they say—in ways that read as "quiet," "discreet," "harmonious," "restrained and pacific," "majestic and thoughtful," "quietly innocuous," "sweetly cultivated," and, yes, "worked out with feminine acuteness."[13] One could easily imagine, without the "quietly innocuous," a worse string of adjectives; the effects that gave rise to them, moreover, were clearly intentional on Krasner's part; Pollock found them her best painting to date. In fact the evidence that suggests how much these fourteen

9. Lee Krasner, *Untitled*, 1951. New York, Museum of Modern Art, Mrs. Ruth Dunbar Cushing Fund.

10. Lee Krasner, *Untitled*, 1951. New York, Courtesy of Robert Miller Gallery.

11. Lee Krasner, *Untitled*, 1951, destroyed. Washington, D.C., photograph from Betty Parsons Papers, Archives of American Art (© *Smithsonian Institution*).

12. Lee Krasner, *Untitled*, 1951, destroyed. Washington, D.C., photograph from Betty Parsons Papers, Archives of American Art (© *Smithsonian Institution*).

paintings were meant as a unified showing, a kind of calculated broadside, is telling. Krasner apparently arrived at the new format after Parsons had committed to giving her a show—a commitment made on the basis of a series of big paintings on view in her studio. These pictures survive not at all; they are known only through Hans Namuth's contact sheet [13]; big black and white quasi-figural abstractions, they seem to point most clearly in the direction Pollock was about to take in his 1951 show. Instead Krasner took another route, that of the understated presence of the Museum of Modern Art picture, and as a result the reviews mention neither Pollock nor, for that matter, Krasner's marital status. Yet the terms in which the pictures *were* seen—the readings of their otherness to Pollock, with their stress on discretion and restraint, quietude and harmony—must have struck the painter as pointing to the failure of another of her

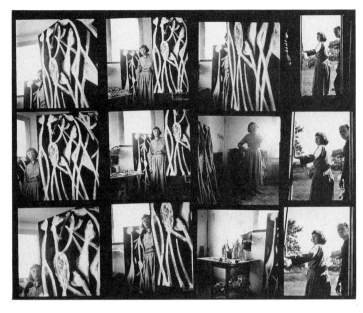

13. Hans Namuth, *Contact Sheet: Lee Krasner at The Springs Studio*, 1950. New York, Estate of Hans Namuth (© *Hans Namuth, 1988*).

allegiances—in this case to the recalcitrant, self-lacerating modernism of *A Season in Hell.* In this instance negating Pollock ended up as a kind of neutrality too easily equated with the condition and mental habits of womanhood. That posture was inimical to L.K.—above all to her fierce insistence on the possibility both of entering high culture on its terms and of making that culture her own. Thus she abandoned (wrongly, Pollock would have said) a pictorial strategy on which the label feminine could be hung.

I do not wish to end by adjudicating the rightness or wrongness of that move, though you may think my essay would have a better ending if it could show Krasner embracing difference, exploring the implications of "feminine acuteness" (remember, however, that the term meant something rather particular and more horrific back in 1951—personally I take satisfaction in knowing that Krasner first showed with a group of women in 1954). But her entry into public identity as a painter happened earlier and differently; it happened in ways that are poignant and still problematic. If it makes sense to imagine Krasner inventing a personal myth; or imagining, fearing, and resenting the reception of her painting; or regearing her art in both anticipation and response, it is because such strategies of self-definition and production, and their distortions in the public realm, continue to mediate the intersection between an individual practice, male or female, and its representation in social space. Going public—producing a self in public—means losing control and taking the consequences; even, sometimes, picking up the pieces after an outright collision between the self and gender.

NOTES

1. This canonical story, as well as much of the biographical material currently on record about Krasner, was provided by her in an interview with Cindy Nemser, published in Nemser, ed., *Art Talk: Conversations with Twelve Women Artists* (New York, 1975), pp. 80–112. The other fundamental account of Krasner's career through the 1940s is Ellen G. Landau's two-part article, "Lee Krasner's Early Career," *Arts,* October 1981, 110–22; and November 1981, 80–89. See also Barbara Rose, *Lee Krasner* (New York, 1983).

2. Arthur Rimbaud, *A Season in Hell,* trans. Delmore Schwartz (Norfolk, Conn., 1939).

3. Krasner's self-presentation here, it should be noted, carefully avoids most stereotypes of the feminine, by means that are rather like those used by Cindy Sherman in her most studiously androgynous roles. The short-sleeved denim shirt, the apron, and the cropped hair are determinedly "boyish" and businesslike, in ways that contrast with the bosky setting.

4. [Berton Roueché], "Unframed Space," *New Yorker*, 5 August 1950, 16.

5. Mark Rothko to Barnett and Annalee Newman, 31 July 1945, Newman Papers, Archives of American Art, Smithsonian Institution. I am grateful to Michael Leja for sharing with me the fruits of his research on the artistic culture of New York in the 1940s.

6. G.T.M. [Gretchen T. Munson], "Man and Wife," *Art News*, October 1949, 45.

7. Despite nearly two decades of feminist art history, the deep-seated opposition to inclusion of art made by women in the dominant histories of the discipline has shifted very little, for reasons analyzed by Griselda Pollock in her essay "Vision, Voice, and Power: Feminist Art History and Marxism," *Block* 6 (1982): 2–21.

8. For Greenberg's verdict on Sterne, see his review for the *Nation* of 27 May 1944, reproduced in Clement Greenberg, *The Collected Essays and Criticism*, ed. John O'Brian, vols. 1 and 2 (Chicago, 1986), 1:209–10; Edward Alden Jewell's review "Shall We Join the Ladies?" formed part of his regular column, "American Perspectives," *New York Times*, 11 January 1942; Greenberg's worries about the fate of Barrer, first published in the *Nation*, 8 March 1947, are reprinted in *Collected Essays*, 2:132. The general issues presented by the language of criticism in the 1940s—its sexual stereotypes and expectations—have yet to be studied. It seems worth examining the extent to which the epithets and encomia awarded to artists by Greenberg, as well as other critics, contain fairly explicit assumptions about sexual identity. Concerning William Baziotes, for example, Greenberg wrote, "Baziotes . . . is unadulterated, natural painter, and all painter. He issues in a single jet." Of Robert Motherwell: "His constant quality (in oils and collage) is an ungainliness, an insecurity of placing and drawing which I prefer to the gracefulness of his watercolors" (both citations from the *Nation*, 11 November 1944; *Collected Essays*, 1:239–41). The point, obviously, is not that a man's work could not be dismissed as graceful. Nonetheless, it remains still to be determined how much the biases of criticism—against gracefulness, or toward the ungainly—functioned to limit acceptance of women's art in particular. Was it more or less acceptable for a man to make a graceful picture than a woman? Certainly Jewell's 1942 review suggests that women were routinely expected to "try harder," to be better than "average":

It would be pleasant indeed to report that the annual exhibition of the National Association of Women Artists proves the most exhilarating show in town. But although it contains, sure enough, a lot of good, competent painting, the spark, collectively speaking, just isn't there. Individual entries might be called outstanding, and anyone who denied that there are frequent technical felicities and adroitnesses of brush simply would not know what he [*sic*] was talking about. Despite all that, I found the exhibition as a whole no better than, shall we say, "average." And art has got to be a bit more than that nowadays to expect any rousing cheers.

To date, feminist art historians in England have been most successful in attending to language not only as an artifact of gender assumptions but as a primary vehicle in enacting them. See for example, Rozsika Parker and Griselda Pollock, *Old Mistresses: Women, Art, and Ideology* (New York, 1981); Griselda Pollock and Deborah Cherry, "Woman as Sign in Pre-Raphaelite Literature: A Study of the Representation of Elizabeth Siddall," *Art History* 7, no. 2 (June 1984): 206–27; and Hilary Taylor, " 'If a young painter be not fierce and arrogant, God . . . help him': Some Women Art Students at the Slade, 1895–99," *Art History* 9, no. 2 (June 1986): 232–44.

9. Nemser, *Art Talk*, 88.

10. Landau, "Krasner's Early Career," part 2, p. 82. The fact that Krasner's work was not in the show, though her name was included on the printed checklist, suggests that she pulled out at the last moment.

11. These details and others cited here concerning the 1951 show come from frames 123–25, Betty Parsons Papers, Archives of American Art.

12. The Museum of Modern Art canvas was acquired in 1969 from Marlborough Gallery, Krasner's dealer at the time. I am grateful to the Robert Miller Gallery for their courtesy in showing me the many Krasner works in their possession.

13. These phrases are taken from the following reviews of Krasner's show: R. G. (Robert Goodnough], *Art News* 50 (November 1951): 53; D. A. [Dore Ashton], *Art Digest*, 1 November 1951, 56, 50; Stuart Preston, *New York Times*, 21 October 1951; undated clipping, "Abstract and Real," October 1951, frame 123, Betty Parsons Papers, Archives of American Art. It should be said that Krasner was not the only Abstract Expressionist artist to receive poor notices following a solo show that year; the response to Newman's exhibition was equally disastrous. And of course the issue of being other than Pollock confronted male artists, too. My emphasis here falls on the ways the "normal" phenomena of careers in art—criticism, exhibitions, and influence, for example—can become more problematic when the artist is female.

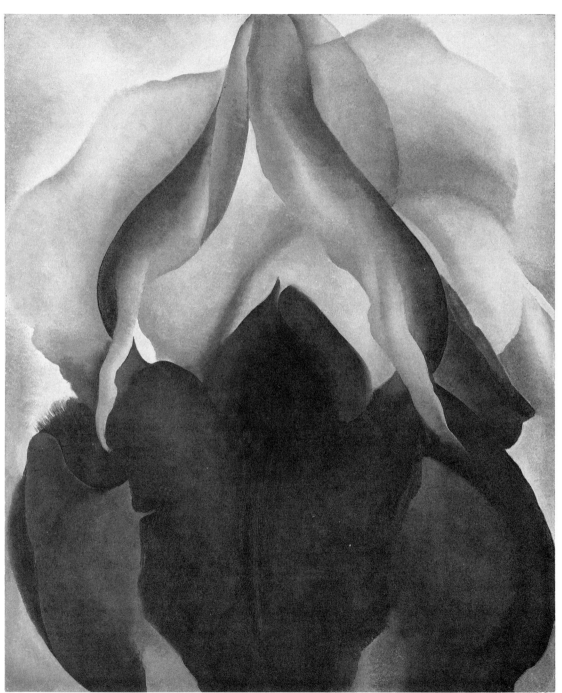

1. Georgia O'Keeffe, *Black Iris III,* 1926. New York, Metropolitan Museum of Art, The Alfred Stieglitz Collection, 1949.

GEORGIA O'KEEFFE AND FEMINISM:

A Problem of Position

BARBARA BUHLER LYNES

After Frances O'Brien interviewed Georgia O'Keeffe in 1927, she made the following observations:

If Georgia O'Keeffe has any passion other than her work it is her interest and faith in her own sex. . . . You must not, if you value being in her good graces, call her "Mrs. Stieglitz." She believes ardently in woman as an individual—an individual not merely with the rights and privileges of man but, what is to her more important, with the same responsibilities. And chief among these is the responsibility of self-realization. O'Keeffe is the epitomization of this faith.[1]

To the end, O'Keeffe epitomized the self-realized woman and artist; and thus, when certain feminist artists in the 1970s sought a similar self-realization, they naturally viewed her—then in her eighties—as a kindred spirit, a mentor. They actively praised her achievements as a woman artist and, furthermore, defined certain aspects of her paintings as among the first manifestations of an iconography they believed was specifically representative of the female. They were particularly drawn to centralized forms in her work that, to

them, closely resembled parts of a woman's sexual anatomy.

For example, in 1973 Judy Chicago and Miriam Schapiro characterized the major form in O'Keeffe's *Gray Line with Black, Blue, and Yellow* [2] as "constructed like the labia of the vagina, opening into a thin, black, membranous cavity," and they went on to describe a "central orifice" in the painting, made up of "a series of delicately painted folds, which suggest nothing less than orgiastic throbbing or contractions of labor . . . [surmounted by] a dark movement towards a peak where again the sensuous perception is that of the highly focused feeling of clitoral sensation." After exploring other aspects of her imagery that evinced what they considered "O'Keeffe's femininity," they concluded that "the range of expression in her work is far greater than one ordinarily sees in the lifetime of a man's work"; that her "oeuvre opens up the possibility of human expressiveness heretofore unavailable, particularly to men."[2]

About the same time, the art historian Linda Nochlin proposed O'Keeffe's large-format depictions of natural forms as prototypes of a particular kind of symbolic realism she recognized in the work of some contemporary women artists. Using

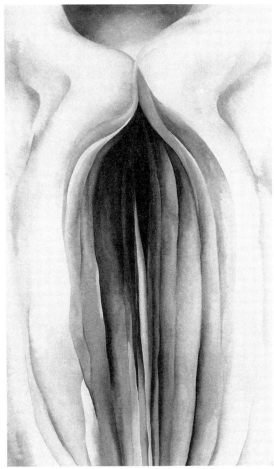

2. Georgia O'Keeffe, *Gray Line with Black, Blue, and Yellow*, 1923. Houston, Museum of Fine Arts, Agnes Cullen Arnold Endowment Fund *(A. Mewbourn)*.

O'Keeffe's *Black Iris III* [1] to illustrate her point, she stated that the painting "is a hallucinatingly accurate image of a plant form at the same time that it constitutes a striking natural symbol of the female genitalia or reproductive organs. . . . The connection 'iris–female genitalia' is immediate." She called paintings like *Black Iris III* "realist analogs, suggesting and evoking a feminine content," and O'Keeffe "a major woman artist . . . [who] made such imagery her trademark."[3]

But O'Keeffe would have none of it. Apparently ignoring the veneration implicit in these assessments of her art, she refused to validate feminist ideas or, in general, to support feminist projects.

For instance, she would not cooperate with Ann Sutherland Harris and Nochlin, who were organizing their 1977 exhibition *Women Artists—1550–1950*. As Nochlin explained, "O'Keeffe not only refused to permit any of her flower pieces to be included in this exhibition, but even refused to have them reproduced in the catalog, presumably for fear they would be misinterpreted in the context of a show of women artists."[4] What O'Keeffe told Irene Moss, who requested an interview in 1973 for the *Feminist Art Journal*, summarized her position: "I am tired of interviews and I doubt very much that I could say anything of interest to these people."[5]

O'Keeffe's attitude toward "these people" has been the subject of much speculation. She herself seemed to confirm one of the more obvious explanations when, close to her ninetieth birthday, she suggested that women, in general, had been of little value to her in her career. About a book on women artists, she stated: "A silly topic. . . . Write about women. Or write about artists. I don't see how they're connected. Personally, the only people who ever helped me were men."[6] When she gained prominence in the 1920s, however, in addition to being recognized as a feminist by the press, she was, in fact, an active member of the National Woman's Party, a radical feminist group.[7] Did O'Keeffe refuse to align herself with feminist artists and art historians five decades later because she had developed an aversion to feminism?

It is my opinion that she had not. Although no information currently available indicates that O'Keeffe was still a committed feminist in the 1970s, I will demonstrate here that she was probably no less a feminist then than in the 1920s. Furthermore, to explain why, late in life, she "resisted articulating her commitment to a female art," as Chicago put it,[8] I will argue that the idea of a "female art," as defined by feminists in the 1970s, was anathema to O'Keeffe—fundamentally at odds with the way she had promoted her intentions as an artist from the 1920s, after she determined to try to offset what critics were insinuating about her as a "woman artist."

The O'Keeffe perceived by most critics in the early years of her career was essentially the inven-

tion of Alfred Stieglitz, and his theories about creativity in general and O'Keeffe's creative drive in particular are a key to understanding why she chose to define herself as an artist as she did. Summarizing his ideas in "Woman in Art," an essay of 1919, he asserted that women had the potential to make art that might "live side by side with male produced Art,"[9] implying that the creative powers of women transcended traditional definitions of them—those that had centered on the female's ability to bear children. By 1916, when Stieglitz introduced O'Keeffe's art at 291 in a group show that included ten of her charcoal drawings—among them, *Special No. 9* [3]—he had already demonstrated his respect for women artists by staging exhibitions of the work of Marion H. Beckett, Katharine N. Rhoades, and Pamela Colman Smith.

But to Stieglitz, O'Keeffe's art was another matter entirely. In the October 1916 issue of *Camera Work,* he made it clear that he believed her work surpassed that of other women: "[The] exhibition, mainly owing to Miss O'Keeffe's drawings, attracted many visitors and aroused unusual interest and discussion. It was different from anything that had been shown at '291.' . . . Miss O'Keeffe's drawings besides their other value were of intense interest from a psycho-analytical point of view. '291' had never before seen woman express herself so frankly on paper."[10]

Stieglitz also published comments about the drawings written by Charles Duncan, one of the artists in the show, and Evelyn Sayer, a woman who had apparently attended the exhibition. Duncan called the forms in O'Keeffe's art "delicate, frequently immense, feminine," and by pointing out that they expressed the "fire and flow of a fresh sensualism," he suggested that their inspiration was something other than the visual world.[11] Sayer, however, was unequivocal about the origin of O'Keeffe's imagery. She viewed the drawings as a manifestation of female sexuality: "I feel very hesitant about trying to write an appreciation of the woman pictures. I was startled at their frankness; startled into admiration of the self-knowledge in them. How new a field of expression such sex consciousness will open."[12]

When he first saw them in January 1916, Stieglitz responded immediately to O'Keeffe's drawings as the work of a woman: "Why they're genuinely fine things—you say a woman did these—She's an unusual woman—She's broad minded, she's bigger than most women, but she's got the sensitive emotion—I'd know she was a woman—Look at that line."[13] Moreover, Duncan's and Sayer's observations affirm that from the first Stieglitz promoted the idea that the art of this "unusual woman" was, in fact, a visualization of female sexual nature. And in stating that O'Keeffe's work had generated "intense interest from a psycho-analytical point of view," he encouraged Freudian interpretations of it, a fact also confirmed in Duncan's and Sayer's remarks.

In "Woman in Art," Stieglitz maintained that, because of her extraordinary expressive powers, O'Keeffe had been able to transcend the training she received from male teachers: "In the past a

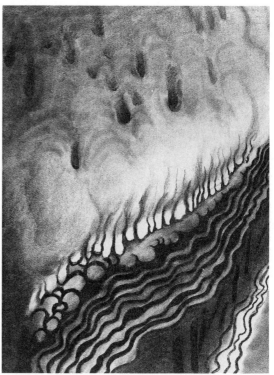

3. Georgia O'Keeffe, *Special No. 9,* charcoal on paper, 1915. Houston, The Menil Collection *(Paul Hester).*

few women may have attempted to express themselves in painting. . . . But somehow all the attempts I had seen, until O'Keeffe, were weak because the elemental force & vision back of them were never overpowering enough to throw off the Male Shackles. Woman was afraid. She had *her* secret. Man's Sphinx!!" Although he did not specify the source of O'Keeffe's "elemental force & vision," he described her as "the Woman unafraid," who was able to reveal an aspect of herself that earlier women artists had concealed.[14]

Furthermore, he declared that O'Keeffe's creative powers were comparable to "any man's," but that notion—remarkable for 1919—was tempered by his agreement with the widely held belief that men's and women's elemental feelings (which he called "one of the chief generating forces crystallizing into art") were "differentiated through the difference in their sex make-up." As he stated, "Woman *feels* the World *differently* than Man feels it. . . . The Woman receives the World through her Womb. That is the seat of her deepest feeling."[15] By suggesting that there might be equality between the sexes in art, Stieglitz adopted a revolutionary position; but by simultaneously calling attention to biological differences between men and women, he implicitly categorized them as separate and unequal and, thus, neutralized the strength of that position.[16]

The inconsistency of his thinking about O'Keeffe herself was made very clear in the forty-five photographs of her that were part of his retrospective exhibition at the Anderson Galleries in New York in 1921. In some of the images, he presented her as an assertive and independent woman and as an artist—a category from which women traditionally had been excluded. But in others, he presented her as a femme fatale and explored her body in a personal tribute to female sexuality. Because of their still-remarkable candor, these nudes sensationalized the exhibition, weakening the effect of whatever Stieglitz may have intended to state about O'Keeffe's distinctiveness as an artist and as a woman. And by having her gesture suggestively in front of her work in several images [4], he confirmed that in his view her expression was intricately related to her body and,

therefore, a revelation of female sexual experience.

Stieglitz's ideas about O'Keeffe and her work strongly influenced Marsden Hartley and Paul Rosenfeld, two of his close friends, whose essays of 1921–22 further eroticized O'Keeffe's art and reconfirmed the idea that she was obsessed with the sexual dimension of her nature.[17] The following excerpt from Hartley is rife with oblique references to the Stieglitz photographs and, in particular, to "the Woman unafraid" pictured in some of them: "With Georgia O'Keeffe one . . . sees the world of a woman turned inside out and gaping with deep open eyes and fixed mouth at the rather trivial world of living people. . . . The pictures of O'Keeffe . . . are probably as living and shameless private documents as exist, in painting certainly, and probably in any other art. By shamelessness I mean unqualified nakedness of statement. . . . The work . . . startles by its actual experience in life."[18]

Rosenfeld's ideas reflected what Stieglitz had expressed about O'Keeffe both in his photographs and in "Woman in Art." For example:

The pure, now flaming, now icy colours of this painter, reveal the woman polarizing herself, accepting fully the nature long denied, spiritualizing her sex. Her art is gloriously female. Her great painful and ecstatic climaxes make us at last to know something the man has always wanted to know. For here, in this painting, there is registered the manner of perception anchored in the constitution of the woman. The organs that differentiate the sex speak. Women, one would judge, always feel, when they feel strongly, through the womb.[19]

The idea that Hartley and Rosenfeld publicized—that O'Keeffe's art was a correlative of female sexual experience—held an extraordinary appeal. It was the dominant theme of the reviews of her first major exhibition in 1923 and continued to shape the thinking of most critics who reviewed her work in that decade. Again and again, their articles implied that this "woman artist" was expressing her femaleness in her art, which, therefore, revealed an essential truth about the female (sexual) experience.

O'Keeffe disagreed. Almost from the beginning she expressed her aversion to Hartley's and Rosenfeld's ideas about her and their interpretations of

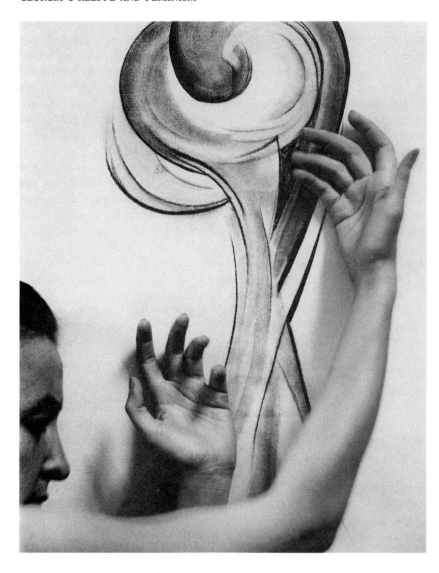

4. Alfred Stieglitz, *Georgia O'Keeffe: A Portrait*, gelatin silver print, 1918. Washington, D.C., National Gallery of Art, Alfred Stieglitz Collection.

her art. As she wrote in 1922, "You see Rosenfeld's articles have embarrassed me—[and] I wanted to lose the one for the Hartley book when I had the only copy of it to read—so it couldn't be in the book. The things they write sound so strange and far removed from what I feel of myself."[20] But although she obviously did not approve of these elaborate, Stieglitz-inspired assumptions about her as a woman artist, she could not have disapproved, at the time, of a simple association of her art with herself as a woman.

In 1916, shortly after she learned that Stieglitz had reacted to her art *primarily* as the work of a woman, she made the first statement that indicated her awareness of a female quality in her work. About a drawing, she wrote, "The thing seems to express in a way what I want it to but—it also seems rather effeminate—it is essentially a woman's feeling—satisfies me in a way."[21] By 1926, she had evidently come to believe in the importance of her work as an expression of the feminine. As she told critic Blanche Matthias,

"You seem to feel something about women akin to what I feel—and if what I am doing moves towards that—it is something."[22] (The year before, she had implied to Mabel Dodge Luhan that men had not been able to comprehend her art because its meaning was bound to her femaleness: "I thought you could write something about me that the men cant. . . . I feel there is something unexplored about woman that only a woman can explore."[23]) Finally, in 1930, in a debate with *New Masses* editor Michael Gold, she stated straightforwardly that she was attempting as an artist to express herself as a woman: "Before I put brush to canvas, I question 'Is this mine? Is it all intrinsically of myself? Is it influenced by some idea or some photograph of an idea which I acquired from some man?' . . . I am trying with all my skill to do painting that is all of a woman, as well as all of me."[24] But in 1943 she refused to participate in an exhibition of women's art, organized by Peggy Guggenheim at Art of This Century, insisting that she was not a "woman artist" and, more than thirty years later, she pointed out, "I have always been very annoyed at being referred to as a 'woman artist' rather than an 'artist.' "[25]

But if, as she stated, O'Keeffe considered her art a reflection of her womanliness, how could she object to being described as a "woman artist"? She objected, I believe, because she felt the term *woman artist* imposed limitations on the expressive meaning of her work—a conclusion she reached in the early 1920s, when she became convinced that, as a female working within a male-structured profession, her art was being evaluated solely within male-conceived ideas of what it was about and, in addition, her career was being inhibited by male-conceived ideas of what it should be. As a feminist, she was particularly sensitive to issues of sex discrimination, and she expressed her feelings about this subject through her association with the National Woman's Party (NWP).[26]

The NWP's Equal Rights Amendment (ERA), presented to Congress in December 1923 without the support of other feminist groups, made no concessions to sex-based legislation. Although many members of the NWP had earlier supported protective labor laws, the party took the position in the 1920s that they were discriminatory and would continue to facilitate the "law's keeping women 'segregated as a class.' "[27] As the banker Mrs. Jacob Riis was quoted in the 6 March 1926 issue of the party's publication, *Equal Rights*, "Because economic independence is essential to real freedom, women must fight for equal opportunity in the economic world."[28]

O'Keeffe subscribed to this position, and at the height of the controversy over the ERA, she was among those invited to speak at a dinner held on 28 February 1926 in Washington, D.C., to honor Jessie Dell, chair of the Government Workers' Council of the NWP, who had recently been appointed Civil Service Commissioner. *Equal Rights* quoted O'Keeffe's speech to the assembly as follows:

I have always resented being told that there are things I cannot do because I am a woman. I remember how I used to argue with my brother about which were best, boys or girls. When I argued that girls were best, and gave as proof the fact that mother was a woman, he said, "But father is a man, and God is a man, too!" I think that has always rankled.

When a woman singer sings, they do not expect that she sing exactly like a man. But if a woman painter paints differently from a man, they say, "Oh, that is woman. That has nothing to do with painting." They have objected to me all along; they have objected strenuously. It is hard enough to do the job without having to face the discriminations, too. Men do not have to face these discriminations.

I never belonged to anything. But when Miss (Anita) Pollitzer began to talk to me about the Woman's Party, I said, "I do not see why every woman does not belong." I still do not understand why every woman does not join the Woman's Party.[29]

About a year earlier, O'Keeffe had faced one aspect of the discriminations she spoke about, when she began to consider using the city as subject matter in her paintings and, as she put it, "the men decided they didn't want me to paint New York."[30] It was suggested that painting the city was not in the best interest of her career: "I was told that it was an impossible idea—even the men hadn't done too well with it."[31] Unconvinced, she

completed *New York with Moon* (1925, private collection) and asked that it be included with her other work in the group exhibition "Seven Americans," staged by Stieglitz in March 1925. But her fellow exhibitors—among them Arthur Dove, Hartley, John Marin, and Stieglitz himself—refused to allow the painting to be hung. As she commented in 1965, "In that day . . . the painters and the art patrons figured it was strictly a man's world,"[32] and apparently, by appropriating the subject of the city in *New York with Moon*, O'Keeffe had invaded that world.

But the following year, when the painting (along with several others of similar subject matter) was included in her one-woman show, which opened on 11 February 1926—just seventeen days before she spoke in Washington—it sold immediately. And although she recalled later with some irony, "From then on they *let* me paint New York,"[33] the words she spoke at the Dell event conveyed how bitterly she resented that opinions about what she could or could not do as an artist had been based on the fact that she was a woman. O'Keeffe's belief "in woman as an individual . . . with the rights and privileges of man" (as O'Brien reported in 1927) reflects what Nancy Cott has called the NWP's "language of liberal individualism,"[34] through which O'Keeffe and its other members advocated equal rights and opportunities for women. In so doing, they hoped to transcend what an *Equal Rights* editorial described in 1926 as the "circumstance that for some several ages the sex of women has been regarded as a badge of innate inferiority."[35]

Well into the 1940s, O'Keeffe declared her continuing loyalty to this position, in comments quoted by *Equal Rights* in its June 1942 issue[36] and in a letter she wrote to Eleanor Roosevelt in 1944, admonishing her for not supporting the ERA:

May I say to you that it is the women who have studied the idea of Equal Rights and worked for Equal Rights that make it possible for you, today, to be the power that you are in our country, to work as you work and to have the kind of public life that you have. . . . Equal Rights and Responsibilities is a basic idea that . . . could very much change the girl child's idea of her place in

the world. I would like each child to feel responsible for the country and that no door for any activity they may choose is closed on account of sex.[37]

Clearly, O'Keeffe was intolerant of all thinking that differentiated between men and women on the basis of sex; and this provides a broad basis for her objection to sex-based opinions about what she expressed as a "woman artist."

By the mid-1920s, she had had enough of these opinions. She wondered in a letter to Sherwood Anderson if "man has ever been written down the way he has written woman down";[38] and when she asked Luhan to write about her, she stated, "What I want written—I do not know—I have no definite idea of what it should be—but a woman who has lived many things and who sees lines and colors as an expression of living—might say something a man cant— . . . Men have done all they can do about it."[39] What is apparent in these mid-decade complaints about the criticism is her belief that the feminine dimensions of her work had been misunderstood and, thus, that what she thought she expressed as a woman (which she never made clear) was something quite apart from her sexuality. And it is also apparent that O'Keeffe ignored the fact that, beginning with Evelyn Sayer in 1916, female as well as male critics had perpetuated the idea that as a woman she expressed her sexuality in her art.

O'Keeffe knew from the beginning that Stieglitz was the ultimate source of the declarations that her work had erotic content, and she found those declarations insupportable. As she stated in 1974, "Eroticism! That's something people themselves put into the paintings. They've found things that never entered my mind. That doesn't mean they weren't there, but the things they said astonished me. It wouldn't occur to me. But Alfred talked that way and people took it from him."[40] Stieglitz believed O'Keeffe was the first woman to allow her sexual feelings to inform her art—a condition he felt essential to artistic expression—and this belief, which he never abandoned, was the basis of his claim that she was "the first real woman painter not only of [America] but in the world."[41] Accordingly, critics who followed

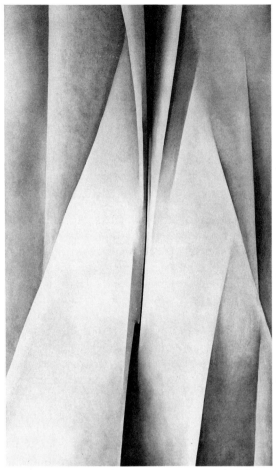

5. Georgia O'Keeffe, *Abstraction*, 1926. New York, Whitney Museum of American Art *(Geoffrey Clements)*.

his lead unfailingly viewed her "woman's art" as the quintessence of female eroticism.

The term *woman artist,* as applied generally in the early decades of this century, isolated a woman's art and, therefore, effectually denied it access to broad critical associations. And furthermore, as applied specifically to O'Keeffe by critics in the early 1920s, the term implied that the expression of female sexuality was fundamental to her intentions as an artist. Thus, although O'Keeffe could never have protested the recognition of qualities in her work centered in female experience (she recognized them herself), she resented being discriminated against as a "woman

artist," with the limiting associations with eroticism implied in the term, and began a campaign in 1923 to persuade critics to write about her work without referring to her sex.

At this point in her career, O'Keeffe knew that she could neither reverse Stieglitz's thinking about her art nor openly contradict the idea of her he was promoting. He was one of the most powerful figures in the New York art community, and his promotion had given O'Keeffe a prominence that rivaled male artists in the vanguard of America's fledgling modernist movement. Moreover, as her work achieved critical distinction under Stieglitz's support, she could see that she might realize financial independence through its sales, and in the early 1920s, such sales were generated and controlled solely by him. Finally, she had been intimately involved with Stieglitz since 1918, and her loyalties to him were profound.

So, when her exhibition opened in 1924, she had done as much as she felt she could to address the problem of the criticism. The catalogue contained excerpts from reviews of her 1923 show and a brief statement by O'Keeffe; but the reviews had been edited—apparently at her insistence—to eliminate references to Hartley's and Rosenfeld's ideas about her, and her statement expressed hope that the exhibition would "clarify some of the issues written of by the critics and spoken about by other people."[42] What she wanted most to clarify were her intentions as an artist, and long before the catalogue was prepared, she took a remarkable step to ensure that the exhibition would make those intentions clear. To forestall a repetition of the Freudian interpretations her abstractions provoked in the 1923 reviews, she addressed the one variable in the artist-critic exchange over which she had complete control and turned most of her attention to the depiction of natural forms.

As she explained, just before the opening of the show, "My work this year is very much on the ground—there will be only two abstract things— or three at the most—all the rest is objective—as objective as I can make it— . . . I suppose the reason I got down to an effort to be objective is that I didn't like the interpretations of my other things."[43] In presenting an exhibition dominated

by "objective" paintings, she was attempting to call into question the critical consensus that, as a woman artist, she was obsessed with her sexual feelings.

For the most part, reviews of the 1924 exhibition compared her "intuitive" paintings with Stieglitz's "intellectual" photographs (which were shown simultaneously), and there were only a few indirect references to eroticism in O'Keeffe's work. So, probably encouraged, she continued to curtail her experiments with nonrepresentational imagery and, consequently, began to change a balance within her art that she had previously felt appropriate to its development. She never worked with abstract imagery as frequently after 1923; and furthermore, the paintings without recognizable subject matter she produced in the second half of the decade, such as *Abstraction* [5], are decidedly less expressive and evocative than those she completed earlier, such as *Special No. 9*, 1915 [3].[44]

In the second half of the decade, she continued her "effort to be objective"[45] and, in addition, began to give interviews. As journalists reported what they actually observed about her and what she said about herself and her art, they described an uncompromisingly serious, professional artist—a woman vastly different from the one Rosenfeld had characterized when he wrote about her work, "All is ecstasy here, ecstasy of pain as well as ecstasy of fulfilment."[46] About the same time, some critics began to define her work in traditionally "masculine" terms—as innovative and intellectual. This afforded O'Keeffe a taste of the status she sought—one that did not differentiate her from her male contemporaries and, as a result, challenged the "woman-expressing-her-woman-self" conception of her that Stieglitz continued to promote.[47]

But such challenges only managed to establish a dichotomy among the critics at large, and pronouncements that O'Keeffe was a woman expressing her feelings persisted in the criticism. More particularly, sexualized interpretations of her work, especially her flower paintings, continued to be aired by critics into the 1930s, much to O'Keeffe's distress.[48]

She began her large-format paintings of flowers in 1924, about a year after she decided to make imagery she believed would not be misinterpreted, and she continued to exhibit them for years. This may seem puzzling because, by the end of the 1920s, the flowers were as controversial as her early abstractions had been. For although a painting like *Black Iris III* [1] can be seen as an exact imitation of a natural form and, thus, unequivocal in its meaning, it can also be seen as a symbol of female sexuality—an interpretation first suggested by Lewis Mumford in 1927.[49] If, as Nochlin has proposed, the presentation of the flower in such paintings—magnified and without context—dramatizes the resemblance of its parts to female genitalia,[50] why did O'Keeffe continue to depict these forms in a manner that invited sexual interpretations?

In the catalogue of her show in 1926, the second consecutive year the flowers were shown, O'Keeffe explained why she painted them: "One rarely takes the time to really see a flower. I have painted what each flower is to me and I have painted it big enough so that others would see what I see."[51] But it was not until some thirty-five years later that she elaborated her reason for enlarging the flowers:

I'll tell you how I happened to make the blown-up flowers. In the twenties, huge buildings sometimes seemed to be going up overnight in New York. At that time I saw a painting by Fantin-Latour, a still-life with flowers I found very beautiful, but I realized that were I to paint the same flowers so small, no one would look at them because I was unknown. So I thought I'll make them big like the huge buildings going up. People will be startled; they'll *have* to look at them—and they did.[52]

And in 1971, she spoke with apparent candor about her motivation.

In those days people weren't buying paintings, period. . . . I began painting my very large flowers, thinking not only that it provided a unique perspective on a familiar object, but frankly, that it would make New York take notice. . . . I remember Alfred looking at my first painting of a large flower, squinting at it and muttering, "Well, Georgia, you aren't planning to show anyone

that, are you?" I sold that painting for $1200—he was impressed, I can tell you.[53]

It seems clear that O'Keeffe continued making the paintings because they served her well. In addition to obvious technical considerations (the subject was easily available and lent itself to variation and simplification in serial interpretations), from the first, the paintings commanded attention and generated sales. She intended the flowers to be shocking—and therefore a stimulus to interest in her work—but in her view, they shocked simply because they were small forms enlarged to many times their actual size. Furthermore, it is probable that she went ahead with them because she believed that, unlike her turn-of-the-decade abstractions, the flower paintings could not be interpreted reasonably as anything but enlarged depictions of natural forms, refusing to entertain the idea that they were any more symbolic of female sexuality than her paintings of skyscrapers were symbolic of male sexuality.

In any case, nothing she ever said or wrote about the flowers suggests that she *intended* to call attention to similarities between them and human anatomy and, in turn, to inspire contentions, like Nochlin's, that a painting such as *Black Iris III* is an icon of female sexuality. In fact, her first public statement that addressed any interpretation of her art specifically repudiated sexualized readings of her flower paintings. As part of a statement for the catalogue of her 1939 show, she wrote, "Well—I made you take time to look at what I saw and when you took time to really notice my flower you hung all your own associations with flowers on my flower and you write about my flower as if I think and see what you think and see of the flower—and I don't."[54]

On numerous occasions late in her life, she denied outright the validity of sexualized readings of her work. As she stated in two interviews in 1970, "The critics [who write about sexual symbolism in my work] are just talking about themselves, not what I am thinking"; and "When people read erotic symbols in my paintings they're really talking about their own affairs."[55] This response to the idea of eroticism in her art had been formu-

lated in 1922, after Hartley's and Rosenfeld's first essays appeared,[56] and O'Keeffe never varied it—steadfastly refusing to entertain the idea, regardless of whatever differences in motivation may have inspired continuing assertions of it down through the years.

Therefore, she would only have responded negatively when, for example, Chicago and Schapiro interpreted *Gray Line with Black, Blue, and Yellow* [2] as an exercise in eroticism, stating with a directness previously unknown in the O'Keeffe criticism that the painting was permeated with suggestions of "orgiastic throbbing" or "clitoral sensation." And their sexualized reading of *Black Iris III* [1] must have revitalized in O'Keeffe's mind the broader ideas that she painted what it was to be a woman and that the forms in her work reflected the forms of her body—ideas she had worked persistently from the 1920s to counteract in the criticism:

O'Keeffe . . . painted a haunting mysterious passage through the black portal of an iris, making the first recognized step into the darkness of female identity. . . . She painted out of an urgency to understand her own being and to communicate as yet unknown information about being a woman. . . . There is now evidence that many women artists have defined a central orifice whose formal organization is often a metaphor for a woman's body. The center of the painting is the tunnel; the experience of female sexuality.[57]

Although Nochlin referred to the same painting as a "striking natural symbol of the female genitalia," her concern did not seem to be whether O'Keeffe set out to make it so. On the other hand, by claiming that O'Keeffe "painted [it] . . . to understand . . . and to communicate . . . information about being a woman," Chicago and Schapiro affirmed that they believed O'Keeffe made *Black Iris III* specifically to be "a metaphor for a woman's body." In stating this, with no reference to the history of O'Keeffe's reaction to such claims, they unintentionally invalidated everything she had said about her intentions as an artist since the 1920s and effectually silenced her own opinions about her work.[58]

But regardless of the subtleties that may have

distinguished Nochlin's from Chicago's and Schapiro's analysis of *Black Iris III*, to O'Keeffe a declaration that there was *any* emblematic content in this painting, let alone female sexual symbolism, would have seemed particularly off the mark. She had painted it in 1926, three years after she consciously decided to make her imagery, as she put it, "as objective as I can," in an effort to end critical speculation about her work.

O'Keeffe never explained her refusal to endorse feminist interpretations of her art or feminist activities in the 1970s, but it seems clear that it had nothing to do with an aversion to or rejection of feminism. Her long-term support of feminist activities is a matter of record, and there is no reason to assume that she abandoned her belief in women's rights when she was in her eighties. The inescapable conclusion is that she simply did not agree with what feminist artists and art historians were doing.

First, she objected to their isolation of the work of women artists and their examination of it as "women's art." When she stated in 1977 that she thought the topic of a book about women artists was "silly," that she did not see a connection between the term *woman* and the term *artist*, she meant exactly what she said. As a result of her determination not to be limited by what she felt the linking of these terms implied about the nature of her expression, she had spent most of her career attempting to assert that she was not a woman artist, she was an artist.[59] And second, she objected to what some feminists were saying about sexual symbolism in her work. Considering her overwhelmingly negative response to such interpretations of her art throughout her career, regardless of their source, she would have rejected statements proposing a connection between her sexuality and her work had they come from *anyone*. That she would not approve of them coming from feminists is incidental.

NOTES

This essay grew out of my study of the early criticism of O'Keeffe's work (O'Keeffe, Stieglitz and the Critics, 1916–1929 [Ann Arbor, Mich.: UMI Research Press, 1989; Chicago: University of Chicago Press, 1991]), which reprints most of the criticism of O'Keeffe's art before 1930, much of which is not readily available. (In the notes, I refer to the book as OS; *and throughout, O'Keeffe's and Stieglitz's words are quoted exactly as they appear in the sources cited.) I am very grateful for the perceptive readings of earlier drafts of this essay that I received from Maurice Berger, Norma Broude, Mary D. Garrard, Lamar Lynes, and Claire Richter Sherman, and for the help and support Lamar Lynes has given me in its preparation.*

1. Frances O'Brien, "Americans We Like: Georgia O'Keeffe," *Nation* 125 (12 October 1927): 362 (in OS, app. A, no. 67).

2. Judy Chicago and Miriam Schapiro, "Female Imagery," *Womanspace Journal* 1 (Summer 1973): 11, 13.

3. Linda Nochlin, "Some Women Realists: Part I," *Arts Magazine* 48 (February 1974): 46–49.

4. Linda Nochlin, "The Twentieth Century: Issues, Problems, Controversies," in Ann Sutherland Harris and Linda Nochlin, *Women Artists: 1550–1950* (New York: Alfred A. Knopf, 1977), p. 59 n. 209. O'Keeffe also would not allow Lawrence Alloway to reproduce six of her paintings in a late-decade article that examined, among other things, Chicago's and Schapiro's interpretations of her work (see Lawrence Alloway, "Author's Note," in "Notes on Georgia O'Keeffe's Imagery," *Womanart* 1 [Spring–Summer 1977]: 18).

5. Irene Moss, "Georgia O'Keeffe and 'these people,'" *Feminist Art Journal* 2 (Spring 1973): 14.

6. In Tom Zito, "Georgia O'Keeffe, at Home on Ghost Ranch," *Washington Post*, 9 November 1977, sec. C, p. 3.

7. For a discussion of the origin and development of the National Woman's Party, see Nancy F. Cott, *The Grounding of Modern Feminism* (New Haven, Conn.: Yale University Press, 1987), pp. 53–81.

8. Judy Chicago, *Through the Flower: My Struggle as a Woman Artist* (Garden City, N.Y.: Doubleday & Co., 1975), p. 177.

9. In Dorothy Norman, *Alfred Stieglitz: An American Seer* (New York: Random House, 1973), p. 138.

10. [Alfred Stieglitz], "Georgia O'Keeffe—C. Duncan—Réné [*sic*] Lafferty," *Camera Work* 48 (October 1916): 12 (in OS, app. A, no. 2).

11. Ibid.

12. Ibid., p. 13.

13. In Anita Pollitzer to O'Keeffe, 1 January 1916, Collection of American Literature, Beinecke Rare Book and Manuscript Library, Yale University, New Haven (hereafter cited as YCAL) (in *Lovingly, Georgia: The Complete Correspondence of Georgia O'Keeffe & Anita Pollitzer,* ed. Clive Giboire [New York: Touchstone/Simon & Schuster, 1990], pp. 115–16).

14. In Norman, p. 137.

15. Ibid. The nineteenth-century medical community had authenticated the longstanding belief that the womb was a powerful force in determining women's feelings. For example, a noted physician, M. L. Holbrook, stated in 1882 that it was "as if the Almighty, in creating the female sex, had taken the uterus and built up a woman around it" (in Charles Rosenberg, *No Other Gods: On Science and American Social Thought* [Baltimore: Johns Hopkins University Press, 1961], p. 56).

16. For a discussion of the apparent contradiction between Stieglitz's thinking about the nature of the female artist, on the one hand, and the nature of the artist, on the other, see *OS,* pp. 9–17.

17. See Marsden Hartley, "Georgia O'Keeffe," in *Adventures in the Arts,* intro. Waldo Frank (New York: Boni and Liveright, 1921), pp. 116–19; and Paul Rosenfeld, "American Painting," *Dial* 71 (December 1921): 666–70, and "The Paintings of Georgia O'Keeffe," *Vanity Fair* 19 (October 1922): 56, 112, 114 (in *OS,* app. A, nos. 5–6, 8).

18. Hartley, p. 116. There is reason to believe that, at the time, O'Keeffe was completely unaware that others would perceive the photographs of her body in ways other than as she saw them—as works of art (see *OS,* pp. 55–57).

19. Rosenfeld, "American Painting," p. 666.

20. O'Keeffe to Mitchell Kennerley, Fall 1922, Mitchell Kennerley Papers, Rare Books and Manuscripts Division, the New York Public Library, Astor, Lenox, and Tilden Foundations (in Jack Cowart, Juan Hamilton, and Sarah Greenough, *Georgia O'Keeffe: Art and Letters* [Washington, D.C.: National Gallery of Art, 1987], letter 28 [hereafter cited as *AL*]).

21. O'Keeffe to Pollitzer, 4 January 1916, YCAL (in *AL,* letter 6).

22. In Blanche C. Matthias, "Georgia O'Keeffe and the Intimate Gallery," *Chicago Evening Post Magazine of the Art World,* 2 March 1926, p. 1 (in *OS,* app. A, no. 50).

23. O'Keeffe to Mabel Dodge Luhan, 1925?, YCAL (in *AL,* letter 34).

24. In Gladys Oaks, "Radical Writer and Woman Artist Clash on Propaganda and Its Uses," *The* [New York] *World,* 16 March 1930, Women's section, pp. 1, 3.

25. In Jimmy Ernst, *A Not-So-Still Life* (New York: St. Martin's Press/Marek, 1984), p. 236, and in Mary Lynn

Kotz, "Georgia O'Keeffe at 90," *Art News* 76 (December 1977): 43.

26. NWP records do not indicate precisely when O'Keeffe joined the party, but she is listed as a founder and life member in 1926 and 1948. Furthermore, a 26 March 1949 letter to O'Keeffe from Pollitzer (who was then head of the NWP) indicates that O'Keeffe was actively involved with the party into the 1950s (see the National Woman's Party Papers, 1913–1974: Financial Records, 1912–1966, Membership Lists, 1913–1965, Correspondence, 1913–1974, the Library of Congress, Washington, D.C. [microfilm, reels 126, 95, McKeldin Library, the University of Maryland, College Park]).

27. Cott, p. 125.

28. In "Commissioner Dell Fêted by Woman's Party," *Equal Rights* 13 (6 March 1926): 26.

29. Ibid., p. 27.

30. In Ralph Looney, "Georgia O'Keeffe," *Atlantic* 215 (April 1965): 108.

31. Georgia O'Keeffe, *Georgia O'Keeffe* (New York: Penguin Books, 1985), opposite fig. 17, n.p.

32. In Looney, p. 108.

33. Ibid.

34. Cott, p. 125.

35. "A Case in Point," *Equal Rights* 13 (6 March 1926): 28.

36. See "Georgia O'Keeffe Honored," *Equal Rights* 28 (June 1942): 41.

37. O'Keeffe to Eleanor Roosevelt, 10 February 1944, Estate of Georgia O'Keeffe, Abiquiu, N.M. (in *AL,* letter 85).

38. O'Keeffe to Sherwood Anderson (probably Fall 1924), Sherwood Anderson Papers, the Newberry Library, Chicago (hereafter cited as NEWB) (in *AL,* letter 29).

39. O'Keeffe to Luhan, as in n. 23, above.

40. In Dorothy Seiberling, "The Female View of Erotica," *New York Magazine* 7 (11 February 1974): 54.

41. Stieglitz to Duncan Phillips, 1 February 1926, Phillips-Stieglitz Correspondence, 1926–30, the Phillips Collection Archives, Washington, D.C.

42. In *Alfred Stieglitz Presents Fifty-One Recent Pictures: Oils, Water-colors, Pastels, Drawings, by Georgia O'Keeffe, American,* exhibition catalogue, New York, Anderson Galleries, 3–16 March 1924, n.p. (in *OS,* app. A, no. 22).

43. O'Keeffe to Anderson, 11 February 1924, NEWB (in *AL,* letter 30).

44. I have argued this point more extensively in "The Language of Criticism: Its Effect on Georgia O'Keeffe's Art in the Twenties," in *Georgia O'Keeffe: From the Faraway Nearby,* ed. Ellen Bradbury and Christopher Merrill (Reading, Pa.: Addison-Wesley, forthcoming).

45. After three years of this effort, at least one critic

noticed what O'Keeffe had accomplished: "Her most seeming abstract pictures are only by elimination abstract. They are not only based on nature, they copy nature, line almost for line. . . . Willingly or unwillingly, she has bound herself down to a copy book with a fidelity that approaches, and this particularly in her most abstract canvases, the photographic" ("Exhibitions in New York: Georgia O'Keeffe," *The Art News* 24 [13 February 1926]: 8 [in *OS*, app. A, no. 45]). Lisa Mintz Messinger has also noted that O'Keeffe's abstractions of the late 1920s are more specifically related to forms in nature than those she completed in the late 1910s and early 1920s (see Lisa Mintz Messinger, *Georgia O'Keeffe* [New York: Metropolitan Museum of Art, 1989], 41–42).

46. Rosenfeld, "American Painting," p. 666.

47. As O'Keeffe commented to Henry McBride about his review of her 1927 show, "I like what you print about me—and am amused and as usual dont understand what it is all about even if you do say I am intellectual[.] I am particularly amused and pleased to have the emotional faucet turned off—no matter what other one you turn on. It is grand—" (O'Keeffe to McBride, 16 January 1927, YCAL [in *AL*, letter 39]).

48. About the reviews of O'Keeffe's 1931 show (which included the *Jack-in-the-Pulpit* series) McBride pointed out, "Too much has been said of Georgia O'Keeffe's eroticism. Especially this year has there been too much said." And he quoted O'Keeffe: " 'If they write about me like that I shall quit being an artist. I can't bear to have such things said of me' " (Henry McBride, "The Palette Knife," *Creative Art* 8 [February 1931]: supp. 45).

49. See Lewis Mumford, "O'Keefe [sic] and Matisse," *New Republic* 50 (2 March 1927): 41–42 (in *OS*, app A. no. 63).

50. Nochlin, "Some Women Realists," p. 47.

51. In *Fifty Recent Paintings, by Georgia O'Keeffe*, exhibition catalogue, New York, Intimate Gallery, 11 February–3 April 1926, n.p. (in *OS*, app. A., no. 44).

52. In Katharine Kuh, *The Artist's Voice: Talks with Seventeen Artists* (New York: Harper & Row, 1962), pp. 190–91.

53. In Leo Janos, "Georgia O'Keeffe at Eighty-Four," *Atlantic* 228 (December 1971): 116.

54. O'Keeffe, *Georgia O'Keeffe*, opposite fig. 24, n.p.

55. In Douglas Davis, "Art: Return of the Native," *Newsweek* 76 (12 October 1970): 105; and in Grace Glueck, "Art Notes: 'It's Just What's in My Head . . . ,' " *New York Times,* 18 October 1970, sec. 2, p. 24.

56. See O'Keeffe to Kennerley, as in n. 20, above.

57. Chicago and Schapiro, "Female Imagery," p. 11.

58. In 1982, after a decade of similar assertions from feminist writers who either ignored or discounted what O'Keeffe said about sexual content in her art, Cassandra L. Langer stated that she found it "indeed perplexing that 'feminist' critics have not yet considered examining Ms. O'Keeffe's art in some other light given the artist's insistence that others are hanging meanings on her images which she herself never put there" (Cassandra L. Langer, "Against the Grain: A Working Gynergenic Art Criticism," *Feminist Art Criticism: An Anthology,* ed. Arlene Raven, Cassandra L. Langer, and Joanna Frueh [Ann Arbor, Mich.: UMI Research Press, 1988], p. 130 n. 36). The most recent feminist writer to silence O'Keeffe about her own work is Anna C. Chave, who quotes extensively from the O'Keeffe criticism but fails to quote O'Keeffe's denials of eroticism in her art (see Anna C. Chave, "O'Keeffe and the Masculine Gaze," *Art in America* 78 [January 1990]: 116, 120).

59. Though perhaps for different reasons, other artists were similarly concerned. For example, in response to Linda Nochlin's article "Why Have There Been No Great Women Artists?" (*Art News* 69 [January 1971], 22–39, 67–71), Elaine de Kooning and Rosalyn Drexler spoke to Nochlin's use of the term *women artists*. De Kooning stated, "To be put in any category not defined by one's work is to be falsified. We're artists who happen to be women or men among other things we happen to be . . . that are in no way relevant to our being artists"; but Drexler's opinion was less uncompromising: "I don't object to being called a woman artist as long as the word 'woman' isn't used to define the kind of art I create" (Elaine de Kooning with Rosalyn Drexler, "Dialogue," in "Why Have There Been No Great Women Artists?: Eight Artists Reply," *Art News* 69 [January 1971]: 40). Had critics in the 1920s not persistently linked the quality of O'Keeffe's expression with her sex, she might have agreed with Drexler. As it was, she would have agreed absolutely with de Kooning.

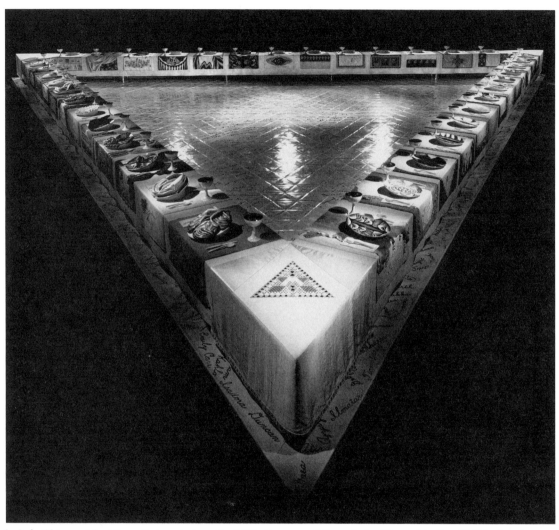

1. Judy Chicago, *The Dinner Party,* mixed media, 1979. Courtesy of Through the Flower (© *Donald Woodman*).

26

JUDY CHICAGO'S *DINNER PARTY*

A Personal Vision of Women's History

JOSEPHINE WITHERS

In the fifteenth century, Christine de Pisan dreamt of building an ideal city for eminent and virtuous women, and with the help of her three "muses," the sisters Reason, Rectitude, and Justice, she reflected on the many women in history and mythology who might live together in this *Cité des Dames*. Almost exactly four centuries later, the American sculptor and feminist Harriet Hosmer envisioned a beautiful temple dedicated to the achievements of women. Now such a grand idea has been realized.

Judy Chicago's *Dinner Party*, which opened at the San Francisco Museum of Modern Art in March 1979, is a synthesis of the decorative and fine arts; it is theater, literature, history; it is a complex set of ideas; it is monumental in conception and execution; it is a transcendental vision of women's history, culture, and aspirations. As the title suggests, *The Dinner Party* uses some of the most familiar objects and experiences of women's lives to illuminate that history through the domes-

tic ritual of serving food, and the material components of that ritual—painted porcelain tableware and embroidered napery.[1]

The Dinner Party is installed within a large room which is entered through a hallway hung with large woven banners that give an idea of what to expect inside. The table within [1], three wings in the form of an equilateral triangle, is forty-six feet on each side and rests on a raised floor covered with porcelain luster tiles. Each of the thirty-nine place settings honors an individual woman, historical or mythical, whose name is embroidered on the front face of her table runner [2].[2] For each of the table settings there is a fourteen-inch painted porcelain plate, its design specific to that woman, and an embroidered runner whose design is specific both to the woman and to the historical period in which she flourished. Linen napkins, porcelain flatware, and gold lustered goblets complete the settings. As one circulates around this richly invested feast table, one glimpses filaments of gold luster on the porcelain floor, which turn out to be the names of women—nine hundred and ninety-nine names—interlaced across the floor.

While *The Dinner Party* stands as an independent work, it is supplemented by a book by Judy

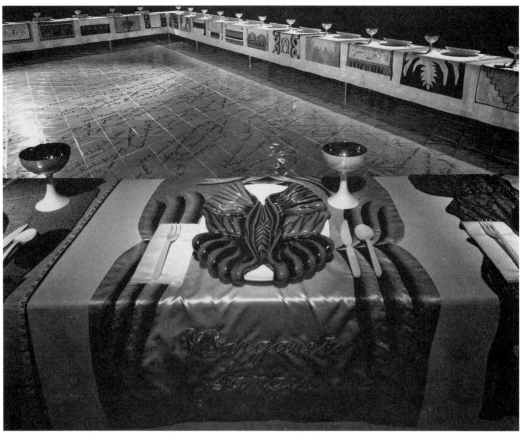

2. Judy Chicago, *The Dinner Party*, from the Margaret Sanger place setting across the Heritage floor. Courtesy of Through the Flower (© *Donald Woodman*).

Chicago *(The Dinner Party: A Symbol of Our Heritage)* and a film by Johanna Demetrakas. As with Demetrakas's film on Miriam Schapiro's and Judy Chicago's *Womanhouse* project, the Dinner Party film presents the finished piece and public response to it; it also documents the complex process of making *The Dinner Party.* Design and execution of each element of the installation, historical research, and the ongoing work, meetings, disagreements, exhilarations, and discoveries in the ceramics, needlework, and graphics studios make up the informative core of this documentary film.

In an unpublished manuscript entitled "The Revelations of the Goddess," Chicago creates a mythic context for *The Dinner Party.* The book begins with the creation of the world and the early

Matriarchy, and then describes the establishment of Patriarchal society. The Great Goddess prophesies that one day the wisdom of women will be needed again:

Until that day, in each generation, some of your daughters and their daughters must be my Disciples and my Apostles as their mothers were before them. . . . Each will be a symbol of her age, demonstrating what women can achieve, preserving the fragments of our power, embodying all that we will be once again. And in the days of affliction that will come to pass, three will be their holy number, the triangle their sign, and my Apostles and Disciples will know each other by the thirteenth letter of the alphabet which signifies the Millennium when I shall at last return. . . .[3]

The first wing of the table begins with a place setting symbolizing the Primordial Goddess [3]

and continues with Ishtar (known also as Isis and Artemis) and the Snake Goddess; the earliest historical personage is Hatshepsut, followed by Judith and Sappho; the wing ends with the Alexandrian philosopher Hypatia. The second wing begins with Marcella, the fourth-century Roman founder of numerous convents, and ends with the Flemish intellectual Anna van Schurman. In between are Saint Bridget, Theodora, Eleanor of Aquitaine, Christine de Pisan, and Queen Elizabeth I, among others. Anne Hutchinson opens the third wing, which brings women's history up to the present with the last place setting, symbolizing Georgia O'Keeffe, the only then living woman represented at the table. In contrast to those of the first wing, most of the women of the third wing are familiar figures: Mary Wollstonecraft,

Sojourner Truth [4], Susan B. Anthony, Emily Dickinson, Virginia Woolf, and Margaret Sanger, among others.

Most of the plate images are organically abstract representations of "great women who have been served up and consumed by history."[4] The Apostles were chosen as exemplars who struggled to change and improve the condition of women. The plates, then, are at the center of the sacramental ritual; the women are both honored and sacrificed.

The images of each of the plates and runners in one fashion or another incorporate symbols and attributes particular to that woman. Saint Bridget, the fifth-century Celtic saint, for example, is represented by her attributes of milk and fire; the

3. Judy Chicago, *The Dinner Party*, place setting for the Primordial Goddess. Courtesy of Through the Flower.

454

JOSEPHINE WITHERS

4. Judy Chicago, *The Dinner Party*, Sojourner Truth, china paint on porcelain plate. Courtesy of Through the Flower (© *Donald Woodman*).

5. Judy Chicago, *The Dinner Party*, Isabella d'Este, china paint on porcelain plate. Courtesy of Through the Flower (© *Donald Woodman*).

majolica glazes on the Isabella d'Este plate refer to her encouragement of that industry in Mantua [5]; the Artemisia Gentileschi plate displays a very muscular, *contrapposto* design; the cool grays and tattered forms of the Anne Hutchinson plate refer to her persecution at the hands of the New England Puritans [6].

Both the imagery and iconography of *The Dinner Party* present a thoughtfully worked out and consistent vision of women's history. Chicago thereby asks us to consider seriously the value of women's culture and women's historical contribution, and to ask ourselves probing questions about the nature and meaning of that past for us today and about the ways in which it has been traditionally perceived.

One historical stereotype that we are still dealing with is that woman's place has always been the ahistorical private realm:[5] to say that women have made history is a contradiction in terms. As recent women's historians have put it, "historians have long assumed that 'woman' was a trans-historical creature who could be isolated from the dynamics of social development."[6] In a recent study, Din-

nerstein observes that "women's status as representative of the flesh disqualifies her, in her own eyes as well as man's, to take part in our communal defiance of the flesh, in our collective counter-assertion to carnality and mortality. [For all of us, the male] affirms the human impulse toward eternity, immortality, the human yearning toward a truth beyond the flesh. It is civilization, history."[7] Elsewhere, Dinnerstein succinctly defines that historical content as a "pool of memorable event, communicable insight, teachable technique, durable achievement."[8] Especially in our secular society, history has become a principal vehicle of self-transcendence. We transcend the particularity of time present to the extent that we can identify and contribute to that "pool of memorable event."

Women, however, have been historically denied that form of transcendence by being excluded both from the making of history and from identifying in any direct way with its creators. They are, quite simply, "the other," to use De Beauvoir's term. "Her misfortune is to have been biologically destined for the repetition of Life,"

6. Judy Chicago, *The Dinner Party,* place setting for
Anne Hutchinson. Courtesy of Through the Flower.

De Beauvoir wrote, "when even in her own view Life does not carry within itself its reasons for being, reasons that are more important than Life itself."[9] Following this argument, the few women who have participated in the making of history and have survived the subsequent process of history writing[10] are conventionally perceived as exceptional people, whose achievements are isolated and fragmented, rather than part of an ongoing continuum. Exclusion both from the creation of and identification with the history-making process has had, and continues to have, a devastating effect on women's intellectual and creative development beyond reckoning.

On a personal level, the significance of being able to place oneself within a larger historical continuum was clearly, if only incidentally, demonstrated by Freud in his studies of Leonardo, Goethe, and Michelangelo. These studies are part self-projection and part spiritual dialogue with the creative men with whom he felt an intellectual affinity.[11] The well-documented fact that Freud made some serious interpretive errors does not lessen the importance that this process of projec-

tion and identification has, or can have, for all of us. It is the way to one kind of self-knowledge—the revelation gained from seeing aspects of ourselves mirrored in others and the understanding that we thereby transcend present time.

With the candor of an artist not needing to plead a scientific case, Chicago has recognized the implications of this process of creative identification. When asked which women of *The Dinner Party* she most closely identified with, she observed: "I identify with all of them; I think they all represent some aspect of me, and of women's lives and condition, which I identify with totally. . . .[12] They are aspects of myself. . . . What do I know of the person? I take all this historical material and I weave it together. I weed through it and I take out of it what I can relate to, and what I can identify with and then I make an image. The result is some of the person and a lot of me. But then, of course, it begins to take on an identity outside of me. . . . When the piece is done, all of a sudden it will exist outside of me and it—*they* will be personages and people will identify with *them.*"[13] It is, of course, a question of identifying

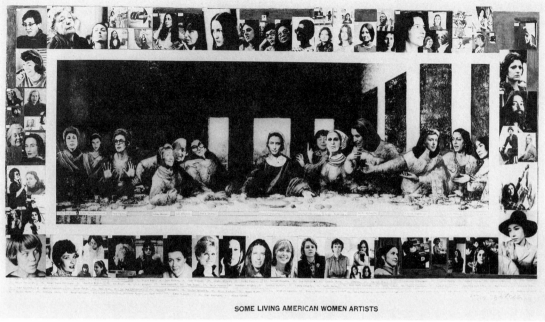

SOME LIVING AMERICAN WOMEN ARTISTS

7. Mary Beth Edelson, *Some Living American Women Artists/Last Supper,* offset poster, 1971 *(Jim Strong).*

with an abstract, invented image "that exists only as an embodiment for the feeling or for the idea or the thought. It doesn't have an independent, objective existence. It *is* what it means."[14]

The Dinner Party should be seen as a symbolic assemblage of women worthies[15] representing most periods of Western history. Chicago has remarked, "I also wanted to make a linear history so that there would seem to be a straight line and that [the women] were somehow linked through history. And so I wanted to do that by . . . having them all be women who had made a contribution to the situation of women."[16] In the manner of Christine de Pisan's *Cité des Dames,* the Apostles of *The Dinner Party*—as symbolized by the plates—are surrounded and rise up from their specific historical and cultural milieus, and come together in some ideal timeless place. Each of the women of the table is self-actualizing, grounded in and supported by her own history—represented both by the runners and by the Disciples of the history floor.

The Apostles are both historical figures and models for the future. They are an ideal gathering in the same sense that a *sacra conversazione,* Ingres's *Parnassus,* Raphael's *School of Athens,* or Courbet's *The Painter's Studio* are ideal assemblages bringing together a diversity of people under the aegis of a single motivating idea. There is, however, an important distinction to be made with the celebrants of *The Dinner Party:* there is no Madonna, no Zeus, no artist at the center of things, no *dea ex machina.* Neither is there a Christ figure, whose absence is suggested by the obvious analogy of *The Dinner Party* to the Last Supper. All the Apostles, in a sense, have become Christ figures, women who have been sacrificed, "great women who have been served up and consumed by history."[17]

Probably the first feminist artist to use Christ's Last Supper to illuminate the situation of women was Mary Beth Edelson. In 1971, she created a poster, *Some Living American Women Artists/ Last Supper* [7], which set out to correct Leo-

8. *The Dinner Party*, detail, illuminated capital letter for Emily Dickinson, needlework by L. A. Hassing. Courtesy of Through the Flower.

9. The Dinner Party, Millennium Triangle, needlework by Marjorie Biggs. Courtesy of Through the Flower.

nardo's gathering of the Apostles, with Georgia O'Keeffe now presiding at the banquet of thirteen, and surrounded by an additional fifty-nine women artists.[18] Chicago uses a similar inversion to make her point; she wanted, she said, "to make a relationship between dinner parties and how women give dinner parties, and the Last Supper where women weren't at. And how women probably prepared the food they ate, but weren't in the picture. And how women really have been crucified. And so they're being offered up on the plates."[19]

Two of the major themes of *The Dinner Party* are the ideal or imaginary gathering, and the ritual of sacrifice. It is at the level of communion, in both its general and sacramental senses, that these two fundamental ideas are joined. While the Apostles are cast in the sacrificial role, Apostles and visitors come together as communicants. The sacrament of the Eucharist similarly has this dual meaning, combining as it does a symbolic reenactment of Christ's sacrifice, and a ritual in which all believers come together—hence the expression "to be in communion with." The idea of spiritual communion, of course, was also central to the early Christian *agape,* or love feast, often depicted in the paintings of the catacombs.

Most ritual sacrifices comprehend, as does the Christian Eucharist, the dual theme of destruction and regeneration. The ancient cultures of Greece and Babylon, Ireland and India, Germany and Rome, all had ritual sacrifices whose proper enactment promised regeneration or salvation. "The true worth of my Apostles and Disciples and their long toil for your redemption," says the Great Goddess, "will neither be seen nor known until the day when I shall call thirty-nine of my Apostles and nine hundred ninety-nine of my Disciples to my side. Then shall we celebrate at a heavenly banquet when my daughters will at last arise from their servitude and be resurrected in glory."[20]

Both the exquisite richness of materials and perfection of craft [8,9], as well as specific associa-

10. *The Dinner Party*, Emily Dickinson china plate being painted by Judy Chicago and Judye Keyes. Courtesy of The Dinner Party (© *Lyn Jones*).

tions with the Eucharist, such as the goblets and runners—developed from the idea of the ecclesiastical fair linen—create the atmosphere of a consecrated temple or sacramental chamber. All aspects of *The Dinner Party*, however, work to suggest both the negative and destructive side, as well as the positive and regenerative side of women's struggles. Most of the designs of the plates, for example, are powerful central core images with great expansive force; yet most of them are contained and even compressed within the edges of the plates. The plate is a "metaphor for the containment of women throughout history." Chicago has observed that it is a "perfect metaphor for containment and . . . simultaneously a perfect whole. . . . It comes up around the corners

and that . . . holds the image in it the way women have been held in."[21] Even the plates carved in very high relief which seem to rise up off the table and defy containment are expressive of this compression [10].

This image is carried through in the dynamic relationship between the plate and its setting. The paraphernalia of a domestic milieu could be thought to diminish and trivialize the plates, despite the opulence of that setting. The drama of this conjunction has an effect similar to that of Tintoretto's *Last Supper* as described by Janson: "Tintoretto has gone to great lengths to give the event an everyday setting, cluttering the scene with attendants, containers of food and drink, and domestic animals. But this serves only to contrast dramatically the natural with the supernatural, for there are also celestial attendants. . . ."[22]

It is an instructive comparison to regard the plate in this setting [6], and then alone [4, 5]. If the plate is viewed vertically, it becomes simply a picture, and as pictures are wont to do in modern times, it tends to create its own context. As it is, the plates have a variety of relationships to their runners, symbolically suggesting the relationship of the woman to her culture. While all of the runner embroideries on the first wing are held within the front and back drops [2], in order to set off the plates clearly, other possibilities were considered as work progressed. The imagery of the Anne Hutchinson runner, for example [6], is based on early nineteenth-century embroidered mourning pictures: the weeping willow, done in pale grays and browns, rises up on the table and surrounds the plate; the pale recessive colors of both plate and runner and the mourning figures at front and back of the runner are in keeping with Hutchinson's banishment from the Massachusetts Puritan colony for her religious views, and her ultimate death in an Indian massacre. The runner for Petronilla de Meath, a fourteenth-century Irish woman tortured and burned as a witch, is a Celtic interlace pattern executed in couched fleece and wrapped cords to create a high relief; the strong interlace design also comes up and invades the area of the table and appears to attack and engulf the plate. The Hutchinson and Pe-

tronilla settings are two examples of the way in which women's aspirations and struggles are symbolically pitted against their containment and invisibility.

Even the large bustling studio where *The Dinner Party* is coming into being mirrors the work. Most of the myriad activities and productions happen within the four walls of a confined space [11]. Yet despite the large number of people working in the studio, it is a private place; the mental or psychological space of the studio is not accessible to the casual visitor. This very containment acts as a catalyst to intensify the work and the experiencing of that work. Curiously enough, this perception is indirectly corroborated by the psy-chologist, Erich Neumann, in his discussion of the relationships of women in primitive family and kin groups. Neumann observed that in exogamous societies, the containment of women within the same kin group, symbolized by the "primordial relation to the mother, means a certain intensification of womanhood." He contrasts this with the situation of men in such groups, whose assertion of manhood must mean leaving the female group and breaking the incestuous bond with the mother.[23] Having observed the workings of *The Dinner Party* studio at close hand, I can verify that this intensification of focus and energy created by the mutuality of women—and a few men!—working together is a real phenomenon.

11. *The Dinner Party,* in progress, view of the ceramics studio. Courtesy of The Dinner Party (© *Gelon/Hunt/McNally*).

The technique of china painting is also suggestive of women's containment, and is one reason why it was chosen. China painting is an extremely laborious and exacting technique, requiring a separate firing after every color application with the attendant risks of breakage at each firing. By the late nineteenth century this technique had limited commercial application and in the course of time came to be exclusively a "lady's accomplishment."[24] It was from such skilled amateurs that Chicago learned her craft. As with most women's activities, be it cooking, needlepoint, or raising children, china painting is considered to be devalued, worthless, and invisible work. Chicago recounted seeing a twenty-four-place luncheon set which took the owner three years to complete: "this was really the pride of her life, and she couldn't sell it. . . . If she sold this, somebody would pay a couple of hundred dollars for it. How's that for three years' work?"[25]

But if china painting is exacting and laborious, it is also, Chicago claims, feminine. "China painting allows a kind of merging of surface, image, and color that I sought when I painted on plexiglass, and earlier in my sculpture. China painting has the double quality of strength and femininity; it has a kind of lushness that simply would not be possible in any other technique."[26] The technical difficulty of china painting, then, combined with its particular aesthetic qualities and its "invisibility," are all congruent with the symbolism and visual imagery of *The Dinner Party.*

It is a widely acknowledged and well-documented fact that the history of women's contributions to the visual arts, as to music, is far behind the contribution to literature. Indeed, what Virginia Woolf had to say about nineteenth-century women novelists still is true of visual artists. "Whatever effect discouragement and criticism had upon their writing," she asserted, "was unimportant compared with the other difficulty which faced them . . . when they came to set their thoughts on paper—that is *they had no tradition behind them,* or one so short and partial that it was of little help. For we think back through our mothers if we are women" (emphasis added).[27] The tradition of a female-identified form-language

is still "short and partial," and artists are still in the very early stages of creating such a tradition.

The Dinner Party represents an impressively ambitious and imaginative attempt to build that next step. Since Chicago did not have a strong or coherent visual tradition to build on, this meant that her goal "was to take that which is the basis of thinking in western civilization and the basis of imaging in western civilization and recast it in feminine terms."[28] Thus *The Dinner Party* mirrors traditional conceptions of history.

First of all, history is here represented, for the most part, by individuals who had power. Many of the Apostles, moreover, obtained their power or influence through their alliances with powerful men. The most consistent exceptions to this, understandably, are the modern women. Women's history seen as biography, or the lives of "women worthies," to use Davis's phrase, has been an established genre for several centuries going back at least as far as Christine de Pisan's *Cité des Dames.*[29] For the professional historian, this approach has its limitations, in that it cannot be used to discover what was the life of a "typical" woman; the very survival of enough personal documents to reconstruct the life of an individual woman means almost by definition that she was exceptional.[30]

Second, these exceptional women are seen as essentially isolated from men. This, of course, mirrors traditional history which is, for the most part, conceived as apart from women. As with earlier compensatory histories, this approach seeks to isolate and highlight women and their achievements, partly in reaction to those traditional histories which see women only in their role relationships to men. One of those roles, incidentally, commonly experienced by most women—motherhood—is scarcely alluded to, either in the *Revelations of the Goddess* or in the imagery of *The Dinner Party.* Even though Mary Beard (*Woman as Force in History,* 1946) breathed new life into women's compensatory history, her work was flawed in that women were treated in isolation, and not as subject to the oppression and domination of men. Just as limiting, however, are those studies that treat women's lives as a continuous

chain of unmitigated oppressions and victimizations. The most devastatingly thorough presentation of this viewpoint is still Simone de Beauvoir's *The Second Sex* (1953). Chicago has utilized both of these models, but has brought them into conjunction with each other. She has created a more balanced synthesis of women's achievements seen in the context of their confinement. This, for example, is the fundamental meaning of the Eucharistic imagery of *The Dinner Party*.

The third way in which *The Dinner Party* mirrors cultural stereotypes is the major reference made to women's transcendent power. The basic premise of *The Dinner Party* is that the Apostles and Disciples come together at the bidding of the Great Goddess, as representatives of the once-powerful Matriarchy. Despite a great deal of literature, going back to J.J. Bachofen (*Mutterrecht*, 1861), who asserted the historical existence of primitive matriarchal cultures, this idea is today widely discounted among social anthropologists. The evidence in history and present-day primitive societies is simply lacking. And yet the idea persists.[31] The very fact that the possibility of a primitive matriarchy preceding patriarchal culture is so hotly debated attests, at the very least, to its continued power as myth—the myth which is, after all, our principal source for our ideas about such a Matriarchy. There are some who would argue, however, that such theories do not demonstrate the existence of female power and status which was then lost, but to the contrary, were created to explain and reinforce the patriarchal status quo.[32]

Whether or not that is the best way to explain the prevalence of matriarchal mythologies, it does throw into relief the fundamental problem of the matriarchal myth and the patriarchal reality. The more or less extreme polarization of the human race which such ideas represent gives conceptual form to a world view which is becoming increasingly intolerable and unworkable. Men have not created culture, nor have women. It has been a joint enterprise—the record notwithstanding—and will continue to be. The stark isolation of the Apostles and Disciples gathered in the cloistered space of *The Dinner Party* makes us confront the profound perversion of any system which seeks to fragment and isolate the totality of human experience.

Judy Chicago's Dinner Party: An Afterword

More than thirteen years have passed since I wrote this article, commissioned for the occasion of H. W. Janson's sixty-fifth-birthday festschrift. Although it was the first extended article on *The Dinner Party*, Judy and I knew that it would be unlikely to reach its primary audience, much less a wide one. It was buried at the end of a book of scholarly essays dedicated to a man who, though a lifelong supporter of his female colleagues and students, was peculiarly resistant to the feminist groundswell just then beginning to make itself felt in the academy. But it seemed a worthwhile price to pay in order to be in a strategic location of rupture from within.

In the intervening years, *The Dinner Party* has become embedded in our collective consciousness as a celebratory icon and conflicted symbol of the women's movement in complex ways that none of us could have predicted. To date (1991), *The Dinner Party* has traveled to fourteen cities in six countries around the world, where it has been seen by many hundreds of thousands of people. This exhibition tour was sponsored by arts organizations and ad-hoc committees, and it was coordinated with happenings, fund-raising "dinner parties," and other events which galvanized the local women's communities.

The informal as well as the published response to *The Dinner Party* has always been passionate, and the work continues to have an extraordinary ability to move people to tears or to rage. Much of that response has come from outside the insular domain of the art world, which can variously be seen as a strength and a liability.

It is to Chicago's credit that she has always sought to communicate to a large public, and from the moment *The Dinner Party* first opened in San Francisco in 1979, it attracted attention and comment from all sorts of people not accustomed to visiting art museums or familiar with the art world's self-referential discourse. What was never

in doubt was the seriousness of Chicago's ambition to reclaim a history and invent a form-language for and about women on a sufficiently grand scale that could not be ignored. In its own way, *The Dinner Party* has become a lightning rod, drawing to it praise and vilification for the claims it makes on behalf of women's past accomplishments and future aspirations.

In the summer of 1990, it was the focus of a vicious debate on the occasion of its acceptance as a permanent gift to the black, urban land-grant University of the District of Columbia. While the gift could have finally resolved the problem of finding a permanent home for *The Dinner Party*, it was also intended as the centerpiece of an ambitious endowment plan and multicultural center which would have significantly enhanced the university's public image and its fiscal well-being. After the gift was accepted in June 1990, a disinformation campaign mounted in the neo-conservative Washington *Times* soon spread to the floor of the House of Representatives. As part of a larger discussion of the District's budget request, *The Dinner Party* became the focus of an hour-long impassioned debate that centered on its allegedly obscene imagery. The claims of Representatives Rohrabacher and Dornan that *The Dinner Party* is "weird sexual art," and "three-D ceramic pornography" are themselves obscenities, but in their perverse way, a cogent demonstration of the powerful emotions which *The Dinner Party* can bring forth.

Hindsight has allowed us to see that the House debate over *The Dinner Party* was a rehearsal for the National Endowment for the Arts' reauthorization hearings, which had been in the works for more than a year and which finally came to a vote in September 1990. The House debate also came in the midst of the obscenity trial in which the director of the Contemporary Arts Center, Cincinnati, was indicted (though subsequently acquitted) for showing the "pornographic" work of Robert Mapplethorpe. At the same time, in the face of these political pressures, the Endowment rescinded several grants awarded to performance artists who deal with sexual themes.

Unfortunately, this attack from the right was successful, with the result that the gift of *The Dinner Party* was ultimately withdrawn and, as of this writing, the work is in storage and still awaits a permanent home.

The conflicted response to *The Dinner Party* within the art world and the academy is also complex, if more genteel. It is featured in most textbooks and courses on contemporary art, yet its populist appeal is disdained by those who see the history of modern art solely as a "modernist" history. This ambivalence was unintentionally highlighted in Judith Stein's catalogue essay for the large and widely circulated survey exhibition *Making Their Mark: Women Artists Move into the Mainstream, 1970–85* (1988). While Stein observed that "Judy Chicago's 1975 autobiography, *Through the Flower*, and her collaborative chef d'oeuvre, *The Dinner Party*, are likely the most widely known markers of the feminist art movement in America" (p. 122), neither Chicago nor any of her work were discussed in Stein's text or represented in the exhibition!

While the nature of the sexual symbolism of the plates and the historical concepts conveyed in *The Dinner Party* have been problematized by some feminist critics as essentialist, this has not always been balanced by an appreciation of its historical moment. It seems unrealistic to expect *The Dinner Party*—a late-seventies embodiment of feminist dichotomized polemics—to also reflect the evolution of feminist critical thinking during the intervening years. Like our fantasies about Mom, we continue to yearn for perfection in this larger-than-life vision of women's history and culture. When *The Dinner Party* finds a permanent exhibition home and is retrieved from its ghostly limbo, we will be able to assess its historical place in the formation of late twentieth-century feminist consciousness more accurately. Let us allow *The Dinner Party* to emerge as a valiant character in that drama.

APPENDIX

Women Represented in *The Dinner Party*

First Wing

PRIMORDIAL GODDESS	The feminine principle as the source of life, the female creator who conceived the universe
FERTILE GODDESS	Woman as the symbol of birth and rebirth; seen as the source of nourishment, protection, and warmth
ISHTAR	Great Goddess of Mesopotamia, the female as giver and taker of life, whose power was infinite
KALI	Traditionally positive view of female power misrepresented as a destructive force
SNAKE GODDESS	The remnants of female power expressed in the snake as the embodiment of feminine wisdom
SOPHIA	The highest form of feminine wisdom representing the transformation of real female power into a purely spiritual dimension
AMAZON	Embodiment of Warrior Women who fought to preserve gynocratic societies
HATSHEPSUT Egypt d. 1479 B.C.	Pharaoh of the 18th Dynasty in Egypt, considered to be the human incarnation of the deity
JUDITH	Jewish heroine, representative of the strength and courage of early biblical women
SAPPHO Greece ca. 500 B.C.	Lyric poet and lover of women, symbolizing the last flowering of uninhibited female creativity
ASPASIA Greece 470–410 B.C.	Scholar, philosopher, and leader of women after eclipse of female power
BOADACEIA Britain d. A.D. 62	Stands for the tradition of warrior queens extending back into legendary times
HYPATIA Alexandria ca. A.D. 380–415	Roman scholar and philosopher, martyred for her power and her efforts on behalf of women

Second Wing

MARCELLA Rome A.D. 325–410	Founded the first convent and provided a haven for women in Rome
SAINT BRIDGET Ireland 453–523	Irish feminist saint; helped spread Christianity in Ireland and established education for women
THEODORA Byzantium 508–548	Byzantine empress; ruled equally with her husband, Justinian, and initiated reforms on behalf of women
HROSVITHA Germany 935–1002	German playwright, historian, and religious woman
TROTULA Italy d. 1097	Physician and gynecologist; wrote a treatise on women's diseases that was used for 500 years
ELEANOR OF AQUITAINE France 1122–1204	Queen, politician, and patron, founder of Courts of Love, which attempted to improve the inhuman relations between men and women
HILDEGARDE OF BINGEN Germany 1098–1179	Represents the power of the medieval abbess; visionary, medical woman, scientist, writer, and saint

Second Wing *(continued)*

PETRONILLA DE MEATH Ireland d. 1324	Burned as a witch, she is a symbol of the terrible persecution of women that occurred from the 13th to 17th century
CHRISTINE DE PISAN France 1363–1431	Writer, humanist, early feminist
ISABELLA D'ESTE Italy 1474–1539	Noblewoman, scholar, archaeologist, patron, stateswoman, and political figure
ELIZABETH I England 1533–1603	One of the greatest female rulers who ever lived, distinguished stateswoman and scholar
ARTEMISIA GENTILESCHI Italy 1593–1652	Renowned Italian painter, first woman artist to express a female sensibility
ANNA VAN SCHURMAN Holland 1607–1678	Flemish scholar, artist, linguist, theologian, philosopher, utopian, advocate of women's rights

Third Wing

ANNE HUTCHINSON New England 1590/91–1643	American Puritan, reformer, preacher, and leader of women
SACAJAWEA North America ca. 1787–1812	Symbolizes exploitation of native Americans by Europeans; unpaid and not honored for leading the Lewis and Clark Expedition
CAROLINE HERSCHEL Germany 1750–1848	Pioneer woman scientist and astronomer, first woman to discover a comet
MARY WOLLSTONECRAFT England 1759–1797	Stands at the threshold of the modern feminist movement; wrote "A Vindication of the Rights of Woman"
SOJOURNER TRUTH United States 1797–1885	Courageous abolitionist and feminist; personifies both the oppression and heroism of black women
SUSAN B. ANTHONY United States 1820–1906	International feminist, suffragist, political leader
ELIZABETH BLACKWELL United States 1821–1910	First woman doctor of medicine in America; pioneer in hygiene and medical education for women
EMILY DICKINSON United States 1830–1886	American poet and embodiment of women's struggle to find their own voices
ETHEL SMYTH England 1858–1944	English composer and writer; wrote operas, choral works, and orchestral pieces
MARGARET SANGER United States 1883–1966	Pioneer advocate of birth control; believed that liberated motherhood would bring world peace and equality
NATALIE BARNEY United States 1877–1972	Writer, aphorist, lover of women, and bon vivant; lived openly as a lesbian
VIRGINIA WOOLF England 1882–1941	English writer, feminist, and pioneer in creating a female form-language in literature
GEORGIA O'KEEFFE United States 1887–1986	American painter; pioneer in creating a female form-language in art

NOTES

1. This essay was written more than one year before the completion of *The Dinner Party;* minor revisions were made after its opening. Writing about an unfinished work presented an unusual challenge, and would not have been remotely possible without the generous cooperation of Judy Chicago; Diane Gelon, Director of the Project; Susan Hill, Director of Needlework; and Anne Isolde, Director of History Research.

2. See Appendix for complete listing of the thirty-nine women represented on the table.

3. Judy Chicago, "Revelations of the Goddess: A Chronicle of the Dinner Party," unpublished ms. (courtesy of the author), 18.

4. Transcript of an interview by Arlene Raven with Judy Chicago, September 8, 1975, p. 6. Hereafter referred to as Interview of September 1975.

5. The classic formulation and feminist critique of this truism is Elizabeth Janeway's *Man's World, Woman's Place; A Study in Social Mythology,* New York, 1971.

6. Ann Gordon, Mari Jo Buhle, and Nancy Schrom Dye, "The Problem of Women's History," in *Liberating Women's History,* ed. Berenice Carroll, Urbana, Ill., 1976, 75.

7. Dorothy Dinnerstein, *The Mermaid and the Minotaur; Sexual Arrangements and Human Malaise,* New York, 1977, 210.

8. Op. cit., 208.

9. Simone de Beauvoir, *The Second Sex,* New York, 1953.

10. It is a commonplace observation among women's historians that knowledge about women tends to get leached out of the record over a period of time. It is a pervasive process that affects equally women of status and accomplishment as well as ordinary or undistinguished women.

11. For a comprehensive analysis of Freud's studies of these men, and a review of the literature, see Jack Spector, *The Aesthetics of Freud: A Study in Psychoanalysis and Art,* New York, 1974.

12. Transcript of an interview by Josephine Withers with Judy Chicago, August 22, 1977, 14. Hereafter referred to as Interview of August 1977.

13. Interview of August 1977, 18.

14. Interview of August 1977, 6.

15. The concepts of "women worthies" and compensatory history are discussed on pp. 460–61.

16. Interview of September 1975, 10–11.

17. Interview of September 1975, 6. Chicago's language is similar in important respects to that of Méret Oppenheim, also a feminist artist, who has observed that "since the installation of Patriarchy and until recently, free women have been killed or silenced." (Correspondence with the author, April 15, 1977.)

18. This has had an enormous success and is now in its second edition of 1,000. It was shown at the Whitney Museum of American Art, New York, in Spring 1978.

19. Interview of September 1975, 6.

20. *Revelations of the Goddess,* 18.

21. Interview of September 1975, 3.

22. H. W. Janson, *History of Art,* second ed., New York, 1977, 450.

23. Erich Neumann, *The Great Mother: An Analysis of the Archetype,* Princeton, N.J., 1972, 271.

24. See the historical essay by Judy Chicago in *Overglaze Imagery, Cone 019–016,* Visual Arts Center, California State University, Fullerton, 1977.

25. Interview of September 1975, 5.

26. "Judy Chicago in Conversation with Ruth Iskin," *Visual Dialog,* 2, 3 (Spring 1977), 15.

27. Woolf, *A Room of One's Own,* New York, 1959, p. 79; first published 1929.

28. Interview of August 1977, 25.

29. Natalie Zemon Davis, "Women's History in Transition: The European Case," *Feminist Studies,* 3, nos. 3–4.

30. For a discussion of four types of traditional histories of women, see Ann Gordon et al., "The Problem of Women's History," in Carroll, op. cit.

31. Two recent studies which argue this point of view are: Evelyn Reed, *Woman's Evolution: From Matriarchal Clan to Patriarchal Family,* New York, 1975; and Elizabeth Gould Davis, *The First Sex,* New York, 1971.

32. See Joan Bamberger, "The Myth of Matriarchy: Why Men Rule in Primitive Society," in Michelle Zimbalist Rosaldo and Louise Lamphere, *Woman, Culture, and Society,* Stanford, Calif., 1974.

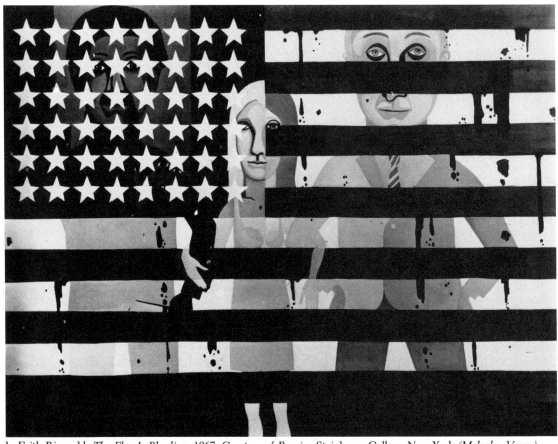

1. Faith Ringgold, *The Flag Is Bleeding*, 1967. Courtesy of Bernice Steinbaum Gallery, New York *(Malcolm Varon)*.

RACE RIOTS. COCKTAIL PARTIES. BLACK PANTHERS. MOON SHOTS AND FEMINISTS

Faith Ringgold's Observations on the 1960s in America

LOWERY S. SIMS

There is one great difference . . . between Pop Art and Black Art. While the Pop artists tend to objectify their images, stripping them of their original associations, the Black Art Movement artists are deeply committed to the images and forms in their work. [1]

A funny thing happened to the art of the 1960s. It got cool. Not "cool" as in "hip," "with it," "right on," "savvy," but cool in the sense of "non-personal," "mechanical," "non-involved." In an intensely political world (i.e., "hot"), art was to have no politics, to be non-engaged (i.e., "cool"). As a result the politically engaged art of African, Latin, Asian and Native Americans, women, etc., was seen to be "social realist" ergo "retardataire," out of sync with the current values of the art world, and in an insidious way, invalid.[2] The assertion of a "cool" aesthetic may be the ultimate goal of art according to modernist precepts of historical reductivism. In actuality, however, the art scene opened the decade of the 1960s in a "hot" frame

From *Faith Ringgold: A 25 Year Survey*, exhibition catalogue, Fine Arts Museum of Long Island (FAMLI), Hempstead, N.Y., April 1–June 24, 1990, published by FAMLI, 1990, pp. 17–22. Copyright © 1990 by Fine Arts Museum of Long Island. Reprinted by permission of the author and FAMLI.

of mind. The previous two decades had seethed in the heat of the Abstract Expressionists' intensely personalized and mythologized art-making, centered on the psychic and intellectual energy of the individual artist. As the new art of the 1960s began to make its impact on the art world, its rambunctiousness and defiant celebration of the "garbage and detritus"[3] of popular and mass culture as serious content in their art was recognized by critics like Dorothy Gees Seckler as "a brutal force that often makes it seem more related to the sardonic content of the dadaists. . . ."[4]

Three years later, the critic and art historian Irving Sandler wrote that Pop art as well as minimalist and color field paintings were now "dead pan," emphasizing technique over content. Sandler postulates that "this is the product of a nihilist generation . . . positive values . . . [are] . . . being discovered in impassiveness and boredom."[5] Certainly the artistic techniques of the 1960s—taken as they were from commercial printing and from reductive painting maneuvers—i.e., staining the canvas and blocking geometric patterns with masking tape—were "cooler" than the grunting aggressiveness of Abstract Expressionist gestural painting. It is difficult, however, to read the content of these paintings as such. Appropriated from

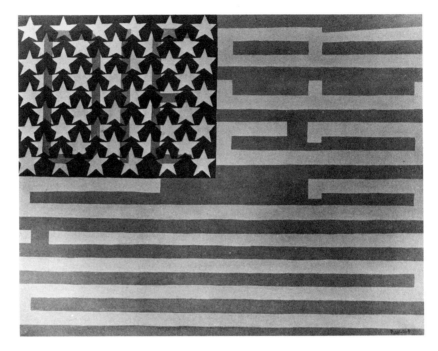

2. Faith Ringgold, *Flag for the Moon: Die Nigger*, 1969. Courtesy of Bernice Steinbaum Gallery, New York.

movie star magazines, gossip and romance rags, and comic books, characters like G.I. Joe, Dick Tracy, Elvis Presley, James Dean, Marilyn Monroe, Elizabeth Taylor, the American consumer society were some of the "hottest" commodities in American popular culture. Their transference from the tabloid and movie screen, from the news stand to the gallery and the museum implied that they were embodying the values and attitudes of the establishment. But what did images of G.I. Joe mean relative to our escalating involvement in Vietnam? And what were those pinup poses of Marilyn Monroe and Liz Taylor implying vis-à-vis the nascent women's movement? According to the critical community, absolutely nothing. This cultivated disjuncture between content and technique, consequently, left a black feminist artist like Faith Ringgold in a peculiar position with regard to the art mainstream.

The flag is the only truly subversive and revolutionary abstraction one can paint. [6]

Faith Ringgold once noted that, at the beginning of her career, "I didn't have to worry about

... collectors, or whether my work was acceptable. ... All I had to worry about was that my work was acceptable to me." [7] Within this psychic freedom she produced some of the most powerful icons of the 1960s, including her *American People* series: *The Cocktail Party* (1964), *The American Dream* (1964), *God Bless America* (1964), *The Flag Is Bleeding* (1967), *Die* (1967), and *U.S. Postage Stamp Commemorating the Advent of Black Power* (1967). Ringgold developed her political message utilizing the flag, the poster, the commemorative stamp, the map, the group encounter, and iconic figures. The American flag was one of the most widely used subjects in American art during the 1950s and 1960s. As the challenges posed to the American establishment escalated in the "real world," it also became a political symbol that electrified the polarization between the various ideological camps. The scene of construction workers and hippies in full confrontation over their respective interpretations of the symbolism of the flag is an enduring souvenir of this epoch. Ringgold claimed her own connection with this potent and highly charged symbol in two works:

The Flag Is Bleeding (1967) [1], and *Flag for the Moon: Die Nigger* (1969) [2]. There is a distinct difference in sentiment between the two works, mired as they both are in specific political protest. *The Flag Is Bleeding* is a bittersweet plea for racial harmony. The American flag is superimposed on three figures: a black male and a white male, flanking a white female. The black male holds a knife that is dripping blood, and presses his right hand against his shoulder to stay the flow of blood from a wound. The white male stands, unscathed, confident with his hands on his hips, his eyes staring out at us impassively. The blond woman links arms with the two males. It is only the black male and the red stripes of the flag that are shedding blood.

This composition has been interpreted symbolically as capturing "the ironies of American democratic ideals."[8] It also has been given a feminist reading, when discussed in conjunction with the painting *Die*, another of the trio created by Ringgold in the summer of 1967 [3]. "In . . . these canvases women play a pacifying role in the racial battle between black and white men. A frail young blonde attempts to hold apart the two black and white opponents in *The Flag Is Bleeding*, and, in

Die, black and white women jointly intervene in the fight and try to protect the children."[9]

In this way *The Flag Is Bleeding* personalizes the responsibility of the protagonists in the race relations in this country. But it is also an enigmatic work. Several questions are posed, and remain unanswered, by Ringgold's cast of characters and their relationship with one another. For instance: Why a white woman and not a black one? Why is only the black male both armed with a weapon and wounded? Was his wound self-inflicted? Was it inflicted by the white male? Is the black male a scapegoat for the injustices caused by racism?

Flag for the Moon: Die Nigger, executed two years later, is devoid of any human figures. The flag is presented flat, erect, motionless as it remains in the atmosphereless ambience of the moon. The harshness of the taunt "Die Nigger," which has been camouflaged within the stripes of the flag, is a scathing indictment of American society. Ringgold juxtaposes a symbol of the high-minded universal ideals of the space program with the venomous, base instincts of racism in American society. The economic anachronisms are too patently clear: in the face of poverty in the U.S., the government would spend millions of dollars on

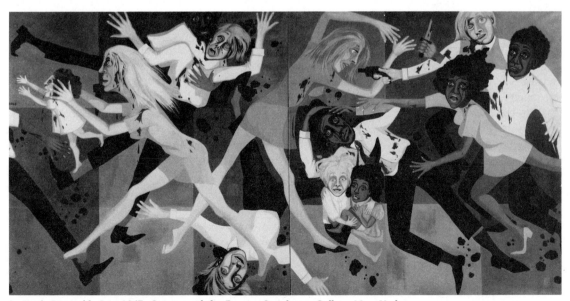

3. Faith Ringgold, *Die*, 1967. Courtesy of the Bernice Steinbaum Gallery, New York.

4. Faith Ringgold, *U. S. Postage Commemorating the Advent of Black Power,* 1967. Courtesy of Bernice Steinbaum Gallery, New York.

the space program. Ringgold seems to have lost faith in the system by this time, and the cautious optimism of her work, executed just two years before, has been changed forever.

Another symbolic vehicle for Ringgold's political purpose was the map. *United States of Attica* is a so-called poster work that similarly subverts a signifier of American identity to demonstrate the betrayal of its vaunted ideals in the reality of contemporary life. Here Ringgold takes the map of the United States, paints it red, and then marks key events that took place in various locales. As touristic historians we eagerly search out the events inscribed in black. Then we realize we are not being told about the heroics of some white, male Revolutionary military hero. Instead we are bombarded with atrocities that have been inflicted on Native Americans, blacks, Asians, and other disenfranchised people by the American system. Massacres, jailings, lynchings, etc. crowd over the map, literally turning it red with the blood of all the victims. The aforementioned *Die* is a powerful evocation of racial violence. In

United States of Attica Ringgold conveys a comparable sense of violence wreaked simply using words. The accumulative impression of all the marks on the map makes us aware of the gravity and persistence of the injustices. Also, where once one region of the country bore the brunt of all the blame for racial conflict, this map clearly demonstrated that the guilt was collective.

In *U.S. Postage Stamp Commemorating the Advent of Black Power* [4] Ringgold sets up two panels of fifty faces each—framed so that all we see is the area of the face from the eyebrows to the bottom of the nose. A diagonal register of darker brown faces crisscrosses with letters that spell "Black Power." There are a total of ten faces among the other ninety white, as if representing the percentile of black Americans within the total American population at that time. Ringgold plays on the commemorative function of the postal stamp, daring to suggest that the United States would welcome and note the moment when its black citizens made a call for an equitable participation in American society.

I employed African art as my "classical" art form. Instead of looking to Greece I looked to Africa. [10]

Starting in the mid-1960s Ringgold developed a hard-edged style, with a flat, relatively unarticulated paint surface. Her stylized figures functioned as iconic symbols rather than individual portraits. She outlined individual planes or segments of her figures in black—like stained glass. Her simplification of form was influenced by Cubism and African art, particularly the decorative work of the Kuba peoples in Zaire. [11] She had also studied with Robert Gwathmey, a white artist who was noted for his depictions of rural blacks in the South, rendered in an angular style that might be called Cubistic, with strong outlines. Ringgold designs her faces like masks. [12] Ovals within ovals define lidded eyes and pupils. The curves of the eyebrows continue downward to define the nose, which is flattened at the bottom. This physiognomic conceit readily calls to mind the serial portraits of the Kuba kings. This line is in turn arched out to trace the limits of the cheeks, and below the nose one or two more or less parallel lines indicate the mouth. This stylization allowed Ringgold to present a portrait of black people that was neither caricature or adapted from white standards, that was neither purely African or merely decorative. The resulting interplay of ovoid and circular areas would be repeated in compositions such as *The Cocktail Party* (1964), creating an overall design. She has described this compositional conceit as "polyrythmical space" or "polyspace." [13]

After 1967 the artist also became concerned about the issue of color in her paintings—not merely color as it pertained to race, but also how the physical dynamics of various commercial painting pigments influenced her ability to create a new "classical" art form. She has written about this problem: "When you do a lot with white . . . you may lose your sensitivity to other colors. The white gathers the light. . . . Black art must use its own color black to create its own light since that color is the most immediate black truth. General black art must not depend on lights or light contrast in order to express its blackness, either in principle or fact." [14] She found a solution sug-

gested in the work of Ad Reinhardt, which helped her to realize the optical possibilities of the color black. This led in turn to her so-called black light series, executed after 1967. *Flag for the Moon: Die Nigger* shows the new chromatic system in her work. In contrast to the pinks, yellows, and light blues of *The Flag Is Bleeding,* here Ringgold uses red and green in closely related chromatic scales with no highlights and relatively few shadings.

In addition she has changed the colors of the American flag from red, white, and blue to the black nationalist colors of red, black, and green, co-opting the symbolism to accommodate the aspirations of black nationhood.

What can a well-intentioned upper-middle-class white family do to calm the frustration, cool the anger, assuage the rage of a black ghetto child who comes to live with them? [15]

Ringgold provides several interesting comments on the social aspects of race relations during the 1960s. *Cocktail Party* is about the well-meaning tokenism that gripped American mores and manners in the 1960s. Ringgold has most effectively conveyed the discomfort of the lone black male by crowding the faces of the gawking white guests up against his face and against the picture plane. *The American Dream* [5] portrays a lone woman who sits admiring her rather large diamond ring. On second look we realize that the woman is both white and black, establishing a symbolic presentation of great poignancy. The theme of the American Dream certainly fueled the polemics of the decade. Its goals and aspirations were at once reviled for displaying the most banal of bourgeois pretensions, and also held up as a beacon for disenfranchised peoples clamoring for their fulfillment of the American Dream. Ringgold also alerts us to the class distinctions that exist both between white and black, and within the black community, and reminds us that material aspirations are common to all peoples. The tenacious resistance of the bourgeoisie in the face of change is vividly symbolized in *God Bless America* [6]. Here again the artist presents a lone elderly white woman—the type that swells the

5. Faith Ringgold, *The American Dream*, 1964. Courtesy of the artist.

6. Faith Ringgold, *God Bless America*, 1964. Courtesy of Bernice Steinbaum Gallery, New York.

ranks of organizations such as the Daughters of the American Revolution. Her face almost fills the pictorial space. She is imprisoned within the flag she so fiercely protects. *Angela Davis*, another of the artist's "poster" works, can be seen as the ideological pendant to this portrait.

Faith Ringgold's images of the 1960s, grounded as they were in references to popular imagery such as the flag, the cocktail party, the social upheaval, provide a telling comparison to the works of her contemporaries. The flag images of such artists as Claes Oldenburg and Jasper Johns betray an ambivalence about "American" values, but Ringgold pushed the dialogue to critical mass by depicting the stark realities of racism juxtaposed with that same flag. Andy Warhol reduced the newspaper photo reportage of the Birmingham race riot to a serial repetition of anonymous ("cool") segments in a serial, repetitive pattern. Ringgold's *Die* is so exaggerated in its depiction of racial violence that

it heats it up again, and we can empathize with the experience of the figures. And while Marisol's life-sized sculptural grouping *The Party* satirizes the deadened existence of the *haute bourgeoisie* in this country, *Cocktail Party* vividly indicates the sterility of bourgeois conformity, especially on the part of those who are excluded, yet seek to get in.

Ringgold established a dynamic tension with the interaction between technique (or style) and content in her work. She never wavered in her mission to explore new ways to express the changing social situation. Ringgold's straightforward depictions etch the essence of these images in our minds so effectively that they have become American icons.

NOTES

1. Elsa Honig Fine, *The Afro-American Artist: A Search for Identity.* New York: Holt, Rinehart and Winston, 1973, pp. 198, 201.

2. Some of our readers will remember heated exchanges between critics like Hilton Kramer and David Shirey, and black apologists such as Henri Ghent and Benny Andrews debating not only the existence of a black aesthetic, but also the qualitative viability of the work by black artists, as well as politically engaged art.

3. Dorothy Gees Seckler, "Folklore of the Banal," *Art in America,* Winter 1962, pp. 52–61.

4. Ibid.

5. Irving Sandler, "The New Cool Art," *Art in America,* January 1965, pp. 96–101.

6. Faith Ringgold quoted in Fine, op. cit., p. 209.

7. Bucknell University, *Since the Harlem Renaissance: 50 Years of Afro-American Art.* Lewisburg, Penn., Center Gallery, 1985, p. 37.

8. Freida High-Wasikhongo, "Afrofemcentric: Twenty Years of Faith Ringgold," in Studio Museum in Harlem, *Faith Ringgold: Twenty Years of Painting, Sculpture and Performance, 1963–1983.* New York Studio Museum in Harlem, 1984.

9. Moira Roth, "Keeping the Feminist Faith," in Studio Museum, op. cit., p. 13.

10. Bucknell University, op. cit., p. 37.

11. Terrie S. Rouse, "Faith Ringgold—A Mirror of Her Community," in Studio Museum, op. cit, p. 9.

12. Later Ringgold would create masks as soft sculptures. These eventually became props for her performance works. See Lowery Stokes Sims, "Aspects of Performance in the Work of Black American Women Artists," in Arlene Raven, Cassandra L. Langer, and Joanna Frueh, ed., *Feminist Art Criticism: An Anthology.* Ann Arbor, Mich., and London: U.M.I. Research Press, 1988, pp. 207–25.

13. Lucy R. Lippard, "Beyond the Pale: Ringgold's Black Light Series," Studio Museum, op. cit., p. 22.

14. Ibid.

15. Alice Walker, "The Almost Year," *In Search of Our Mothers' Gardens: Womanist Prose by Alice Walker.* San Diego, New York, and London: Harcourt, Brace, Jovanovich, 1983, p. 139.

1. Faith Ringgold, *The Screaming Woman,* mixed media, 1981.
New York, Bernice Steinbaum Gallery *(Freida High Tesfagiorgis).*

AFROFEMCENTRISM AND ITS FRUITION IN THE ART OF ELIZABETH CATLETT AND FAITH RINGGOLD

FREIDA HIGH W. TESFAGIORGIS

Black women artists of today project a state of consciousness that asserts their race, sex and artistic ability, the three major entities of their existence which direct their lives and work. That consciousness was succinctly articulated by acclaimed sculptor and printmaker Elizabeth Catlett, as she recently introduced herself to an audience in the following manner: "I'm Elizabeth Catlett and what's important to me is first that I am black, and secondly that I'm a woman and thirdly that I'm a sculptor."[1] Catlett's self-actualized and self-defined statement not only identified her most significant characteristics as black, female and creative, but also indicated their sequential order of importance. Though she spoke quite candidly and personally, she conveyed the sentiments of black women across America who, like herself, draw upon their common consciousness and experience to express themselves in two- and three-dimensional form.

Within its limitation, this article examines the ideological and aesthetic fruition of Afro-female-centered, or "Afrofemcentric," consciousness in the visual arts.[2] It focuses on the black woman subject as depicted by the black woman artist, exploring the distinct manner in which the latter envisions and presents black women's realities. The principal artists of discussion are Elizabeth Catlett (b. 1919) and Faith Ringgold (b. 1930), women of two different generations who have had a significant impact on the art arena with their black female sociocultural and political voices and works for over two decades. Through an examination of the ideas and representative art works of two important black women artists, it is anticipated that the uniqueness of Afro-American women's self-depiction in the visual arts will be clarified, and further that a greater appreciation of their forms and techniques will be stimulated.

No major text exists on the art of Afro-American women. Neither does any major art-historical text on American art include the art of Afro-American women. The dearth of information on this subject indicates the invisibility of black women artists in the minds of conventional art historians and critics. Nonetheless, pertinent information about the subject exists in a few books on Afro-American art and women's art. The most significant of the former are *Negro Art: Past and*

From *Sage: A Scholarly Journal on Black Women* 4, no. 1 (Spring 1987): 25–29. Copyright © 1987 by The Sage Women's Educational Press. Reprinted by permission of the author and The Sage Women's Educational Press.

Present (1936) by Alain L. Locke, *Modern Negro Art* (1943) by James Porter (the two pioneering works in Afro-American art history) and *Art: African American* (1978) by Samella Lewis. Each work provides a basic introduction to Afro-American art, Porter's offering the most comprehensive exposition up to its date of publication. Among recent works, *Originals: American Women Artists* (1979) by Eleanor Munro and *American Women Artists: From Early Indian Times to the Present* (1982) by Charlotte S. Rubenstein are two of the more informative; however, they present few black women artists and provide minimal information.

The single most important presentation of the work of black women artists is *Forever Free: Art by African-American Women (1862–1980),* an exhibition catalogue by curator/art historian Jacqueline Fonvielle-Bontemps and Arna A. Bontemps. This work, published to accompany a national traveling exhibition in 1981–82, provides information about forty-nine black women artists and brings to light the wealth of exciting and powerful art works by the exhibiting artists, stimulating the appetite of the interested scholar. Most of the other important works on the subject are informative catalogues that document works of individual artists: e.g., *Faith Ringgold: Twenty Years of Painting, Sculpture and Performance, 1963–1983,* edited by Michele Wallace, which catalogues an exhibition that was held at the Studio Museum in New York in 1984; or *Betty Saar: Selected Assemblages* (July 1984–October 1984) and *Oasis* by Peter Clothier cataloguing a show held at the Museum of Contemporary Art in Los Angeles (October 1984–January 1985). Less informative is periodical literature, which tends to be more biographical than analytical. *Black Art: An International Quarterly* (now *The International Review of African American Art*), published by Samella Lewis, is the only existing periodical in this country that focuses on the art of the African diaspora and presents both analytical and biographical material on the art of black women and men.

To say that there is paucity in the literature of this area is an understatement. However, the increasing number of informative catalogues which document the works of black women artists is encouraging. That, along with a few publications on individual artists, such as *The Art of Elizabeth Catlett* (1984) by Samella Lewis, suggests that more critical attention to this area can be anticipated in the near future.

The term "Afrofemcentrism" was first introduced by me in 1984 to designate an Afro-female-centered worldview and its artistic manifestations. It was applied to the ideology and art of Faith Ringgold, who is lauded as a "black feminist" by Europe-American feminist art critics. Although "black feminism" has standard usage today and has been connected to the ideas of certain black women's art, Afrofemcentrism appears more accurate in identifying the associated perspective and, therefore, replaces the former in this writing.

Conceptually, Afrofemcentrism gives primacy to black-female consciousness-assertiveness by centralizing and enlarging intrinsic values, and as a result liberates "black feminism" from the blackenized periphery of feminism. It assumes "an African Cultural System, the juxtaposition of African and Afro-American ways, and values developed from the African-American experience," as does Afrocentric ideology.[3] However, it is "shaped by traditions of core Black culture and distinctive Afro-American female experience, both within and outside of that culture. Embracing principles of natural harmony, Afrofemcentrism affirms holistic existence while particularizing an assertive female stance."[4]

Through art, Afrofemcentrism emerges in a plethora of ideas which thematically project black women's realities over idealism, and it assimilates collective experience and history. Its images show the black woman actively engaged in the circumstance of the moment, portrayed in a manner that is refreshingly distinctive and identifiable by the following characteristics: 1) the black woman is subject as opposed to object, 2) the subject is contextually exclusive or primary, 3) the subject is active rather than passive, 4) the subject conveys the sensitivity of Afro-American women's self-recorded realities and 5) the subject is imbued with aesthetics of the African continuum. Styles

range from realism to abstraction, sustaining a personal vision that embraces Afrocentric tastes in color, texture and rhythm. Techniques show mastery of Western traditions, which are adapted to suit the thematic and aesthetic persuasions of the artists, while the aesthetics contain elements of "black art" and "feminist art." Its form and content are best understood within the context of a brief summation of black and feminist art, since both have been documented and, by comparison, highlight the uniqueness of Afrofemcentric directions.

Leading critics, artists and art historians emerged in the sixties to characterize black art amidst the most controversial circumstances. Among them, the late Larry Neal, literary critic, metaphorically identified it as "the aesthetic and spiritual sister of the Black Power concept," pointing out that it "speaks directly to the needs and aspirations of Black America."[5] Art critic Barry Gaither defined it as didactic form "arising from a strong nationalistic base and characterized by its commitment to: a) use the past and its heroes to inspire heroic and revolutionary ideals, b) use recent political and social events to teach recognition, control and extermination of the 'enemy' and c) project the future which the nation can anticipate after the struggle is won."[6] Preeminent in these postulations is the premise of ethics. Aesthetic taste is equally significant, although all too often it was overshadowed by content in the criticism of the sixties. This important dimension has recently received more critical attention, particularly from major contributors to Afro-American art history—e.g., Gaither, David Driskell, Samella Lewis and Keith Morrison. Contemporary scholars concur that certain elements predominate in black art and that those peculiarities are manifest in bright or bold colors, expressive polyrhythmic shapes and spatial relationships, and variable tactile qualities.

Feminist art, on the other hand, in its early stages assumed a totally different position. It evolved from women's "political, biological and social experience in this society," according to feminist art critic Lucy Lippard, who further explained the essential concerns of feminist artists:

Some feminist artists have chosen a fundamentally sexual or erotic imagery. Others have opted for a realist or conceptual celebration of female experience in which birth, motherhood, rape, maintenance, household imagery, menstruation, autobiography, family background, and portraits of friends figure prominently. Others feel the only feminist art is with a "right-on" political posterlike content. Others are involved in materials and colors formerly denigrated as "feminine" or in a more symbolizing abstract parallel to their experiences; for example, images of veiling, confinement, enclosure, pressures, barriers, constrictures, as well as growth, unwinding, unfolding, and sensuous surfaces are common. Others are dealing with organic "life" images and others are starting with the self as subject, moving from the inside out.[7]

The commonality of this art is its origin in women's culture, summarized by feminist writer Gayle Kimball as women's experience and expression which draws "inspiration from the heart and body as well as from the conscious mind."[8] Stylized motifs of vaginal images exemplify the literal association of woman's body in some of these works. Other forms conveying the idea of "central core image," floral patterns and butterflies (defined as a symbol of liberation) are identified as female symbols that conceptually celebrate women's culture.[9] And as Lippard noted, "woman's media," which include sewing, embroidery and china painting, are sometimes chosen as the vehicle for artistic expression, which subsequently liberates them from the state of "craft" to that of "fine art." In general, while styles and forms vary in feminist art, the content is unified in its association with female self-consciousness and experience, however abstract.

The "double jeopardy" of black women's experience nurtured the double consciousness of black women's culture, which in art birthed a sensitive and powerful offspring, committed to the African diaspora, connected in female bonding and adorned with rhythmic colors and textures, each contributing to its essence. Identified as Afrofemcentrism, its intersecting black and feminist aesthetic qualities are immediately visible. Aesthetic tastes in color, rhythm and texture appear essentially the same as those in black art for obvious

reasons, having the same Afro-American cultural base. The factor that distinguishes Afrofemcentrism in black art is the black female perspective, which insightfully enlarges and activates images of black women, celebrating heroines and documenting herstory while integrally addressing political, social and personal issues. The idea of woman's media does not appear to be a major gender issue in black art, since some black male artists also employ such materials, primarily influenced by the African continuum, especially mixed-media African sculpture and tapestry. Also, painting, printmaking and other traditionally male associated materials are more often than not used in Afrofemcentrist art as a result of the conventional academic training of black women artists. Overall, the most distinguishing feature in Afrofemcentrist art is the unique focus on and presentation of black females. The focus parallels the one on white females in feminist art, differing in racial depiction and perspective. Most important in the portrayal of woman in the ideology of Afrofemcentrism is the reaffirmation of her involved, thinking personage, rather than the demystification of the feminine body and the response to sexism which often occurs in feminist art. Subsequently, Afrofemcentrist and feminist motifs differ. The preoccupation with vaginal forms, for example, is nonexistent in the former. Rather, icons of the African diaspora are assimilated into works of art to symbolize femaleness, life, fertility, liberation and other pertinent concepts; the Ghanian akuaba and Guinean nimba life/fertility symbols are classic examples. Geometric and curvilinear African diaspora patterns are also predominant, as opposed to floral patterns, butterfly motifs and other forms generally identified with feminism. Despite these differences, however, the idea of recording "herstory," of celebrating women's culture, of addressing women's issues and of presenting self-defined images are factors which, to some degree, unify Afrofemcentrism and feminism.

Elizabeth Catlett and Faith Ringgold are the two most prominent American artists who have been identified as "black feminist" and who are regarded by the writer as Afrofemcentrists. In their ideas and works, there is uniformity and diversity; uniformity in their intimate focus on real-type black women subjects and issues, and diversity in their particular visions, styles and media. Collectively, they magnify the thoughts, actions and sensibilities of Afro-American women, often embracing those of the African diaspora, and certainly serving as models for younger black women artists who are in search of themselves.[10]

As Afrofemcentrists, Catlett and Ringgold espouse total self-acknowledgment, operating from the center of themselves and outwards. The self-effacing adages "I happen to be black" and "I happen to be a woman," which are often voiced by individuals who are "human first" or "artist first" are adamantly rejected by them as they insistently proclaim their complete identities. Ringgold demonstrates this point in the following statement as she addresses the battle in the art arena: "No other field is as closed to those who are not white and male as is the visual arts. After I decided to be an artist, the first thing I had to believe was that I, a black woman, could penetrate the art scene, and that, further, I could do so without sacrificing one iota of my blackness or my femaleness or my humanity."[11] Catlett's similar stance is evident in her following response to the potential identification of her works as "female-produced":

I would be very happy. I have nothing against being identified as a woman or a female artist. I think there is definitely a woman's estheticism, different from the traditional male estheticism. I think that the male is aggressive and he has a male supremacist idea in his head, at least in the United States and Mexico. We need to know more about women. I like to interpret women: women's ideas, women's feelings. The female estheticism is more sensitive, and I'm happy to be part of it.[12]

The positions of both artists are earthy and without the pretensions of a number of successful women artists who disavow female references to their work. Catlett's views reflect the self-recognition influences of leading scholars and artists in the field of Afro-American art history and art

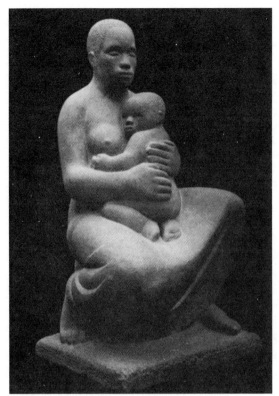

2. Elizabeth Catlett, *Mother and Child*, marble, 1940. Courtesy of Samella Lewis.

(Alain Locke, James Porter, James Wells, Lois Mailou Jones and James Herring) which she imbibed as a student at Howard University in the 1930s, and similar influences from the American artist Grant Wood, at the University of Iowa, where she completed her Master of Fine Arts in 1940. The longevity of her self-recognition and its penetration into her art work is evident in statements about her work that were made in 1943 by Porter and in 1980 by Jacqueline Fonvielle-Bontemps and Driskell. The former refers to an identifiable black aesthetic quality in a marble sculpture, *Mother and Child* [2], which won first prize at the Negro Exposition in Chicago in 1940: "The Negroid quality in 'Mother and Child' is undeniable and the work has poise and a profound structure."[13] The latter two discuss her achievement some decades after the production of that work:

Out of her personal experience as an Afro-American, a Black woman and a long time resident in Mexico, she has developed a philosophy of deliverance in art, a sense that artists have a responsibility to "create an art for liberation and for life. . . ."[14]

Indeed, Catlett's prints and sculptural creations produced during the Sixties and Seventies are among the most compelling and meaningful visual images created or inspired by the Black Liberation Movement.[15]

The younger Ringgold's position hints at her "coming of age" during her years of maturation after completion of her graduate work at the City College of New York in 1959. Assimilating her "grassroots" experience as a Harlemite, she organized and participated in protests and demonstrations against racism in the museums during that time while also developing her work and conceptualizing her future directions. But while confronting racism in the "establishment," she encountered sexism from black male artists through a series of events which, she indicated, brought about her feminism. Reminiscing, she recounted, "I had to find out who I was again—I was back at the drawing board. And that's when I figured it out, in 1970–71, that I was a Black *woman.* "[16] Yet in turning to feminist groups (white) she still faced the problem of racism and contradictions. Lippard noted Ringgold's frustrating circumstance of that period:

As a Black woman in a predominantly white movement, Faith Ringgold worked square in the middle of contradictions, confronting the exclusion of Blacks from the art world and the controversial position of feminism in the Black Movement.[17]

Subsequently, Ringgold co-founded a black women's art group in 1971 with Dinga McCannon and Kay Brown, which they called Where We At: Black Women Artists, and focused more on her black female sensibility, leaving avenues open for networking with other artists and groups. Within the next two years, she had "begun to speak almost exclusively for women, Black women," who in turn began to speak to the world through her art.[18]

The philosophical directions of Catlett and Ringgold formed the rudiments for their artistic

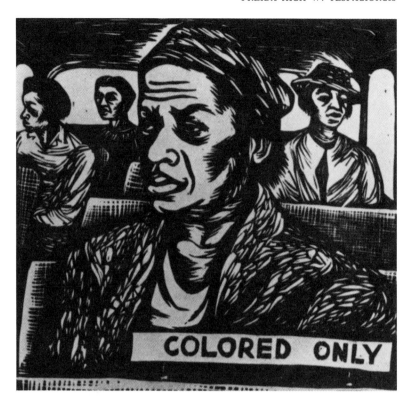

3. Elizabeth Catlett, *I Have Special Reservations,* linocut, from *The Negro Woman* series, 1946–47. Courtesy of Samella Lewis.

4. Elizabeth Catlett, *Harriet,* linocut, developed from the original done for *The Negro Woman* series, 1946–47. Courtesy of Samella Lewis.

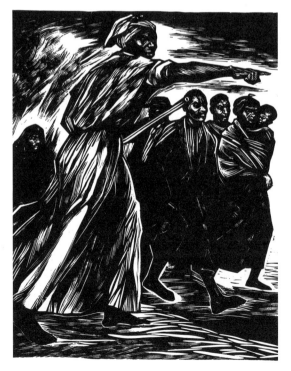

creativity, which effected classically Afrofemcentric productions. While the forms of Catlett are sculpted in wood, terra cotta, stone, marble and bronze or printed in linocut, those of Ringgold are assembled in sewn fabric, embroidery, raffia and other soft sculptural media, as well as including painting, and altogether representing materials and techniques that are traditionally associated with both men and women. The black woman subject remains primary in their depictions, about which both artists comment. Catlett recalled Wood's influence. "He insisted that we work from what we know best and I started then working with black subject matter and with the subject matter of woman, I guess."[19] Elaborating on this point, she imparted to art historian Samella Lewis:

I don't have anything against men but, since I am a woman, I know more about women and I know how they feel. Many artists are always doing men. I think that somebody ought to do women. Artists do work with women, with the beauty of their bodies and the refinement of middle-class women, but I think there is

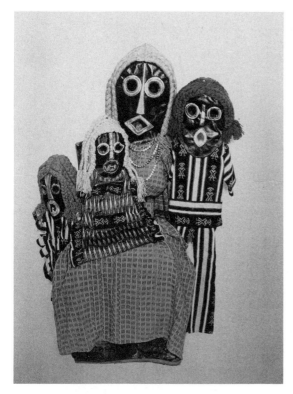

5. Faith Ringgold, *Mrs. Jones and Family*, mixed media, from *Family of Woman* mask series, 1973 *(Faith Ringgold)*.

6. Faith Ringgold, *Fight: To Save Your Life*, painting, from *Slave Rape* painting series, 1973.

a need to express something about the working class Black woman and that's what I do.[20]

Her linocut series *The Negro Woman*, which was printed in 1946–47 [3, 4], delineated black working-class women in images of the ordinary and heroic (women of the blues, women of intellect, women of servitude and women of revolution), revealing Catlett's commitment and sensitivity to their struggles. This series, which was funded by a Julius Rosenwald Fellowship, was indeed a landmark in the pictorial representation of black women, for it liberated them from their objectified status in the backgrounds and shadows of white subjects in the works of white artists, and from the roles of mother, wife, sister, other in the works of black male artists.

Ringgold's consistent involvement with the black woman subject, some twenty-five years after Catlett's *Negro Woman* series, began with a mural at the Women's House of Detention on Riker's Island that was immediately followed by her *Family of Woman* masks and *Slave Rape*

7. Elizabeth Catlett, *Homage to My Young Black Sisters*, cedar, 1968. Courtesy of Samella Lewis.

painting series in 1973 [5,6].[21] The following statement addresses one of these works and implies her purpose of speaking for an unheard people: "I have a strong story to tell—the story is about the rape of women during slavery. We know the story of the Black man in slavery; everybody tells it. I'm a Black woman. I'm telling her story."[22] Paramount in this statement is her determination to depict aspects of black women's realities, and explicit is her confidence in being equipped to do so successfully, a view quite similar to Catlett's.

Two exciting works that offer insight into their Afrofemcentric visions are *Homage to My Young Black Sisters* [7], a sculptural form carved in cedar by Catlett, and *The Screaming Woman* [1], a soft sculptural form in mixed media by Ringgold. Produced in1968 in Mexico, where Catlett has lived since 1947, *Homage* reveals Catlett's compassion for black women as it addresses their participation

in the global struggle against racism and imperialism, particularly during the sixties. As a monument to "Young Black Sisters," its presence is impacting, communicating tensions of political activism juxtaposed with female attributes of character, strength and beauty, and the added sense of female bonding. This quasi-abstract standing female form figuratively portrays a black woman subject in an arrested motion of protest. Its symbolic gestures, particularly the upturned head and the clenched fist that thrusts above it, are imbued with energy and hope, reinforcing the power conveyed in its subtly sensuous robust body. The exciting interplay of impressive geometric and curvilinear volumes is enhanced by the negative oval space and surrounding surface reiterations in the torso area, suggesting woman's procreative and nurturing potential. Displaying the Afrocentric aesthetic influence of an African prototype in near-symmetrical balance, angularity, monochromatic darkness, smoothness and luminosity, *Homage* also evokes references to Mexican sculpture while importantly revealing Catlett's technical mastery of modernism and her innovative approach to the human figure.

As Afrocentrism is immediately recognizable in the overall form of *Homage,* Afrofemcentrism is clearly visible in its details—i.e., the head-face, breast-shoulders, torso and buttocks. First, the upturned head and simplified bas-relief facial features, in their dignified and spiritual resonance, are particularly reminiscent of ancestral funerary terra-cotta heads made by Asante women of Ghana, suggesting the African continuum in artistic elements, gesture and feeling. Secondly, the breasts are modestly represented in stylized form and balanced with massive angular shoulders, thereby conveying strength in femaleness rather than nurturance or sexuality, which is most often suggested in the breasts of females rendered by men. Thirdly, the idea of maternity is evoked in the symbolic egg shape in the torso area. While this overlaps with the prevailing theme of woman as mother in the art of men, its uniqueness is discerned in the position chosen for its central negative space. This detail deemphasizes motherhood, while reinforcing woman's personage and

action as foremost in her existence. Lastly, hefty buttocks which reflect that aspect of black women's physique are shown here as both beautiful and strong, not simply as sensual, as often suggested by men. More discussion of this final point is warranted, especially in view of similar aesthetic tastes regarding women's bodies and concepts of feminine beauty, among the Mende in Sierra Leone, documented in the recent publication of anthropologist–art historian Sylvia Boone.[23] Overall, these details contribute to the unique sensibility in *Homage,* which in its totality presents an aspect of the black woman's multidimensional personage and defies any single interpretation.

As *Homage* conveys the prevailing mood of the turbulent sixties epoch, *The Screaming Woman* [1] captures the apprehension surrounding a recent chilling episode in American history—the sequence of murders of black children in Atlanta. Produced in 1981 during the period of those tragic incidents, *The Screaming Woman* emerged to confront society with the challenge to "Save Our Children in Atlanta." With a poster in one hand, graphically illustrating that idea, and a white cloth in the other, symbolic of infancy and innocence, the woman has thrown down her bag of groceries and purse, which lie at her feet, suggesting the ludicrousness of routine shopping and spending when young lives are being taken. Ringgold comments, "When a woman's purse is on the ground, you know something is terribly wrong."[24]

While black political consciousness is expressed in the theme of this work, the Pan-African vernacular is evident in its Afrofemcentric aesthetic and technique. The body proportions (comparatively large head) suggest African influences, as do the architectonic features of the masklike face. The mixed-media soft sculptural form is infused with dramatic textural qualities of the African and feminine continuum, complemented by subtle red, black and green colors, symbolic of black nationalism: red and sienna facial tones, black hands, legs and patterned outlines in the dress, and dominating green colors in the hair, dress and shoes, which represent life. Raffia, embroidered cloth, sewn fabric and sequins are details that contribute to

8. Faith Ringgold, *Atlanta Children,* mixed
media sculptures, 1981.

the evocative and aggressive character of this
form.

Through this work and others (eg., fig. 8), one
sees Ringgold's affirmation of women's creativity,
about which she talks freely, implying its contro-
versial status: "But I love soft sculpture. I am crazy
about it. I like doing things with sewing, and I
don't see any reason why I shouldn't just because
somebody said that's what the women do. It is
what women do, so what?"[25] This aspect of her
work and the embedded African character
prompted art historian/critic Moira Roth to state,
"Any reading of Ringgold's work must take
equally into account these two traditions" if her
art and allegiances are to be understood, a point
that is also applicable to the work of Catlett.

In the work of Catlett and Ringgold, there
emerge images of black women as real-type in-
dividuals who are "thinkers, feelers, human be-
ings, conscious beings, with race, sex [and] some-
times situations in common."[26] They stand as
testament of Renita Weems's response to Abby
Lincoln's seventeen-year question (Who Will Re-
vere the Black Woman?) by demonstrating that
the "Black woman artist will (and does) revere the
Black woman."[27] And she does so because she is
"sane, secure and sensitive"[28] enough to express
her innermost feelings; also audacious enough to
introduce into "fine art" a new dimension in sub-
ject and aesthetic, the exponent of Afrofemcen-
tric consciousness.[29]

NOTES

1. Elizabeth A. Catlett, speaking on a panel entitled "Afro-American Art of the 1940s and 1950s, Symposium: Since the Harlem Renaissance," at Pennsylvania State University, University Park, October 5, 1985.

2. I coined this term in 1984 to designate what I see as a unique assertiveness-consciousness in Afro-American women—"black feminism" appearing much too incomplete.

3. Molefi K. Asante, *Afrocentricity: The Theory of Social Change* (Buffalo, N. Y.: Amulefi Publishing, 1980), p. 4.

4. Freida High-Wasikhongo (Tesfagiorgis), "Afrofemcentric: Twenty Years of Faith Ringgold," in *Faith Ringgold: Twenty Years of Painting, Sculpture and Performance (1963–1983)*, ed. Michele Wallace (New York: Studio Museum in Harlem, 1984), pp. 17–18.

5. Larry Neal, "The Black Arts Movement," in *The Black Aesthetic*, ed. Addison Gayle, Jr. (New York: Doubleday, 1972), p. 257.

6. Barry Gaither, *Afro-American Artists: New York and Boston* (Boston: National Center of Afro-American Artists and Museum of Fine Arts, 1970), n.p.

7. Lucy Lippard, *From the Center: Feminist Essays on Women's Art* (New York: E.P. Dutton, 1976), p. 7.

8. Gayle Kimball, "Women's Culture: Themes and Images," in *Women's Culture: Renaissance of the Seventies*, ed. Gayle Kimball (Metuchen, N. J.: Scarecrow Press, 1981), p. 2.

9. Judy Chicago, *Embroidering Our Heritage: The Dinner Party Needlework* (New York: Anchor Press/Doubleday, 1980).

10. Many younger Afro-American women artists refer to Elizabeth Catlett as a role model. Despite her living in Mexico, she has remained visible to black American artists as she has championed modern art, black aesthetic traditions and black liberation ideology. Through her affiliation with the National Conference of Artists (an organization of professional black artists, critics and art historians, which was founded in 1959), younger artists have had the opportunity to meet her and to experience her personal warmth.

11. Michele Wallace, "Daring to Do the Unpopular," *Ms.* 1, no. 7 (1973): 24–27.

12. Samella Lewis, *The Art of Elizabeth Catlett* (Claremont, Calif.: The Museum of African American Art and Handcraft Studios, 1984), p. 104.

13. James Porter, *Modern Negro Art* (New York: Dryden Press, 1943), p. 142.

14. Jacqueline Fonvielle-Bontemps and Arna A. Bontemps, *Forever Free: Art by African-American Women, 1862–1980* (Alexandria, Va.: Stephenson, 1980), p. 33.

15. Ibid., p. 41 (crediting Dr. David Driskell).

16. Joseph Jacobs, "Faith Ringgold," *Since the Harlem Renaissance: 50 Years of Afro-American Art* (Lewisburg, Penn.: Center Gallery of Bucknell University, 1985), p. 30.

17. Lucy Lippard, "Dreams, Demands and Desires: The Black, Antiwar, and Women's Movements," in *Tradition and Conflict: Images of a Turbulent Decade, 1963–1973*, ed. Mary Schmidt Campbell (New York: Studio Museum in Harlem, 1985), p. 79.

18. Moira Roth, "The Field and the Drawing Room," in *Faith Ringgold Change: Painted Story Quilts* (New York: Bernice Steinbaum Gallery, 1987), p. 4.

19. Elizabeth Catlett, "Symposium: Since the Harlem Renaissance," panel.

20. Samella Lewis, *The Art of Elizabeth Catlett*, p. 102.

21. Eleanor Munro, *Originals: American Women Artists* (New York: Simon & Schuster, 1979), pp. 413–15.

22. Doris Brown, "Social Comment Rings True," *The Home News*, New Brunswick, N.J., March 4, 1973, p. C21.

23. Sylvia Boone, *Radiance from the Waters: Ideals of Feminine Beauty in Mende Art* (New Haven, Conn., and London: Yale University Press, 1986). Boone discusses physical and metaphysical aspects of feminine beauty among the Mende in Sierra Leone and explains that beauty among the Mende implies beauty in "being" and beauty in "doing," the latter associated with "goodness and morality." She indicates that large buttocks are considered beautiful not only because of their appearance, but also because of their association with child care—i.e., "child-carrying buttocks." One would suspect that similar aesthetic taste in the United States is an aspect of the African continuum.

24. Faith Ringgold, oral communication with author, 1987.

25. Lynn Miller and Sally Swenson, *Lives and Works: Talks with Women Artists* (Metuchen, N.J.: Scarecrow Press, 1981), p. 165.

26. Barbara Christian, *Black Feminist Criticism: Perspectives on Black Women Writers* (New York: Pergamon, 1985), p. 16. Christian refers to black women writers; however, these ideas embrace the sensitivities of black women artists as well.

27. Renita Weems, "Artists Without Art Form: A Look at One Black Woman's World of Unrevered Black Women," in *Home Girls: A Black Feminist Anthology*, ed. Barbara Smith (New York: Kitchen Table Women of Color Press, 1983), p. 94.

28. Ibid.

29. See Crystal Britton's "Faith Ringgold," *Art Papers* (Atlanta) II, no. 5 (September/October 1987): 23–25, for further information on Ringgold. See Thalia Gouma-Peterson and Patricia Mathews, "The Feminist Critique of Art History," *The Art Bulletin* LXIX (September 1987): 326–57.

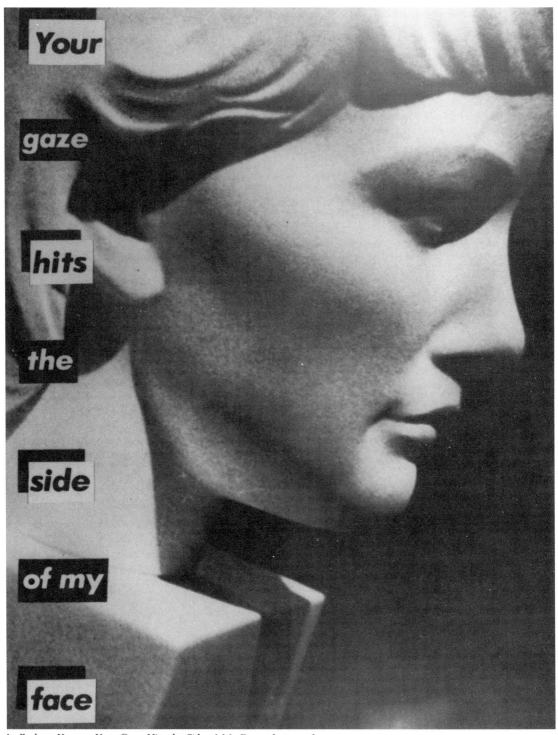

1. Barbara Kruger, *Your Gaze Hits the Side of My Face,* photograph,
1981. New York, Mary Boone Gallery, New York *(Zindman/Fremont).*

THE DISCOURSE OF OTHERS

Feminists and Postmodernism

CRAIG OWENS

Postmodern knowledge [le savoir postmoderne] is not simply an instrument of power. It refines our sensitivity to differences and increases our tolerance of incommensurability.

—J.-F. Lyotard, *La Condition postmoderne*

Decentered, allegorical, schizophrenic . . . — however we choose to diagnose its symptoms, postmodernism is usually treated, by its protagonists and antagonists alike, as a crisis of cultural authority, specifically of the authority vested in Western European culture and its institutions. That the hegemony of European civilization is drawing to a close is hardly a new perception; since the mid-1950s, at least, we have recognized the necessity of encountering different cultures by means other than the shock of domination and conquest. Among the relevant texts are Arnold Toynbee's discussion, in the eighth volume of his monumental *Study in History,* of the end of the modern age (an age that began, Toynbee contends, in the late fifteenth century when Europe began to exert its influence over vast land areas and populations not its own) and the beginning of a new, properly postmodern age characterized by the coexistence of different cultures. Claude Lévi-Strauss's critique of Western ethnocentrism could also be cited in this context, as well as Jacques

Derrida's critique of this critique in *Of Grammatology.* But perhaps the most eloquent testimony to the end of Western sovereignty has been that of Paul Ricoeur, who wrote in 1962 that "the discovery of the plurality of cultures is never a harmless experience."

When we discover that there are several cultures instead of just one and consequently at the time when we acknowledge the end of a sort of cultural monopoly, be it illusory or real, we are threatened with the destruction of our own discovery. Suddenly it becomes possible that there are just *others,* that we ourselves are an "other" among others. All meaning and every goal having disappeared, it becomes possible to wander through civilizations as if through vestiges and ruins. The whole of mankind becomes an imaginary museum: where shall we go this weekend—visit the Angkor ruins or take a stroll in the Tivoli of Copenhagen? We can very easily imagine a time close at hand when any fairly well-to-do person will be able to leave his country indefinitely in order to taste his own national death in an interminable, aimless voyage.[1]

Lately, we have come to regard this condition as postmodern. Indeed, Ricoeur's account of the more dispiriting effects of our culture's recent loss of mastery anticipates both the melancholia and the eclecticism that pervade current cultural pro-

duction—not to mention its much-touted pluralism. Pluralism, however, reduces us to being an other among others; it is not a recognition, but a reduction to difference to absolute indifference, equivalence, interchangeability (what Jean Baudrillard calls "implosion"). What is at stake, then, is not only the hegemony of Western culture, but also (our sense of) our identity as a culture. These two stakes, however, are so inextricably intertwined (as Foucault has taught us, the positing of an Other is a necessary moment in the consolidation, the incorporation of any cultural body) that it is possible to speculate that what has toppled our claims to sovereignty is actually the realization that our culture is neither as homogeneous nor as monolithic as we once believed it to be. In other words, the causes of modernity's demise—at least as Ricoeur describes its effects—lie as much within as without. Ricoeur, however, deals only with the difference without. What about the difference within?

In the modern period the authority of the work of art, its claim to represent some authentic vision of the world, did not reside in its uniqueness or singularity, as is often said; rather, that authority was based on the universality modern aesthetics attributed to the *forms* utilized for the representation of vision, over and above differences in content due to the production of works in concrete historical circumstances.[2] (For example, Kant's demand that the judgment of taste be universal— i.e., universally communicable—that it derive from "grounds deep-seated and shared alike by all men, underlying their agreement in estimating the forms under which objects are given to them.") Not only does the postmodernist work claim no such authority, it also actively seeks to undermine all such claims; hence, its generally deconstructive thrust. As recent analyses of the "enunciative apparatus" of visual representation—its poles of emission and reception—confirm, the representational systems of the West admit only one vision—that of the constitutive male subject—or, rather, they posit the subject of representation as absolutely centered, unitary, masculine.[3]

The postmodernist work attempts to upset the reassuring stability of that mastering position. This same project has, of course, been attributed by writers like Julia Kristeva and Roland Barthes to the *modernist* avant-garde, which through the introduction of heterogeneity, discontinuity, glossolalia, etc., supposedly put the subject of representation in crisis. But the avant-garde sought to transcend representation in favor of presence and immediacy; it proclaimed the autonomy of the signifier, its liberation from the "tyranny of the signified"; postmodernists instead expose the tyranny of the *signifier*, the violence of its law.[4] (Lacan spoke of the necessity of submitting to the "defiles" of the signifier; should we not ask rather who in our culture is defiled by the signifier?) Recently, Derrida has cautioned against a wholesale condemnation of representation, not only because such a condemnation may appear to advocate a rehabilitation of presence and immediacy and thereby serve the interests of the most reactionary political tendencies, but more importantly, perhaps, because that which exceeds, "transgresses the figure of all possible representation," may ultimately be none other than . . . the law. Which obliges us, Derrida concludes, "to thinking altogether *differently.*"[5]

It is precisely at the legislative frontier between what can be represented and what cannot that the postmodernist operation is being staged—not in order to transcend representation, but in order to expose that system of power that authorizes certain representations while blocking, prohibiting, or invalidating others. Among those prohibited from Western representation, whose representations are denied all legitimacy, are women. Excluded from representation by its very structure, they return within it as a figure for—a representation of—the unrepresentable (Nature, Truth, the Sublime, etc.). This prohibition bears primarily on woman as the subject, and rarely as the object of representation, for there is certainly no shortage of images *of* women. Yet in being so represented, women have been rendered an absence within the dominant culture as Michèle Montrelay proposes when she asks "whether psychoanalysis was not articulated precisely in order to repress femininity (in the sense of producing its symbolic representa-

tion)."[6] In order to speak, to represent herself, a woman assumes a masculine position; perhaps this is why femininity is frequently associated with masquerade, with false representation, with simulation and seduction. Montrelay, in fact, identifies women as the "ruin of representation": not only have they nothing to lose; their exteriority to Western representation exposes its limits.

Here, we arrive at an apparent crossing of the feminist critique of patriarchy and the postmodernist critique of representation; this essay is a provisional attempt to explore the implications of that intersection. My intention is not to posit identity between these two critiques; nor is it to place them in a relation of antagonism or opposition. Rather, if I have chosen to negotiate the treacherous course between postmodernism and feminism, it is in order to introduce the issue of sexual difference into the modernism/postmodernism debate—a debate which has until now been scandalously in-different.[7]

"A Remarkable Oversight"[8]

Several years ago I began the second of two essays devoted to an allegorical impulse in contemporary art—an impulse that I identified as postmodernist—with a discussion of Laurie Anderson's multimedia performance *Americans on the Move.*[9] Addressed to transportation as a metaphor for communication—the transfer of meaning from one place to another—*Americans on the Move* proceeded primarily as verbal commentary on visual images projected on a screen behind the performers. Near the beginning Anderson introduced the schematic image of a nude man and woman, the former's right arm raised in greeting, that had been emblazoned on the Pioneer spacecraft. Here is what she had to say about this picture; significantly, it was spoken by a distinctly male voice (Anderson's own processed through a harmonizer, which dropped it an octave—a kind of electronic vocal transvestism):

In our country, we send pictures of our sign language into outer space. They are speaking our sign language in these pictures. Do you think they will think his hand is permanently attached that way? Or do you think they will read our signs? In our country, good-bye looks just like hello.

Here is my commentary on this passage:

Two alternatives: either the extraterrestrial recipient of this message will assume that it is simply a picture, that is, an analogical likeness of the human figure, in which case he might logically conclude that male inhabitants of Earth walk around with their right arms permanently raised. Or he will somehow divine that this gesture is addressed to him and attempt to read it, in which case he will be stymied, since a single gesture signifies both greeting and farewell, and any reading of it must oscillate between these two extremes. The same gesture could also mean "Halt!" or represent the taking of an oath, but if Anderson's text does not consider these two alternatives that is because it is not concerned with ambiguity, with multiple meanings engendered by a single sign; rather, two *clearly defined but mutually incompatible* readings are engaged in blind confrontation in such a way that it is impossible to choose between them.

This analysis strikes me as a case of gross critical negligence. For in my eagerness to rewrite Anderson's text in terms of the debate over determinate versus indeterminate meaning, I had overlooked something—something that is so obvious, so "natural" that it may at the time have seemed unworthy of comment. It does not seem that way to me today. For this is, of course, an image of sexual difference or, rather, of sexual differentiation according to the distribution of the phallus—as it is marked and then re-marked by the man's right arm, which appears less to have been raised than erected in greeting. I was, however, close to the "truth" of the image when I suggested that men on Earth might walk around with something permanently raised—close, perhaps, but no cigar. (Would my reading have been different—or less in-different—had I known then that, earlier in her career, Anderson had executed a work which consisted of photographs of men who had accosted her in the street?[10]) Like all representations of sexual difference that our culture produces, this is an image not simply of anatomical difference, but of the values assigned to it. Here, the phallus is a signifier (that is, it represents the subject for an-

other signifier); it is, in fact, the privileged sig-
nifier, the signifier of privilege, of the power and
prestige that accrue to the male in our society. As
such, it designates the effects of signification in
general. For in this (Lacanian) image, chosen to
represent the inhabitants of Earth for the extrater-
restrial Other, it is the man who speaks, who
represents mankind. The woman is only repre-
sented; she is (as always) already spoken for.

If I return to this passage here, it is not simply
to correct my own remarkable oversight, but more
importantly to indicate a blind spot in our discus-
sions of postmodernism in general: our failure to
address the issue of sexual difference—not only in
the objects we discuss, but in our own enunciation
as well.[11] However restricted its field of inquiry
may be, every discourse on postmodernism—at
least insofar as it seeks to account for certain re-
cent mutations within that field—aspires to the
status of a general theory of contemporary culture.
Among the most significant developments of the
past decade—it may well turn out to have been
the most significant—has been the emergence, in
nearly every area of cultural activity, of a specifi-
cally feminist practice. A great deal of effort has
been devoted to the recovery and revaluation of
previously marginalized or underestimated work;
everywhere this project has been accompanied by
energetic new production. As one engaged in
these activities—Martha Rosler—observes, they
have contributed significantly to debunking the
privileged status modernism claimed for the work
of art: "The interpretation of the meaning and
social origin and rootedness of those [earlier]
forms helped undermine the modernist tenet of
the separateness of the aesthetic from the rest of
human life, and an analysis of the oppressiveness
of the seemingly unmotivated forms of high cul-
ture was companion to this work."[12]

Still, if one of the most salient aspects of our
postmodern culture is the presence of an insistent
feminist voice (and I use the terms *presence* and
voice advisedly), theories of postmodernism have
tended either to neglect or to repress that voice.
The absence of discussions of sexual difference in
writings about postmodernism, as well as the fact
that few women have engaged in the modernism/

postmodernism debate, suggest that postmodern-
ism may be another masculine invention engi-
neered to exclude women. I would like to propose,
however, that women's insistence on difference
and incommensurability may not only be compati-
ble with, but also an instance of postmodern
thought. Postmodern thought is no longer binary
thought (as Lyotard observes when he writes,
"Thinking by means of oppositions does not cor-
respond to the liveliest modes of postmodern
knowledge [*le savoir postmoderne*]").[13] The cri-
tique of binarism is sometimes dismissed as intel-
lectual fashion; it is, however, an intellectual im-
perative, since the hierarchical opposition of
marked and unmarked terms (the decisive/divi-
sive presence/absence of the phallus) is the domi-
nant form both of representing difference and
justifying its subordination in our society. What
we must learn, then, is how to conceive difference
without opposition.

Although sympathetic male critics respect fem-
inism (an old theme: respect for women)[14] and
wish it well, they have in general declined the
dialogue in which their female colleagues are try-
ing to engage them. Sometimes feminists are ac-
cused of going too far, at others, not far enough.[15]
The feminist voice is usually regarded as one
among many, its insistence on difference as testi-
mony to the pluralism of the times. Thus, femi-
nism is rapidly assimilated to a whole string of
liberation or self-determination movements. Here
is one recent list, by a prominent male critic: "eth-
nic groups, neighborhood movements, feminism,
various 'countercultural' or alternative life-style
groups, rank-and-file labor dissidence, student
movements, single-issue movements." Not only
does this forced coalition treat feminism itself as
monolithic, thereby suppressing its multiple inter-
nal differences (essentialist, culturalist, linguistic,
Freudian, anti-Freudian . . .); it also posits a vast,
undifferentiated category, "Difference," to which
all marginalized or oppressed groups can be assim-
ilated, and for which women can then stand as an
emblem, a *pars totalis* (another old theme: woman
is incomplete, not whole). But the specificity of
the feminist critique of patriarchy is thereby de-
nied, along with that of all other forms of opposi-

tion to sexual, racial, and class discrimination. (Rosler warns against using woman as "a token for all markers of difference," observing that "appreciation of the work of women whose subject is oppression exhausts consideration of all oppressions.")

Moreover, men appear unwilling to address the issues placed on the critical agenda by women unless those issues have first been neut(e)ralized—although this, too, is a problem of assimilation: to the already known, the already written. In *The Political Unconscious*, to take but one example, Fredric Jameson calls for the "reaudition of the oppositional voices of black and ethnic cultures, women's or gay literature, 'naive' or marginalized folk art *and the like*" (thus, women's cultural production is anachronistically identified as folk art), but he immediately modifies this petition: "The affirmation of such non-hegemonic cultural voices remains ineffective," he argues, if they are not first *rewritten* in terms of their proper place in "the dialogical system of the social classes."[16] Certainly, the class determinants of sexuality—and of sexual oppression—are too often overlooked. But sexual inequality cannot be reduced to an instance of economic exploitation—the exchange of women among men—and explained in terms of class struggle alone; to invert Rosler's statement, exclusive attention to economic oppression can exhaust consideration of other forms of oppression.

To claim that the division of the sexes is irreducible to the division of labor is to risk polarizing feminism and Marxism; this danger is real, given the latter's fundamentally patriarchal bias. Marxism privileges the characteristically masculine activity of production as the *definitively human* activity (Marx: men "begin to distinguish themselves from animals as soon as they begin to produce their means of subsistence");[17] women, historically consigned to the spheres of nonproductive or reproductive labor, are thereby situated outside the society of male producers, in a state of nature. (As Lyotard has written, "The frontier passing between the sexes does not separate two parts of the same social entity."[18]) What is at issue, however, is not simply the oppressiveness of

Marxist discourse, but its totalizing ambitions, its claim to account for every form of social experience. But this claim is characteristic of all theoretical discourse, which is one reason women frequently condemn it as phallocratic.[19] It is not always theory per se that women repudiate, nor simply, as Lyotard has suggested, the priority men have granted to it, its rigid opposition to practical experience. Rather, what they challenge is the distance it maintains between itself and its objects—a distance which objectifies and masters.

Because of the tremendous effort of reconceptualization necessary to prevent a phallologic relapse in their own discourse, many feminist artists have, in fact, forged a new (or renewed) alliance with theory—most profitably, perhaps, with the writing of women influenced by Lacanian psychoanalysis (Luce Irigaray, Hélène Cixous, Montrelay . . .). Many of these artists have themselves made major theoretical contributions: filmmaker Laura Mulvey's 1975 essay "Visual Pleasure and Narrative Cinema," for example, has generated a great deal of critical discussion on the masculinity of the cinematic gaze.[20] Whether influenced by psychoanalysis or not, feminist artists often regard critical or theoretical writing as an important arena of strategic intervention: Martha Rosler's critical texts on the documentary tradition in photography—among the best in the field—are a crucial part of her activity *as an artist.* Many modernist artists, of course, produced texts about their own production, but writing was almost always considered supplementary to their primary work as painters, sculptors, photographers, etc.,[21] whereas the kind of simultaneous activity on multiple fronts that characterizes many feminist practices is a postmodern phenomenon. And one of the things it challenges is modernism's rigid opposition of artistic practice and theory.

At the same time, postmodern feminist practice may question theory—and not only *aesthetic* theory. Consider Mary Kelly's *Post-Partum Document* (1973–79), a 6-part, 165-piece art work (plus footnotes) that utilizes multiple representational modes (literary, scientific, psychoanalytic, linguistic, archaeological, and so forth) to chronicle the first six years of her son's life. Part archive, part

exhibition, part case history, the *Post-Partum Document* is also a contribution to as well as a critique of Lacanian theory. Beginning as it does with a series of diagrams taken from *Ecrits* (diagrams which Kelly presents as *pictures*), the work might be (mis)read as a straightforward application or illustration of psychoanalysis. It is, rather, a mother's interrogation of Lacan, an interrogation that ultimately reveals a remarkable oversight within the Lacanian narrative of the child's relation to the mother—the construction of the mother's fantasies vis-à-vis the child. Thus, the *Post-Partum Document* has proved to be a controversial work, for it appears to offer evidence of *female* fetishism (the various substitutes the mother invents in order to disavow separation from the child); Kelly thereby exposes a lack within the theory of fetishism, a perversion heretofore reserved for the male. Kelly's work is not anti-theory; rather, as her use of multiple representational systems testifies, it demonstrates that no one narrative can possibly account for all aspects of human experience. Or as the artist herself has said, "There's no single theoretical discourse which is going to offer an explanation for all forms of social relations or for every mode of political practice."[22]

A la recherche du récit perdu

"No single theoretical discourse . . ."—this feminist position is also a postmodern condition. In fact, Lyotard diagnoses *the* postmodern condition as one in which the *grands récits* of modernity—the dialectic of Spirit, the emancipation of the worker, the accumulation of wealth, the classless society—have all lost credibility. Lyotard defines a discourse as modern when it appeals to one or another of these *grands récits* for its legitimacy; the advent of postmodernity, then, signals a crisis in narrative's legitimizing function, its ability to compel consensus. Narrative, he argues, is out of its element(s)—"the great dangers, the great journeys, the great goal." Instead, "it is dispersed into clouds of linguistic particles—narrative ones, but also denotative, prescriptive, descriptive, etc.—each with its own pragmatic valence. Today, each

of us lives in the vicinity of many of these. We do not necessarily form stable linguistic communities, and the properties of those we do form are not necessarily communicable."[23]

Lyotard does not, however, mourn modernity's passing, even though his own activity as a philosopher is at stake. "For most people," he writes, "nostalgia for the lost narrative [*le récit perdu*] is a thing of the past."[24] "Most people" does not include Fredric Jameson, although he diagnoses the postmodern condition in similar terms (as a loss of narrative's social function) and distinguishes between modernist and postmodernist works according to their different relations to the " 'truth-content' of art, its claim to possess some truth or epistemological value." His description of a crisis in modernist literature stands metonymically for the crisis in modernity itself:

At its most vital, the experience of modernism was not one of a single historical movement or process, but of a "shock of discovery," a commitment and an adherence to its individual forms through a series of "religious conversions." One did not simply read D.H. Lawrence or Rilke, see Jean Renoir or Hitchcock, or listen to Stravinsky as distinct manifestations of what we now term modernism. Rather one read all the works of a particular writer, learned a style and a phenomenological world, to which one converted. . . . This meant, however, that the experience of one form of modernism was incompatible with another, so that one entered one world only at the price of abandoning another. . . . The crisis of modernism came, then, when it suddenly became clear that "D.H. Lawrence" was not an absolute after all, not the final achieved figuration of the truth of the world, but only one art-language among others, only one shelf of works in a whole dizzying library.[25]

Although a reader of Foucault might locate this realization at the origin of modernism (Flaubert, Manet) rather than at its conclusion,[26] Jameson's account of the crisis of modernity strikes me as both persuasive and problematic—problematic because persuasive. Like Lyotard, he plunges us into a radical Nietzschean perspectivism: each oeuvre represents not simply a different view of the same world, but corresponds to an entirely different world. Unlike Lyotard, however, he does so only in order to extricate us from it. For Jame-

son, the loss of narrative is equivalent to the loss of our ability to locate ourselves historically; hence, his diagnosis of postmodernism as "schizophrenic," meaning that it is characterized by a collapsed sense of temporality.[27] Thus, in *The Political Unconscious* he urges the resurrection not simply of narrative—as a "socially symbolic act"—but specifically of what he identifies as the Marxist "master narrative"—the story of mankind's "collective struggle to wrest a realm of Freedom from a realm of Necessity."[28]

Master narrative—how else to translate Lyotard's *grand récit*? And in this translation we glimpse the terms of another analysis of modernity's demise, one that speaks not of the incompatibility of the various modern narratives, but instead of their fundamental solidarity. For what made the *grands récits* of modernity master narratives if not the fact that they were all narratives of mastery, of man seeking his telos in the conquest of nature? What function did these narratives play other than to legitimize Western man's self-appointed mission of transforming the entire planet in his own image? And what form did this mission take if not that of man's placing of his stamp on everything that exists—that is, the transformation of the world into a representation, with man as its subject? In this respect, however, the phrase *master narrative* seems tautologous, since all narrative, by virtue of "its power to master the dispiriting effects of the corrosive force of the temporal process,"[29] may be narrative of mastery.[30]

What is at stake, then, is not only the status of narrative, but of representation itself. For the modern age was not only the age of the master narrative, it was also the age of representation—at least this is what Martin Heidegger proposed in a 1938 lecture delivered in Freiburg im Breisgau, but not published until 1952 as "The Age of the World Picture" [*Die Zeit des Weltbildes*].[31] According to Heidegger, the transition to modernity was not accomplished by the replacement of a medieval by a modern world picture, "but rather the fact that the world becomes a picture at all is what distinguishes the essence of the modern age." For modern man, everything that exists does

so only in and through representation. To claim this is also to claim that the world exists only in and through a *subject* who believes that he is producing the world in producing its representation:

The fundamental event of the modern age is the conquest of the world as picture. The word "picture" [*Bild*] now means the structured image [*Gebild*] that is the creature of man's producing which represents and sets before. In such producing, man contends for the position in which he can be that particular being who gives the measure and draws up the guidelines for everything that is.

Thus, with the "interweaving of these two events"—the transformation of the world into a picture and man into a subject—"there begins that way of being human which means the realm of human capability given over to measuring and executing, for the purpose of gaining mastery of that which is as a whole." For what is representation if not a "laying hold and grasping" (appropriation), a "making-stand-over-against, an objectifying that goes forward and masters"?[32]

Thus, when in a recent interview Jameson calls for "the *reconquest* of certain forms of representation" (which he equates with narrative: " 'Narrative,' " he argues, "is, I think, generally what people have in mind when they rehearse the usual post-structuralist 'critique of representation' "),[33] he is in fact calling for the rehabilitation of the entire social project of modernity itself. Since the Marxist master narrative is only one version among many of the modern narrative of mastery (for what is the "collective struggle to wrest a realm of Freedom from a realm of Necessity" if not mankind's progressive exploitation of the Earth?), Jameson's desire to resurrect (this) narrative is a modern desire, a desire *for* modernity. It is one symptom of our postmodern condition, which is experienced everywhere today as a tremendous loss of mastery and thereby gives rise to therapeutic programs, from both the Left and the Right, for recuperating that loss. Although Lyotard warns—correctly, I believe—against explaining transformations in modern/postmodern culture primarily as effects of social transformations

(the hypothetical advent of a postindustrial society, for example),[34] it is clear that what has been lost is not primarily a cultural mastery, but an economic, technical and political one. For what if not the emergence of Third World nations, the "revolt of nature" and the women's movement—that is, the voices of the conquered—has challenged the West's desire for ever-greater domination and control?

Symptoms of our recent loss of mastery are everywhere apparent in cultural activity today—nowhere more so than in the visual arts. The modernist project of joining forces with science and technology for the transformation of the environment after rational principles of function and utility (Productivism, the Bauhaus) has long since been abandoned; what we witness in its place is a desperate, often hysterical attempt to recover some sense of mastery via the resurrection of heroic large-scale easel painting and monumental cast-bronze sculpture—mediums themselves identified with the cultural hegemony of Western Europe. Yet contemporary artists are able at best to *simulate* mastery, to manipulate its signs; since in the modern period mastery was invariably associated with human labor, aesthetic production has degenerated today into a massive deployment of the signs of artistic labor—violent, "impassioned" brushwork, for example. Such simulacra of mastery testify, however, only to its loss; in fact, contemporary artists seem engaged in a collective act of disavowal—and disavowal always pertains to a loss . . . of virility, masculinity, potency.[35]

This contingent of artists is accompanied by another, which refuses the simulation of mastery in favor of melancholic contemplation of its loss. One such artist speaks of "the impossibility of passion in a culture that has institutionalized self-expression"; another, of "the aesthetic as something which is really about longing and loss rather than completion." A painter unearths the discarded genre of landscape painting only to borrow for his own canvases, through an implicit equation between their ravaged surfaces and the barren fields he depicts, something of the exhaustion of the earth itself (which is thereby glamorized); another dramatizes his anxieties through the most

conventional figure men have conceived for the threat of castration—Woman . . . aloof, remote, unapproachable. Whether they disavow or advertise their own powerlessness, pose as heroes or as victims, these artists have, needless to say, been warmly received by a society unwilling to admit that it has been driven from its position of centrality; theirs is an "official" art which, like the culture that produced it, has yet to come to terms with its own impoverishment.

Postmodernist artists speak of impoverishment—but in a very different way. Sometimes the postmodernist work testifies to a deliberate *refusal* of mastery—for example, Martha Rosler's *Bowery in Two Inadequate Descriptive Systems* (1974–75) [2], in which photographs of Bowery storefronts alternate with clusters of typewritten words signifying inebriety. Although her photographs are intentionally flat-footed, Rosler's refusal of mastery in this work is more than technical. On the one hand, she denies the caption/text its conventional function of supplying the image with something it lacks; instead, her juxtaposition of two representational systems, visual and verbal, is calculated (as the title suggests) to "undermine" rather than "underline" the truth value of each.[36] More importantly, Rosler has refused to photograph the inhabitants of Skid Row, to speak on their behalf, to illuminate them from a safe distance (photography as social work in the tradition of Jacob Riis). For "concerned" or what Rosler calls "victim" photography overlooks the constitutive role of its own activity, which is held to be merely representative (the "myth" of photographic transparency and objectivity). Despite his or her benevolence in representing those who have been denied access to the means of representation, the photographer inevitably functions as an agent of the system of power that silenced these people in the first place. Thus, they are twice victimized: first by society, and then by the photographer who presumes the right to speak on their behalf. In fact, in such photography it is the photographer rather than the "subject" who poses—as the subject's consciousness, indeed, as conscience itself. Although Rosler may not, in this work, have initiated a counter-discourse of drunkenness—which would

```
plastered      stuccoed

rosined      shellacked

       vulcanized

inebriated

polluted
```

2. Martha Rosler, *The Bowery in Two Inadequate Descriptive Systems,*
mixed media, 1974–75 (*from Hal Foster,* The Anti-Aesthetic).

consist of the drunks' own theories about their conditions of existence—she has nevertheless pointed negatively to the crucial issue of a politically motivated art practice today: "the indignity of speaking for others."[37]

Rosler's position poses a challenge to criticism as well, specifically, to the critic's substitution of his own discourse for the work of art. At this point in my text, then, my own voice must yield to the artist's; in the essay "in, around and afterthoughts (on documentary photography)" which accompanies *The Bowery* . . . , Rosler writes:

If impoverishment is a subject here, it is more certainly the impoverishment of representational strategies tottering about alone than that of a mode of surviving. The photographs are powerless to *deal with* the reality that is yet totally comprehended-in-advance by ideology, and they are as diversionary as the word formations—which at least are closer to being located within the culture of drunkenness rather than being framed on it from without.[38]

The Visible and the Invisible

A work like *The Bowery in Two Inadequate Descriptive Systems* not only exposes the "myths" of photographic objectivity and transparency; it also upsets the (modern) belief in vision as a privileged

means of access to certainty and truth ("Seeing is believing"). Modern aesthetics claimed that vision was superior to the other senses because of its detachment from its objects: "Vision," Hegel tells us in his *Lectures on Aesthetics*, "finds itself in a purely theoretical relationship with objects, through the intermediary of light, that immaterial matter which truly leaves objects their freedom, lighting and illuminating them without consuming them."[39] Postmodernist artists do not deny this detachment, but neither do they celebrate it. Rather, they investigate the particular interests it serves. For vision is hardly disinterested; nor is it indifferent, as Luce Irigaray has observed: "Investment in the look is not privileged in women as in men. More than the other senses, the eye objectifies and masters. It sets at a distance, maintains the distance. In our culture, the predominance of the look over smell, taste, touch, hearing, has brought about an impoverishment of bodily relations. . . . The moment the look dominates, the body loses its materiality."[40] That is, it is transformed into an image.

That the priority our culture grants to vision is a sensory impoverishment is hardly a new perception; the feminist critique, however, links the privileging of vision with sexual privilege. Freud identified the transition from a matriarchal to a

patriarchal society with the simultaneous devaluation of an olfactory sexuality and promotion of a more mediated, sublimated visual sexuality.[41] What is more, in the Freudian scenario it is by looking that the child discovers sexual difference, the presence or absence of the phallus according to which the child's sexual identity will be assumed. As Jane Gallop reminds us in her recent book *Feminism and Psychoanalysis: The Daughter's Seduction,* "Freud articulated the 'discovery of castration' around a sight: sight of a phallic presence in the boy, sight of a phallic absence in the girl, ultimately sight of a phallic absence in the mother. *Sexual difference takes its decisive significance from a sighting.*"[42] Is it not because the phallus is the most visible sign of sexual difference that it has become the "privileged signifier"? However, it is not only the discovery of difference, but also its denial that hinges upon vision (although the reduction of difference to a common measure—woman judged according to the man's standard and found lacking—is already a denial). As Freud proposed in his 1926 paper "Fetishism," the male child often takes the last visual impression prior to the "traumatic" sighting as a substitute for the mother's "missing" penis:

Thus the foot or the shoe owes its attraction as a fetish, or part of it, to the circumstance that the inquisitive boy used to peer up at the woman's legs towards her genitals. Velvet and fur reproduce—as has long been suspected—the sight of the pubic hair which ought to have revealed the longed-for penis; the underlinen so often adopted as a fetish reproduces the scene of undressing, the last moment in which the woman could still be regarded as phallic.[43]

What can be said about the visual arts in a patriarchal order that privileges vision over the other senses? Can we not expect them to be a domain of masculine privilege—as their histories indeed prove them to be—a means, perhaps, of mastering through representation the "threat" posed by the female? In recent years there has emerged a visual arts practice informed by feminist theory and addressed, more or less explicitly, to the issue of representation and sexuality—both masculine and feminine. Male artists have tended

to investigate the social construction of masculinity (Mike Glier, Eric Bogosian, the early work of Richard Prince); women have begun the long-overdue process of deconstructing femininity. Few have produced new, "positive" images of a revised femininity; to do so would simply supply and thereby prolong the life of the existing representational apparatus. Some refuse to represent women at all, believing that no representation of the female body in our culture can be free from phallic prejudice. Most of these artists, however, work with the existing repertory of cultural imagery—not because they either lack originality or criticize it—but because their subject, feminine sexuality, is always constituted in and as representation, a representation of difference. It must be emphasized that these artists are not primarily interested in what representations say about women; rather, they investigate what representation *does* to women (for example, the way it invariably positions them as objects of the male gaze). For, as Lacan wrote, "Images and symbols *for* the woman cannot be isolated from images and symbols *of* the woman. . . . It is representation, the representation of feminine sexuality whether repressed or not, which conditions how it comes into play."[44]

Critical discussions of this work have, however, assiduously avoided—skirted—the issue of gender. Because of its generally deconstructive ambition, this practice is sometimes assimilated to the modernist tradition of demystification. (Thus, the critique of representation in this work is collapsed into ideological critique.) In an essay devoted (again) to allegorical procedures in contemporary art, Benjamin Buchloh discusses the work of six women artists—Dara Birnbaum, Jenny Holzer, Barbara Kruger, Louise Lawler, Sherrie Levine, Martha Rosler—claiming them for the model of "secondary mythification" elaborated in Roland Barthes's 1957 *Mythologies.* Buchloh does not acknowledge the fact that Barthes later repudiated this methodology—a repudiation that must be seen as part of his increasing refusal of mastery from *The Pleasure of the Text* on.[45] Nor does Buchloh grant any particular significance to the fact that all these artists are women; instead, he

provides them with a distinctly male genealogy in the Dada tradition of collage and montage. Thus, all six artists are said to manipulate the languages of popular culture—television, advertising, photography—in such a way that "their ideological functions and effects become *transparent*"; or again, in their work, "the minute and seemingly inextricable interaction of behavior and ideology" supposedly becomes an "*observable* pattern."[46]

But what does it mean to claim that these artists render the invisible visible, especially in a culture in which visibility is always on the side of the male, invisibility on the side of the female? And what is the critic really saying when he states that these artists reveal, expose, "unveil" (this last word is used throughout Buchloh's text) hidden ideological agendas in mass-cultural imagery? Consider, for the moment, Buchloh's discussion of the work of Dara Birnbaum, a video artist who re-edits footage taped directly from broadcast television. Of Birnbaum's *Technology/Transformation: Wonder Woman* (1978–79), based on the popular television series of the same name, Buchloh writes that it "unveils the puberty fantasy of Wonder Woman." Yet, like all of Birnbaum's work, this tape is dealing not simply with mass-cultural imagery, but with mass-cultural *images of women.* Are not the activities of unveiling, stripping, laying bare in relation to a female body unmistakably male prerogatives?[47] Moreover, the women Birnbaum re-presents are usually athletes and performers absorbed in the display of their own physical perfection. They are without defect, without lack, and therefore with neither history nor desire. (Wonder Woman is the perfect embodiment of the phallic mother.) What we recognize in her work is the Freudian trope of the narcissistic woman, or the Lacanian "theme" of femininity as contained spectacle, which exists only as a representation of masculine desire.[48]

The deconstructive impulse that animates this work has also suggested affinities with poststructuralist textual strategies, and much of the critical writing about these artists—including my own—has tended simply to translate their work into French. Certainly, Foucault's discussion of the West's strategies of marginalization and exclu-

sion, Derrida's charges of "phallocentrism," Deleuze and Guattari's "body without organs" would all seem to be congenial to a feminist perspective. (As Irigaray has observed, is not the "body without organs" the historical condition of woman?)[49] Still, the affinities between poststructuralist theories and postmodernist practice can blind a critic to the fact that, when women are concerned, similar techniques have very different meanings. Thus, when Sherrie Levine appropriates—literally takes—Walker Evans's photographs of the rural poor or, perhaps more pertinently, Edward Weston's photographs of his *son* Neil posed as a classical Greek torso [3], is she simply dramatizing the diminished possibilities for creativity in an image-saturated culture, as is often repeated? Or is her refusal of authorship not in fact a refusal of the

3. Sherrie Levine, *Photograph After Edward Weston*, photograph, 1980. (from Hal Foster, *The Anti-Aesthetic*).

role of creator as "father" of his work, of the paternal rights assigned to the author by law?[50] (This reading of Levine's strategies is supported by the fact that the images she appropriates are invariably images of the Other: women, nature, children, the poor, the insane. . . .[51]) Levine's disrespect for paternal authority suggests that her activity is less one of appropriation—a laying hold and grasping—and more one of expropriation: she expropriates the appropriators.

Sometimes Levine collaborates with Louise Lawler under the collective title "A Picture Is No Substitute for Anything"—an unequivocal critique of representation as traditionally defined. (E.H. Gombrich: "All art is image-making, and all image-making is the creation of substitutes.") Does not their collaboration move us to ask what the picture is supposedly a substitute for, what it replaces, what absence it conceals? And when Lawler shows "A Movie Without the Picture," as

she did in 1979 in Los Angeles and again in 1983 in New York, is she simply soliciting the spectator as a collaborator in the production of the image? Or is she not also denying the viewer the kind of visual pleasure which cinema customarily provides—a pleasure that has been linked with the masculine perversions voyeurism and scopophilia?[52] It seems fitting, then, that in Los Angeles she screened (or didn't screen) *The Misfits*—Marilyn Monroe's last completed film. So that what Lawler withdrew was not simply a picture, but the archetypal image of feminine desirability.

When Cindy Sherman, in her untitled black-and-white studies for film stills (made in the late '70s and early '80s), first costumed herself to resemble heroines of grade-B Hollywood films of the late '50s and early '60s and then photographed herself in situations suggesting some immanent danger lurking just beyond the frame [4], was she

4. Cindy Sherman, *Untitled Film Still,* photograph, 1980. Metro Pictures, New York.

simply attacking the rhetoric of "auteurism by equating the known artifice of the actress in front of the camera with the supposed authenticity of the director behind it"?[53] Or was her play-acting not also an acting out of the psychoanalytic notion of femininity as masquerade, that is, as a representation of male desire? As Hélène Cixous has written, "One is always in representation, and when a woman is asked to take place in this representation, she is, of course, asked to represent man's desire."[54] Indeed, Sherman's photographs themselves function as mirror-masks that reflect back at the viewer his own desire (and the spectator posited by this work is invariably male)—specifically, the masculine desire to fix the woman in a stable and stabilizing identity. But this is precisely what Sherman's work denies: for while her photographs are always self-portraits, in them the artist never appears to be the same, indeed, not even the same model; while we can presume to recognize the same person, we are forced at the same time to recognize a trembling around the edges of that identity.[55] In a subsequent series of works, Sherman abandoned the film-still format for that of the magazine centerfold, opening herself to charges that she was an accomplice in her own objectification, reinforcing the image of the woman bound by the frame.[56] This may be true; but while Sherman may pose as a pinup, she still cannot be pinned down.

Finally, when Barbara Kruger collages the words "Your gaze hits the side of my face" over an image culled from a '50s photo-annual of a female bust [1], is she simply "making an equation . . . between aesthetic reflection and the alienation of the gaze: both reify"?[57] Or is she not speaking instead of the *masculinity* of the look, the ways in which it objectifies and masters? Or when the words "You invest in the divinity of the masterpiece" appear over a blown-up detail of the creation scene from the Sistine ceiling, is she simply parodying our reverence for works of art, or is this not a commentary on artistic production as a contract between fathers and sons? The address of Kruger's work is always gender specific; her point, however, is not that masculinity and femininity are fixed positions assigned in advance by the representational apparatus. Rather, Kruger uses a term with no fixed content, the linguistic shifter ("I/you"), in order to demonstrate that masculine and feminine themselves are not stable identities, but subject to ex-change.

There is irony in the fact that all these practices, as well as the theoretical work that sustains them, have emerged in a historical situation supposedly characterized by its complete indifference. In the visual arts we have witnessed the gradual dissolution of once fundamental distinctions—original/copy, authentic/inauthentic, function/ornament. Each term now seems to contain its opposite, and this indeterminacy brings with it an impossibility of choice or, rather, the absolute equivalence and hence interchangeability of choices. Or so it is said.[58] The existence of feminism, with its insistence on difference, forces us to reconsider. For in our country good-bye may look just like hello, but only from a masculine position. Women have learned—perhaps they have always known—how to recognize the difference.

NOTES

1. Paul Ricoeur, "Civilization and National Cultures," *History and Truth*, trans. Chas. A. Kelbley (Evanston, Ill.: Northwestern University Press, 1965), p. 278.

2. Hayden White, "Getting Out of History," *diacritics*, 12, 3 (Fall 1982), p. 3. Nowhere does White acknowledge that it is precisely this universality that is in question today.

3. See, for example, Louis Marin, "Toward a Theory of Reading in the Visual Arts: Poussin's *The Arcadian Shepherds,*" in S. Suleiman and I. Crosman, eds., *The Reader in the Text* (Princeton, N.J.: Princeton University Press, 1980), pp. 293–324. This essay reiterates the main points of the first section of Marin's *Détruire le peinture* (Paris: Galilée, 1977). See also Christian Metz's discussion of the enunciative apparatus of cinematic representation in his "History/Discourse: A Note on Two Voyeurisms" in *The Imaginary Signifier*, trans. Britton, Williams, Brewster and

Guzzetti (Bloomington: Indiana University Press, 1982). And for a general survey of these analyses, see my "Representation, Appropriation & Power," *Art in America*, 70, 5 (May 1982), pp. 9–21.

4. Hence Kristeva's problematic identification of avant-garde practice as feminine—problematic because it appears to act in complicity with all those discourses which exclude women from the order of representation, associating them instead with the presymbolic (Nature, the Unconscious, the body, etc.).

5. Jacques Derrida, "Sending: On Representation," trans. P. and M. A. Caws, *Social Research*, 49, 2 (Summer 1982), pp. 325, 326, italics added. (In this essay Derrida is discussing Heidegger's "The Age of the World Picture," a text to which I will return.) "Today there is a great deal of thought against representation," Derrida writes. "In a more or less articulated or rigorous way, this judgment is easily arrived at: representation is bad. . . . And yet, whatever the strength and the obscurity of this dominant current, the authority of representation constrains us, imposing itself on our thought through a whole dense, enigmatic, and heavily stratified history. It programs us and precedes us and warns us too severely for us to make a mere object of it, a representation, an object of representation confronting us, before us like a theme" (p. 304). Thus, Derrida concludes that "the essence of representation is not a representation, it is not representable, *there is no representation of representation*" (p. 314, italics added).

6. Michèle Montrelay, "Recherches sur la femininité," *Critique*, 278 (July 1970); translated by Parveen Adams as "Inquiry into Femininity," *m/f*, 1 (1978); repr. in *Semiotext(e)*, 10 (1981), p. 232.

7. Many of the issues treated in the following pages—the critique of binary thought, for example, or the privileging of vision over the other senses—have had long careers in the history of philosophy. I am interested, however, in the ways in which feminist theory articulates them onto the issue of sexual privilege. Thus, issues frequently condemned as merely epistemological turn out to be political as well. (For an example of this kind of condemnation, see Andreas Huyssens, "Critical Theory and Modernity," *New German Critique*, 26 [Spring/Summer 1982], pp. 3–11.) In fact, feminism demonstrates the impossibility of maintaining the split between the two.

8. "What is unquestionably involved here is a conceptual foregrounding of the sexuality of the woman, which brings to our attention a remarkable oversight." Jacques Lacan, "Guiding Remarks for a Congress on Feminine Sexuality," in J. Mitchell and J. Rose, eds., *Feminine Sexuality* (New York: Norton and Pantheon, 1982), p. 87.

9. See my "The Allegorical Impulse: Toward a Theory of Postmodernism" (part 2), *October*, 13 (Summer 1980),

pp. 59–80. *Americans on the Move* was first performed at The Kitchen Center for Video, Music, and Dance in New York City in April 1979; it has since been revised and incorporated into Anderson's two-evening work *United States, Parts I–IV*, first seen in its entirety in February 1983 at the Brooklyn Academy of Music.

10. This project was brought to my attention by Rosalyn Deutsche.

11. As Stephen Heath writes, "Any discourse which fails to take account of the problem of sexual difference in its own enunciation and address will be, within a patriarchal order, precisely indifferent, a reflection of male domination." "Difference," *Screen*, 19, 4 (Winter 1978–79), p. 53.

12. Martha Rosler, "Notes on Quotes," *Wedge*, 2 (Fall 1982), p. 69.

13. Jean-François Lyotard, *La Condition postmoderne* (Paris: Minuit, 1979), p. 29.

14. See Sarah Kofman, *Le Respect des femmes* (Paris: Galilée, 1982). A partial English translation appears as "The Economy of Respect: Kant and Respect for Women," trans. N. Fisher, *Social Research*, 49, 2 (Summer 1982), pp. 383–404.

15. Why is it always a question of *distance?* For example, Edward Said writes, "Nearly everyone producing literary or cultural studies makes no allowance for the truth that all intellectual or cultural work occurs somewhere, at some times, on some very precisely mapped-out and permissible terrain, which is ultimately contained by the State. Feminist critics have opened this question part of the way, but *they have not gone the whole distance.*" "American 'Left' Literary Criticism," *The World, the Text, and the Critic* (Cambridge, Mass.: Harvard University Press, 1983), p. 169. Italics added.

16. Fredric Jameson, *The Political Unconscious* (Ithaca, N.Y.: Cornell University Press, 1981), p. 84.

17. Marx and Engels, *The German Ideology* (New York: International Publishers, 1970), p. 42. One of the things that feminism has exposed is Marxism's scandalous blindness to sexual inequality. Both Marx and Engels viewed patriarchy as part of a precapitalist mode of production, claiming that the transition from a feudal to a capitalist mode of production was a transition from male domination to domination by capital. Thus, in the *Communist Manifesto* they write, "The bourgeoisie, wherever it has got the upper hand, has put an end to all feudal, patriarchal . . . relations." The revisionist attempt (such as Jameson proposes in *The Political Unconscious*) to explain the persistence of patriarchy as a survival of a previous mode of production is an inadequate response to the challenge posed by feminism to Marxism. Marxism's difficulty with feminism is not part of an ideological bias inherited from outside; rather, it is a structural effect of its privileging of

production as the definitively human activity. On these problems, see Isaac D. Balbus, *Marxism and Domination* (Princeton, N.J.: Princeton University Press, 1982), especially chapter 2, "Marxist Theories of Patriarchy," and chapter 5, "Neo-Marxist Theories of Patriarchy." See also Stanley Aronowitz, *The Crisis in Historical Materialism* (Brooklyn: J.F. Bergin, 1981), especially chapter 4, "The Question of Class."

18. Lyotard, "One of the Things at Stake in Women's Struggles," *Substance*, 20 (1978), p. 15.

19. Perhaps the most vociferous feminist antitheoretical statement is Marguerite Duras's: "The criterion on which men judge intelligence is still the capacity to theorize and in all the movements that one sees now, in whatever area it may be, cinema, theater, literature, the theoretical sphere is losing influence. It has been under attack for centuries. It ought to be crushed by now, it should lose itself in a reawakening of the senses, blind itself, and be still." In E. Marks and I. de Courtivron, eds., *New French Feminisms* (New York: Schocken, 1981), p. 111. The implicit connection here between the privilege men grant to theory and that which they grant to vision over the other senses recalls the etymology of *theoria;* see below.

Perhaps it is more accurate to say that most feminists are ambivalent about theory. For example, in Sally Potter's film *Thriller* (1979)—which addresses the question "Who is responsible for Mimi's death?" in *La Bohème*—the heroine breaks out laughing while reading aloud from Kristeva's introduction to *Théorie d'ensemble*. As a result, Potter's film has been interpreted as an antitheoretical statement. What seems to be at issue, however, is the inadequacy of currently existing theoretical constructs to account for the specificity of a woman's experience. For as we are told, the heroine of the film is "searching for a theory that would explain her life and her death." On *Thriller*, see Jane Weinstock, "She Who Laughs First Laughs Last," *Camera Obscura*, 5 (1980).

20. Published in *Screen*, 16, 3 (Autumn 1975).

21. See my "Earthwords," *October*, 10 (Fall 1979), pp. 120–32.

22. "No Essential Femininity: A Conversation Between Mary Kelly and Paul Smith," *Parachute*, 26 (Spring 1982), p. 33.

23. Lyotard, *La Condition postmoderne*, p. 8.

24. Ibid., p. 68.

25. Jameson, " 'In the Destructive Element Immerse': Hans-Jürgen Syberberg and Cultural Revolution," *October*, 17 (Summer 1981), p. 113.

26. See, for example, "Fantasia of the Library," in D.F. Bouchard, ed., *Language, counter-memory, practice* (Ithaca, N.Y.: Cornell University Press, 1977), pp. 87–109. See also Douglas Crimp, "On the Museum's Ruins," in *The Anti-Aesthetic: Essays on Postmodern Culture*, Hal

Foster, ed. (Port Townsend, Wash.: Bay Press, 1983), pp. 43–56.

27. See Jameson, "Postmodernism and Consumer Society," ibid., pp. 111–125.

28. Jameson, *Political Unconscious*, p. 19.

29. White, p. 3.

30. Thus, the antithesis to narrative may well be allegory, which Angus Fletcher identifies as the "epitome of counter-narrative." Condemned by modern aesthetics because it speaks of the inevitable reclamation of the works of man by nature, allegory is also the epitome of the antimodern, for it views history as an irreversible process of dissolution and decay. The melancholic, contemplative gaze of the allegorist need not, however, be a sign of defeat; it may represent the superior wisdom of one who has relinquished all claims to mastery.

31. Translated by William Lovitt and published in *The Question Concerning Technology* (New York: Harper & Row, 1977), pp. 115–54. I have, of course, oversimplified Heidegger's complex and, I believe, extremely important argument.

32. Ibid., pp. 149, 50. Heidegger's definition of the modern age—as the age of representation for the purpose of mastery—coincides with Theodor Adorno and Max Horkheimer's treatment of modernity in their *Dialectic of Enlightenment* (written in exile in 1944, but without real impact until its republication in 1969). "What men want to learn from nature," Adorno and Horkheimer write, "is how to use it in order wholly to dominate it and other men." And the primary means of realizing this desire is (what Heidegger, at least, would recognize as) representation—the suppression of "the multitudinous affinities between existents" in favor of "the single relation between the subject who bestows meaning and the meaningless object." What seems even more significant, in the context of this essay, is that Adorno and Horkheimer repeatedly identify this operation as "patriarchal."

33. Jameson, "Interview," *diacritics*, 12, 3 (Fall 1982), p. 87.

34. Lyotard, *La Condition postmoderne*, p. 63. Here, Lyotard argues that the *grands récits* of modernity contain the seeds of their own delegitimation.

35. For more on this group of painters, see my "Honor, Power and the Love of Women," *Art in America*, 71, 1 (January 1983), pp. 7–13.

36. Martha Rosler interviewed by Martha Gever in *Afterimage* (October 1981), p. 15. *The Bowery in Two Inadequate Descriptive Systems* has been published in Rosler's book *3 Works* (Halifax: The Press of The Nova Scotia College of Art and Design, 1981).

37. "Intellectuals and Power: A Conversation Between Michel Foucault and Gilles Deleuze," *Language, counter-memory, practice*, p. 209. Deleuze to Foucault: "In my

opinion, you were the first—in your books and in the practical sphere—to teach us something absolutely fundamental: the indignity of speaking for others."

The idea of a counter-discourse also derives from this conversation, specifically from Foucault's work with the "Groupe d'information de prisons." Thus, Foucault: "When the prisoners began to speak, they possessed an individual theory of prisons, the penal system, and justice. It is this form of discourse which ultimately matters, a discourse against power, the counter-discourse of prisoners and those we call delinquents—and not a theory *about* delinquency."

38. Martha Rosler, "in, around, and afterthoughts (on documentary photography)," *3 Works*, p. 79.

39. Quoted in Heath, p. 84.

40. Interview with Luce Irigaray in M.-F. Hans and G. Lapouge, eds., *Les Femmes, la pornographie, l'erotisme* (Paris, 1978), p. 50.

41. *Civilization and Its Discontents*, trans. J. Strachey (New York: Norton, 1962), pp. 46–47.

42. Jane Gallop, *Feminism and Psychoanalysis: The Daughter's Seduction* (Ithaca, N.Y.: Cornell University Press, 1982), p. 27.

43. "On Fetishism," repr. in Philip Rieff, ed., *Sexuality and the Psychology of Love* (New York: Collier, 1963), p. 217.

44. Lacan, p. 90.

45. On Barthes's refusal of mastery, see Paul Smith, "We Always Fail—Barthes' Last Writings," *SubStance*, 36 (1982), pp. 34–39. Smith is one of the few male critics to have directly engaged the feminist critique of patriarchy without attempting to rewrite it.

46. Benjamin Buchloh, "Allegorical Procedures: Appropriation and Montage in Contemporary Art," *Artforum*, XXI, 1 (September 1982), pp. 43–56.

47. Lacan's suggestion that "the phallus can play its role only when veiled" suggests a different inflection of the term "unveil"—one that is not, however, Buchloh's.

48. On Birnbaum's work, see my "Phantasmagoria of the Media," *Art in America*, 70, 5 (May 1982), pp. 98–100.

49. See Alice A. Jardine, "Theories of the Feminine: Kristeva," *enclitic*, 4, 2 (Fall 1980), pp. 5–15.

50. "The author is reputed the father and owner of his work: literary science therefore teaches *respect* for the manuscript and the author's declared intentions, while society asserts the legality of the relation of author to work

(the '*droit d'auteur*' or 'copyright,' in fact of recent date since it was only really legalized at the time of the French Revolution). As for the Text, it reads without the inscription of the Father." Roland Barthes, "From Work to Text," *Image/Music/Text*, trans. S. Heath (New York: Hill and Wang, 1977), pp. 160–61.

51. Levine's first appropriations were images of maternity (women in their natural role) from ladies' magazines. She then took landscape photographs by Eliot Porter and Andreas Feininger, then Weston's portraits of Neil, then Walker Evans's FSA photographs. Her recent work is concerned with Expressionist painting, but the involvement with images of alterity remains: she has exhibited reproductions of Franz Marc's pastoral depictions of animals, and Egon Schiele's self-portraits (madness). On the thematic consistency of Levine's "work," see my review, "Sherrie Levine at A & M Artworks," *Art in America*, 70, 6 (Summer 1982), p. 148.

52. See Metz, "The Imaginary Signifier."

53. Douglas Crimp, "Appropriating Appropriation," in Paula Marincola, ed., *Image Scavengers: Photography* (Philadelphia: Institute of Contemporary Art, 1982), p. 34.

54. Hélène Cixous, "Entretien avec Françoise van Rossum-Guyon," quoted in Heath, p. 96.

55. Sherman's shifting identity is reminiscent of the authorial strategies of Eugenie Lemoine-Luccioni as discussed by Jane Gallop; see *Feminism and Psychoanalysis*, p. 105: "Like children, the various productions of an author date from different moments, and cannot strictly be considered to have the same origin, the same author. At least we must avoid the fiction that a person is the same, unchanging throughout time. Lemoine-Luccioni makes the difficulty patent by signing each text with a different name, all of which are 'hers.'"

56. See, for example, Martha Rosler's criticisms in "Notes on Quotes," p. 73: "Repeating the images of woman bound in the frame will, like Pop, soon be seen as a *confirmation* by the 'post-feminist' society."

57. Hal Foster, "Subversive Signs," *Art in America*, 70, 10 (November 1982), p. 88.

58. For a statement of this position in relation to contemporary artistic production, see Mario Perniola, "Time and Time Again," *Artforum*, XXI, 8 (April 1983), pp. 54–55. Perniola is indebted to Baudrillard; but are we not back with Ricoeur in 1962—that is, at precisely the point at which we started?

NOTES ON THE CONTRIBUTORS

MARILYNN LINCOLN BOARD is Assistant Professor of Art History at the State University of New York, Geneseo. Her other publications include articles on G. F. Watts, Alice Neel, and Nancy Spero. Two books in progress explore the iconography of Spero and Watts.

PETER BROOKS is Tripp Professor of Humanities and Director of the Whitney Humanities Center at Yale University, where he teaches in the departments of French and Comparative Literature. He is the author of *The Novel of Worldliness* (1969), *The Melodramatic Imagination* (1976; paperback reprint, 1985), and *Reading for the Plot* (1984; paperback reprint, 1985). His latest book, *Storied Bodies*, a study of narrative and the body, is in press. His articles and reviews have appeared in such periodicals as *The New York Times Book Review, Critical Inquiry,* and *Times Literary Supplement.*

NORMA BROUDE, Professor of Art History at The American University in Washington, D.C., is the author of *The Macchiaioli: Italian Painters of the Nineteenth Century* (1987), *Impressionism, A Feminist Reading: The Gendering of Art, Science, and Nature in the Nineteenth Century* (1991), and *Georges Seurat* (1992). In addition to the present volume and *Feminism and Art History* (1982), both co-edited with Mary D. Garrard, she has also edited and contributed to *Seurat in Perspective* (1978) and *World Impressionism: The International Movement, 1860–1920* (1990; editions in English, French, German, and Italian). She is currently General Editor of The Rizzoli Art Series.

MARGARET D. CARROLL, Associate Professor of Art History at Wellesley College, has published several articles on aspects of Rembrandt, and on peasants and politics in the sixteenth century. She is currently writing a book, *Paradigms of Power: Gender Imagery and Political Theory in European Art.*

MARY ANN CAWS is Distinguished Professor of French and Comparative Literature at the Graduate School of the City University of New York, and co-director of the Henri Peyre Institute for the Humanities. Among her many books are *The Poetry of Dada and Surrealism, The Eye in the Text: Essays in Perception, The Metapoetics of the Passage: Architextures in Surrealism and After, Reading Frames in Modern Fiction,* and most recently, *The Art of Interference: Stressed Readings in Visual and Verbal Texts.* She is past president of the Modern Language Association and of the American Comparative Literature Association.

CAROL DUNCAN is Professor of Art History in the School of Contemporary Arts, Ramapo College of New Jersey. She has published numerous articles on a variety of aspects of modern art, from the eighteenth through twentieth centuries, and on the art museum, virtually all of which have been anthologized. Her influential social and feminist analyses will soon appear in a collected edition of her writings, to be published by Cambridge University Press. A book on the art museum, *Civilizing Rituals: A Study of Public Art Museums* is also in progress.

YAEL EVEN, Assistant Professor of Art History at the University of Missouri at Saint Louis, has published articles and reviews on aspects of Italian Renaissance art. In her recent work and work in progress, she has examined the relationship between Ghiberti and Brunelleschi, Michelangelo's images of women, images of women by male and female artists, and the heroine as hero.

TAMAR GARB is Lecturer in History of Art at University College of the University of London. She has published *Women Impressionists* (1986), *The Correspondence of Berthe Morisot with Her Family and Friends* (ed., with Kathleen Adler, 1986), and *Berthe Morisot* (with K. Adler, 1987). Her published and forthcoming articles concern Berthe Morisot, Marie Bashkirtseff, women artists and the nude, and issues of gender and representation.

MARY D. GARRARD is Professor of Art History at The American University, Washington, D. C. She is the au-

thor of *Artemisia Gentileschi: The Image of the Female Hero in Italian Baroque Art* (1989; paperback edition, 1991) and of articles and reviews on feminism and art history, Jacopo Sansovino, Michelangelo and Raphael, and Renaissance sculpture. With Norma Broude, she co-edited *Feminism and Art History* (1982) and the present volume. Her current work includes a study of Sofonisba Anguissola and a book in progress entitled *Nature, Art, and Gender in Renaissance Italy.*

RONA GOFFEN is Distinguished Professor and Chair of the Department of Art History at Rutgers University. She is the author of numerous articles and reviews, and of *Piety and Patronage in Renaissance Venice: Bellini, Titian, and the Franciscans* (1986; revised paperback edition, 1990); *Spirituality in Conflict: Saint Francis and Giotto's Bardi Chapel* (1988); *Giovanni Bellini* (1989; Italian edition, 1990); and co-editor, with Marcel Tetel and Ronald Witt, of *Life and Death in Fifteenth-Century Florence* (1989). Another book, *Titian's Women,* is in progress.

JANICE HELLAND is Assistant Professor of Art History at Concordia University in Montreal, Canada. She recently completed her doctorate at the University of Victoria, B.C., and has published articles and reviews on Frances MacDonald, Leonora Carrington, and feminist art history. Her current work examines the relation between friendship and art-making among women of the Glasgow School.

ANNE HIGONNET is Assistant Professor of Art History at Wellesley College. Her publications include articles on gender and representation in nineteenth-century France, on women's visual culture in the nineteenth and twentieth centuries, and on the National Museum of Women in the Arts. Her book *Berthe Morisot: A Biography* (Paris, 1989; New York and London, 1990; Stockholm, 1991) will be followed by *Berthe Morisot's Images of Women* (1992).

NATALIE BOYMEL KAMPEN, Professor of Women's Studies and Art History at Barnard College, has published many articles and reviews on Greek and Roman art. She is the author of *Image and Status: Roman Working Women in Ostia* (1981); a curriculum manual, *Women in Classical Antiquity* (with Sarah B. Pomeroy, 1983); and the catalogues *Renaissance Graphics* (with Winslow Ames, 1971) and *Hera: Five Years* (1979). She is a co-author of the forthcoming *Sourcebook for Women in Antiquity.*

HELEN S. LANGA is a Ph.D. candidate in American art history at the University of North Carolina, Chapel Hill. She has published an article on Lilly Martin Spencer, and

has lectured on women printmakers, Nicaraguan art and popular culture, and other topics. Also an artist, she has exhibited in North Carolina and Washington, D. C.

BARBARA BUHLER LYNES, Professor and Chair of the Art History Department at the Maryland Institute, College of Art, Baltimore, has published articles and reviews on aspects of Italian Renaissance art, and on Georgia O'Keeffe. She is the author of *O'Keeffe, Stieglitz and the Critics, 1916–1929* (1991). Work in progress includes *Critics on the Art of Georgia O'Keeffe: 1930–1990.*

MARGARET R. MILES, Bussey Professor of Theology at Harvard Divinity School, is the author of numerous articles and reviews that connect theology, art, and feminism. Her publications include, among many books, *Image as Insight: Visual Understanding in Western Christianity and Secular Culture* (1985); *Immaculate and Powerful: The Female in Sacred Image and Social Reality* (co-editor, with Clarissa W. Atkinson and Constance H. Buchanan, 1985; United Kingdom edition, 1987); and *Carnal Knowing: Female Nakedness and Religious Meaning in the Christian West* (1989).

LINDA NOCHLIN is Professor of the History of Art at Yale University. Author of the ground-breaking article "Why Have There Been No Great Women Artists?" (1971), she is widely known for her work on women artists and issues of gender in nineteenth-century art. Her collected essays have appeared in two volumes, *Women, Art, and Power and Other Essays* (1988) and *The Politics of Vision: Essays on Nineteenth-Century Art and Society* (1989). She is also the author of *Realism* (1971) and was co-curator of the exhibitions "Women Artists, 1550–1950" (with Ann Sutherland Harris, 1976) and "Courbet Reconsidered" (with Sarah Faunce, 1988).

CRAIG OWENS, recently deceased, was a critic and senior editor at *Art in America.* He published widely on issues of contemporary art. The article included here and his "Representation, Appropriation and Power" (*Art in America,* May 1982), were among his many influential contributions to the discussion of postmodern art theory.

GRISELDA POLLOCK is Professor of the Social and Critical Histories of Art, and Director of the Center for Cultural Studies, at the University of Leeds (England). Known also for her work on Van Gogh and on Pre-Raphaelite art, she is the author of books on feminist art history, as well as several volumes of collected essays. These books include *Mary Cassatt* (1980); *Old Mistresses: Women, Art and Ideology* (with Rozsika Parker, 1981); *Framing Feminism: Art and the Women's Movement, 1970–85* (with R.

Parker, 1987); and *Vision and Difference: Feminism, Femininity and the Histories of Art* (1988). Forthcoming is *Differencing the Canon: Desiring Feminist Histories* (1992).

PATRICIA L. REILLY earned her M. A. degree in the history of art at Bryn Mawr College, and is currently working on her Ph.D. dissertation in the Department of Rhetoric at the University of California, Berkeley. The essay included here, also published in *Genders*, is her first publication.

JAMES M. SASLOW is Associate Professor of Art History at Queens College of the City University of New York. He is the author of *Ganymede in The Renaissance: Homosexuality in Art and Society* (1986; Spanish edition, 1990) and *The Poetry of Michelangelo: An Annotated Translation* (1991). A specialist in Italian Renaissance art, he is also a pioneer in the emerging field of lesbian and gay studies, and has written articles and lectured widely on aspects of homosexuality and the arts.

PATRICIA SIMONS is Associate Professor of the History of Art and Women's Studies at the University of Michigan. She has written articles and reviews and delivered papers on Renaissance art, especially portraiture, and on women's art; she was co-editor, with F. W. Kent, of *Patronage, Art, and Society in Renaissance Italy* (1987). In 1988, she compiled *Gender and Sexuality in Renaissance and Baroque Italy: A Working Bibliography* (a second, annotated edition is forthcoming).

LOWERY S. SIMS is Associate Curator in the Department of Twentieth-Century Art at the Metropolitan Museum of Art, New York, where she recently curated a major exhibition on Stuart Davis. She has written extensively on contemporary artists, with a special interest in African, Latin American, Native American, and Asian-American artists. She holds an M.A. degree in art history from the Johns Hopkins University, and is currently a Ph.D. candidate at the Graduate Center of the City University of New York. She received the 1991 Frank Jewett Mather Award

from the College Art Association for distinction in art criticism.

ABIGAIL SOLOMON-GODEAU is an art historian and critic, who has written widely on issues of modern and contemporary art and photography in such journals as *Art in America*. She currently teaches at the University of California at Santa Barbara. A book of her essays, *Photography at the Dock*, is forthcoming.

FREIDA HIGH W. TESFAGIORGIS, who is both an artist and an art historian, is Professor of African and Afro-American Art in the Department of Afro-American Studies at the University of Wisconsin. She has curated numerous exhibitions of African and Afro-American art, including "The Wisconsin Connection: Black Artists Past and Present" (1987), and has published essays in exhibition catalogues, periodicals, and encyclopedias. Her art has been exhibited nationally and in West Africa.

ANNE M. WAGNER is Associate Professor at the University of California, Berkeley. Her publications include articles on Carpeaux, nineteenth-century sculpture, Courbet, Rodin, and Monet, as well as diverse reviews. Her book, *Jean-Baptiste Carpeaux: Sculptor of the Second Empire*, was published in 1986 (paperback edition, 1990).

JOSEPHINE WITHERS, Associate Professor of Art History at the University of Maryland, is the author of *Julio Gonzalez: Sculpture in Iron* (1978) and *Women Artists in Washington Collections* (exhibition catalogue, 1979). She has written articles on a wide variety of artists and topics, including nineteenth-century women artists, "blockbuster" exhibitions, Méret Oppenheim, Jody Pinto, Eleanor Antin, May Stevens, and the Guerrilla Girls. A book in progress is entitled *Musing About the Muse*.

LILIAN H. ZIRPOLO is a Ph.D. candidate in art history at Rutgers University. The article included here, her first publication (which also appeared in *Woman's Art Journal*), was delivered as a paper at the Frick Collection and Institute of Fine Arts Symposium, New York, in 1989.

INDEX